RENAISSANCE ART AND ARCHITECTURE

Gordon Campbell

OXFORD

UNIVERSITY PRESS

OXFORD
UNIVERSITY PRESS

Great Clarendon Street, Oxford OX2 6DP

Oxford University Press is a department of the University of Oxford.
It furthers the University's objective of excellence in research, scholarship,
and education by publishing worldwide in

Oxford New York

Auckland Bangkok Buenos Aires Cape Town Chennai
Dar es Salaam Delhi Hong Kong Istanbul Karachi Kolkata
Kuala Lumpur Madrid Melbourne Mexico City Mumbai Nairobi
São Paulo Shanghai Taipei Tokyo Toronto

Oxford is a registered trade mark of Oxford University Press
in the UK and in certain other countries

Published in the United States
by Oxford University Press Inc., New York

© Oxford University Press 2004

Database right Oxford University Press (maker)

First published by Oxford University Press 2004

British Library Cataloguing in Publication Data
Data available

Library of Congress Cataloging in Publication Data
Data available

ISBN 0-19-860985-X

1 3 5 7 9 10 8 6 4 2

Typeset by Pantek Arts Ltd, Maidstone, Kent
Printed in Great Britain
on acid-free paper by
Biddles Ltd
King's Lynn

CONTENTS

ACKNOWLEDGEMENTS

This book contains some 1,400 entries, each of which has at some stage been read by someone with an eye more learned than my own. Those who have read entries and improved them with their observations include Francis Ames-Lewis (Birkbeck College, London), Peter Burke (Emmanuel College, Cambridge), Iain Fenlon (King's College, Cambridge), Susan Foister (National Gallery, London), John Dixon Hunt (University of Pennsylvania), Robert Knecht (University of Birmingham), Stella Lanham (University of Leicester), John Law (University of Wales, Swansea), Jeremy Lawrance (University of Manchester), and Catherine Packham (University of Leeds). The polymath J. V. Field and the composer-musician Eleanor Graff-Baker have rewritten entries and also drafted new ones, and in several of the entries in this volume there is more of their prose than mine.

This volume was suggested by Oxford University Press editors in the United States, but editorial responsibility was undertaken by OUP editors in Oxford. The commissioning editor was Pam Coote, who was pleased that my notion of Renaissance art and architecture included gardens, a subject in which she has formidable expertise. Day-to-day oversight of the project was the responsibility of Rebecca Collins, who dealt with the usual crises with aplomb and prepared the thematic index herself. Once the text was submitted, she departed on maternity leave, during which time editorial responsibilities were ably managed by Judith Wilson, who carried the volume through to publication. I was fortunate in being able to secure once again the services of Edwin Pritchard and Jackie Pritchard as copy editors. I am also grateful to Kathie Gill, who proofread the text, production manager Emma Gotch, and designer Nick Clarke. The team seemed happy to be inconvenienced by late insertions designed to bring the volume up to date, the last of which was the identification in May 2004 of the sitter in Holbein's *Lady with a Squirrel and a Starling*.

I have been privileged in being able to travel widely in Europe for decades and to see at first hand the work of many of the artists and architects represented in this volume. Many of my European travels have been holidays, and on these journeys I have been accompanied by my wife Mary, my companion of some forty years. At the conclusion of holidays dominated by demanding schedules of cultural and historical excursions, she has sometimes thought that she deserved a certificate for what seemed to be attendance at a particularly taxing summer school rather than the rest required by her own demanding professional life. I should like to dedicate this book to her in tribute to her perseverance in cheerfully staying the course on these peripatetic seminars and throughout the periods of intensive writing between seminars.

Leicester G.C.
May 2004

INTRODUCTION
The Renaissance

Words and phrases in small capitals (e.g. VASARI) indicate entries in the main body of the book.

1. Retro Renaissance

At the turn of the millennium the Chrysler Corporation introduced a new model, the PT Cruiser. Its retro design, which recalls the shape of 1930s cars, discreetly accommodates many modern features, such as a CD player that takes six discs. Chrysler's blurb-writers describe the car as 'classic in form, flexible in function, modern where it matters most, and timeless in appeal'. It is these qualities that have appealed to buyers in North America and in Europe: it is not a thirties car, but in appearance it evokes one, and so creates an image that reaches to the past, bypassing the decadent vulgarity of the chrome monsters of the post-war period, instead connecting the buyer to what is seen as a classic age of motoring.

The most important retro movement in western cultural history is the Renaissance. There was a classic age, that of ancient Greece and Rome. There was then a period of decline now known as the Middle Ages, a term first used in the early fifteenth century. Whether the Middle Ages really constituted a period of decline is open to serious doubt, as anyone who has visited a medieval cathedral must know, but that is not the point at issue: the idea of a cultural rebirth (that being the literal meaning of 'renaissance') in art became entrenched in western historiography. This was a model that glorifed the present and the remote past but disparaged the intervening centuries.

The term 'Renaissance' (Italian *Rinascimento*) might now be defined as a model of cultural history in which the culture of fifteenth- and sixteenth-century Europe is represented as a repudiation of medieval values in favour of the revival of the culture of

ancient Greece and Rome. The parallel religious model is the Reformation, in which the Church is seen as repudiating its medieval degeneracy in favour of a renewal of the purity of the early Church. In the arts, it was Giorgio VASARI who first used the term *rinascità* to denote the period from CIMABUE and GIOTTO to his own time. The broadening of the term 'renaissance' to encompass a period and a cultural model is a product of the nineteenth century. In 1855 the historian Jules Michelet used the term 'Renaissance' in the title of a volume on sixteenth-century France. Five years later Jakob Burckhardt published *Die Cultur der Renaissance in Italien* ('The Civilization of the Renaissance in Italy'), in which he identified the idea of a Renaissance with a set of cultural concepts, such as individualism and the idea of the universal man. Vasari's designation of a movement in art had become the term for an epoch in history associated with a particular set of cultural values.

The historical model of a European Renaissance is a partial truth. There was indeed an attempt to revive the glories of ancient Greece and Rome. On the other hand, there was more continuity with the Middle Ages than is acknowledged by this model. Just as the technology of the PT Cruiser is based on the achievements of the 'dark ages' of motoring, so the Renaissance grew out of the Middle Ages. The revival of classical antiquity is an important feature of the period, but so is continuity with the immediate past.

2. Renaissance art

The term 'art' is now associated primarily with painting, but in this volume it extends to sculpture (in ALABASTER, BRASS, MARBLE, and PORPHYRY) and the various forms known collectively as the decorative arts, which include ARMS AND ARMOUR, CALLIGRAPHY, CARPETS AND RUGS, CLOCKS AND WATCHES, COINS, EMBROIDERY, ENGRAVING, FURNITURE, GLASS (including STAINED GLASS), INTARSIA, MEDALS, PLAQUETTES, POTTERY, PRINTING, ROCK CRYSTAL and TAPESTRY . Each of these terms has a general entry that leads to other entries, all of which are listed in the thematic index. For the purposes of this introductory essay, the term 'art' is for the most part restricted to painting and sculpture.

Italian art
A national style of art began to emerge in Italy in the mid-thirteenth century, some 600 years before Italy was united as a single state. In sculpture, the classical elements in the work of artists such as Nicola and Giovanni PISANO and ARNOLFO DI CAMBIO formed a style that was imitated all over Italy. In succeeding centuries, the gradual rediscovery of antique sculpture meant that Italian sculpture became the most classical of Renaissance art forms. The study of the CONTRAPPOSTO of antiquity caused the composition of classical sculptures to be revived, but the absence of paint on any surviving ancient sculpture misled Renaissance artists into thinking that ancient sculptors had not coloured their statues, and Renaissance statues, in marble and bronze at least, were therefore normally unpainted. The bronze statues of DONATELLO and the marble statues of MICHELANGELO remained unpainted, and the sense that such materials would be defaced by paint has persisted through the centuries; paradoxically, unpainted POTTERY seems unfinished to a modern eye, perhaps because the pottery of the Renaissance was richly coloured.

In the historiography of painting it is said to be CIMABUE who was the harbinger of GIOTTO and therefore the progenitor of Italian Renaissance painting. It is difficult to be confident of Cimabue's importance in this respect, but the dramatic realism of Giotto

was undoubtedly an important influence on the development of Italian art, and forms an important element in the style of successors such as Ambrogio and Pietro LORENZETTI. In the early fifteenth century, Florence became the most important artistic centre in Italy. In painting the seminal figure was MASACCIO, whose classical modelling of the human figure owes much to Donatello. Masaccio's FRESCOES in the Brancacci Chapel of Santa Maria del Carmine also mark a considerable technical advance in his creation of the illusion of a single source of light to unify a composition extending over several walls. In the middle decades of the fifteenth century the Florentine inheritors of Masaccio included Fra ANGELICO and Filippo LIPPI. In late fifteenth- and early sixteenth-century Florence, the most important artists included BOTTICELLI, PIERO DI COSIMO, and GHIRLANDAIO. The decline of Florence was marked by the death of Lorenzo de' Medici in 1492, the French invasion of Italy in 1494, and the iconoclastic rule of Savonarola (1494–8). Painting and sculpture were subsequently revived in Florence, but by then other Italian cities had become established as artistic centres, in some cases stimulated by the work of Florentine exiles. In Umbria, VERROCCHIO and PIERO DELLA FRANCESCA shaped the style of Perugian painters such as PERUGINO and PINTORICCHIO. Artists such as Piero and Paolo UCCELLO worked in Urbino, where the court of Federico da Montefeltro became an important cultural centre, and LEONARDO DA VINCI moved to Milan. In Padua, the sculptures of Donatello shaped the sculptural paintings of MANTEGNA. Mantegna was

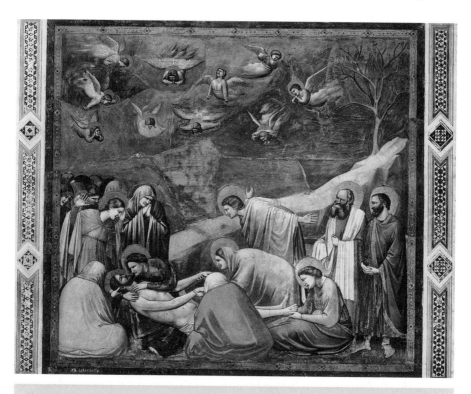

Giotto, *The Lamentation*, in the fresco cycle on *Lives of the Virgin and Christ* (1305–8) in the Arena Chapel, Padua. The cycle is unusual in its tendency to displace miracle stories in favour of human emotion, and this scene is typical in its representation of human grief. In about 1308 the fresco was copied into a choir book which is now in the Biblioteca Capitolare in Padua.

in turn an important influence on the work of his Venetian brother-in-law Giovanni BELLINI, and through him the paintings of GIORGIONE and TITIAN), and may also have influenced the fresco painters of the Este court in Ferrara, including Cosimo TURA and Francesco del COSSA.

The richness of cultural life in Renaissance Italy was largely dependent on patronage, which could be civic or private. The wealth of centres such as Florence, Milan, and Venice sustained generations of distinguished artists. In the early years of the sixteenth century the most important artistic centre in Italy was Rome, where the most powerful patron was Pope Julius II. Artists such as Michelangelo, who continued the decoration of the SISTINE CHAPEL (inaugurated by Sixtus IV), and RAPHAEL, who painted the Vatican *Stanze*, enjoyed his patronage. This period of Roman ascendancy came to an abrupt end with the Sack of Rome by imperial troops in 1527; this calamity created a hiatus in the cultural life of Rome, and when order was eventually re-established much of Italy was under Spanish control. Artistic patronage was affected by these changes, and the Counter-Reformation led to the regulation of art. In the remainder of the sixteenth century, the period of the style known as MANNERISM, the principal painters were GIULIO ROMANO and PARMIGIANINO, and the most important sculptors CELLINI and GIAMBOLOGNA.

Spanish and Portuguese art

With the exception of the Asturias, early medieval Spain was under Islamic domination, and the earliest distinctively Hispanic art is the hybrid form known as Mozarabic, the art of Spanish Christians in Moorish Spain. Throughout the period of the *Reconquista* it was Moors who were the most skilled craftsmen, and their MUDÉJAR architecture and architectural decoration inevitably influenced the development of Spanish art. The POTTERY of fifteenth- and sixteenth-century Spain, for example, is known as 'Hispano-Moresque', and the fine tiles known as *AZULEJOS* are clearly Moorish in origin.

Spain was not a unified country until the late fifteenth century, and artistic culture was markedly regional in character. The principal schools of art in fourteenth- and fifteenth-century Spain are known as the Catalan School and the Hispano-Flemish School. In the 1430s the most important figures in Catalan art were Bernat MARTORELL and Lluís DALMAU; later in the century the most important Catalan painter was Jaume HUGUET. In the Valencian School, which is sometimes distinguished from the Catalan School, the principal artist was JACOMART, whose stylistic influence can be discerned in the surviving altarpiece of Rodrigo de OSONA.

In the fifteenth century, Castile and León had important commercial links with Flanders, and Flemish art became fashionable in the court of Queen Isabella, who collected Flemish paintings and appointed one Fleming as her royal architect (Juan GUAS) and another, JUAN DE FLANDES, as her court painter. The gradual blending of Flemish styles with the native traditions of Mudéjar architectural decoration produced the distinctive style known as Hispano-Flemish or Hispano-Flamencan, which is characterized by a sombre palette, a love of architectural settings, and a demotic realism in portraiture and narrative composition. The cultural hegemony of Castile gave Hispano-Flemish art a national standing; the greatest artists in this tradition were Fernando GALLEGO and Bartolomé BERMEJO.

In the first half of the sixteenth century, the PLATERESQUE dominated architecture and decorative art. In painting and sculpture, the other important stylistic presence was Italian Mannerism. The most prominent mannerist sculptors were JUAN DE JUNI, Alonso

BERRUGUETE, and Gaspar BECERRA. In painting, the principal exponents of the mannerist style were Pedro de CAMPAÑA, Joan Vicent MAÇIP, and, above all, Pedro BERRUGUETE.

In the second half of the sixteenth century, Spanish art was dominated by the patronage of Philip II, who was preoccupied with the construction and decoration of the ESCORIAL. King Philip employed many foreign artists for his monastery-palace, but the small number of Spanish artists that he employed included the mannerist Juan FERNÁNDEZ DE NAVARRETE. Philip also introduced the tradition of the court PORTRAIT to Spain, employing the Dutch artist Antonio MORO and then the Portuguese Alonso SÁNCHEZ COELLO as court portraitists, so inaugurating the tradition that was to culminate in Velázquez and introducing the first wholly secular genre in Spanish art. Philip's patronage did not extend to those of whose style he did not approve, so neither Luis de MORALES nor El GRECO received the call to the Escorial.

In the late sixteenth and early seventeenth centuries, a new style of naturalistic Spanish painting emerged, anticipated by Juan Fernández de Navarrete's dramatic use of shading (*tenebrismo*) and characterized by the use of light and shade to portray three-dimensional shapes which were often sculptural in form. The principal exponents of this style were the painters Francisco RIBALTA, Juan Bautista Maíno (1578–1649), and Juan SÁNCHEZ COTÁN, who before he became a monk painted STILL LIFES of food.

The characteristics of Portuguese art before the mid-fifteenth century are virtually unknown, because only a few mural fragments precede the earliest surviving Portuguese paintings, the magnificent panels executed by Nuno GONÇALVES in the 1460s. In the sixteenth century a native school of Portuguese painters emerged; these prolific painters are often described as the 'Portuguese Primitives', but the term 'primitive' makes insufficient allowance for the pronounced influence of Flemish art on their paintings, and they are more accurately described as the Luso-Flemish School of painting. The only significant Portuguese painter to adopt an Italianate style was the miniaturist Francisco de HOLANDA. In sculpture, however, the influence of the Italian Renaissance was to become a central feature of sixteenth-century Portuguese art. The first artist to introduce the idioms of Italian Renaissance sculpture into Portugal was the French decorative sculptor Nicolas Chanterene (*c*.1485–*c*.1555), who worked on the north door of the Hieronymite monastery at Belém before establishing himself in Coimbra, where he became the principal sculptor and the inaugurator of the Coimbra School of sculpture, a group of French and Portuguese sculptors whose work was avowedly Italianate and erudite.

French art

Late medieval and early modern France was neither politically united nor culturally homogeneous. In fifteenth-century Burgundy, which was not part of France, the artistic culture was more Flemish than French (especially after the ducal court moved from Dijon to Bruges in 1420); in Avignon, which became a papal possession in 1348, the artistic culture was more Sienese than French, and in the fifteenth century, when artists such as Enguerrand QUARTON and Nicholas FROMENT worked in Avignon, the dominant influence was Flemish.

In the fourteenth century, Paris was Europe's most important centre of book illumination, and artists such as Jean PUCELLE were among the first to deploy the iconography and techniques of perspective that derive from the early period of the Italian Renaissance. In the fifteenth century the court at Tours offered patronage to artists such

as Jean FOUQUET, who lived for several years in Rome and introduced Italian elements into his paintings and illuminations. These isolated examples of Italian influence did not become an important force in French art until the end of the fifteenth century, when the onset of the Wars of Italy exposed French patrons to Italian art.

In the sixteenth century Italian decorative motifs began to appear in French architecture, and the interior decoration of French chateaux became the most important medium of Italian art in France. The most influential chateau was FONTAINEBLEAU, to which King Francis I brought Italian artists such as Il ROSSO FIORENTINO, PRIMATICCIO, and NICCOLÒ DELL'ABBATE. King Francis also bought and commissioned paintings by artists such as RAPHAEL and TITIAN, and persuaded LEONARDO DA VINCI and ANDREA DEL SARTO to come to France.

Italian mannerist art was quickly adapted to French courtly tastes to produce a distinctive French style characterized by emotional restraint, a secular treatment of mythological themes, and a taste for elegant etiolated nudes. Flemish influence was most important in portraiture, as is apparent in the work of the CLOUET FAMILY. In sculpture, the presence of Benvenuto CELLINI in France from 1540 to 1545 was to have a lasting influence on sculptors such as Jean GOUJON; similarly, the work of Germain PILON was shaped by his period as an assistant to Primaticcio at Fontainebleau.

Northern art
The term 'northern art' includes the art of the Netherlands, Germany, Scandinavia, central Europe, and Britain. The most important artistic centres in northern Europe were in Flanders and Germany. In the fifteenth century Burgundian patronage extended all over the Netherlands, and there was a common culture of Netherlandish art, within which there were regional centres. As north and south gradually separated, distinctive Flemish and Dutch artistic cultures began to emerge, and this process was accelerated by the population movements in the wake of the Revolt of the Netherlands, which made the north more Protestant and the south more Catholic. The proximity of Flanders to the Burgundian and Habsburg courts meant that patronage was centred there rather than in the north, and the artistic culture of Flanders soon assumed a European importance on a scale wholly disproportionate to the small size of Flanders.

In fifteenth-century Flanders the most important painters were Dieric BOUTS, Robert CAMPIN, Petrus CHRISTUS, Jan van EYCK, Hugo van der GOES, Hans MEMLING, and Rogier van der WEYDEN. Their art grew out of the indigenous tradition of manuscript illumination, and was not significantly indebted to the art of Italy; indeed, influence ran in the other direction, because fifteenth-century Flemish art had an influence on painting all over Europe. In the late fifteenth and early sixteenth centuries this pattern changed, and Flemish art, such as that of Jan GOSSAERT and Quentin MASSYS, came to be influenced by the style of Italian artists, though Pieter BRUEGEL the Elder and Hieronymus BOSCH remained firmly rooted in Flemish traditions.

In the early sixteenth century the centre of Flemish art shifted from Bruges to Antwerp, where the artists included JOOS VAN CLEVE, Jan Sanders van HEMESSEN, MARINUS VAN REYMERSWAELE, and visitors such as DÜRER and HOLBEIN. Fifteenth-century Flemish artists such as JOOS VAN WASSENHOVE had travelled to Italy as painters and teachers, but their sixteenth-century successors increasingly went to Italy to learn the art of painting and then returned home as northern mannerists. In the traditional historiography of the Flemish Renaissance, the moment deemed to symbolize the advent of the

Renaissance style in Flanders was the arrival of Raphael's cartoons for the tapestries in the SISTINE CHAPEL in Brussels in 1517; it is true that the cartoons influenced artists such as Bernaert van ORLEY, but Italian motifs had been apparent in the art of Flanders for at least a generation before the arrival of the cartoons. The most important sixteenth-century Flemish artists to paint in an Italian idiom were Lanceloot BLONDEEL, Pieter COECKE VAN AELST, Franz FLORIS, Hendrik GOLTZIUS, Willem KEY, and Lambert LOMBARD. In sixteenth-century sculpture, the influence of Italy can be seen in the work of Konrad MEIT, Jean MONE, and Jacques DU BROEUCQ, whose pupil GIAMBOLOGNA, the greatest of Flemish sculptors, pursued his career in Italy.

The most important indigenous tradition of sixteenth-century Flemish art was LAND-SCAPE PAINTING, of which the finest exponents were Herri Met de BLES, Pieter Bruegel the Elder, Gillis van CONINXLOO, and Joachim PATINIR. This tradition was continued in the late sixteenth and early seventeenth centuries in the art of painters such as Jan BRUEGHEL the Elder, Joost de MOMPER II, and Roelandt SAVERY, whose works reflect the transition from constructed to naturalistic landscapes. There was also a tradition of STILL LIFE painting which was distinguished from the parallel tradition in the northern Netherlands by a predilection for flowers (notably in the work of Jan Brueghel) and the absence of any overt didactic element.

In the sixteenth century Dutch painting achieved great distinction, and the fact that it seems to have been overshadowed by Flemish art is exaggerated by the loss of so many northern paintings. It is nonetheless true that Flanders benefited from proximity to the Burgundian court, and many Dutch artists either moved to the south (e.g. Pieter AERT-SEN and Gérard DAVID) or adopted a style influenced by painting in Antwerp (e.g. Cornelis ENGELBRECHTSZOON and LUCAS VAN LEIDEN). The link with Flanders was also maintained in Catholic Utrecht, where late sixteenth- and early seventeenth-century painters such as Abraham Bloemart, Paulus Moreelse, and Hendrick TERBRUGGHEN worked in a distinctively Flemish idiom. In the late fifteenth century Haarlem was the home of artists such as Albert van OUWATER and GEERTGEN TOT SINT JANS, and early in the sixteenth century of Jan JOEST and Jan MOSTAERT. At the end of the sixteenth century Haarlem emerged as the most important centre of Dutch art; during this period the city's artists included Cornelis CORNELISZOON, Hendrik GOLTZIUS, and Karel van MANDER.

The modern state of Germany is a creation of the nineteenth century, and its antecedent state, the Holy Roman Empire, extended far beyond the borders of modern Germany. The establishment of the imperial court in Prague led in the late sixteenth century to the emergence of Prague as the most important artistic centre in the Empire. Within what is now Germany the principal artistic centre was Nuremberg, which had strong commercial and artistic links with Italy; Augsburg, Basel (which joined the Swiss Confederation in 1501), and Cologne were the other important centres for the arts. Germany produced some of Europe's greatest painters, notably Dürer and Holbein; Germany was also the home of PRINTING and the principal European centre for ENGRAVING (including BOOK ILLUSTRATIONS). The first signs of the influence of the Italian Renaissance on German art become apparent in the 1490s (Dürer first visited Italy in 1494), but the transition from Gothic to Renaissance styles is a phenomenon of the 1520s. During this period Mathias GRÜNEWALD painted the greatest of Gothic paint-ings, the Isenheim altarpiece, but at the same time artists such as Holbein and CRANACH were beginning to incorporate Italian elements into their work.

The principal citizens of the seaports of fifteenth-century Sweden and Denmark were German traders, and the art that they installed in their churches was German, notably Bernt NOTKE's free-standing group of *St George* in Stockholm Cathedral and his carved and painted altarpiece in Århus, and Claus BERG's altarpiece in Odense. With the advent of the Reformation, art became secularized and its purpose to satisfy the tastes of the royal courts. The most important cultural centre of late sixteenth- and early seventeenth-century Scandinavia was Copenhagen, to which Kings Frederick II and Christian IV invited large numbers of Dutch and German architects, painters, sculptors, and musicians.

In central Europe main artistic centres were Kraków (which was the capital of Poland until 1569) and Prague. Polish painting began to adopt Italian idioms in the 1460s, and a decade later the German sculptor and woodcarver Veit STOSS (Polish Wit Stwosz) moved to Kraków, where he carved the vast altarpiece for the Church of Our Lady. The Emperor Charles IV established his principal residence at Prague, where he established in 1348 the university that still bears his name and attracted to his imperial court scholars and artists from all over Europe. Prague thus became an important artistic centre, but its art was international rather than Bohemian, because the artists came from Strassburg, Nuremberg, and the cities of northern Italy. By the mid-fifteenth century, Bohemia had declined in importance as a cultural centre, but a second period of artistic importance began in the early 1580s, when the Emperor Rudolf II moved the imperial court from Vienna to Prague; his court included artists such as Hans von AACHEN, Bartholomäus SPRANGER, Adriaen de VRIES, and Joris HOEFNAGEL. For the next 30 years Bohemia was one of Europe's most important artistic centres. On the death of Rudolf in 1612 the artists were dispersed and the collections gradually moved to Vienna.

In the late fourteenth and fifteenth centuries England was an important centre of ALABASTER sculptures, STAINED GLASS, and EMBROIDERY. The finest painting of the period is the Wilton Diptych (*c*.1395–9, National Gallery, London), a depiction in the style of INTERNATIONAL GOTHIC of the presentation of King Richard II to the Virgin by his patron saints; the artist may have been English or French. Towards the end of the fifteenth century, the style of Flemish art began to influence English painting; the best surviving example of this style is William Baker's series of wall paintings (1479–83) in the chapel of Eton College depicting the miracles of the Virgin.

In the sixteenth century the English Reformation stifled religious art and architecture, but the secular art of portraiture flourished early in the century with Hans Holbein's two visits to England and late in the century with portrait MINIATURISTS such as Nicholas HILLIARD and Isaac OLIVER; in the seventeenth century the principal portrait painters in England were Flemish (Sir Anthony Van Dyck), Dutch (Sir Peter Lely), or German (Sir Godfrey Kneller), and King Charles commissioned Rubens to paint the ceiling of the Banqueting House. The English architecture of the period achieved great distinction, notably in country houses, but in art England was more remarkable for its collections and the presence of foreign artists than for its indigenous traditions.

3. Renaissance architecture

Italian architecture

In the late twelfth century the Romanesque and Byzantine traditions of Italian architecture began to be penetrated by GOTHIC architecture, which in Italy as elsewhere was introduced from France by the Cistercian order, initially with Fossanova Abbey, in Lazio

(begun 1187, consecrated 1208), which has a fine Gothic chapter house (c.1250); this was the first Cistercian building in Italy, and its fame was enhanced by the presence of the grave of Thomas Aquinas, who had died in the guesthouse in 1274. Cistercian architecture in Italy culminated in the construction of the Certosa di Pavia (1396–1481).

Italian Gothic soon became a distinctive architectural style. The powerful vertical lines of Gothic architecture north of the Alps are subdued in Italian Gothic churches by horizontal cornices and string courses. Italian Gothic churches typically have a flat roof, a circular window in the west front, stripes of coloured marble instead of mouldings, and small windows without tracery; unlike northern churches, they have neither pinnacles nor flying buttresses. By the fourteenth century, Italy's Gothic churches had become much more spacious than their French prototypes, principally because the openings in the arcades are typically twice the width of those in French Gothic churches.

Many of the finest Gothic ecclesiastical buildings of the thirteenth and fourteenth centuries are Franciscan churches, such as the Church of San Francesco in Assisi (begun 1228, apparently modelled on Angers Cathedral), the Church of Santa Croce in Florence (begun 1294, attributed to ARNOLFO DI CAMBIO on stylistic grounds), and the Church of San Francesco in Siena (begun 1326). The Dominicans also built Gothic churches, notably SS Giovanni e Paolo in Venice (1246–1430) and Santa Maria Novella in Florence (1278–1470). In the ecclesiastical architecture of Rome, the Gothic style made little impact; the only Gothic church in Rome is the Dominican Santa Maria sopra Minerva (c.1290). Elsewhere in Italy, there are important Gothic churches in Bologna (San Petronio, 1390–1437), Padua (Basilica del Santo, 1232–1307), and Verona (Sant'Anastasia, 1261). The principal Gothic cathedrals in Italy are those in Florence (1296–1462), Milan (1385–1485), Orvieto (1290–1310), and Siena (1245–1380).

In secular architecture, Italy's greatest Gothic building is the Doge's Palace in Venice (1309–42). Gothic buildings continued to be built in Venice throughout the fifteenth century, including the Ca' d'Oro (1421–36), the upper part of the Campanile of San Marco (collapsed 1902 and subsequently rebuilt), and several palaces on the Grand Canal, such as the Foscari and the Contarini-Fasan (now advertised as Casa di Desdemona). The Ponte Vecchio in Florence (1345) is Gothic, as are the towers of San Gimignano; the finest example of an Italian Gothic city is Siena.

The Renaissance style was inaugurated in Florence by BRUNELLESCHI, who in 1421 began work on the Ospedale degli Innocenti (Foundling Hospital, see p. xiv), which has a loggia with a classical colonnade, semicircular arches, and hemispherical domes; the design, like those of his subsequent buildings, observes the mathematical proportions of classical antiquity. Brunelleschi also designed the sacristy (now known as the Old Sacristy) of San Lorenzo (from 1419), the dome of the cathedral (1420–34), the churches of San Lorenzo (1425) and San Spirito (1436–82), the Pazzi Chapel (from 1429/30), and the PITTI PALACE. Brunelleschi's successors included MICHELOZZO, who built the Palazzo Medici-Riccardi (begun 1444), which has the first three-storeyed façade and the first palace courtyard (cortile) in the new style, and Giuliano da SANGALLO, who erected many buildings on the principles established by Brunelleschi.

The Renaissance style was introduced to Rome by ALBERTI, who also built the first Renaissance church in Mantua (San Sebastiano, begun 1460). Michelozzo and FILARETE took the style to Milan in the 1450s. The earliest Renaissance structure in Venice is the portal of the Arsenale (1457). In Urbino, construction on the Palazzo Ducale began in the 1460s; Luciano LAURANA was appointed architect in 1468 and the palace was later completed by FRANCESCO DI GIORGIO.

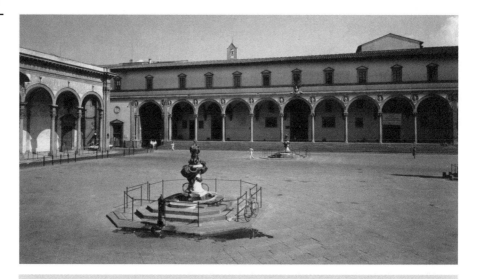

The loggia of the Ospedale degli Innocenti (1421–4), in Piazza della SS Annunziata in Florence. The building was designed by **Brunelleschi**, who received the commission in 1419. The façade was the first since classical antiquity to revive the conventions of ancient Roman architecture; its loggia consists of an arcade of Corinthian columns and semicircular arches; the roundels in the spandrels depict babies, and are the work of Andrea DELLA ROBBIA. The arcaded elevation of the Ospedale was subsequently imitated on in the church of SS Annunziata on the left of the picture.

In 1499 BRAMANTE moved from Milan to Rome and inaugurated what is known as the High Renaissance, a period deemed to last until the Sack of Rome in 1527. Bramante began ST PETER'S BASILICA (1506) and built the BELVEDERE COURT in the Vatican; RAPHAEL built the Villa MADAMA and PERUZZI built the Villa Farnesina for the banker Agostino Chigi.

The High Renaissance was followed by the style known as MANNERISM, in which motifs are used in deliberate opposition to their original purposes and contexts. The most important Italian mannerist architects are MICHELANGELO (especially his Biblioteca Laurenziana in Florence, which has columns that carry no cornices, but also his contributions to St Peter's in Rome), GIULIO ROMANO (especially his Palazzo del TÈ in Mantua, which has keystones out of line and twisted pilasters), VIGNOLA (especially his Villa FARNESE and Villa GIULIA), LIGORIO (especially the CASINO of Pope Pius IV), VASARI (especially the UFFIZI), SANSOVINO (especially the Libreria Vecchia), and SANMICHELE (the palaces of Verona). Vignola's Il Gesù Church in Rome, which was begun in 1568, had chapels instead of aisles, transepts, and an oval dome. This was the design that led to the development of BAROQUE architecture in the seventeenth century.

Spanish and Portuguese architecture

The substantial Moorish presence in late medieval Spain meant that there was a significant Islamic element in Spanish architecture. As late as the fourteenth century, it was possible to have in the Alhambra of Granada a Moorish building that was virtually untouched by the architectural traditions of Europe. In areas where the *Reconquista* had been completed in the thirteenth century, however, there was a tradition of Christian architecture, albeit transformed by MUDÉJAR traditions into distinctively Hispanic forms:

the thirteenth-century Mudéjar towers of Calatayud, Teruel, and Zaragoza are Christian belfries, but they are unmistakably based on minaret design.

In the eleventh century, the Lombard Romanesque style appeared in Catalonia, first in Ripoll (the heavily restored Church of Santa Maria, built 1010–32) and then in Cardona (San Vicenç, consecrated 1040); French Romanesque architecture started at its highest point with Santiago de Compostela (c.1075–1188). In the thirteenth century, French Romanesque yielded to French Gothic (e.g. Burgos, León, and Toledo), except in Catalonia, where a distinctive style of Catalan Gothic emerged in the cathedrals and churches of Barcelona and Palma (Majorca). The late Gothic style in Spain was inaugurated by masons from the Netherlands and Germany, most distinctively in Juan de COLONIA's Germanic spires on Burgos Cathedral.

Despite these important northern influences, the handling of space in Spanish cathedrals remained unique because of its debt to the tradition of mosque architecture which reaches back to the eighth-century mosque of Córdoba. The combination of Islamic floor space and Gothic height produced the largest cathedrals in Europe in Seville (from 1402), Salamanca (1512), and Segovia (1525). The spirit of Islam also lived on in the PLATERESQUE architectural decoration of the late fifteenth and early sixteenth centuries.

The influence of Renaissance Italian architecture can be discerned in the early sixteenth century in the staircase (1504) of the Hospital de Santa Cruz in Toledo (now the Museo Provincial) and in the courtyard of the Castle of La Calahorra (1509–12). The most Italianate of Spain's palaces is Pedro MACHUCA's unfinished palace for Charles V in the grounds of the Alhambra in Granada (1526–68). The structural features of the palace, which is designed around a circular courtyard, are entirely Italian, but some of the decorative features, such as the garlanded window frames, are Plateresque.

The last great Italianate building to be built in Spain was the ESCORIAL, which in its final form was the work of Juan de HERRERA. The Herreran style, which may reflect the austerity of King Philip II as much as the predilections of the architect of the Escorial, draws on the principles of Italian mannerism, and is chiefly remarkable for its uncompromising lines and avoidance of ornament. The eschewing of ornament has given the style its Spanish name, *estilo desornamentado*. At its best, as in the Escorial, the Herreran style can be noble, even magnificent, but to some eyes and in some buildings it can be cold, forbidding, and monotonous. The Herreran style remained the dominant style of Spanish architecture throughout the seventeenth century, especially in cathedral architecture: the cathedral in Valladolid was not completed to his vast designs, but is unmistakably Herrera's building. Herreran monumental severity also characterizes the style of the cathedrals of Salamanca and, in Spanish America, Mexico City, Puebla, and Lima.

Until the end of the fifteenth century, the history of Portuguese architecture was part of the common architectural history of the Iberian peninsula. The Mozarabic architecture of the tenth century (e.g. Lourosa) yielded to the Romanesque of the twelfth century (e.g. the cathedrals of Braga, Coimbra, and Évora) and then to the Gothic, which was introduced by the Cistercians in the Abbey of Santa Maria Alcobaça (1178–1252) and flowered in the early fourteenth-century cloisters of the cathedrals in Coimbra, Évora, and Lisbon.

The advent of the late Gothic (or Flamboyant Gothic) period is marked in its triumphant expression at Batalha Monastery, where between 1402 and 1438 an architect called Huguet built the façade, the Chapel of John I, and vaults for the cloister and the chapter house. In the 1490s the late Gothic idiom reached its zenith in the first distinctly

Portuguese architectural style, the MANUELINE, which was a Portuguese version of the Plateresque in which Mudéjar design inspired structures as well as decorations and so facilitated a totality of design that was uniquely Portuguese.

The influence of Renaissance Italian architecture is most magnificently evident in the Claustro dos Felipes in the Convento de Cristo in Tomar; this large two-storeyed Palladian cloister was built by Diogo de TORRALVA between 1557 and 1566. The only cathedral built in the style of the Italian CINQUECENTO is Leiria, which was built by Afonso Álvares between 1551 and 1575. The baroque did not arrive in Portugal until the mid-seventeenth century, but dominated Portuguese architecture until the Lisbon earthquake of 1755 inaugurated a period of French influence.

French architecture

The Gothic style that was to dominate European architecture in the late Middle Ages originated in France, where it is known as the *style ogivale*. Individual features of Gothic architecture had long been apparent in late Romanesque architecture (and, in the case of pointed arches, Islamic architecture), but Gothic first emerged as an integrated style in the Île de France in the mid-twelfth century: the first building to be conceived in what later became known as the Gothic style was the choir and chevet (i.e. apse and ambulatory) of the Abbey of Saint-Denis (1140–4). In the second half of the twelfth century construction began on the Gothic cathedrals of Sens, Noyon, Laon, Soissons, Paris, Bourges, and Chartres, and in the early thirteenth century the cathedrals built or rebuilt in the Gothic style included Reims, Amiens, and the abbey Church of Saint-Denis. The style of these buildings is characterized by soaring vertical lines and the use of pointed arches, rib vaults, flying buttresses, traceried stained-glass windows, high clerestory windows, and pinnacles. The Gothic style of French churches and cathedrals changed very little from the early thirteenth to the late fourteenth centuries, when Flamboyant tracery (which derived from English cathedrals) began to appear in France. Flamboyant Gothic survived into the sixteenth century in structures such as the west porch of the Church of Saint-Maclou in Rouen (*c.*1500–14) and the west front of Troyes Cathedral (from *c.*1507).

In secular architecture, the country house began to replace the castle in the fifteenth century, initially in the Gothic style (e.g. Plessis-lès-Tours, 1463–72) that was also favoured in towns for both large private houses (e.g. the Palais Jacques Cœur in Bourges, 1442–53) and civic buildings (e.g. the fifteenth-century Hôtel de Ville in Compiègne and the Palais de Justice in Rouen, 1499–1509). The style of the Italian Renaissance began to appear as decorative motifs in the closing years of the fifteenth century, but did not begin to affect structural design until the early sixteenth century, when some of France's finest palaces and CHATEAUX were built. The most important Renaissance palaces were the LOUVRE, the TUILERIES (destroyed 1871), and SAINT-GERMAIN-EN-LAYE, and the principal chateaux were AMBOISE, ANET, BLOIS, CHAMBORD, CHENONCEAUX, and FONTAINEBLEAU.

By the middle of the sixteenth century Italian motifs introduced into the structures and decorative schemes of chateaux such as Blois, Chambord, and Fontainebleau had been adapted to French tastes and conditions to the point at which distinctive French Renaissance buildings were being designed by French architects such as Philibert DELORME, Pierre LESCOT, Jean BULLANT, Jacques DUCERCEAU the Elder, and (later in the century) Salomon de BROSSE.

Northern architecture

Gothic ecclesiastical architecture in fourteenth- and fifteenth-century Flanders was a syncretic and distinctive blend of south German *Sondergotik* traditions in its exteriors (especially its very tall towers) and its vaultings and French Flamboyant elements in its interior fittings (especially rood-screens and pulpits). These stylistic features were characteristic of the work of masons from Brabant who dominated architecture during this period, and so the style is known as the Brabantine School. The finest churches from the Brabantine period are those of Antwerp Cathedral (with its 130-metre (425-foot) tower) and Mechelen/Malines Cathedral (with its 100-metre (330-foot) tower, originally planned to be 170 metres (560 feet)). The same architectural elements are evident in secular architecture of the period, notably in the town halls of Bruges (*c.*1376–1482), Brussels (1402–55), Louvain (1448–63), Ghent (1517), and Oudenaarde (1525–30), but also in the guildhalls and merchants' houses that survive in Bruges, Ghent, and Tournai.

In 1517 Margaret of Austria rebuilt part of her palace in Mechelen (which was the capital of the Netherlands from 1517 to 1530) in a resolutely Italianate Renaissance idiom; although two years earlier Bruges had been decorated in the Italian style (with GROTESQUES and relief medallions) for the triumphal entry of the future Emperor Charles V, the façade of Margaret's palace, with its Italianate scrolls and swags, was the first monumental embodiment of the Renaissance style. This style was used again in the design of Granvelle's palace in Brussels (*c.*1550), but in most sixteenth-century buildings the Renaissance style was either restricted to decorative details or combined with indigenous styles; surviving examples of this mixed mode include the courtyard of the Bishop's Palace in Liège (1526), the Hôtel du Saumon in Mechelen (1530–4), the Maison de l'Ancien Greffe ('Old City Clerk's Office', now the courthouse) in Bruges (1535–7), with its magnificent CHIMNEY PIECE commemorating the Peace of Cambrai, the home of the PLANTIN family in Antwerp (1550, now the Musée Plantin-Moretus), the Town Hall in Ypres (1575–1621, destroyed in the First World War and replaced by a replica), and Cornelius FLORIS DE VRIENDT's Antwerp Town Hall (1561–6), the grandest and most influential of Flemish Renaissance buildings. Awareness of Italian architecture models was enhanced by the publication of Pieter COECKE's Flemish translation of SERLIO in Antwerp in 1539. The most influential decorative element in Flemish Renaissance architecture was the combination of French STRAPWORK (which originated at FONTAINEBLEAU) and Italian grotesques. This Flemish motif was widely disseminated in the pattern books of Jan VREDEMAN DE VRIES.

The prevailing style of architecture in the northern Netherlands from the thirteenth to the fifteenth centuries is known as 'Dutch Gothic', which in ecclesiastical architecture is distinguished by a large nave, usually without side chapels, by a preference for brick rather than stone, and by a principled plainness with respect to decorative detail; the best example of Dutch Gothic is the Great Church in The Hague. In the secular architecture of the thirteenth to fifteenth centuries there was less inhibition about decoration, notably in the façades of town halls (e.g. Middelburg, 1412–1599, destroyed in the Second World War and since rebuilt) and in the stepped gables of merchants' houses.

Renaissance architecture was introduced in the 1530s in buildings constructed by Italians, including the Bolognese architects Alessandro Pasqualini (who built the tower of Ijsselstein church, 1532–5) and Tommaso Vincidor (who built the courtyard of Breda Castle, on which work began in 1536). Dutch architects began to consult Pieter Coecke's translations of VITRUVIUS and Serlio and to use Renaissance decorative motifs on the

façades of town halls such as Nijmegen (c.1555) and The Hague (1564–5). The interpenetration of indigenous Dutch structures and Italianate decoration produced a distinctive style of Dutch Renaissance architecture characterized by the adventurous mixture of stone and brick and the elaborate and varied development of the gable. The most important Dutch architect to use this style in secular buildings was Lieven de KEY. In Dutch Renaissance ecclesiastical architecture, interiors were adapted to the Protestant ideal of a focus on the pulpit rather than the altar, most successfully in the Amsterdam churches of Hendrick de KEYSER.

In Scandinavia, Dutch architects designed buildings in the style of the Netherlandish Renaissance: Antonius van Opbergen (1543–1611) and Hans Steenwinckel the Elder (c.1545–1601) built Frederick II's palace of Kronborg at Helsingør (Hamlet's Elsinore) and Hans Steenwinckel the Younger (1587–1639) and his brother Lourens (c.1585–1619) built Christian IV's magnificent palace at Frederiksborg (now the Museum of National History). The Steenwinckels were also responsible for the Exchange (Børsen) in Copenhagen (1619–25); its spire is one of the city's landmarks. In Scania, which was Danish until 1658 and is now Swedish, the church at Kristianstad (1618), which may be the work of the Steenwinckels, is one of the finest Protestant churches ever built; it is a hall church (i.e. its aisles are as high as the nave) with slender piers, and its gables are Netherlandish in style. In Sweden, the royal castles in Stockholm and Kalmar were refashioned under Dutch influence, and new castles, notably the royal palace at Vadstena (1545–1620) were built.

The late Gothic (*Spätgotik*) architecture of late fourteenth- and fifteenth-century Germany took different forms in north and south Germany. In north Germany the preferred building material was brick, and the simplified Gothic of its churches and public buildings, notably the brick town halls in Thorn (now Polish Toruń), Lübeck, and Stralsund, is called *Backsteingotik*. The corresponding style in south Germany, Austria, and Bohemia is called *Sondergotik*, which finds its fullest expression in the hall churches of the PARLER FAMILY; in these churches the aisles are approximately the same height as the naves, and so the naves are lit from the windows of the aisles rather than from above; the preferred building material was stone, though Hans STETHAIMER chose to work in brick. Elsewhere in the German territories, the earliest example of the Italian Renaissance style is the Fugger funeral chapel (Fuggerkapelle) in St Anne's Church in Augsburg (1509–18). The small number of monumental buildings in the Renaissance style included Schloss Hartenfels in Torgau (1483–1622) and the Stadtresidenz at Landshut (1537–43).

In the second half of the sixteenth century, the imitation of Italian forms yielded to a distinctive German Renaissance style, which was characterized by the use of gables, of relatively short columns, and of a decorative style that owes as much to Flanders as to Italy. The most important surviving German Renaissance buildings are the town halls of Leipzig (1556), Altenburg (1562–4), Lemgo (1565–1612), Rothenburg ob der Tauber (1573–8), and Augsburg (1615–20, by Elias HOLL), the Plassenburg in Kulmbach (rebuilt in 1559), the eastern façade of the Gewandhaus (Linen Hall) in Brunswick (1592), the Pellerhaus in Nuremberg (1602–7, reduced to a shell during the Second World War and since rebuilt); the greatest of the lost buildings was the Neues Lusthaus in Stuttgart (1584–93) by George Beer (d. 1600) and Heinrich SCHICKHARDT. Contemporaneous with these buildings are syncretic German Renaissance buildings that incorporate elements from other architectural traditions: Schloss Johannisburg in Aschaffenburg (1605–14, reduced to a shell in 1944 and since rebuilt) is in some respects

French, the Ottheinrichsbau in Heidelberg (1556–9) and the portico of the Town Hall in Cologne (1567–70) are both Flemish, as is the work of Pieter de WITTE, and many of the buildings of Hans KRUMPPER and Frederick SUSTRIS are distinctly Italianate, as is the Jesuit Michaelskirche in Munich (1583–97), which is modelled on the Order's Gesù Church in Rome.

The principal conduit of foreign architectural styles in medieval Poland was Germany, and in many respects Polish Romanesque and Gothic architecture is part of the tradition of German architecture. Renaissance architecture may have been mediated through Hungary and Bohemia, but there is also evidence of direct borrowing from Italian models. The domed Chapel of King Sigismund on the south side of Kraków Cathedral (1517–38) is the work of an Italian architect, as are the early Renaissance parts of the castle (Zamek Wawelski) in Kraków (from 1502); on the other hand, the Wawel's windows draw on Benedikt RIED VON PIESTING's Vladislav Hall in Prague and its chapel seems to be indebted to the Royal Chapel in Esztergom. Indigenous elements include the use of perforated or decorated crestings instead of crenellation on buildings such as the Cloth Hall (Sukiennice) in Kraków (1555). In Gdańsk, which was the Hanse city of Danzig, the Arsenal (1602–5), which is executed in the Flemish Renaissance style, is the work of the Fleming Antonius van Opbergen.

The most extraordinary example of Renaissance architecture in Poland is Zamość, a new town commissioned by Jan Zamoyski and laid out and constructed by the Venetian architect Bernardo Morando from 1587 to 1605; Zamość is the finest example of Italian Renaissance town planning and architectural ensembles in northern Europe.

The dominant architectural style of Bohemia from the fourteenth to the sixteenth centuries was Gothic. In the fourteenth century, the German mason Peter Parler completed Prague Cathedral, installing structural features (especially the window tracery and the rib vaults) that were to remain influential in Germany and Austria for more than a century. The architect who effected the transition from Gothic to Renaissance in Bohemia was Benedikt Ried, who sometimes worked in Gothic and sometimes combined both styles. His finest work is the Vladislav Hall (1493–1502) in the Old Royal Palace (Starý Královský Palác) on the Hradčany in Prague; this room, which was large enough to accommodate jousting competitions, combines extravagantly decorated Gothic vaulting with windows executed in Italian Renaissance style.

There are only two examples of sixteenth-century Bohemian buildings conceived in a purely Italian Renaissance style. The elegant Belvedere Palace (Czech Belvedér Palác) in Prague (1534–63), set in a fine Bohemian garden, is wholly Italianate in design. The other Italian Renaissance building is Hvezda Castle (near Prague), a star-shaped hunting lodge built in 1555 and imaginatively decorated with stucco. Many Bohemian buildings of the late sixteenth and early seventeenth centuries contain features (especially portals) that show Italian influence mediated through the interpretation of Renaissance conventions in Polish architecture and German architecture. In Prague, the Schwarzenberg Palace (on which work began in 1545) has sculpted gables and cut ashlar blocks, and the Ball Court (on the Hradcany) designed by Bonifaz Wohlmut has *sgraffito* (see GRAFFITO) decoration.

English ecclesiastical architecture has long drawn on continental styles but articulated those styles in ways that are distinctly English. Norman architecture in England clearly shares many features with French Romanesque architecture north of the Loire, but English architects eschewed the tunnel vaults of France and the groin vaults of Germany in favour of rib vaults, which were developed at Durham and later imitated on the Continent. Similarly, the distinctive features of English Gothic require a

taxonomy of styles separate from those used on the Continent. English Gothic architecture is divided into three phases: Early English, Decorated, and Perpendicular.

The Perpendicular architecture of late medieval England is so called from the upright lines of the window tracery and the panels of churches, and is sometimes divided into Early Perpendicular in the late fourteenth and early fifteenth centuries (e.g. the chancel of Gloucester Cathedral) and Late Perpendicular in the late fifteenth and early sixteenth centuries (e.g. King's College Chapel in Cambridge). The most striking feature of Late Perpendicular architecture is the fan vault, of which there are fine examples in King's College Chapel in Cambridge, the Divinity Schools in Oxford, Sherborne Abbey, Trinity Church in Ely, Gloucester Cathedral, St George's Chapel in Windsor, and the Chapel of Henry VII in Westminster Abbey.

The architecture of sixteenth- and early seventeenth-century England retains strong Perpendicular features, but nonetheless reflects the advent of Flemish, French, and Italian influences. The decorative features of Italian Renaissance architecture first appeared in the Henry VII Chapel in Westminster Abbey, where the Florentine Pietro TORRIGIANO built the Italianate tombs of King Henry VII and his queen Elizabeth of York, who are represented in bronze effigies. Until the middle of the sixteenth century the Italian Renaissance style was restricted to architectural decoration (such as the detail on the screen and stalls in the Chapel of King's College, Cambridge, and GIOVANNI DA MAIANO's terracotta roundels of Roman emperors at Hampton Court) and did not affect structural designs. The first building to articulate in its structure the style of the Italian Renaissance was Somerset House (1547–50, demolished 1775), the predecessor of the present building on the Strand; the first Somerset House had symmetrical façades in the Italian fashion, decorative details drawn from Flemish architecture (including STRAPWORK, which originated at FONTAINEBLEAU), and large transomed and mullioned windows in the Perpendicular tradition.

Somerset House was enormously influential, and soon houses with large Perpendicular windows and Flemish decorative motifs in wood and plaster began to appear in the English countryside, notably in Elizabethan houses such as Burghley House in Northamptonshire (1552–87), Charlecote in Warwickshire (from 1558), Loseley House in Surrey (from 1562), Haddon Hall in Derbyshire (1567–84), Longleat House in Wiltshire (from 1568), Kirby Hall in Northamptonshire (1570, unfinished), Longford Castle in Wiltshire (from 1578), WOLLATON HALL in Nottinghamshire (1580–5), Montacute House in Somerset (1580–99), and Hardwick Hall in Derbyshire (1591–7); in the seventeenth century similar features appeared in Jacobean houses such as Audley End in Essex (1603–16), Chastleton House in Oxfordshire (1603–14), Knole House in Kent (from 1605), HATFIELD HOUSE in Hertfordshire (1607–12), and Cope Castle (now Holland House) in Kensington (from 1607). This was also a period of considerable building at the universities, notably of the Old Schools (now the Bodleian Library) in Oxford. In the early seventeenth century Inigo JONES introduced the classical principles of PALLADIO into English architecture, beginning with the Queen's House in Greenwich (1616) and culminating in his BANQUETING HOUSE in Whitehall (1619–22).

4. Renaissance gardens

Italian gardens

The renaissance of gardening in Italy was inaugurated by ALBERTI's publication of *De re aedificatoria* in 1452. In Florence, the garden of the Villa Quaracchi, which was built by Giovanni Rucellai in about 1459, contains various medieval elements (arbours, pergolas,

a rose garden, and a MOUNT), but it conforms in so many respects to the principles enunciated by Alberti that its design has been confidently attributed to him. The house was built on a small hill, as Alberti had recommended, and the axis of the garden was extended beyond the GIARDINO SEGRETO along a tree-lined avenue to the river Arno; box and scented evergreens amenable to clipping were planted and shaped into hedges and figures, apparently in imitation of the first-century gardens of Pliny the Younger.

Quaracchi had a central axis, and in that respect anticipated one of the central features of later gardens, but the garden was designed independently of the house. The transition from separate designs for house and garden to fully integrated designs can be seen in two gardens designed by MICHELOZZO DI BARTOLOMEO. In about 1451 Michelozzo laid out a garden at Il Trebbio, the Medici hunting box at Cafaggiolo; the garden is a walled rectangle detached from the house. A lunette by UTENS shows that the garden was laid out in eight square beds of flowers and vegetables; it was originally bounded by vine pergolas (one of which survives with its original brick columns), and the enclosure blocks out the views. This inwardness is a medieval feature; Il Trebbio is the last of the great medieval gardens of Tuscany. In 1458 Michelozzo began work on the MEDICI VILLA at Fiesole, and there he constructed open gardens on two terraces. The house opens out directly onto the upper terrace, which overlooks Florence in the valley below; the enclosure has shrunk to a *giardino segreto*, which still survives. In this design the essential features of the sixteenth-century Italian Renaissance garden are adumbrated. Michelozzo was not, however, the first architect to integrate house and garden: that ideal had already been realized in Rome in the BELVEDERE COURT in the Vatican and the villa MADAMA. It was these Roman buildings, and others now lost, that became the model for garden design in Tuscany.

Sixteenth-century Italian gardens were fully integrated with the houses to which they were attached, and retained the use of terraces with attractive views; to this late fifteenth-century outline, designers added four distinctive features that were to influence gardens all over the world: symmetry, statues, water, and a balance between constructed and natural materials. The first garden to have a symmetrical layout around a central axis was Niccolò TRIBOLO's garden at the Medici Villa at Castello; Tribolo subsequently laid out the BOBOLI GARDENS in accordance with the same principle. In the second half of the sixteenth century some designers adopted the principle of the axial design, notably the architect of the Villa Bernadini in Saltocchio (now overgrown), but others chose to place features in opportunistic ways: PRATOLINO, for example, has an avenue that formed a central axis, but BUONTALENTI chose to scatter features around the garden rather than arrange them symmetrically on either side of the axis.

The gardens of classical antiquity were furnished with statues. The first garden to revive this tradition was the Vatican's Belvedere Court, which contained a collection of ancient statues. Statues modelled on those of antiquity soon began to adorn the fountains at the focal point of gardens such as the Medici villa at Castello and the Palazzo DORIA PRINCIPE in Genoa. At the Villa d'ESTE in Tivoli, ancient statues excavated from the nearby villa of Hadrian were placed in the garden, and at the Villa ORSINI in Bomarzo monstrous statues were carved out of rock outcrops (see p. xxiii).

The terraces of Italian gardens often contained springs that provided natural sources of water, and in some gardens aqueducts and conduits were used to ensure a constant supply of water under pressure. The Renaissance garden that uses water to greatest advantage is the Villa d'Este at Tivoli, which has scores of magnificent fountains and had an abundance of AUTOMATA which included singing birds and a roaring dragon.

Some gardens, such as the Villa LANTE, the Villa CICOGNA, the Villa FARNESE at Caprarola, and the whimsically named Villa d'Este at Cernobbio, have water-staircases or water contained within sculpted channels (*catene d'acqua*) flanked by dry staircases, and Frascati villas such as Villa ALDOBRANDINI had water-theatres. Water was also used to power GIOCHI D'ACQUA which may seem jejune to modern tastes but delighted visitors for several centuries.

The sculptor Baccio BANDINELLI decreed that 'le cose che si murano debbono essere guidi e superiori a quelle che si piantano' ('that which is constructed should be the model and master of that which is planted'). This principle was implemented in every major Italian garden of the sixteenth century. Sometimes, as in the Boboli Gardens, an architectonic structure was achieved by adapting a natural AMPHITHEATRE, but in most cases the effect was achieved with stone. The form of gardens was outlined with galleries (modelled on the ancient Roman cryptoporticum), covered walks, and staircases, and fountains were placed at focal points. The interpenetration of house and garden was often achieved by having elements of the house extended into the garden, as at Villa GIULIA. Gardens were furnished with pavilions, and many contained elaborate GROTTOES. In some gardens, CASINI were built in *giardini segreti*, of which the finest is at the Villa Farnese.

Italian gardens influenced the development of garden design throughout Europe, both in layout and in content. This influence also extended to the proliferation of new species of plants, because the first BOTANICAL GARDENS were in Italy.

Spanish and Portuguese gardens

The two greatest gardens of Renaissance Spain were commissioned by King Philip II at ARANJUEZ and the ESCORIAL. The gardens of the Escorial were laid out by the architect Juan de HERRARA and the gardener Marcos de Cordona. The gardens outside the palace are not well documented, save for a hanging garden of which early travellers speak, but the original terraces on which the gardens were built have survived. Inside the palace there are gardens in the courtyards; the finest of the courtyards is the vast Court of the Evangelists (Patio de los Evangelistas), which has at its centre an octagonal temple surrounded by four square pools fed by small fountains built into the statues of the evangelists; the original geometrical parterres that filled the court were replaced in the eighteenth century by an arabesque box garden which is more subdued than was its predecessor. The other courtyards of the Escorial also contain gardens, all of which originally looked more Italianate than they do now, because they contained 76 fountains and scores of statues, many imported from Italy.

In the early seventeenth century the garden of Buen Retiro was laid out on the eastern edge of Madrid; the designer was the Florentine Cosimo Lotti, who began work in 1628 and later went on to contribute to Aranjuez. The garden was the setting for meetings of literary academies, and in the mid-seventeenth century accommodated at least seven hermits; these genuine hermits were the predecessors of the ornamental hermits of eighteenth-century English gardens.

Portuguese gardens of the sixteenth and seventeenth centuries incorporated features that can be traced to the Roman occupation (tessellated tiles) and the Moorish occupation (notably the Arab water-tank, an architectural pool of still water), but the design elements came from France (box PARTERRES and pleached trees) and Italy (FOUNTAINS, grottoes, statues, and *GIARDINI SEGRETI*). The fact that the terrain is hilly occasioned a natural preference for the Italian terrace rather than the flatter French garden.

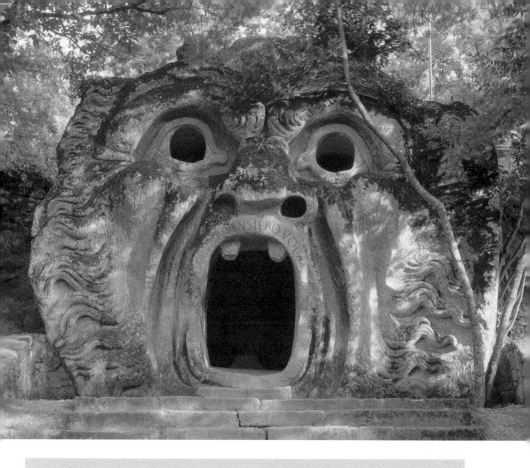

A stone figure, now known as the *Orc*, in the garden of the Villa **Orsini** in Bomarzo. On the upper lip of the ogre an inscription says *Lasciate ogni pensiero voi ch'entrate* (Abandon all thought, you who enter here), an adaptation of the sign that Dante sees on the gates of Hell: *Lasciate ogni speranza voi ch'entrate* (Abandon all hope, you who enter here, *Inferno* 3.12). Inside the cave mouth there is a stone dining table with benches.

The combination of AZULEJOS and water-tanks was uniquely Portuguese. Arab architecture had traditionally used still water to reflect clouds and trees. The Portuguese water-tank achieves a similar effect by setting *azulejos* above the stone sides of the water-tank, so that the water is reflected in the shimmering blues, purples, yellows, greens, and oranges of the *azulejos*. And just as rich surface decoration in mosaic is an important element in Islamic architecture, so the constructed elements in Portuguese gardens (PAVILIONS, fountains, grottoes, loggias) were covered in *azulejos*. The important difference between these traditions, however, is that Sunni Islamic decoration is geometrical, whereas from the mid-fifteenth century Portuguese *azulejos* were representational, depicting plants, animals, and humans; they were used, like frescoes in Italy, to illustrate classical and biblical legends.

The best surviving Renaissance gardens in Portugal are the Quinta da Bacalhoa (Estremadura) and Castelo Branco (Beira Baixa). The villa at Bacalhoa, which was built in 1480, was acquired in 1528 by Afonso de Albuquerque, the son (and namesake) of the Portuguese admiral. The garden is a square bounded on two sides by the house and on the third side by a clipped hedge. This is an open Renaissance garden rather than an enclosed medieval garden, so the fourth side is unbounded. A long terrace leads to the

pavilion and water-tank that are the glory of the garden. The huge water-tank is flanked on one side by a high wall, in front of which seats covered in green and white *azulejos* are set amongst climbing roses and jasmines. The pavilion consists of three small square buildings linked by an elegant arcaded loggia; inside, the pavilion is divided into a series of small rooms, all richly decorated with *azulejos* in blues, greens, and yellows; one of these panels depicts Susanna and the Elders; it is the earliest dated *azulejo* picture in Portugal (1565).

In 1598 the bishop of Guarda built a palace and laid out a terraced garden in Castelo Branco, a hill town in the Serra da Estrela. On the highest terrace there is an oblong water-tank surrounded by a stone balustrade; at one end a flight of steps leads down to the water. The tank was once decorated with masks and pebble mosaics and *azulejos*, most of which have disappeared, but even in its denuded state the tank is very beautiful. On the terraces below there are twin staircases lined with statues of kings on the balustrades. There is also a hidden pool, through the surface of which protrude marble flower beds; the effect of brightly coloured flowers apparently growing out of the water derives ultimately from Mughal gardens, and was probably transmitted to Portugal through Moorish influence.

French gardens

In 1495 King Charles VIII of France visited Poggio Reale, the Neapolitan summer residence of Alfonso II of Aragon, and was so impressed by the gardens that he took the Neapolitan garden designer PACELLO DA MERCOGLIANO back to France with him; the gardens that Pacello designed at AMBOISE, BLOIS, and GAILLON introduced elements of Italian gardening into French garden design. These Italian features, such as the marble fountains imported from Italy at Gaillon, remained incidental to French garden design. Indeed, the fundamental design of French gardens of this period was rooted in the tradition of the enclosed garden wholly independent of the house rather than in the Italian ideal of the interpenetration of house and garden in a unified design. The major difference between Italian and French design was that Italian gardens were usually terraced, but French gardens, with the important exception of the Italianate garden at SAINT-GERMAIN-EN-LAYE (and the mid-seventeenth-century garden at Vaux-le-Vicomte), tended to be flat. An important consequence of this distinction is that flowing water was a relatively minor feature in French gardens of the sixteenth century; until the gardens at Versailles were constructed, French FOUNTAINS produced mere trickles of water, whereas Italian fountains produced torrents.

The rediscovery of VITRUVIUS affected garden design in both Italy and France, in that it shifted the conceptual emphasis of the garden from the traditional horticultural stress on fruit, vegetables, and medicinal herbs to an architectural stress on form and harmony. In France the dominant architectural features of gardens were PAVILIONS, such as those at Amboise, Blois, and Gaillon, and galleries, such as the monumental wooden gallery at Montargis (the castle of Renée de France), the stone gallery at Gaillon, the gallery beyond the moats at Chantilly, and the free-standing painted gallery at FONTAINEBLEAU.

The ideal of a design encompassing both house and garden was first achieved by Philibert DELORME, who established at ANET (1546–52) the prerogative of the architect to design the garden as well as the house. At about the same time SERLIO retrospectively imposed a unified design on ANCY-LE-FRANC by enclosing both house and garden within a huge rectangular terrace. The influence of the gardens of Roman cardinals, especially

the Villa Farnese, ensured the continued life of small gardens set apart from the main house: in the 1550s Cardinal de Bourbon built such a private retreat at Gaillon, constructing a CASINO (the Maison Blanche), a hermitage carved out of a rock, and a canal. Such canals were one of the distinctive features of French gardens of the sixteenth century; at Fleury-en-Bière, the first of these canals (c.730 metres (800 yards) long) still survives, and is thought to have inspired the Grand Canal at Fontainebleau. Philibert Delorme subsequently incorporated a canal into the garden at Anet, and in the seventeenth century grand canals became an important element in Le Nôtre's gardens at Vaux-le-Vicomte, Chantilly, Maintenon, Sceaux, and Versailles.

Plantings in French gardens were arranged in PARTERRES, which were well established by the time Serlio printed designs for geometrical parterres in L'architettura (1537). A comparison of this volume to the 1572 edition of L'Agriculture et maison rustique, by Charles ESTIENNE and Jean Liébault, shows how parterres had developed in the intervening half-century: in 1537 parterres were individual creations sealed in separate compartments (compartiments de broderie), but by 1572 parterres had been integrated into an overall architectonic plan. Claude MOLLET, who traced this development to Anet, designed parterres for Fontainebleau, Saint-Germain-en-Laye, and the TUILERIES; his designs are printed in the Théâtre d' agriculture (1600) of Olivier de SERRES.

The first BOTANICAL GARDEN in France was the Jardin des Plantes at Montpellier, which was built by Richer de Belleval between 1593 and 1607. It is one of the few French examples of a garden with a terraced MOUNT (which still survives). Every plant in the garden was labelled, and 1,332 species and varieties are listed in Belleval's Onomatologia (1598). The garden was destroyed during Richelieu's siege of Montpellier in 1622, and subsequently rebuilt on a smaller scale; in the late seventeenth century one of the curators was the taxonomist Pierre Magnol, the eponym of the magnolia.

Northern gardens

Flemish gardens of the fifteenth and sixteenth centuries inevitably had much in common with Dutch gardens, but Spanish influence was always more pronounced in the southern Netherlands than in the northern provinces. The most important south Netherlandish gardens of the period were in Brussels and Antwerp. In about 1520 the Emperor Charles V redesigned the private garden (reserved for the court) at Brussels Court in the Renaissance style. He retained the summer house, but placed it on marble piles in the middle of a bathing pool. The single FOUNTAIN was replaced with a large number of fountains set in a garden that was designed to look like a labyrinth. The old mixed plantings were uprooted in favour of groups of trees of the same species, pruned to form walls flanking paths and porticoes and outdoor rooms (cabinets de verdure); the overall effect was of a giant labyrinth. The fashion for elaborate pruning spread beyond the confines of Brussels Court to the public squares and private gardens of the region, some of which included bowers sculpted from trees and supported by wooden frameworks; one such bower survives at Mâcon, a small town on the Belgian–French border.

Italian influence on garden design became more pronounced in the late sixteenth century. The blend of Italian influence and native Flemish traditions is clearly articulated in Jan VREDEMAN DE VRIES's collection of garden plans, published as Hortorum viridariorumque formae (Antwerp, 1568 and 1583). Gardens in this period tended to be flat, not so much because of French influence, but rather because the terraces of Italian gardens could only be achieved if the land was already hilly and if gardens were being constructed on a grand scale; neither was the case in the southern Netherlands. The

other difference between Italian and Flemish gardens in this period is that although there were fountains, water played a relatively small part in Flemish gardens. A continued medieval influence manifested itself in a tendency to enclose gardens with walls and hedges. Gardens were laid out in PARTERRES, and the geometrical intricacy of the patterns of planting became the most characteristic feature of Flemish design. The shrubs planted in the parterres were pruned into geometrical shapes, and were laid out in regular patterns. Individual parterres were typically enclosed with palisades, rows of trees clipped into green walls reaching to the ground. Architectural features tended to be restricted to fountains and statues. Instead of the stone loggias of Italian gardens, Flemish designers favoured outdoor rooms walled entirely by clipped hedges, often supported on wooden frames. Sometimes even the expected statue at the centre of the parterre was replaced by a bare-trunked tree with sculpted foliage. The introduction of exotic plants was encouraged by the publications of the Flemish botanist Julius Dodoens. There was particular enthusiasm for the tulip and the lily, but collectors' gardens, such as the one established in Borgerhout (near Antwerp) in about 1550, built up collections of hundreds of foreign plants.

French influence became more pronounced in about 1600, when Salomon de CAUS revamped and enlarged the private garden at Brussels Court. He imposed a more geometrical form on the labyrinth, which was reorganized as a sloping rectangle bordered and bisected by clipped greenery; within these green borders he laid out parterres and built fountains. In the extended part of the garden he built grottoes decorated with shells in the Italian style, and fitted them with ornamental waterworks and AUTOMATA, including water-organs. This new emphasis on constructed elements in the garden gradually softened the tendency of Flemish gardens to use only plants as architectonic structures. Salomon de Caus also inaugurated a fashion for embroidered parterres (*parterres de broderie*), in which box was planted in intricate patterns, often imitating botanical shapes.

The Dutch Renaissance garden derives from three distinct traditions. First, the medieval Dutch garden, of which examples survive in attenuated form at Het Binnenhof in The Hague and at Rosendael in Gelderland, bequeathed the idea of outdoor rooms variously containing ornamental and fragrant flowers, pavilions with statues, lakes, orchards, vineyards, and menageries. Second, the example of Italian Renaissance gardens influenced the design of Dutch gardens. Third, the insistent piety that is a distinctive feature of the Dutch Renaissance is responsible for Christian images in Dutch gardens; this is a marked contrast to the paganism typical of Italian gardens that prompted the remark of Queen Christina of Sweden, on seeing the gardens of the Villa Farnese, that 'I dare not speak the name of Jesus lest I break the spell.'

A strong sense of spirituality pervades the ideal and emblematical garden of Erasmus' *Convivium religiosum* ('The Godly Feast', 1522). Erasmus proclaims the protector of his garden to be Jesus rather than Priapus, and at the entrance visitors encounter the Fountain of St Peter rather than pagan monsters. His square garden is bounded on three sides by a pillared gallery accommodating a library and an aviary. The walls of the gallery are covered with TROMPE-L'ŒIL frescoes depicting plants and animals. The garden is divided by a brook which drains a fountain and flows into a decorated stucco basin; the purpose of the water is to refresh and cleanse the soul. The ornamental and fragrant plants are laid out in beds, and each species is labelled with its name and virtues. Beyond the galleried garden there are two summer houses and a kitchen

garden, bordered on one side by a meadow and on the other by an orchard containing trees not native to Europe and beehives.

All the elements of this garden of the godly mind were present in Dutch gardens of the sixteenth century. The gardens of Jan VREDEMAN DE VRIES, the most influential designer of the century, contained medieval and Erasmian elements laid out with a painterly attention to detail and form; he was the first landscape architect to present the garden as a work of art. The most important architectonic element in his gardens was the Erasmian gallery, which overlooked complementary structures containing fountains and parterres.

The intricate parterres of Dutch gardens included a much higher proportion of rare foreign plants than did gardens elsewhere. This predilection for the exotic was encouraged by the establishment in Leiden of what was to become Europe's most important BOTANICAL GARDEN, not least because of the cultivation of tulips by Carolus Clusius.

Spanish recognition of the independence of the northern provinces in 1609 exacerbated the cultural (and horticultural) distinctions between north and south, in that Flemish gardens perpetuated the mannerist tradition of the sixteenth century, whereas the Dutch gardens of the United Provinces championed classical principles of harmony and proportion as articulated by ALBERTI and VITRUVIUS. The finest embodiment of these principles was the Buitenhof, a garden in The Hague laid out c.1620 by the stadtholder, Maurice of Nassau. This garden was designed as a double square containing two circles. The only vestige of the Italian mannerist tradition was the fantastic grotto (the first in the Netherlands) designed by Jacques de GHEYN the younger.

Maurice's younger brother Frederik Hendrik, who succeeded him as stadtholder in 1625, was an amateur architect and landscape designer of distinction. His classical garden at Honselaarsdijk, laid out on 8 hectares (20 acres) on a polder south of The Hague, inaugurated the Dutch tradition of the canal garden; this garden, which was destroyed in 1815, was the first large garden in northern Europe to be designed on Albertian principles of harmonic ratios.

The Renaissance garden in Germany is confined to the few years between 1590 and the outbreak of the Thirty Years War in 1618; it was stimulated during this period both by travellers who had seen the gardens of Italy and by the translation into German of French and Italian books on gardening. In 1597 Johann Peschel published the first German book on gardening, which contains a series of garden plans with rectangular layouts and covered walks. The engraver Josef Furttenbach of Ulm (1591–1667) published designs for parterres which combined French and Italian elements (*Architectura recreationis*, Augsburg, 1640); he was the first garden designer in Europe to advocate the use of a garden for the education of children, and so became the remote progenitor of Friedrich Froebel's *Kindergarten*.

Many German Renaissance gardens, including four important Italianate gardens in Munich, are known only from the descriptions provided by Philipp Hainhofer in his *Reise-Tagebuch* (travel diary) of 1612. Only one Renaissance garden within what is now Germany is fully documented, and that is the HORTUS PALATINUS at Heidelberg. In Austria, the principal Renaissance gardens are HELLBRUNN (near Salzburg), Ambras (near Innsbruck), and Neugebäude ('New Building', near Vienna). Ambras was the chateau of Archduke Ferdinand, second son of the Emperor Ferdinand I; it was described by a visitor in 1574 as a garden with large fountains, TOPIARY, pergolas, grottoes, and a PAVILION for banqueting. The principal parterre was divided into nine squares, in the centre of which was another

pavilion, mounted on pillars; this parterre is the only French element in what was otherwise an Italian garden in Innsbruck. Neugebäude was built in 1569 by an unknown designer who was probably Italian but could have been French; the upper garden was a square surrounded by an arcaded gallery with pavilions at the corners, laid out in sixteen parterres and decorated with fountains, and the lower garden fell away towards the Danube in four terraces.

Poland has one of the richest collections of historic gardens in Europe, and the sixteenth and early seventeenth centuries are well represented. The influence of Italian gardens is clear, both in the preference for terraces over flat sites and in the laying out of symmetrical beds on either side of an axis extending from the house. The emphasis on the view from the house anticipates the later development of the picturesque. Seven important sixteenth-century terraced gardens have survived in Balice (1518; near Kraków), Wola Justowska (c.1540; now part of Kraków), Prądnik Biały (1551; now part of Kraków), Mogilany (c.1560; south of Kraków), Gdańsk (c.1560), Neipołomice (c.1571; east of Kraków), and Książ Wielki (c.1595; north of Kraków). Renaissance gardens have been restored at Pieskowa Skała (north-west of Kraków), Baranów, and Brzeg.

The first Renaissance garden in Bohemia was the royal garden (Královská Zahrada) on the west side of Prague Castle, which was built in 1534 as the garden of the summer palace, the Belvedér. Under the Emperor Rudolf II, Jan VREDEMAN DE VRIES introduced elements of the Dutch style into the garden, including tulips from Turkey. He also built grottoes lined with mirrors in which music was played; it is not clear whether the music was produced mechanically or by a hidden orchestra. The garden also included an orangery, a fig-house, a famous singing well, and accommodation for Rudolf's menagerie, including an aviary and a lion-court.

The burgeoning of English gardens in the eighteenth and nineteenth centuries often obliterated earlier gardens on the same sites, so English medieval and Renaissance gardens are usually known only from written and pictorial documentation. An illumination of a royal couple playing chess in an English garden made c.1400 shows that the herbaceous border was already a feature of gardens by that date, and the diamond-shaped earthworks of a pleasance (the Pleasance en Marys, i.e. on the marsh) 1.5 kilometres (1 mile) to the west of KENILWORTH CASTLE, which are the remains of a garden and summer house constructed for Henry V between 1414 and 1417, constitute one of the few surviving remnants of the English double-moated garden with rows of trees planted on the lists between the moats. There is evidence that monastic gardens dedicated to the cultivation of edible plants and medicinal herbs also contained roses, lilies, and violets, but such flowering plants may have been valued for their emblematic and medicinal qualities as much as for their beauty.

Many of the plants that were to become important elements in Renaissance gardens had been established in the preceding century. Rosemary had been introduced in 1340, and its advent had ushered in a fashion for evergreens. Juniper, holly, box, and bay (*Laurus nobilis*) were all cultivated in early fifteenth-century gardens. By this time evergreens were being clipped, KNOT GARDENS were being laid out in heraldic patterns, and the double-clove gillyflower (i.e. carnation) had become highly valued for its beauty and aroma.

The transition from the *hortus conclusus* (on which see GIARDINO SEGRETO) of the Middle Ages to the pleasure garden of the Renaissance was effected by the Burgundian influences which began to be felt in English gardens at the end of the fifteenth century.

The earliest large Renaissance garden was laid out at Henry VII's palace at Richmond (1498–1501); this garden, which did not survive the destruction of the palace in the eighteenth century, was laid out in enclosures linked by covered walks and galleries.

Three important gardens were built by Henry VIII at Hampton Court Palace (1531–4), Whitehall (1545), and Nonsuch Palace (1538–47). All three evinced the direct influence of French gardens in their common situation beneath the windows of the state apartments and in their common geometrical design, consisting of a square surrounded by a covered walk and divided into quarters; each quarter was laid out in knot gardens, and at the centre of each garden was a fountain. The only markedly English element was painted heraldic decoration. At Hampton Court Palace the Privy Garden on the south side contained a MOUNT constructed from 250,000 bricks, covered with earth, and planted with hawthorns; it was topped by a three-storey lantern-arbour with a cupola roof crowned by a wind-vane in the form of a heraldic lion. The Privy Garden was decorated with painted heraldic models of the King's Beasts; it also contained sixteen sundials and a kitchen garden, and Queen Elizabeth later added a knot garden. This Privy Garden was lost when Queen Mary laid it out in parterres at the end of the seventeenth century, and Queen Anne comprehensively redesigned the other gardens; the gardens now called the 'Tudor Gardens' were laid out in the eighteenth century.

The garden at Nonsuch (which, together with the palace, has disappeared) was laid out afresh between 1579 and 1591, and in this version reflected Italian influences originating in a visit to Italy by its owner, the antiquarian John Lumley; the most Italianate element was a grotto with polychrome statutes of Diana and Actaeon. Elsewhere in the garden, the Italian influence was mediated through France, because the design was a copy of the garden of King Francis I at FONTAINEBLEAU (not the later Henri IV version); the Nonsuch garden contained woodland, a MAZE, imitation animals, and an outdoor banqueting hall which seems to have been the first in England.

In the second half of the sixteenth century innovation in garden design shifted from the royal palaces to the houses of the aristocracy, notably Kenilworth Castle, THEOBALDS PARK, and WIMBLEDON HOUSE, all of which show the direct influence of French or Flemish gardens and the indirect influence of Italian gardens in their designs. In smaller houses knot gardens became fashionable; designs and advice on the selection and care of plants began to appear in printed form with Thomas Hill's *The Profitable Art of Gardening* (1564). One small garden that is particularly well documented is William Turner's garden at Kew; Turner records that he grew fruit trees (peaches, apricots, medlars, figs, and almonds) and a large number of ornamental flowers which must have originated in continental gardens. The most surprising flower in Turner's garden is the French marigold (*Tagetes patula*), which, despite its common name, came from Mexico: the Aztec capital did not fall to Cortés until 1521, and yet by 1544 its flowers were being grown in English gardens.

Salomon de CAUS only lived in England for a few years, but he brought with him a knowledge of Italian and French gardens (notably PRATOLINO, SAINT-GERMAIN-EN-LAYE, and Fontainebleau), and his incorporation of elements of these gardens in his designs for the royal gardens at Somerset House, Greenwich Palace, and Richmond Palace (all laid out between 1610 and 1612) changed the face of English garden design. In all three commissions he produced designs in which house and garden were conceived as integrated parts of single designs, so that the gardens were extensions of the houses. His enthusiasm for hydraulics greatly increased the importance of water in the English

garden, because the fountains, grottoes, and AUTOMATA that he installed in the royal gardens quickly became features of aristocratic gardens that were built between 1610 and 1615, including Ham House (in Richmond, overlaid with a garden built in 1671, and rebuilt as a late seventeenth-century garden in 1975), Twickenham Park, Ware Park (Hertfordshire), Gorhambury (near St Albans), and Chastleton (Oxfordshire; both house and garden survive); hydraulics were also introduced into established gardens, such as those at Wimbledon House and Theobalds Park. The influence of de Caus waned after his departure for Germany, but was revived by the arrival in England of his kinsman (son or brother or nephew) Isaac de Caus, who in the 1620s and early 1630s designed new gardens (all with grottoes) at the Whitehall Banqueting House, Woburn Abbey, Moor Park (Hertfordshire; now overlaid with a Capability Brown garden), and Wilton House (Wiltshire).

In 1613, when Salomon de Caus left for Germany, Inigo JONES travelled to Italy, and he returned the following year as the principal English exponent of PALLADIO. English gardens constructed between 1615 and 1640 – Arundel House (London), Oatlands Palace (Surrey), Albury Park (Surrey; the garden was redesigned in 1677 by John Evelyn), and Danvers House (Chelsea) – were all constructed on the Palladian principles championed by Jones.

Just as Erasmus envisaged an imaginary garden that described the features of Dutch gardens, so Francis Bacon, in his essay *On Gardens* (1625), imagined an ideal English garden, though in his case he spoke with horticultural authority, as he had overseen the gardens at the family home at Gorhambury and had redesigned the gardens at Gray's Inn, one of the inns of court. The princely garden that Bacon planned (but never built) was intended to fill 12 hectares (30 acres). In some ways his garden adhered to English conventions, in that it contained features such as ornamented galleries, covered walks, and a mount topped with a banqueting hall. In other respects, however, his garden adumbrates later English tastes, in that he eschews topiary and knot gardens but enthusiastically advocates lawns in which the grass was to be shorn. Bacon's imaginary garden was thus the remote progenitor of the twenty-first-century English suburban garden, in which the central feature is a closely cut lawn.

THEMATIC INDEX

Thematic Index

NOTE TO THE READER

This book is designed for ease of use, but the following notes may be of use to the reader.

Alphabetical arrangement Entries are arranged in letter-by-letter alphabetical order following punctuation of the headword.

Cross-references are denoted by small capitals and indicate the entry headword to which attention is being directed. Cross-references appear only where reference is likely to enhance understanding of the entry or passage being read, and so are not given in all instances in which a headword appears. Cross-references to major figures do not necessarily appear in specialized entries. 'See' or 'see also' followed by a headword in small capitals is used to indicate a cross-reference when the precise form of a headword does not appear naturally in the text.

Place names The spelling of place names reflects a gradual decline in the use of exonyms. Exonyms that have been retained include Cologne, Florence, Geneva, Munich, and Vienna (instead of Köln, Firenze, Genève, München, and Wien); those that have been supplanted by forms in local languages include Frankfurt, Livorno, Lyon, Marseille, and Reims (instead of Frankfort, Leghorn, Lyons, Marseilles, and Rheims). The demographic balance of the early modern period is reflected in the use of the German forms Basel, Luxemburg, and Strassburg rather than the French Bâle (or the exonym Basle), Luxembourg, and Strasbourg.

Personal names The modern convention of the surname emerged during the period covered by this volume. If the second name carried a strong sense of place or profession, as was often the case in the fifteenth century, the first name is treated as the main name: Leonardo da Vinci was born near Vinci and is therefore listed under Leonardo rather than under 'da' or 'Vinci'. If, on the other hand, the surname was no longer felt to be a place of origin, it is here used as the main name: Hans von Aachen was not a native of Aachen, so he is listed under 'Aachen' rather than under 'von' or 'Hans'. Spanish names are listed by the patronymic that precedes the final matronymic. In the case of Dutch names ending in 'sz.', the abbreviated patronymic is expanded to 'szoon'.

Thematic Index The list of entries under major topics that appears at the front of the book (see pp. xxxi–xxxix) offers another means of accessing the material in the main alphabetical sequence. It allows the reader to see at a glance all the entries relating to a particular subject.

Readers' comments Every effort has been made to ensure that the information in the text is accurate and up to date. Readers are invited to call attention to any minor errors or inconsistencies that they notice, or to comment on individual entries, by writing to

Rebecca Collins, Trade and Reference Department, Academic Division, Oxford University Press, Great Clarendon Street, Oxford OX2 6DP, UK.

Readers' comments will be passed to the author.

A

Aachen, Hans von

(1552–1615), German painter, born in Cologne, the son of a native of Aachen. He studied and worked in Italy from 1574 to 1588, living in Venice and visiting Florence and Rome. On returning to Germany he worked as a landscape and portrait painter; his subjects included several members of the Fugger family. In 1592 Hans von Aachen was appointed court painter to the Emperor Rudolf II, but did not move to Prague until 1597. Once established in Prague, he turned to mythological and allegorical subjects, notably his series of *Allegories on the Wars against the Turks*, of which some survive as oil sketches in the Vienna Kunsthistorisches Museum and the Budapest Museum of Fine Arts.

Abaquesne, Masséot

(*fl.* 1528–64), French potter who established the manufacturing of FAIENCE in Rouen. His workshop specialized in tile pavements decorated with heraldic designs and mythological, allegorical, and GROTESQUE figures. Some of the finest examples are those designed by Geoffrey DU-MONSTIER and made by Abaquesne for the duke of Montmorency's Château d' Écouen (now the Musée de la Renaissance) between 1542 and 1549. Italianate elements in his work, particularly his drug jars, may imply that he was trained by an Italian.

acanthus

A Mediterranean plant for which the English vernacular name is bear's breech. The scalloped leaves of *Acanthus spinosus* were, according to Callimachus, the model for the distinctive foliage that decorates the capitals in the Corinthian and Composite ORDERS of architecture in antiquity; it was this stylized foliage that was revived in the Renaissance. In French such ornament is (inaccurately) termed *chicorée*.

acorn cup

In late sixteenth- and early seventeenth-century England, a stemmed cup made of silver or gold in which the bowl and lid are shaped like an acorn cup, i.e. the shell (*cupulate involucre*) of the acorn.

Adlerglas

or *Adlerhumpen* or *Reichsadlerhumpen*, a German drinking-glass, sometimes with a cover, developed in the mid-sixteenth century. Each glass was decorated in enamel with an image of the eagle of the Holy Roman Empire; the wings of the eagle bore the armorial bearings of the families of the Empire.

Adriano Fiorentino

or Adriano di Giovanni de' Maestri (*c*.1450/60–*c*.1499), Italian sculptor and medallist, born in Florence, where he cast the bronze statuette of *Bellerophon and Pegasus* (Kunsthistorisches Museum, Vienna) by BERTOLDO DI GIOVANNI. At an unknown date in the 1480s Adriano moved to Naples, where he entered the service of King Ferrante I, for whom he worked as a military engineer, artillery-founder, and portrait medallist. In the late 1490s he moved to Mantua and then to Saxony, where his work included a bell-metal bust of the Elector Friedrich III (1498, Albertinum, Dresden).

Aertsen

or Aertszoon, Pieter (*c*.1507/8–1575), Dutch painter who worked both in his native Amsterdam and (from 1535 to *c*.1555) in Antwerp. His paintings, which are often huge, are usually GENRE PAINTINGS or STILL LIFE pictures, characteristically representing butchers and meat. Aertsen also painted ALTARPIECES, most of which have perished or survive only in fragments.

agate glass

or (Italian) *calcedonio* or (German) *Schmelzglas*, an imitation of agate made by blending molten GLASS of two or more colours. The technique was known in antiquity and revived in late fifteenth-century Venice and Germany.

Agostino di Duccio

(1418–c.1481), Italian sculptor, a native of Florence who worked as a mercenary soldier in his youth. His principal works are reliefs on the pulpit of Modena Cathedral (1442), on the interior of Sigismondo Malatesta's Tempio Malatestiano at Rimini (c.1450–7), and on the façade of the Oratory of San Bernardino in Siena (c.1457–61). A relief of *The Virgin and Child*, which was sculpted while Agostino was in Rimini, is now in the Victoria and Albert Museum in London.

alabaster

In Renaissance usage the term 'alabaster' was used to denote two distinct kinds of stone, a carbonate of lime and a sulphate of lime. In Latin and Greek the term sometimes denoted the translucent or variegated stalagmitic carbonate of lime used by the ancients (especially the Egyptians) to fashion containers for unguents and now known variously as 'oriental alabaster', 'calcareous alabaster', 'onyx marble', and 'Mexican onyx'. In vernacular languages the term tended to denote the sulphate of lime now known as 'gypsum' (to mineralogists) or 'gypseous alabaster'.

Gypseous alabaster can be white, yellow, or red, but the variety used by medieval and Renaissance artists was usually pure white, and in Renaissance poetry the term denotes whiteness and smoothness. From the fourteenth century alabaster was quarried and carved in the Meuse valley (Lorraine) and in the English Midlands (Derbyshire, Nottinghamshire, and Staffordshire); Lincoln and York also became important centres for the sculpting of alabaster. In medieval and Renaissance art, alabaster was used principally for tombs and religious statues.

Álava, Juan de

(c.1480–1537), Spanish master mason and architect who was one of the nine master masons assembled in 1512 to plan the cathedral at Salamanca, and in 1513 became one of the three master masons (along with Francisco de COLONIA) who advised on the recently renewed work on Plasencia Cathedral. From 1513 to 1537 he served as master of the works at Plasencia, where he was responsible for the late Gothic chancel and the magnificent crossing. He began contributing to the construction of Salamanca Cathedral in 1520, and in 1526 succeeded Juan GIL DE HONTAÑÓN the Elder as master mason.

He designed the cloister of Santiago Cathedral, where he began to work in 1521. His greatest works are the crossing at Plasencia and the Church of San Esteban in Salamanca, which he designed and began to build in 1524.

albarello

or alberello, a cylindrical apothecary jar used for the storage of dried herbs and medicines. The neck and foot have a slightly smaller circumference than the body of the jar, and the neck is grooved with a flange to enable a parchment lid to be affixed. Albarelli were manufactured in Spain from the fourteenth century, and from the late fifteenth century they were also made in Italy. From the sixteenth to the eighteenth centuries they were manufactured all over western Europe.

The spouted apothecary jars designed to hold medicinal liquids are often called by their French name, *chevrettes*.

Alberti, Leon Battista

(1404–72), Italian humanist writer on the theory of art and architecture, designer of buildings, and, in varying degrees, athlete, lawyer, mathematician, moral philosopher, musician, painter, playwright, and satirist, born in Genoa, the illegitimate son of a Florentine exile. In 1431 he moved to Rome, where he worked in the papal secretariat and was eventually appointed as papal adviser for the restoration of Rome (1437–55), and so worked alongside Bernardo ROSSELLINO; in 1432 he made his first documented visit to Florence, travelling in the train of Pope Eugenius IV.

In 1435, apparently in reaction to the new classicizing style in art that he had seen for the first time in Florence, he wrote *De pictura*, an essay on painting dedicated to Gianfrancesco Gonzaga, marquis of Mantua. In this treatise, which is concerned with the theory of painting rather than the painter's practice of the craft, Alberti draws heavily on the descriptions of ancient Greek paintings given by Pliny in his *Historia naturalis*. Like Pliny, Alberti believed that good art requires an understanding of optics and careful attention to the imitation of nature; the first book of Alberti's treatise is given over almost entirely to a discussion of the geometrical optics of vision and the mathematical rules for correct PERSPECTIVE. Alberti's principal concern, however, is with the *historia*, which is what the picture is about, the story it tells and

The nave of the Church of Sant' Andrea in Mantua, designed by Leon Battista **Alberti** in 1470 and completed after his death. This vast barrel-vaulted nave is one of the most dramatic of Renaissance church interiors; it is modelled, as Alberti explained in a letter to Ludovico Gonzaga, on the design of Etruscan temples. The nave has no aisles, but the walls have vast pilasters that form a series of bays in which there are barrel-vaulted chapels. Construction was protracted, and the building was not completed until the dome was added in 1733.

the way it tells it; these are matters on which a patron would express an opinion when commissioning a work of art. *De pictura* establishes what was to prove to be a long-lived and influential connection between humanism and the new style in art. In 1436 Alberti translated the treatise into Italian (*Della pittura*), introducing some small changes and dedicating the work to BRUNELLESCHI, DONATELLO, MASACCIO, GHIBERTI, and Luca DELLA ROBBIA; the Italian text was not printed until the late nineteenth century. The Latin *De pictura* was printed in 1540, then in a new Italian translation in 1547, and in another new translation in 1568 as part of a collection of Alberti's *Opuscoli morali*.

In 1450 Alberti received his first important architectural commission when he was asked by Sigismondo Malatesta to refashion the Gothic Church of San Francesco in Rimini into the building now known as the Tempio Malatestiano. Alberti designed a marble shell to encase the church; the front, which was based on a Roman triumphal arch, was never finished. The original design, which included a large dome, is preserved on a commemorative medal.

Alberti's next patron was Giovanni Rucellai, for whom he designed the façades of the Church of Santa Maria Novella in Florence (1456–70) and of the Palazzo Rucellai, for which he also designed the Loggia dei Rucellai at right angles with the palace; he designed the Shrine of the Holy Sepulchre (1467) in the Rucellai Chapel in San Pancrazio, and may have been the architect of the chapel. The façade of Santa Maria Novella, which is covered with marble inlay, is based on a geometrical design and on an

ideal of harmonic proportion based on ratios derived from music: the pitch of a resonating cord will rise by an octave if its length is halved, by a fifth if its length is reduced by a third, and by a fourth if its length is reduced by a quarter; the ratios 1 : 2, 2 : 3, and 3 : 4 were therefore deemed by Alberti to be as harmonious in architecture as in music. The façade of Santa Maria Novella was the first Renaissance building to embody these ratios in its structure.

Alberti designed buildings, but never worked on site while building was in progress: he designed the Palazzo Rucellai, for example, but construction was overseen by Rossellino. The only buildings that he designed in their entirety (unless he was the architect of Cappella Rucellai) were two churches in Mantua, San Sebastiano (from 1460) and Sant' Andrea (see p. 3), neither of which was completed during his lifetime. In 1452 he published *De re aedificatoria*, the first architectural treatise of the Renaissance, and dedicated it to Pope Nicholas V; a complete edition appeared in 1485. In this treatise Alberti articulated his understanding of VITRUVIUS, described the architectural ORDERS, and set out the principles of town planning and the ideals of mathematical proportion.

Albertinelli, Mariotto

(1474–1515), Italian painter, a native of Florence, where he trained alongside Fra BARTOLOMEO in the studio of Cosimo ROSSELLI. Albertinelli collaborated with Fra Bartolomeo until the latter entered the Dominican Order in 1499; the products of their collaboration include the ALTARPIECE of Santa Maria della Quercia (3 kilometres (2 miles) from Viterbo). Albertinelli eventually abjured painting and became an innkeeper.

Albertinelli's paintings, which owe much to the style of LEONARDO DA VINCI and PERUGINO, include a *Visitation* (1503, Uffizi) and an *Annunciation* (1510, Accademia, Florence).

Alcaraz carpets

The two principal regions for the manufacture of CARPETS in Spain from the fifteenth to the mid-seventeenth centuries were Alcaraz and CUENCA. Alcaraz carpets typically have a woollen pile dyed red and blue, tied with Spanish knots (i.e. single warp knots) on an undyed woollen foundation. The designs are usually geometrical, though the fifteenth-century sub-group known as 'admiral carpets' incorporates the arms of the Enriquez family and some sixteenth-century Alcaraz carpets depict pine cones and pomegranates.

Aldegrever, Heinrich

(c.1502–1555/61), German engraver and painter who lived and worked in Soest (Westphalia). His engravings show the clear influence of DÜRER, and the small scale of both his engravings and his paintings has led to Aldegrever being associated with the LITTLE MASTERS of Nuremberg. His portraits include engravings of the religious radicals John of Leiden and Bernd Knipperdollinck, who were at the time both imprisoned.

Aldobrandini Villa

The baroque villa at Frascati (26 kilometres (16 miles) south-east of Rome) was constructed between 1598 and 1603. The architect was Giacomo DELLA PORTA, who designed the house and garden for Cardinal Pietro Aldobrandini, nephew of Pope Clement VIII; della Porta died in 1602, before construction was completed, and the project was completed by Carlo Maderno.

The steeply sloping site was flattened and, in the area to be covered by the villa, levelled; the garden was built on the flattened incline and an abundant supply of water was provided by an aqueduct; this remarkable feat of engineering is celebrated in an inscription. In front of the villa there are three terraces, and from the house, which is unusually high (but only two rooms deep), there were views over the terraces to the Campagna, Rome, and the sea. The garden terraces contain a GIARDINO SEGRETO and a garden room called the Stanza dei Venti (the room of the winds) with GIOCHI D'ACQUA that were repeatedly described by seventeenth-century travellers; John Evelyn, for example, enthusiastically describes water-theatres in which storms rage and monsters roar. The terraces at the sides of the house were planted with plane trees that still survive. Scattered around the gardens there were statues (of which only a few remain) and FOUNTAINS, two of which are in the form of boats (*barchette*).

The central feature of the garden is a hemispherical water-theatre (a type of NYMPHAEUM) at the rear of the house, the practical purposes of which were to provide relief from summer heat and to retain the hillside. A large retaining wall surmounted by carved ilex trees is cut into the hillside in a huge arc. The area within the semicircle is in effect the stage of a water-theatre, the water for which flows down a staircase (topped

with two columns) that divides the ilex trees. The wall has five niches with statues, and there is a water-jet in front of each niche. In the central niche water falls from the roof through a star (the Aldobrandini emblem) onto a statue of Atlas carrying a globe. The small terrace above the water-staircase contains a fountain; originally there were two fountains, and this area was surrounded by clipped hedges, beyond which was woodland. The staged retreat from the formality of the house to the distant woodland is a characteristic feature of baroque gardens.

The villa and gardens were damaged by bombing during the Second World War, but have been restored.

Aldus Manutius

or Aldo Manuzio (c.1450–1515), Venetian printer of texts from the literature of classical antiquity, especially ancient Greek texts. Aldus was born at Bassiano (Velletri), south-west of Rome; he was educated in Ferrara, where he was taught by the humanist Guarino da Verona. In 1495 he opened a press and publishing house in Venice, at a house marked by a sign of a dolphin entwined around an anchor, a device originating on coins of the Emperor Titus Vespasianus; the anchor and dolphin became Aldus' IMPRESA, and the press and publishing house came to be known as the Aldine Press.

Between 1495 and 1515 Aldus published some 130 editions of classical and post-classical texts, some 30 of which had never before been printed. Many of the texts that he published were in Greek, including important editions of Aristotle (5 vols., 1495–8), Aristophanes (1498), Thucydides, Sophocles, and Herodotus (1502), Euripides and Xenophon (1503), Plutarch (1509), and Plato (1513). The books were printed in a Greek cursive type that Aldus had commissioned.

Aldus also published Latin texts, including works by Petrarch and Dante and by contemporaries such as Poliziano, Sannazaro, and Francesco Colonna; he also published the *Adages* of Erasmus. These Latin texts were printed in an elegant cursive type designed by Francesco GRIFFO, later known as italic; they were often published in small (octavo) formats with large print runs (c.1,000) and low prices.

Problems with cash flow occasioned by a recession led to the suspension of the massive publication programme in 1505, and the torrent of publications was reduced to a trickle until 1512. On Aldus' death the business passed to his son Paulus (1512–74) and thereafter to his grandson Aldus the Younger (1547–79), who developed a large list of publications in Italian.

Alessi, Galeazzo

(1512–72), Italian architect, born in Perugia and trained in Rome (c.1536–42), where he was influenced by MICHELANGELO. By 1548 he had settled in Genoa, where his early work included the Church of Santa Maria Assunta di Carignano, the basilica plan of which was adapted from BRAMANTE's design for ST PETER'S BASILICA. He was the principal architect of the Strada Nuova, a street of palaces in which Alessi overcame the challenge of sloping sites by designing huge staircases and colonnades and sets of courtyards imaginatively situated on different levels. His Genoese palaces include Palazzo Pallavicini (c.1550), Palazzo Cataldi (1558, now the Chamber of Commerce), Palazzo Cambiaso (1565, now the Banco d'Italia), and Palazzo Parodi (1567); his Genoese villas include the Villa Cambiaso (1548).

Alessi worked in Milan from the late 1550s until 1569. His surviving Milanese buildings include the Palazzo Marino (1557, now the Municipio; the façade on Piazza della Scala is a nineteenth-century addition), the Church of SS Paolo e Barnaba (1561–7), and the façade of Santa Maria presso San Celso, which was completed in 1573 by Martino Bassi (1542–91).

Aleviz

or Alevizo Friasin or Alevizo Novi or Aloiso da Carcano (fl. 1505–9), Italian architect, possibly of Venetian origin, invited to Moscow by Ivan III, grand duke of Muscovy. He was the architect of the Cathedral of the Archangel (Arkhangelsky Sobor) in the Moscow Kremlin, a church that combines Russian domes with a north Italian quattrocento façade with scalloped gables.

Alkmaar, Master of

(fl. c.1475–c.1515), Dutch artist whose name derives from the ALTARPIECE of *The Seven Works of Mercy* painted for the Church of St Lawrence in Alkmaar and now in the Rijksmuseum in Amsterdam. The anonymous artist may be Cornelius Buys (d. 1520), the brother of CORNELISZOON VAN OOSTSANEN. The depiction of peasants in the altarpiece is an early instance of the Dutch form that was later to be known as GENRE PAINTING.

Allori, Alessandro

(1535–1607), Italian painter, trained in the workshop of BRONZINO, who became his adoptive father. The imprint of Bronzino's style is most apparent in Allori's nudes, such as *The Pearl Fishers* (1570–1, Palazzo Vecchio, Florence). As a young man he visited Rome (1554–6), where he saw the work of MICHELANGELO, whose influence can be seen in Allori's *Last Judgement* (1560, Church of SS Annunziata, Florence). His frescoes include GROTESQUES for the Uffizi and historical paintings for the *salone* of the MEDICI VILLA at Poggio a Caiano. Allori's later works include a *Birth of the Virgin* (1602, SS Annunziata).

Alsloot, Denis van

(*c.*1570–*c.*1627), Flemish LANDSCAPE artist who in 1599 became a painter at the court in Brussels, and for the next decade painted landscapes in a style redolent of Gillis van CONINXLOO and Jan BRUEGHEL; during this period the human figures in Alsloot's paintings were often drawn by Hendrik de Clerck (*c.* 1570–1630). After 1610 Alsloot increasingly adopted a more naturalistic idiom in his landscapes. He is best known for his depictions of processions and festivals in landscapes that sometimes include biblical or mythological figures. In 1615, at the command of Archduchess Isabella, Alsloot executed a series of paintings of the Ommegang (an annual procession in honour of the Virgin) held in Brussels on 31 May 1615; paintings in the series are now in Brussels (Musée d'Art Ancien), London (Victoria and Albert), Madrid (Prado), and Turin (Galleria Sabauda). He painted another series depicting the festivals at the Abbaye de la Cambre at Brussels.

altarpiece

The term used in ecclesiastical architecture for a picture or a carved screen behind and above an altar; in theological terms, an altarpiece is a decorative adjunct to an altar and not a liturgical object, so the blessing or consecration of an altar by a bishop does not extend to the altarpiece. The usual subject of an altarpiece is the saint to whom the church is dedicated.

The terms 'reredos' and 'retable' are sometimes used interchangeably with the term 'altarpiece', but the semantic fields of the three terms do not overlap altogether. The term 'reredos' is often used to denote a large construction in wood or stone decorated with carved figures, but is sometimes used in a broader sense for any decoration mounted above and behind or in front of an altar (e.g. the golden Pala d'Oro refashioned in 1345 for the altar of Basilica San Marco in Venice); these reredoses could be very large (e.g. Veit STOSS's painted reredos of 1477–9 in the Church of Our Lady in Kraków), in some cases covering the entire wall (e.g. the restored fifteenth-century reredos in the chapel of All Souls College, Oxford). The 'retable' (Latin *retabulum*, i.e. rear table) evolved from the shelf at the back of the altar on which candlesticks were placed into part of the framework of panels forming a reredos, and eventually came to mean a carved or painted altarpiece made up of panels fixed together rather than hinged like a triptych. The 'predella', which evolved (like the retable) from the shelf at the back of the altar, came also to be used to denote the strip of paintings at the base of an altarpiece; when placed below a triptych so that the doors could be opened and closed, the predella would be painted with scenes related to those on the altarpiece. In Italian an altarpiece consisting of a single picture is called a *pala d'altare*, and an altarpiece with several panels in a single frame is called an *ancona*. Altarpieces sometimes take the form of triptychs, in which two hinged side panels fold over the central panel; the diptych (which consists of two panels) is rare in altarpieces, but there was a tradition of polyptychs, which had at least four panels side by side and sometimes had a crowning panel; two of the most complex polyptychs are the Ghent altarpiece of Jan and Hubert van EYCK and the Isenheim altarpiece of GRÜNEWALD.

In Italy the altarpiece typically consisted of a panel painting in an elaborate gilt frame. The panel was often divided into compartments, but in the course of the fifteenth century the number of compartments was reduced and all the paintings in the frame were organized into a single composition, typically with a SACRA CONVERSAZIONE in the central panel and saints looking towards the Holy Family from the side panels, which shared a landscape background with the central panel. The ascendancy of pictorial values meant that the altarpiece differed from other easel paintings only in the architectural use of the surrounding frame.

In Germany and Flanders, the altarpiece typically consisted of a central panel flanked by hinged leaves. The leaves of this 'winged altar' (German *Wandelaltar*) would normally be painted on both sides; some altars had a second

pair of wings, painted on the outside in GRI-SAILLE, for use on days of penitence. In France, where altars were usually made of stone, altar-pieces were typically mounted in arched archi-tectural frames; the influence of Flanders meant that painted triptychs became increas-ingly popular. In Spain large retables (Spanish *retablos*) accommodated extensive narrative cy-cles of paintings; the enormous carved reredos filled with figures and scenes was also popular (e.g. Damià FORMENT's reredos in the Cistercian abbey of Poblet, which introduced Renaissance sculpture in the Roman style to Catalonia).

In England the wooden reredos developed into a distinctive national form in the four-teenth century, typically a large construction with niches for figures of Christ and the saints; no complete sets of figures survived the Reformation. The painted reredos was always rare; the few that survived the Reformation in-clude an early fourteenth-century *Crucifixion with Eight Saints* found in its original frame in a stable in 1927 and now restored to the thatched parish church of Thornham Parva in Suffolk.

There were no altarpieces in Orthodox churches (where images were mounted on the iconostasis), and the iconoclastic ideology of the Reformation meant that many altarpieces in Protestant countries were destroyed, though wooden reredoses survived, albeit stripped of their statuary. Strong Counter-Reformation support for altarpieces, including a stipulation that every altar should bear the image of the titular saint of the church in which it was placed, ensured that the genre remained alive in Catholic countries. In the late sixteenth century, large altarpieces tended to be attached to the wall behind the altar and surrounded with architectural frames that reflected structures within the church.

Altdorfer, Albrecht

(c.1480–1538), German painter, born in Regensburg, of which he became a burgher in 1505. His syncretic style reflects the influence of MANTEGNA, CRANACH, and DÜRER. Altdorfer's preferred subject was LANDSCAPE. His early works experiment with the presentation of fig-ures in landscapes; the best-known painting of this period is *Christ Taking Leave of his Mother* (National Gallery, London). Many of his later works (some of which are miniatures) eschew figures in favour of pure landscapes. From 1526 until his death Altdorfer served as civic architect

of Regensburg, in which capacity he built forti-fications and a slaughterhouse; his interest in ar-chitecture and his skill in perspective are evident in his *Birth of the Virgin* (Alte Pinakothek, Munich). He also painted an important battle-piece, *The Battle of Alexander at Issus* (Alte Pinakothek, Munich).

Altichiero

(1320/30–c.1393), Italian painter, born in Zevio, near Verona. His principal surviving works, all of which echo the style of GIOTTO, are a fresco in the Church of Sant' Anastasia in Verona and, in collaboration with another painter called Avanzo, the fresco cycles in the Basilica del Santo and the Oratorio di San Giorgio in Padua.

Amadeo, Giovanni Antonio

(1447–1522), Italian sculptor and architect, born in Pavia, and from 1466 employed carving sculp-tures for the Certosa di Pavia; from 1481 to 1499 he served as principal architect, in which capac-ity he designed the façade. His other work in-cludes the sculptures on the Colleoni Chapel in Bergamo (1470–3) and the dome over the cross-ing of Milan Cathedral (1490).

Amati family

Italian violin-makers in Cremona. Andrea (c.1511–1577) is thought to be responsible for the form which the violin, viola, and cello have today. The instruments' design, which used contemporary standards of measurement and proportion, established a model for subsequent generations of instrument-makers; the rules for scroll design remain virtually unchanged. The characteristic tone of these instruments is sweet, if somewhat delicate compared to later models. Antonio (c.1540–1607) and his half-brother Girolamo (c.1561–1630) were sons of Andrea. Known as 'the brothers Amati', they developed the work started by their father, mak-ing alterations to the shape of the soundhole and strengthening the instrument. The superior quality of instruments from the Amati work-shop was sustained even allowing for the exper-imental work they carried out on the outline and arching of instruments; it is possible they were the inventors of the contralto viola (the size commonly used today) at a time when the larger tenor viola was in common use.

The Amati family were the first of many to work as violin-makers in Cremona. Their repu-tation spread far beyond north Italy, and the

influence of their designs was felt as far afield as the Tirol and the Netherlands. The effect of these sophisticated instruments on composers of the period is incalculable.

Amberger, Christoph

(*c*.1505–1561/2), German portrait painter who worked in Augsburg, which by virtue of its position on the principal trade route from the Mediterranean to northern Europe was the first important humanist centre in the north and the first northern city in which painters fell under the influence of Italian artists. The portraits of Amberger, such as his *Charles V* (Gemäldegalerie, Berlin), are in their emphasis on the splendour of dress and their delight in fabric and jewellery products of the Venetian school.

Amberger was the son-in-law and pupil of Leonhard BECK, with whose work his portraits are sometimes confused.

Amboise, Château d'

The birthplace and principal residence of King Charles VIII. It overlooks the Loire from a triangular rocky outcrop above the town of Amboise. Construction of the castle began in 1434. The principal wing, facing the Loire, is the Logis du Roi (the royal apartments), which was built in the French Gothic style by Charles VIII; the other wing, at a sharp angle to the Logis du Roi, was commissioned by Louis XII, and was demolished at the Revolution.

The Italian campaign of Charles VIII instilled in him a taste for Italian gardens, and on his return in 1496 he commanded PACELLO DA MERCOGLIANO to provide a garden for Amboise on a terrace within the castle precincts. A later drawing of the chateau by Jacques DUCERCEAU shows that the garden, which was entirely enclosed by buildings which have since disappeared, was divided into ten square (or rectangular) planted areas, each of which was divided into four smaller squares; on the end of the garden overlooking the Loire there was a gallery pierced by windows. There is also a PAVILION in the Italian Renaissance style, like those which Pacello designed for BLOIS and GAILLON.

LEONARDO DA VINCI was invited to Amboise by Francis I, and died there in 1519; he is said to be buried in the Chapelle Saint-Hubert, an exquisite French Gothic building on the ramparts.

Amerbach, Johannes

(*c*.1440–1513), Swiss humanist printer and art collector, born in Basel and educated in Basel and Paris. In 1484 he established a printing workshop in Basel, specializing in the production of patristic works. The humanist Jean Heynlen, who had taught Amerbach in Paris, later migrated to Basel, where he joined a small circle of humanist scholars responsible for the textual accuracy of Amerbach's editions. His most important publication was an eleven-volume edition of Augustine. The presence of a group of humanists associated with the press attracted other humanists to what quickly became an important humanist centre.

Amerbach's son Bonifacius was the subject of an important portrait by Hans HOLBEIN (1519, Kunstmuseum, Basel).

Amman

or Ammann, Jost (1539–91), Swiss engraver. He was born in Zürich but spent most of his working life in Nuremberg. He was a prolific producer of WOODCUTS and ENGRAVINGS for use as illustrations in popular books. The artistry of his illustrations may not achieve the highest standards, but they are nonetheless valuable as documents in the social history of sixteenth-century Nuremberg. Some of his biblical illustrations were later imitated by Rubens.

Ammanati, Bartolomeo

(1511–92), Italian architect and sculptor, born in Settignano (near Florence) and trained in the workshop of Pisa Cathedral. He worked in Venice with SANSOVINO on the Libreria del Sansovino (which was to house the Biblioteca Marciana until 1812) and subsequently moved to Rome, where from 1550 he worked with VASARI and VIGNOLA on the Villa GIULIA. In Florence he built the Ponte Santa Trinita (1567–70, destroyed 1944 and rebuilt) and the rusticated court of the PITTI PALACE (1558–70), completed the Palazzo Grifoni (1557), and supervised the construction of MICHELANGELO's vestibule stairway in the Biblioteca Laurenziana; elsewhere in Tuscany, he built the Tempietto della Vittoria near Arezzo (1572) and contributed to the Palazzo Provinciale in Lucca (1578). His last important building was the Collegio Romano in Rome (*c*.1582–5), which Ammanati designed for the Jesuit Order.

Ammanati's principal surviving sculpture is the FOUNTAIN (see p. 99) in the Piazza della Signoria in Florence, in which a marble *Neptune* is surrounded by bronze nymphs (1571–5).

amphitheatre

The amphitheatres of ancient Rome, such as the Colosseum, were oval auditoriums used for gladiatorial combats and, when flooded, naval displays; the term 'amphitheatre', which was borrowed from Greek, means 'double theatre', i.e. two elliptical buildings facing each other in an oval. Roman amphitheatres were free-standing buildings, and so differed from Greek theatres, which were elliptical auditoriums scooped out of the side of hills; Roman theatres imitated this construction, but supplemented the natural support of the hillside with concrete vaulting.

In the Renaissance the term 'amphitheatre' was used to denote what the Greeks and Romans would have called a 'theatre', i.e. an open semicircular or elliptical structure. In the garden to the west of the Villa MADAMA, Raphael hollowed out the hillside to build an *exedra*, i.e. a modern imitation of the classical debating theatre. Behind the villa at PRATOLINO there is a vast amphitheatre carved out of the Tuscan hillside. The most celebrated amphitheatre of the sixteenth century is in the BOBOLI GARDENS, where TRIBOLO regulated the shape of a natural hollow so that it resembled a U, and then planted the banks; the seating that later replaced the plantations was not built until 1637.

anamorphosis

A seventeenth-century term transliterated from a Greek word meaning 'transformation' and used to denote images that are distorted when viewed from the front but become properly proportioned when viewed from a particular angle or by reflection in a special mirror. The optical principles were understood and implemented in antiquity by Greek sculptors whose statues were designed to be viewed from below, and this practice was described by Plato (*Sophist* 236). The earliest examples of the technique occur in the notebooks of LEONARDO DA VINCI. The two best-known examples in painting are Guillim SCROTS's portrait of King Edward VI (National Portrait Gallery, London) and the skull in HOLBEIN's *Ambassadors* (1533, National Gallery, London); in woodcuts, the most familiar image is Erhard Schön's *Anamorphosis of Emperor Ferdinand* (c.1531–4).

Ancy-le-Franc, Château d'

An Italian Renaissance house and garden near Auxerre, in Burgundy. The architect was SERLIO, who was employed at the court of Francis I.

The house and garden were commissioned by Antoine de Clermont, brother-in-law of Diane de Poitiers; construction on a large, level site began c.1546.

The house is built around a large rectangular courtyard of majestic proportions. The twelve principal rooms on the ground floor, notably the Chambre des Nudités and the Chambre de Diane, are adorned with tapestries and frescoes. On the first floor, the apartments and galleries were sumptuously decorated by PRIMATICCIO.

A drawing by Jacques DUCERCEAU shows that the original gardens echoed the rectangular shape of the house. A huge rectangular raised terrace was constructed around the house and garden, and this terrace was used as a promenade from which house and gardens could be viewed. In the late seventeenth century *bosquets* (see BOSCO) and PARTERRES *de broderie* were added, and in the mid-eighteenth century a FOUNTAIN was built on an island in the lake.

Andrea del Castagno

or Andrea di Bartolo di Bargilla or Andreino degli Impiccati (*fl.* 1442, d. 1457), Italian painter and designer of stained glass. He was born in the Castagno (Tuscany) and spent most of his career in Florence. The origin of the nickname that associates him with hanged men (*impiccati*) is not known, unless the aetiological myth that he painted frescoes of condemned men in the Bargello in the aftermath of the battle of Anghiari contains a grain of historical truth. His short career ended when he died of plague.

In 1442 Andrea collaborated with an otherwise unknown painter called Francesco da Faenza on frescoes for the Cappella di San Tarasio in the Church of San Zaccaria in Venice; the decoration, which is the earliest example of Tuscan Renaissance painting in Venice, includes naturalistic representations of St John (who is sharpening his quill) and St Luke (who is scratching his ear). From 1444 until his early death in 1457 Andrea lived in Florence, where he designed a window for the cathedral and painted the series of frescoes (including the *Last Supper* or *Cenacolo*) in the Cenacolo di Sant'Apollonia, the refectory of the Monastery of Sant'Apollonia. His other works include an *Assumption* (1449, Gemäldegalerie, Berlin), an equestrian portrait (in fresco) of *Niccolò da Tolentino* (1455–6, Florence Cathedral), and a series of frescoes of *Famous Men and Women* (three soldiers, three women from antiquity, and Dante, Petrarch, and

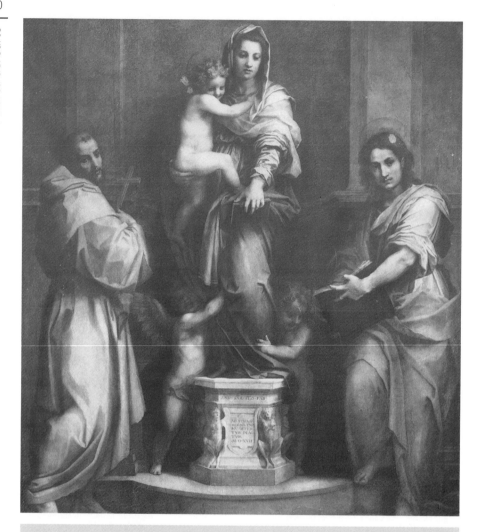

Andrea del Sarto, *The Madonna of the Harpies* (1517), in the Uffizi Gallery, Florence. This altarpiece was commissioned by the nuns of San Francesco dei Macci, whose patron saint, St Francis, is shown on the left; the figure on the right is St John the Evangelist. The Virgin stands with the infant Jesus on a pedestal decorated at the corners with monsters that are traditionally said to be harpies. On the front of the pedestal, beneath Andrea's name and the date, are the opening words of a hymn to Our Lady of the Assumption. The iconography of the painting is not fully understood, but it may represent the triumph of good over evil as described by St John in the Book of Revelation; if this is correct, then the monsters are the locusts of Revelation, not harpies. The painting was restored in 1984, and the colours are now vivid.

Boccaccio) for the Villa Carducci in Legnaia, near Florence (now in the Uffizi).

Andrea del Sarto

(1486–1530), Italian painter, born in Florence. The son of a tailor (*sarto*), he trained in the studio of PIERO DI COSIMO. His most important paintings, all in Florence, are the GRISAILLE mu-rals *The Life of John the Baptist* in Chiostro dello Scalzo (1511–26), the frescoes of *The Nativity of the Virgin* (1514) and *The Madonna del Sacco* (1524), both in the cloister of the Church of the SS Annunziata, and *The Last Supper* (1526–7) in the refectory of the Convent of San Salvi. He also painted gentle Madonnas, such as *The Madonna delle Arpie* (1517, Uffizi, Florence).

VASARI, who trained in Andrea's studio, declared his paintings to be faultless but condemned him for allowing his life to be ruled by a domineering wife. Robert Browning's dramatic monologue 'Andrea del Sarto' derives from Vasari's account, as does Ernest Jones's influential essay (1913), which links the languor of Andrea's art with his timidity in the domestic arena; this psychoanalytical silliness still colours popular accounts of Andrea's art.

Andrea Vanni

See VANNI, ANDREA.

Andreoli, Giorgio

or Maestro, or Giorgio da Gubbio (c.1465/70 c.1553), Italian potter, born in Intra (on Lake Maggiore). In the early 1490s he settled in Gubbio (Umbria), where he established a pottery specializing in MAIOLICA, working alongside his brothers Salimbene (d. c.1522) and Giovanni (d. c.1535). In 1536 Andreoli handed over the workshop to his sons Vicenzo and Ubaldo.

Andreoli specialized in the iridescent metallic surfaces known as 'lustres', and his plates are characteristically finished in a golden or deep red lustre. Pottery bearing his mark is often decorated with GROTESQUES, but his Gubbio factory also produced ISTORIATO pottery.

Andries family

Sixteenth-century Antwerp potters. Guido Andries (fl. 1512, d. 1541), a potter of Italian origin (probably from CASTEL DURANTE), began making TIN-GLAZED EARTHENWARE in Antwerp in or before 1512. His sons Lucas (b. before 1535, d. c.1573), Frans (b. before 1535, d. after 1565), and Joris (c.1535–c.1579) inherited the workshop. In 1567 Joris and his brother Jasper (1535/41 c.1580) moved from Antwerp to Norwich with a potter called Jacob Jansen (d. 1593), where they founded a pottery workshop specializing in tiles and pharmacy jars.

Anet, Château d'

A Renaissance chateau some 80 kilometres (50 miles) west of Paris. It was built between 1546 and 1552 by King Henri II for his mistress Diane de Poitiers. The house and gardens were designed by Philibert DELORME. The house was built around a large courtyard which was entered through the Portail d'Entrée, which is surmounted with a tympanum by CELLINI depicting Diane as the huntress of classical mythology, a motif repeated in the fountain (now in the Louvre) which stood in the courtyard. On either side of the gateway there was a small garden (one part of which survives) leading through a grove to a terrace that ended in a building designed to resemble a sarcophagus, a gesture towards Diane's widowhood.

The main garden, behind the house, was designed to be viewed from a terrace; the garden was divided into compartments with heraldic designs associated with Diane's family. In the 1570s these compartments were swept away in favour of a PARTERRE de broderie, which was surrounded by galleries with pavilions at the corners furthest from the house. Between the pavilions (and beyond the rear gallery) there was a room for bathing which was surrounded on three sides by a moat. These galleries, pavilions, and parterres, which can all be seen in a drawing by Jacques DUCERCEAU, were replaced in the 1680s by a vast parterre, and a canal and lawns were added. In the nineteenth century the grounds were transformed into a park in the English style and the canal was naturalized.

The buildings that survive include the Portail d'Entrée, the left wing of the house, Delorme's domed chapel with its two pyramid-topped towers, and the funerary chapel built in 1566 to accommodate the remains of Diane de Poitiers (which were discarded during the Revolution, when her tomb was used as a horse trough); the statue of Diane kneeling, which is still in the chapel, is attributed to BONTEMPS.

Angelico, Fra Giovanni da Fiesole

or Guido di Pietro (1395/1400–1455), Italian painter who entered the Dominican Order in Fiesole in 1418, renouncing his secular name, Guido di Pietro, and assuming the name Fra Giovanni da Fiesole; the name Fra Angelico originated in the fifteenth century (when he was called Fra Giovanni Angelico) and is a reflection of the religious quality of his art rather than a formal name.

Fra Angelico's earliest datable work is the Madonna dei Linaiuoli (1433, Uffizi), a triptych with a marble frame made by Lorenzo GHIBERTI. The buildings of the Convent of San Marco were restored to the Order in 1436 at the initiative of Cosimo de' Medici, and from 1441 Fra Angelico and his assistants painted more than 45 frescoes in the convent, notably the two Annunciations (one at the head of the stairs and the other in one of the cells).

In 1447 Fra Angelico executed two frescoes in Orvieto Cathedral (assisted by Benozzo GOZZOLI), part of an *Apocalypse* cycle that was later to be finished by Luca SIGNORELLI. He then moved to Rome at the invitation of Pope Eugenius IV, and there decorated the private chapel of Pope Nicholas V (the successor of Eugenius) with frescoed *Scenes from the Lives of SS Stephen and Lawrence* (1447–9), again assisted by Gozzoli. He returned to Fiesole to serve as prior of his convent (1449–52) and then went once more to Rome to paint frescoes in the Chapel of the Sacrament (later demolished) in the Vatican.

In the nineteenth century Fra Angelico was championed by the Pre-Raphaelites, and Ruskin declared that he was 'not an artist properly so-called but an inspired saint'. The attitudes that informed this hagiographical proclamation led to his beatification (1984) and still linger on, so obscuring the extent to which Fra Angelico was a professional artist who drew on the work of his predecessors and contemporaries.

Anguissola, Sofonisba

(1531–1626), Italian painter, born in Cremona, the daughter of a Piedmontese nobleman. She trained in the studio of Bernardino CAMPI and thereafter specialized in portrait paintings. She moved to Madrid in 1559 and subsequently worked in Sicily before returning to Cremona at the end of her life. Her surviving paintings include several self-portraits (e.g. Uffizi, Florence, and Althorp House, Northants) and a group portrait of her sisters playing chess (National Museum, Poznań).

Antico

or Pier Jacopo di Antonio Alari Bonacolsi (*c.*1460–1528), Italian sculptor and bronze-founder, born in Mantua, where he trained as a goldsmith. His nickname derives from his practice of making bronze statuettes of antique sculpture such as the *Apollo Belvedere* (versions in Vatican Museum and Liebieghaus, Frankfurt) and *Hercules and Antaeus* (versions in the Kunsthistorisches Museum in Vienna and the Victoria and Albert Museum). His principal patron was the Gonzaga family, especially Isabella d'Este.

Antonello da Messina

(*c.*1430–1479), Sicilian painter, born in Messina. The Flemish qualities in his paintings and his innovative use of oils led VASARI to assume that Antonello had trained in the studio of Jan van EYCK, but Antonello is unlikely ever to have visited the Netherlands; it is more likely that he encountered Flemish painters and paintings in Naples and that he was influenced by the Flemish style of COLANTONIO, in whose studio he may have trained. His early paintings, executed in Messina, include a *Crucifixion* (Brukenthal Museum, Sibiu, Romania) and a *St Jerome in his Study* (National Gallery, London). In the early 1470s his figures became more sculptural but his backgrounds remained Flemish, as is apparent in paintings such as a second *Crucifixion* (National Gallery, London).

In about 1475 Antonello visited Venice, where he painted his San Cassiano altarpiece, of which three fragments survive (Kunsthistorisches Museum, Vienna); this altarpiece was admired by Giovanni BELLINI, who exercised considerable influence on Antonello's style, as is apparent in his *St Sebastian* (Gemäldegalerie, Dresden).

apostle spoons

Small silver spoons manufactured in England and Germany from the late fifteenth to the late seventeenth centuries. The tops of the handles were each shaped into the figure of an apostle. When manufactured in sets of thirteen, the handle of the 'master spoon' was a figure of Jesus.

arabesques

(early modern English 'moresques', Italian *rabeschi*), the French and English term for the scrolling plant motifs used in medieval Islamic ornament. The term is used more loosely to denote Renaissance decorative motifs in which geometrical and botanical lines are used to create elaborate patterns. The Italian term *rabeschi* was also used to denote ACANTHUS foliage. In LACE and EMBROIDERY such patterns are usually known as 'moresque' or 'mauresque'. An anonymous *Passements de moresques* published in 1563 was the first pattern book to offer such designs. After *c.*1530 arabesques were often used in GROTESQUE decorative schemes.

Aranjuez

The summer residence of King Philip II of Spain, 50 kilometres (30 miles) south of Madrid on the left bank of the river Tagus. The fourteenth-century palace at Aranjuez passed to the Spanish crown in 1522. Charles V built a hunting lodge on the site, and this was enlarged by

Philip II, who planted the English elms which render the landscape so distinctive. Remnants of the chateau survive only in the east face of the eighteenth-century palace that now dominates the site.

The gardens that Philip II laid out in the early 1560s showed the influence of both Flemish and Italian gardens. The chief Flemish element was the use of small compartments with clipped hedges; the Italian influence is apparent in the large statues of mythological figures. This garden contained many FOUNTAINS, some with stacked basins; some of the fountains now in the garden may date from this early garden. In the 1580s Philip decided to incorporate a nearby island in the Tagus into the garden that is now known as the Jardin de la Isla (where Schiller later set his play *Don Carlos*); this garden, which is bounded by the canal (La Ría) on one side and the river on the other sides, was laid out with avenues of plane trees. Details of the original layout are not known, but by the mid-seventeenth century the Hercules fountain (which derives from the sixteenth-century Ocean Fountain in the BOBOLI GARDENS) had been constructed, and *GIOCHI D'ACQUA* had been installed, one of which drenched unwitting pedestrians on a path called Los Burladores ('The Jesters'). In the eighteenth century PARTERRES and avenues of lime trees were planted, but elements of the Renaissance gardens can still be seen.

Arcimboldo

or Arcimboldi, Giuseppe (*c*.1527–1593), Italian painter in Prague, a native of Milan, where he worked as a designer of stained-glass windows for the cathedral. He entered the imperial service as a court painter, and from 1562 to 1587 worked in Prague and Vienna in the courts of Ferdinand I, Maximilian II, and Rudolf II (who in 1592 ennobled Arcimboldo as count palatine). His paintings, of which some twenty survive, are typically bizarre heads composed of fruits, vegetables, flowers, and leaves (e.g. *Rudolf II as Vertumnus*, *c*.1591, Skokloster Slott, Skokloster).

Arcimboldo's paintings were long regarded as curiosities in questionable taste, but in the twentieth century he was championed by Salvador Dalí and the Surrealists, who valued Arcimboldo for his visual punning and use of *objets trouvés*.

Arciniega, Claudio de

(*c*.1527–1593), Spanish architect, who lived and worked in Mexico from the mid-1540s. He was appointed as master of the works (*maestro mayor*) at Mexico Cathedral in 1584, and promptly changed the plan of the cathedral. He was probably also the architect of Puebla Cathedral. These buildings displaced the PLATERESQUE style which had previously prevailed in favour of the more austere style of Juan de HERRERA.

Arfe

or Arphe family, a dynasty of Spanish goldsmiths who specialized in monstrances. Enrique de Arfe (*c*.1470–*c*.1545) was born in Germany (probably in Cologne) and by 1500 had settled in León, where he embarked on a huge silver-gilt monstrance (completed 1522, destroyed 1809) for the cathedral. He made similar monstrances for Córdoba Cathedral (1518) and Cádiz Cathedral (1528); his processional cross for Toledo Cathedral (1515–24) is 3 metres (10 feet) high and is decorated with 260 silver-gilt statuettes.

Enrique's style was uncompromisingly Gothic, but the work of his son Antonio de Arfe (1510–*c*.1566) is PLATERESQUE. Antonio's tabernacles include those in Santiago Cathedral (1539–45) and the Church of Santa María in Medina de Rioseco (Valladolid).

Antonio's son Juan de Arfe y Villafañe (1535–1603) made the monstrances for Ávila Cathedral (1564–71) and Seville Cathedral (1580–7, now altered) and the processional cross for Burgos Cathedral (1592). He published a treatise on the goldsmith's art (*Quilatador de la plata, oro y piedras*, Valladolid, 1572), an account of his Seville monstrance (*Descripción del traço y ornato de la custodia de plata de la Sancta Iglesia de Sevilla*, Seville, 1587), and a treatise (partly in verse) on proportions in sculpture and architecture (*De varia comensuración para esculptura y architectura*, 1585).

arms and armour

Arms are weapons of offence and armour is defensive equipment. Arms wielded by hand in close combat included swords, daggers, axes (including the halberd and the bill), clubs, maces, hammers, lances (cavalry spears fitted with a circular handguard known as a vamplate), pikes (very long spears used by infantry to form a palisade against cavalry), and partisans (spears, still

in use in parade grounds, with a triangular blade with pointed lugs at its base). Projectile weapons included bows, crossbows, catapults, guns, and artillery.

Armour consisted of body armour (including protection for limbs and head) and shields. Metal armour was constructed by one or more of five distinct methods: lamellar (laced overlapping oblong plates), scale (small leaf-shaped plates secured to a textile garment like roof tiles), mail or (popularly) chain mail (interlinked rings), coat-of-plates (small overlapping plates or hoops riveted to a textile garment), and plate (large plates, each of which covers part of the body).

In the second half of the fourteenth century, armour typically consisted of chain mail or coat-of-plates with a solid plate breastplate, covered with a sleeveless surcoat (known as a jupon or as coat-armour) embroidered with the coat of arms of the wearer. The helmet was made of metal, and by the thirteenth century completely enveloped the head; this 'great helm', as it is now known, was used in warfare until the mid-fourteenth century and in tournaments until the sixteenth century. In the late fourteenth century it was replaced on the battlefield by the basinet (or basnet), a new type of helmet with a detachable pointed visor and a chain-mail tippet (called an aventail or gorget) to protect the neck.

In the fifteenth century, the gowns previously worn over armour were discarded, and armour increasingly came to be made from polished steel plates. By the 1410s armour had assumed the form that it was to retain until it ceased to be used at the end of the seventeenth century. A typical fifteenth- and sixteenth-century armour consisted of a cuirass (a linked polished steel breastplate and backplate) with a skirt of iron hoops worn over a quilted undergarment, a coat-of-plates covering for the arms and the front of the legs, and a helmet. The left side of the armour was thicker than the right, because the lance of an opponent was held in the right hand couched diagonally across the

horse's neck to the left. In tournament armours this imbalance was exaggerated, and the right arm and shoulder were lightly armoured or left unprotected. In helmets, the chain-mail aventail of the basnet was replaced by plate, and a series of new designs emerged: the Italian *barbuta* was a one-piece helmet that extended to the cheeks; the sallet (or salade) had a visor worn with a separate chin piece (called a beaver); the armet had hinged cheek pieces that fastened at the chin, leaving only the eyes visible; the close-helmet, which was popular in the sixteenth century, looked like an armet, except that the cheek pieces were made from a continuous piece of metal and pivoted like the visor. The close-helmet was worn with full armour, but sixteenth-century light cavalry wore the burgonet (a peaked open helmet with cheek pieces, fitted to the gorget so that the head could be turned without exposing the neck) and infantry wore either the burgonet or the morion (a descendant of the medieval kettle-hat resembling a broad-brimmed hat).

The most important centres for armour production were south Germany (especially Augsburg and Nuremberg) and north Italy (especially Milan and Brescia); in the early sixteenth century Maximilian I founded an imperial armoury in Innsbruck (1504) and Henry VIII founded a royal armoury in Greenwich (1515). The most prominent armourers were the HELM-SCHMIED FAMILY of Augsburg and the MISSAGLIA FAMILY of Milan. Fifteenth-century German armours were angular, and were decorated with fluting (which survived into the sixteenth century with the 'Maximilian armours' popular from c.1515 to c.1530), whereas Italian armours of the same period had rounded lines. These national styles began to merge at the end of the fifteenth century, and in the sixteenth century there were pan-European fashions in armour; until the 1510s breastplates were rounded, but thereafter they became flatter and featured a vertical ridge down the middle; in the last 30 years of the century the prevailing fashion was a

Detail of the *Boar and Bearhunt Tapestry*, one of the four *Devonshire Hunts* (Victoria and Albert Museum, London), which were probably woven in **Arras** (see p. 16) in the second quarter of the fifteenth century. The four tapestries are also known as the *Chatsworth Hunts*, and until 1957 hung in Chatsworth House, seat of the dukes of Devonshire.

pea-pod or waistcoat form curving down to a blunt point at the bottom. By the 1520s tournament armour had evolved away from field armour, but thereafter armours that could be used for either purpose were developed, often with alternative or additional pieces (called garnitures) to facilitate the change of use; during the same period a new kind of armour emerged, the decorative parade armour.

Sixteenth-century armours were often decorated with etched and gilt designs which could survive the use of armour in the field or at the tournament. Parade armours, however, were intended only as symbols of the wealth and power of their wearers, so decoration and design were not constrained by practical considerations. Parade armours were sometimes elaborately embossed, etched, or damascened, and designs included adaptations of ancient Roman armour. Artists such as DÜRER and HOLBEIN executed designs for armours, and others, such as Daniel Hoffner and Jörg SORG the Younger, specialized in the decoration of armour. Embossed armour was made by the NEGROLI FAMILY of Milan and Bartolommeo Campi of Pesaro.

The Roman practice of equipping horses with armour was revived intermittently in the twelfth and thirteenth centuries (when horses were sometimes covered with mail), and from the fourteenth to the seventeenth centuries horses were sometimes armoured with plate (though the legs were usually left uncovered). Riders wore a spiked spur until the early fourteenth century, after which the spike was replaced with the rowel that has remained in use to the present day.

Arnolfo di Cambio

or Arnolfo di Lapo (*c*.1245–1310), Italian architect, mason, and sculptor, recorded as an assistant to Nicola PISANO in 1266. He was appointed master mason of the new cathedral in Florence in 1296; his design was implemented in the nave and aisles, but the east end is the work of his successor, Francesco TALENTI. Surviving buildings that have been attributed to Arnolfo on stylistic grounds include the Florentine churches of Badia and Santa Croce and the tower of the Palazzo Vecchio.

Arnolfo's work as a sculptor includes a bust of *Pope Boniface VIII* (Grotte Vaticane, Rome), the ciboria in San Paolo fuori le Mura in Rome (1285) and in Santa Cecilia in Rome (1293), and

the tomb of Cardinal De Braye (after 1282, San Domenico, Orvieto), which was imitated in wall tombs for more than a century.

Arras tapestries

(*c*.1313–1477), a group of TAPESTRY workshops in the town of Arras (Artois). The tapestries of Arras are first mentioned in 1313, and by the middle of the fourteenth century Arras had become the most important tapestry centre in Europe. In 1384 Artois was annexed to the duchy of Burgundy, and thereafter Arras enjoyed the patronage of the Burgundian court and gained access to the English export market. In 1477 King Louis XI of France captured Arras and dispersed its inhabitants; the workshops were re-established on a small scale, but the centre of production shifted to Tournai, and the Arras workshops closed early in the sixteenth century.

The similarity of Arras and Tournai tapestries creates problems of attribution. The only tapestries for which documentary evidence demonstrates an Arras provenance are the set depicting the lives of St Piat and St Éleuthère (1402, Tournai Cathedral), which formerly bore the signature of Pierrot Feré of Arras. Attributed works (all of which could have been made in Tournai) include a *Passion* series (now divided between the Musée Cinquantenaire in Brussels, Zaragoza Cathedral, and the Vatican Museum) and the *Chatsworth Hunts* (Victoria and Albert Museum; also known as the *Devonshire Hunts*).

Arrighi, Ludovico

(d. 1527), Italian calligrapher, type designer, and printer, a native of Vicenza who worked as a scrivener in the papal chancery. In 1522 he published *Operina da imparare di scrivere littera cancellaresca*, which was the first printed handbook on CALLIGRAPHY. His typeface, which was an elaboration of the chancery hand (*cancelleresca corsiva*) used in the Vatican secretariat, influenced the development of italic type (which had been invented by Francesco GRIFFO), and his script, which combines revived Carolingian minuscules with angular inscriptional majuscules, became the standard correspondence script of sixteenth-century Italy.

Arruda, Diogo de

(*c*.1470–1531) and Francisco de (*c*.1480–1547), Portuguese architects who introduced the MANUELINE style to Portugal. Diogo's main work

is the exuberantly decorated nave and chapter house of the Convento de Cristo in Tomar (1510–14); the sculpted west front of this building, which includes maritime motifs such as sails and ropes (around the windows) and buttresses carved with coral and seaweed, represents the Manueline style at its most extravagant.

Francisco de Arruda, who was probably the brother of Diogo, was the military architect who built the Tower of Belém (1516–21) in subdued Manueline style on an island in the Tagus; the river has since changed course, and the tower is now on the north shore.

artesonado

An architectural term, derived from Spanish *artesón* (a wooden trough or panel), used to denote a marquetry ceiling in which geometrical ornaments constructed of small wooden ribs (*lacería*) outline rows of concave projections that resemble the bottoms of troughs. These ceilings, which were painted in bright colours and gilded, were a particular feature of MUDÉJAR design in the fifteenth and sixteenth centuries, and in Spanish America continued to be constructed throughout the seventeenth century.

Aspertini, Amico

(*c*.1474/5–1552), Italian painter and sculptor, a native of Bologna. He was trained in the Ferrara studio of ERCOLE DE' ROBERTI and on returning to Bologna worked in 1506 as an assistant to Lorenzo COSTA (who had also been trained by Ercole) and FRANCIA when they were painting the frescoes in the Oratory of Santa Cecilia in the Church of San Giacomo Maggiore. Aspertini's surviving independent paintings include frescoes in the Church of San Frediano in Lucca. As a sculptor he contributed to the doorways (begun by JACOPO DELLA QUERCIA) of the Church of San Petronio in Bologna.

Aspetti, Tiziano

(1559–1606), Italian sculptor, born in Venice, where in 1577 he secured the patronage of Giovanni Grimani, patriarch of Aquilea. His work in Venice includes reliefs of *St Mark* and *St Theodore* for the new Rialto Bridge (1589–90) and a bronze statuette of *Mars* (1590s, Metropolitan Museum, New York). In 1604 he accompanied Bishop Antonio Grimani (great-nephew of Giovanni) to Florence, where he remained for the rest of his life. His only surviving Tuscan work is a bronze relief of

The Martyrdom of St Lawrence (1604–6, Santa Trinita, Florence).

Attaignant, Pierre

(*c*.1494–1551/2), French music printer, probably born in Douai. He established a workshop in Paris, where he developed typefaces for music; in 1537 he was appointed printer of the king's music. In his *Chansons nouvelles en musique* (1527) and *Chansons de Maître Clément Janequin* (*c*.1528) he uses characters consisting of a short segment of staff lines to which diamond-shaped notes with stems are attached. This system of single-impression printing obviated the need to print music and staff lines separately. The consequent reduction in costs enabled Attaignant to create a European network for his publications, which in turn disseminated the French chanson all over Europe.

Augusta, Cristóbal de

(*fl.* 1569–84), Spanish potter, born in Estella (Navarre). He moved to Seville, where in 1569 he married the daughter of a potter who manufactured MAIOLICA tiles. From 1577 to 1584 he supplied tiles for the public rooms in the Alcázar. His best-known work is *The Virgin of the Rosary* (1577), a large panel (156 tiles) now in the Museo de Bellas Artes in Seville.

Auricular Style

or Lobate Style or (Dutch) *Kwabornament* or *Ohrmuschel* or (German) *Knorpelwerk*, an early seventeenth-century Dutch silverwork style characterized by curving forms that resemble a human ear (hence its name) or a sea-shell. Its originator was Paulus van VIANEN, who was using it by 1607, and by 1614 it was in use by his elder brother Adam and Adam's son Christiaen.

automata

An automaton is a machine with a source of movement contained within its own mechanism; in this broad sense it came to be used to describe clocks and watches, but in earlier usage it referred to devices such as mechanical animals (including singing birds), water-organs, water-trumpets, and fire-engines that sprayed water at those who accidentally triggered them. In Renaissance Europe automata were used primarily in gardens; water-powered automata in gardens could include GIOCHI D'ACQUA but also included more serious displays.

Automata first appeared in the gardens of Italy, such as Villa d'ESTE (Tivoli) and Villa LANTE. The hydraulic effects at Villa d'Este were imitated in gardens at PRATOLINO, HELLBRUNN (Austria), and, in England, Wilton and Enstone (a lost garden in Oxfordshire). The English diarist John Evelyn describes his visit in 1645 to the Villa ALDOBRANDINI, where he saw singing birds (constructed c.1600) 'moving and chirping by the force of water'; he also describes devices that spray unwary spectators and 'a copper ball that dances about three foot above the pavement, by virtue of a wind conveyed secretly to a hole beneath it'. Similarly, Descartes, proposing in his early mechanistic Traité de l'homme (1629) an analogy between humans and automata, describes the automata at SAINT-GERMAIN-EN-LAYE, noting that water pressure is used to play musical instruments.

Avelli, Francesco Xanto

(1486/7–1542), Italian MAIOLICA painter who worked in Urbino, where he made plates in the ISTORIATO style, usually signing his work 'FLR' or 'FR'. His designs were often adapted from prints by well-known artists (particularly RAPHAEL) and his favoured subjects were mythological scenes and contemporary events.

aventurine

A brown GLASS with golden specks, manufactured in antiquity and rediscovered in the sixteenth century by the glassmakers of the Venetian island of Murano; the name (Italian avventurino) implies that its rediscovery was accidental. Aventurine was made by the admixture of copper crystals to molten glass, and was used both for glassware and as a porcelain glaze. Since the nineteenth century the term 'aventurine' has also been used in a transferred sense to denote a variety of quartz in which the golden specks are pieces of mica.

azulejo

The Spanish and Portuguese name (from Arabic al-zulayj, 'the tile') for a glazed polychrome TILE used in Moorish architecture for exterior and interior walls and for floors. The tiles were typically about 15 centimetres (6 inches) square and brightly coloured, sometimes with geometrical patterns. The reflective surface of azulejos caught the sun, and in gardens they were used to reflect water. After the Reconquista the manufacturing of azulejos continued, often in MUDÉJAR designs.

The iconoclasm of Sunni Islam meant that designs were geometrical rather than representational, and until the end of the fifteenth century each tile had a self-contained geometrical design which was repeated in adjoining tiles. In about 1498 Francisco NICULOSO of Pisa began to manufacture tiles in Seville, and he introduced the idea of a single pictorial design made up of panels of azulejos. Geometrical designs continued to dominate the production of azulejos in most centres, but in TALAVERA DE LA REINA pictorial design was favoured, and Talavera tiles were exported to the Spanish and Portuguese empires around the world. The styles of Spanish and Portuguese tiles could not be readily distinguished in the fifteenth and sixteenth centuries, in that all tiles used a similar range of colours, and designs were specific to cities and regions rather than to countries. In the mid-seventeenth century, however, a distinctively Portuguese style developed, characteristically consisting of large pictorial panels with blue designs on a white background, often depicting episodes from history or religion.

From the early sixteenth century azulejos were decorated by a technique known as cuerda seca, in which the coloured glazes were kept separate by outlining the decorative pattern in a compound consisting of manganese and grease. In the middle of the sixteenth century another technique, known as cuenca ('shell'), addressed the problem of colours intermingling by impressing the pattern of the design into the unbaked clay so that thin clay borders separate the different coloured areas.

B

Bacchiacca

or Francesco di Ubertino (1494–1557), Italian painter, trained in the Florentine studio of PERUGINO. His paintings include *Moses Striking the Rock* (c.1535, National Gallery, Edinburgh) and *The Gathering of Manna* (c.1540, National Gallery, Washington). He also worked as a decorative artist, in which capacity he decorated a *studiolo* (see CABINET) in the Palazzo della Signoria in Florence with illusionistic pictures of fish and birds.

Baccio d'Agnolo

or Bartolomeo Baglioni (1462–1543), Italian woodworker, INTARSIATORO, and architect, a native of Florence. His surviving woodwork from the 1490s includes the choir of the Cappella Maggiore in the Church of Santa Maria Novella in Florence (subsequently altered by VASARI) and the church's organ case (now in the Church of SS Pierre et Paul in Rueil-Malmaison, near Paris) and its gallery (now in the Victoria and Albert Museum). His architectural commissions included the Palazzo Bartolini-Salimbeni in Florence (1520–3).

Baccio da Montelupo

or Bartolomeo Sinibaldi (1469–1535), Florentine sculptor and architect who worked initially as a sculptor of terracotta busts. He became a disciple of the preacher Savonarola (1452–98), and on the death of Savonarola in 1498 fled to Venice. He returned to Florence in 1504 and worked as a decorative sculptor on Orsanmichele and the Church of San Lorenzo; his son RAFFAELLO DA MONTELUPO trained in his studio in Florence. Baccio eventually left Florence for Lucca, where he was the architect of the Church of San Paolino.

Bachelier, Nicolas

(c.1500–1557), French sculptor, mason, and architect, a native of Toulouse, where he carved stone altarpieces and reredoses in local churches and in the Cathedral of Saint-Étienne. His architectural work, such as the doors of the Hôtel de Ville (1546), is designed in an idiom inspired by SERLIO. His finest work is the Hôtel d'Assézat (1555), but the exact extent of his contribution to the building is unclear: he certainly provided the sculptural decoration (1555–8) and may have designed the building, but construction was supervised by another mason.

Baço, Jaume

See JACOMART.

baldacchino

or umbraculum or ciborium, an architectural canopy, made from wood, stone, metal, silk, or velvet, suspended over an altar or bishop's throne or tomb; it may be portable (and so a form of ceremonial umbrella) or suspended from a ceiling or mounted on a wall. A freestanding canopy mounted on pillars over an altar is called a ciborium.

Baldovinetti, Alessio

(1425–99), Italian painter and mosaicist who worked in Florence and its *contado* (dependent territory). His work is documented by the diary of his commissions, one of the few to survive from the fifteenth century. His paintings, which usually include plants and brocades, include a *Sacra Conversazione* painted for the MEDICI VILLA at Caffaggiolo (now in the Uffizi), an *Annunciation* in the Uffizi, a *Madonna* in the Louvre, and a badly damaged fresco of *The Nativity* in the atrium of the Church of the SS Annunziata in Florence. His principal work was a cycle of frescoes in the Cappella Maggiore of Santa Trinita (now largely destroyed). His attributions include *Portrait of a Lady in Yellow* (c.1465) in the National Gallery in London.

In 1450 Baldovinetti began to work as a decorator and mosaicist for the cathedral in Florence; he made MOSAICS for the baptistery in Florence (in the soffit of the north door) and for

the tympanum over the south door of the cathedral in Pisa.

Baldung Grien, Hans

(1484/5–1545), German painter who may have been trained in the workshop of DÜRER. He settled in Strassburg, but also worked across the Rhine in Freiburg, where he painted his best-known work, the ALTARPIECE (1512–16) in the cathedral. Baldung was also an accomplished designer of WOODCUTS, in which medium he deployed CHIAROSCURO to create dramatic effects.

Bambaia

or Agostino Busti (c.1483–1548), Italian sculptor, born near Milan and trained in Padua. His tombs include those of the poet Lancino Curzio (1513, Castello Sforzesco, Milan), Gaston de Foix (1515, Castello Sforzesco), Cardinal Marino Caracciolo (Milan Cathedral), Canon Giovanni Vimercati (Milan Cathedral), and the Venetian *condottiere* Mercurio Bua (Santa Maria Maggiora, Treviso).

Bandinelli, Baccio

or Bartolommeo (1488–1560), Italian architect and sculptor in marble and bronze. He was born in Florence, the son of a goldsmith; he trained with his father and then with Giovanni RUSTICI. Bandinelli secured the patronage of Cosimo I de' Medici and his duchess Eleanor of Toledo, whom he served as an architect on the Palazzo della Signoria and on the choir of Florence Cathedral, to which he contributed several fine sculptures, including low-relief sculptures of the *Prophets* (1555).

Bandinelli was disliked by his contemporaries, and the sneers of fellow artists such as Benvenuto CELLINI (who on returning to Florence in 1525 became Bandinelli's rival) have echoed down through the centuries. The obloquy heaped on his work makes it particularly difficult to judge his long succession of unfinished commissions, including the tombs of Popes Leo X and Clement VII in the Church of Santa Maria sopra Minerva in Rome (both commissioned in 1536) and the statue of Duke Cosimo's father, Giovanni de' Medici, in Piazza San Lorenzo in Florence (commissioned 1540). His finest competed work is the *Hercules and Cacus* (1534) in the Piazza della Signoria in Florence. He also executed versions of classical statues, notably *Orpheus and Cerberus* (1519, Palazzo Medici-Riccardi, Florence) and *Laocoön* (1525, Uffizi).

Banqueting House

or Hall. Built at Whitehall in classical Palladian style by Inigo JONES between 1619 and 1622, the Banqueting House was one of few buildings to survive the fire at Whitehall palace in 1698. The ceiling, completed by Rubens in 1634, celebrates the wisdom of James I; his son Charles I stepped from a window of the Hall onto the scaffold and his death in 1649. The Hall is open to the public and still in use for formal occasions.

Barbari, Jacopo de'

(1460/70–c.1516), Italian painter and engraver; nothing is known of his early life, save that he was a Venetian. In the first decade of the sixteenth century he worked in Germany in the service of the Emperor Maximilian, the Elector Friedrich III of Saxony, and the Elector Joachim I of Brandenburg. In about 1509 he moved to the Netherlands, where he worked as court painter to the Habsburgs, first for Maximilian's son Duke Philip of Burgundy (later King Philip I of Castile) and later for Margaret of Austria.

Jacopo's paintings include a *Dead Bird* (1504, Residenzmuseum, Munich), one of the earliest STILL LIFES. His engravings, many depicting mythological figures, were very influential, and were largely responsible for the dissemination of the Italian depiction of the nude in northern Europe. His best-known woodcut is a large aerial view of Venice (1500), which was the first comprehensive picture of a city as viewed from its highest buildings. Jacopo signed his paintings and his engravings with a caduceus.

Barbaro, Villa

A villa and garden in Maser (Veneto), 27 kilometres (17 miles) north-west of Treviso. The villa and gardens were designed by PALLADIO, who describes it in his *Quattro libri dell'architettura* (1570); the villa and garden were constructed between 1554 and 1558. The interior of the villa is sumptuously decorated with frescoes by VERONESE. The garden made extensive use of water, and was rich in statues, including stone warriors on the boundary walls, within which there were PARTERRES and simple arbours; the main drive was lined with statues of Olympian gods. The villa, which is now called the Villa di Maser, is well preserved, but Palladio's garden has largely disappeared, except for a small GIARDINO SEGRETO.

The *giardino segreto*, which is entirely enclosed by the house and the hill, is dominated

by a magnificent semicircular NYMPHAEUM built by Alessandro VITTORIA. The fountain, which is decorated with fourteen statues of classical figures, is cut into the hill. The fountain feeds a round ornamental fish pond, from which the water runs into the kitchen of the villa and thence to the gardens on either side of the access road and to the distant orchards. Palladio's description of the garden does not specify the size of the pool; nineteenth-century photographs show that the pool was then smaller than it is now, but its original size is not known.

Barili, Antonio

or Antonio di Neri (1453–1516), Italian civil engineer, architect, engraver, and INTARSIA designer, a native of Siena. As a young man he was employed in the repairing of bridges and the construction of fortifications. From 1483 to 1502 he worked in Siena Cathedral, providing carving and intarsia for the choir stalls in the Chapel of San Giovanni (1483–1502; seven panels survive in La Collegiata in San Quirido d'Orcia and one in the Kunstgewerbemuseum in Vienna) and building the benches for the Piccolomini library (1496) and the cathedral's organ case, organ loft, and cantoria (1510). He also built the choir stalls in Santa Maria Nuova in Fano (1484–9; nineteen survive in the church).

Barocci, Federico

or Il Fiori (c.1535–1612), Italian painter and draughtsman. He was a native of Urbino who in 1550 moved to Rome, where he trained and then worked as an assistant to Taddeo ZUCCARO on the CASINO of Pope Pius IV, painting one of the ceilings (1561–2). In the mid-1560s he returned permanently to Urbino, escaping from an allegation of poisoning. Between protracted bouts of ill health he painted hundreds of religious pictures in a style indebted to CORREGGIO, including The Madonna of St Simon (1567, Galleria Nazionale delle Marche, Urbino), The Martyrdom of St Vitalis (1580–3, Brera, Milan), The Virgin with Kitten (c.1576, National Gallery, London), The Madonna del rosario (1588–91, Palazzo Vescovile, Senigallia, Marches), The Madonna della popolo (1579, Uffizi), The Calling of St Andrew (1580–3, Musée des Beaux-Arts, Brussels), and The Circumcision (1590, Louvre). Barocci also produced a large number of drawings, and was one of the first artists to make extensive use of pastel chalks in his drawings.

Baroncelli, Niccolò

or Niccolò del Cavallo (fl. 1434, d. 1453), Italian sculptor, born in Florence. In 1436 he moved to Padua, where his surviving works include a terracotta relief of St Aegidius made for the Church of San Clemente and now in the Museo Civico. In 1443 he was invited to Padua by Leonello d'Este, who commissioned Baroncelli and Antonio di Cristoforo to make an EQUESTRIAN STATUE of Niccolò III d'Este; Antonio made the effigy of the duke and Baroncelli made the horse.

baroque

An art-historical term of uncertain origin (possibly from Portuguese barocco or Spanish barrueco, an irregular pearl) for the dominant style of art and architecture from the late sixteenth to the early eighteenth centuries, characterized by curved forms and exuberant decoration; in the conventional sequence of styles, it follows MANNERISM and precedes Rococo.

Barovier family

Italian glassmakers, active on the Venetian island of Murano from at least 1330, when Jacobello Barovier was recorded as a glassmaker. Jacobello's great-grandson Angelo Barovier (d. 1460) was one of three brothers who owned glasshouses on Murano. There is evidence that Angelo was one of the pioneers in the technology for making crystal GLASS (cristallo) and LATTIMO. A marriage-cup in the Museo Vetrario Murano was formally attributed to Angelo, but is now thought to have been made after his death and so is likely to have been the work of another member of his family; no other work can be securely attributed to Angelo. After Angelo's death the workshop passed to his son Marino (d. c.1490) and thence to other members of the family. The Barovier glasshouse is now the most prominent of the ancient glasshouses of Murano.

Bartolomeo

or Bartolommeo, Fra, or Baccio della Porta (1472–1517), Italian painter and draughtsman, born in Florence, where he trained in the studio of Cosimo ROSSELLI. He fell under the influence of Savonarola and in 1498 was in the Convent of San Marco when it was raided and Savonarola was captured; in 1500, after witnessing Savonarola's execution, he entered the Dominican Order. He became head of the San Marco workshop (a post once held by Fra ANGELICO) in 1504. Visits to Venice

(1508) and Rome (1514–15) broadened his artistic experience, and in his own paintings he developed a distinctive style characterized by facial expressions of rapt devotion, deeply folded drapery, and an air of gravity and decorum.

Fra Bartolomeo's surviving paintings include a *Vision of St Bernard* (1504–7, Uffizi), *God the Father with Mary Magdalene and Catherine of Siena* (1507, Villa Guinigi, Lucca), *The Madonna in Glory with Saints* (1512, Besançon Cathedral), at least two versions of *The Mystic Marriage of St Catherine* (Louvre, 1511, and Accademia, Florence, 1512), and many Madonnas, often pictured (like those of RAPHAEL) together with the infant Jesus and his cousin John in a landscape (e.g. *Holy Family*, National Gallery, London).

Bassano, Jacopo dal Ponte

(*c*.1517/18–1592), Italian painter, born in Bassano, the son of the painter Francesco da Ponte the Elder (*c*.1475–1539). He usually painted religious subjects, the distinctive feature of which is the presence of peasants and animals; he was therefore drawn to the subject of the Adoration of the Magi, of which there are examples in the National Gallery in Edinburgh and the Kunsthistorisches Museum in Vienna. From the late 1560s he sometimes abandoned the religious element altogether, instead painting LANDSCAPES.

Beccafumi, Domenico di Pace

(*c*.1484–1551), Italian painter, born in a village near Siena, the son of a peasant, and trained in Siena and Rome. He later assumed the name of his Sienese patron, Lorenzo Beccafumi. Returning to Siena in 1512, Beccafumi painted frescoes for the Palazzo Pubblico (1529–35), designed 35 biblical scenes for the marble floor in the cathedral, contributed to the decoration of the façade of Palazzo Borghese, decorated the ceiling of the Palazzo Bindi Sergardi, and made a mosaic for the Church of San Bernardino. Many of his panel paintings are in the Pinacoteca in Siena, including *The Trinity and Saints* (1513), *St Catherine Receiving the Stigmata* (*c*.1514), *The Mystic Marriage of St Catherine* (1528), and *Christ in Limbo* (*c*.1536). His *Story of Papirius* (1540–50, National Gallery, London) depicts small figures in an architectural setting.

Becerra, Francisco

(1545–1605), Spanish architect in Mexico and Peru, born in Trujillo (Extremadura), where he worked as a master mason before leaving for Mexico in 1573. He was master of the works at Puebla Cathedral from 1575 until about 1580, when he moved to Quito (then in Peru), where he designed the churches of San Agustín and Santo Domingo. In 1582 he moved to Lima, where he was responsible for the severe designs of the cathedrals at Lima (1582–1601) and Cuzco (1582–1654); the heavily baroque façade of Cuzco Cathedral is the work of a later architect.

Becerra, Gaspar

(*c*.1520–1568), Spanish painter and sculptor. In the mid-1540s Becerra moved to Rome, where he studied the work of MICHELANGELO; there is no documentary evidence of collaboration, but the influence of Michelangelo is readily apparent in his paintings and sculpture. The works of Becarra's Roman period include the *Birth of the Virgin* (1548–53) in the Della Rovere Chapel, Trinità dei Monti, which he painted under the direction of Michelangelo's associate DANIELE RICCIARELLA DA VOLTERRA.

In 1558 Becarra returned to Spain and settled in Valladolid, where he introduced to Spain the style of Michelangelo's paintings. In the last decade of his life he became the most important MANNERIST artist in Spain. His finest surviving work from this period is the reredos of the high altar in Astorga Cathedral. His design for this seminal altar (which included sculptural elements as well as painting) shows the influence of Michelangelo in its nude figures and its scrupulous representation of anatomical detail.

In 1562 Becerra was appointed as a court painter (*pintor del rey*) to King Philip II, in which capacity he painted Italianate mythological frescoes, notably a series of scenes from the story of Perseus in the Pardo Palace (near Madrid) in which the king is represented as Perseus, resolute in his persecution of heretics.

Beck, Leonhard

(*c*.1480–1542), German painter and woodcut engraver, born in Augsburg, the son of a manuscript illuminator. He was apprenticed to Hans Holbein the Elder in 1495; he became an independent member of the guild in 1503. Beck collaborated with Hans BURGKMAIR the Elder and Hans SCHÄUFELIN on the cycles of woodcuts commissioned by the Emperor Maximilian I and known as the *Teuerdank* and the *Weisskunig*. The emperor also commissioned a series called

the *Sipp- Mag- und Schwägerschaften* for which Beck designed 123 WOODCUTS of saints.

beds

Until the seventeenth century most Europeans spread bedding on the bare floor or on rushes, but in wealthy households bedding was laid on a dais or a raised bed, which from the twelfth century was sometimes surmounted by a canopy which was originally called a celure and from the seventeenth century was known as a tester (a term previously used to denote the headboard). By the early fourteenth century French celures were supported by four posts, a fashion which later spread to England. The state bed of the fifteenth century, which was hung with tapestries, was only used on ceremonial occasions, but by the sixteenth century beds with celures and embroidered curtains had become common in prosperous households; the most famous example is the Great Bed of Ware (*c.*1590) mentioned in Shakespeare's *Twelfth Night*, when it was kept in the Saracen's Head in Ware; it was later removed to Rye House and is now in the Victoria and Albert Museum. Less affluent and spacious houses had press beds that fitted into cupboards when not in use: when hinged at the top the opened door served as a canopy with supporting poles at the foot, and when hinged near the bottom the opened door supported the bedding and rested on supports at the foot.

Beham, Hans Sebald

(1500–50) and Bartel (1502–40), Nuremberg engravers, brothers who engraved illustrations for the Bible and for mythological and historical books. Their style is characteristic of the art of the LITTLE MASTERS. In 1525 the brothers were found guilty of blasphemy and sedition and expelled from the city.

Bellano, Bartolomeo

(1437/8–1496/7), Italian sculptor and architect, born in Padua, the son of a goldsmith. He was trained in the studio of DONATELLO in Florence. In 1467 he visited Perugia, where he sculpted a life-sized statue of Pope Paul II (destroyed 1798), and may have worked in the papal service in Rome. By 1469 Bellano had returned to Padua, where he fashioned his most famous work, a marble reliquary chest for the relics of St Anthony of Padua (now in the treasury chapel of the Basilica del Santo in Padua). He later made the ten bronze bas-reliefs in the chancel of the Basilica del Santo in Padua (1484–8).

bellarmine

or (German) *Bartmannskrug* ('beardedman jug'), a type of German glazed stoneware jug produced from the fifteenth to the nineteenth centuries and from the seventeenth century known in English as the bellarmine, the eponym of which was Cardinal Roberto Bellarmino, who was detested in England because of his anti-Protestant polemics. The jugs, which are decorated with the moulded face of a bearded man (sometimes with a coat of arms below it), are also known as 'Greybeards' and as 'd'Alva bottles'; the latter name alludes to the duke of Alba, who persecuted Protestants in the Netherlands.

Bellechose, Henri

(d. *c.*1445), Flemish painter from Brabant who in 1415 succeeded Jean MALOUEL as Burgundian court painter at Dijon. His only documented work is *The Martyrdom of St Denis* (Louvre), which was formerly thought to have been started by Malouel but is now thought to be solely the work of Bellechose.

Bellegambe, Jean

(*c.*1470–*c.*1535), Flemish painter, architect, furniture designer, and embroiderer, born in Douai (now in France but then in the Spanish Netherlands), the son of a cabinetmaker and musician; he remained in Douai throughout his life. His paintings are a syncretic blend of French and Flemish influences and were remarkable for their skilled use of colour; in the seventeenth century Bellegambe attracted the epithet 'Master of Colours'. He was primarily a painter of ALTARPIECES; his best-known work is the nine-panel polyptych known as the *Credo* altarpiece (Musée Municipal, Douai).

Belli, Valerio

or Il Vicentino (1468–1546), Italian engraver of gems, especially ROCK CRYSTAL, born in Vicenza. He may have trained in Venice before moving in 1520 to Rome, where Pope Clement VII commissioned an engraved cross and three medallions, all in rock crystal (1524); they are now in the Vatican Library. In 1530 Belli returned to Vicenza, where in 1532 he completed a casket consisting of twenty panels of engraved rock crystal depicting the life of Jesus; the casket was commissioned by Clement VII, who presented

it to King Francis I, and it is now in the Museo degli Argenti in the Pitti Palace in Florence.

Bellini, Gentile

(*c*.1429–1507), Italian painter, born in Venice; he was the son of Jacopo BELLINI and elder brother of Giovanni BELLINI. In 1474 he was commissioned by the Venetian Senate to decorate the Sala del Maggior Consiglio in the Ducal Palace, reworking some of the canvases painted by his father; these paintings were lost in the fire of 1577. Gentile lived at the Ottoman court in Constantinople from 1479 to 1481, and there painted the portrait of *Sultan Mehmet II* (National Gallery, London). In 1493 he contributed three paintings to a cycle on *The Legend of the True Cross* (now in the Accademia, Venice) for the Scuola di San Giovanni Evangelista in Venice. His *Martyrdom of St Mark* (begun 1504) and his *St Mark Preaching in Alexandria* (begun 1506) were both left unfinished at his death; the former is still in the Scuola di San Marco in Venice, whilst the latter is now in the Brera, Milan. The finest aspect of his pictures is the treatment of townscapes peopled with crowds attending religious processions, as in the *True Cross* paintings.

Bellini, Giovanni

called Giambellino (*c*.1431/6–1516), Italian painter, born in Venice; he was the son of Jacopo BELLINI and younger brother of Gentile BELLINI. He was trained in his father's workshop, and, after his sister Nicolosia's marriage to MANTEGNA in 1454, fell under the latter's beneficent influence. Art historians often compare their treatments of *The Agony in the Garden*, both painted in the early 1460s and now hanging together in the National Gallery in London. The composition and the treatment of the foreground figures in Bellini's version is clearly indebted to Mantegna; the landscape background of the two pictures, however, demonstrates the originality which makes Bellini a seminal figure: Mantegna's background is precisely drafted, minutely observed, and rigorously representa-

tional, but Bellini's brushwork evokes light and space and colour by moving away from representation in order to capture the effect of the dim sunlight on the contours of the countryside. This break from the sculptural definition of form in favour of a lyrical use of light and colour was passed by Bellini to his pupil PALMA VECCHIO and to GIORGIONE (who may have been his pupil) and later to TITIAN. His innovations changed the course of western art.

Bellini was a prolific painter who continued throughout his long life to innovate in all forms of painting from small devotional pictures to large altarpieces. The landscapes of paintings such as *The Crucifixion* (*c*.1465, Correr, Venice), *St Francis* (*c*.1480, Frick, New York), and *The Madonna of the Meadow* (*c*.1510, National Gallery, London) use light to create a contemplative mood, and increasingly light becomes the unifying force of his paintings; similarly, colour ceases to be representational and decorative, and in a painting such as *The Dead Christ with St John and the Virgin* (Brera, Milan) the cold colour of the clothing and the steely chill of the sky and landscape combine to produce the mood of desolation that Bellini sought.

Bellini's ALTARPIECES also use light and colour to create both coherence and mood. From his early *St Vincent Ferrer* (if it can confidently be said to be his) in SS Giovanni e Paolo in Venice (*c*.1465), in which both figures and landscapes are transfigured by light, to the versions of *The Madonna with Saints* in the Church of the Frari in Venice (which Ruskin thought one of the three finest paintings in the world) and in San Zaccaria in Venice, his altarpieces increasingly show independence from both the early influence of Mantegna and the later influence of ANTONELLO DA MESSINA; in these altarpieces Bellini achieves an unprecedented coherence not only through his use of light and colour but also through his attentiveness to the relationships between the paintings and their settings.

Bellini's small paintings are usually devotional, and he returned on many occasions to

Giovanni Bellini, *Madonna and Child* (*c*.1489). The painting hung for centuries in the Palazzo Barberini in Rome and is now in the Burrell Collection in Glasgow. This is a typical example of Bellini's many half-length Madonnas. The painting is devotional in subject but secularized in content. The sprig of rosemary is an emblem of the constancy of Mary, but it is also an object that a child is dangling on a string, and his mother's hand is ready to catch the plant should it fall.

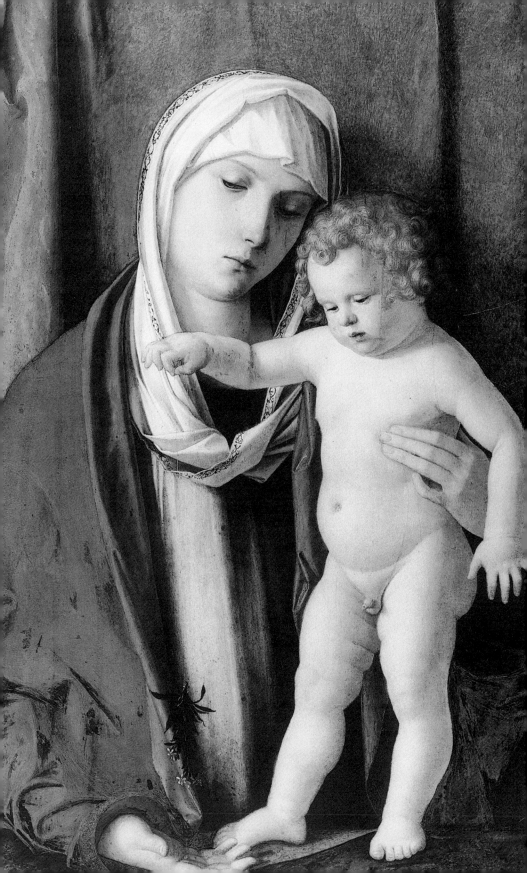

the *Madonna and Child*; a particularly fine example is the *Madonna and Child* (*c.*1489) now in the Burrell Collection in Glasgow. He painted a small number of portraits, notably *The Doge Loredan* (*c.*1501) (see plate 1), now in the National Gallery in London, in which the light gives the skin a translucent quality. His late works, several of which deploy abstract patterning, include the innovative *Fra Teodoro* (1515) in the National Gallery in London, the comic *Feast of the Gods* in the National Gallery in Washington (1514), and his only known female nude, the reticently sensuous *Young Woman with a Mirror* (1515) in the Kunsthistorisches Museum in Vienna.

Bellini was appointed chief painter to the Venetian republic in 1483 and remained pre-eminent among Venetian painters until his death in 1516.

Bellini, Jacopo

(*c.*1400–1470/1), Italian painter, born in Venice, the son of a pewterer, and trained in the studio of GENTILE DA FABRIANO. In 1436 he painted a *Crucifixion* in Verona (destroyed 1759) and in 1441 won a competition in Ferrara to paint the young Lionello d'Este (now lost); another portrait was painted by PISANELLO. On returning to Venice he established a studio with his two sons, Gentile BELLINI and Giovanni BELLINI.

Jacopo Bellini's signed paintings include a *Jesus on the Cross* (Museo Civico, Verona), a *Virgin and Child* (Accademia, Venice), and two Madonnas (Louvre and Brera); he also painted a *St Jerome* (Museo Civico, Verona) and an *Annunciation* (Church of Sant'Alessandro, Brescia). Jacopo's two surviving sketchbooks (Louvre and British Museum) contain more than 230 drawings, many of which are experiments in PERSPECTIVE and composition. The drawings were occasionally adapted by Jacopo's two sons and by his son-in-law MANTEGNA for their own works, although this does not seem to have been one of the acknowledged functions of the books.

Belvedere Court

or (Italian) Cortile di Belvedere, a Vatican court (built 1503–15) designed by BRAMANTE to link St Peter's with the Villa Belvedere (which no longer exists). The original dimensions of the vast court were *c.*300 × 100 metres (330 × 130 yards). The buildings which enclosed the court now house the Vatican Museums. Originally the court was used for pageants, and at one end

there was a garden museum for the display of ancient statues. In 1580 the court was divided by a building designed to accommodate the library of Sixtus V, so what is now the Giardino della Pigna was originally the northern end of the Belvedere Court.

Benedetto da Maiano

or Benedetto di Leonardo (1442–97), Italian sculptor, the younger brother of GIULIANO DA MAIANO. He trained in the studio of Antonio ROSSELLINO in Florence. He sculpted the pulpit in the Church of Santa Croce in Florence (1472–5), an altar in the Chapel of Santa Fina in the Cathedral of San Gimignano (*c.*1475) and another in the Chapel of San Bartolo in the Church of Sant'Agostino in San Gimignano (1494), and a reredos in the Church of Monte Oliveto in Naples (*c.*1485), where his brother had worked. His portrait busts include one of Pietro Mellini, the donor of the Santa Croce pulpit (1474, Bargello), and another of Filippo Strozzi (Louvre). It is possible that Benedetto was, like his brother, an architect, if he was indeed responsible for the portico of Santa Maria delle Grazie in Arezzo (1490–1), which is sometimes attributed to him.

Bening

or Benig family, a family of fifteenth-century Flemish book illuminators. The family was founded by Sanders (also known as Alexander) Bening (d. 1518), who painted MINIATURES in Bruges and Ghent. The illuminations in the Prayer Book of Ingelbert of Nassau (Bodleian Library, Oxford) are attributed to Sanders Bening, who has also been identified with the Master of Mary of Burgundy, so named from his most celebrated work, the Hours of Mary of Burgundy (Nationalbibliothek, Vienna). Sanders's son Simon Bening (*c.*1483–1561) adopted a naturalist Flemish style similar to his father's; the magnificent *Grimani Breviary* (Marciana Library, Venice) is the work of Simon Bening.

Benson, Ambrosius

or (Italian) Ambrogio Benzone (b. late fifteenth century, d. before 12 January 1550), Flemish painter of Italian birth who in 1518 became a citizen of Bruges, where he worked in the studio of Gérard DAVID. Many of his paintings were exported to Spain, including his triptych of *St Anthony of Padua*, which is now in the

Musée d'Art Ancien in Brussels. Spanish elements in Benson's work led scholars to believe that he was a Spaniard who had been influenced by Flemish art, and so his works were long attributed to an unidentified Master of Segovia.

Berg, Claus

(*c.*1478/80–1532/5), German sculptor, a native of Lübeck. He worked in Denmark (from a workshop in Odense) from 1504/5 till 1532, whereupon he moved to Mecklenburg, possibly as a religious refugee. His religious works, notably the *Güstrower Domapostel* (the carved apostles in Güstrow Cathedral, *c.*1530), are often characterized by dramatic expression of sorrow.

Bergamasco, Il

See CASTELLO, GIAMBATTISTA.

Bermejo, Bartolomé

(*c.*1440–1495), Spanish painter and designer of stained glass who worked in Barcelona from 1486. His *Pietà* in the Museum of Barcelona Cathedral, which is executed in the Hispano-Flemish style, is signed and dated 1490; it is one of the earliest surviving oil paintings in Spain as well as the work that inaugurates the Renaissance style in Spanish painting.

Bernardi, Giovanni Desiderio

(1494–1553), Italian engraver of ROCK CRYSTAL, born in Castel Bolognese, the son of a goldsmith. He moved to Ferrara, where he entered the service of Alfonso I d'Este as an engraver and medallist. By 1530 he had moved to Rome, where he secured the patronage of the Medici Pope Clement VII and Cardinal Ippolito de' Medici, for both of whom he executed rock-crystal carvings (now lost and known from casts) that had been designed by MICHELANGELO. His best-known work is a set of six rock-crystal panels of the Cassetta Farnese designed by PERINO DEL VAGA and made by Bastiano SBARRI (1561, Museo Nazionale, Naples).

Bernini, Pietro

(1562–1629), Italian sculptor. He was born in Sesto Fiorentino (Tuscany) but in 1584 moved to Naples, where he worked for twenty years; his finest Neapolitan work is the *Madonna* group in the Certosa di San Martino (1596–8). In 1604 he was called to Rome by Camillo Borghese (then the inquisitor and later Pope Paul V), for whom he collaborated with other sculptors on the Cappella Paolina (Pauline Chapel or Borghese Chapel) in the Basilica of Santa Maria Maggiore, where he carved the large *Assumption* now in the baptistery. He later carved the *St John the Baptist* (1616) in the Barberini Chapel in the Church of San Andrea della Valle.

Pietro Bernini was the father of Gianlorenzo Bernini (1598–1680), the most important BAROQUE architect and sculptor of the seventeenth century.

Berruguete, Alonso

(*c.*1488–1561), Spanish painter, the son of Pedro BERRUGUETE. For an unknown period between 1504 and 1517 he lived in Italy, where he completed Filippino LIPPI's *Coronation of the Virgin* (now in the Louvre). The other paintings of his Italian period, notably the *Salome* now in the Uffizi, show a marked debt to MICHELANGELO (who mentions Berruguete in his *Letters*, as did VASARI in his *Lives*); the Uffizi also holds a collection of his ink drawings.

By 1517 Berruguete had returned to Spain to take up an appointment as court painter to Charles V. His principal work during this period was the 16-metre (53-foot) high composite ALTARPIECE (painted panels, grisailles, and statues in an architecture frame) made between 1526 and 1532 for the Church of San Benito in Valladolid, now dismantled and shown in three rooms in the Valladolid Museo Nacional de Escultura. His last important work was the tomb of Cardinal Juan de Tavera in the Hospital de Tavera in Toledo (1552–61).

Berruguete, Pedro

(*c.*1450–*c.*1500), Spanish painter who served as court painter to Ferdinand and Isabella. He is the most likely candidate for the unidentified 'Pietro spagnuolo' employed in 1477 alongside JOOS VAN WASSENHOVE and MELOZZO DA FORLÌ to work on the library of the Ducal Palace in Urbino. He worked in Toledo from 1483. His ten panels painted for the Dominican convent at Ávila (now in the Prado) show signs of Renaissance Italian influence, but are nonetheless predominantly in the style of Spanish art known as Hispano-Flemish.

Bertoldo di Giovanni

(*c.*1430/40–1491), Italian bronze sculptor and medallist, born in Florence, where he trained in the studio of DONATELLO; he later completed

two pulpits in the Church of San Lorenzo left unfinished by Donatello at his death. Bertoldo specialized in small bronzes which were made for the *studioli* (see CABINET) of private collectors. His most important works are a bronze relief of *The Crucifixion with St Jerome and St Francis* (*c*.1478) and a *Battle* relief, both in the Bargello; attributions include an *Orpheus* statuette in the Bargello and a *Hercules* in the Galleria Estense in Modena. His medals include one depicting the Pazzi Conspiracy.

Bertoldo became the first head of the Academy of Art instituted by Lorenzo de' MEDICI in the Giardino di San Marco. His pupils included MICHELANGELO.

Bettisi, Leonardo

or Don Pino (*fl.* 1566–89), Italian potter in FAENZA and an important manufacturer of BIANCHI. He worked with Virgiliotto CALAMELLI, on whose death in 1570 Bettisi leased his workshop from his widow. Some of his MAIOLICA services include hundreds of pieces (a set manufactured in 1568 had 307 pieces). Products of his factory are marked 'Don Pino'.

bianchi

or *bianco di Faenza* a type of MAIOLICA covered with a thick white glaze. *Bianchi* ware was often extravagantly shaped and pierced but tended to be lightly decorated, usually in blue and orange. The decorative technique was known as *compendiario* (Italian; 'perfunctory') and characteristically consisted of boldly drawn figures which left most of the glazed surface untouched. It was introduced in the FAENZA potteries in the 1540s but was eventually produced all over Europe. The most prominent Faenza manufacturers of *bianchi* were Leonardo BETTISI, Virgiliotto CALAMELLI, and Francesco MEZZARISA.

Biccherna covers

The painted wooden covers used in Siena for tax account books; the dates of surviving covers range from 1258 to 1682. The covers were adorned with paintings by artists such as Ambrogio LORENZETTI, GIOVANNI DI PAOLO, and Domenico BECCAFUMI.

Biliverti, Jacopo

or (Dutch) Jan Bijlivelt (1550–1603), Dutch goldsmith. He moved to Augsburg as a young man, and in 1574 was invited to Florence to manage the gallery of Grand Duke Francesco I de'

Medici; he remained in Florence for the rest of his life. He made a ducal crown for the Medici (1577–83) which is now lost, and is known only from paintings and a drawing. His only documented work known to have survived is the enamelled gold setting of a lapis lazuli urn designed by Bernardo BUONTALENTI (Museo degli Argenti, Palazzo Pitti, Florence).

Bles, Herri Met de

or Herri Patenier or (Italian) Civetta (1510–*c*.1550), Flemish LANDSCAPE painter, in 1535 admitted as Herri Patenier to the Antwerp guild; 'Met de Bles' is a nickname meaning 'with the white forelock', and 'Civetta' (Italian; 'owl') is a nickname bestowed by Italian collectors of his landscapes, which often include depictions of owls. He is likely to have been a relative of Joachim PATINIR (or Patenier), whose painting strongly influenced that of Herri Met de Bles; both artists painted panoramic landscapes which seem to overwhelm the small groups of figures. None of the paintings attributed to him is signed, but the *Mountain Landscape with the Holy Family and St John* (Kunstmuseum, Basel) was attributed to 'Heinrich Blesius' in 1568.

block books

or xylographs are books printed from WOODCUTS, and so are the product of the technology that preceded GUTENBERG's movable type. Woodcuts appeared in Europe in the early fifteenth century, and by the 1440s binders had begun to assemble woodcut sheets into books. The process was much more labour-intensive than the setting of movable type, because each letter had to be cut into wooden blocks; the technique was best suited to books which were predominantly pictorial. Block books were superseded by books printed from movable type by the end of the fifteenth century, partly because movable type was more efficient, but also because the advent of humanism created a market for books with a high proportion of text.

Block books were printed in Germany and in the Netherlands. At least 37 block books or fragments from block books survive from the fifteenth century, and of these 23 seem to be German and 14 Dutch.

Blois

A town 56 kilometres (35 miles) south-west of Orléans, on the right bank of the Loire. It is dominated by a chateau which in the early

fifteenth century was the favourite residence of the poet Charles d'Orléans. The fort that he inherited contained a Salle des États (in which the Estates-General of 1576 and 1588 were held) and the Tour de Foix, both of which were built in the thirteenth century and still survive. Charles built a gallery (which now bears his name) that combined the use of brick and stone, an innovation that was subsequently to become an important feature of French Renaissance architecture. The gallery originally connected the two ends of the courtyard, but is now only half its original length; the rest was dismantled by François Mansart, who rebuilt Blois for Gaston d'Orléans between 1635 and 1638.

In 1498, when Charles's son Louis succeeded to the house as King Louis XII, Blois became a royal residence, and throughout the sixteenth century assumed the national role that was later to be associated with Versailles under the Bourbons, Louis XII and his queen, Anne of Brittany, added a wing to the medieval castle, and also built the Chapelle Saint-Calais, of which only the chancel remains; the nave was removed by Mansart. The king also commissioned PACELLO DA MERCOGLIANO to build gardens on the site of what is now Place Victor Hugo. These gardens, which were built on three terraces between 1499 and 1515, were reached by a bridge across the moat. Little is known of the upper garden, which may have been a kitchen garden, but a drawing by Jacques DUCERCEAU shows that the principal garden, on the middle terrace, was divided into ten rectangular compartments, like that at AMBOISE which Pacello had built four years earlier. Each compartment contained geometrically arranged plantings which included orange and lemon trees in tubs which were moved indoors in winter. The lowest garden, the small Jardin de Bretonerie, was reached by a staircase descending from the main garden; the Pavillon d'Anne de Bretagne, which is now the Syndicat d'Initiative, is the only surviving remnant of this garden.

Francis I added a new wing, the style of which is distinctly Italianate. The inner façade of this wing is dominated by a magnificent spiral staircase turret (see plate 10) which was, until Mansart demolished part of the wing, in the centre of the façade; the staircase (which was rebuilt in 1932 to a design by Mansart) is contained within an octagon, three faces of which are embedded in the main structure; the other five faces, with their sculpted balustrades, project into the courtyard.

Blondeel, Lanceloot

(1488–1581), Flemish painter, architect, and designer of sculptures, tapestries, and pageant decorations. He was a native of Poperinghe who was admitted to the Guild of Painters in Bruges in 1519. His paintings include the triptych *The Martyrdom of SS Cosmas and Damian* (in the Hôpital de Saint-Jean in Bruges) and his sculpture designs the chimney piece (1530) in the Greffe du Franc in Bruges. In 1550 he worked with Jan van SCOREL on the restoration of the finest of fifteenth-century Netherlandish ALTARPIECES, *The Adoration of the Lamb* (the Ghent altarpiece) by Hubert and Jan van EYCK.

Böblinger family

A family of south German architects and masons. Hans Böblinger the Elder (1412–82) trained in Constance, where he was a journeyman in 1435, and then became the assistant of Matthäus ENSINGEN at the Frauenkirche in Esslingen; Ensinger moved to Strassburg in 1399, and the following year Böblinger was appointed master mason at Esslingen. Matthäus Böblinger (d. 1505), who was probably one of Hans's sons, seems to have trained in Cologne; he worked for a time with Hans Böblinger at Esslingen and then moved in 1477 to Ulm, where he was appointed master mason of the minster in 1480. He modified the plans for the west tower that he had inherited from his predecessors (Ulrich and Matthäus Ensingen). In 1492 cracks appeared in the tower and Matthäus Böblinger was dismissed and expelled before he could erect his spire; his drawing for the spire survived, and when the spire was finally built 400 years later (1881–90), it became, at 161 metres (528 feet), the world's tallest church spire.

Boboli Gardens

In 1549 the unfinished PITTI PALACE was bought by Eleanor of Toledo, the duchess of Cosimo I de' Medici. Niccolò TRIBOLO was quickly commissioned to design a garden; he died the following summer, and the work was completed by Bartolomeo AMMANATI. The garden was laid out symmetrically around a central axis, in the middle of which is a U-shaped AMPHITHEATRE carved out of a natural hollow in the hill; below the amphitheatre there is a large courtyard adjoining the palace, and above it is a pond. A

lunette by Giusto UTENS now in the Museo Topografico in Florence shows that the amphitheatre was thickly planted when he painted it in 1599. There were also PARTERRES laid out at the side of the palace. Immediately behind the palace there was a huge FOUNTAIN of Neptune (the Ocean Fountain) by GIAMBOLOGNA; his statue of *Ocean* is now in the Bargello. Bernardo BUONTALENTI added a three-chambered GROTTO (1583–93) filled with statues, the pedestals of which were decorated with sea-shells. The first grotto contained four unfinished statues of *Slaves* by MICHELANGELO, intended for the tomb of Julius II and since 1908 in the Accademia. The third grotto, which is the work of Bernardino Pocetti, contains a statue of *Venus Leaving her Bath* by Giambologna. Originally the grotto was fitted with GIOCHI D'ACQUA designed by Buontalenti.

In the seventeenth century the design of the garden was altered considerably. The plantations around the amphitheatre were uprooted when seats were built on the banks in 1637, at which point festivities were moved from the courtyard to the amphitheatre. Later in the century a GIARDINO SEGRETO (the Giardino de Cavaliere) was built on the ramparts. The narrow track that followed the line of Tribolo's axis up the hill was widened into an avenue with a double series of shallow sloping steps (*cordonate*). The Ocean Fountain, which originally stood by the palace, was moved up the hill to the baroque Piazzale dell' Isolotto, which was designed by Alfonso Parigi in 1618 in exuberant imitation of the Maritime Theatre of Hadrian's villa (Tivoli), which had been excavated in the sixteenth century; Parigi's design was in turn imitated at ARANJUEZ. Finally the area beyond the Isolotto, which was originally planted with *ragnaie* (thickets for netting small birds), was cleared for a monumental avenue lined with cypresses and pines.

The seventeenth-century garden, which is the form in which the garden survives today (the only subsequent addition was a *kaffeehaus* built in 1776), is more monumental than its Renaissance predecessor, but both gardens served the same purpose, which was to provide settings for great pageants. The gardens continue to fulfil that role when events are mounted there by the Maggio Musicale Fiorentino.

Boccaccino, Boccaccini

(b. before 1466, d. 1525), Italian painter, born in Ferrara, where he trained in the studio of ERCOLE DE' ROBERTI. His early works include *The Death of the Virgin* (Louvre). In 1510, after a long peripatetic period in which he fell out with a series of patrons, Boccaccino settled in Cremona, where he decorated the cathedral with frescoes (1519) depicting scenes from the New Testament and the life of the Virgin Mary.

Boitac

or Boytac, Diogo (*fl.* 1498–1525), Portuguese architect (whose name may imply French origins) responsible for some of the earliest MANUELINE buildings in Portugal. He designed and built the Church of Jesus (Igreja de Jesus) at Setúbal (1491–8); this was the first building in Portugal to be decorated in the Manueline style. Boytac planned the Hieronymite monastery at Belém (c.1502), near Lisbon, and was probably the architect of the Manueline stage of Guarda Cathedral (1504–17), which included the window on the north façade and the main doorway on the west façade.

Boltraffio, Giovanni Antonio

(c.1467–1516), Italian painter and draughtsman, born into an aristocratic family in Milan, where he became a disciple of LEONARDO DA VINCI, who mentioned Boltraffio's silverpoint drawings in his Notebooks. He painted portraits (e.g. *Portrait of a Musician* (Biblioteca Ambrosiana, Milan) and *Portrait of a Gentleman* (National Gallery, London)) and Madonnas, such as the *Madonna of the Bowl* (Museum of Fine Arts, Budapest) and *Madonna of the Flower* (Museo Poldi Pezzoli, Milan).

Bomarzo

See ORSINI, VILLA.

Bon, Bartolomeo

See BUON, BARTOLOMEO.

Bontemps, Pierre

(c.1512–c.1570), French sculptor, who worked as an assistant to PRIMATICCIO at FONTAINEBLEAU. His best-known work, executed in collaboration with François Marchand (d. 1551), is the monument to King Francis I and his family (1547–88) in the Abbey (now Basilica) of Saint-Denis, near Paris (now a northern suburb of Paris); Bontemps's contribution to the monument, which was designed by Philibert DELORME, was the execution of the recumbent figures (*gisants*) and the bas-reliefs. He also contributed to a monument for the heart of King

Francis, originally intended for the Priory of Hautes-Bruyères (near Rambouillet) and now in Saint-Denis.

bookbinding
In late fifteenth-century Europe, printers employed craftsmen to bind the sheets of their books in simple bindings. By the early sixteenth century, however, it had become standard practice for books to be sold in unbound sheets, so allowing the buyer to exercise personal taste within an individual budget. A few books, such as liturgical books intended for display on altars, were fitted with covers made from metal or ivory and decorated with enamel or gems, but the principal material for bookbinding was leather, which was often decorated with engraved panel stamps. In the mid-fifteenth century gold tooling was introduced in Venice, from which the technique spread throughout Europe.

In the fifteenth century the principal centre of bookbinding was Venice, and the finest bindings were those of ALDUS MANUTIUS. In the early sixteenth century the centre of bookbinding shifted to France, initially to Paris (where GROLIER BINDINGS were made). In the mid-sixteenth century, the principal innovations were MAIOLI BINDINGS made in Paris and LYONESE BINDINGS, both of which took advantage of the new technique of GAUFFERING. The most important stylistic development in late sixteenth-century France was the FANFARE BINDING.

book illustration
The earliest printed books were illustrated with illuminations added by hand with a view to making the books resemble ILLUMINATED MANUSCRIPTS. Subsequently books were illustrated with WOODCUTS and occasionally with copperplate ENGRAVINGS. The woodcut illustrations include some CHIAROSCURO WOODCUTS (French; gravures en camaïeu). The practice of making printed books look like illuminated manuscripts disappeared by the end of the fifteenth century except in France, where this tradition survived until the mid-sixteenth century in printed BOOKS OF HOURS in which every page was framed by a decorative woodcut border; in England this convention was imported for a single book known as Queen Elizabeth's Prayer Book but actually entitled A Book of Christian Prayers (1578).

The first printer to use woodcuts as illustrations was Albrecht PFISTER of Bamberg, who introduced hand-coloured woodcut illustrations in 1460. Ten years later the Augsburg printer Erhard RATDOLT began to use woodcuts to replicate the elaborate borders of illuminated manuscripts on the first page of his books, and so became the inventor of the title page. By the end of the fifteenth century woodcut illustration had been established as an important adjunct of printing throughout Europe. In Germany woodcut illustrations became a prominent feature of works such as Bernhard von Breydenbach's Reise ins Heilige Land (1486; Latin Sanctae peregrinationes), Hartmann Schedel's 'Nuremberg Chronicle' (Weltchronik, 1491), and the Teuerdank commissioned by the Emperor Maximilian and illustrated by Hans SCHÄUFELIN (1517). In the sixteenth century German artists such as BURGKMAIR, CRANACH, DÜRER, and HOLBEIN designed woodcut illustrations and decorations, and their designs were used all over Europe.

In Italy the first woodcut illustrations were the line drawings used in Juan de Torquemada's Meditationes (Rome, 1463). The most important centres of woodcut illustration were Venice, Verona, and Florence. In Venice, ALDUS MANUTIUS used woodcut illustrations in his editions of classical texts, and in 1499 produced his magnificent illustrated edition of Francesco Colonna's Hypnerotomachia Polifili. In Verona the most important illustrated book of the fifteenth century was Roberto Valturio's De re militari (1479), for which the woodcuts were designed by Matteo de' PASTI. In Florence the most prominent printer was Piero PACINI, who used woodcut illustrations for works such as his edition of Aesop's Fables (1496).

In France the earliest centre of woodcut illustrations was Lyon, where the first book with woodcut illustrations was Miroir de la rédemption (1478), which was followed by an edition of the comedies of Terence (Commoediae, 1493) and a book on the DANCE OF DEATH (La Grande Danse macabre, 1500). In Paris Jean Dupré (fl. 1481–8) published the first illustrated book, a missal published in 1484. In the early sixteenth century the MANIÈRE CRIBLÉE was introduced, but did not supplant woodcut illustration.

In England woodcut illustrations were introduced by CAXTON in Mirror of the World (c.1481) and more sophisticated woodcuts were used by his successor Wynkyn de WORDE. Illustrated books were not common in early sixteenth-century England, but books often had decorative woodcut title pages. The first popular book to be illustrated was Foxe's Book of Martyrs (1563).

The technique of making copperplate engravings was well known to printers, but the practical difficulties of combining a relief method (printing from type) with an INTAGLIO method (engraving) defeated most printers; the small number of fifteenth-century books illustrated with engravings include Caxton's *Recuyell of the Histories of Troy* (1474–6) and an edition of Ptolemy's *Cosmographia* (Bologna, 1477). By the late sixteenth century, however, the engraving had replaced the woodcut illustration in learned books, and the woodcut was reduced as a medium to modest tasks such as printers' decorations. At the end of the century Christophe PLANTIN, the most influential printer in Europe, established the convention of confining book illustration to title pages, and for the next two centuries book illustration was a rare exception to a continuous expanse of print.

Book of Hours

or (Latin) *Horae* or (French) *Livre d' heures*, a type of breviary intended for lay use and often lavishly illustrated. The finest surviving examples are from the fifteenth-century ducal courts of Burgundy and Berry, notably *Les Très Riches Heures du duc de Berry* (Musée Condé, Chantilly). A Book of Hours always included a calendar in which each month was illustrated by its 'occupation'; a typical calendar might depict feasting (January), warming (February), pruning (March), flower gathering or tending sheep (April), hunting (May), mowing (June), reaping (July), threshing (August), treading grapes (September), gathering acorns and feeding hogs (October), slaughtering hogs (November), feasting (December). The prayers associated with each of the eight canonical Hours of the Virgin were also illustrated with miniatures: *Annunciation* (Matins), *Visitation* (Lauds), *Nativity* (Prime), *Annunciation to the Shepherds* (Sext), *Presentation in the Temple* (None), *Massacre of the Innocents* (Vespers), and *Coronation of the Virgin* (Compline); sometimes a *Flight into Egypt* is substituted in Vespers or Compline.

Borgoña, Juan de

(*fl.* from 1495; d. 1535), Spanish painter who spent most of his working life in Toledo. He worked with Pedro BERRUGUETE on the main ALTARPIECE at Ávila Cathedral (*c.*1508), and later worked extensively in Toledo Cathedral, to which he contributed a fresco of the *Last Judgement* and a polychromed wooden effigy of *King John II*. His style combines Gothic and Renaissance elements, particularly the Florentine style as represented by GHIRLANDAIO.

Borman

or Borreman, Jan (*fl. c.*1479–1520), Flemish wood-sculptor who specialized in carved altars; his most famous work is the altar of *St George* (1493), which is now in the Musée du Cinquantenaire in Brussels. Borman's son, who was also called Jan, worked in his father's workshop; his most important independent work is the Saluces altar, which is now in the Municipal Museum in Brussels.

Bos, Cornelius

(*c.*1510–*c.*1566), Netherlandish engraver. He was born in 's-Hertogenbosch (Brabant) and seems to have studied in Rome in the studio of Marcantonio RAIMONDI. He was settled in Antwerp by 1540, but persecution of the proscribed religious sect to which he belonged forced him to leave the city in 1544; he died in Groningen. Many of his engravings are versions of Italian paintings, but he also produced his own designs.

Bosch, Hieronymus

(*c.*1450–1516), Netherlandish painter, born in 's-Hertogenbosch (Brabant); his baptismal name was Jerom van Aken, and the name by which he is known derives from the Latin form of his given name and the final syllable of his birthplace. He spent his entire life in 's-Hertogenbosch, where he became a wealthy lay member of a local religious order. His paintings were admired and collected in orthodox Catholic circles; the finest collection was assembled by King Philip II and is now in the Prado in Madrid.

The canon of Bosch's work consists of some 40 paintings, none of which is dated. It is usually assumed that his relatively conventional paintings are either early (e.g. the *Crucifixion* in the Musée d'Art Ancien, Brussels) or commissioned works (e.g. donor paintings such as *The Adoration of the Kings* in the Prado). His paintings are usually religious in subject and are typically peopled by fantastic part-human creatures, many of whom are suffering or inflicting pain on others; his depictions of hell portray the suffering of sinners with morbid glee. His best-known paintings are *The Haywain* and *The Garden of Earthly Delights*, both of which are in the Prado.

Hieronymous **Bosch**, *The Garden of Earthly Delights* (*El jardín de las delicias*) in the Prado, Madrid. This triptych shows the *Earthly Paradise* (i.e. the Garden of Eden) on the left inner wing and *Hell* on the right inner wing. The central panel, which gives the triptych its title, depicts the false paradise of love (*pseudo-paradisus amoris*). The outer wings, which can be seen when the triptych is closed, depict the *Creation of the World*.

bosco

(plural *boschi*) or (French) *bosquet*. The *bosco* of Italian gardens is a woodland descended from the sacred groves of classical antiquity. In Renaissance gardens, the *bosco* was a contrast to the axial geometry of the garden design. It was usually planted with evergreen ilex (holm-oak), which provided deep shade and exotically twisted tree trunks; its dark leaves resemble those of holly, its near relative. The finest surviving examples are the two ilex *boschi* in the garden of the Villa Gamberaia in Settignano (near Florence) and the parkland of the Villa LANTE.

The link between the Italian *bosco* and the French *bosquet* may have been the *boschi* planted c.1590 at the Villa Bernadini in Lucca, where the studied anarchy of the woodland is broken with a sequence of geometrical clearings. In France the *bosquet* evolved into an ornamental grove, usually with a lawn and fountain at the centre, and sometimes the *bosquet* was planted as a MAZE. The enclosed space within a *bosquet* was called a *salle de verdure* (a green room) if it was large and a *cabinet de verdure* if it was small. In the early seventeenth century the paths that pierced *bosquets* were laid out in geometrical patterns, but these lines were gradually softened, and this process led to the evolution of the *bosquet* into the wildernesses planted in seventeenth-century English gardens, of which the first were André MOLLET's wilderness at WIMBLEDON HOUSE (1642) and Wren's wilderness at Hampton Court (1689).

Bosschaert, Ambrosius

(1573–1621), Flemish painter. He was born in Antwerp, which he fled in the turmoil of the Revolt of the Netherlands, seeking refuge in Middelburg (1593–1616) and later settling in Utrecht, where he became a member of the guild in 1616; he died in The Hague while delivering a painting commissioned by the stadtholder Maurice of Nassau. In common with many Flemish artists, Bosschaert chose to concentrate on flowers in his STILL LIFE paintings. Together with his three sons (Ambrosius the Younger, Abraham, and Johannes) and his brother-in-law Balthasar van der Ast, Bosschaert popularized the painting of flowers in the United Provinces. He often chose to paint on copper, and his paintings are remarkable for their colour-tones and for a high degree of finish in which individual brush-strokes are invisible. Examples of his paintings are preserved in the Mauritshuis (The Hague) and in the Ashmolean Museum in Oxford.

botanical gardens

The purpose of the botanical gardens of the Renaissance was to facilitate the study of plants for medicinal purposes. The origins of these gardens are disputed, but they may combine elements of the physic gardens of earlier centuries and the Aztec gardens that the conquistadors had discovered in Mexico.

Both Pisa and Padua claim to possess the earliest botanical garden in Europe. The founding of the Paduan garden can be dated to 1545 by a bill passed by the Venetian Senate authorizing its foundation. The evidence for Pisa is inconclusive, but the garden is normally dated *c.*1543.

The Orto Botanico in Pisa was planted by Luca Ghini (*c.*1490–1556), who taught botany and medicine at the University of Pisa. The garden, which is on a 3-hectare (7-acre) site between the cathedral and the river, was planted with medicinal plants gathered by Ghini and his students on field trips in north Italy. The botanist Andrea Cesalpino (1524/5–1603) succeeded Ghini as curator of the garden in 1555, and used the collection as the basis of his taxonomical research, in which he classified plants according to fruits and seeds. An account of the garden written by the French botanist Pierre Belon after his visit in 1555 (*Observations de plusieurs singularités et choses mémorables*) confirms that the garden had already developed an international reputation both for the range of its collections and for its beauty. Pisa was the first garden in Europe to cultivate the horse-chestnut (*Aesculus hippocastanum*), the black walnut (*Juglans nigra*), the ailanthus (*Ailantus glandulosa*), the camphor tree (*Cinnamomum camphora*), the Japanese quince (*Chaenomeles japonica*), the magnolia (*Magnolia grandiflora*), and the tulip tree (*Liriodendron tulipifera*). The garden is still owned by the university, but now specializes in lilies, water-lilies, and amaryllis.

The botanic garden in Padua (Giardino Botanico dell'Università di Padova) occupies a 1.8-hectare (4-acre) site close to the Basilica del Santo; its first curator, Luigi Squalerno, had been a pupil of Ghini at Pisa. The garden, which was jointly owned by the University of Padua and the Venetian republic, was designed by the Bergamese painter Giovanni Battista MORONI and constructed under the supervision of Pietro da Noale (representing the university) and the humanist polymath Daniele Barbaro (representing the Venetian Senate). The garden was laid out as an enormous circle, some 82 metres (90 yards) in diameter; the broad outline of the original design has survived, but details of the beds have been changed. The circle was enclosed in 1551, but this wall was replaced in the eighteenth century by the one which now surrounds the garden. The area within the circle was divided into sixteen equal parts, each of which was divided into four beds. The beds were planted with medicinal herbs, which were used for the instruction of medical students. A palm planted in one of the greenhouses in 1585 was later to inspire Goethe's theory of the morphology of plants (*Die Metamorphose der Pflanzen*, 1790), and still survives, as does the chaste tree (*Vitex agnus-castus*) planted in 1550. Padua was the first garden in Europe to cultivate the potato (*c.*1575), the bignonia (*Bignonia radicans*), the Indian cedar (*Cedrus deodara*), the common acacia (*Robinia pseudoacacia*), the pelargonium (*Pelargonium cuccullatum*), the cyclamen (*Cyclamen persicum*), and the winter jasmine (*Jasminum nudiflorum*), which was rediscovered three centuries later by Scottish plant-collector Robert Fortune.

Botanical gardens were subsequently planted at Florence (1550), Bologna (1568), Leipzig (1580), Heidelberg (1593), and Montpellier (1593), but the most important botanical garden of the late sixteenth century was in Leiden. The Hortus Academicus at Leiden was founded by the University of Leiden in 1587, but planting did not begin until 1594. The delay was caused in part by the difficulty in securing the appointment of Carolus Clusius (1526–1609), the greatest living botanist, as the founding curator of the garden. The garden was used for teaching, but also became the main European centre for the collection and dissemination of plants from around the world; most of the world's cultivated geraniums (*Pelargonium*) and evening primroses (*Oenothera*) originate in this garden, which also bequeathed the tulip to the world. The garden is now 2.6 hectares (6 acres), which is slightly larger than the original garden, and is still used for research by the university's botanists. The original design was submerged in a new planting plan devised in 1730 (in part by Linnaeus), but the original layout and planting of Clusius and his head gardener Clutius (Dirck Outgaerzoon Cluyts) were replicated in a new garden built in 1931 across the canal from the original garden.

In the seventeenth century botanical gardens were planted in Giessen (1605), Strassburg

(1620), Oxford (1621), Altdorf (1625), Jena (1629), Paris (Jardin du Roi, later called the Jardin Royal des Plantes Médicinales, 1635), Uppsala (1657), Edinburgh (1670), Chelsea (1673), and Amsterdam (1682).

Botticelli, Sandro

or Alessandro di Moriano Filipepi (1444/5–1510), Italian painter and draughtsman, born in Florence, the son of a tanner; his youth is not well documented, but he may have trained alongside Filippino LIPPI in the studio of Filippo LIPPI. In the 1470s and early 1480s his most important paintings were pictures of the *Adoration of the Magi* (Uffizi; National Gallery, London; National Gallery, Washington); the Uffizi panel incorporates portraits of many members of the Medici family. In 1481 Botticelli was one of the painters invited to contribute to the fresco cycle on the walls of the SISTINE CHAPEL in Rome. He painted a series of mythological paintings, notably *Primavera* (*c*.1478, Uffizi), *Mars and Venus* (*c*.1485, National Gallery, London), *The Birth of Venus* (*c*.1484, Uffizi) (see plate 11), and *The Calumny of Apelles* (1490s, Uffizi); the figures in these paintings derive from Ovid's frolicking Olympians, but have been related by scholars to the Florentine Neoplatonism of philosophers such as Marsilio Ficino and to the Virgilian culture of Poliziano and Lorenzo de' Medici.

Vasari states that Botticelli fell under the spell of Savonarola, repudiated his secular pictures, and forsook painting. This statement cannot be entirely correct, because Botticelli continued to paint, but it is hard to judge the precise nature of the conversion that Vasari is misrepresenting. Botticelli did not repudiate his patron, Lorenzo di Pierfrancesco de' Medici, who was an avowed opponent of Savonarola, nor did Botticelli follow his brother in committing himself to Savonarola's programme of reform. That said, there is some evidence that Botticelli developed millenarian sympathies; the inscription on his *Mystic Nativity* (1500, National Gallery, London), a quotation from the Book of Revelation, seems to imply the expectation that the world would end shortly, and the late *Pietà* in the Alte Pinakothek in Munich has an extraordinary spiritual intensity.

Botticelli's finest drawings are his illustrations for Dante's *Divine Comedy*, now divided between the Gemäldegalerie in Berlin and the Vatican.

Bouts, Dieric

(*c*.1415–1475), Dutch painter. He was born in Haarlem but spent most of his working life in Louvain, where his commissions included an ALTARPIECE of *The Holy Sacrament* (1464–8) for the collegiate Church of St Peter. In 1468 the town council commissioned three sets of panels: two sets were to be double panels representing the administration of justice in secular history and the third was to be a triptych depicting the divine justice of the Last Judgement. Bouts completed the triptych of *The Last Judgement* in 1470; the central panel is lost, but the wings may be a set now in the Musée des Beaux Arts in Lille. At the time of his death Bouts was still working on the first set of secular panels; the one completed panel, *Ordeal by Fire*, was installed in the Court of Justice in the Town Hall in 1473, and the other panel in the pair was completed in 1481 by other hands. Bouts also painted a series on the *Life of the Virgin*, of which four panels survive in the Prado in Madrid. His style is individualistic, particularly in its dramatic use of colour, and his background LANDSCAPES are unusually evocative.

Boytac, Diogo

See BOITAC, DIOGO.

Bramante, Donato

or Donato di Pascuccio d'Antonio (*c*.1443/4–1514), Italian architect and painter, born near Urbino. He may have had contact with artists in the ducal court such as FRANCESCO DI GIORGIO, who may have stimulated or created Bramante's interest in PERSPECTIVE. He began his career as a painter: in 1477 he was employed painting the perspectival *Philosophers* on the façade of the Palazzo del Podestà in Bergamo, and subsequently painted the *Men at Arms* frescoes (1480–5) now in the Brera in Milan.

In about 1479 Bramante entered the service of Duke Ludovico Sforza, for whom he worked at Vigevano (Lombardy) on the ducal palace. His first important architectural commission was the rebuilding of the ninth-century Cappella della Pietà (Milan), which he transformed into the Church of Santa Maria presso San Satiro (now known as San Satiro) by encasing the chapel in a drum topped by a dome (the first since antiquity to have a coffered interior) and an octagonal lantern. He remodelled the interior as a Latin cross with a barrel-vaulted nave and incorporated the ancient baptistery, which

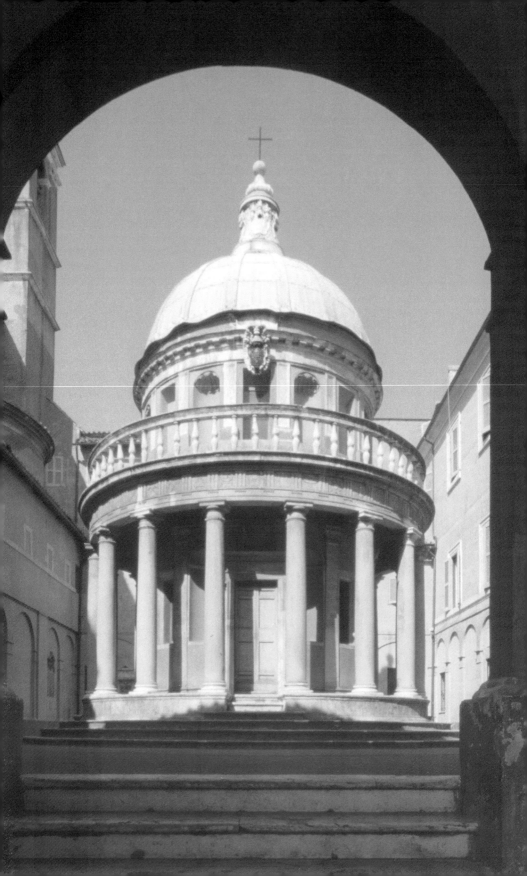

he rebuilt as an octagonal sacristy (now once again the baptistery); the building could not accommodate a chancel, so Bramante constructed the illusion of a chancel with a TROMPE L' ŒIL painting and relief.

Bramante's next project was the remodelling of the east end of the abbey Church of Santa Maria delle Grazie (Milan), for which he encased the dome in a sixteen-sided drum with an elegant arcaded gallery (c.1488–99); as this church was originally constructed on the plan of a basilica, he is sometimes said to have remodelled the tribune, which in ecclesiastical architecture denotes the apse of a basilican church. In the 1490s Bramante also worked on the ancient Basilica of Sant'Ambrogio, to which he added the Canons' Cloister (1492; only one wing was built) and a further group of four cloisters (1497; two were completed to his plans in the late 1570s).

In 1499 King Louis XII of France occupied Milan and dislodged the Sforza rulers who were Bramante's patrons. Bramante fled to Rome, where his architectural style was soon adapted to the Roman taste for gravity and majesty, as is exemplified in his cloister at Santa Maria della Pace (1500) and his circular Tempietto di San Pietro in Montorio (commissioned 1502 by Pope Alexander VI, constructed c.1510). In 1503 Giuliano della Rovere was elected as Pope Julius II, who commissioned Bramante to rebuild the Vatican, including ST PETER'S BASILICA; Pope Julius decided to defray the cost of rebuilding by the sale of indulgences, a decision that proved to be one of the sparks which ignited the Reformation. Bramante began with a range of buildings later incorporated into the Cortile di San Damaso, and then built the Belvedere Court of the Vatican, in which he incorporated a spiral staircase ramp (c.1505); a humorous account of Bramante by Andrea Guarna (Simia, 1516) suggested that when Bramante arrived in heaven, his remodelling of the celestial city would include a spiral ramp to facilitate disabled access.

For St Peter's Basilica Bramante proposed a huge church shaped like a Greek cross and covered with a dome, with a smaller Greek cross in each of the four arms, each of which would have a corner tower and a dome. Elsewhere in Rome he built the choir of Santa Maria del Popolo (1505–9) and designed Palazzo Caprini (c.1510, subsequently much altered), which had a heavily rusticated ground floor accommodating shops and pedimented windows between half-columns on the upper floor, a design that was to prove immensely influential for centuries. Outside Rome, Bramante's most important project was the Santa Casa at Loreto (begun 1509).

Bramantino

or Bartolomeo Suardi (c.1465–1530), Italian architect and painter, born in Milan. He was trained by BRAMANTE, from whom his name derives. His most important architectural work is the octagonal chapel (begun 1512) commissioned by the Trivulzio family for the Church of San Nazaro Maggiore in Milan. His surviving paintings include an *Adoration of the Magi* (National Gallery, London) and a *Crucifixion* (Brera, Milan).

brass

The terms 'brass' and 'brazen', which are unique to English, were in early modern English used as generic terms for all alloys of copper with tin or zinc, and so denoted what would now be called bronze as well as brass. In the nineteenth century the term 'bronze' came to denote alloys of copper with tin and the term 'brass' was reserved for alloys of copper with zinc.

The principal centre for the production of brass in medieval Europe was Dinant, near Liège (Flanders, now Belgium), from which the name of the kitchen utensils (especially kettles) known as 'dinanderie' derives. Brass imported to England in flat sheets was long used for engraved monumental brasses, of which some 7,000 survive in English churches. The

Donato **Bramante**, the Tempietto di San Pietro in Montorio, Rome; the building was commissioned in 1502 and constructed c.1510. The Tempietto is a martyrium built over the spot where St Peter was crucified, and is centred on the posthole (preserved in the crypt) in which the cross was placed. The shrine is encircled by 16 Doric columns surmounted by an entablature that includes the earliest Doric frieze of the Renaissance; the frieze has Doric triglyphs (blocks with three vertical grooves) and metopes (square spaces between triglyphs), the latter decorated with Christian liturgical symbols.

destruction of Dinant by Philip the Good in 1466 made brass a rare commodity and therefore a valuable one; in England no brass was produced until 1568, and then only in small quantities, but sufficient to facilitate a modest revival of the tradition of monumental brasses.

Brass was often used for liturgical objects like censers, candlesticks, and fonts, such as the paschal candlestick by Renier van Thienen (1483, Church of St Leonard, Zoutleeuw). In Venice it was used for the brass vessels (basins and ewers, candlesticks, caskets, etc.) encrusted with gold and silver and now variously known as 'Venetian-Saracenic metalwork' or 'Azzimina work' or 'All'Aggiamina work'. In Augsburg and Nuremberg, brass was used from the fifteenth to eighteenth centuries to make alms-dishes, the centres of which were decorated with biblical and mythological scenes in relief made with metal stamps.

Bregno, Andrea

(1418–1503), Italian sculptor, born in Osteno, near Lugano. In about 1465 he established a workshop in Rome, where he became the principal monumental sculptor in the second half of the fifteenth century, specializing in altars and tombs characterized by innovative uses of the niche. His most important work is in the Roman Church of Santa Maria del Popolo, which Bregno remodelled together with Baccio PONTELLI. Bregno also made the Piccolomini altar (1485) in Siena Cathedral (for which some of the statues of popes and saints were made by MICHELANGELO) and the tabernacle (1490) in the Church of Santa Maria della Quercia near Viterbo.

Brenzone, Villa

The Villa Guarienti di Brenzone was designed by Michele SANMICHELI for the lawyer and humanist philosopher Agostino Brenzone. The house and gardens were built in the early 1540s on the promontory of San Vigilio, overlooking Lake Garda. The garden became famous in the sixteenth century, in part because its owners invited the public to visit it. The gardens of cedars, lemons, and oranges that were described by visitors have now been replaced by lawns, and a Garden of Apollo surrounding a tomb of Catullus has disappeared, but many original features remain, including a pergola on a terrace by the lake, a Tempietto of San Vigilio, and a MOUNT encircled by clipped cypresses and a wall with niches containing busts of Roman emperors which may well be the original of William Kent's temple of British worthies at Stowe. The original avenue still exists, and the cypresses with which it is lined now stand in magnificent maturity.

Breu, Jörg the Elder

(1475/80–1537), German painter who worked in Augsburg. His principal surviving work, the Herzogenburg altarpiece (1501), so called from the survival of eight of its twelve panels at Herzogenburg, was a *Passion* cycle painted for the Carthusian monastery at Aggsbach. He worked alongside Albrecht ALTDORFER and Albrecht DÜRER on the illumination of the margins of the Emperor Maximilian's prayer book (1513), which is now in the Bayerische Staatsbibliothek in Munich.

Briot, François

(c.1550–c.1612), French metalworker, born in Damblain (Lorraine); he was a Huguenot, and in 1579 fled to the Protestant sanctuary of Montbéliard (a fiefdom of the duchy of Württemberg), where he established himself as a pewterer and was in 1585 appointed engraver to the Montbéliard mint, where he designed COINS and medals. Briot is widely regarded as

Donatello, *David* (1430–2), a **bronze** statue (see p. 40) commissioned by Cosimo de' Medici for the courtyard of Palazzo Medici and now in the Bargello in Florence; it was the first life-size nude statue of the Renaissance. The near-nudity of David is classical in origin, and the sword and head of Goliath are traditional details in the depiction of David, but his costume is neither biblical nor classical. It is possible that the statue is meant to represent divine love, but the original courtyard setting may have been intended to embody a different meaning: the statue stood on a pedestal at the centre, and was in some way not now understood related to the eight marble medallions (images of ancient gems) on the walls above the arcade.

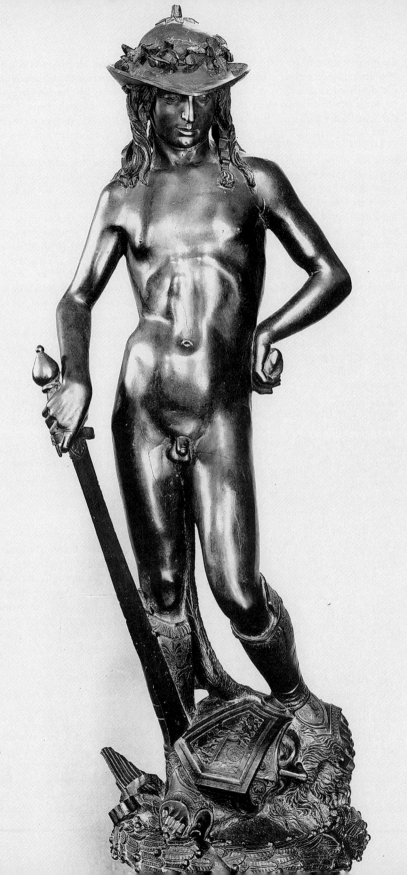

the greatest artist to have worked in PEWTER. The work often described as his masterpiece is the *Temperantia* dish (1585–90) now in the Museum für Kunsthandwerk in Dresden; this dish was often copied, notably by ENDERLEIN in pewter and by Bernard PALISSY in FAIENCE.

brocade

or (Spanish and Portuguese) *brocado* or (French) *brocart* or (Italian) *broccato*, a fabric woven with a pattern of raised figures. In Renaissance usage the term referred to a cloth in which the figures were woven in silver or gold, but in later use it came to denote any cloth with a raised pattern. Brocades originate in the Islamic world, from which the practice of brocading passed to Sicily (represented in the magnificent twelfth-century imperial robe now in the Bishop's Palace in Regensburg) and Spain; by the fourteenth century brocades were primarily associated with Lucca, Genoa, Florence, and Venice; in the sixteenth and seventeenth centuries the most important centre for the manufacturing of brocades was Lyon.

bronze and bronze sculpture

In early modern English, the terms 'BRASS' and 'brazen' denoted what would now be called bronze as well as brass. In the nineteenth century 'bronze', like Italian *bronzo* and Spanish *bronce*, came to denote alloys of copper with tin and the term 'brass' came to be reserved for alloys of copper with zinc.

Renaissance bronze statues were cast from clay or plaster models. All but the smallest statues were hollow, which gave a greater degree of flexibility to represent limbs in movement than was possible with marble statues. Hollow statues were made by the method of casting now known as *cire-perdue* ('lost wax'), which is described by CELLINI in his *Trattato della scultura* with reference to the casting of his *Perseus* (1545–54, Loggia dei Lanzi, Florence).

In the *cire-perdue* process a plaster cast taken from a clay model is enveloped in wax, which is then surrounded by a heat-proof mould, usually a mixture of clay, ashes, and pulverized crockery or brick. The composite structure of core, wax layer, and mould is then placed in a kiln; the wax runs out through a vent, whereupon molten bronze is poured into the space previously filled by the wax. Once cooled, the clay envelope can be removed and the core broken up and extracted through a hole in the base.

The grandest bronze monument of the fourteenth century is the tabernacle (almost 10 metres (30 feet) high) in the Marienkirche in Lübeck. In the fifteenth century DONATELLO made the first free-standing bronze nude (*David*, *c*.1434, now in the Bargello) and the first bronze EQUESTRIAN STATUE (*Gattamelata*, 1443–53). Later in the century, the VISCHER workshop manufactured the bronze shrine (1490) mounted over the silver sarcophagus of St Sebaldus in the Sebalduskirche in Nuremberg. In England, most bronze monuments of the period are in Westminster Abbey, including TORRIGIANO's effigies of King Henry VII and Elizabeth of York.

Bronzino, Il

or Agnolo Tori di Cosimo di Moriano (1503–72), Italian painter and poet, born in Florence, where he trained in the studio of Jacopo da PONTORMO, whose *Martyrdom of San Lorenzo* (in the Florentine Church of San Lorenzo) he was to complete in 1569. Bronzino's subjects were often religious (e.g. *Christ in Limbo*, 1552, Uffizi) or mythological (e.g. *An Allegory of Venus and Cupid*, 1540/50, National Gallery, London). His finest and most influential pictures were courtly portraits, such as his *Portrait of a Young Man*, *Portrait of a Lady*, and *Piero de' Medici* (all in the National Gallery in London), *Eleanor of Toledo and her Son* (Uffizi), and *Portrait of a Young Man* (Metropolitan Museum, New York).

Brosamer, Hans

(*c*.1500–1554), German painter and engraver who worked in Fulda and Erfurt. The small scale of his engravings implies the influence of the LITTLE MASTERS of Nuremberg. His woodcut portraits include one of Philip of Hesse (*c*.1546). Brosamer published *Ein neue Kunstbüchlein* (*c*.1548), which contained designs for silver in German Renaissance style; the volume was widely used throughout northern Europe.

Brosse, Salomon de

(*c*.1571–1626), French architect, born in Verneuil, where his maternal grandfather Jacques DUCERCEAU was building the chateau. Brosse moved to Paris in 1598, and in 1608 he was appointed royal architect. He was commissioned to build three important chateaux: Coulommiers (from 1613) for the duchess of Longueville, Blérancourt (1612–19; only one pavilion survives) for Bernard Potier, and the

Palais du Luxembourg (from 1615, rebuilt in the nineteenth century) for Marie de Médicis. In 1618 he began the Palais du Parlement in Rennes (Brittany). His classical façade for the Church of Saint-Gervais-Saint-Protais (1616–21) was the first in Paris. In 1623 he rebuilt the Protestant Temple at Charenton. Brosse's importance for French architecture is that his classical ideals led him to concentrate on sharply defined mass rather than surface decoration.

Bruegel or Brueghel, Pieter

the Elder (c.1525–1569), Flemish painter; his surname, which he spelt with an 'h' until 1559 and without thereafter, may derive from a village in north Brabant which could have been his birthplace. He is sometimes called 'Peasant' Bruegel to distinguish him from his sons Pieter BRUEGHEL the Younger ('Hell' Brueghel) and Jan BRUEGHEL ('Velvet' Brueghel). Bruegel trained in the Antwerp studio of Pieter COECKE VAN AELST; in 1551, the year after Coecke's death, Bruegel was admitted to the Antwerp Guild of Painters. He soon left for a protracted visit to Italy, and while in Rome collaborated with the Croatian painter Giulio CLOVIO; in Italy he made LANDSCAPE drawings, including *Mountain Landscape in an Italianate Cloister* (1552, Louvre) and *River Valley with Mountain* (Küpferstichkabinett, Berlin), and on returning to Antwerp in 1555 he designed a set of twelve landscapes (now known as the *Large Landscapes*) which were engraved and published by Hieronymus Cock. For the next eight years he concentrated on drawings, many of which have a moral edge, including parables such as *Big Fish Eat Little Fish* (Albertina, Vienna; published 1557; see p. 75); many of these drawings show the influence of BOSCH in their use of fantasy and grotesque. In 1563 Bruegel moved to Brussels, where he married the youngest daughter of Pieter Coecke van Aelst.

In the last ten years of his life Bruegel worked principally as a painter; some 50 oil paintings survive, fourteen of which are in the Kunsthistorisches Museum in Vienna. His landscapes included an important series on the theme of the calendar, of which five survive: three in the Kunsthistorisches Museum in Vienna (including *Hunters in the Snow*), one in the Metropolitan Museum in New York, and one formerly in the National Gallery in Prague and now in a private collection. His subjects included his famous peasant village scenes (such as *The Peasant Dance* and *Peasant Wedding*, both in Vienna), religious themes (such as *The Adoration of the Kings*, National Gallery, London, and *The Procession to Calvary*, Vienna) and mythological figures (such as *The Fall of Icarus*, Musée d'Art Ancien, Brussels). Some of his allegorical paintings, such as *The Dulle Griet* (1562, Koninklijk Museum voor Schone Kunsten, Antwerp) and *Triumph of Death* (Prado, Madrid), seem to combine overt moral satire with covert criticism of the harshness of Spanish rule in the Netherlands.

Brueghel, Jan

(1568–1625), Flemish painter, born in Brussels, the second son of Pieter BRUEGEL the Elder and the younger brother of Jan BRUEGHEL; he is sometimes called 'Velvet' Brueghel to distinguish him from his father ('Peasant' Bruegel) and his brother ('Hell' Brueghel). His father died when he was an infant, and so he trained in the studio of another painter, possibly Gillis van CONINXLOO. In 1590 he travelled to Rome, where he secured the patronage of Federico Borromeo (1564–1631), who in 1595 was appointed archbishop of Milan. Brueghel moved with Cardinal Borromeo to Milan, and in 1596 returned to the Netherlands and settled in Antwerp, where he enjoyed the patronage of Albrecht von Habsburg and his consort the Infanta Isabella (daughter of Philip II).

The subjects and style of Jan Brueghel's paintings are very different from those of his father. In STILL LIFES, he worked in the Flemish tradition of flower painting, and was the most distinguished exponent of this genre. In LANDSCAPE painting he specialized in small forest scenes, typically with mythological figures or horses and carriages in the foreground. He collaborated with many other painters, including Joos MOMPER (for whom he painted foreground figures) and Rubens. A large number of his paintings survive, as do large numbers of similar paintings by his sons Jan Brueghel the Younger (1601–78) and Ambrosius (1617–75).

Brueghel, Pieter the Younger

(1564/5–1637/8), Flemish painter, born in Brussels, the elder son of Pieter BRUEGEL the Elder and the elder brother of Jan BRUEGHEL; he is sometimes called 'Hell' Brueghel to distinguish him from his father ('Peasant' Bruegel) and his brother ('Velvet' Brueghel). His father died when he was 5, and so he had to train in the studio of another painter, probably Gillis van

CONINXLOO. Like his father and brother, he pursued his career in Antwerp, where he was admitted to the Guild of Painters in 1585. He was, like his son Pieter Brueghel III (1589–c.1640), primarily a copyist of the paintings of Pieter Bruegel the Elder; as the original paintings had often been sold before his father's death, Pieter the Younger seems to have worked from drawings and engravings.

Brüggemann, Hans

(c.1480/90–1540), north German sculptor and woodcarver, known principally for his monumental carved Bordesholm altarpiece (1514–21), which was originally made for a house of Augustinian canons at Bordesholm (south of Kiel) and was moved to its present location in Schleswig Cathedral in 1666. The altarpiece, which is carved from oak, is 16 metres (53 feet) high and contains 392 figures; it draws heavily on DÜRER's *Small Passion* series (1510–11) and the paintings of Hieronymus BOSCH.

Brunelleschi, Filippo

or Filippo di Ser Brunellesco (1377–1446), Italian architect and engineer, born in Florence, the son of a notary. He trained as a goldsmith and sculptor, and in 1401 he entered the competition for the bronze baptistery doors, which GHIBERTI won. Brunelleschi came to architecture as a builder and construction engineer with an acute sense of practical issues and of the mathematics of natural optics; he was less interested than his successors (e.g. ALBERTI) in the revival of ancient Roman architecture. In or shortly before 1413, Brunelleschi invented a method of giving a naturalistic impression of depth in flat pictures and made two paintings of city views (the first showed the baptistery and the second the Palazzo Vecchio) to demonstrate how well the method worked; it is not known what the method was. See PERSPECTIVE.

Brunelleschi's architectural commissions, all in Florence, began in 1418. His early projects, some of which cannot be dated precisely, include a domed chapel in San Jacopo Oltrarno (destroyed 1709), the Barbaradori Chapel in the Church of San Felicità (now known as the Capponi Chapel), the Palazzo di Parte Guelfa (now largely rebuilt), and the Church of San Lorenzo (1421–8). In San Lorenzo Brunelleschi first built what is now known as the Old Sacristy (the New Sacristy, 1523–9, was added by MICHELANGELO), a cube surmounted by a dome

in which ribs radiate from the lantern at the centre; Brunelleschi described this construction, which mimics the effect of canvas pressed over the ribs, as having 'crests and sails' (*a creste e vele*). The church is designed as a basilica, but differs from the basilicas of late antiquity in its use of the proportions 1 : 2 and 1 : 4 throughout the building. In the interior Brunelleschi used ribbons of the grey Macigno stone mined in Fiesole and known as *pietre serena* to emphasize the architectural lines.

In 1419 Brunelleschi received the commission to design and build the Ospedale (or Spedale) degli Innocenti (constructed 1421–44), which is sometimes said to be the first Renaissance building. The façade of the Ospedale (then a foundling hospital, now a museum) is a loggia (see p. xiv) consisting on the ground floor of an arcade of thin Corinthian columns (the glazed terracotta roundels depicting babies were later added by Andrea DELLA ROBBIA); above each semicircular arch is a pedimented window, and every detail honours the canons of mathematical proportion. The design proved to be seminal, and created the definitive form of the Renaissance loggia, which was to be imitated for centuries.

In 1420 Brunelleschi began his greatest work, the dome of Florence Cathedral (see plate 9), which was intended to be built in partnership with Ghiberti (with whom he had won the competition jointly) but in the event became Brunelleschi's project; the design is in some respects Gothic, but the engineering that enabled Brunelleschi to raise the dome without supports is an imaginative revival of the ancient Roman technique of herringbone brickwork. Construction was completed in 1436, and a second competition was initiated for the construction of the lantern; this time Brunelleschi was the unequivocal winner, but construction of the lantern was delayed until 1446; in the interval Brunelleschi built the niched semicircular tribunes (1438) beneath the drum of the dome.

In 1429 Brunelleschi began to build the Pazzi Chapel in the cloister of the Church of Santa Croce. In the interior Brunelleschi again used *pietre serena* to emphasize the architectural lines. The façade, which has a blank upper storey with rectangular panels, is so different from Brunelleschi's other work that it seems possible that his designs were replaced with those of another architect when it was constructed after his death.

In 1433 Brunelleschi started to build the Scolari Oratory in the Convent of Santa Maria degli Angeli, but construction stopped before the building was roofed; a roof was added in 1503, and the building was 'completed' in 1934, but only the lower parts of Brunelleschi's walls survived this restoration. These remnants clearly delineate the ground plan of the church, which was to have been the first centrally planned church of the Renaissance: the centre of the church was an octagon, and from each of the eight sides a chapel projected; externally the church was to have had sixteen sides.

Brunelleschi's last church, started in 1436, was San Spirito. The church is in some respects a reversion to the geometrical basilican plan of San Lorenzo, but Brunelleschi aspired to create the sense of a central space by constructing an aisle around the whole church; his successors demurred, and the west aisle was never built.

Of attributions to Brunelleschi, the most important is the Palazzo PITTI. The rustication and geometry of the façade make it likely that Brunelleschi was the architect who drew up the initial plans for the central section; construction began in 1435, and the palace was eventually finished in 1570 by AMMANATI.

Brussels tapestries

The origins of tapestry manufacturing in Brussels are not known, but by the mid-fifteenth century the city was exporting TAPESTRIES to the Burgundian court, and by 1516, when Pope Leo X sent RAPHAEL's cartoons of *The Acts of the Apostles* (now in the Victoria and Albert Museum in London) to the Brussels weaver Pieter van Aelst (d. *c.*1530), Brussels had become Europe's most important centre for the manufacturing of tapestries; it was to retain this pre-eminence until the middle of the eighteenth century. In the early sixteenth century the Habsburgs commissioned their court painters Bernaert van ORLEY and Jan VERMEYEN to design tapestries which were then woven in Brussels. The most prominent family of weavers was the PANNEMAKER FAMILY.

In 1528 the tapestry factories of Brussels introduced the mark of a shield between two Bs to designate their products. Brussels tapestries made before 1528 are difficult to distinguish from those made elsewhere in Flanders or in France; attributions from the period before 1528 include the *Allegory of the Virgin as a Source of Living Water* (1485, Louvre) and the *Virgin and Child with a Donor* (*c.*1500, Musée des Tissus, Lyon). Differences between the cartoons of the *Acts of the Apostles* series (1516–19) and the finished tapestries sent to Rome to hang on the walls of the SISTINE CHAPEL on important occasions show that the weavers felt free to elaborate the decorative details of the designs from which they were working: the flowers on the robe of Jesus, for example, are not present on Raphael's cartoon.

Bullant, Jean

(*c.*1515–1578), French architect and geometer, born in Amiens. From *c.*1540 to 1545 he studied classical antiquities in Italy. On returning to France he entered the service of Anne de Montmorency, for whom he designed additions to the Château d' Écouen which include the earliest façade in France in the colossal ORDER. He also built the MANNERIST bridge and gallery at Fère-en-Tardenois (1552–62) and the Petit Château at Chantilly (*c.*1561).

In 1570 Bullant succeeded Philibert DELORME as architect to Catherine de Médicis, but most of his commissions (including his work on the TUILERIES) have been destroyed; his only surviving building for Queen Catherine is at CHENONCEAUX, for which he designed the gallery on the bridge and the western part of the forecourt. Bullant's publications include an architectural treatise which expounds the five orders (*La Règle générale d'architecture, étude sur les cinq ordres de colonnes*, 1563) and a manual of geometry (*Petit Traité de géométrie*, 1564).

Buon

or Bon or Bono, Bartolomeo (*c.*1400/10–*c.*1464/7), architect and sculptor, born in Venice, the son of the sculptor Giovanni Buon, in whose workshop he was trained. Bartolomeo built the well-head in the courtyard of the Cà d'Oro (1424–31) and a fine lunette on the Porta della Carta of the Ducal Palace (1438–42); he later built the portals of the churches of Santi Giovanni e Paolo (1458–63) and Madonna dell'Orto (1460–6) and the upper storey of the Arco Foscari in the Ducal Palace (1460–4). His sculpture includes a relief of *The Madonna della Misericordia* (1441–5) carved as a lunette for the façade of the Scuola Grande della Misericordia and now in the Victoria and Albert Museum. Buon's style was almost wholly Gothic, though at his death he was working on the Ca' del Duca on the Grand Canal; had he completed more than the basement he

would be regarded as an early exponent of the Renaissance style rather than the last important Gothic architect in Venice.

Buon is sometimes confused with his unrelated namesake Bartolomeo Buon or Bon (d. 1529), a Lombard architect in Venice who built the ground floor of the Scuola di San Rocco.

Buontalenti, Bernardo

or Bernardo delle Giràndole (1531–1608), Italian architect, military and hydraulic engineer, painter, sculptor, and designer of waterworks and AUTOMATA. He was a native of Florence, where he worked in the service of the Medici grand dukes of Tuscany, for whom he built the Casino di San Marco (c.1580–8, now the Tribuna), the Galleria and Tribuna of the Uffizi (1584), the façade of the Church of San Trinita (1592–4), and the GROTTOES (1583–93) in the BOBOLI GARDENS; in 1593 he began work on what was to be called the Palazzo Nonfinito, the 'unfinished palace'. He painted a self-portrait (Uffizi) and fashioned a vase (Museo degli Argenti, Palazzo Pitti, Florence) for which a gold setting was made by Jacopo BILIVERTI.

Buontalenti was the architect of PRATOLINO (for which he designed the automata). His FORTIFICATIONS include the Belvedere of the Medici and the port of Livorno. He built the canal between Livorno and Pisa (where in 1605 he designed the Loggia dei Banchi). The *spettacoli* that he organized for the Medici often included firework displays, which gave rise to his nickname (*giràndole* means 'Catherine wheels').

Bürgi, Jost

(1552–1632), Swiss clockmaker, instrument-maker, and mathematician. He served from 1579 to 1592 as maker of clocks, mechanical globes, and astronomical instruments to the Landgrave Wilhelm IV of Hesse in Kassel; on the landgrave's death in 1592, Bürgi moved to Prague to take up a similar post in the service of Rudolf II. He was regarded as the leading clockmaker of his day. Bürgi's technical innovations included a device which directed a constant driving force to the escapement; he was one of the first horologists to fit his clocks with sweep hands to measure seconds.

Burgkmair, Hans the Elder

(1473–1531), German engraver and painter, born in Augsburg. He trained with Martin SCHONGAUER in Colmar and returned to Augsburg in 1498. The Venetian elements in his paintings, which include ALTARPIECES in the Alte Pinakothek in Munich and the Städtische Kunstsammlungen in Augsburg, have been adduced as evidence that Burgkmair also studied in Venice, but there is no documentary evidence of any visit to Italy. He contributed the woodcut illustrations to the Emperor Maximilian's *Der Weißkunig* (an unfinished autobiography not published until 1775) and some of the illustrations in his *Teuerdank* (1517). He also contributed (as did his friend DÜRER) to the *Triumph of Maximilian*, a series of imperial woodcuts.

C

cabinet

The fifteenth- and early sixteenth-century term for a room in a palace or scholar's house devoted to the display of a collection of art or natural history; the term could also refer to the objects in a collection. In France such rooms were called *cabinets de curiosités*, in Italy *studioli*, and in Germany *Wunderkammern* or *Kunstkammern*.

In the course of the sixteenth century the term 'cabinet' gradually came to refer to a piece of FURNITURE used to store objects. Cabinets were distinguished from cupboards in having drawers or pigeonholes rather than shelves. The cabinet originated in early sixteenth-century Italy and was soon being manufactured in Spain, Germany, the southern Netherlands, and Bohemia. The Spanish cabinet, which has been known since the nineteenth century as the *vargueño*, consisted of a rectangular case (containing drawers) set on an arcaded stand; the exterior was relatively plain, but the drop-leaf front opened to reveal a highly ornate interior typically decorated with carving and INTARSIA. The German cabinet, which derived from the Spanish *vargueño*, was known as a *Kunstschrank* or *Kabinettschrank*, and was variously decorated with marquetry, metals, and semi-precious stones; Augsburg was the principal centre of production, and early seventeenth-century baroque cabinets are sometimes called *Augsburger Kabinette*. In the southern Netherlands, where the principal centre of production was Antwerp, cabinets were typically made of ebony and decorated with marquetry flowers and mother-of-pearl; the interiors of the doors and the drawer fronts were often painted with biblical or mythological or genre scenes. Cabinets made in the Bohemian town of Cheb (formerly German Eger) were distinguished by panels carved in low relief with religious scenes based on engraved designs. In Florence, where PIETRE DURE was revived in the sixteenth century, a workshop established under the patronage of Grand Duke Cosimo I de' Medici (and refounded in 1588 as the Opificio delle Pietre Dure) manufactured panels of *pietre dure* for assembly into cabinets.

Cafaggiolo pottery

In 1498 Stefano and Piero di Filippo, who had been trained as potters in MONTELUPO, acquired a pottery housed in the outbuildings of the MEDICI VILLA at Cafaggiolo. The finest work of the pottery was produced between 1500 and 1530, though the manufacture of dated pieces continued until at least 1570 and thereafter the pottery continued to operate until the eighteenth century. The pottery's products included capacious MAIOLICA jugs decorated with designs based on peacock feathers and ISTORIATO wares depicting mythological scenes or classical triumphs, often based on Florentine designs. The Cafaggiolo pottery was the only pottery in Tuscany to produce products finished with the iridescent metallic surfaces known as 'lustres'.

Calamelli, Virgiliotto

(*fl.* 1531–70), Italian potter in FAENZA; he worked with Francesco MEZZARISA and later with Leonardo BETTISI and became with these colleagues one of the most important manufacturers of BIANCHI. His *bianchi*, which were sold all over Europe, were often decorated with putti. His factory also produced ISTORIATO wares.

Calcar, Jan Steven van

or (Latin) Johannes Stephanus (*c.*1499–*c.*1546), Dutch painter and engraver, a native of Calcar (now Kalkar) who is thought to have eloped with a young woman to Venice, where he trained in the studio of TITIAN, whose style he emulated. He subsequently lived in Naples, where he died. He was the engraver of the anatomical figures in Vesalius' *De humanis corporis fabrica* (1543).

Calliergis, Zacharias

(*c.*1473–after 1524), Cretan printer and calligrapher in Italy, born into a noble Byzantine family in Rethymnon (Crete). Details of his education are unknown, but by 1493 he was living in Venice, where he established a Greek press in which the principal posts were filled by Cretans. The first publication of the press was a huge dictionary of Byzantine Greek, the *Etymologicum magnum* (1499). ALDUS MANUTIUS advertised books printed by the Calliergis press in his own catalogues, which seems to imply that Aldus and Calliergis saw each other as colleagues rather than competitors.

The recession that caused Aldus to suspend his programme of publications in 1505 claimed Calliergis's press a few years later. By 1515 Calliergis had re-established himself in Rome as the city's first printer of Greek. Greek printing had begun in Milan in 1476 with the *Erotemata* of Constantinos Lascaris, and in 1484 the publication of the *Erotemata* of Chrysoloras in Venice had inaugurated Greek printing there, but Rome lagged far behind in this respect, and the first Greek book to be published there was Calliergis's edition of Pindar, which appeared on 13 August 1515. Five months later, on 15 January 1516, he published an important edition of Theocritus which included the *scholia*. The last book known to have been published by Calliergis is dated 27 May 1523, and the last surviving manuscript in his hand is dated 1524; thereafter he disappears from the historical record.

calligraphy

The earliest surviving examples of writing were produced by sharp tools cutting characters out of rock; in the fifteenth century mechanical means such as WOODCUTS or movable type were again used to produce writing. The usual term for writing produced with tools is 'lettering', and it is to be distinguished from calligraphy, which is the art of fine handwriting; the study of ancient lettering is called epigraphy and the study of early handwriting is called palaeography.

Since Greek antiquity there has been a distinction in European calligraphy between the uncial hands used for literary works and the cursive hands used for documents and correspondence. Greek uncial hands remained in use in liturgical works until the twelfth century, and were familiar to Renaissance scholars through manuscripts such as the Codex Vaticanus (a fourth-century Greek Bible that has been in the Vatican Library since at least 1475) and the Codex Bezae (a text of the Gospels once owned by the Reformer Theodorus Beza and now in the Cambridge University Library). Despite these survivals, uncial hands had for most purposes been superseded by cursive minuscule hands by the ninth century. The alternative to the small letters of minuscules is majuscules, which are large letters written as uncials or capitals. A capital letter, like the capital of a column, is the form used at the head of a word, though some early manuscripts, notably those of Virgil's poems, are written entirely in capitals.

The Roman minuscule cursive hand survived the fall of the Roman Empire and slowly evolved into the simple and elegant style known as Carolingian minuscule. It was this style that was revived at the Renaissance and in the handwriting of humanists displaced the Gothic calligraphy of late medieval Europe, which lived on in the handwriting of merchants. Revived Carolingian minuscule, when combined with majuscules derived from ancient Roman inscriptions (which were chiselled and therefore angular), formed the basis of the 'roman' typeface, which was first used in 1465 by Arnold PANNARTZ and Konrad Sweynheym.

Of the specialist hands, the most important were those of the scriveners of the papal chancery. During the pontificate of Eugenius IV (1431–47) a cursive chancery hand known as 'short hand' (*brevi manu*) came to be reserved for documents known as 'briefs'. This hand, which from the sixteenth century was known as *cancelleresca corsiva*, became the standard correspondence script of sixteenth-century Italy.

The earliest studies of letter formation concentrated on ancient Roman inscriptions, which were written in capital letters. The calligrapher Felice Feliciano wrote *Alphabetum Romanum* (*c.*1460), a treatise on the shape of inscriptional letters, and dedicated his collection of ancient inscriptions (the manuscript of which is dated 1463) to MANTEGNA, who introduced copies of inscriptions into the frescoes (largely destroyed in the Second World War) of the Church of the Eremitani in Padua. In 1509 the Italian mathematician Luca PACIOLI published his *De divina proportione*, which includes an appendix on letter formation. The first printed handbook on calligraphy was the

Operina da imparare di scrivere littera cancellaresca (1522) of Ludovico ARRIGHI.

Italian calligraphy was imitated and assimilated with national styles throughout Europe. In France, where the most important style was a Gothic hand known as *cursive française* (from which the typeface known as *civilité* derived), Italian hands were introduced when Francis I brought Italian calligraphers to FONTAINEBLEAU. The gradual assimilation of *cancelleresca corsiva* into *cursive française* created the *ronde* which in the seventeenth century was codified into three forms (the upright *financière*, the inclined *bâtarde*, and the running style known as *coulée*) and was for centuries the French national hand.

In sixteenth-century England, Gothic, secretary, and italic hands were all in use and were collected by Jean de Beauchesne and John Baildon in *A Book Containing Divers Sorts of Hands* (1571). The English hand known in English as copperplate, in France as *anglaise*, in Italy as *lettere inglese*, and in Spain as *letra inglesa*, was originally a commercial hand which was in the seventeenth century influenced by Dutch commercial calligraphy. This hand was carried to America by early colonists, and in the course of the twentieth century influenced or displaced national hands throughout Europe.

Calvaert, Denys

or (Italian) Dionisio Fiammingo (*c*.1540– 1619), Flemish painter in Italy, a native of Antwerp who moved *c*.1560 to Bologna, where he trained in the studio of Prospero FONTANA; apart from a short period in Rome in 1570–1, Calvaert remained in Bologna for the rest of his life. In 1572 he established a painting academy in Bologna; more than 100 painters were trained in the academy, including Francesco Albani ('the Anacreon of Rome'), Domenichino, and Guido Reni.

Cambiaso, Luca

(1527–85), Italian painter, born in Moneglia (near Genoa), the son of the painter Giovanni Cambiaso. He worked in Genoa as a decorator of palaces until 1583, when he moved to Spain to assist in the decoration of the ESCORIAL. His paintings (e.g. *Adoration of the Child*, Brera, Milan) are remarkable for their innovative use of dry paint, and the geometrical forms of his drawings anticipate the work of early twentieth-century Cubists.

cameo

An engraved GEM (usually agate or sardonyx) with layers in two different colours in which the upper layer is carved in RELIEF and the lower is used as a ground, so that the design stands up in relief above the surface; the process, which can also be used with glass or shell or ceramics, is the reverse of INTAGLIO, which is incised carving. In Renaissance Europe the finest cameos were made in Nuremberg, where they were often mounted in silver or gold cups. Seventeenth-century German glass engraved in cameo is known as *Hochschnitt* glass.

Campagnola, Domenico

(1500–64), Italian painter, draughtsman, and engraver, the pupil and adopted son of Giulio CAMPAGNOLA. His paintings, such as the fresco of *Joachim and Anna* in the Scuola del Carmine in Padua (1520), show the influence of TITIAN. His LANDSCAPE drawings (e.g. *Landscape with Two Boys*, British Museum), like those of Titian, helped to shape the landscape painting of the seventeenth century.

Campagnola, Giulio

(*c*.1482–after 1515), Italian engraver who trained in the Mantua studio of MANTEGNA, and in 1499 entered the service of the Este family in Ferrara. Many of his engravings are copies of works by DÜRER and were the principal medium through which Dürer's work became known in Italy. In 1509 he moved to Venice, where his engravings show the influence of GIORGIONE.

Campaña, Pedro (de)

or (Flemish) Pieter de Kempeneer (*c*.1503– *c*.1580), Flemish painter in Italy and Spain, born in Brussels. He worked in various Italian cities, including Bologna and Venice, and sometime before 1537 moved to Seville, where he painted works for the cathedral, including a *Descent from the Cross* (1547) and a *Group of Donors* (1555). On returning to Brussels he was appointed by the city as a designer of tapestry cartoons (28 May 1563) and opened a tapestry factory.

Campi family

A family of Italian painters from Cremona. Galeazzo Campi (*c*.1477–1536) worked with his sons Giulio (*c*.1508–1573) and Antonio (1523–87) and their relative Bernardino (1522–91) on the frescoes in the Church of San Sigismondo in

Cremona. The church had been built by Francesco Sforza in 1463, in honour of his marriage in 1441 to Bianca Visconti in a chapel that had previously occupied the site; Giulio Campi's fresco *The Madonna Appearing to Francesco and Bianca* commemorates the marriage. Giulio painted the fresco cycle depicting *The Life of St Agatha* for the Church of Sant'Agata in Cremona (1537); Antonio painted the *Pietà with Saints* in Cremona Cathedral (1566), and also published a history of Cremona (1585) which he illustrated with his own engravings. Vincenzo Campi (1530/5–1591), Galeazzo's third son, painted STILL LIFES, such as *Fish Market* (Brera, Milan). Bernardino Campi's paintings include a *Pietà* (1574) now in the Brera.

Campin, Robert

(*c*.1375/9–1444), Flemish artist generally believed to be the Master of FLÉMALLE. The pupils in his Tournai studio included Jacques DARET and one Rogelet de la Pâture, who is probably Rogier van der WEYDEN.

Only one picture associated with Campin, the Werl Wings (1438, Prado, Madrid), can be dated on the basis of documentary evidence; attempts to construct a chronology of his work are therefore based only on stylistic evidence. The *Marriage of the Virgin* (Prado) and the Seilern Triptych (Courtauld Institute Galleries, London) may date from the beginning of the fifteenth century. The *Dijon Nativity* (now in the Musée des Beaux-Arts in Dijon) may be a work of the early 1420s. The clothing of the sitters in the matched pair of portraits (painted on marble) *Portrait of a Man* and *Portrait of a Woman* (National Gallery, London, *c*.1430) is consistent with the hypothesis that they are portraits of a Tournai merchant and his wife. The Städelsches Kunstinstitut in Frankfurt, which has the largest collection of Campin's paintings, has a GRISAILLE of the *Trinity* (part of an unprovenanced and otherwise lost ALTARPIECE) and a fragment of the

Crucified Thief from a lost *Deposition* triptych (which survives in a copy in the Walker Art Gallery in Liverpool). The harsh realism of these pictures stands in marked contrast to what are assumed to be Campin's later pictures, which include the Mérode altarpiece (Metropolitan Museum, New York), set in a comfortable middle-class room.

Candido, Pietro

See WITTE, PIETER DE.

Capadiferro, Giovanni Francesco

(d. *c*.1533), woodcutter and *intarsitoro* whose only surviving work is the series of panels (designed by Lorenzo LOTTO) on the choir screen and stalls of Santa Maria Maggiore in Bergamo. Capadiferro began the execution of the designs in INTARSIA in 1522; they were completed by other hands after his death.

Caporali, Bartolomeo

(*c*.1420–*c*.1505), Italian painter and illuminator, a native of Perugia who during his lifetime was regarded as the greatest painter in Umbria. His extant works include an *Adoration of the Shepherds* (Galleria Nazionale, Perugia) painted for the convent at Monteluce (Perugia) and a fresco of the *Virgin and Child* in the church at Rocchicciola (near Assisi).

Caradosso

or Cristoforo Foppa (*c*.1452–1526/7), Italian goldsmith, medallist, and sculptor, born in Mondonico (near Pavia); he worked in Rome in 1477 and in 1480 entered the service of Ludovico Sforza in Milan; in the 1490s he worked in several north Italian cities. In 1505 Caradosso returned to Rome, where he worked in the service of Popes Julius II, Leo X, Adrian VI, and Clement VII. His work in gold (which included MEDALS and COINS) was praised by CELLINI and VASARI, but no examples are known to survive.

Robert **Campin**, *The Nativity*, in the Musée des Beaux-Arts in Dijon. This small panel was probably commissioned for the Chartreuse de Champmol in about 1420, and has traditionally been attributed to the Master of Flémalle. The orientalized costumes of the two midwives on the right evince an unusual awareness that the biblical narrative is set in the East. The representation of the countryside (which is integrated with the foreground by the winding road), the use of light to create a unified atmosphere, and the meticulousness of the surface detail all represent significant developments in Flemish painting.

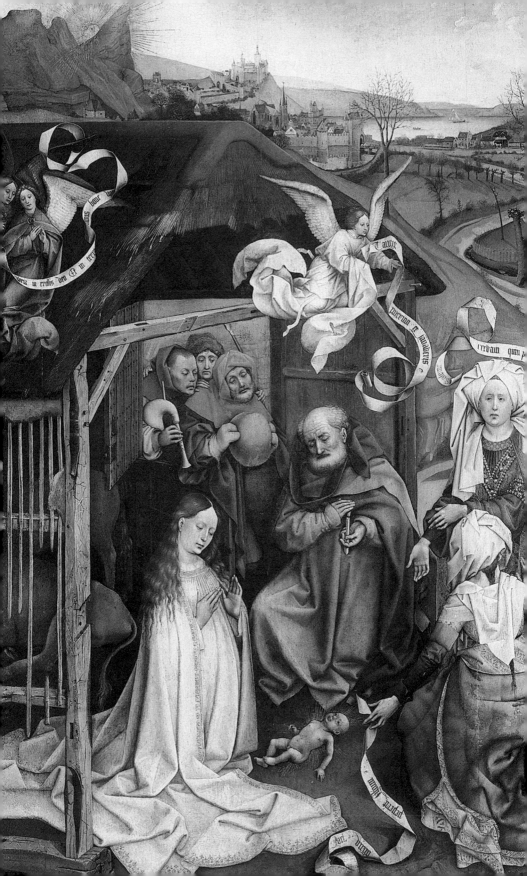

The papal tiara that he made for Pope Julius II in 1510 was destroyed and is known only from a drawing executed in 1725 (now in the British Museum).

Caravaggio, Michelangelo Merisi da

(1571–1610), Italian painter. He was born in Caravaggio (near Bergamo), and by 1592 had settled in Rome. He fled from Rome in 1606 after killing a man in a brawl, and spent the final years of his life as a fugitive in Naples, Sicily, and Malta. He died of malaria while travelling to Rome in the hope of securing a pardon.

Caravaggio's early works, such as *Boy with a Fruit Basket* (*c.*1593, Borghese Gallery, Rome), are typically non-dramatic subjects with a strong element of STILL LIFE. His mature habit of using a shaft of light to unify his compositions is apparent in the late 1590s in paintings such as the *Lute Player* (Hermitage, St Petersburg). Caravaggio's public paintings, which were executed between 1599 and 1605, include *The Crucifixion of St Peter* and *The Conversion of St Paul* (both in the Cerasi Chapel of Santa Maria del Popolo), *St Matthew and the Angel*, *The Calling of St Matthew*, and *The Martyrdom of St Matthew* (all in the Contarelli Chapel in the Church of San Luigi de' Francesci, the French church in Rome), *The Deposition* (Vatican), the *Madonna di Loreto* (Church of Sant'Agostino, Rome), and the *Madonna de' Palafrenieri* (Borghese Gallery, Rome). The finest painting of Caravaggio's exile is *The Beheading of John the Baptist* (St John's Co-Cathedral, Valetta, Malta).

In the historiography of art, Caravaggio is depicted as the founder of stylistic naturalism. It is certainly the case that he eschewed idealized beauty in favour of a realistic presentation of his subjects: his *St Matthew* is the earliest representation to show the disciple with dirty feet.

Caron, Antoine

(1521–99), French painter associated with the second FONTAINEBLEAU SCHOOL. Caron worked as an assistant to PRIMATICCIO at Fontainebleau and later became court painter to Catherine de Médicis. His historical paintings include *Massacres under the Triumvirate* (1566, Louvre) and *Augustus and the Sybil* (*c.*1575–80, Louvre).

Carpaccio, Vittore

(*c.*1460/6–1525/6), Italian painter, born in Venice and probably trained in the studio of Lazzaro Bastiani (*c.*1425–1512); his paintings show the influence of both Bastiani and Gentile BELLINI. Carpaccio's most important paintings were cycles of *The Life of St Ursula* (painted in the 1490s and now in the Accademia in Venice) and of *The Lives of SS George and Jerome* (painted in the early 1500s for the Scuola di San Giorgio degli Schiavone in Venice, where they remain). Carpaccio was one of the first artists to paint townscapes, and his depictions of contemporary Venice have considerable documentary value.

carpets and rugs

The term 'carpet' now refers primarily to a floor covering, but until the eighteenth century floors were normally covered with rush matting, and carpets were used either as coverings for furniture such as beds and tables or as wall hangings. Domestic carpets were often made by NEEDLEWORK (working threads through a cloth mesh), but more sumptuous carpets were TAPESTRIES made by WEAVING on a loom; the laborious medieval knotted-pile carpets had largely ceased to be manufactured in the early modern period, except for a small number of German wall- carpets. Most carpets were made from wool, but some contained silk threads and decorative motifs woven in gold and silver threads.

In addition to these indigenous European carpets, merchants imported large numbers of Middle Eastern carpets, principally from the Ottoman Empire. Sunni Islam is iconoclastic, so carpets from Egypt and what is now Turkey were woven in geometrical patterns; Shia Islam, however, has a rich pictorial tradition, so Persian carpets and those from Mughal India often portrayed subjects such as animals, gardens, vases, and hunting scenes. Both types of designs were widely imitated by European designers. The knots used to make these carpets differed markedly: the Persian knot (also known as the Sehna knot) used in Persian, Mughal, central Asian, and Chinese carpets was effected by twisting the yarn around one warp thread and under the adjacent thread, a process which produced carpets with a very close pile; the Ghiordes knot (also known as the Turkish knot) used in Turkey, Egypt, and the Caucasus was tied symmetrically on two adjacent warp threads, and produced a coarse pile.

The types of Anatolian carpets (and their European imitations) named after artists such as BELLINI, CRIVELLI, HOLBEIN, LOTTO, and MEMLING

are those represented in their paintings. The carpet in Holbein's *Madonna of Burgomaster Meyer* (c.1526, Kunstmuseum, Basel), for example, has a border of illegible Kufic lettering and a red ground with octagonal motifs decorated in blues and yellows; the carpet in Lorenzo Lotto's portrait of *Giovanni Giuliano* (c.1520, National Gallery, London) is similar, but the motifs are of stylized palmettes rather than octagons. Painters were not always consistent in the types of carpets that they depicted, but their repeated use of the same carpets renders the taxonomy sufficiently stable to be of use. In the early seventeenth century Ushak and Transylvanian carpets became popular in western Europe. Ushak carpets were made in the Turkish province of Ushak (now spelt Uşak), and typically depicted a large medallion ('medallion Ushaks') or a repeated eight-pointed star ('star Ushaks'). Transylvanian carpets, which were either Anatolian carpets or Transylvanian imitations, were hung in the Protestant churches of Transylvania; their colours were more subdued than those of Ushak carpets, and their designs typically consisted of two halves that mirrored each other, and so were vertically but not horizontally symmetrical.

Carpi, Girolamo da

or Girolamo da Ferrara (c.1501–1566), Italian painter, a native of Ferrara, where he trained in the studio of GAROFALO. He painted pictures on religious themes for churches in Bologna (notably his *Marriage of St Catherine* in San Salvatore and his *Adoration of the Magi* in San Martino Maggiore) and Ferrara (of which three survive in Ferrara Cathedral) and portraits in the style of PARMIGIANINO. He lived for a time in Rome, where he compiled a sketchbook of antiquities which is the most important early modern compilation of Roman antiquities.

Carracci, Agostino

(1557–1602), Italian artist, born in Bologna; he was the elder brother of Annibale CARRACCI and the cousin of Ludovico CARRACCI. Agostino painted a well-known altarpiece, *The Communion of St Jerome* (1593–4, Pinacoteca, Bologna). His engravings include a portrait of TINTORETTO, whom Agostino visited in Venice in 1582. His most important drawings were anatomical studies which were engraved after his death and used in European drawing schools for centuries. In 1597 Agostino left Bologna for Rome, where he

assisted his brother Annibale in the decoration of the Farnese Gallery. In 1600 he moved to Parma, where he decorated the vault of a room in Palazzo del Giardino.

Carracci, Annibale

(1560–1609), Italian artist, born in Bologna; he was the younger brother of Agostino CARRACCI and the cousin of Ludovico CARRACCI. As a young man in Bologna he specialized in GENRE PAINTINGS such as *The Butcher's Shop* (Christ Church, Oxford) and *The Bean Eater* (Colonna Gallery, Rome). Between 1583 and 1595 he painted a series of altarpieces (notably *The Almsgiving of St Roch*, Gemäldegalerie, Dresden) and LANDSCAPES (e.g. *Fishing* and *Hunting*, both in the Louvre).

In 1595 Annibale moved to Rome at the invitation of Cardinal Odoardo Farnese, and in the course of the next ten years decorated the Farnese Palace with fresco cycles on *The Legend of Hercules* and *The Loves of the Gods*. These cycles, for which Annibale made more than 1,000 preparatory drawings, are one of the masterpieces of early baroque art; they exercised an important influence on seventeenth-century Roman art and on the development of the baroque style, and until the nineteenth century were thought fit to stand alongside MICHELANGELO's Sistine Chapel and RAPHAEL's Stanza della Segnatura, to both of which Annibale was indebted.

Carracci, Ludovico

(1555–1619), Italian artist, born in Bologna; he was the cousin of Agostino CARRACCI and Annibale CARRACCI. His finest pictures, which were painted in the late 1580s and early 1590s, include a portrait of *The Tacconi Family* (c.1588–90, Pinacoteca Nazionale, Bologna), a *Madonna and Child with St Joseph and St Francis* (1591, Pinacoteca Civica, Cento), and *The Preaching of St John the Baptist* (Pinacoteca, Bologna).

cartoon

or (French) *carton* or (Italian) *cartone*, the art-historical term for a full-size design on paper, drawn in charcoal or chalk for the purpose of transferring the design to an easel painting, a fresco, or a large work such as a MOSAIC or TAPESTRY. The designs of early frescoes were drawn directly onto the walls, but cartoons seem to have been introduced for fresco painting early in the fifteenth century; the idea may have been

borrowed from the use of cartoons in the production of STAINED GLASS. Surviving cartoons include LEONARDO's *Virgin and Child with St Anne and St John* (National Gallery, London) and RAPHAEL's designs (Victoria and Albert Museum) for the tapestries depicting *The Lives of SS Peter and Paul* woven for the SISTINE CHAPEL. Sometimes the cartoons were cut out and then used both frontwards and backwards: in MICHELANGELO's paintings in the Sistine Chapel, for example, each pair of putti supporting a cornice is a mirror image of another pair.

Tapestry cartoons such as Raphael's *Peter and Paul* series differed from other cartoons in two important respects: they were painted in full colour, and they were drawn in reverse for the benefit of tapestry weavers using low-warp looms; that is why the figures in Raphael's cartoons appear to be left-handed.

Cartoons were normally used for large-scale works, but some finished drawings for small works were used as cartoons. Raphael's small oil painting of *The Vision of a Knight* (*c*.1504) hangs beside the pen and ink sketch on which it is based (National Gallery, London). Small oil paintings used as cartoons (such as those painted by Rubens) are known in Italian as *cartoncini*.

casino

(plural *casini*). In Italian VILLAS, a *casino* is either a term for the main house, if it is small by comparison with the scale of the gardens, or for a secondary house or PAVILION in the grounds of a grand house. There are *casini* at Villa LANTE (where there is no large house), the MEDICI VILLA at Castello, and in the GIARDINO SEGRETO of the Villa FARNESE. See also MONDRAGONE, VILLA; PIA, VILLA; GAILLON.

cassone

(plural *cassoni*), a large Italian chest, often a dower chest, manufactured in Italy in the fifteenth and sixteenth centuries and used principally to hold clothing. A *cassone* could be built from planks which were then covered with friezes executed in GESSO and then painted; alternatively, it could be made from wooden panels and then painted. The subjects of *cassone* paintings include mythological and religious scenes, battles, and tournaments. In the sixteenth century painted *cassoni* were displaced by a new fashion for carved decoration, usually on thick walnut and typically depicting a mythological scene.

Castagno, Andrea del

See ANDREA DEL CASTAGNO.

Castel Durante

A small town near Urbino which was renamed Urbania (in honour of Pope Urban VIII) in 1636. Castel Durante was an important centre for MAIOLICA, and in the sixteenth century developed with the potters of Urbino the display pottery known as ISTORIATO ware.

Castello, Giambattista

or Il Bergamasco (*c*.1509–1569), Italian painter and architect who worked as a painter in Genoa before turning to architecture. His Gothic palaces and churches in Genoa include the Church of San Matteo (1554). He also built palaces, including the Palazzo Podestà in the Strada Nuova (*c*.1563–1565) and the Palazzo Vincenzo Imperiale in Campetto (*c*.1560–1566). In 1567 he moved to Spain to enter the service of Philip II, but died before completing any substantial work.

Castro, Antonio de

(*fl.* 1565), Portuguese silversmith and goldsmith in Genoa, known principally for a magnificent silver ewer and basin (1565) decorated with fifteen scenes depicting a fourteenth-century private war. The ewer and basin are now in the Palazzo Cini (formerly Grassi) in Venice.

Caus

or Caux, Salomon de (1576–1626), Huguenot engineer and architect. Caus was a native of Normandy who, as a young man, had lived in Italy; during this period (1595–8) he studied the design and waterworks of PRATOLINO. In 1605 he was employed as an engineer in Brussels by Archduke Albrecht. In 1610 he was brought to the English court as mathematics tutor to Henry, prince of Wales, advising him on the construction of waterworks at Richmond; his treatise on *La Perspective, avec les raisons des ombres et miroirs* (1612) is dedicated to Henry. Caus also worked for the queen, Anne of Denmark, at Somerset House and Greenwich, and for Robert Cecil at HATFIELD HOUSE. On the marriage in 1613 of Princess Elizabeth to Friedrich V, the elector palatine, Caus moved with her court to Heidelberg, where he laid out the castle gardens known as the HORTUS PALATINUS. In 1623 Caus left the service of the elector and returned to France. His *Raisons des forces mouvantes* (1615)

Benvenuto **Cellini**, golden salt cellar (1540–3), formerly in the Kunsthistorisches Museum in Vienna but stolen on 11 May 2003. The salt cellar was commissioned by King Francis I, and Cellini made it while living in Paris; it subsequently passed as a gift from King Charles IX to Archduke Ferdinand II of Tirol. Cellini explains in his *Autobiography* that 'the sea, depicted as a man, holds a richly decorated ship, which can hold salt enough; the Earth I depicted as a woman, of such lovely form and as graceful as I knew how to create. Next to her I placed on the ground a richly decorated temple, which was intended to hold pepper.' At the base are personifications of *Morning, Day, Evening*, and *Night* that are copies of figures on Michelangelo's Medici tombs in the New Sacristy, San Lorenzo, Florence.

explains the hydraulic principles on which garden waterworks were built and illustrates AUTOMATA built for GROTTOES; it also adumbrates the technology of the steam-engine.

Caxton, William

(*c.*1422–1492), English printer. A merchant from Kent, Caxton learned printing in the Low Countries, where from 1465 to 1469 he was governor of the English merchants in Bruges. In 1476 he established a press in Westminster on which he published nearly 100 volumes on a variety of subject matter, including literary works by Chaucer and Malory.

Cellini, Benvenuto

(1500–71), Italian sculptor, goldsmith, medallist, and autobiographer, born in Florence, where he trained as a goldsmith. He lived from 1519 to 1540 in Rome, working as a goldsmith and medallist. During the Sack of Rome (1527) Cellini defended Castel Sant'Angelo, and according to his own account shot Charles, duc de Bourbon. In 1540 Cellini moved to FONTAINEBLEAU at the invitation of King Francis I, for whom he fashioned a bronze relief of the *Nymph of Fontainebleau* (Louvre). His golden salt cellar, the finest surviving goldsmith's work of the Renaissance, was begun in Rome in 1540 for

Cardinal Ippolito d'Este and completed in France for King Francis; King Charles IX presented it in 1570 to Archduke Ferdinand of Tirol; in 2003 it was stolen from the Kunsthistorisches Museum in Vienna. This oval salt cellar, which is some 25 centimetres (10 inches) high, is surmounted by two voluptuous nude statuettes: a female figure representing Earth reclines beside an Ionic temple which holds the pepper; opposite her sits Neptune, who represents the source of salt, which is held in a small ship. The recumbent figures around the base are modelled on MICHELANGELO's Medici tombs.

In 1545 Cellini returned to Florence, where he spent the rest of his career in the service of Duke Cosimo de' Medici, of whom he made a bronze bust (Bargello). During this period Cellini cast his finest sculpture, the bronze *Perseus* (1545–54) now in the Loggia dei Lanzi. His sculptures in marble from this period include *Apollo and Hyacinth* (Bargello), *Narcissus* (Bargello), and a *Crucifix* (Escorial).

Cellini's autobiography, which he began in 1558, was first printed in Naples in 1728. It was translated into German by Goethe, and so became a central document of the Romantic ideal of the artist. He also wrote treatises on the art of the goldsmith (*Trattato della oreficena*) and the art of the sculptor (*Trattato della scultura*).

Cennini, Cennino

(*c.*1370–*c.*1440), Italian painter and art theorist, trained in the Florentine studio of Agnolo GADDI; none of Cennini's paintings is known to survive. Cennini was the author of the *Libro dell'arte*, the first Renaissance treatise on painting. The treatise is a practical guide, and so discusses matters such as TEMPERA techniques, and also contains art history and theory (such as the contention that Nature is the master of the artist). The earliest extant manuscript is dated 1437, 'in the Debtors' Prison in Florence'.

ceramics

or (French) *céramique*, a nineteenth-century term, derived from Greek, for POTTERY and the art of making pottery. In specialist usage, when PORCELAIN is distinguished from pottery, the term 'ceramics' is deemed to encompass both arts.

chairs, settles, and stools

The chair existed in antiquity, but survived in the Middle Ages only in the form of thrones and other ceremonial chairs, such as the doge's chair. In the church, the bishop's seat (*sedes*) or throne (*cathedra*) was the symbol of his authority; the *sedia gestatoria* was the portable throne on which the pope was carried by twelve bearers (*palafrenieri*). The throne of England was (and is) the Gothic oak chair occupied by the monarch in the House of Lords (not the coronation chair in Westminster Abbey). In France and the Netherlands, the seigneurial chair was the remote ancestor of the modern armchair. The notion of the chair as the seat of authority survives in attenuated form in the conventions whereby meetings are 'chaired' by the person in authority and in the idea of the professorial chair in universities.

In the fifteenth century the chair ceased to be used only as an apanage of Church and state and began to be used as a form of seating in wealthy houses. Chairs were normally made from oak or walnut, and were sometimes elaborately carved. Specialized chairs in use as seating included the French *caquetoire* (a small low chair favoured by women who wished to chatter, i.e. *caqueter*), the chair-table (an armchair with a hinged back that could be swung forward to rest on the arms as a table), the farthingale chair (the modern name for a sixteenth-century upholstered chair with a low back and no arms), and the chair known in Spain as the *sillon de caderas* and in England as the Dante chair or Savonarola chair (a chair with no back in which the seat is supported on an X-shaped frame). Some chairs were extravagantly decorated for purposes of display, such as the iron chair (now in Longford Castle in Wiltshire) made in 1574 by Thomas RUCKER, and the twelve sumptuous chairs (of which seven survive) commissioned in 1585 by the Elector Augustus I and made by Giovanni Maria NOSSENI.

In taverns and farmhouses, the settle, which was a bench with a straight back and arms, provided seating for more than one person; settles remained in use until the nineteenth century. The settee, which was the predecessor of the nineteenth-century sofa, was introduced in early seventeenth-century England as a comfortable alternative to the settle.

From the Middle Ages to the nineteenth century the most common type of seat in European houses was the three-legged stool known in Italy as a Strozzi stool; the Cambridge term 'tripos', which now refers to final examinations, originates in the three-legged stool on

which sat the person appointed to conduct mock disputations with candidates for degrees. The cucking stool or pining stool (known from the eighteenth century as the ducking stool) was used to duck scolds and disorderly women into ponds and rivers; in Scotland the repentance stool was one placed in a conspicuous position in a church for the use of sinners repenting publicly for sins of a sexual nature. The type of stool known as the *tabouret* (which was shaped like a drum mounted on four upright legs) was used in the French court (where a protocol of entitlement to sit on the *tabouret* evolved) and later in the English court.

Chambord, Château de

A royal chateau on the left bank of the Cosson, a tributary of the Loire. The chateau was commissioned by Francis I and construction began in 1519 on the site of a former hunting lodge; the architect may have been DOMENICO DA CORTONA, to whom the wooden model (now lost, but known through drawings) which formed the basis of the design is attributed. The structure of the chateau was inspired by the MEDICI VILLA at Poggio Caiano and its 440 rooms are laid out and decorated in the style of the Italian Renaissance. Internal features include a double spiral staircase, almost certainly inspired by LEONARDO DA VINCI, in which the spirals are superimposed but do not meet; the central nucleus is pierced so that each spiral can be seen from the other.

chandelier

A branched ornamental light fixture hanging from a ceiling; the English term derives from the French word for candlestick, but since the eighteenth century the French term for such a hanging fixture has been *lustre*. The progenitor of the chandelier was the late medieval candle beam, a suspended piece of wood with candles on it. The type of chandelier used in churches was called a corona or *corona lucis* (crown of light), which was a suspended iron hoop with spikes for candles or cups for oil. By the sixteenth century chandeliers used in domestic and civic settings contained up to 24 branches; these chandeliers were fashioned from precious metals and suspended by chains from the ceiling. Glass chandeliers were not manufactured until the eighteenth century, when they were produced in Venice and in the Spanish glasshouse at La Granja.

Charonton, Enguerrand

See QUARTON, ENGUERRAND.

château, palais, and *hôtel*

(plurals *châteaux, palais,* and *hôtels*), the French terms for a large house. The *château* is a large country house, the *palais* is a royal or episcopal residence or a building representing the authority of the crown (such as a court of justice), and the *hôtel* is a large urban residence or a building representing a civic authority (such as a town hall); the distinctions are not rigid, so the house of Jacques Cœur (1442–53) in Bourges, which is arguably the finest private house in France, is called Palais Jacques Cœur.

The designs of chateaux and the residential *palais* derive from the architecture of the Italian PALACE, designs for which were disseminated all over Europe through engravings and architectural treatises. The most important Renaissance palaces in France were the LOUVRE, the TUILERIES (destroyed 1871), and SAINT-GERMAIN-EN-LAYE, and the principal chateaux were AMBOISE, ANET, BLOIS, CHAMBORD, CHENONCEAUX, and FONTAINEBLEAU. Public buildings were often built in the older GOTHIC style; the Hôtel de Ville in Compiègne is one of the finest surviving examples.

Chenonceaux, Château de

The chateau was built by Thomas Bohier between 1513 and 1521. The site is the river Cher, which the chateau spans. After the death of Bohier and his widow the chateau passed to the crown in lieu of debts to the royal treasury. When Henri II ascended the throne in 1547, he gave Chenonceaux to his mistress Diane de Poitiers, who commissioned Philibert DELORME to build a bridge carrying a two-storey gallery (La Grande Galerie) to link the chateau (which extended from the medieval keep on the north bank of the Cher) to the south bank; she also commissioned the garden that bears her name on the north bank. On Henri's death in 1559, Diane was displaced at Chenonceaux by the regent, Catherine de Médicis, who forced her to trade Chenonceaux for Chaumont. When Henri was killed, work was suspended on the bridge; the arches had been completed, but the gallery had not been built. Catherine ordered work on the gallery to be resumed. During this period great pageants were staged to mark the arrival of important guests. One was mounted for the arrival of Francis II and Mary Stuart

Colour plates 1–8

1. **Giovanni Bellini,** *Doge Loredan* (c.1501), National Gallery, London. Leonardo Loredan, who is shown in his robes of state, was doge of Venice from 1501 to 1521. In this painting Bellini used the innovative technique known as impasto, in which oil paint was applied thickly rather than built up in thin glazes like TEMPERA; the result is a picture in which the textures are much more subtle than would have been possible with tempera. Bellini signed his name (in Latin) on the *cartellino* (small paper) at the bottom of the picture.

2. **Masaccio,** *Peter Curing the Sick with his Shadow* (c.1425–8), a fresco on the altar wall of the Brancacci Chapel of the Church of Santa Maria del Carmine in Florence. The picture portrays the miracle described in Acts 5: 16. The far right side of the painting, with its Corinthian column behind the apostle John, was long obscured by an altar which has now been removed.

3. **Mathias Grünewald,** *The Crucifixion* (c.1515, the date on Mary Magdalene's ointment jar), on the front wings of the Isenheim altarpiece, in the Musée d'Unterlinden, in Colmar. This huge picture is the greatest of GOTHIC paintings and the most powerful depiction of the horror of crucifixion in western art. It originally stood in a monastic hospital, where the tortured body of Jesus reflected the suffering of the patients. On the left, the Virgin Mary is comforted by John the apostle and Mary Magdalene kneels in prayer; on the right John the Baptist points to Jesus. The letters on the sign above Jesus stand for *Iesus Nazarenus Rex Iudaeorum* (Jesus of Nazareth, King of the Jews; John 19: 19).

4. **Hans Holbein the Younger,** *The Ambassadors* (1533), in the National Gallery, London. On the left is Jean de Dinteville (1504–57), French ambassador to England in 1533; on the right is his friend Bishop Georges de Selve (1509–42), who served as ambassador to the Holy Roman Empire, the Republic of Venice, and the Papal State. The learning of the two men is attested by the books and scientific instruments on the shelves. The object in the foreground is a distorted representation of a skull, a reminder of human mortality; the ANAMORPHOSIS can be corrected if the skull is viewed from a point to the right of the painting.

5. **Leonardo da Vinci,** *Mona Lisa* (c.1503–7), in the Louvre, Paris. Vasari's identification of the sitter as Lisa Gherardini was confirmed in 1991 with the publication of new documentary evidence. Lisa, who was born in Florence in 1479, had married the eminent Florentine Francesco del Giocondo, and so the painting is also known as *La Gioconda* (Italian) or *La Gioconde* (French). 'Mona' is an abbreviation of 'Madonna', a title of respect comparable to 'Madam'. The portrait was painted over a long period, beginning in about 1503 in Florence and finished in Milan or Rome; Leonardo then took it to France, where it was acquired by King Francis I. The visual evidence of this protracted gestation is the contrast between the craquelure (hairline surface cracking) of the face, which was painted at an early stage, and the surface of the hands, which is characteristic of the thinness of Leonardo's later technique.

6. **Titian,** *Flora* (c.1515–20), in the Uffizi, Florence. Flora was the Roman goddess of flowers and spring, and Titian portrays her as a Venetian courtesan. The painting was in Amsterdam in the 1630s, and suggested the subject of Rembrandt's pictures of Flora.

7. **Raphael,** *La Belle Jardinière* (1507), in the Louvre, Paris. The painting is properly entitled *The Virgin and Child with St John the Baptist*; its nickname derives from its distinctive pastoral background. Raphael painted it in Florence, and inscribed the date in Roman numerals in the hem of the Virgin's mantle. the SFUMATO technique and the pyramidical composition both imply the influence of Leonardo da Vinci, but draughtsmanship and the serenity of the composition are peculiar to Raphael. The painting was acquired by King Francis I and remained in the royal collection until the French Revolution.

8. **Jan van Eyck,** *Arnolfini and his Wife* (1434), in the National Gallery, London; the painting was formerly (and mistakenly) known as the *Arnolfini Marriage*. The painting is signed 'Johannes de eyck fuit hic 1434' ('Jan van Eyck was here in 1434'). The woman is not pregnant, but is rather lifting the front of her full-skirted dress. The man is raising his hand in greeting to the two figures reflected in the mirror.

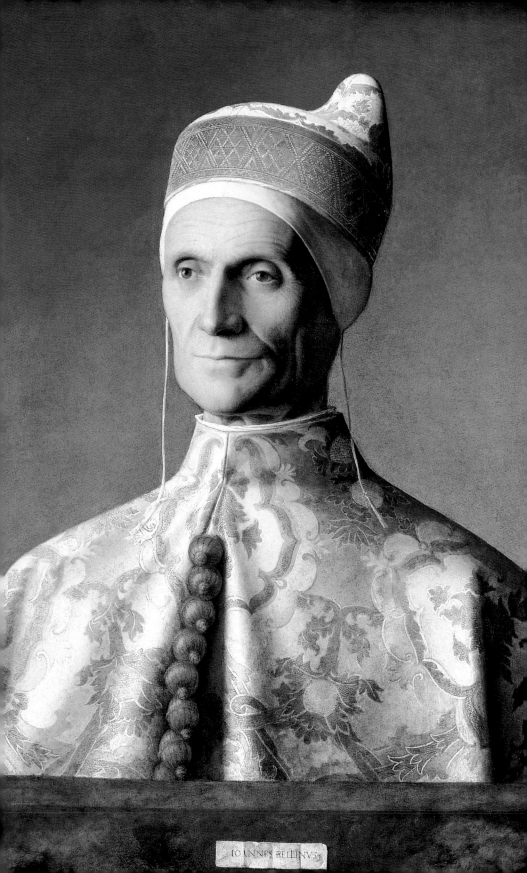

IOANNES BELLINVS

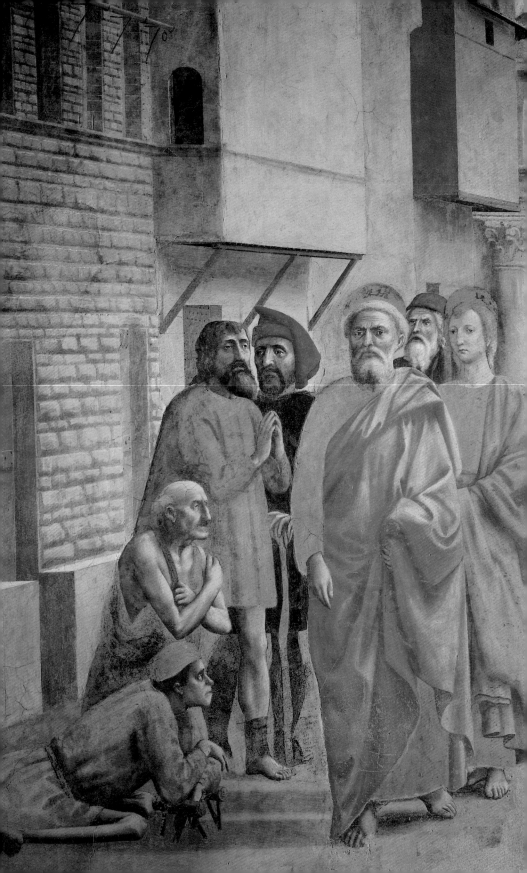

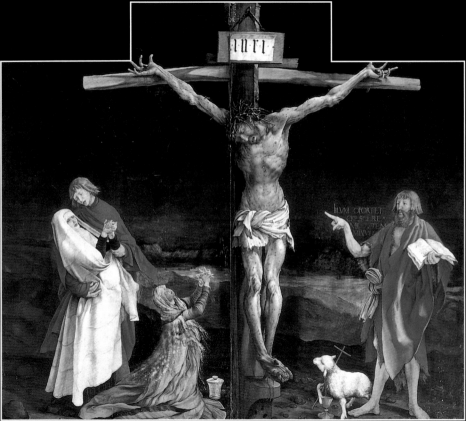

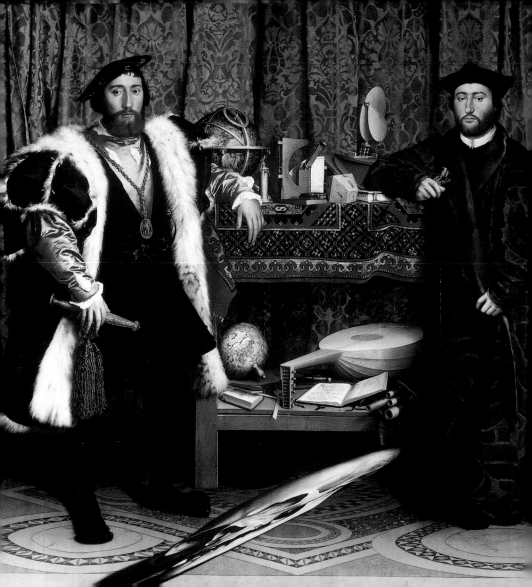

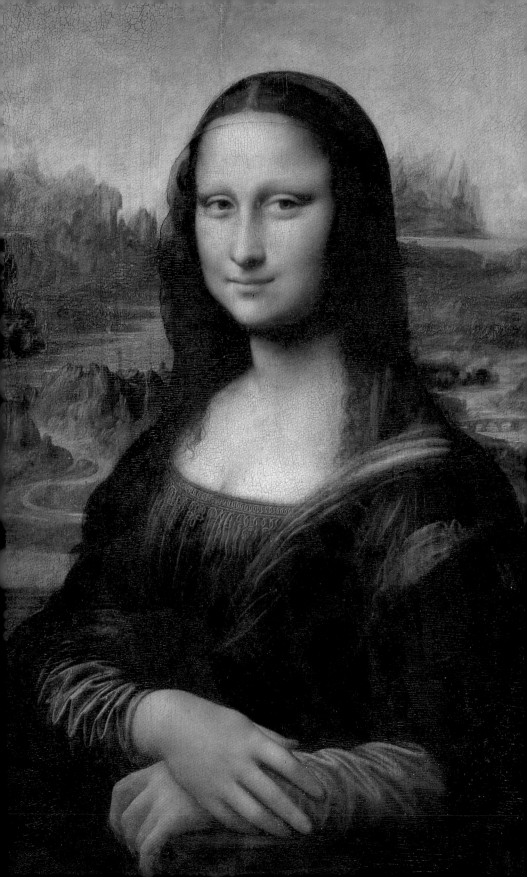

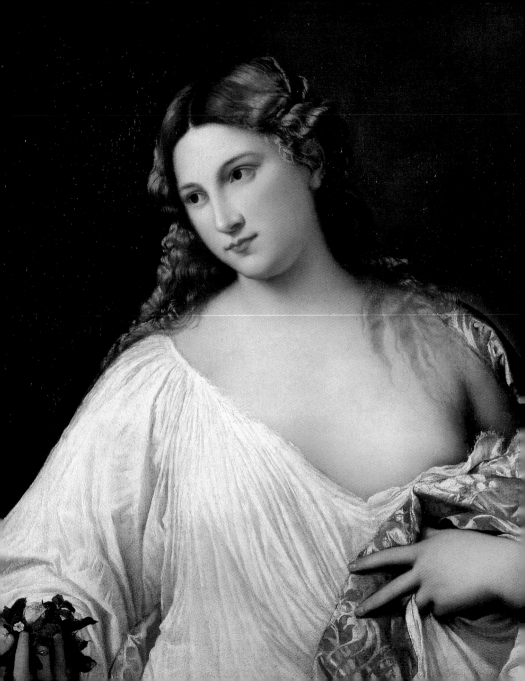

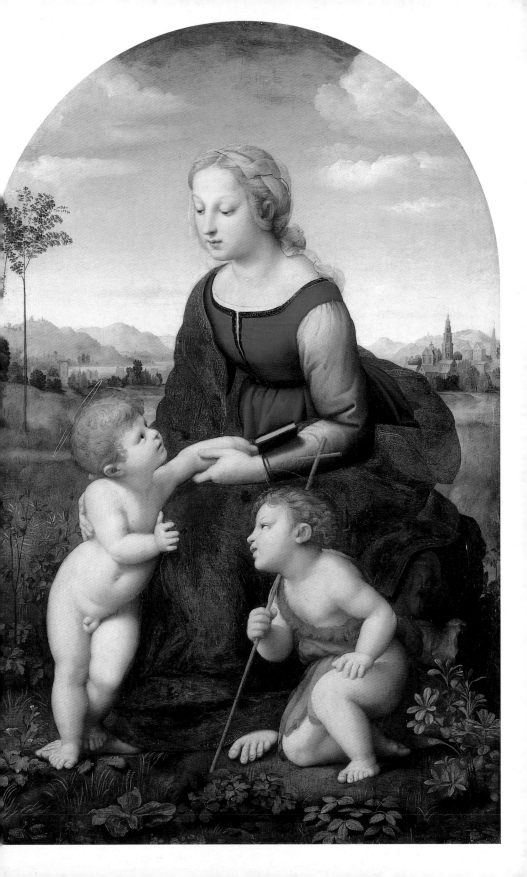

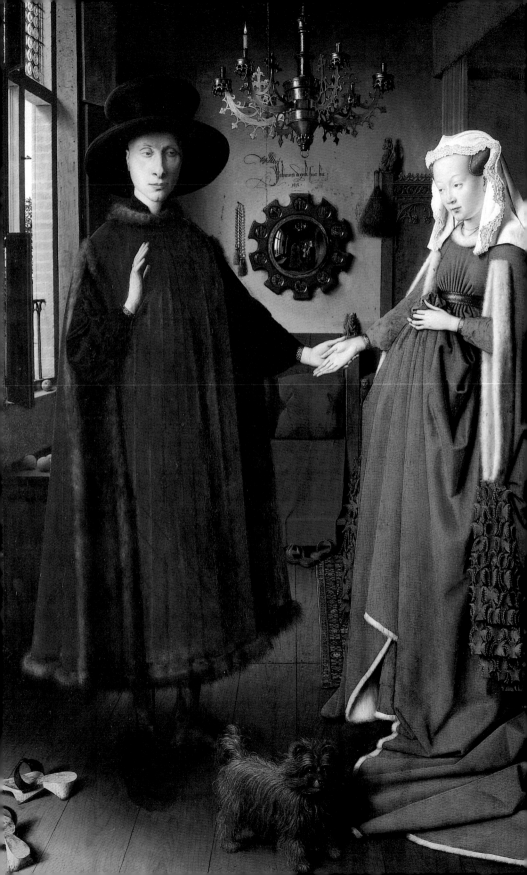

(Mary, queen of Scots), and another for the arrival of Catherine's son Henri III in 1574. On the latter occasion guests were welcomed by singers dressed as mermaids and wood nymphs, and there were fireworks, masquerades, and a naval battle on the Cher. On Catherine's death she bequeathed Chenonceaux to her daughter-in-law Louise of Lorraine, wife of Henri III. When Henri was assassinated in 1589, Louise retired in mourning to the chateau for the rest of her life. Thereafter Chenonceaux fell into desuetude, though it enjoyed a revival in the eighteenth century, when the salon of Mme Dupin attracted visitors such as Voltaire, Montesquieu, and Lord Chesterfield, and Rousseau acted as tutor to the Dupin boys, for whom he wrote *Émile* (1762), his treatise on education.

The gardens constructed for Diane de Poitiers were laid out between 1551 and 1555 on a 1-hectare ($2\frac{1}{2}$-acre) terrace east of the entrance to the chateau. The garden was planted with fruit trees, flowers, and vegetables in rectangular beds which are depicted in a drawing by DUCERCEAU. When Catherine took possession of the chateau, she built a garden (now named after her) on the west side of the entrance; this garden was dominated by a circular FOUNTAIN in the form of a rock. Both gardens are now laid out in a French classical style rather than a Renaissance style, though the site of the fountain is marked by a circular depression in the west garden. Catherine also laid out a garden and park on the south side of the river, arranged around an axis that is an extension of the approach road and the line of the chateau as it crosses the river.

chevron

The term used in heraldry for an inverted V; the term derives from rafters meeting at an angle at the ridge. In the fifteenth and sixteenth centuries the chevron was used as a decorative motif on wood (in which it was carved or inlaid) and plaster. When used in mouldings the chevron was known as a dancette.

chiaroscuro

(Italian; 'bright-dark'), a late seventeenth-century oxymoron used to denote monochrome paintings (such as GRISAILLES), woodcuts (see next entry), and engravings (particularly those of Rembrandt) characterized by the dramatic use of gradations of lightness and shade. The term is also used in a broader sense to denote the use of

light and shadow to model form in paintings such as those of LEONARDO DA VINCI.

chiaroscuro woodcut

or (French) *gravure en camaïeu*, a WOODCUT in which the illusion of depth is created by printing from a succession of blocks in which the intensity of the tone is varied. The earliest dated CHIAROSCURO woodcut is Hans BURGKMAIR's equestrian portrait of the Emperor Maximilian (1508). German artists who subsequently made chiaroscuro woodcuts include Albrecht ALTDORFER, Hans BALDUNG GRIEN, and Lucas CRANACH. In Italy, where the medium remained popular until the advent of colour wood engraving in the nineteenth century, UGO DA CARPI was the most important exponent of the form; many of his prints were designed by RAPHAEL and PARMIGIANINO (the most prolific chiaroscuro woodcut designer of the Renaissance).

chimney piece

Until the end of the seventeenth century, the term 'chimney piece' denoted an ornament, typically a painting or a tapestry, placed over a fireplace. In the eighteenth century the term acquired its modern sense of an ornamental structure built around the open recess of a fireplace. By the fourteenth century, the hearth, which had traditionally stood in the middle of a room, had begun to be set in the thickness of one of the walls. The decoration of the protruding hood or chimney breast soon evolved into chimney pieces that dominated the rooms in which they were built.

The earliest surviving high-quality chimney pieces are those installed by Luciano LAURANA in the Palazzo Ducale in Urbino (1464–72). In the sixteenth century chimney pieces became popular in northern Europe, and designs were often taken from those printed in Sebastiano SERLIO's *Architettura* (1537), Jacques Androuet DUCERCEAU's *Second Livre d'architecture* (1561), Philibert DELORME's *Architecture* (1567), and Wendel DIETTERLIN's *Architectura und Ausstheilung der V. Seuln* (1593–4).

Christmas, Gerard

or Garrett (1576–1634), English sculptor. He was appointed carver to the navy (1614–34) and designed pageantry for lord mayors' shows from 1619 to 1632. His works include an equestrian figure of King James I on the city gate at Aldersgate (demolished 1761), through

which James had entered London for the first time as king; he also carved (and perhaps designed) a three-tiered frontispiece on Northumberland House on the Strand (demolished 1874). Christmas worked together with his sons John and Matthias; their workshop produced a large number of sculpted tombs, of which the best known is the tomb of George Abbot, archbishop of Canterbury, in Holy Trinity, Guildford.

Christus, Petrus

(c.1410–1475/6), Netherlandish painter who became a master in Bruges in 1444 and worked there throughout his career. The style of his paintings is indebted to Jan van EYCK and Rogier van der WEYDEN. In the case of Jan van Eyck, Petrus Christus copied some of his paintings and may have completed some of the paintings that Jan van Eyck left unfinished at his death; the influence of Rogier van der Weyden is apparent in Petrus Christus' *Lamentation* (c.1450, Musée d'Art Ancien, Brussels), which is based on Rogier's *Deposition* (Prado, Madrid). He differed from his predecessors in eschewing their dark backgrounds in favour of interiors or landscapes seen through a window in paintings such as *St Eligius with Two Saints* (1449, Metropolitan Museum, New York), *Portrait of Edward Grimston* (1446, on loan to the National Gallery in London), and the undated *Portrait of a Young Man* (National Gallery, London). His innovative treatment of PERSPECTIVE is evident in *Virgin and Child with SS Francis and Jerome* (1457, Städelsches Kunstinstitut, Frankfurt am Main), which is the earliest dated painting in northern Europe to use geometrical perspective.

Cicogna, Villa

A VILLA and garden in Bisuschio (Piedmont), near Lake Lugano. The villa was built in the fifteenth century as a hunting box to which the Mozzoni family invited the dukes of Milan for boar-hunts. In the sixteenth century the villa was rebuilt in the Renaissance style, with two decorated loggias: one leads to the villa, and the other to a porticoed court bordering a sunken garden with clipped hedges, gravel paths, and small FOUNTAINS; below this level there are two ornamental fish ponds. The most remarkable features of the garden are the water-staircase and the large terrace that runs at right angles to it. The elegant water-staircase leads from the sunken garden to the meadows above the house. The terrace was used as a sheltered promenade from which the Lombard countryside and the PARTERRES of the lower gardens could be viewed; the arcaded retaining wall of the terrace contains an underground gallery (imitative of the ancient Roman cryptoporticus) that was intended as a cool retreat from the heat of summer. Both house and garden have survived in their sixteenth-century form.

Cigoli

or Ludovico Cardi (1559–1613), Italian painter, architect, and writer on perspective, a native of Cigoli (Tuscany); he trained in the Florentine studio of Alessandro ALLORI. His surviving paintings include frescoes in the Church of Santa Maria Novella in Florence (1581–4) and a fine *Madonna and Child* (1582, Szépmüvészti Múzeum, Budapest); in Rome he painted *St Peter Healing the Lame Man* (St Peter's Basilica). Cigoli's principal surviving architectural work is the courtyard of BUONTALENTI's Palazzo Nonfinito, the 'unfinished palace' in Florence. The manuscript of Cigoli's unpublished *Trattato della prospettiva pratica* is in the Uffizi.

Cimabue

or Cenni di Pepe (c.1240–1302), Italian painter, probably a native of Florence. He was famously said by Dante to have 'held the field in painting' and then to have been eclipsed by GIOTTO ('Credette Cimabue nella pintura | tener lo campo, e ora ha Giotto il grido | sì che la fama di colui è scura', *Purgatorio* 11. 94–6). This passage was the basis of the subsequent belief that Cimabue was the harbinger of Giotto and therefore the progenitor of Italian Renaissance painting. The only documented work by Cimabue is a mosaic of *St John* (1301), which was his restoration of a considerably older and larger mosaic (possibly by a twelfth-century artist) in the apse of Pisa Cathedral. Attributions, all of which are contested, include the *Madonna of Santa Trinita* (c.1285/6, Uffizi), a crucifix in the Church of Santa Croce in Florence (seriously damaged in the flood of 1966), and a cycle of damaged murals in the Upper Church of San Francesco in Assisi.

Cima da Conegliano, Giovanni Battista

(1459/60–1517/18), Italian painter. He was born in Conegliano, on the Venetian terraferma, and spent his career in Venice. Although Cima painted a considerable number of small

devotional works, his reputation rests on his altarpieces, of which he painted a large number. In the early years of the sixteenth century he painted altarpieces for several Venetian churches, including Santa Maria della Carità (*c*.1510, now in the Accademia), Corpus Domini (*c*.1505, now in the Brera, Milan), and Santa Maria dei Carmini (*c*.1510, still in the church). His later works include a pair of secular tondi (*Endymion Asleep* and *The Judgement of Midas*, *c*.1505–10, Galleria Nazionale, Parma) and a signed and dated *Incredulity of St Thomas* (1504, National Gallery, London) painted for a flagellant community in Portogruaro.

cinquecento
An apheretic form of *mil cinque cento* ('one thousand five hundred'), the Italian term for the sixteenth century (15—) and for the art and architecture of the period.

Civitali, Matteo
(1436–1501), Italian sculptor, born in Lucca. He trained in the Florentine studio of Antonio ROSSELLINO and later introduced the Florentine style to Lucca, where his first important work was the marble tomb of Piero da Noceto (1472) in Lucca Cathedral; his other work for the cathedral includes a pulpit (1494–8) and the Tempietto del Volto Santo (1484), a marble reliquary which contains a wooden image of Jesus believed to have been fashioned by Nicodemus. Civitali also designed the Palazzo Pretorio (1492) in Lucca, and his statue now stands in the portico. Beyond Lucca, Civitali sculpted a lectern and candelabra in Pisa Cathedral and six free-standing statues of patriarchs in Genoa Cathedral (1496).

clocks and watches
The first mechanical clocks were the turret clocks of the late thirteenth century. These clocks were structures of iron wheels mounted in openwork frames set in the bell towers of churches and civic buildings, and their purpose was to sound the hours; they had no clock face. The central machinery of the mechanical clock is a set of toothed wheels with an escapement device to regulate the turning of the wheels. Turret clocks were driven by weights suspended by ropes wound around wooden drums that were connected to the first toothed wheel of the clock movement. The earliest surviving turret clock is the Salisbury Cathedral clock of

1386, which has been restored and now sounds the hours. The earliest surviving clock that sounds the quarter-hour is the one in Rouen Cathedral (1389); the Wells Cathedral clock (1392), the movement of which is now in the Science Museum in London, also chimes the quarter-hours. Some early clocks were fitted with AUTOMATA, such as the one in Strassburg Cathedral (1574), in which the Magi pass in front of the Virgin and Child while a cock flaps its wings, and Sebastian LINDENAST's Männleinlaufen (1506–9), the clock with animated figures of the electors mounted above the porch of the Liebfrauenkirche in Nuremberg.

The earliest domestic clocks were scaled-down versions of these ecclesiastical and civic clocks, and were fitted with faces. These clocks were enclosed in iron cases, and were known as Gothic clocks because of the style of their decorative mouldings. In the sixteenth century the most prominent makers of Gothic clocks were the LIECHTI family, whose workshop was in Winterthur. Early domestic clocks (like turret clocks) were driven by suspended weights, and this technology eventually led to the long-case clock (or grandfather clock) of the seventeenth century. In the mid-fifteenth century, however, the spring-driven clock was developed, and this technology was used in the TABLE CLOCKS AND TABERNACLE CLOCKS of the sixteenth century; it also made possible the development of the watch. The technology of the clock continued to develop through the sixteenth century, at the end of which one of the most important centres of horology was the court of Rudolf II in Prague, where Jost BÜRGI was the court clockmaker and Christoph Margraf developed a type of clock driven by a ball running down an inclined plane; examples of their work are preserved in the Kunsthistorisches Museum in Vienna.

The watch evolved out of the table clock. The earliest examples, which were suspended from the waist or the neck rather than carried in a pocket, are the portable box clocks made from *c*.1510 by the Nuremberg locksmith Peter HENLEIN, the inventor of the mainspring. Spherical box clocks in this style, which are known as Nuremberg eggs (*Nürnberger Eier*), were made throughout the sixteenth century. Most sixteenth-century watches, however, retained the drum shape of the table clock, and like those clocks had the dial mounted on the top of the drum; the dial was not covered by glass, but was rather placed under a hinged cover or (in a small

number of early seventeenth-century watches) provided with a ROCK-CRYSTAL cover. Some sixteenth-century watches were fitted with striking mechanisms as well as dials. The pocket watches of the first quarter of the seventeenth century, which were usually enclosed in silver cases, are normally oval rather than circular.

Clouet

or Cloet family, a family of French painters. Jean (or Janet) Clouet (*c*.1485–1540/1), who was the son and namesake of a Flemish painter who worked in France and Burgundy, worked in Burgundy before being appointed court painter to King Francis I of France. He drew and painted members of the royal court, including portraits of *Francis I on Horseback* (Uffizi) and a *Man Holding Petrarch's Works* (Royal Collection, Windsor).

Jean's son François Clouet (*c*.1516–72) was a portraitist and painter of GENRE scenes. His signed portraits include *Charles IX* (1570, Kunsthistorisches Museum, Vienna) and *Lady in her Bath* (*c*.1570, National Gallery, Washington), which may represent Marie Touchet, the mistress of Charles IX.

Clovio, Giulio

or (Croatian) Julije Klovic or Il Macedone (1498–1578), Croatian painter and illuminator who moved to Venice in 1516 and from 1523 worked at the imperial court in Bohemia and Hungary. He returned to Rome in 1526, and was captured in the Sack of Rome (1527) but escaped and became a Benedictine monk in Mantua. When Pieter BRUEGEL visited Rome in the course of his long Italian journey (1551–5), he collaborated with Clovio, who owned several works by Bruegel (now lost). Giulio Clovio's illuminations include a series on the victories of Charles V (British Library), the Towneley Lectionary (New York Public Library) and St Paul's Epistle to the Romans (Sir John Soane's Museum, London); he also painted the Farnese Hours (Pierpont Morgan Library, New York), which was bound in silver by Antonio GENTILI. Clovio's oil paintings include a *Pietà* of 1553 now in the Uffizi.

Codussi

or Coducci, Mauro (*c*.1440–*c*.1504), Italian architect. He was born near Bergamo and by 1469 had settled in Venice, where, together with Pietro LOMBARDO, he supplanted Venetian Gothic with a syncretic Byzantine-Renaissance

style of architecture. His first church, on Venice's cemetery island, was San Michele in Isola (1469–77), the earliest Renaissance church in Venice; it has a Renaissance façade indebted to the design of ALBERTI's Tempio Malatestiano at Rimini but topped with a Veneto-Byzantine semicircular pediment. Codussi subsequently completed the Church of San Zaccaria (1480–1500), which had been begun by Antonio Gambello in 1458, designed the campanile of San Pietro di Castello (1482–8), which was the cathedral of Venice until 1807, and built San Giovanni Crisostomo (1497–1504). He also restored the Church of Santa Maria Formosa on a twelfth-century plan (1492–1504); the present interior is largely Codussi's, but the exterior and dome are later accretions.

Codussi excelled in the design of staircases. His staircase at the Scuola di San Marco (1490–5) was destroyed in the nineteenth century, but his elegant double staircase at the Scuola di San Giovanni Evangelista (1498) is one of the finest works of Venetian architecture.

There is no documentary evidence to link Codussi with any Venetian palace, but attributions include Palazzo Corner-Spinelli (*c*.1485–90) and Palazzo Loredan (from 1502, later completed by Pietro LOMBARDO and now called Palazzo Vendramin-Calergi). The clock tower in Piazza San Marco has also been attributed to Codussi.

Coecke van Aelst, Pieter

(1502–50), Flemish painter, architect, sculptor, translator, designer of tapestries and stained glass, born in the south Netherlandish village of Aelst (where his father was deputy mayor) on 14 August 1502. He was trained in the Brussels studio of Bernaert van ORLEY and was admitted to the Antwerp guild in 1527. He visited Rome and in 1533–4 went on to Constantinople in the hope of soliciting tapestry commissions from Süleyman the Magnificent; the drawings that he made on his journey were later published by his widow as woodcuts and were collected in 1873 as *The Turks in 1533*. In 1549 he became a member of the group of artists who prepared the pageant decorations for the ceremonial entry of Charles V and his son Philip (later King Philip II). Artists trained in his studio included Pieter BRUEGEL the Elder, who married his daughter.

Coecke's best-known painting is his *Last Supper* (Musée d'Art Ancien, Brussels). His greatest services to architecture were his translations of VITRUVIUS' *De architectura* into Flemish

(Antwerp, 1539) and SERLIO's *L'architettura* into High German, Flemish, and French (Antwerp, 1539–53).

Coecke is sometimes confused with his namesake Pieter van Aelst (d. *c.*1530), the Brussels weaver to whom Pope Leo X sent RAPHAEL's cartoons of *The Acts of the Apostles.*

coins

Metal discs struck or cast with the head or effigy of a person on the obverse and a design related to the state for which they were produced on the reverse. Coins are primarily a medium of exchange, and it is their monetary value that distinguishes coins from MEDALS (which are primarily commemorative). Printed banknotes were not in public use until the end of the eighteenth century, so for most purposes, beyond the specialized world of banking (where bills of exchange were used), coins were the only form of money. Coins also differ from medals in that they were issued by states, whereas all Renaissance medals except those of the Papal State were privately manufactured.

Coins were usually made from copper and silver alloys. Whereas medals were usually cast, coins were normally struck by hand with hammers. Dies could be used repeatedly, but until the mid-sixteenth century all coins were manufactured by hand. Such coins were irregular in shape, partly because the blank discs were not uniform, but also because the force of the hammer often caused the blank to spread unevenly. These irregularities left coins vulnerable to clipping, a criminal process whereby small quantities of precious metal were pared from the edges (which were not milled) and made into new coins.

In the second half of the sixteenth century, new technologies were developed which enabled coins to be mass produced: rolling mills produced sheets of metals with a consistent depth, cutting presses facilitated the production of uniform discs, and screw-driven vices (developed in Augsburg *c.*1550) enabled mints to make coins by placing a heated metal disc between two engraved dies, which were then forced together with a screw-driven vice.

Colantonio, Niccolò

(*c.*1420–*c.*1460/70), Italian painter, based in Naples, where he painted religious paintings in a style marked by Flemish influence. His surviving paintings include his early *St Jerome in his Study Removing the Thorn from the Lion's Paw* (Museo Nazionale, Naples), which was painted as part of an altarpiece for the Church of San Lorenzo in Naples, and his later *St Vincent* (San Pietro Martire, Naples). Colantonio's pupils may have included ANTONELLO DA MESSINA.

Colombe, Michel

(*c.*1430–*c.*1514), French sculptor. Little is known of his early life, but in the early sixteenth century he was commissioned by Anne of Brittany to work with Jean PERRÉAL on the tomb (1502–7) of her father Duke François II of Brittany in Nantes Cathedral. Colombe also made the relief carving for an altarpiece of *St George* at GAILLON (now in the Louvre).

Colonia, Juan de

(d. 1481), Simón de (d. *c.*1511), and Francisco de (d. 1542), a family of architects naturalized in Burgos. Juan de Colonia came from Cologne to Burgos in about 1440, and built the distinctively German late Gothic spires on the west towers of the cathedral.

Juan's son Simón succeeded his father as master of the works at Burgos Cathedral in 1481, and built the distinctively Spanish late Gothic (i.e. PLATERESQUE) Chapel of the Constable (1486–98). He was also responsible for the Plateresque façade of San Pablo, Valladolid (1486–99), which is an early example of a façade designed in the manner of a sculpted reredos; the fashion for such church fronts in Spain and in Spanish America may be traced at least in part to this church. In 1497 Simón was appointed as master mason of Seville Cathedral.

Simón's son Francisco assisted his father on the façade of San Pablo, and was responsible for the retable above the altar of San Nicolás in Burgos (*c.*1503–5), which mingles Plateresque and Renaissance elements. He succeeded his father as master of the works at Burgos Cathedral in 1511, and was responsible for the Puerta de la Pellejería (1516, in early Renaissance style) and, together with Juan de Vallejo, for the late Gothic crossing tower, on which work began in 1540. In 1513 Francisco was appointed as master mason of Plasencia Cathedral together with his rival Juan de ÁLAVA, but the collaboration was not a success, because they quarrelled constantly.

Colt

or Coult, Maximilian, formerly surnamed Poultrain or Poutrain (*fl.* 1595–1641), a sculptor

from Arras who migrated to England c.1595. From 1605 to 1608 he carved monuments in Westminster Abbey, notably the canopied tomb of Queen Elizabeth, which was painted by Johan DE CRITZ. He entered the service of Robert Cecil, earl of Salisbury, and worked extensively at HATFIELD HOUSE, where his commissions included fireplaces and the memorable tomb of Robert Cecil, in which his effigy lies on a black marble slab which is supported by four kneeling Virtues. In 1608 Colt was appointed master sculptor to King James, in which capacity he carved the decorations on the royal barges (1611–24). His post was renewed by King Charles I, but Colt received only a few minor commissions. He disappeared from the historical record while a prisoner in the Fleet in 1641.

Columbine cup

The term 'columbine', which derives from the Latin columbinus ('like a dove'), was used in a transferred sense both to suggest the mildness of the dove (as in Columbina, the character in commedia dell'arte) and to suggest the shape of a group of doves (as in the Columbine flower Aquilegia vulgaris). Silver goblets shaped like the flower of the Columbine were manufactured in Nuremberg in the sixteenth century (they were first mentioned in 1513), often by candidates applying for admission to the guilds of goldsmiths. There are two fine examples in the Victoria and Albert Museum and another in the British Museum. Georg WECHTER is sometimes said (in error) to have been the inventor of the Columbine cup, but his influential design was not published until 1579.

Condivi, Ascanio

(1525–74), Italian painter, and the biographer of MICHELANGELO; his Vita di Michelagnolo Buonarroti, which was published in 1553, was in part a reaction to the view of Michelangelo advanced by VASARI in his Lives, which had been published in 1550. Condivi was a close associate of Michelangelo, and at times his biography seems to encapsulate Michelangelo's perspective so sympathetically that its subject seems to be a silent collaborator in the biography.

Coninxloo, Gillis van

(1544–1607), Flemish LANDSCAPE painter, born in Antwerp. He lived in Frankenthal from 1587 to 1595, and then settled permanently in Amsterdam. His early landscapes are backdrops

to biblical or mythological figures, but in his later works, such as the Forest (Kunsthistorisches Museum, Vienna), his voluptuous landscapes become the subject of his paintings.

contrapposto

The Renaissance Italian term (literally 'opposite') for the pose of the erect human figure as portrayed in sculpture. The robed human figure is relatively unproblematical for the sculptor, but the naked figure constitutes a practical problem of balance, particularly if the sculptor seeks to avoid the impersonality and solemnity of a symmetrical figure.

Renaissance sculptors such as DONATELLO, VERROCCHIO, and MICHELANGELO studied antique sculpture, and also experimented with the classical pose in their live models. The most innovative and radical treatment of the contrapposto is the statuary of Michelangelo, who boldly balanced projecting masses of stone against one another. In his David (see p. 167), the forward motion of the left knee is balanced by the backward movement of the left shoulder, which means that the chest is twisted on its axis; similarly, the forward movement of the upper arm is balanced by the backward movement of the head. This interpretation of contrapposto was to set the style of Italian and German sculpture until the end of the eighteenth century. The term contrapposto is also used to denote a posture in which the weight is carried on one leg and the other leg is relaxed.

Coornhert, Dirck Volckertszoon

(1522–90), Dutch humanist, translator, poet, dramatist, politician, notary, and engraver, born in Amsterdam, the son of a cloth merchant. In 1547 he settled in Haarlem, where he worked as an engraver for Maarten van HEEMSKERK. He lived for several years (1568–72) as a religious exile in Cleves, where he taught the art of engraving to GOLTZIUS; he returned to Haarlem (where he worked as a notary) and then moved to Delft and (in 1588) to Gouda. His engravings include illustrations to the German edition of Jan van der Noot's epic Das Buch Extasis (1576).

Corneille de Lyon

or Corneille de la Haye (1500/10–1575), Dutch painter. He was born in The Hague and c.1540 moved to Lyon, where he worked as a painter of portrait miniatures. The canon of his paintings was long regarded as unstable, but in 1976 the

Louvre acquired Corneille's recently recovered portrait of *Pierre Aymerie*, which has become the basis of subsequent attributions. In 1536 the royal court visited Lyon, and Corneille painted three of the children of King Francis I: the Dauphin Henri (Galleria Estense, Modena), Madeleine (Musée Municipal, Blois), and Charles d'Angoulême (Uffizi).

Corneliszoon van Oostsanen

or van Amsterdam, Jacob (*c.*1472/7–1533), Dutch painter, book illustrator, and designer of woodcuts and stained glass. He was Amsterdam's most prominent and innovative designer of woodcuts, of which the best surviving examples are a series on *The Passion*. His surviving paintings include a *Self-Portrait* (1533, Rijksmuseum, Amsterdam) and a *Nativity* (1512, Palazzo di Capodimonte, Naples); he died before 18 October 1533.

Correggio

or Antonio Allegri (1494–1534), Italian painter who took his name from his birthplace, the small town of Correggio (east of Parma). Nothing is known of his youth or training, but the indebtedness of his style to MANTEGNA may imply an apprenticeship in Mantua. His early paintings, which are characterized by elegant poses and the use of SFUMATO, include a *St Francis* altarpiece (1514, Gemäldegalerie, Dresden) and *Jesus Taking Leave of his Mother* (National Gallery, London).

By 1518 Correggio had settled in Parma, where his first important commission was the decoration of the ceiling of the Camera di San Paolo (1519), the dining room of the abbess of the Convento di San Paolo; the painting is entirely secular, and includes depictions of Diana (goddess of chastity), Adonis, putti, the Graces, and the Fates. In 1520 Correggio painted an illusionist fresco of *The Vision of St John* (who sees Christ ascending and the apostles) on the dome of the Church of San Giovanni Evangelista, and in 1526 he painted a similar fresco of *The Assumption of the Virgin* on the dome of Parma Cathedral. His altarpieces include *The Virgin with St Jerome* (1527–8, Galleria Nazionale, Parma) and *The Nativity* (Gemäldegalerie, Dresden). His mythological paintings include a series (started in 1530) on *The Loves of Jupiter* for Federico Gonzaga, which is now dispersed; surviving paintings include *Io*, in which Jupiter appears as a cloud, *Ganymede* (both in the Kunsthistorisches Museum, Vienna), and *Leda* (Louvre).

Cossa, Francesco del

(*c.*1435–1476/7), Italian painter who worked in his native Ferrara, where he painted some of the frescoes of the *Months* commissioned by Borso d'Este for the Palazzo Schifanoia. These paintings, with their astrological symbols and complex iconography, exemplify the intellectual dimension of the culture of mid-fifteenth-century north Italian courts. Cossa later left Ferrara for Bologna, where he worked as a painter of ALTARPIECES, portions of at least three of which survive, including a *Crucifixion* in the National Gallery in Washington which was part of a polyptych for the altar of San Petronio in Bologna.

Costa, Lorenzo

(*c.*1460–1535), Italian painter. He began his career in Ferrara, where he painted *The Concert* (National Gallery, London). In about 1483 Costa moved to Bologna, where he entered into a partnership with FRANCIA, with whom he worked for the Bentivoglio family on the decoration of the Bentivoglio Palace; the palace has since been destroyed, but some of Costa's frescoes survive in the nearby Bentivoglio Chapel. In 1506 Costa left Bologna for Mantua, where he succeeded MANTEGNA as court painter to the Gonzaga family. His Mantua paintings include an allegorical *Isabella d'Este in the Garden of the Muses* (now in the Louvre) painted for Isabella d'Este, marchioness of Mantua.

Court, Jean de

(*fl.* 1541–64) and Suzanne de (*fl.* 1600), French enamellers in Limoges. Jean de Court typically painted bright colours on black backgrounds; many of his designs are taken from prints by other artists, including Étienne DELAUNE. Suzanne de Court, who may have been the daughter of Jean de Court, was the last important Limoges enameller; she painted brightly coloured figures on a large range of decorative objects such as plates and caskets.

Cousin, Jean the Elder

(*c.*1500–1560) and Jean the Younger (1522–94), French painters and engravers. Jean the Elder was born near Sens, and in 1538 moved to Paris, where he worked as a painter and designer of stained glass. Attributions include the *Eva Prima Pandora* (Louvre), the stained-glass *Life of*

St Eutropius (1536) in Sens Cathedral, and a tapestry cycle on *The Life of St Mammès* (eight panels, of which two survive in Langres Cathedral and one in the Louvre).

Jean's son, Jean the Younger, was a book illustrator and glass painter. His only authenticated work is a painting of *The Last Judgement* (1616, Louvre). His most famous work is an emblem book, the *Livre de fortunes* (Bibliothèque de l'Institut de France).

Covarrubias, Alonso de

(1488–1570), Spanish mason, architect, and decorative sculptor, one of the nine architects who were called in to advise on the plans for the Gothic New Cathedral in Salamanca in 1512. His own work is often described as Renaissance-PLATERESQUE: his structures are Gothic, but his decoration is conceived in a light and elegant early Renaissance style. He worked on Sigüenza Cathedral early in his career (from 1515) and returned in his maturity to build the tunnel-vaulted sacristy (1532–4). He built the Church of the Piedad at Guadalajara (1526; now in ruins) and the staircase of the Archbishop's Palace in Alcalá de Henares (c.1530, destroyed 1939).

Covarrubias was appointed master mason at Toledo Cathedral, where he built the magnificent Chapel of the New Kings (Capilla de los Reyes Nuevos, 1531–4). He was appointed as architect to the royal palaces in 1537, and proceeded to convert the Alcázar in Toledo into a palace. His other works in Toledo include the Hospital de Tavera (from 1537) and the reconstruction of the Bisagra Gate (from 1559). In his late Toledo buildings Covarrubias moved away from Renaissance-Plateresque lightness towards the austere severity epitomized by Juan de HERRERA.

Crabeth, Dirck Pieterszoon

(*fl.* 1539, d. 1574) and Wouter Pieterszoon (*fl.* 1559, d. 1589), Dutch brothers in Gouda who were makers of stained glass and designers of maps. On 1 January 1552 a fire in St Jans Church in Gouda destroyed 46 of the stained-glass windows. Dirck was commissioned to make nine of the new windows and Wouter was commissioned to make four. The windows completed by 1566 survived the iconoclastic attacks of Protestants and are still in the church, but work on the other windows was soon discontinued; the full-scale cartoons for the most of the windows survive and are still stored in the church.

Cranach, Lucas

(1472–1553), German painter, sometimes styled Lucas Cranach the Elder to distinguish him from his son Lucas Cranach the Younger (1515–86). He was born in Kronach (in Upper Franconia) and trained with an otherwise unknown painter called Hans Maler (i.e. Hans the Painter). Cranach first appears in the historical record as a portrait painter in Vienna in about 1500. Pictures from Cranach's Vienna period include the portraits of *Dr Johannes Cuspinian* and his wife *Anna Cuspinian* (Winterthur, Switzerland), *The Crucifixion* (Alte Pinakothek, Munich), and *The Rest on the Flight into Egypt* (1504, Gemäldegalerie, Berlin).

In 1505 Cranach moved to Wittenberg as court painter to Friedrich III, elector of Saxony. He embraced the Reformation and soon became its principal visual apologist. His woodcut *Luther as Junker Jörg* (1521–2) inaugurated a long series of portraits of Martin Luther (mostly in oil). He also painted nudes, sometimes clad in transparent veils, and these paintings, which often have a classical or biblical theme, have a mildly erotic quality. His pictures, which often exist in several versions, are signed with his initials or with a winged snake.

Credi, Lorenzo di

See LORENZO DI CREDI.

Crivelli, Carlo

(1430/5–c.1495), Italian painter, born in Venice, where he probably trained in the VIVARINI workshop. After a period of imprisonment for adultery, Crivelli left Venice in 1468 and spent the rest of his life in Ascoli Piceno (Marches). His paintings usually have religious subjects and are characterized by the presence of ornamental decorative motifs. Eight of his paintings are held by the National Gallery in London, including a perspectival *Annunciation* (1486).

Cronaca, Il

or Simone del Pollaiuolo (1457–1508), Italian architect and stonemason, a native of Florence who as a young man spent several years in Rome (1475–85). On returning to Florence he collaborated with Giuliano da SANGALLO on the sacristy of Santo Spirito and the Casa Horne and with BENEDETTO DA MAIANO on the Palazzo Strozzi, for which Il Cronaca designed the elegant courtyard and the magnificent cornice. His finest independent work is the aisleless Church

of San Salvatore al Monte (1487–1504), which reflects Il Cronaca's study of ancient buildings in Rome and Romanesque buildings in Florence (which were thought to be ancient). Il Cronaca also contributed to the Salone dei Cinquecento which was built in the Palazzo Vecchio (July 1495–February 1496) to accommodate Savonarola's Grand Council.

Crutched Friars glass

In 1565 Jean Carré, a native of Amiens, established a GLASS factory in Hart Street (London) on the site of the monastery of the Friars of the Holy Cross (of which 'crutched' is a corruption). He employed glassmakers from Lorraine and Venice to produce crystal glassware in the Venetian fashion. On Carré's death in 1572 the factory was taken over by the Venetian Giacomo VERZELINI. The factory was destroyed by fire in 1572, but Verzelini rebuilt it and continued to manufacture glass until his retirement in 1592.

Cuenca carpets

The two principal regions for the manufacture of CARPETS in Spain from the fifteenth to the mid-seventeenth centuries were Cuenca and AL-CARAZ. There is documentary evidence of carpet manufacturing in Cuenca from the twelfth century, but the earliest surviving examples were woven in the fifteenth century. From the fifteenth to the mid-seventeenth centuries designs were based on Turkish carpets, but the pile was tied with the Spanish knot (i.e. single warp knot).

cuir bouilli

(French; 'boiled leather'), the term used in England from the fourteenth to the sixteenth centuries to denote leather moulded or pressed into forms; if the moulded leather was designed to hold a liquid (e.g. in jugs and goblets) it was lined with pitch or resin, and if it was moulded into a case for a precious object, the surfaces were impregnated with wax and then incised or tooled in gold. The spelling now in use corresponds to modern French, but in fourteenth- and fifteenth-century English it variously appears as *qwyrbolle* and *coerbuille*.

Cure, Cornelius

(*fl.* 1574, d. *c.*1609), Netherlandish stonemason and sculptor who emigrated to England and established a workshop in Southwark, on the south bank of the Thames opposite London. Cure was appointed master mason to Queen Elizabeth and King James I. He was responsible for the design and construction of the monuments of Queen Elizabeth and Mary, queen of Scots in Westminster Abbey. The effigy of Queen Elizabeth was carved by Maximilian COLT, but Cornelius carved that of Queen Mary himself. The tomb was finished after Cure's death by his son William (d. 1632), who succeeded his father as master mason to King James and worked under Inigo JONES on the BANQUETING HOUSE.

cutwork

or (Italian) *punto tagliato*, an openwork linen fabric made by cutting away portions of the fabric and filling the gaps with ornamental designs made with needle and thread. The technique was evolved prior to that of LACE, of which it is an early form, and cutwork clothing became fashionable in sixteenth-century Italy. The most important designer of cutwork patterns was Mateo PAGANO.

Cutwork patterns were also used in garden design in the cutwork PARTERRES (French *parterres de pièces coupées*) of Jan VREDEMAN DE VRIES.

D

Daddi, Bernardo

(*fl. c.*1320–48), Italian painter, a native of Florence. His triptych of the *Madonna* (1328), painted for the Church of the Ognissanti (the predecessor of the present church) and now in the Uffizi, is indebted to GIOTTO's *Madonna Enthroned* (Uffizi), which was painted for the same church; it therefore seems possible that Daddi was a pupil or assistant of Giotto. His surviving paintings include two frescoes depicting the *Martyrdoms of St Lawrence and St Stephen* (Church of Santa Croce), a large altarpiece of the *Madonna* in Orsanmichele, and a triptych now in the National Gallery in Edinburgh. He also painted small panels, often with detailed depictions of domestic interiors (e.g. the predella on the *Life of the Virgin* in the Uffizi).

Dalmau, Lluís

(*fl.* 1428–61), Valencian painter who worked in Valencia and became court painter to Alfonso V of Aragon, under whose patronage he lived in Bruges from 1431 to 1437, after which he returned to Valencia (though he also worked in Barcelona). His sojourn in Flanders is significant for the history of Spanish art because it is the earliest known connection between a Spanish painter and the traditions of Flemish art. His *Virgin of the Counsellors* (1443–5), now in the Barcelona Museum, was influenced by the Ghent ALTARPIECE of Jan van EYCK.

damascening

A process used to decorate steel, usually sword blades, with a watered pattern; the name derives from Damascus, which was one of the early centres in which the process was developed. The term is also used to denote an inlaying process in which steel is decorated with gold or silver that is beaten into grooves.

damask

The term used variously to denote a wavy pattern on steel (see DAMASCENING), a pink rose, a figured silk fabric and a twilled linen fabric. In general English usage 'damask' could simply mean 'silk', but with reference to table linen (sometimes known as 'linen damask') the term referred specifically to a richly figured textile in which a surface sheen is created by opposing reflections of light from two faces of the same weave. In the fifteenth and sixteenth centuries linen damask was woven in the Netherlands, from which table-cloths and napkins were exported all over Europe. In the seventeenth century it began to be manufactured elsewhere in Europe, notably Ireland and Germany.

Dance of Death

or (French) *danse macabre* or (German) *Totentanz*, a pictorial or literary representation of a procession or a dance in which both the living and the dead participate. The term was first used by Jean Lefèvre in 1376, who introduced the term *macabré* (which was consistently so spelt until the sixteenth century) into French; the word clearly has Semitic origins, but its precise meaning is unknown. The earliest known pictorial Dance of Death is a *Danse macabre* mural that was painted in 1424–5 in the cloisters of the Cimetière des Innocents in Paris; the procession consisted of a series of couples, one living and one dead, arranged in an order of precedence beginning with pope and emperor and ending with a hermit and a baby. Underneath each dancer an eight-line octosyllabic stanza offered a moralistic commentary with a distinct social edge: death treats all classes equally. The wall was destroyed in 1669, but the verses had been copied by the Parisian printer Guyot Marchant, who in 1485 published an illustrated *Danse macabre* in which the woodcuts were accompanied by short verses; these woodcuts were often reprinted, and created a genre which spread throughout Europe.

In England there was a *Dance of Death* mural in the old St Paul's Cathedral, but the mural was destroyed in 1549 (and the cathedral in 1666).

John Stow said that the pictures were similar to those in Paris; the verses under the pictures were translated from those in Paris by the poet John Lydgate. Sir Thomas More recorded in his *Four Last Things* that

> we were never so greatly moved by the beholding of the Dance of Death pictured in Paul's, as we shall feel ourselves stirred and altered by the feeling of that imagination in our hearts. And no marvel. For those pictures express only the loathly figure of our dead, bony bodies, bitten away the flesh, which though it be ugly to behold, yet neither the light thereof, nor the sight of all the dead heads in a charnel house, is half so deep as the deep conceived fantasy of death in his nature, by the lively imagination graven in thine own heart.

This passage represents one of the rare occasions in which sixteenth-century viewers yield some sense of how they looked at pictures.

The only known sculpted representation of a Dance of Death in England was in Coventry Cathedral, and was destroyed along with the cathedral in 1944. There are, however, two surviving painted versions of the Dance of Death in English churches: one is in the priory at Hexham (Northumberland) and the other is in the Church of St Mary Magdalene in Newark (Nottinghamshire). Elsewhere in Europe, there is a painted *Dance of Death* in the Marienkirche in Lübeck and sculpted series in the Church of St Maclou (Rouen) and in the Dreikönigskirche in Dresden Neustadt; the latter is the work of Christoph Walther (d. 1546).

The most famous representation of the Dance of Death is the series of 40 woodcuts designed by Hans HOLBEIN the Younger (c.1523–6) and executed by the German woodcutter Hans Lützelburger (fl. c.1517–26). Holbein's designs may be indebted to a fourteenth-century *Totentanz* fresco made for the nunnery at Klingenthal and moved in the mid-fifteenth century to the Predigerkloster in Basel, where it was restored in 1568 and destroyed when the wall collapsed in 1805. The first edition of these designs was published in Lyon in 1538; a Basel edition reached proof stage but was not printed. Holbein's designs have shaped all subsequent representations of the Dance of Death. The finest products of the revival of interest in the Dance of Death in the nineteenth century were Liszt's *Totentanz* for piano and orchestra, Saint-Saëns's symphonic poem *Danse macabre*, and Strindberg's two *Dödsdansen* plays; in the twentieth century Ingmar Bergman portrayed the Dance of Death in his film *The Seventh Seal*.

Daniele Ricciarella da Volterra

(1509–66), Italian painter and sculptor, born in Volterra and trained in the studio of Il SODOMA in Siena. He moved to Rome c.1541 and executed frescoes such as the *Deposition* in the Orsini Chapel in the Church of Santa Trinita dei Monti.

Daniele became a close associate of MICHELANGELO, of whom he made a bronze portrait bust (c.1564, Bargello) after attending him on his deathbed. His best-known commission was the painting of draperies on the nude figures that Michelangelo had painted on the ceiling of the SISTINE CHAPEL, a task that led to the nickname 'Il Braghettone' ('maker of breeches').

Danti, Vincenzo

(1530–76), Italian sculptor, goldsmith, and writer on perspective, born into a family of goldsmiths in Perugia. His first important work was a monumental bronze statue of Pope Julius III (1555) still in its original position outside Perugia Cathedral. In 1557 he moved to Florence to enter the service of Cosimo I de' Medici, and thereafter his works show the marked influence of MICHELANGELO, for whose funeral (1564) he supplied sculpture and paintings. In 1567 he published a treatise on proportion, *Delle perfette proporzioni*, which is dedicated to Grand Duke Cosimo. His Florentine sculptures include a small bronze *Venus Anadyomene* (Palazzo Vecchio), a marble *Honour Overcoming Falsehood* (Bargello), and a bronze group of *The Beheading of John the Baptist* made for the baptistery (completed 1571). In 1573 Danti returned to Perugia, where he became city architect and a founding professor at the Accademia del Disegno.

Daret, Jacques

(c.1400/5–c.1468), Flemish painter, born in Tournai and trained from 1427 to 1432 in the studio of Robert CAMPIN, where his fellow pupil was one Rogelet de la Pâture, who is assumed to be Rogier van der WEYDEN. His principal surviving works are four panels from the *St Vaast* altarpiece, now divided: the *Nativity* is in the Thyssen Collection in Madrid, the *Visitation* and the *Adoration* are in the Gemäldegalerie in Berlin, and the *Presentation* is in the Petit Palais in Paris.

Daucher, Adolf

(c.1460–1523/4) and Hans (c.1485–after 1538), German sculptors in Augsburg who worked in the service of the Fugger family. Adolf's best-known work is the high altar of the Annenkirche in Annaberg-Buchholz; the altar was commissioned by Georg der Bärtige, duke of Saxony, in 1519 and is still in the church. Hans entered the service of Charles V and also accepted commissions from the dukes of Württemberg. His best-known work is *Christ with the Virgin and St John*, which he made for the altar of the Fugger Chapel in Augsburg.

David, Gérard

(c.1460–1523), Netherlandish painter. He was a native of Oudewater (near Gouda) and worked in Bruges from 1484 and in Antwerp from 1515. His finest pictures are those that depict domestic scenes from the life of Jesus; the popularity of these paintings ensured that they were often copied, and many exist in several versions: the *Virgin Feeding the Christ-Child with Porridge*, for example, exists in four versions. David's compositional skills are apparent in works such as his triptych *The Baptism of Christ* (Groeninge Museum, Bruges) which, despite the fracturing effect of three panels separated by frames, is a single picture in which the viewers on the wings are integrated with the baptism in the central panel, in the background of which a landscape recedes without an artificial break.

da Vinci, Leonardo

See LEONARDO DA VINCI.

da Vinci, Pierino

See PIERINO DA VINCI.

De Critz, Johan

or John (c.1551/2–1642), Flemish painter. He left his native Antwerp for England as a refugee c.1570. He was appointed serjeant-painter to the crown in 1603, and in this capacity was responsible for the decorative work in the royal palaces, though he did not undertake all of the painting himself. He was associated with a group of painters that included Marcus GHEERAERTS the Elder and the Younger, Isaac and Peter OLIVER, and Sir Robert Peake (1592–1667), to all of whom he was related by marriage. Some court portraits are attributed to more than one member of this group, and it is possible that in some cases they collaborated on portraits. In his ca-

pacity as serjeant-painter, de Critz painted Maximilian COLT's tomb of Queen Elizabeth in Westminster Abbey.

Delaune, Étienne

(1518/19–1583), French engraver and medallist who published influential designs for armourers, cabinetmakers, enamellers, jewellers, and silversmiths, typically filled with fanciful human figures and sea monsters and decorated with fruit and flowers. His medals include one of *Henri II* (of which an example survives in the Bibliothèque Nationale in Paris).

Del Chierico, Francesco d'Antonio

(1433–84), Italian illuminator in Florence. He may have been trained by Fra ANGELICO, whose style he imitated; his illuminations are not merely decorations, but often consist of small paintings. From 1463 to 1471 he illuminated a series of books for the cathedral in Florence. His patrons included the Medici of Florence, the Montefeltro dukes of Urbino, the Aragonese kings of Naples, and Matthias Corvinus of Hungary. His books include a breviary now in the Bibliotecca Laurenziana and Petrarch manuscripts in the Bibliothèque Nationale in Paris (commissioned by Lorenzo de' Medici) and Castello Sforzesco in Milan.

Delftware, English

The modern term for TIN-GLAZED EARTHENWARE manufactured in England; the term is anachronistic, because such earthenware was introduced into England from Antwerp in 1567, when Jasper and Joris ANDRIES established a pottery in Norwich, but Delft did not emerge as an important pottery centre until the 1650s. In the Netherlands the pottery was called 'Delf' and in Britain 'English Delfware'; the addition of the paragogic *t* to the name of the town in modern Dutch was in turn adopted in Britain. Jacob Jansen (d. 1593), who had accompanied the Andries brothers to Norwich, established a pottery in Aldgate (London), and soon 'English Delftware' factories were established in Lambeth, Southwark (both on the south bank of the Thames opposite London), and Bristol.

della Gatta, Bartolomeo

or Pietro Dei (1448–1502), Italian painter, born in Florence, where he became a Camaldolese monk. He worked in Rome as an assistant to PERUGINO and SIGNORELLI on the frescoes in the

SISTINE CHAPEL, and subsequently became abbot of his order's house in Arezzo. His surviving paintings include an *Assumption of the Virgin* (*c*.1475, Museo Diocesano, Cortona).

della Porta, Antonio

or Il Tamagnino (*fl.* 1491–1501), Italian sculptor. He worked as a decorative sculptor at the Certosa di Pavia (1491–9), but no works by his hand can now be identified. In 1501 he moved to Genoa, where his work included carved doors for the city's palaces, one of which survives in Palazzo Grillo-Cattaneo; he also collaborated with his nephew Pace Gagini on a series of tombs.

della Porta, Giacomo

(1532–1602), Italian architect, born in Porlezza and trained in the Roman studio of MICHELANGELO, whom he succeeded as architect of the Capitol. He completed several works by Michelangelo, including the Palazzo dei Conservatori and (with Domenico FONTANA) the dome of ST PETER'S BASILICA; in both cases he altered Michelangelo's designs. He also completed the façade of Il Gesù, the mother church of the Jesuits, after the death of Giacomo VIGNOLA in 1573, again altering the design; this façade was subsequently copied in Jesuit churches all over the world. His secular designs include the Palazzo della Sapienza (from 1575), the Palazzo Marescotti (*c*.1590), and the Villa ALDOBRANDINI in Frascati (1598–1603). His Roman churches include Santa Maria dei Monti (1580–1), Sant'Atanasio (1580–3), the nave of San Giovanni dei Fiorentini (1582–92), and the initial stage of Sant'Andrea della Valle (1591, completed by Carlo Maderno, 1608–23).

della Porta, Guglielmo

(*c*.1490–1577), Italian sculptor, trained in his family's workshop in Milan. He subsequently worked in Genoa with his uncle Giovanni Giacomo della Porta (from *c*.1534) and then Rome (from *c*.1540), where he entered the papal service, succeeding SEBASTIANO DEL PIOMBO as *piombatore* (keeper of the papal seal) in 1547. His principal commission was the tomb of Pope Paul III (d. 1549), over the design and location of which he quarrelled with MICHELANGELO; the tomb, which includes a seated effigy in bronze, now stands against the wall to the left of the high altar of St Peter's Basilica.

della Robbia, Andrea

(1435–1525), Italian decorative sculptor and potter, the nephew of Luca DELLA ROBBIA. The most famous of his reliefs is the set of roundels of babies on the façade of BRUNELLESCHI's Ospedale degli Innocenti (1463–6) in Florence.

della Robbia, Girolamo

(1488–1566), Italian sculptor and potter, the son of Andrea DELLA ROBBIA. He was trained in the family workshop in Florence and in 1527 moved to Paris, where he worked from 1529 on pictorial tiles for the Château de Madrid; fragments of the tiles survive in the Musée de Sèvres.

della Robbia, Luca

(1399–1482), Italian sculptor, trained in the workshop of Florence Cathedral, for which he carved a marble cantoria (singing gallery) that now hangs in the Museo dell'Opera del Duomo opposite a similar cantoria by DONATELLO; the ten relief panels of Luca's cantoria depict angelic child musicians (see p. 70).

Luca was the first important artist to use a ceramic medium for sculpture; he invented 'glazed TERRACOTTA' which was impervious to damp and so could be used in outdoor architectural settings. His surviving reliefs include *The Resurrection* (1442–5) and *The Assumption of Jesus* (1446–51) in lunettes above the sacristy doors of the cathedral, and *The Labours of the Months* (*c*.1460) in the *studiolo* (see CABINET) of Piero de' Medici, which is now in the Victoria and Albert Museum.

Luca was the originator of a sub-genre of representations of the Virgin, a half-length *Madonna with Child* in glazed white terracotta set against a blue background. These sculptures were innovative not only in their use of terracotta but also in the sweetness of temperament with which Luca endowed his Madonnas.

Luca della Robbia's workshop passed to his nephew Andrea DELLA ROBBIA and then to Andrea's five sons, who included Girolamo DELLA ROBBIA. The della Robbia workshop is the eponym of a type of glazed terracotta relief, typically portraying a Virgin and Child in a circular frame formed like a wreath of leaves, fruit, and flowers.

Delorme

or de L'Orme, Philibert (1514 –70), French architect, born in Lyon, the son of a master mason. He visited Rome as a young man (*c*.1533–6), and

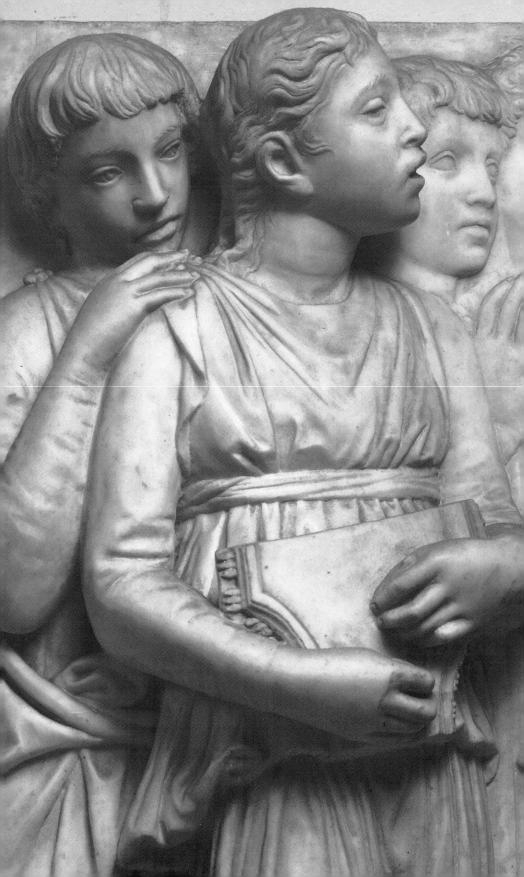

the influence of the Roman High Renaissance is apparent in the work that he executed after his return to France. Most of his buildings have been destroyed, but surviving examples of his work include the tomb of Francis I at Saint-Denis and parts of Château d'ANET, which he built for Diane de Poitiers; his frontispiece for the chateau is now in the École des Beaux Arts in Paris. The most complete survival is the Hôtel Bulliod in Lyon. At the end of his life Delorme began to build the Palace of the TUILERIES (never completed, and burnt in the Commune of 1871) for Catherine de Médicis.

Delorme was an important influence on the development of French architecture, partly through his buildings, but also through his writings, *Nouvelles Inventions* (1561) and *L'Architecture* (1567).

del Tasso family

A large family of Florentine woodworkers of whom the most prominent was Domenico di Francesco del Tasso (1440–1508). Domenico completed the choir stalls in Perugia Cathedral after the death of GIULIANO DA MAIANO in 1490; it was he who made most of the delicate INTARSIA panels of flowers in vases. He also carved the seats in the Sala del Cambio in Perugia.

Giovan Battista di Marco del Tasso (1500 –55), who was Domenico's nephew, trained in the studio of Benvenuto CELLINI in Rome (1519). His most important commission was the ceiling of the Biblioteca Laurenziana (Florence), which he carved together with Antonio Carota (1485–1568) to MICHELANGELO's design.

Deruta potteries

A pottery centre in Umbria, active since the fourteenth century and in the sixteenth century one of the most important centres (together with Gubbio) of MAIOLICA finished with the iridescent metallic surfaces known as 'lustres'. Its finest and most distinctive pieces were made in the first half of the sixteenth century, typically apothecary jars or large dishes painted in blue

with a gold lustre. In the second half of the sixteenth century the Deruta potteries introduced GROTESQUE motifs in imitation of Urbino pottery. Examples are collected in the Museo Regionale della Ceramica di Deruta.

Desiderio da Settignano

(1429/32–1464), Italian sculptor, born in Settignano (near Florence). His surviving work, which shows the pronounced influence of DONATELLO, includes the *Panciatichi Madonna* (now in the Bargello in Florence) and the tomb of the humanist Carlo Marsuppini in Santa Croce (Florence).

diamonds

See GEMS AND DIAMONDS.

Dietterlin, Wendel

(1550/1–1599), German architect and engraver. He was born in Pfullendorf, near Konstanz, and died in Strassburg. He was the author and engraver of *Architectura und Ausstheilung der V. Seuln* (1593–4), which contains designs for architectural decoration in the northern mannerist idiom at its most extreme; the designs include improbably interlaced strapwork and human figures that range from the erotic to the macabre. A second edition with additional plates was published in Nuremberg in 1598–9. Both editions were widely used by architects and decorative artists.

Domenico da Cortona

or Domenico Bernabei or Le Boccador (*c*.1470–*c*.1549), Italian architect and woodcarver who moved to France in 1495 at the invitation of King Charles VIII. He was probably the designer of the wooden model (now known only from engravings) which may have formed the basis of the design of the Château de CHAMBORD. The model contains innovative features such as a double central staircase and a keep laid out as a Greek cross with a suite of apartments in each corner, an idea derived from Giuliano da

Detail from **Luca della Robbia's** marble *cantoria* (singing gallery) carved under the supervision of Brunelleschi between 1432 and 1437 for Florence Cathedral and now in the Museo dell'Opera del Duomo; the ten panels illustrate Psalm 150; this panel depicts a group of psaltery players. The naturalistic portrayal of the young musicians reflects Luca's study of ancient statuary that he had seen in Pisa. The *cantoria* was dismantled in 1688, and reassembled from its surviving parts in 1883.

SANGALLO which was to be very influential in France. Domenico's other work includes the design of the Hôtel de Ville in Paris (1532).

Domenico di Bartolo

or Domenico Ghezzi (*c*.1400–*c*.1445), Italian painter. He was born in Asciano (near Siena) and may have trained in the studio of Il SASSETTA in Siena, where he was admitted to the Guild of Painters in 1428. His principal surviving work is a series of five frescoes in the Ospedale della Santa Maria della Scala in Siena (1440–3). His Madonnas include a *Madonna with Five Angels* in the Pinacoteca in Siena. Domenico's depictions of contemporary dress and customs have considerable documentary value.

Domenico Veneziano

(*fl. c*.1438–61), Italian painter, mostly active in Florence; little is known about his life, though his name may imply that he was Venetian by birth or origin. VASARI credited Domenico with the introduction of OIL PAINTING into Tuscany; this claim is mistaken, but Domenico did use an exceptional amount of linseed oil in his fresco cycle on *The Life of the Virgin* (1438–45) in the Church of Sant'Egidio in Florence; his assistants on this cycle (now lost) included PIERO DELLA FRANCESCA.

Domenico's two surviving works, both in egg tempera, are the *Carnesecchi Madonna* (*c*.1440, National Gallery, London) and the *St Lucy* altarpiece (*c*.1445), of which the *Madonna* is in the Uffizi and the panels from the predella are dispersed in the Gemäldegalerie in Berlin, the Fitzwilliam Museum in Cambridge, and the National Gallery in Washington. Attributions include a tondo of the *Adoration of the Magi* (*c*.1440, Gemäldegalerie, Berlin) and a portrait of *Matteo Olivieri* (National Gallery, Washington).

Donatello

or Donato di Niccolò di Betto Bardi (1386/7–1466), Italian sculptor, born in Florence; his training included a period in the workshop of GHIBERTI (1404–7), so he may have contributed to the bronze baptistery north doors. His early work includes a series of marble statues for niches in the façade of Florence Cathedral (*St John the Evangelist*, 1408, now in the Museo dell'Opera del Duomo) and in Orsanmichele (*St Mark*, 1411–13, *in situ*, and *St George*, *c*.1415, now in the Bargello). Between 1415 and 1436 he made four statues of prophets

for the campanile of the cathedral (now in the Museo dell'Opera del Duomo). His shallow reliefs in marble include *St George and the Dragon* (*c*.1415, Bargello), *The Feast of Herod* (Musée des Beaux-Arts, Lille), and *The Ascension of Christ* (*c*.1425, Victoria and Albert Museum).

Donatello's bronzes include *St Louis of Toulouse* (*c*.1418–22), made for Orsanmichele and now in the refectory of Santa Croce, the effigy of the antipope John XXIII for the baptistery (*c*.1424), on which he collaborated with MICHELOZZO, and several gilt-bronze statuettes for the font of Siena Cathedral, on which he collaborated with JACOPO DELLA QUERCIA and Ghiberti. His finest bronze, a statue of *David* (1430–2, see p. 39), was commissioned to stand in the courtyard of the Palazzo Medici and is now in the Bargello; this celebrated statue was the first life-size nude statue of the Renaissance.

From 1443 to 1453 Donatello lived in Padua, where he worked primarily in bronze. His greatest Paduan work was the EQUESTRIAN STATUE of the *condottiere* Il Gattamelata, which now stands outside the Basilica del Santo. His other important commission in Padua was the group of 22 bronze reliefs, 7 bronze figures (including the bronze crucifix), and a stone *Entombment* for the high altar of the Basilica.

Donatello returned to Tuscany in 1453, and thereafter worked in Florence and Siena. His three most important statues from this period, all intensely dramatic, were a bronze *John the Baptist* for Siena Cathedral, a bronze *Judith and Holofernes* for the garden of the Palazzo Medici (now in Palazzo Vecchio), and a wooden *St Mary Magdalene* (*c*.1456–60, Museo dell'Opera del Duomo). His final statues, commissioned by Cosimo de' Medici, were bronze narrative reliefs for the twin pulpits of the Church of San Lorenzo.

donor portrait

A portrait depicting the giver of a work of art or architecture in company with holy figures (Jesus, the Virgin, or saints); the convention goes back at least as far as the sixth century. By the fourteenth century donors were inevitably portrayed kneeling in prayer, usually on a smaller scale than the sacred figures. The last of GIOTTO's 38 frescoes in the Arena Chapel (or Cappella della Scrovegni) in Padua (1303–6) portrays Enrico Scrovegni (who had built the chapel in expiation for his father's usury) kneeling before the *Last Judgement*; similarly,

Philip the Bold and his duchess Margaret of Flanders on the porch of the Chartreuse de Champmol in Dijon.

In the fifteenth century donor portraits became more naturalistic, and donors became integrated into the compositions, as exemplified in the donors in MASACCIO's *Trinity* (Santa Maria Novella, Florence) and Jan van EYCK 's Ghent altarpiece, and, later in the century, GOZZOLI's portraits of the Medici among the retinue accompanying the Magi to Jerusalem (in the chapel of the Medici-Riccardi Palace), Hugo van der GOES's portrayal of the Portinari family in the wings of the Portinari altarpiece (Uffizi), and GHIRLANDAIO 's portraits of the Sassetti family in the Church of Santa Trinita in Florence.

By the earlier seventeenth century the donor portrait had all but disappeared: Rubens's *Ildefonso* altarpiece of 1630–2, now in the Kunsthistorisches Museum in Vienna, is the last great exemplar of the tradition. Thereafter the donor portrait has survived only in the self-consciously archaic iconography of STAINED GLASS.

Doria Principe, Palazzo

or Palazzo Doria Pamphili, the Doria villa at Fassolo, outside the city walls of Genoa, so named to distinguish it from the Palazzo Doria Tursi (now the Palazzo Municipale) built in 1564 in the city centre.

The Palazzo Doria Principe was designed by Domenico Caranca for Andrea Doria between 1521 and 1529. PERINO DEL VEGA, who had earlier assisted RAPHAEL with the decoration of the Vatican loggias, worked from 1527 until *c.*1540 on the frescoes and stuccoed decoration of the palace and its loggias. The gardens and the loggias on the main building were designed by Giovanni MONTORSOLI. The magnificent fireplace was the work of Giambattista CASTELLO. The palace was badly damaged by bombing during the Second World War, but has been restored, as has the garden.

The garden consisted of three terraces descending to the sea, embellished with FOUNTAINS, PARTERRES, and pergolas and planted with orange trees, lemon trees, pomegranates, and beds of flowers; there were also pools, one of which was sufficiently large to be used by Admiral Doria to test models of his galleys. The garden climbing the hill behind the house was structured around linking staircases. In front of the house there was a level enclosed garden which contained what John Evelyn described in

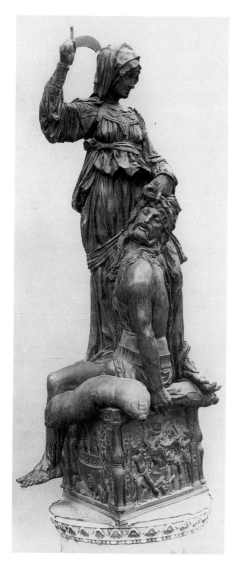

Donatello, *Judith and Holofernes*, a bronze statue commissioned by Cosimo de' Medici for a fountain in the garden of Palazzo Medici and now in the Palazzo Vecchio in Florence. The story of Judith's beheading of the drunken Assyrian commander Holofernes is told in the apocryphal Book of Judith. An early inscription, now lost, described the statue as an allegory of Humility triumphing over Pride.

ALTICHIERO's frescoes in Sant'Anastasia in Verona depict the knights of the Cavalli family who had commissioned the murals and in Burgundy Claus SLUTER sculpted portraits of

1644 as a 'colossal Jupiter, under which is the sepulchre of a beloved dog'; the statue ('Gigante') and the tomb of the Emperor Charles V's dog Roland are all that survive of this garden. The view from the house over the garden was painted in 1561 by Jan Massys (son of Quentin MASSYS) as the background to his picture of *Flora* (or *Venus Cythereia?*), which is now in the National Museum in Stockholm.

At the sea front there was a long terrace supported by marble columns, beside which there was an aviary supported by ironwork which Evelyn described as 'stupendous'. It was on this terrace or on a ship moored close to it that Andrea Doria entertained the Emperor Charles V and his son Philip (later Philip II of Spain), famously ordering that the three silver services from which they had eaten be hurled into the sea; prudence lay beneath the ostentation, for Admiral Doria had arranged for fishermen to catch the plates with their nets. The focal point of the sea-front garden was a large stucco statue of Neptune. This was replaced in 1599 by a marble Fountain of Neptune on a sea chariot pulled by horses by Taddeo Carlone and his brother Giuseppe; this fountain is all that survives of the lower terrace garden.

Dosio

or Dosi, Giovanni Antonio (1533–1609), Italian architect and sculptor. He was born in Florence, but worked for many years in Rome, where in 1569 he published *Urbis Romae*, an illustrated treatise on the antiquities of Rome. From 1576 to 1590 he worked mostly in Florence, initially as an assistant to Bartolomeo AMMANATI and then as an independent architect; his Florentine buildings include Palazzo Giacomini-Larderel. He spent his last years in Naples, where he worked as an engineer at the royal court; his work in Naples included the tabernacles (1598) in the Brancaccio Chapel in the cathedral.

Dossi, Dosso

or Giovanni Luteri (c.1490–1541/2), Italian painter sometimes described as the last painter of the Ferrarese School. He may have been born in Mantua or Ferrara; little is known of his early life, but, according to VASARI, Dossi was trained in the studio of Lorenzo COSTA. His early paintings include a sentimental *Nymph and Faun* (Pitti Palace, Florence). In 1512 Dossi was working with his brother Battista (d. 1548) on the decoration of the Ducal Palace in Mantua,

but by 1517 both brothers had entered the service of the Este family in Ferrara, where they remained for the rest of their lives, working with the poet Ludovico Ariosto on court entertainments and triumphs as well as painting and designing tapestries.

Dosso Dossi's paintings, which often imitate the Venetian style of GIORGIONE, include a misnamed *Circe* in the Borghese Palace in Rome (which probably portrays Melissa, the sorceress in Ariosto's *Orlando furioso*), the *Poet and the Muse* (National Gallery, London), *St John the Baptist* (Pitti Palace, Florence), and *Circe and her Lovers in a Landscape* (National Gallery, Washington). His paintings characteristically use light to create an unworldly atmosphere; their most individualistic feature is a tendency to portray characters with parted lips.

drapery

The artistic depiction of draped clothing in classical antiquity was not recovered at the Renaissance, but rather had a continuous history from antiquity to the Renaissance. For centuries after the disappearance of the Greek chlamys and the Roman toga as articles of clothing, sculptors and painters continued to depict Jesus and the apostles in classical attire. In the INTERNATIONAL GOTHIC art of northern Europe, drapery was depicted with the soft folds characteristic of woollen fabrics.

The soft lines of late medieval drapery are evident in the sculptures of GHIBERTI, but many artists chose instead to stress the heaviness of the material and the angularity of folds characteristic of linen; the most extreme example of this reaction against the soft style was the work of Konrad WITZ, but it also finds clear echoes in Jan van EYCK, MASACCIO, and DONATELLO. In the late fifteenth and early sixteenth centuries the emphasis on angular folds became even more marked, both in northern Europe (Tilman RIEMENSCHNEIDER, Martin SCHONGAUER, and Veit STOSS) and in Italy (e.g. Cosimo TURA). The finest painter of drapery was RAPHAEL, who in his *School of Athens* (Stanza della Segnatura, Vatican) clothed his philosophers in robes of great dignity.

drawing

or (Italian) *disegno*. Renaissance artists drew with chalk, charcoal, pens, and silverpoint. Drawing was usually undertaken as a prepara-

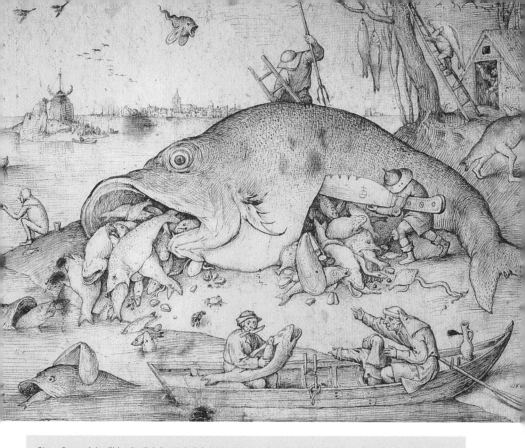

Pieter Bruegel the Elder, *Big Fish Eat Little Fish* (1556, engraved and published 1557), a **drawing** in pen and brush in grey and black ink, in the Albertina, Vienna. The Flemish inscription on the engraving (beneath the titular Latin proverb which it paraphrases) represents words being said by the pointing man to his small son: 'look, my son, I have long been aware that big fish eat little fish.' The boy is pointing to the other passenger, who just extracted a small fish from a large one, and the father is pointing to the disembowelled large fish to illustrate his lesson that in the world at large, the big and powerful prey on the weak and small. The drawing is signed and dated in the lower right corner, but the publisher of the engraving replaced Bruegel's name with that of BOSCH, whose work commanded higher prices.

tion for a painting, sculpture, or building, but as early as the thirteenth century it also existed as a semi-autonomous form, as is evident in the pattern book of the French architect Villard d'Honnecourt (*c*.1235, Bibliothèque Nationale).

The earliest surviving fully autonomous drawings date from the fourteenth century. The first treatise to outline the techniques of drawing (and the first treatise on painting) was Cennino CENNINI's *Libro dell'arte*, which proclaimed drawing as the triumphal arch to painting. The largest surviving collections of Italian drawings are those by PISANELLO (now in the Louvre), Jacopo BELLINI (Louvre and British Museum), and LEONARDO DA VINCI (now mostly in Windsor Castle). Leonardo's drawings, which

range over his vast field of artistic and scientific interests, include the earliest drawings to be executed in red chalk. RAPHAEL, the greatest draughtsman of the Renaissance, used red chalk for drawings such as his *Girl Holding a Mirror* (Louvre). MICHELANGELO, whose early pen drawings are often as close-hatched as an engraving, made presentation drawings for his friends and patrons, such as the *Jesus on the Cross* (British Museum) drawn for the poet Vittoria Colonna.

The principal centre of drawing was Tuscany, but in Venice artists such as Jacopo Bellini, Vittore CARPACCIO, and TINTORETTO were accomplished draughtsmen; the first centre outside Tuscany where drawing was taught was the Bologna academy of the CARRACCI family.

In northern Europe the tradition inaugurated by Jan van EYCK in drawings such as his portrait of *Cardinal Albergati* (1434, Gemäldegalerie, Dresden), which has colour notes in the margins, was continued by DÜRER, HOLBEIN, and Pieter BRUEGEL. Many of Dürer's drawings survive in the Albertina in Vienna; drawings in other collections include those in the margins of the Emperor Maximilian's prayer book (1513), which is now in the Bayerische Staatsbibliothek in Munich. Holbein followed Jan van Eyck in drawing portraits, but his preferred medium was coloured chalk rather than ink. Bruegel's drawings of LANDSCAPES are, like his paintings, minutely observed.

drawing frame

A rectangular frame fitted with vertical and horizontal wires or threads placed between the artist and his subject; the transference of the image to paper was sometimes further assisted by the use of paper squared in the same way as the drawing frame. LEONARDO described a drawing frame in one of his notebooks (and advocated the use of squared paper). DÜRER described and illustrated a drawing frame in his treatise on measurement (*Unterweisung der Messung*, 1525).

drypoint

A method of making or enhancing PRINTS in which a design is scratched on a copper plate with a sharply pointed tool (sometimes called an etching needle) which is held like a pen. The scoring of the plate creates a burr which retains ink when the plate is wiped with a cloth, and so the lines on the prints are slightly fuzzy; the darkness of these blurred lines varies with the pressure applied to the etching needle. Drypoint was sometimes used by ENGRAVERS to sketch their designs before applying the burin, and was also used in combination with other methods (usually engraving) to create special effects. Prints made exclusively by drypoint are relatively rare, but include DÜRER's *St Jerome in the Wilderness* (1512) and his *Agony in the Garden* (1515).

Du Broeucq, Jacques

(*c.*1505–1584), Flemish sculptor and architect. He was born near Mons and travelled as a young man to Italy, where he is believed on the basis of stylistic evidence to have studied the work of GHIBERTI, MICHELANGELO, and SANSOVINO. He re-

turned to the Netherlands and in 1535 received a commission to undertake the carvings for the Cathedral of St Waltrudis in Mons; he worked in the cathedral until 1548, and in the late 1540s had as his pupil GIAMBOLOGNA. Most of his carvings were destroyed during the French Revolution, but much of the rood-screen survived the destruction. In 1545 he was appointed as an imperial painter to Charles V, and in this capacity designed and built for Mary of Hungary (regent of the Netherlands and sister of Charles) the chateaux of Binche (15 kilometres (9 miles) east of Mons) and Mariemont (Hainaut) and the Castle of Marienbourg (Namur).

Duca, Giacomo del

(*c.*1520–1604), Sicilian architect and sculptor who worked as an assistant to MICHELANGELO on the tomb of Pope Julius II (1542) and on the Porta Pia (1562). His most important independent works in Rome are the Church of Santa Maria in Trivio (*c.*1575) and the cupola of Antonio da SANGALLO the Younger's Church of Santa Maria di Loreto. He returned to Messina in 1588, but most of his Sicilian buildings have been destroyed by earthquakes.

Duccio di Buoninsegna

(*fl.* 1278–1319), Italian painter active in Siena; little is known of his life. His early commissions include the *Rucellai Madonna* (1285, Uffizi) and a *Virgin in Majesty* for the Palazzo Pubblico in Siena (1302, now lost). His only surviving fully documented work (and the basis of all attributions) is an altarpiece of the *Virgin in Majesty* commissioned in 1308 for the high altar of Siena Cathedral; most of this *Maestà* is in the Museo dell'Opera del Duomo, but the predella panels depicting the life of Jesus and the Virgin Mary are dispersed in the National Galleries of London and Washington, the Frick Collection in New York, and the Kimbell Art Gallery, Fort Worth, Texas. The two most important paintings attributed to Duccio are the triptych of the *Virgin and Child with Saints* (National Gallery, London) and the tiny *Madonna of the Franciscans* (Pinacoteca, Siena).

Duccio's Madonnas are indebted to the Byzantine tradition of hieratic poses, but he softens the poses with naturalistic gestures: the infant of the *Madonna of the Franciscans* struggles in order to bless the three kneeling friars. Duccio was also an innovator in his handling of

space, in that his figures are integrated with their surroundings. The most remarkable feature of his panels is the mastery of narrative, which was well established as a component of fresco cycles but had not previously been a pronounced feature of panel paintings.

Ducerceau

or Du Cerceau family, a family of French architects and engineers. Jacques Androuet the Elder (c.1515–1585) was an architect, decorator, engraver, and publisher. During his life he was famous as an engraver with a relish for decorative detail and fantastic ornament, but he is now valued chiefly for the images that his engravings supply of the buildings and gardens of sixteenth-century France, which he collected in the two volumes of his *Les Plus Excellents Bâtiments de France* (1576 and 1579). Ducerceau's *Livre d'architecture* (1539) was the first French textbook of architecture, and his *Second Livre d'architecture* (1561) contains designs of buildings and gardens in a MANNERIST idiom. His engravings include designs for the chateaux at Verneuil-sur-Avre and Charleval, east of Rouen; in both cases Ducerceau wilfully disregarded classical principles of composition and so incurred the obloquy of architectural historians who regard Mannerism as decadent.

Three of Jacques's sons followed him into the profession, and his daughter Julienne was the mother of Salomon de BROSSE. His son Baptiste (c.1545–1590) succeeded Pierre LESCOT as the architect responsible for the reconstruction of the LOUVRE, and built the Pont Neuf, the oldest surviving bridge in Paris, between 1578 and 1604. Jacques the Younger (1550–1614) was responsible for parts of the Louvre and the TUILERIES. Charles (d. 1600) is known to have worked on the chateau at Châtellerault. Baptiste's son Jean (c.1585–c.1649) designed the Hôtel Brentonvilliers (of which only a small part survives) on the Île Saint-Louis and the horseshoe staircase at FONTAINEBLEAU.

Dumonstier family

A family of French portrait painters active in Rouen in the sixteenth and seventeenth centuries. Étienne Dumonstier the Elder (d. 1501) was an illuminator in the service of Cardinal Georges d'Amboise. His relationship to the painter and illuminator Jean Dumonstier (d. c.1535) is unknown. Jean's son Geoffrey

Dumonstier (c.1510–1573) was an illuminator whose best-known work is the frontispiece to the *Registre du chartrier de l'hospice général de Rouen* (Bibliothèque Municipale, Rouen); he also designed the tile pavements made by Masséot ABAQUESNE for the Château d'Écouen (now the Musée de la Renaissance). Geoffrey's sons Étienne Dumonstier the Younger (c.1540 –1603) and Pierre Dumonstier the Elder (c.1545–1625) both made portrait drawings of members of the French court (including King Henri IV, Catherine de Médicis, and Marguerite de Valois), now in the Bibliothèque Nationale.

Du Pérac

or Du Pérat, Étienne (1525/35–1604), French architect and garden designer. He moved to Rome in 1550 and stayed for twenty years; the Italian form of his name was Stefano du Perac. His engravings of sixteenth-century Rome are valued not so much for their technical or artistic excellence as for the records that they provide of the ruins of antiquity (*I vestigi dell'antichità di Roma*, 1575), the contemporary architecture of Rome, the gardens at Tivoli (*Vues perspectives des jardins de Tivoli*, 1570), and especially the work of MICHELANGELO, including some of his unrealized plans. He returned to France in 1570, and in 1595 was appointed by Henri IV as *architecte du roi*. In that capacity he painted the decoration in the bathroom at FONTAINEBLEAU and may have contributed to the design of its gardens; he also continued the work of Philibert DELORME at SAINT-GERMAIN-EN-LAYE, where he laid out the terraces.

Dürer, Albrecht

(1471–1528), German painter and engraver, born on 21 May 1471 in Nuremberg, the son of a goldsmith; his earliest surviving self-portrait, a silverpoint drawing now in the Albertina in Vienna, was drawn in 1484, when Dürer was 13, which implies that he was trained in drawing by his father before entering the workshop of Michael WOLGEMUT in 1484. Dürer's godfather was the printer Anton KÖBERGER, and through him the young Dürer had access to the humanists of Nuremberg.

In 1490 Dürer embarked on a journey to the western part of the German lands. His itinerary is not fully understood, but he certainly visited Colmar (in a vain attempt to visit Martin SCHONGAUER, who died before Dürer arrived), Basel (where he worked as a book illus-

trator, contributing woodcuts to Sebastian Brant's *Narrenschiff*), and Strassburg (again working as an illustrator) and he may have visited the Netherlands. He returned to Nuremberg on 7 July 1494 and a few weeks later married Agnes Frey, a merchant's daughter. He travelled to Italy *c*.1495, and on this journey began to paint his innovative WATERCOLOURS, which were Europe's first important LANDSCAPE PAINTINGS. On returning to Germany, Dürer established a workshop in Nuremberg. As well as painting, including a *Self-Portrait* in 1500 and the Paumgärtner altarpiece in 1504 (both in the Alte Pinakothek, Munich), he also worked on WOODCUTS and ENGRAVINGS, notably his series on *The Apocalypse* (1498), and *The Life of the Virgin* (1510).

Dürer's interest in PERSPECTIVE seems to have developed in the early years of the sixteenth century: he discussed perspective with Jacopo de' BARBARI, who lived in Nuremberg from 1500 to 1503, and read VITRUVIUS' *De architectura*; engravings such as *Nemesis* (1501–3) and *The Nativity* (1504) reflect Dürer's experiments in perspective. In 1505–6 he undertook a second journey to Venice, where he painted his *Feast of the Rose-Garlands* (National Gallery, Prague), which reflects the influence of BELLINI.

In the years following his return to Nuremberg, Dürer painted several altarpieces, including *The Assumption of the Virgin* (1509; now lost, but the drawings survive in the Albertina in Vienna) and *The Adoration of the Trinity* (1511, Kunsthistorisches Museum, Vienna). He also produced two series of woodcuts, the *Great Passion* (1510) and the *Little Passion* (1511). In 1514 he produced two of the finest of Renaissance engravings, *Melancholia I* (the 'I' seems to be an allusion to the taxonomy of melancholy in Florentine Neoplatonism rather than the first number in a series) and *St Jerome in his Study*. He also began to experiment with DRYPOINT, and with this technique produced prints of *St Jerome* and *The Agony in the Garden* (1515).

In 1520–1 Dürer travelled with his wife to the Netherlands to seek a renewal of his imperial pension from Charles V. His journal, of which copies survive in the Bamberg Staatsarchiv and the Nuremberg Archiv, records his visual and verbal impressions of the artists and humanists that he met (who included Erasmus, who praised him as 'the Apelles of black lines') and the news that he heard (including the kidnapping of Luther after the Diet of Worms, which Dürer wrongly thought the work of malefactors), and is the earliest of its kind to survive.

Dürer returned to Nuremberg on 12 July 1521, and in the years that followed, his work, with the exception of a small number of portraits, was mostly related to religious subjects, including a second engraved *Passion* series (1521–3) and two panels depicting the *Four Apostles* (Alte Pinakothek, Munich). He also wrote and designed three important theoretical treatises, one a book of instruction in measurement (*Unterweisung der Messung*, 1525), a second a treatise on FORTIFICATION (*Etliche Unterricht zu Befestigung der Stett, Schloss und Flecken*, 1527), and the third a four-book examination of human proportion (*Vier Bücher von menschlicher Proportion*, 1528). He died in Nuremberg on 6 April 1528.

Duvet, Jean

or Jehan, or The Master of the Unicorn or (French) Le Maître à la Licorne (*c*.1485–*c*.1561), French goldsmith and copperplate engraver who worked in his native Langres. The name 'Master of the Unicorn' derives from a set of prints (engraved in the 1540s) on the subject of the hunting of the unicorn. Duvet's best-known work is a series of 24 etchings which depict *The Apocalypse* (1546–56), which were published together in 1561 in Lyon. His style seems untouched by the elegance valued by artists of the School of FONTAINEBLEAU, and instead articulates the emotional intensity associated with Italian MANNERISM.

E

editio princeps

(plural *editiones principes*), the first printed edition of a classical text.

Egas family

A family of architects of Flemish origin who worked in Toledo in the fifteenth and sixteenth centuries. The family came from Brussels, where their name may have been Coeman. The first member of the family to appear in the records of Toledo Cathedral was Hanequín de Bruselas (*fl.* 1448–70), who is sometimes erroneously called 'Hanequín de Egas'. Hanequín was responsible for the late Gothic Portal of the Lions (1452) in the south transept of the cathedral.

Hanequín's brother was Egas Cueman de Bruselas (*fl.* 1452, d. 1495); his early work includes the tomb of Alfonso de Velasco in Guadalupe (1467–8). He later assisted Juan GUAS on the carved screen around the sanctuary of Toledo Cathedral (1483–c.1491).

Antón Egas (*fl.* 1495, d. by 1532), son of Egas Cueman, succeeded his father as assistant master of the works at Toledo Cathedral in 1495. In 1510 he collaborated with Alfonso Rodriguez (d. 1513) on the plans for the new cathedral at Salamanca, and two years later he was included in the nine architects convened to discuss the plans for the construction of the cathedral.

Enrique Egas (*fl.* c.1480, d. 1534), son of Egas Cueman, worked with his brother Antón at Toledo Cathedral from about 1480. Enrique designed the royal hospital at Santiago de Compostela (1501–11); his cruciform design, which shows the influence of north Italian Renaissance architecture, was soon repeated in his designs for the royal hospitals in Toledo (Santa Cruz, 1504–14) and Granada (from 1511). In 1505 Enrique was appointed as master of the works at Granada, where he built the Chapel Royal (from 1506) and designed the cathedral in the Gothic style; construction began according to his plan in 1521, but in 1528 Enrique was succeeded by Diego de SILOÉ, who completed the building in the Renaissance style. Enrique's reputation meant that he was often consulted on the construction of cathedrals; there are records of his consultations on the cathedrals in Zaragoza (1505), Seville (1512 and 1525), Málaga (1528), and Segovia (1529).

Elsheimer, Adam

(1578–1610), German painter and designer of engravings, a native of Frankfurt. His early work, such as his *Sermon of St John* (Alte Pinakothek, Munich), is painted in a Flemish realist idiom that reflects the influence of exiled Netherlandish landscape painters; similarly, the illustrations published in *Messrelationen* (1598) are modelled on recently published Dutch designs. Elsheimer's visit to Strassburg in 1596 introduced the influence of south German and Swiss designs to his work.

In 1598 Elsheimer moved to Italy, living first in Venice and from 1600 in Rome, where he became part of the Flemish community of artists (which included Rubens). His pictures, which are always small, eschew the contemporary MANNERIST idiom in favour of lyrical depictions of biblical and mythological scenes set against idyllic landscapes. *St Paul in Malta*, the *Baptism of Christ*, and *St Lawrence Prepared for Martyrdom*, all in the National Gallery in London, are painted in oil on copper. Elsheimer died in 1610 shortly after his release from imprisonment for debt.

Elsinore tapestries

or (Danish) Kronborg *tapeterne*, a set of tapestry panels woven between 1581 and 1584 for King Frederick II's palace of Kronborg at Helsingør (Hamlet's Elsinore) to designs provided by a Flemish painter, Hans Knieper (d. 1587). The panels are imaginary portraits of Danish kings (both historical and legendary) depicted in

outdoor settings which include hunts and battlefields. The fifteen surviving panels are now divided between Kronborg and the Nationalmuseum in Copenhagen.

emblems and emblem books

An emblem is a pictorial and literary representation of an abstraction. The emblem has a tripartite structure, and consists of a motto, a woodcut illustration, and an epigrammatic gloss (often in verse but sometimes in prose). The first emblem book was Andrea Alciato's *Emblemata* (Augsburg, 1531), which was translated into many languages and appeared in almost 200 editions; thereafter emblem books appeared all over Europe, initially in Latin and later in the vernaculars. The emblem is sometimes distinguished from the device, which is deemed to be personal rather than public and so deliberately enigmatic, but the terms are often used interchangeably, as in Georgette de Montenay's *Emblèmes, ou Devises chrétiennes* (1571).

Embriachi

or Ubriachi, Baldassare degli (*fl. c.*1390– 1410), Italian carver in wood, bone, and ivory who worked with his sons Antonio and Giovanni in Florence and, from about 1400, in Venice. Their workshops produced both luxurious secular goods (notably caskets and CASSONI) and ALTAR-PIECES. The frames of their mirrors and altar-pieces and the surfaces of their CASSONI are characteristically composed of *certosina*, a geometrical inlay with polygonal tesserae made from wood, bone, ivory, and mother-of-pearl.

Embriachi received commissions for altar-pieces from Duke Philip the Bold of Burgundy (Musée de Cluny, Paris), the duke of Berry (Louvre), and Gian Galeazzo Visconti (Certosa di Pavia).

embroidery

or (Italian) *ricamo*, the ornamentation of textiles with decorative NEEDLEWORK. The ground was usually linen, but leather and silk were also used. The thread was usually wool or (for delicate work such as flowers) silk; gold and silver thread were in occasional use, sometimes twisted into wire known as 'bullion'. There are more than 300 named embroidery stitches, many of which were developed in the early modern period. Needles were usually made from twisted wire, which was supplanted in the early sixteenth century by steel; needles used

for embroidery include bead needles, bodkins, chenilles, crewels, and tapestry needles. For large embroideries the ground was stretched over a wooden frame, but small embroideries were made with the cloth held loose in the hand. This technique is one of the features of embroidery that distinguish it from TAPESTRY, which from the perspective of the embroiderer is a technique in which bare warps are embroidered with the weft; embroidery and tapestry have in common the use of a CARTOON, a design prepared by the embroiderer or commissioned from an artist.

In medieval and Renaissance Europe, embroidery had a prestige that derived from centuries of use in ecclesiastical vestments (e.g. the Syon Cope of 1300–20 in the Victoria and Albert Museum) and the clothing and domestic furnishings of the aristocracy. This prestige, which was protected by sumptuary laws, meant that embroidery was a craft practised both by artisans (who were organized into guilds) and also by aristocratic women who typically embroidered small items such as gloves with silk and gold threads and designed embroideries that were executed by their attendant needlewomen.

The finest embroidery was made in France, where the principal centre of commercial production was Caen. The ARMOUR of French noblemen was worn under richly embroidered surcoats, and their houses were hung with embroidered curtains (called *salles*, because they hung from the ceiling and partitioned large rooms into smaller ones); the soft furnishings of noble houses (e.g. bed-curtains and canopies) were also elaborately embroidered, and were known as *courtepointerie* (a term now associated with QUILTS). In the sixteenth century the designers of French embroidery included RAPHAEL, from whom King Francis I commissioned embroideries now in the Musée Cluny in Paris. Catherine de Médicis made embroideries, and taught the techniques to Mary, queen of Scots. In 1578 the establishment of the Order of the Holy Spirit by King Henri III led to a revival of heraldic embroidery at his court.

In Italy, where embroidered hangings had been made in Palermo since the twelfth century, embroidery attracted noble patrons in the fifteenth century, and by the end of the sixteenth century Italian embroidery enjoyed a European reputation, partly because of the quality of its designs (designers included Dosso DOSSI, Antonio POLLAIUOLO, Raphael, and

Cosimo TURA), but also because Italian pattern books for embroidery were widely disseminated throughout Europe. The finest Italian embroidery was linen, mostly in openwork patterns. Embroidery needles were manufactured in Milan. As in the rest of Europe, most embroidery was made by women in homes and in convents, but some was made in urban workshops by men such as PAOLO DA VERONA.

In Spain the Moorish influence in design was particularly apparent in embroidery, where black scrolled patterns, often in the form of vines, leaves, and flowers, were set against white backgrounds; Spanish designs were also influenced by the Inca designs of pre-conquest tapestries brought from Peru. In Andalusia fine nettings were embroidered with designs that resemble those of LACE; in Castile the embroidery in blue and tan threads was known as *toallas*. In Portugal, where embroidery was principally a craft associated with aristocratic women, early Moorish influences on design began in the late sixteenth century to be displaced by oriental influences which are apparent in the depiction of birds, flowers, butterflies, and dragons.

In the German lands, where the aristocratic tradition of embroidery was already established in the Carolingian court, the principal centre for the production of linen embroideries was Cologne. In the fifteenth century, when linen was displaced by wool in embroideries for wall hangings and soft furnishings, the Cistercian convents at Lüneburg and Wienhausen (near Celle) emerged as important centres; both convents (now women's retreats) show their collections of embroideries once a year. During the fifteenth and sixteenth centuries German embroideries with coloured linen thread were made in designs that resembled those of needlepoint lace.

In England there was a continuous aristocratic tradition of embroidery throughout the Middle Ages: Queen Edith embroidered the coronation robe of her husband Edward the Confessor and Queen Matilda, the wife of William the Conqueror, was sufficiently well known as an embroiderer for her name to be associated with the Bayeux Tapestry (which is technically an embroidery rather than a tapestry). English ecclesiastical embroidery, which was known as *opus Anglicanum*, was favoured by many popes; continental embroidery in the style of *opus Anglicanum* was known as *façon Angleterre*.

Embroidery in English religious houses ended with the dissolution of the monasteries (1536 and 1539), but the aristocratic secular tradition remained buoyant: Catherine of Aragon was an embroiderer, and introduced Spanish styles to English embroidery which persisted for more than a century. Queen Mary I was an embroiderer, as was Queen Elizabeth, who in 1561 granted a charter to the Broderers' Company, which had been incorporated since 1376; their hall in Gutter Lane (1515) was burnt in 1666. Elizabethan embroideries were usually floral, and in the late sixteenth century designs became increasingly botanical: the woodcuts in John gerard's *Herbal* (1597) were used as designs by embroiderers, and botanical designs were published by Richard Shoreleyker in *The School House of the Needle* (1624) and by John Taylor, the 'Water Poet', in *The Needle's Excellency* (1631). During this period many English embroideries took the form of 'paned work' in which varied embroidery materials were juxtaposed in contrasting panels. Another distinctly English style was embroidery on velvet, which was really a form of appliqué: velvet resists needlework, so designs were fashioned from linen or silk, embroidered and then attached to a foundation of velvet, which achieves a result similar to BROCADES; curtains and hangings decorated with such embroidery are preserved in Penshurst Place in Kent and Oxburgh Hall in Norfolk.

enamel

or (French) *émail* (plural *émaux*). In modern usage 'enamel' can refer to any hard, smooth surface, but in early modern usage it specifically denotes the inlaying or encrusting of metal with a vitreous composition, usually lead-soda or lead-potash glass, applied to the surface by fusion; if the surface to be covered is pottery, the covering is called a GLAZE. Five types of enamel are usually distinguished: *cloisonné*, *champlevé*, *basse-taille*, encrusted, and painted; the French terms have no agreed equivalents in English.

Cloisonné ('cell-work') enamel is made by constructing wire cells (*cloisons*) on the surface of the metal, filling the cells with vitreous paste, and firing the object to melt and then fuse the enamel to the surface. *Cloisonné* was the principal technique of Byzantine enamelling, and from Byzantium the technique was taken to Venice, where the finest example of *cloisonné* is the golden reredos known as the Pala d'Oro, which was refashioned in 1345 for the altar of

the Basilica di San Marco in Venice; the Pala d'Oro contains 83 *cloisonné* enamelled panels of Byzantine origin. Enamel FILIGREE is a form of *cloisonné* enamel that was to flourish for centuries. Another form of *cloisonné* enamel is *plique à jour* ('against the light'), in which the backing metal is melted away, so leaving the enamel suspended in the *cloison*. The only surviving example of this technique is the Mérode Cup (*c.*1430, Victoria and Albert Museum), which was made in Burgundy or France.

Champlevé ('raised field') enamel, which is also known as *émail en taille d'épargne*, is made by incising the design on a copper ground and placing vitreous paste in the incisions before firing. From the twelfth to the fifteenth centuries the technique is particularly associated with LIMOGES ENAMELS.

Basse-taille ('shallow cut') enamel, which is known in English as 'translucent enamel' and in Italian as *lavoro di basso rilievo*, is a refinement of *champlevé* in which the depth to which the reliefs are cut is varied, so that when enamelled the higher parts of the relief are paler than the lower parts. This technique for producing graduated effects of light and shade seems to have originated in late thirteenth-century Italy; the earliest surviving Italian example of *lavoro di basso rilievo* is a chalice made during the pontificate of Pope Nicholas IV (1288–92) by the Sienese goldsmith Guccio di Mannaia and now in the treasury of the Basilica of San Francesco in Assisi, and the finest surviving example is UGOLINO DI VIERI's gilt-brass reliquary of the Sacro Corporale (1337–8) in Orvieto Cathedral, which is decorated with enamel panels. In the early fourteenth century the art of *basse-taille* enamel was perfected by the goldsmith-enamellers of Paris, whose work includes the Royal Gold Cup (mentioned in an inventory of 1391) in the British Museum, a triptych in Namur Cathedral, a crozier in Cologne Cathedral, and one secular piece, a silver ewer (*c.*1330–40) in the National Museum in Copenhagen. From Paris the techniques of *basse-taille* enamel spread throughout western Europe, and it was widely used to decorate ecclesiastical objects, including chalices (notably those made in fourteenth-century Stockholm) and portable triptychs.

Encrusted enamel (French *émail en ronde bosse*) is a technique introduced in the fifteenth century to cover figures or decorative devices moulded in the round. In the late fourteenth and early fifteenth centuries the goldsmith-enamellers of Paris produced pieces such as the Reliquary of the Holy Thorn (formerly in the Geistliche Schatzkammer in Vienna and now in the British Museum), which includes an enamel figure of God the Father, the Goldenes Rössel (1403, in the pilgrimage church of Altötting, in Bavaria), the reliquary from the Chapel of the Order of the Saint-Esprit (Louvre), and the Monkey Cup (Metropolitan Museum, New York) made by Netherlandish goldsmiths for the Burgundian court.

Painted enamel is a technique developed in Limoges in the late fifteenth century. The metal surface (usually copper) was covered with white enamel and then fired; the design was then applied in a series of colours, each of which was fired separately. From the mid-sixteenth century the first covering was black or dark blue enamel, which then formed the basis for the type of GRISAILLE painting known as *camaïeu*, in which a layer of white enamel paste spread on the dark enamel ground was carved to make a design consisting of exposed dark enamel; the technique is analogous to that of CAMEO carving.

The technique of enamelling on glass, which was developed in Venice in the fifteenth century (the earliest surviving piece is a blue glass goblet dated 1465), transformed the technology of STAINED-GLASS windows in the sixteenth century. Enamelled armorial glasses were made by Venetian glassmakers for the German market, and from the mid-sixteenth century were also made in Germany (notably in Nuremberg), where they continued to be produced until the eighteenth century.

Enderlein, Caspar

(1560–1633), German metalworker, a native of Basel who settled in Nuremberg in 1583. He established his reputation as a master of display PEWTER with a copy of BRIOT's famous *Temperantia* dish. He collaborated with Jacob Koch the Younger (d. 1619) on pewter tableware, notably jugs and tankards. His moulds remained in use until the eighteenth century, but no surviving piece is known to bear Enderlein's stamp.

Engelbrechtszoon

or Engelbrechtsen, Cornelis (1460/5–1527), Dutch painter, born in Leiden and trained in Brussels; he worked for a time in Antwerp before returning permanently to Leiden, where one of his pupils was LUCAS VAN LEIDEN. His most important works, two triptychs painted

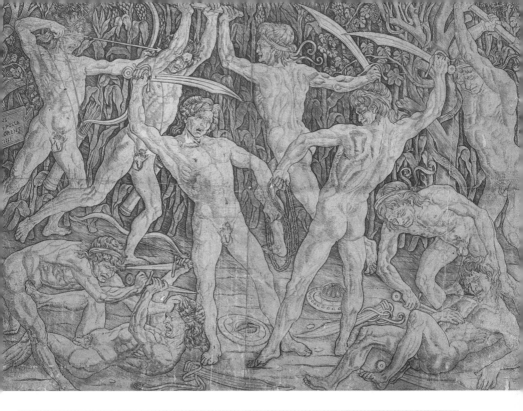

Antonio Pollaiuolo, *Battle of the Naked Men* (*c.*1470), an **engraving** in the Metropolitan Museum of Art, New York. The engraving (the largest produced in fifteenth-century Florence) is signed on a tablet hanging from a tree on the left. The subject of the work has never been explained, but it is clear that Pollaiuolo's purpose is to draw the male body in a state of animated action with a view to elucidating its musculature. The ten figures are paired, and the main foreground figures are drawn from a single model turned through 180 degrees. This engraving was widely disseminated throughout Italy and beyond, and so was used by artists such as Signorelli (see p. 237) and Dürer.

for the Marienpoel convent and now in the Municipal Museum in Leiden, are remarkable for their intensity of emotion.

engraving

A process for making PRINTS in which the design is engraved on a metal plate with a burin (a short steel rod cut obliquely at the end to provide a point) which is pushed through the surface of the plate; the process is sometimes called 'line engraving' to distinguish it from the nineteenth-century process of wood engraving.

Engraving seems to have originated in the workshops of goldsmiths in mid-fifteenth-century Germany and Italy; the early German engravers, such as the MASTER OF THE PLAYING CARDS, MASTER E.S., and Martin SCHONGAUER, were certainly goldsmiths as well as engravers, as was the early Italian engraver Maso

FINIGUERRA; the exception was MANTEGNA, who was not a goldsmith, but, like POLLAIUOLO and Schongauer, a painter.

In the early sixteenth century, the most important engravers were DÜRER, RAIMONDI (who often engraved designs by RAPHAEL), and LUCAS VAN LEIDEN (who engraved his first plate, *The Milkmaid*, at the age of 14). In the late sixteenth century the engraving increasingly came to be used as a means of reproducing designs rather than a medium for the creation of original designs.

Ensingen family

A family of south German masons and architects. In 1393 Ulrich von Ensingen (*c.*1360–1419) was appointed master mason of the cathedral at Ulm, where he remodelled what had been a hall church in which the aisles were the same height

as the nave into a five-aisled basilica. Ensingen worked on Milan Cathedral (possibly as an adviser) in 1394–5 and then returned to Ulm, where in 1397 he was appointed master mason for life. He designed a west tower and supervised the construction of the lower stage, which is faced with a magnificent porch; the upper stages of the tower were later built by Matthäus BÖBLINGER, who altered Ensingen's plans.

Ensingen's post at Ulm did not inhibit him from accepting simultaneous commissions for other buildings. In 1398 he began to work at the Frauenkirche (1321–1516) in Esslingen, where he designed the west tower; the tower was eventually completed by Hans Böblinger, who may have altered the design. In 1399 Ensingen moved to Strassburg, where he established an office from which he directed work at Ulm and Esslingen and also attended to his latest commission, the completion of the west tower of Strassburg Cathedral. He designed and began the tower and built it as far as the octagon stage, but the openwork spire with its extraordinary spiral staircase was built by his successor, Johann Hültz; at 142 metres (466 feet), this spire was the tallest to be completed in the Middle Ages.

Ulrich had three sons who became masons. Of these the most prominent was Matthäus Ensinger (c.1390/1400–1463), who was trained by his father at Strassburg and then became master mason at Bern, where he designed the minster (1420–1). From his base in Bern he also worked in Esslingen, continuing his father's work on the tower, but in 1440 he was succeeded by Hans Böblinger. In 1446 he was appointed master mason at Ulm, where he was eventually succeeded by Matthäus Böblinger.

Epiphanius of Evesham

(c.1570–c.1623), English sculptor, born into a prominent Herefordshire family. The scanty documentary record of his early life shows that Epiphanius was working in 1592 in the London studio of an exiled Brabantine sculptor whose English name was Richard Stevens (and who died in the same year). In 1601 Epiphanius established a studio in Paris, where he remained until c.1614, but no work from his Paris studio is known to survive. On returning to England he specialized in the carving of tombs; he was responsible for the tomb of Edmund West (1618, Marsworth, in Essex), which is decorated with engraved brasses, and for the signed tomb of

Lord Teynam (1632, Lynsted, Kent), which includes a kneeling figure of Lady Teynam and reliefs portraying their grieving children. Epiphanius was probably the sculptor of the tomb (c.1619) of Robert Rich, earl of Warwick (the first husband of Penelope Devereux, Sir Philip Sidney's Stella), in Felsted (Essex), which contains a series of allegorical reliefs.

Epischofer, Hans

(d. 1585), German goldsmith, a native of Augsburg who in 1561 moved to Nuremberg, where he specialized in the engraving of scientific instruments, especially globes, astrolabes, and navigational instruments. Examples of his work are preserved in the Germanisches Nationalmuseum in Nuremberg.

equestrian statues

The most important models for the equestrian statues of the Renaissance were the four bronze horses of San Marco (Venice) and the statue of *Marcus Aurelius* preserved outside San Giovanni in Laterano for centuries (in the belief that it was a statue of Constantine, the first Christian emperor) and transferred in 1538 to its present location in Piazza del Campidoglio. Painted GRISAILLE equestrian monuments, such as Paolo UCCELLO's *Sir John Hawkwood* (1436) and ANDREA DEL CASTAGNO's *Niccolò da Tolentino* (1456), both in Florence Cathedral, were a common memorial form in fifteenth-century Italy, but the first free-standing equestrian statue to be executed since classical antiquity was DONATELLO's *Il Gattamelata* (c.1446), which stands outside the Basilica del Santo in Padua. Later in the century, the most important equestrian statue was VERROCCHIO's *Colleoni* (1485–8) on the Campo SS Giovanni e Paolo in Venice. The technical problems of depicting a rearing horse had been anticipated by LEONARDO DA VINCI in his plans for a prancing horse in the Sforza and Trivulzio monuments, but the only legacies of Leonardo's intentions are his drawings and a few small sixteenth-century bronzes.

Ercole de' Roberti

or Ercole da Ferrara (1455/6–1496), Italian painter, born in Ferrara, where he may have been a pupil of Francesco del COSSA, whom he assisted on works such as the *Months* in the Schifanoia. He also worked with Cossa in Bologna, assisting with Cossa's altarpieces. His earliest independent work is the *Madonna*

Enthroned with Saints (1480) painted for the Church of Santa Maria in Porto in Ravenna and now in the Brera (Milan). Ercole was appointed court painter to the Bentivoglio family in Bologna, and in this capacity painted portraits of Giovanni II Bentivoglio and his wife Ginevra (1486, National Gallery, Washington).

In 1486 Ercole returned to Ferrara, where he succeeded Cosimo TURA as court painter to the Este family. In this period he painted *Harvest of the Madonna* (National Gallery, London), a *Pietà* (Walker Art Gallery, Liverpool), and *Way of the Cross* (Gemäldegalerie, Dresden), which was part of a predella painted for the Church of San Giovanni in Monte, Bologna.

Ercole was formerly confused with the Bolognese painter Ercole di Giulio Cesare de' Grande (d. 1531), none of whose pictures is known to survive.

Escorial, San Lorenzo de El

A monastery, royal palace, and royal mausoleum near Madrid. On 10 August 1557, the feast day of St Lawrence, the Spanish army of King Philip II defeated the French army of Duke Anne de Montmorency at the battle of Saint-Quentin. King Philip decided to commemorate the victory by building a monastery assigned to the Hieronymite Order and dedicated to St Lawrence; the building, which was originally known as San Lorenzo el Real, is now known as El Escorial.

In 1563 Juan Bautista de TOLEDO, the royal architect, drew up the ground plan for the Escorial and began the construction of the two-storeyed Patio de los Evangelistas (modelled on SANGALLO's Palazzo Farnese in Rome) and the forbiddingly severe south façade. On his death in 1567 Juan Bautista was unofficially succeeded by his assistant Juan de HERRERA, who in completing the building modified the plans of Juan Bautista. Philip II entrusted the various tasks on which Juan Bautista had embarked to several architects, including Giambattista CASTELLO (who built the monumental staircase), Francesco PACIOTTO (who designed the church), and Antonio de Villacastín (who proposed the extra storey to increase the monastic accommodation). Juan de Herrera co-ordinated the entire project and personally designed the infirmary and chapel. The building was completed within 21 years (1563–84).

The vast scale of the Escorial is apparent in its external measurements (206 metres / 680 feet by 161 metres / 531 feet), its 1,200 doors, and its 2,600 windows. Inside, the principal painter of frescoes was TIBALDI, who in the library (54 metres (177 feet) long) painted the ceiling with allegorical representations of the liberal arts; Luca CAMBIASO also contributed to the decoration, and Federico ZUCCARO painted altarpieces. The private apartments of King Philip were decorated with TALAVERA tiles. The royal mausoleum (Panteón de los Reyes), which is reached by a marble and jasper staircase, contains the remains of all but three Spanish monarchs from Charles V to the present (the exceptions are Philip V, Ferdinand VI, and Amadeus I).

Este, Villa d'

Two Renaissance villas are now called Villa d'Este. The villa that belonged to the Este family is at Tivoli (ancient Tibur), a hill town 30 kilometres (20 miles) east of Rome. The other Villa d'Este, at Cernobbio, on Lake Como, has never had any connection with the Este family; it was built for Cardinal Tolomeo Gallio (1527–1607), and whimsically renamed Villa d'Este by Caroline of Brunswick when she bought it in 1815; this villa, which is now a hotel, was once surrounded by a Renaissance garden, but the only original feature that survives in the present gardens is a double water-staircase framed by an avenue of cypresses and magnolias.

Villa d'Este in Tivoli was transformed from a Benedictine monastery into a villa for Cardinal Ippolito d'Este, who was appointed governor of Tivoli in 1550. The house is a typical Roman villa, but the magnificence of the greatest of Italian gardens reduces the house to a supporting role; the house retains a niche in literary and musical history, however, as the place where Tasso wrote his *Aminta* and Franz Liszt lived for many years.

The gardens were laid out between 1560 and 1575 on a steep slope on the west side of Tivoli. The architect, Pirro LIGORIO, drew on two nearby classical sites as models. One was Praeneste (now Palestrina), a Roman villa resort that in the first century BC boasted the largest temple in Italy; in the sixteenth century all that remained was a series of vast descending terraces linked by sweeping ramps. Ligorio's carefully surveyed drawings of the site testify to its impact on him, and it seems likely that the terraces and ramps of Praeneste inspired the terraces of the Villa d'Este. The other important classical model was Hadrian's villa in

Tivoli, which Ligorio had excavated for Cardinal Ippolito between 1550 and 1560, plundering many statues which were subsequently placed in the garden of the Villa d'Este.

The central axis of the garden is marked by a grand stairway that climbs from a gateway at the bottom of the garden across a series of majestic terraces to the villa. The two lowest terraces descend in staircases from the house and in ramps (*cordonate*) from the hill on the northwest side, which is the source of the water used to such spectacular effect in the garden. The main source of water is a conduit built by Ligorio to supply water from the river Aniene. The conduit delivered a constant flow of water (at 1,140 litres (250 gallons) per second) under the pressure required to lift water through the FOUNTAINS and AUTOMATA.

Access to the garden is now from the villa, but originally the garden was entered through a gate at the bottom. The centre of the lowest terrace is dominated by a round plantation of cypresses (the Rotonda dei Cipressi), outside of which were four MAZES. Beyond the cypresses, the first water feature was the Fountain of the Organ, which fed a series of waterfalls linked by three fish ponds. The Fountain of the Organ contained a water-organ that could imitate the sound of a trumpet and play in harmony; DU PÉRAC even claimed that it could play madrigals in four or five parts, but Montaigne complained that it only played a single note.

On the next terrace, the most important water feature is the Fountain of the Owl, Ligorio's realization of a contrivance described in late antiquity by HERON. Small birds perched on branches, their singing facilitated by the ingenious use of water; when an owl turned towards them to remonstrate with a water-driven hoot, the birds fell silent. Above this level, the central staircase divides in two in order to encircle the Fountain of the Dragons, whose fearsome roaring noises delighted Montaigne and John Evelyn.

Beyond the Fountain of the Dragons, the path reunites to climb still higher, to the Terrace of a Hundred Fountains, which consists of three magnificent rows of fountains. Behind the middle row there were 100 terracotta reliefs depicting scenes from Ovid's *Metamorphoses*. The north-west end of the pathway is dominated by the Fountain of the Ovata, in which a waterfall flows from beneath the feet of a giant statue of the Tiburtine Sibyl mounted on a rounded log-

gia cut into the hillside. At the other end of the terrace Ligorio built the Rometta, a fountain backed by a miniature cityscape (of which little now remains) depicting ancient Rome on its seven hills. Beyond the Terrace of a Hundred Fountains, a series of ramps (now open, but originally thickly planted with evergreen ilex) leads to the highest terrace, at the end of which there is a triumphal arch which frames the distant spectacle of Rome; in 1620 Fulvio Teste described this view over the Roman Campagna as unequalled in the world.

The maturity of the plantations at Villa d'Este has created effects that would not have been possible in the Renaissance garden, but much has nonetheless been lost. The greatest loss is the antique statuary; the statues (not all of which were installed) were the central features of the iconography of the garden, little of which survives. The special effects of the fountains have largely disappeared, as have the GIOCHI D'ACQUA that sprayed unsuspecting visitors.

In the seventeenth century the gardens were maintained and a few new features added, such as the Fountain of the Bicchierone built in 1660 by Gianlorenzo Bernini. In the eighteenth century the gardens were neglected and the statues disappeared, but the decay was deemed to be picturesque, and in this decayed state the garden was recorded by Jean-Honoré Fragonard and Hubert Robert. Fragonard's chalk drawings of the fountains are in the Museum of Besançon and his luxuriant *Gardens of the Villa d'Este* hangs in the Wallace Collection in London; Robert's chalk drawings and his evocative wash drawing of the Fountain of the Ovata are now in the Louvre.

Estienne

or (Latin) Stephanus or (modern French) Étienne or (Victorian English) Stephens, a dynasty of French scholar-printers active in Paris and Geneva from 1502 to 1674. The founder of the family was Henri Estienne the Elder (*c*.1460–1520), who opened his Paris workshop *c*.1502. On his death his three sons were too young to assume control of the business, so he was succeeded by his partner Simon de Colines, who in 1521 married Henri's widow. Robert Estienne the Elder ran the business from 1526 (when he introduced the device of the olive-tree on his books) to 1551, when he moved to Geneva and opened a branch of the press there. He was succeeded in Geneva by his

sons Henri Estienne the Younger (1531–98) and François (1537–82). Paul Estienne (1567–1627), son of Henri the Younger, inherited the business from his father but eventually returned to Paris. Paul's son Antoine (d. 1674) was the last printer in the dynasty.

After the departure of Robert Estienne for Geneva in 1550, the Paris workshop was run by his younger brother Charles Estienne, who was in turn succeeded by his nephew Robert Estienne the Younger (1530–71), who was appointed royal printer in 1564.

etching

A method of making PRINTS in which a design is bitten into a metal plate with acid. The metal plate is first covered with an acid-resistant compound (typically made of wax, bitumen, and resin) which is melted onto the plate; this covering is called the 'etching ground', and is the medium in which the etcher draws the design with an etching needle held like a pen. The plate is then immersed in acid, which bites into the exposed metal of the design. The ground is later removed from the plate, which is then ready for inking and printing.

Etching was less labour-intensive than ENGRAVING, and so was often used to save time: plates were sometimes begun as etchings and finished as engravings. Similarly, portions of etchings were sometimes finished with DRYPOINT.

Etching found its greatest exponent in Rembrandt, and his Renaissance predecessors, some of whom were great artists, were nonetheless not able to produce work of the highest quality in etchings. Artists who experimented with etching included ALTDORFER, DÜRER (whose *Landscape with a Cannon* of 1518 is an etching), Urs GRAF, LUCAS VAN LEIDEN, and PARMIGIANINO.

Eulenkrug

(German; 'owl-jug'), a type of TIN-GLAZED EARTHENWARE jug shaped like an owl and manufactured in Nuremberg in the mid-sixteenth century. The design may be the work of Augustin HIRSCHVOGEL.

Eworth

or Ewouts, Hans (*fl.* 1540–*c*.1573), Flemish portrait painter, born in Antwerp. He emigrated to England in the late 1540s. The evolution of the style of his portraits from Flemish MANNERISM (often with allegorical elements in the FONTAINEBLEAU tradition) to an Elizabethan concentration on details of clothing and drapery or tapestry is a barometer of changing tastes in the third quarter of the sixteenth century. His early portraits are typified by an allegorical portrait of Sir John Luttrell (1550, Courtauld Institute Galleries, London) in which Sir John is portrayed standing half-naked in a stormy sea with his clenched fist raised. His other sitters included Lady Dacre (*c*.1555, National Gallery, Ottawa), Queen Mary I (1554, Society of Antiquaries, London), and Lady Burghley (Hatfield House). He may have been the painter of the allegorical portrait of *Queen Elizabeth and the Three Goddesses* (1569, Hampton Court, London), but this traditional attribution is now regarded as insecure. Eworth also worked as a painter for pageants and masques.

Eworth was long confused with Lucas de HEERE; portraits signed with an 'HE' monogram were formerly attributed to Lucas de Heere, but most are now believed to be the work of Eworth.

Eyck, Hubert van

(*c*.1385/90–1426), Flemish painter, born in Maastricht (or in nearby Maaseik); he was probably the elder brother of Jan van EYCK. There are no surviving pictures known to be entirely the work of Hubert. Scholars have speculated that he may have collaborated with Jan on *The Three Marys at the Sepulchre* (Boymans Museum, Rotterdam). His contribution to the Ghent altarpiece is better attested, but is nonetheless disputed, because the authenticity of the inscription on the frame that describes it as being left unfinished at Hubert's death and then finished by Jan has been called into doubt.

Eyck, Jan van

(*c*.1395–1441), Flemish painter, probably the younger brother of Hubert van EYCK. In 1422 he moved to The Hague to enter the service of John of Bavaria, uncle (and opponent) of Jacqueline, countess of Holland, and three years later was appointed court painter and *valet de chambre* to Jacqueline's cousin Philip the Good, whose court was in Lille; Duke Philip sent Jan on diplomatic missions to Spain (1426) and Portugal (1428). In about 1430 he left Lille for Bruges, where he married (1434) and lived for the rest of his life.

In many of Jan van Eyck's paintings, such as *The Virgin in the Church* (Gemäldegalerie,

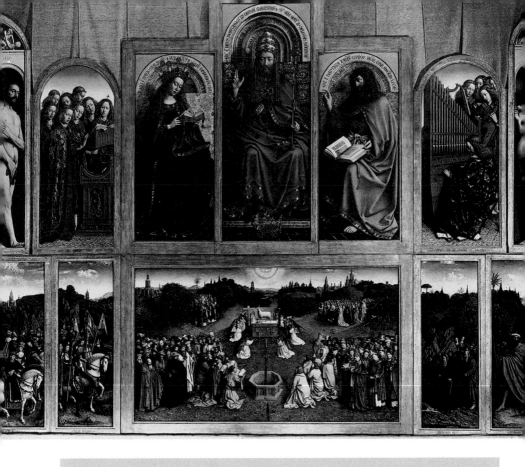

Hubert and **Jan van Eyck**, the Ghent altarpiece (1432), also known (from the subject of its central panel) as *The Adoration of the Lamb*, in the Cathedral of St Bavo, Ghent. The altarpiece was commissioned for St Bavo's by Jodocus Vijd (d. 1439) and his wife Elisabeth Borluut (d.1443). The altarpiece has two tiers, each with four hinged wings; eight of the twelve panels are painted on both sides. When fully opened for a major feast (as shown here), the top tier depicts Adam and Eve (far left and far right) beneath grisaille pictures of Cain and Abel, angelic musicians (two panels), and a central group (from left to right) of the Virgin Mary reading a missal, Jesus wearing a papal tiara, and John the Baptist reading the opening words of Isaiah 40 ('Comfort ye'). Below, *Soldiers of Christ* and *Just Judges* process from the left (*Just Judges* is a modern copy; the original was stolen in 1934) and *Hermit Saints* and *Pilgrim Saints* process from the right. In the central scene of the *Adoration of the Lamb*, biblical figures and confessors gather by a fountain (representing the mass) and in the background processions of saints and martyrs approach the Lamb. When closed for weekday masses and during Lent, the four top panels depict the Annunciation and the four lower panels Vijd and his wife kneeling before grisaille statues of John the Baptist and John the Evangelist.

Berlin), *The Annunciation* (National Gallery of Art, Washington), the *Van der Paele Madonna* (Groeninge Museum, Bruges), and the triptych of *The Virgin* (Gemäldegalerie, Dresden), figures are characteristically set against meticulously precise architectural backgrounds; in *The Madonna of Chancellor Rolin* (Louvre), however, the figures are set against a panoramic landscape. Hubert and Jan's most celebrated work is *The Adoration of the Lamb* (Cathedral of St Bavo, Ghent), usually known as the Ghent altarpiece, which was finished in 1432; its twelve panels (eight of which are painted on both sides) are based on the Book of Revelation.

Jan van Eyck's portraits include *Portrait of a Man* (1432), which is also known as *Léal Souvenir* ('Loyal Remembrance'), *Man in a Red Turban*

(1433), which may be a self-portrait, and *Arnolfini and his Wife* (1434) (see plate 8), all in the National Gallery in London; the Arnolfini double portrait, which was formerly known as the *Arnolfini Marriage* (because it was mistakenly thought to be a wedding painting), depicts the Luccan merchant Giovanni di Nicolao Arnolfini standing with his wife Giovanna (and their dog) in an interior setting. Jan's portrait of *Cardinal Albergati* survives as both an annotated drawing (1431, Kupferstichkabinett, Dresden) and a finished portrait (*c.*1433, Kunsthistorisches Museum, Vienna).

Jan van Eyck's unprecedented technical mastery of light and space, together with his innovative use of oils, gained him the admiration of painters (notably DÜRER) and collectors (particularly in Italy). VASARI attributed the invention of OIL PAINTING to Jan van Eyck; this claim is inaccurate, but it is an extraordinary testimony to Jan van Eyck's reputation in fifteenth- and sixteenth- century Europe.

F

Faenza potteries

The Italian city and episcopal see of Faenza (ancient Faventia), 50 kilometres (30 miles) southeast of Bologna, was a pottery centre as early as 1142, but the scale of production remained small until the mid-fifteenth century, when Faenza potters began to make the fine MAIOLICA that soon came to be known in northern Europe as FAIENCE. The earliest dated maiolica from Faenza is a plaque dated 1466 now in the Musée de Cluny in Paris. The maiolica produced in Faenza in the last quarter of the fifteenth century used bold colour schemes, often dominated by blue, purple, and orange, on its dishes, ALBARELLI, religious plaques, and tiles; designs typically included human figures surrounded by scrolling foliage. Surviving examples of Faenza maiolica from this period include a plaque of the *Virgin and Child* (1489, Victoria and Albert Museum) and a set of over 1,000 tiles (one of which is dated 1487) in the Cappella dei Vaselli in the Basilica of San Petronio, Bologna.

In 1501 Faenza was captured by Cesare Borgia, who drowned the surviving members of the ruling Manfredi family in the Tiber. After a few years under the control of Venice, Faenza was incorporated into the Papal State in 1509. In the course of these turbulent years the style of Faenza pottery changed to accommodate changing tastes and new markets. Colours were toned down, and in 1515 ISTORIATO wares began to be manufactured, typically with a blue glaze called *berettino*; the most prominent of the istoriato painters was Baldassare MANARA. New potteries included Casa Pirota, which produced two of the finest surviving pieces of maiolica, a plaque dated 1525 (Musée National de la Céramique, Sèvres) and a plaque depicting the coronation of Charles V in 1530 (Museo Civico, Bologna). In the 1540s BIANCHI (or *bianco di Faenza*) production began in Faenza; the most prominent Faenza manufacturers were Leonardo BETTISI, Virgiliotto CALAMELLI, and Francesco MEZZARISA.

Many fine examples of Faenza maiolica were lost when the city's Museo della Ceramica was destroyed during the Second World War, but the collection has been rebuilt in a new museum.

faience

The name used in France, Germany, Scandinavia, and Spain to denote TIN-GLAZED EARTHENWARE; the word derives from the Italian potteries in FAENZA; in Italy such pottery is called MAIOLICA and in Britain and the Netherlands it is called DELFTWARE.

Falconetto, Giovanni Maria

(1468–1535), Italian architect and painter. He was born in Verona but spent most of his career in Padua. His Odeon Cornaro (finely decorated with stucco on the inside) and Loggia in Padua (1524), built for the amateur architect and theorist Alvise Cornaro, were later incorporated into the Palazzo Giustiniani. His city gates for Padua, Porta San Giovanni (1528) and Porta Savonarola (1530), are modelled on Roman triumphal arches. He also completed the hilltop Villa dei Vescovi (i.e. of the bishops of Padua) at nearby Luvigliano, using loggias and staircase ramps to accommodate the steepness of the site. PALLADIO, who owned architectural drawings by Falconetto, greatly admired these buildings.

Falconetto's surviving paintings include architectural frescoes (1503) in the cathedral in Verona and a fresco of *The Annunciation* (1514) in the Church of San Pietro Martire in Verona.

Fancelli, Domenico di Alessandro

(1469–1519), Italian sculptor, born in Settignano, near Florence. He established his studio close to the MARBLE quarries in Carrara, and specialized in tombs for the Spanish market; he regularly visited Spain to install his work. His tombs, which were among the earliest Italian Renaissance works in Spain, include those of Cardinal Hurtado de Mendoza (1509, Seville Cathedral), Ferdinand and Isabella (1517,

Capilla Real, Granada), and their only son, 10-year-old Prince Juan (1512, Monasterio de Santo Tomás, Ávila).

fanfare bindings

A decorative style of BOOKBINDING used by Parisian binders between 1578 and 1634. The STRAPWORK recalls the decoration of the GROLIER and MAIOLI BINDINGS, but is reduced to a geometrical design of oval and circular patterns based on the figure 8. The spaces between the patterns were often decorated with tooled clusters of olive, bay, or laurel leaves.

The use of the epithet 'fanfare' to denote these bindings dates from 1829, when the French binder Thouvenin revived the style on his binding of a book entitled *Fanfares et corvées abbadesques des Roules-Bontemps* (1613). The introduction of the style is sometimes attributed to Nicolas and Clovis Ève, who were successively the royal binders from 1578 to 1634, but there is no evidence that they invented the style and little evidence that they used it extensively.

Farnese, Villa

In 1556 Cardinal Alessandro Farnese (1520–89) commissioned Giacomo VIGNOLA to build a villa at Caprarola, 55 kilometres (35 miles) north of Rome; the building was erected on the foundations of an earlier villa begun by Antonio SANGALLO the Younger. The villa was finished in 1583, and is widely considered to be the finest in Italy. Villa Farnese is built on the scale of a palace, and so is sometimes called Palazzo Farnese; it is sometimes confused with the Palazzo Farnese in Rome, which was built by Sangallo for an earlier Cardinal Alessandro Farnese (later Pope Paul III).

Villa Farnese stands theatrically above terraces joined by enormous horseshoe staircases. The house has five floors; above the basement separate floors were built for clerics, noblemen, knights, and servants. The apartments are decorated with frescoes by the brothers Federico and Taddeo ZUCCARO and Antonio TEMPESTA.

The decision to retain the pentagonal shape of the original foundations created a difficulty for the design of the garden. By 1578 a walled summer garden had been laid out squarely in front of one face and a walled winter garden squarely in front of its neighbour; this design left an awkward triangle between the two gardens. Each of the two gardens was about 70 metres (80 yards) square, and divided into four

PARTERRE squares, and they were linked to the principal rooms on the first floor (*piano nobile*) of the house by bridges. The winter garden had a GROTTO and a sheltered walk for inclement weather; the summer garden, which is now lined with camellias (and alive with birdsong), was planted with fruit trees, and contained a fish pond with a gilded FOUNTAIN.

The best feature of the garden lies through a woodland some 365 metres (400 yards) beyond and above the summer garden. There is an ornamental PAVILION (the Casino Villino) of a quality matched only by the pair at Villa LANTE, and behind it is a *GIARDINO SEGRETO* (finally completed in 1620) that is commonly judged to be the world's finest; VASARI memorably declared it to have been born rather than built. The garden is approached by a walled ramp, down the centre of which runs a sculpted cascade (*catena d'acqua*) similar to the one at Villa Lante; at the top of the ramp two river gods lounge against a large fountain. A curved stairway climbs around the fountain to the parterre adjoining the CASINO. The garden of the *casino* is enclosed by stone *canephori* (female caryatides with baskets on their heads) on a low wall, beyond which stand stately cypresses. The ground level is mostly on the level of the floor of the house, and the sense of interpenetration of house and garden is enhanced by the carpeting of the garden with pebble mosaics. The fountains now in the garden are the survivors of a much larger number of fountains adorned with statues that once stood in this superb garden.

Fernández, Alejo

(*c.*1475–1545), Spanish painter who appears in the documentary record as 'Maestro Alexos—pintor Alémán', which would seem to indicate German birth or ancestry. He married the daughter of the painter Pedro Fernández and assumed her patronymic surname. The works attributed to Alejo are all in Seville, where he was employed to work on the main ALTARPIECE in the cathedral in 1508. His best-known work is the unsigned *Virgen de los navegantes* (now in the Archivo de Indias in Seville), which is attributed to Alejo on stylistic grounds by analogy to signed works such as the *Virgen de la rosa* in the Church of Santa Ana de Triana in Seville (1510–20) and the altarpiece of the *Lamentation of Christ* in Seville Cathedral (1527).

Fernández

or Hernández, Gregorio (c.1576–1636), Spanish sculptor of reredoses, probably born in Ponferrada; he worked in Valladolid from about 1605. Like JUAN DE JUNI, his predecessor in Valladolid, Gregorio executed sculptures (subsequently painted) on religious subjects, but his work is markedly more dramatic (especially in gesture) than that of Juan. His colouring technique also differs, because whereas Juan's painters used gold and brilliant colours, Gregorio directed his polychromists to use more naturalistic colours. His principal works are the reredoses in the Church of San Miguel in Valladolid (1606) and in the cathedral in Plasencia (1624–34). The room in the Museo Nacional de Escultura in Valladolid devoted to Fernández has several of his works, including a *Baptism of Christ*, a gruesome *Cristo yacente* ('Recumbent Christ'), and a *Pietà* in which the legs of the thieves have been viciously slashed; the Convento de la Encarnación in Madrid has a *Flagellation* and another of his many recumbent Christs. He also sculpted the statues of John of the Cross and of *Christ at the Column* in the Convento de Carmelitas Descalzas in Ávila.

Fernández de Navarrete, Juan

(c.1538–1579), Spanish painter, known as 'El Mudo' ('the silent one') because he was a deaf mute. After a long period of study in northern Italy, Navarrete returned to Spain in about 1567 and was appointed court painter to King Philip II, in which capacity he was commissioned to paint 32 ALTARPIECES for the ESCORIAL, of which he completed eight before he died. His dramatic use of light shows the influence of Venetian art, notably in the *Burial of St Lawrence* painted for the Escorial in 1579. This emphatic use of CHIAROSCURO in Spanish painting is called *tenebrismo*, and so Navarrete is sometimes described as the first of the *tenebristas*; the same term is used of seventeenth-century Neapolitan painters, but the similarities in the use of light between the works of Navarrete and the art of early seventeenth-century Naples seem to reflect a common debt to CARAVAGGIO rather than the influence of Navarrete.

Ferrara tapestry workshop

In 1445 Flemish weavers who had been working in Ferrara for at least ten years were organized into a large workshop which wove tapestries for the Este court to designs by Cosimo TURA. Ferrarese tapestries deriving from Tura's designs include a *Deposition* (c.1475, Cleveland Museum of Art) and may include the *Ryerson Annunciation* (c.1500, Art Institute, Chicago), though the presence of the Gonzaga arms on the latter may imply that it was made in Mantua.

In the mid-sixteenth century the Ferrara factory continued to attract Flemish weavers, notably Nicolas KARCHER; he left for Mantua in 1539, but the Ferrara workshop continued under his nephew Luigi Karcher (d. 1580), whose tapestries included a *Life of the Virgin* (1569–90, Como Cathedral).

Ferrari, Gaudenzio

(1475/80–1576), Italian painter. He was born in Valduggia (Piedmont) and worked in Piedmont and Lombardy. His paintings are characterized by emotional intensity and by bold illusionism. In his *Crucifixion* in the mountain shrine of Sacro Monte (above the Piedmontese town of Varollo), the foreground figures are modelled in terracotta in full relief and the rest of the composition is painted. He also painted an illusionistic *Assumption* or *Concert of Angels* (1534–7) in the dome of Santa Maria dei Miracoli in Saronno (Lombardy). His other works include the *Madonna degli Aranci* (1529, San Cristoforo, Vercelli) and two paintings of the *Annunciation* (National Gallery, London).

Ferrucci, Francesco

(1497–1585), Italian sculptor, born in Fiesole or Florence. He was the most distinguished Renaissance sculptor in PORPHYRY. His most important surviving work in this medium is the basin of VERROCCHIO's Putto with Dolphin Fountain in the courtyard of the Palazzo Vecchio in Florence (1555). He also carved relief portraits, including one of Cosimo de' Medici the Elder (1569, Victoria and Albert Museum).

Filarete

or Antonio Averlino (c.1400–c.1469), Italian sculptor, architect, and goldsmith, born in Florence; his nickname is an Italian form of the Greek 'lover of virtue'. In 1445 Filarete completed the bronze doors on the Old ST PETER'S BASILICA in Rome (now rehung as the west door of the new St Peter's), on which his reliefs depict religious figures and scenes in large panels, with mythological subjects portrayed in the borders; scenes from the pontificate of Pope Eugenius IV and especially the Council of Ferrara of

1438–9 are also shown. He subsequently moved to Milan, where he practised as an architect; in 1456 he began work on the Ospedale Maggiore (subsequently enlarged from 1625 to 1649, largely destroyed during the Second World War, and since rebuilt). Filarete's work as a sculptor includes a bronze equestrian statuette of Marcus Aurelius (a reduced version of the ancient statue which stood outside San Giovanni in Laterano and since 1538 in Piazza del Campidoglio) which was then believed to represent the Emperor Constantine. This piece, which was made in the early 1440s, was presented to Piero de' Medici in 1465; it is now in the Albertinum in Dresden. It is the earliest datable bronze statuette of the Renaissance and the earliest known copy of an ancient statue.

Filarete was the author of *Il trattato d'architettura* (1461–4), an illustrated dialogue in 24 books (21 of architecture and three of painting and drawing) which includes a utopian vision of a star-shaped city called Sforzinda (named in honour of Francesco Sforza, Filarete's patron) and a coastal town called Plousiapolis; the symmetrical layout of Sforzinda is an early example of town planning in the Renaissance style. The buildings that Filarete planned included a ten-storey Tower of Vice and Virtue with a brothel on the ground floor and an observatory on the roof. VASARI condemned the treatise as ridiculous, but its appreciative readers included BRAMANTE, MICHELANGELO, and SCAMOZZI.

filigree and filigree enamel

Filigree (French *filigrane*, Italian and Spanish *filigrana*, German *Drahtegeflecht*) is ornamental openwork of gold or silver wire twisted and plaited into a design. In sixteenth-century Germany, where the most important centre for filigree was Siedenburg (near Bremen), large caskets and dishes made from filigree were laboriously manufactured for the *Kunstkammer* market. Thereafter filigree survived only in attenuated form as a folk art, and the craft still survives in Italy and Norway for the manufacturing of tourist souvenirs.

In fourteenth- and fifteenth-century Venice filigree was used for mounting ROCK-CRYSTAL cups and was on occasion enriched with ENAMEL by soldering twisted silver wires to a silver base, so forming partitions to separate the applications of polychrome enamels. Filigree enamel became a distinctive art form which spread from Venice to northern Italy (e.g. the reliquary

of the cross in the treasury of the cathedral in Padua), Spain, and eastern Europe. In the late fourteenth century Hungary became an important centre of filigree enamel, and from there it spread to Prague, Kraków, Vienna, and (as a folk art) Russia. In Hungary the enamel was made on small plates which were then attached to the object to be decorated; the enamel covered the entire surface of each plate, not only the spaces within the wire design. Decorations consisted of flowers and foliated scrolls, and characteristically depicted the carnation and the pomegranate; the tulip was introduced into Hungarian gardens in the sixteenth century, and was soon added to the plants depicted in filigree enamels. Several examples of Hungarian filigree enamel survive in the treasury of Esztergom Cathedral, including the Nyitra Evangelistary (*c.*1370), on which the silver cover is decorated with floral filigree medallions at each corner, the Széchy Chalice (*c.*1450), in which bubbles of gilded silver are soldered to the filigree wire, and the Suky Chalice (*c.*1440). The National Museum in Budapest has a viaticum casket (for carrying the eucharist to the dying) dated 1451 and the Támas Bakócz Chalice.

Transylvanian filigree enamels of the mid-sixteenth century resemble Hungarian filigrees, but the designs are characteristically outlined with a silver frame rather than with filigree wire, and the details of the design are often overpainted in a contrasting colour. The finest surviving example of Transylvanian filigree is the helmet made for Stefan Bátory now in the Muzeum Czartoryskich in Kraków.

Finiguerra, Maso

(1426–64), Florentine goldsmith and engraver who from 1456 to 1464 worked with Antonio POLLAIUOLO. His finest silverware was decorated with NIELLO; most examples of his niello silverware are known only from casts, but one important surviving example is a silver pax in the Museo Nazionale in Florence.

Fioravanti, Aristotele

(1415/20–*c*.1486), Italian engineer and architect, born into a family of architects in Bologna. He worked in Milan, Mantua, and Rome and in 1475 travelled via Hungary to Moscow to build the Cathedral of the Assumption (Uspensky Sobor, 1475–9), which dominates the churches of the Kremlin and was Russia's principal church until 1917, when it became a

museum; there are few hints in the design of the church that it is the work of an Italian Renaissance architect.

Fiorenzo di Lorenzo

(c.1445–c.1522), Italian painter and architect, a native of Perugia, where he worked as a painter of frescoes throughout his career. His principal surviving work is a polyptych of *The Madonna and Child with Saints* (1487–93, Church of Santa Maria Nuova, Perugia). None of his frescoes is now in good condition; his *Madonna of Mercy* (1476), painted in the Hospital of Sant'Egidio during a plague epidemic, is now in the Galleria Nazionale in Perugia.

Flémalle, Master of

(*fl. c.*1420 –*c.*1440), Netherlandish painter whose name derives from paintings in Frankfurt that were wrongly assumed to have come from Flémalle (near Liège). The scholarly consensus is that the Master of Flémalle can be securely identified as Robert CAMPIN.

Florence potteries

or Tuscan potteries, a group of factories in Florence and its *contado* or dependent territory (notably CAFAGGIOLO, MONTELUPO, Pistoia, and Prato), prominent as the finest makers of MAIOLICA until the late fifteenth century, when the Florence potteries were superseded by the FAENZA POTTERIES. Maiolica was made in Florence from about 1300 until the 1530s, and soft-paste PORCELAIN from 1575 to 1587; some of the potteries in the *contado* have a continuous history until the present day.

The products of the potteries, which included ALBARELLI, dishes, and tiles, were generally intended for use rather than display, though some pottery busts were produced, notably one of a black woman now in the Musée de Cluny (Paris) and one of *John the Baptist* in the Ashmolean (Oxford). The most distinctive products of the potteries were oak-leaf jars, which were rounded pots with short necks and a pair of handles, typically decorated with dark blue birds, animals, or humans set amidst stylized leaves that resemble oak. These jars, which were designed to hold medicines, were made throughout the first half of the fifteenth century; in 1430–1 the Hospital of Santa Maria Novella ordered 1,000 oak-leaf jars from the Florentine potter Giunta di Tugo, who marked his products with a manganese asterisk beneath the handle.

Florentine mosaic

The English term for the type of decorative mosaic panels known in Italian as *commeso di pietre dure*. Irregularly shaped pieces of PIETRE DURE were assembled into mosaics to form geometrical or representational designs which were used to adorn furniture or even interior walls (such as the Cappella dei Principi in the Church of San Lorenzo in Florence). In 1588 a workshop that had originally been established under the patronage of Grand Duke Cosimo I de' Medici was refounded as the Opificio delle Pietre Dure, which has continued to manufacture mosaics up to the present day.

Floris de Vriendt family

A Flemish family of artists and architects of which the most prominent were three brothers, Cornelius the Younger (an architect and decorative artist), Frans the Elder (a painter), and Jan (a potter). Cornelius and Frans lived and worked in Italy (c.1540–5) before settling in their native Antwerp, where their work had a distinctly Roman style; Jan pursued an independent career in Spain.

Cornelius Floris de Vriendt the Younger (c.1513/14–1575) published influential engravings of Italian decorative motifs. His greatest achievement was Antwerp Town Hall (1561): the four storeys of the façade (which is 100 metres (110 yards) long) consist of a rusticated arcaded ground floor surmounted by a floor in the Doric ORDER, then one in the Ionic, and finally an open gallery beneath the roof; at the centre of the façade a large three-bayed pavilion culminates in gables in which there are statue niches. Inside the building the grandest room is the Marriage Room, which has a fine sixteenth-century CHIMNEY PIECE. Cornelius also built the House of the German Hansa in Antwerp (c.1566) and the roodscreen in Tournai Cathedral (1572).

Jan Floris de Vriendt (1514–75), who was known in Spanish as Juan Flores, worked in Antwerp as a potter until 1553, when he moved to Spain. He worked in Plasencia (Extremadura) until 1562, when King Philip II appointed him royal tile-maker and made him responsible for the design of tiles produced at TALAVERA DE LA REINA and for the decoration of the royal palaces in Madrid and Segovia.

Frans Floris de Vriendt the Elder (1519/20 –70) trained as a painter in the studio of Lambert LOMBARD in Liège before travelling with his brother Cornelius to Rome, where in 1541 he attended

the unveiling of MICHELANGELO's *Last Judgement* in the SISTINE CHAPEL. The muscular nudes that populate his large religious and mythological paintings (such as his *Fall of the Rebel Angels* of 1554, now in the Koninklijk Museum voor Schone Kunsten in Antwerp) seem to have their origins in Michelangelo's paintings. His portraits, such as his *Portrait of a Woman with a Hound* (1558, Musée des Beaux-Arts, Caen), are painted in a wholly different idiom, in that they are more concerned with characterization than with the physical features of his sitters.

Flötner

or Flettner, Peter (*c.*1486/95–1546), Swiss– German architect, ornamental designer, sculptor, and engraver, born in the Swiss protectorate of Thurgau. By 1518 he was working on the Fugger Chapel in Augsburg, after which he travelled in Italy. He settled in Nuremberg in 1522, and, except for a second visit to Italy in the early 1530s, remained there for the rest of his career. He published engravings of many of his designs for furniture, decorative motifs, and precious metals. He made two fine FOUNTAINS that survive: one is in the market place in Mainz (1526) and the other, one of the greatest of Renaissance fountains, is the Nuremberg Apollo Fountain (1532, Stadtmuseum Fembohaus, Nuremberg). He was the architect of what was arguably the finest example of Renaissance domestic architecture in Germany, the Hirschvogelsaal in Nuremberg (1534, destroyed 1945).

Flower, Bernard

(d. 1517), glass stainer of Dutch or German origin. He settled in England *c.*1496 and in 1505 was appointed king's glazier. He was responsible for the windows in the Henry VII Chapel in Westminster Abbey (now destroyed). In 1515 he began to work on the glass for the Chapel of King's College, Cambridge, for which the windows had been designed by Dirick VELLERT; the series was completed by Galyon HONE.

Fontainebleau, Château de

A royal palace set in a forest 65 kilometres (40 miles) south-east of Paris. It was Francis I who in 1528 began the transformation of the small twelfth-century chateau-fortress of Louis VII into a great Renaissance palace. Francis first commissioned Gilles de Breton (*c.*1500–*c.*1552) to build the Cour de l'Ovale on the site of the old chateau; the finest features of this building are

its southern entrance, the Porte Dorée (an imitation of the entrance to the Ducal Palace at Urbino), which was decorated by Benvenuto CELLINI, and the Salle des Fêtes. Gilles de Breton subsequently built the Galerie François I and the lower storey of the left wing of the Cour de la Fontaine and the Chapelle Saint-Saturnin. The decoration of the Salle des Fêtes, which was commissioned by King Henri II and executed by Francesco PRIMATICCIO and NICCOLÒ DELL'ABBATE, created what is arguably the finest Renaissance interior in France. The Galerie François I was sumptuously decorated by Il ROSSO FIORENTINO and Primaticcio (see plate 16). Gilles de Breton's last commission at Fontainebleau was the Cour du Cheval Blanc (now called the Cour des Adieux, with reference to Napoleon's farewell to his Old Guard in 1814), including the Chapelle de la Sainte-Trinité and the Galerie d'Ulysse (decorated by Primaticcio but subsequently destroyed and rebuilt by Louis XV). The rusticated GROTTO (Grotte des Pins) built as part of this gallery between 1541 and 1543 survives unaltered; it was one of the earliest grottoes in France.

Building was continued on a small scale by Henri II, whose architect was Philibert DE-LORME; the ballroom that he created is one of the greatest rooms in France. Catherine de Médicis commissioned Primaticcio to enclose the Cour de la Fontaine; the façade of this building, which is now known as the Aile de la Belle Cheminée, is the finest exterior in the palace, and its blend of Italian and French elements proved to be very influential. King Henri IV added the court that now bears his name, together with the attached Cour des Princes and the adjoining Galerie de Diane and Galerie des Cerfs. Henri IV also placed the splendid baptistery at the entrance to the Cour de l'Ovale (which he enlarged). In the seventeenth century, Louis XIII commissioned Jean DUCERCEAU to build the elegant horseshoe staircase in the Cour du Cheval Blanc.

The gardens were laid out between 1528 and 1547. A causeway was constructed, and to the west of it a lake was dug, as a setting for the Cour de la Fontaine. On the west side of the lake there was a walk bordered by clipped hedges (the Allée Royale) where scrofula sufferers could come to be healed by the king's touch; there was a fountain (the Fontaine Belleau) on the west side of the road, beyond which a Jardin de Pins was planted; this area is still covered with pines. To the east of the causeway the Grand Jardin was

laid out for Francis I, and this garden was transformed into the Parterre du Tibre by Henri IV. The new name referred to the statue and fountain which were installed at its centre by the designer, Alexandre Francini; he laid the garden out in two pairs of matched PARTERRES, each with a fountain at the centre. In 1595 Henri IV created an island garden (the Jardin de l'Étang) laid out as a *parterre de broderie*; the island was destroyed in 1713. Henri IV also added the vast Grand Canal (1609), which is 35 metres (40 yards) wide and 1,100 metres (1,200 yards) long. In the park to the north of the palace Catherine de Médicis commissioned a pleasure house called Mi-Voye and a garden which was then known as the Jardin de la Reine; it was laid out in intricately planted parterres and furnished with a wooden gallery. Bronze statues cast in imitation of classical marbles (including *Apollo Belvedere*, *Laocoön*, and the *Sleeping Ariadne*) by Giacomo de VIGNOLA for Francis I were placed in the garden; the marble originals are now in the Vatican and the bronze copies in the Louvre. Henri IV added a FOUNTAIN with a statue of Diana, and the garden acquired its present name, the Jardin de Diane; in 1813 the original statue of Diana was replaced with a bronze Diana taken from the TUILERIES. The gardens were redesigned by André Le Nôtre in 1645, and Napoleon commissioned yet another design, but the outlines of the Renaissance garden are still visible.

Fontainebleau, schools of

Two schools of decorative painting are usually distinguished, but references in the singular to the School of Fontainebleau refer to the first school. The first School of Fontainebleau was instituted by the group of Italian artists brought to France by King Francis I to decorate the royal palace of FONTAINEBLEAU. The decoration was carried out between 1528 and 1558, and the principal artists were Il ROSSO FIORENTINO, NICCOLÒ DELL'ABBATE, and Francesco PRIMATICCIO. The style of the murals at Fontainebleau is clearly Italian in origin, but has been adapted to the courtly ideals of France. The style was disseminated both by the French and Flemish assistants who contributed to the murals and by guests at Fontainebleau. Original features of the style include STRAPWORK and the unprecedented combination of mural painting and stucco which came to be known as the French style.

The decorative painting of royal palaces was for the most part suspended during the Wars of Religion (1562–98) but revived by King Henri IV, who employed the Flemish and French decorative artists of the second School of Fontainebleau, who included Amboise Dubois (1543–1614), Toussaint Dubreuil (1561–1601), and Martin FRÉMINET.

Fontana, Annibale

(*c*.1540–1587), Italian sculptor and medallist. He seems to have been a native of Milan, but was probably trained in Rome; he married into the SARACCHI FAMILY, and the style of his work is very similar to theirs. His early work includes five engraved ROCK-CRYSTAL panels set into a casket commissioned by Albrecht V, duke of Bavaria (*c*.1565–70, Residenzmuseum, Munich). His sculpture includes four fine bronze candlesticks made for the Certosa di Pavia (1580). His portrait medals include one of LOMAZZO.

Fontana, Domenico

(1543–1607), Italian architect and engineer, born near Lugano. He settled in Rome *c*.1563, and in 1574 entered the service of Cardinal Montalto; on the accession of Cardinal Montalto as Pope Sixtus V in 1585, Fontana worked with the pope to redesign Rome as a baroque city. In 1585–6 Fontana famously transported the Egyptian obelisk to its present location outside ST PETER'S BASILICA and also laid out the four streets radiating from Santa Maria Maggiore. He was the architect of the Lateran Palace (1586) and the Vatican Library (1587–90), and worked as an engineer with Giacomo DELLA PORTA on the completion of the dome of St Peter's. In 1592 Fontana moved to Naples, where he was appointed as royal engineer, in which capacity he built the viceregal palace (1600–2, now substantially altered) in the Piazza del Plebiscito.

Fontana, Lavinia

(1552–1614), Italian painter, the daughter of the painter Prospero FONTANA. She specialized in historical scenes and portraits. Her portraits include a *Self-Portrait at the Harpsichord* (Galleria dell'Accademia di San Luca, Rome) and *Senator Orsini* (Musée des Beaux-Arts, Bordeaux). Her finest religious painting is a *Noli me tangere* (1581, Uffizi, Florence).

Fontana, Orazio

(d. 1571), Italian potter, the son of Guido Durantino (d. 1576), the owner of a pottery and MAIOLICA workshop in Urbino; in 1553 the family

name was changed to Fontana. Orazio was active in Urbino from 1540 to 1544, during which time he signed and dated several surviving ISTO-RIATO plates. His whereabouts and activities for the next twenty years are unknown, but in 1564 he is known to have been working in the service of Emanuele Filiberto, duke of Savoy, and the following year he returned to Urbino and established his own workshop. After the death of Orazio (who predeceased his father), the workshop was managed by his nephew Flaminio Fontana.

The products of the Fontana workshops in Urbino include maiolica of the highest quality, some of which was designed by Battista FRANCO and Taddeo ZUCCARO. It is likely that the table service designed by Zuccaro for presentation by Duke Guidobaldo II della Rovere to King Philip II of Spain was made in the workshop of Orazio Fontana.

Fontana, Prospero

(1512–97), Italian painter, a native of Bologna who worked in a number of Italian cities (including Florence and Rome) on decorative projects, acting as an assistant to painters such as PERINO DEL VAGA, VASARI, and Taddeo ZUCCARO. In 1560 he worked for a short time at FONTAINEBLEAU as the assistant of PRIMATICCIO. He then returned to Bologna, where he established a studio; his pupils included Ludovico CARRACCI and Denys CALVAERT. Most of his paintings are portraits, in which genre his most talented pupil was his daughter Lavinia FONTANA.

Foppa, Vincenzo

(1427/30–1515/16), Italian painter. He was born near Brescia and probably trained in Padua before settling in Milan, where he painted fresco cycles, notably his *Life of St Peter Martyr* in the Portinari Chapel in the Church of Sant'Eustorgio. His surviving paintings include a *Crucifixion* (1486, Accademia Carrara, Bergamo), an early *Boy Reading Cicero* (Wallace Collection, London), and a late *Epiphany* (National Gallery, London).

Forment, Damià

(*c.*1480–1540), Valencian sculptor of alabaster reredoses whose work embodies the transition in Spanish art from the Gothic style to that of the Renaissance. His reredoses in the Cathedral of Santa María del Pilar in Zaragoza (finished in 1512) and the cathedral in Huesca (started *c.*1520)

place sculptures carved in the Renaissance manner into settings that are resolutely Gothic. The magnificent reredos (damaged but now restored) in the Cistercian abbey of Poblet (Tarragona) introduced Renaissance sculpture in the Roman style to Catalonia, and marks Forment's abandonment of Gothic structures. In 1539 Forment forsook alabaster for wood when he began work on the reredos (now gilded and polychromed) for the Cathedral of Santo Domingo de la Calzada (Rioja).

fortification

Fortification is the architectural expression of the defensive military art of strengthening positions against attack; siegecraft is the complementary offensive art of capturing fortified positions by isolating the fortified town or castle and then attacking its defences. In the thirteenth and fourteenth centuries the enhanced fortifications of castles had given a clear superiority to defence, though in the case of fortified towns the chances of a successful attack were improved. The central structure in fortification was the tall, thin wall with a narrow walkway on the top sheltered by crenellations and with fortified towers at intervals along the wall. Walls were defended from the top, and attack was increasingly directed at the top: the battering ram was displaced by the siege tower and its bridge. One of the principal means of attack was mining, so the rat (the protective structure mounted over the ram) continued in use as protection for the miners. The designers of fortifications made provision for countermining by building chambers at the base of towers and walls and by projecting masonry beyond towers. Attackers used wheeled mantlets to protect bowmen and crossbowmen, and used machines to hurl stones against the parapets and barrels of burning pitch over the parapets.

In the fifteenth century the introduction of gunpowder shifted the balance between fortification and siegecraft. In 1494 Charles VIII invaded Italy in the opening campaign of the Wars of Italy, and the superiority of the artillery in his siege train enabled him to capture castles and fortified towns with relative ease. The Italian reaction to his success was a rethinking of the art of fortification. Fortification became an art in which Italian military engineers led the rest of Europe; of the 33 treatises published in the sixteenth century on the subject of fortification, only six were written by non-Italians, one of

whom was DÜRER (whose *Etliche Underricht, zu Befestigung der Stett, Schlosz und Flecken* was published in 1527). Fortification was one of the arts in which Italian artists and architects developed unrivalled expertise: in Italy the tradition of artists taking an educated interest in military engineering includes GIOTTO, BRUNELLESCHI, LEONARDO (who made designs for Piombino), BUONTALENTI (who designed the Belevedere fortress in Florence), and the builders of the fortifications (now Forte Michelangelo) at Civitavecchia (the port of Rome) who included BRAMANTE (who designed the fort and the Rossa), SANGALLO (who built the fort), and MICHELANGELO (who added the dungeons to the fort).

The defence of fortified positions against artillery capable of destroying masonry at long range necessitated improvements both in defensive artillery and in the design of defences. In the case of artillery, roof towers were removed and replaced with gun platforms, and the loopholes in the lower storeys of towers, formerly used to admit air and light and to view the enemy approach from a safe position, were converted into casemates with embrasures from which grazing fire could be directed over the ditch, albeit in a narrow field of fire.

Defences were improved by the innovation of the bulwark, the strengthening of walls, the redesigning of ditches, and the invention of the bastion. The bulwark was designed to shield the gates against cannonfire, and typically consisted of a semicircular outwork made from earth, reinforced with timber, and faced with masonry. Bulwarks protected the gates and also afforded a forward defensive position which was useful for flanking fire; this latter quality led military architects to place bulwarks in front of towers and at intervals along walls.

Walls consisting of rubble faced by thin masonry proved particularly vulnerable to artillery, and so were banked with soil on the inside. This defence increasingly proved ineffectual against ever more powerful artillery, because the effect of a breach was to allow soil to collapse into a ramp that was convenient for attackers. The refinement that prevented the formation of such ramps was the reinforcement of the banks of soil with layers of brushwood and timber. The occasional use of masonry in the reinforcement of banks of earth developed into counterforts, which were buttresses facing inward from the wall. A refinement attributed to Dürer is the invention of the counterarched revetment, a se-

ries of arches between the counterforts with their axes at right angles to the wall; these counterarches, which were sometimes tiered, both strengthened the wall and constituted an additional obstacle should the wall be breached.

The ditch was primarily an obstacle to prevent attackers from bringing siege towers within range of the walls, and also supplied soil for the reinforcement of the walls. Ditches had traditionally been sloped at the sides, but were redesigned with vertical masonry sides. On the inside of the ditch the defensive walls were extended downwards to the bottom of the ditch, and on the outside of the ditch a masonry counterscarp in effect turned the ditch into a dry canal. This innovation increased the value of the ditch as an obstacle, but also prevented the mounting of sorties by defending troops, who before the advent of the counterscarp had been able to assemble unseen in the ditch and then ascend the slope to attack the enemy.

The ground plan of fortifications, which in military architecture is called the trace, had for centuries consisted of an enclosure wall surmounted by a walkway and reinforced at intervals by towers. In the early sixteenth century Italian engineers began to reconceive the trace with a view to overcoming three problems: the gun platforms on the towers were too small to accommodate more than one or two guns, the field of fire afforded by the embrasures was too narrow, and the forward bulwarks were vulnerable because they were detached from the main defences. The solution to these problems was the bastioned trace. The earliest bastions were modified bulwarks that extended back to join the walls; the semicircular earthworks of the bulwark evolved into the angular projecting masonry bastion, which constituted a forward artillery position connected by flanks to the main wall. In the bastioned trace, flanks faced each other, thus obviating the need for inefficient casemate positions in the main walls, because every position in the ditch could be reached by artillery in the bastions.

The first example of a complete bastioned trace was Francesco PACIOTTO's fortification of Antwerp in 1568. In the seventeenth century the initiative in bastion design passed from Italy to France, and French military engineers continued to dominate European bastion design until the end of the nineteenth century, when increasingly powerful artillery rendered the bastion ineffective.

Bartolomeo Ammanati, the Neptune **Fountain** (1571–5) in the Piazza della Signoria, Florence. Like Michelangelo's *David*, Ammanati's *Neptune* was carved from marble that had been shaped by another sculptor, in this case Baccio Bandinelli, and so had to be shaped within predetermined constraints. The surrounding bronzes of four deities and a group of fauns and satyrs were modelled in Ammanati's workshop by his assistants.

fountain

or (Renaissance Latin) *fontana*, a decorated water outlet or projection. In antiquity fountains were endowed with mystical and medicinal qualities, and were often dedicated to gods who were thought to frequent the original springs represented by the fountains. There is also evidence—in the form of ancient Breton fountains flowing from dolmens—of an early Celtic fountain cult. The notion that the water of certain fountains had supernatural healing powers was absorbed into Christian folk-belief, and in medieval Europe statues of the Virgin Mary were often placed in the arch that was constructed to cover springs; this form of fountain, which is usually reached by descending a few steps, is known in France as a *fontaine grotte*. Public fountains of the fifteenth and six-

teenth centuries survive in many parts of Europe, including the Fontaine Joubert at Poitiers and the fountain by the church of St Mary Wickford in Lincoln.

In the private gardens of the Renaissance fountains tended to be purely ornamental, and often featured *jets d'eau*. In Italy the fountain was the centrepiece of the garden, and the design of fountains attracted many of the great artists of the period. The most important architect of fountains was GIAMBOLOGNA, whose many designs included the Fountain of Venus at the Villa Petraia near Florence, the Hercules Fountain at the nearby MEDICI VILLA of Castello, the Ocean Fountain in the BOBOLI GARDENS, and the huge Apennine Fountain for PRATOLINO. The most dramatic and extensive use of fountains was at the Villa D'ESTE in Tivoli and at the

Villa ALDOBRANDINI, in which the architectonic use of water eclipsed the statuary. In some Italian gardens, notably that of Villa LANTE, fountains feed or are fed by water-staircases.

French gardens of the fifteenth and sixteenth centuries were usually flatter than Italian gardens, and water was scarce. The great fountains at ANET and GAILLON, for example, produced only trickles of water; the effect was to emphasize the architecture of the fountains and the form of their sculptures rather than the shapes of the water. The revival of HERON in the Renaissance stimulated an interest in hydraulics, and there were occasional successes in artificially fed fountains, such as the high-pressure fountain at CHENONCEAUX in the mid-sixteenth century, but aquatic effects on an Italian scale were not achieved until the seventeenth century, when technology developed by Italian engineers (notably the FRANCINI brothers) was deployed to feed the fountains of Versailles with water under pressure.

In Germany the finest fountains are in Nuremberg. The fourteenth-century Gothic fountain known as the Schöner Brunnen ('Beautiful Fountain'), which is 19 metres (62 feet) high, has many figures around the base, including the seven electors. Peter FLÖTNER was the architect of the Apollo Fountain (1532). The Gänsemännchen Brunnen ('Goose-Boy Fountain', c.1555), which depicts a Franconian peasant carrying two geese with water flowing from their beaks, may be the work of Pankraz Labenwolff (1492–1563).

Fouquet

or Foucquet, Jean (c.1415/20–c.1481), French painter and manuscript illuminator. He was a native of Tours who visited Italy in the 1440s, and is known to have lived in Rome from 1443 to 1447. On returning to France he entered the royal court as a painter of portraits and portrait miniatures; the style of his pictures is structurally French, in that his designs are distinctly sculptural, but Fouquet's experience of Italian art is nonetheless reflected in his art. In 1475 he was belatedly appointed *peintre du roi*.

Fouquet's only authenticated works are illustrations in the manuscript of Josephus known as *Antiquités Judaïques* (1470–6, Bibliothèque Nationale) and a signed self-portrait medallion (Louvre). His best-known surviving work is the Book of Hours (c.1450–60) made for Étienne Chevalier, the royal treasurer;

the book is now incomplete and dismembered, but 40 of the surviving 47 leaves are in the Musée Condé in Chantilly.

Francavilla, Pietro

or Pierre de Francheville or Francqueville (1548–1615), Flemish sculptor, born in Cambrai. He trained in Paris and in 1566 travelled to Innsbruck, where he worked on the tomb of the Emperor Maximilian. In 1571 or 1572 he moved to Italy, where he spent 30 years as an assistant to GIAMBOLOGNA. His principal independent works are statues of *Janus* and *Jupiter* (1585) for the Grimaldi Palace in Genoa, six statues for the Cathedral of San Lorenzo in Genoa, and five statues in the Niccolini Chapel in the Church of Santa Croce in Florence. He was recalled to France in 1604 by Marie de Médicis, who commissioned him to erect Giambologna's EQUESTRIAN STATUE of King Henri IV on the Pont Neuf in Paris; Francavilla modelled the figures of four slaves for the pedestal of the statue. The monument was destroyed during the French Revolution, but bronze casts of Francavilla's four slaves, cast after his death by a pupil, are now in the Louvre.

Francesco di Giorgio Martini

(1439–1501), Italian painter, sculptor, military engineer, and architect, born in Siena, the son of a poultry dealer, and trained in the Sienese studio of VECCHIETTA. As a young man he worked primarily as a painter; his surviving works include a *Coronation of the Virgin* (1472–4) and a *Nativity* (1475; his only signed work), both in the Pinacoteca in Siena. By 1477 he had moved to Urbino, where he worked for Federico da Montefeltro as a fortress designer and military engineer; he constructed more than 70 fortresses and designed many military machines and weapons, including the first landmine. He may have contributed to the design of Luciano LAURANA's Ducal Palace at Urbino. He wrote an architectural treatise, *Trattato di architettura civile e militari*, which was largely devoted to ecclesiastical architecture but also included a section on town planning; a manuscript copy of the treatise was owned by LEONARDO DA VINCI, on whom it exercised a considerable influence. From 1491 to 1497 Francesco lived at the courts of Kings Alfonso II and Ferrante II in Naples, where he made drawings of ancient remains while working as a military engineer; he then returned to Siena for the final years of his life.

Francesco's only documented work as an architect is the Church of Santa Maria del Calcinaio, near Cortona, for which he provided a model (1485); the church, which is designed as a Latin cross, was completed in 1516. He also seems to have provided the design for the austere Palazzo della Signoria in Jesi (1486–90); later additions include a courtyard by Andrea SANSOVINO. Attributions include the churches of Santa Maria degli Angeli in Siena and San Bernardino in Urbino and the Palazzo Ducale in Gubbio.

Francesco Durantino

(fl. 1543–54), Italian potter who specialized in ISTORIATO ware. He worked from 1543 to 1547 in the studio of Guido di Merlino in Urbino, and then moved to Monte Bagnolo (near Perugia), where he worked until 1554 or possibly later. His best-known surviving piece is a MAIOLICA wine cistern (1553) made in Monte Bagnolo and now in the Art Institute in Chicago.

Francia

or Francesco Raibolini (c.1450–1517), Italian goldsmith, medallist, and painter, a native of Bologna. He worked as a goldsmith until the mid-1480s; his two surviving pieces are niello paxes dated 1480 (a *Crucifixion*) and 1481 (a *Resurrection*), both now in the Pinacoteca Communale in Bologna. He turned to painting and formed a partnership with Lorenzo COSTA that lasted until 1506, when Costa departed for Mantua; their principal surviving collaborative work is the cycle of the frescoes in the Oratory of Santa Cecilia in the Church of San Giacomo Maggiore. The influence of RAPHAEL is apparent in many of Francia's paintings, such as his *Madonna Enthroned with Saints* (Pinacoteca, Bologna).

Franciabigio

or Francesco di Cristofano or Francesco Giudici (1484–1525), Italian painter, a native of Florence, where he trained in the studio of PIERO DI COSIMO. He collaborated with ANDREA DEL SARTO on the decoration of the cloisters of the Church of the SS Annunziata and of the Chiostro dello Scalzo (to which he contributed *The Last Supper*). He also painted a *Triumph of Cicero* in the Salone of the MEDICI VILLA at Poggio a Caiano. The influence of both RAPHAEL and Andrea del Sarto is apparent in paintings such as *The Holy Family* (Kunsthistorisches Museum, Vienna) and *The Madonna del Pozzo* (Accademia, Florence).

Francini, Thomas

A Florentine hydraulic engineer who moved to France c.1599 at the invitation of King Henri II. Together with his brothers Alexandre (fl. 1608, d. 1648) and Camille he designed and installed the waterworks at SAINT-GERMAN-EN-LAYE, and subsequently designed waterworks for FONTAINBLEAU, Versailles, the Luxembourg Gardens in Paris (where he designed the aqueduct), and Cardinal Richelieu's garden at Rueil.

Francke, Master

(fl.1424–36), German painter in Hamburg and the principal exponent of the style known as north German INTERNATIONAL GOTHIC. His best-known work is an ALTARPIECE commissioned by the Englandfahrer (a guild of Hamburg merchants engaged in trade with England) which depicts scenes from the Passion of Jesus and the life of St Thomas of Canterbury (now in the Kunsthalle in Hamburg).

Francken, Ambrosius I

(1544–1618), Hieronymus I (1540–1610), and Frans I (1542–1616), Flemish painters, members of a Flemish dynasty of painters that extended over at least five generations. The three brothers, whose work is amply represented in the Musée d'Art Ancien in Brussels, all favoured religious and historical subjects. Attributions are often problematical, not least because their relatives copied their pictures, but those of Ambrosius are marked by the influence of RAPHAEL, those of Hieronymus I by the influence of MICHELANGELO, and those of Frans I (at least in his later period) by a movement away from large canvases in favour of small paintings on copper.

Franco, Battista

(c.1510–1561), Italian painter, probably a native of Venice. By 1530 he was living in Rome, where he was one of the first painters to copy the frescoes in the SISTINE CHAPEL; his copies of MICHELANGELO and his drawings of antique sculptures were all executed in ink.

In 1536 Franco received his first commission for decorative painting when he was asked to paint the decorations on Ponte Sant'Angelo for the triumphal entry of the Emperor Charles V into Rome on 5 April 1536. His later paintings include a *Baptism* (c.1555) in the Church of San Francesco della Vigna in Venice.

In about 1545 Franco received a commission from Duke Guidobaldo II della Rovere to make ISTORIATO designs for MAIOLICA table services. Many of the designs that Franco produced for Duke Guidobaldo over the course of the next six years have survived, as have some of the plates made from these designs in the FONTANA and Patanazzi workshops in Urbino (not, as VASARI mistakenly thought, in CASTEL DURANTE). The two most important table services, a *History of Troy* and a *Labours of Hercules*, do not survive in complete sets, but many individual plates survive in museums.

Frankfurt, Master of

(*fl.* 1500), Flemish artist whose name derives (inappropriately, as he was Flemish rather than German) from the *St Anna* altarpiece (now in the Staedel Institute in Frankfurt) painted for the Dominican monastery in Frankfurt. Some 40 pictures are attributed to this painter, whose style implies some form of association with Quentin MASSYS.

Fréminet, Martin

(1567–1619), French painter and etcher. He was born in Paris and in 1592 travelled to Italy, where he lived principally in Rome, and later in Venice and in Turin. He returned to France in 1602 and entered the service of King Henri IV, for whom he decorated the ceiling of the Chapelle de la Sainte-Trinité at FONTAINEBLEAU. Fréminet is one of the painters associated with the second School of FONTAINEBLEAU.

fresco

(Italian plural *freschi*, English plural frescos or frescoes), a method of wall painting in which powdered pigments dissolved in water are applied to a wet, freshly applied plaster ground. The colour is absorbed into the drying plaster, which acts as the binding medium. The process is described in detail in Cennino CENNINI's early fifteenth-century *Libro dell'arte*. Fresco, which was sometimes called *buon fresco* or *fresco buono*, was distinguished by the wetness of the plaster from paintings executed on dry walls, which were called SECCO or *fresco secco*. The plaster dried quickly, and details were sometimes added in *secco* after the plaster was dry, a practice decried by purists such as VASARI but used to great effect in frescoes such as Fra ANGELICO's series in the Convent of San Marco in Florence. In the 1430s the CARTOON was introduced, but until

then the design was sketched on a rough underlying layer of plaster.

Frescoes were primarily an Italian form; the deleterious effect of dampness on plaster meant that frescoes never became an important medium in Venice or in northern Europe. Many Italian artists painted frescoes, including GIOTTO (Arena Chapel, Padua), MASACCIO (Brancacci Chapel, Florence), PIERO DELLA FRANCESCA (Church of San Francesco, Arezzo), RAPHAEL (the Vatican *Stanze*), and MICHELANGELO (the ceiling of the SISTINE CHAPEL in Rome).

Froben, Johann

(*c.*1460–1527), German humanist printer, born in Hammelburg (Bavaria). He moved to Basel in 1491, and trained as a printer and scholarly editor in the workshop of AMERBACH, where he worked until Amerbach's death in 1516, whereupon Froben established himself as an independent publisher with a particular interest in the printing of biblical and patristic works (notably a nine-volume edition of Jerome), and engaged HOLBEIN and Urs GRAF to design decorative initials and borders for his books; Holbein also painted his portrait (of which a copy is in Windsor Castle). He became a close friend of Erasmus, who lived in Froben's house, and was the publisher of Erasmus' Greek New Testament (the first to be published). He also published tracts by Luther, but when Luther and Erasmus clashed over the doctrine of grace, Froben supported his houseguest. After Froben's death the publishing house was managed by his descendants until 1603.

Froment, Nicholas

(*c.*1425/30–*c.*1480/6), French painter, a native of Uzès (Languedoc) who worked in Avignon, where he painted in a style influenced by that of Flanders. His most important surviving paintings are a triptych of the *Resurrection of Lazarus* (1461, Uffizi, Florence), which has portraits of the donors on the outside, and a triptych of *The Burning Bush* (1475–6, Aix-en-Provence Cathedral).

Frueauf, Rueland the Elder

(*c.*1440/50–1507), Austrian painter, born in Salzburg, where from 1478 he worked principally for the Benedictine monastery. His paintings, notably his *Man of Sorrows* (Alte Pinakothek, Munich), show the stylistic influence of his older contemporary Conrad LAIB. In 1497 Frueauf moved to Passau, where he remained for the rest of his life.

furniture

Late Roman law and subsequent legal systems have distinguished between moveables (which are subject to ownership) and immoveables (which are subject to possession). The legal status of furniture as moveables is reflected in the terms used to denote furniture, such as French *meuble*, Italian *mobilio*, Spanish *mueblaje*, Portuguese *móveis*, German *Möbel*, and Danish *møbler*. The practice of noble families of travelling on progress through their territories meant that secular furniture was constructed in sections to facilitate it being moved on wagons from castle to castle. As late as the seventeenth century, much furniture was designed to be portable; in the late sixteenth century, furniture that was installed was said to be dormant: a 'dormant table' is one that is nailed to the floor. The visual balance between textiles and wooden furniture favoured the former: TAPESTRIES hung on walls, and CARPETS covered beds, tables, and chairs; floors were covered with rush matting.

In the fifteenth century, the courtly furniture of northern Europe was dominated by the INTERNATIONAL GOTHIC style. The most important centre for the commercial production of furniture was Antwerp. Medieval furniture had been constructed from planks, but this method was superseded in Flanders in the early fifteenth century, when the advent of joined PANELLING enabled much lighter furniture to be made. In northern Europe the preferred wood was oak, and elm was used as a cheaper substitute; in southern Europe the finest furniture was made from walnut, though cypress and several fruitwoods were also used.

North European furniture was often carved but not painted; in Italy the emphasis was on painted decoration until the sixteenth century: the fifteenth-century *CASSONE* was painted, but its sixteenth-century successor was usually carved. The Italian emphasis on colour is even apparent in unpainted furniture, because the development of INTARSIA allowed colour contrasts to be achieved without the use of paint.

In France and Burgundy, Renaissance decorative motifs are apparent in sixteenth-century furniture, which was often adorned with ACANTHUS or PUTTI. The Italian style, as interpreted at FONTAINEBLEAU, became the model for French furniture design. In about 1550 Jacques Androuet DUCERCEAU the Elder published a set of engraved designs for household furniture; in Burgundy, a set of designs was published by Hugues SAMBIN in Dijon in 1572. In Germany, Peter FLÖTNER pub-

lished engraved designs for furniture; an oak and ash cupboard built to one of his designs in 1541 is preserved in the Germanisches Nationalmuseum in Nuremberg. In the Netherlands Jan VREDEMAN DE VRIES published a pattern book (c.1580) that set the austere decorative style for Protestant furniture later adopted in the Evangelical Swiss Cantons and adapted in Scandinavia (where some courtly refinement survived). In Spain and Portugal a syncretic Iberian style of furniture blended European design with MUDÉJAR decorative traditions.

The most important pieces of furniture were BEDS, CABINETS, TABLES, and various kinds of seats (CHAIRS, SETTLES, AND STOOLS).

Fust, Johann

(c.1400–1466), German printer, a Mainz lawyer who in 1450 lent Johann GUTENBERG 800 gulden to finance the publication of the 42-line Bible. He subsequently invested another 800 gulden and became Gutenberg's partner. When Gutenberg became bankrupt in 1455, Fust assumed control of the press together with his son-in-law Peter SCHÖFFER. On 14 August 1457 Schöffer and Fust published the elegant Mainz Psalter, which was the first book to use colours, and in 1462 they published a two-volume Latin Bible. Their edition of Cicero's *De officiis* (1465) was the first book to contain Greek characters. Fust died of plague whilst on a business trip to Paris and was succeeded by Schöffer.

fustian

A coarse cloth with a cotton weft and a flax warp, first made in Fustat, the Arab capital of Egypt in the seventh and eighth centuries AD (now a set of ruins south of Cairo). The principal centres of fustian manufacturing in fourteenth- and fifteenth-century Europe were Spain, Tuscany, and southern Germany (especially Ulm) and Flanders. Until the end of the fifteenth century, fustians were bleached but not dyed. In England, fustian was imported (and much admired) in the fifteenth century; an indigenous industry developed in the later sixteenth century with the arrival in Norfolk and Lancashire of Flemish refugees from the Revolt of the Netherlands. The use of 'fustian' to mean gibberish originates (like 'bombast') in its association with Dutch; in Marlowe's *Doctor Faustus* a clown replies to a phrase in Latin with 'God forgive me, he speaks Dutch fustian'.

G

Gaddi, Agnolo

(*fl.* 1369, d. 1396), Italian painter, the son of Taddeo GADDI. As a young man he worked with his brother Giovanni in the Vatican. He contributed frescoes to the chancel (1374) and choir (1388–93) of the Church of Santa Croce in Florence, to the Chapel of the Holy Girdle (Cappella del Sacro Cingolo) in Prato Cathedral (1392–5), and to San Miniato al Monte in Florence (1393–6).

Gaddi, Taddeo

(*fl.* 1325, d. 1366), Italian painter, a native of Florence; he was for 24 years the assistant of GIOTTO. His finest surviving paintings were executed for the Church of Santa Croce in Florence, including a fresco series on *The Life of the Virgin* in the Baroncelli Chapel (1332–8), a fresco of *The Last Supper* in the refectory, and a series of panel paintings on *The Lives of Christ and St Francis* (*c.*1330) intended for the doors of a cupboard in the sacristy and now divided between the Accademia in Florence, the Residenzmuseum in Munich, and the Gemäldegalerie in Berlin. Gaddi subsequently worked in Pisa and Pistoia (where in 1353 he painted the polyptych altarpiece for San Giovanni Fuorcivitas), but eventually returned to Florence, where he became a member of the commission charged with responsibility for works on the cathedral.

Gaggini

or Gagini, Nibilio (*fl.* 1586, d. 1607), Sicilian goldsmith, the last prominent member of a family of Lombard sculptors who migrated to Sicily in the fifteenth century. His surviving works include an elaborate monstrance of 1586 (Chiesa Madre, Polizzi Generosa) and a reliquary of 1599 (Chiesa di San Giacomo, Caltagirone). His works disseminated the designs described in the treatises of Juan de ARFE.

Gaïlde, Jean

(*fl.* 1490–*c.*1519), French mason and sculptor who worked in Troyes, where he made the rood-screen in the Church of Sainte-Madeleine (1508–17), beneath which he is buried. The screen is one of the last great monuments of the GOTHIC tradition.

Gaillon

A chateau and garden near Rouen. The medieval fortress on the site was rebuilt in 1502 for Cardinal Georges d'Amboise, minister of King Louis XII; the castle was remodelled in the Renaissance style, and is now regarded as the first Renaissance chateau in France. The garden, which was designed by PACELLO DA MERCOGLIANO without architectural reference to the house, was laid out between 1502 and 1509 on a level terrace overlooking the Seine valley. The garden was bordered on two sides with galleries, and contained a wooden PAVILION sheltering a FOUNTAIN that had been made in Genoa and presented by the Venetian Senate. Planting was organized in ornamental PARTERRES in square beds, each of which was planted individually with flowers, fruit trees, or herbs against backgrounds of coloured earth, gravel, or terracotta; initially the beds were bordered with wooden fretwork, but this was later replaced by clipped box. One square was planted as a MAZE, and others were designed as coats of arms. Within the garden there was a private retreat called Le Lidieu, with its own house, chapel, and small garden. In the 1550s Charles, cardinal de Bourbon, aggrandized this private retreat in imitation of similar gardens built by the Italian princes of the Church, notably the Villa FARNESE; the house was transformed into a sumptuous *CASINO*, the Maison Blanche, a canal was dug, and a rock hermitage was constructed in the middle of a pool. In the same period a second garden was built at a lower level. Both

gardens were redesigned by Le Nôtre between 1691 and 1707, and have since disappeared, as has the chateau.

Gallego, Fernando

(fl. 1468–1507), Spanish painter of Galician extraction and the principal exponent of the Hispano-Flemish style in Spanish art. Between 1479 and 1493 he painted the ceiling of the Old Library at the University of Salamanca, but this now survives only in fragments; the university museum now houses the fresco that Fernando painted in 1494 for the semi-cupola of the old chapel, which was badly damaged in the Lisbon earthquake of 1755 (which was felt from Scotland to the Levant). Fernando also painted the reredos of San Idelfonso for Zamora Cathedral, the retable of the Church of San Lorenzo in Toro, the triptych of The Virgin, St Andrew, and St Christopher in the New Cathedral in Salamanca, and the macabre triptych of St Catherine in the Old Cathedral. His Piedad and Calvario are now in the Prado.

Garamond, Claude

(1480–1561), French type founder, a native of Paris who worked as a type founder for several Parisian printers. He designed the roman typeface now known as typi regii and the Greek type (now known as grecs du roi) used by Robert ESTIENNE in an edition of Eusebius (1544) commissioned by King Francis I. Garamond's typefaces were to influence French typography for centuries, and a modernized form of his typi regii is now known as Garamond.

Garofalo

or Benvenuto Tisi (1481–1559), Italian painter. He studied in Cremona, and after periods in Venice and Rome settled in Ferrara, where he worked with Dosso DOSSI and executed paintings for the churches of the duchy (e.g. Madonna of the Clouds, c.1514, Pinacoteca Nazionale, Ferrara). The onset of blindness forced him to retire from painting in 1550.

gauffering

A technique in BOOKBINDING in which the gilded edges of a book are decorated with the use of heated finishing tools. The technique was introduced in the mid-sixteenth century in France, where binders used pointed tools which they had heated to create dotted designs.

Geertgen tot Sint Jans

('Little Gerard of the Brethren of St John') or Geertgen van Haarlem (fl. 1475–95), Dutch painter, born in Leiden. He probably trained in the studio of Albert van OUWATER in Haarlem, where he subsequently worked for the religious order from which his name is taken. His only surviving documented works are two panels from an altarpiece painted for the Order's church, the Lamentation of Christ and the Burning of the Bones of St John the Baptist (both now in the Kunsthistorisches Museum in Vienna). These paintings depict brightly painted figures against landscape backgrounds; the doll-like features of the female figures are the most distinctive feature of Geertgen's style. The small canon of some fifteen pictures attributed to Geertgen on stylistic grounds includes a Nativity at Night in the National Gallery in London.

gems and diamonds

Gems are precious stones from a small number of mineral species, including corundums (e.g. sapphire, ruby, emerald, oriental amethyst), feldspars (e.g. moonstone), beryls (e.g. beryl, chrysoberyl, emerald, aquamarine), and quartzes (e.g. agate, amethyst, chalcedony, jasper, onyx, ROCK CRYSTAL, sardonyx). Gems are distinguished from diamonds, which consist of pure carbon crystallized into regular octahedrons, and from JET, which is fossilized driftwood.

Diamonds and the hardest corundums, such as rubies and sapphires, were considered too hard to be cut until the fifteenth century, when diamonds were first cut into a pyramidical shape known as a 'diamond point' or point naïve; the top of the diamond (known to lapidaries as the 'table') was sometimes flattened with a grindstone, and by the sixteenth century the 'table cut' was in use all over Europe for diamonds and gems. The modern 'rose cut', in which the table is replaced by a ring of six triangular facets rising to a single point and the surrounding crown consists of a further eighteen facets, was introduced in France in the mid-seventeenth century.

Engraved gems are either INTAGLIOS, with the design cut into the stone, or CAMEOS, with the design in relief; the art of engraving gems is sometimes called 'glyptics' or 'glyptography'. The principal centre of gem-engraving was Milan. Milanese gems were sold all over Europe, and collectors included Pope Paul II, Lorenzo

de' Medici, and the Emperor Rudolf II. Gems were valued for their natural beauty and for their craftsmanship, which sometimes aspired to virtuosity, as in the crowded intaglio *The Education of Bacchus* (fancifully known as the Signet of Michelangelo because its design derives from the Sistine Chapel) in the Bibliothèque Nationale in Paris; they were also valued for their magical and medicinal properties. Diamond-cutting was the particular province of Jews, particularly the Jewish communities in Amsterdam and Antwerp.

Genga, Gerolamo

(1476–1551), Italian painter and architect, born in Urbino, where he may have trained with Luca SIGNORELLI. In 1502 he accompanied PERUGINO to Florence; several years later he moved to Siena, where his attributed works include frescoes (now detached) of *The Ransoming of Prisoners* and *The Flight of Aeneas from Troy* (Pinacoteca, Siena). On returning to Urbino in 1522 he worked as a court painter and architect. His commissions for the Della Rovere Dukes of Urbino included the restoration and decoration of the Sforza Villa Imperiale (at Colle San Bartolo near Pesaro), to which he contributed stuccoed ceilings, MAIOLICA floors, and a fresco cycle (*c.*1529–32) extending over eight rooms. He subsequently built a second villa on the same site; this villa, which is known as the Della Rovere Villa Imperiale, was not completed until the early twentieth century.

genre painting

The art-historical term for pictures that depict scenes and subjects from everyday life. The French term *genre* was first used of paintings in eighteenth-century France, where it distinguished paintings that depicted scenes and subjects from everyday life from paintings that depicted subjects such as LANDSCAPE and STILL LIFE. The term was imported into English in the mid-nineteenth century. The publication of Jakob Burckhardt's lecture on *Netherlandish Genre Painting* in 1874 narrowed the meaning of the term, which is now used primarily with reference to the subject matter of Dutch painters.

The origins of genre painting lie in northern Europe, where the iconoclasm of the Reformation severely reduced the market for paintings with religious subjects. Painters such as Pieter AERTSEN and Pieter BRUEGEL the Elder portrayed peasants in their everyday surroundings, and so inaugurated a tradition that in the seventeenth century developed into the Dutch School of genre painters, which reached its apogee in the paintings of Vermeer.

Genre painting came late to Italy, but at the end of the sixteenth century the characteristic subjects of genre painting began to appear in the paintings of CARAVAGGIO and the CARRACCI family.

Gentile da Fabriano

(*c.*1385–1427), Italian painter, born in Fabriano (Marches); by 1408 he was employed in Venice painting frescoes (now lost) for the Doge's Palace; his pupils in Venice included Jacopo BELLINI. His most important painting from his Venetian period is the polyptych of *The Coronation of the Virgin* (Brera, Milan). In 1413 Gentile entered the service of Pandolfo Malatesta, and for the next five years lived in Brescia, where he painted frescoes in the chapel of the courthouse (fragments have recently been recovered). In 1420 Gentile moved to Florence, where in 1423 he painted *The Adoration of the Magi*, an altarpiece commissioned for the sacristy of the Church of Santa Trinita in Florence and now in the Uffizi; this painting is now regarded as one of the finest surviving examples of the INTERNATIONAL GOTHIC style in panel painting. In 1425 Gentile painted the Quaratesi Polyptych, of which the elegant *Madonna* is in the Royal Collection in London (on loan to the National Gallery), the saints in the Uffizi, and the predella panels in the Vatican (which has four) and the National Gallery in Washington (which has the fifth, *Pilgrims at the Tomb of St Nicholas*). Both pictures influenced the subsequent development of Florentine art.

In 1425 Gentile left Florence for Siena and Orvieto, and in 1427 moved to Rome, where he painted frescoes (now lost) in the Basilica of San Giovanni in Laterano.

Gentili, Antonio

(1519–1609), Italian silversmith, born in Faenza, the son of a goldsmith. He moved to Rome, where he was admitted to the guild in 1552, and served as assayer to the papal mint from 1586 to 1602, when he resigned in favour of his son Pietro. Gentili specialized in ecclesiastical silver, but very little of his work can now be identified.

In 1578, two years after the death of Manno SBARRI, Cardinal Alessandro Farnese asked Gentili to complete the altar set (a cross and two monumental candlesticks) which Sbarri had been making for St Peter's. Gentili completed

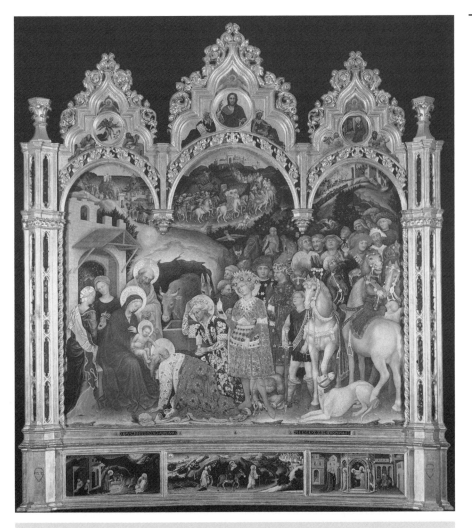

Gentile da Fabriano, *The Adoration of the Magi* (1423), in the Uffizi Gallery, Florence. This altarpiece was commissioned for the sacristy of Santa Trinita by a member of the Strozzi family, and so is known as the Strozzi altarpiece. The main panel shows the three Magi, with their horses and retinue to the right, and, in the background under the arches, scenes from their journey. The three predella panels depict the *Nativity*, the *Flight into Egypt* (both still part of the altarpiece), and the *Presentation in the Temple* (now in the Louvre; a copy has been inserted in its place in the altarpiece). The altarpiece, which proved to be one of the most influential of early fifteenth-century paintings, is chiefly remarkable for its perspectival coherence (especially in the predella panels) and its sophisticated use of light (e.g. the scenes under the arches are lit by the star).

the task and signed the altar set before it was placed in the sacristy of St Peter's in 1582, but his precise role in this collaborative work has been the subject of scholarly debate.

The only silverwork known to be entirely Gentili's own work is the silver binding of the Farnese Hours, a Book of Hours painted by Giulio CLOVIO for Cardinal Alessandro Farnese

and now in the Pierpont Morgan Library in New York.

Gerhaert van Leiden, Nicolaas

or (German) Nicolaus (*fl.* 1462–73), Dutch sculptor in Strassburg (of which he became a citizen in 1464), Trier, Constance, Baden, and Vienna; virtually nothing is known of his life, but the

style of his warmly sympathetic portraits of contemporary and biblical figures is so distinctive that the canon of his work is relatively stable. His best-known work is the tomb of the Emperor Friedrich III in St Stephen's Cathedral in Vienna.

Gerhard, Hubert

(*c*.1545–*c*.1620), Dutch sculptor in Germany who worked in the service of the Fugger family in Augsburg (from 1581) and the Wittelsbach ducal court in Munich (from 1584) and Innsbruck (from 1597). His surviving work includes the FOUNTAINS made for the city of Augsburg (Augustus Fountain, 1594) and for the Fugger castle (1583–95) at Kirchheim unter Teck (for which he also made many decorative fittings) and sculptures for the ducal Residenz in Munich.

gesso

A paste based on gypsum (plaster of Paris), used primarily by sculptors as a medium for casts, but also used for the decoration of furniture, especially CASSONI, and as the ground laid onto panels for panel paintings. It was usually mixed with linseed oil and then applied in thin layers to the surface; it could be moulded when still malleable and carved and gilded when hardened.

Gheeraerts, Marcus the Elder

(*c*.1520–*c*.1590) and Marcus the Younger (1561–1636), Flemish artists in England. Marcus the Elder was active as an engraver in England from 1568, but no painting from this period can be confidently attributed to him. His son Marcus the Younger, who had been trained by his father and Lucas de HEERE, worked alongside the DE CRITZ and OLIVER families. Attributions are problematical, but one painting that can be securely attributed to Marcus the Younger is his portrait of *Queen Elizabeth I* (National Portrait Gallery, London); this portrait, which portrays the queen standing on a map of England on a large globe, has been cut back on both sides, but is nonetheless the largest extant portrait of the queen.

Gheyn, Jacques de, the Younger

(1565–1629), Dutch painter and engraver, the son of Jacques de Gheyn the Elder (1537/8–1581), a glass painter and miniaturist from Antwerp. Jacques the Younger studied in the late 1580s with Hendrik GOLTZIUS, whose influence is discernible both in the lushness of his LANDSCAPE paintings and in the satirical edge of his depictions of contemporary fashions in clothing and behaviour. He entered the service of the Orange family at The Hague, and in 1620 contributed the GROTTO (the first in a Dutch garden) to the garden commissioned by Maurice of Nassau.

Ghiberti, Lorenzo

(1378–1455), Italian bronze sculptor, born in Florence, where he trained as a goldsmith and painter. In 1401 he won the competition sponsored by the Arte di Calimala (Guild of Cloth-Dealers and Refiners) to execute a pair of bronze doors intended for the east portal of the baptistery in Florence; the six sculptors that he defeated included BRUNELLESCHI and JACOPO DELLA QUERCIA; the trial pieces depicting *Abraham and Isaac* prepared by Ghiberti and Brunelleschi are both now in the Bargello. Work on the east doors occupied the first half of Ghiberti's career, from 1403 to 1424, and their completion (and removal to the north portal, where they remain) led to the commission of new doors for the east portal (1425–52), which MICHELANGELO famously described as the 'gates of paradise'. The 28 panels of the north doors, which are modelled on Andrea PISANO's earlier doors and executed in an INTERNATIONAL GOTHIC style, depict the life of Jesus (twenty panels) and portray the four evangelists and four doctors of the Church; Ghiberti's assistants during the years when he worked on the doors included DONATELLO and Paolo UCCELLO. The ten panels of the east doors, which depict scenes from the Old Testament, show many features of Renaissance art, including attentiveness to the possibilities of perspective.

Marcus **Gheeraerts** the Younger, *Queen Elizabeth* (c.1592), in the National Portrait Gallery, London. This painting is known as the 'Ditchley Portrait' because it was commissioned by (or for) Sir Henry Lee, a courtier who had entertained the queen at his house at Ditchley, in Oxfordshire. Elizabeth is standing on a globe of the world, with her feet on Oxfordshire. The sonnet on the right may be the work of Lee.

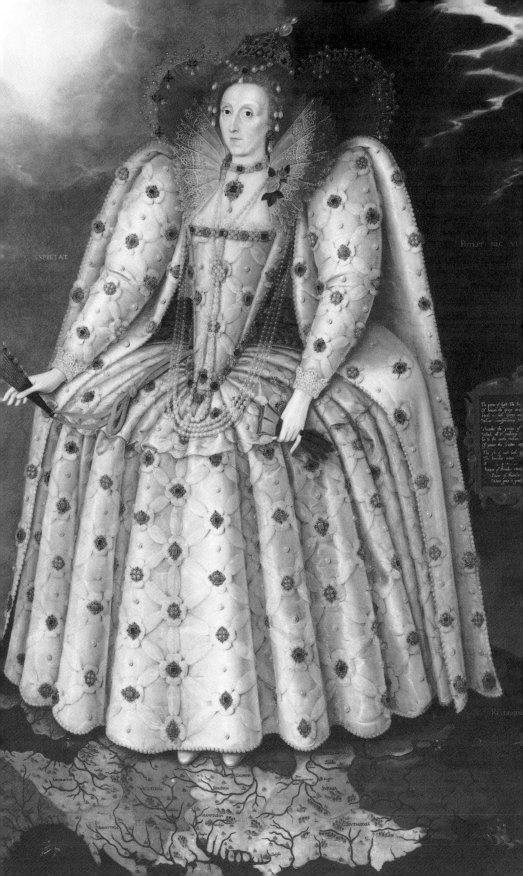

Ghiberti's other commissions include three large bronze statues for Orsanmichele: *St John the Baptist* (1412), *St Matthew* (1419), and *St Stephen* (1426–8). He also made two reliefs for the baptistery at Siena and smaller pieces such as bronze reliquaries. His writings, which were unpublished during his lifetime, comprised three volumes of *Commentaries* in which he discusses fourteenth-century Tuscan artists and drafts his autobiography, the first autobiography by a Renaissance artist.

Ghirlandaio, Domenico Bigordi

(1448/9–94), Italian painter, born in Florence, the son of a goldsmith. He established a workshop together with his two younger brothers, and this *bottega* specialized in altarpieces, of which many survive. Ghirlandaio's unassisted work consisted largely of frescoes, of which the earliest example is the *Last Supper* (1480) in the refectory of the Ognissanti in Florence. He populated his fresco of *Jesus Calling the First Apostles* in the SISTINE CHAPEL in Rome (1481–2) with portraits of prominent Florentines living in Rome, and it seems likely that this pictorial flattery led to further commissions in which Ghirlandaio immortalized wealthy patrons in his paintings, such as the cycle on *The Life of Saint Francis* in the family chapel of Francesco Sassetti in the Church of Santa Trinita in Florence.

Ghirlandaio's most important commission, given to him by Giovanni Tornabuoni (a partner in the Medici Bank), was a fresco cycle on *The Lives of the Virgin and St John the Baptist* (1486–90) in the choir of Santa Maria Novella in Florence; this cycle contains portraits of the Tornabuoni family, and in the domestic settings of the two birth scenes provides a visual record of middle-class life in late fifteenth-century Florence. This documentary impulse is also apparent in Ghirlandaio's panel paintings, notably in his *Old Man and his Grandson* (Louvre), which is at once tender in its representation of human emotions and harsh in its uncompromising representation of elephantiasis.

Ghirlandaio's most famous pupil was MICHELANGELO, who through CONDIVI, his ghost-writer, attempted to play down the influence of Ghirlandaio; VASARI contested this attempt to deny Ghirlandaio's influence, which is most readily apparent in the cross-hatching of Michelangelo's early drawings. Ghirlandaio's son Ridolfo Bigordi (1483–1561) was a portrait painter and a friend of RAPHAEL.

Giambologna

or Giovanni Bologna or Jean Boulogne (1529–1608), Flemish sculptor. He was born in Douai and trained as a sculptor with Jacques DU BROEUCQ in Mons; the 'Bologna' in his name refers to the French port of Boulogne, not the Italian city of Bologna. In 1554 or 1555 he set out on a journey to Italy; he spent two years in Rome and then moved to Florence, where he settled permanently.

Many of Giambologna's finest works are FOUNTAINS, the first of which was the bronze Fontana del Nettuno (1563–6) commissioned by Pope Pius IV for Bologna and still *in situ*. He subsequently built the Fountain of Venus at the Villa Petraia near Florence, the Ocean Fountain in the BOBOLI GARDENS, and the huge Apennine Fountain for PRATOLINO; his *Hercules and the Centaur* (now in the Loggia dei Lanzi in Florence) and *Samson and a Philistine* (Victoria and Albert Museum) were designed as centrepieces for fountains. Giambologna's other works, some of which were executed to his designs by collaborators such as Pietro FRANCAVILLA and Antonio Susini, included the bronze statues and reliefs for the Grimaldi Chapel in Genoa, and EQUESTRIAN STATUES of King Henri IV for Paris (erected on the Pont Neuf and damaged at the French Revolution and now in the Musée des Beaux-Arts in Dijon) and of Grand Duke Cosimo de' Medici (1587–93, Piazza della Signoria, Florence). His most important marble group is the spiralling *Rape of a Sabine* (1579–83) in the Loggia dei Lanzi in Florence, which was carved from a single block of marble.

Giambologna, *Rape of a Sabine* (1579–83), in the Loggia dei Lanzi, Florence (front view; see also p. 112). The Sabine woman is being abducted (that being the Latinate sense of 'rape') by a Roman who has taken her from the man below. The group is carved from a single block of marble; the gaps between the three figures reflect Giambologna's study of Hellenistic sculpture. The interlocked figures turn in a rising spiral, a mannerist device known as the *figura serpentina*. The consequence of this innovative device is that this is the first sculpture to have no principal viewpoint.

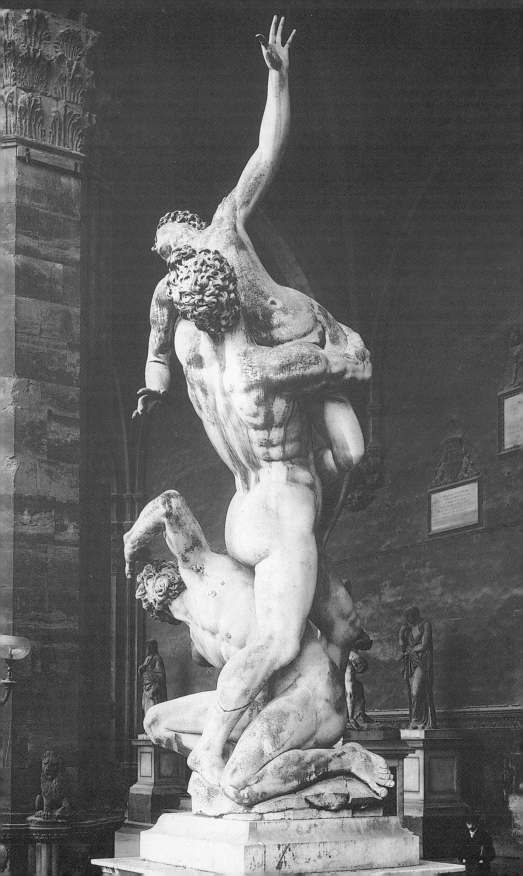

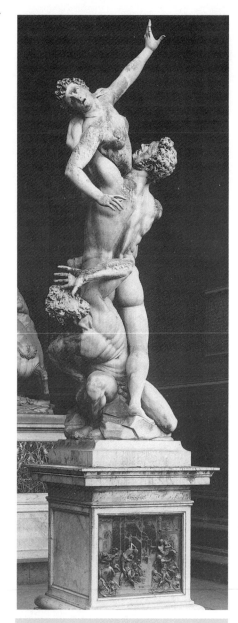

Giambologna, *Rape of a Sabine* (1579–83), in the Loggia dei Lanzi in Florence (rear view).

Gian Cristoforo Romano

See ROMANO, GIAN CRISTOFORO.

giardino segreto

The tradition of the *hortus conclusus* (Latin; 'enclosed garden') was long associated with the virginity of Mary the mother of Jesus, and the roses that it contained were deemed to represent her virtue. The analogies originate in the Song of Solomon 4: 12 ('a garden enclosed is my sister, my spouse, a spring shut up, a fountain sealed'); the fountain metaphor was also related to the biblical metaphor of the fountain of life (Latin *fons vitae*). In literature the *hortus conclusus* (or 'Mary garden') was an allegorical garden compared to the prelapsarian garden of Eden. When implemented in stone and soil, the enclosed garden became a walled or hedged rose garden with a FOUNTAIN, covered walks, and arbours; there was often a turfed seat built against the outer wall or a central fountain or tree, or set into a hedge.

The Renaissance *giardino segreto* (Italian; 'secret garden') is the secular progeny of the medieval *hortus conclusus*. It first appeared in Italian gardens of the fifteenth century as an enclosed outdoor room, and quickly became adapted to the secular purposes of those gardens. In the MEDICI VILLA at Fiesole and the Villa Piccolomini in Pienza, for example, it became a place from which to admire distant vistas. In the VILLAS of Frascati, notably ALDOBRANDINI, the *giardini segreti* are tucked away on one side of the villas, and at the Villa FARNESE, the finest *giardino segreto* of the Renaissance is hidden at the end of a path some 365 metres (400 yards) long.

Gil de Hontañón, Juan the Elder

(*c*.1480–1526), Juan the Younger (*fl.* 1521–31), and Rodrigo (1500–77), the family of Spanish architects responsible for the sixteenth-century Gothic cathedrals of Salamanca and Segovia. Juan Gil the Elder was one of the nine architects assembled in 1512 to discuss the construction of the new cathedral at Salamanca, and he was commissioned to build the cathedral. He was also the architect of Segovia Cathedral, and embarked on its construction *c*.1525. He served as master of the works at Seville Cathedral from 1513 to 1517. In the early 1520s he was assisted by his son Juan Gil the Younger, who succeeded him as architect at Salamanca, where he worked from 1526 to 1531.

Rodrigo Gil was another son of Juan Gil the Elder, and he worked as cathedral architect at Segovia (1521–9) and at Salamanca (from 1538); he also served as master of the works on the cathedrals of Astorga and Palencia. All four of these cathedrals are uncompromisingly Gothic in style. Rodrigo was, however, capable of

working at the highest level in the markedly different idiom of the Renaissance-PLATERESQUE style: the façade (see p. 211) that he constructed for the University of Alcalá (1541–53) is one of the greatest secular buildings of the Spanish Renaissance.

Gili, Paolo

(fl. 1518–66), Sicilian goldsmith whose studio was in Palermo. His early work, such as his reliquary of 1531 for the arm of Sant'Agata (Palermo Cathedral), is wholly Gothic in design and decorative detail, but he later adopted a Renaissance style with distinctive Spanish elements which is represented in a crozier in the Galleria Nazionale in Palermo and a reliquary of 1540/66 for Santa Cristina (Palermo Cathedral).

Gilio da Fabriano, Giovanni Andrea

(d. 1584), Italian art theorist who articulated the position taken by the Council of Trent on the subject of art. His *Dialogo degli errori della pittura* (1564), which was dedicated to Cardinal Alessandro Farnese, inveighed against nudity in pictures and enjoined artists to conform to biblical sources and official dogma.

giochi d'acqua

(Italian; 'water-games'). The term is sometimes used with general reference to water-powered AUTOMATA in gardens such as Villa ALDOBRANDINI and Villa PRATOLINO, but usually refers specifically to devices in sixteenth- and seventeenth-century gardens designed to drench the unsuspecting visitor. The technology that underlay *giochi d'acqua* was transmitted through the Arabic tradition from its classical origins in HERON. In 1588 Montaigne described such a device at the MEDICI VILLA at Castello, explaining that it could be operated by remote control from a distance of 200 paces. Visitors who strayed onto a certain path in the garden at ARANJUEZ were sprayed when they triggered the mechanism. The Fontana della Girandola built in 1614 at the Borghese villa of MONDRAGONE in Frascati contained polypriapic *giochi d'acqua* which soaked visitors who risked playing a water-game. To modern tastes these devices may seem puerile and, at Mondragone, vulgar, but they were repeatedly described by contemporaries as the most remarkable features of gardens, partly because of their technical ingenuity, but also because they appealed to contemporary tastes.

Giocondo, Fra

or Fra Giovanni Giocondo da Verona (1433 –1515), Italian architect, engineer, and humanist. He was born in Verona, and as a young man seems to have become a Dominican friar. He worked in Naples as an architectural consultant (1489–93), and there designed fortifications and gardens. He subsequently moved to France, where he replanned the irrigation system at BLOIS and then built the Pont Notre-Dame in Paris (1500–8), which had collapsed in 1413; he lined the bridge with identical houses with sumptuous façades. This bridge was in turn destroyed, and the present bridge was erected in 1913.

Fra Giocondo returned to Italy, where he was initially employed by the Venetian republic as a hydraulic engineer on the river Brenta and then as a military architect responsible for the construction of fortifications at Cremona, Legnano, Padua, and Treviso. In 1514 he was called to Rome, where he assumed responsibility for the construction of ST PETER'S BASILICA during BRAMANTE's final illness; after Bramante's death Fra Giocondo shared responsibility for the basilica with RAPHAEL.

Giolito Press

A publishing house founded in Venice in 1536 by Giovanni Giolito de' Ferrari and subsequently managed by his son Gabriele (d. 1578). In the 1540s and 1550s Gabriele established the press as the most important vernacular publisher in Italy, producing a large number of dialogues, novellas, and collections of poems and letters by authors such as Aretino, Ariosto, Castiglione, Ludovico Dolce, Anton Francesco Doni, and Tullia d'Aragona. In the 1560s the emergence of the Counter-Reformation led to many secular authors being added to the *Index* (the list of prohibited books), and Giolito therefore began to publish popular religious works. By the end of the century, when the business closed, the Giolito Press had published more than 1,000 titles, each of which bore the emblem of a phoenix rising from the flames.

Giorgione

or Giorgio da Castelfranco or Giorgio Barbarelli (c.1478–1510), Italian painter, born in Venice, where he may have trained in the studio of Giovanni BELLINI alongside Lorenzo LOTTO and PALMA VECCHIO. In 1507 he received a commission to paint pictures for the Audience

Chamber in the Doge's Palace (all of which have been destroyed) and frescoes for the façade of the Fondaco dei Tedeschi (now discernible only in faint traces; a few fragments are preserved in the Ca' d'Oro). Little documentation exists for Giorgione's other paintings, none of which is signed or dated and many of which were completed by his pupils (including TITIAN) after his premature death by plague.

Giorgione's early paintings include the *Castelfranco Madonna* (Church of San Liberale, Castelfranco, Veneto) and *Judith* (Hermitage, St Petersburg), both of which have a symmetrical rigidity of composition softened by the subtle use of colours that recalls Bellini's late paintings. The painting that marks a change in Giorgione's style is the *Tempesta* (Accademia, Venice), the subject of which (possibly the infant Paris) is not clear; this is the first painting in which both the figures and the landscape have been subordinated to the intensity of mood, which is expressed in the storm that breaks over the city. In the *Three Philosophers* (Kunsthistorisches Museum, Vienna), which may represent the Magi waiting for the guidance of the star, Giorgione abandons symmetry and articulates mood in his presentation of the landscape; the picture may have been finished by SEBASTIANO DEL PIOMBO. The portrait of *Laura* (Kunsthistorisches Museum, Vienna) in front of a laurel that puns on her name was attributed to Giorgione in the sixteenth century, when someone wrote on the back that it was the work of 'Zorzo di Castelfranco'; the use of SFUMATO may imply a familiarity with the portraits of LEONARDO, who had visited Venice in 1500.

The paintings left unfinished on Giorgione's death include the *Sleeping Venus* (Gemäldegalerie, Dresden) and *Fête champêtre* (Louvre). Titian finished both paintings, and the latter may be entirely his work, though the two nude women are sometimes claimed for Giorgione.

The surviving corpus of Giorgione's paintings is not large, and several are imperfectly understood both with respect to their subjects and to the precise extent of Giorgione's involvement. In the historiography of Venetian painting, however, Giorgione is recognized as an innovator who built on the achievements of Bellini in the use of colour and proportion by uniting his figures and landscapes through the evocation of atmosphere and the secularization of feeling, and so changing the course of Venetian art.

Giotto di Bondone

(1267/75–1337), Italian painter and architect, a native of Florence. The documentary record of his life is sparse: he owned a house in Florence in 1305, joined the Guild of Painters in 1311, lived from 1329 to 1333 in Naples as court painter to Robert of Anjou, became *capomaestro* (master mason) of Florence Cathedral in 1334, lived in Milan in the service of the Visconti in 1335–6 and died in January 1337. No contemporary record associates Giotto with an extant painting.

The attribution to Giotto of the fresco cycle of *The Lives of the Virgin and Christ* (1305–8; see p. ix) in the Arena Chapel in Padua is widely regarded as secure, and the altarpiece of *The Madonna Enthroned* painted for the Church of the Ognissanti in Florence (and now in the Uffizi) is in the same style. The fresco cycle of *The Life of St Francis* in the Upper Church of San Francesco in Assisi (1297–c.1305) was for centuries attributed to Giotto, but is now attributed to an unidentified 'Master of the St Francis Legend'; the last three scenes in the cycle, which are executed in a different style, are attributed to an anonymous 'Master of St Cecilia'. The attribution of this cycle to Giotto is the central plank of VASARI's argument that 'Giotto alone succeeded in resuscitating art and restoring it to a true path'; Vasari's comment later became embedded in the historiography of Renaissance painting, of which Giotto became the founding father.

Giotto's only architectural work was the campanile of Florence Cathedral, which he began in 1334, when he was appointed *capomaestro* of the cathedral and the city. By the time of his death he had completed only the first storey of the socle (Italian *zoccolo*); the tower was later completed (to altered plans) by Andrea PISANO and Francesco TALENTI.

Giovanni Dalmata

or Ivan Duknović (c.1440–after 1509), Dalmatian sculptor and architect. He was born in Traù (Croatian Trogir), moved to Italy as a young man, and trained in the studio of Andrea BREGNO in Rome. He subsequently collaborated with another sculptor (possibly MINO DA FIESOLE) on the tomb of Pope Paul II in Old St Peter's Basilica (1474–7; destroyed, but fragments are preserved in the Grotte Vaticane and the Louvre) and also carved the tomb of Cardinal Barto Lommeo Roveralla in the Church of San Clemente in Rome (1476–7); his work as an architect included

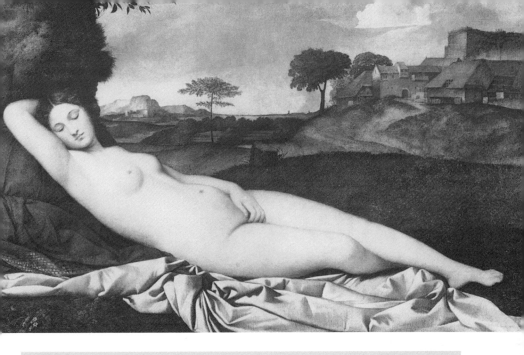

Giorgione, *Sleeping Venus* (*c.*1510), Gemäldegalerie, Dresden; the painting was left unfinished at Giorgione's death, and was completed by Titian. The painting inaugurated the long-lived tradition of the female nude being portrayed in a landscape setting.

part of the Palazzo Venezia in Rome. From 1480 to 1491 he worked in Hungary in the service of Matthias Corvinus; his surviving works from this period include a statue of *Hercules with the Hydra of Lerna* (Višegrad Palace) and a bas-relief of the *Virgin with Two Saints* (Museum of Fine Arts, Budapest).

Giovanni da Maiano

(*fl.* 1520–5), Tuscan sculptor. He worked on the construction of Hampton Court, where he carved the terracotta roundels of Roman emperors (for which he submitted a bill in 1525) and may have sculpted the relief of putti holding the Wolsey arms on the same building. This decorative sculpture is one of the earliest examples of the Italian Renaissance style in England.

Giovanni da Udine

or Giovanni Recamador (1487–1561/4), Italian painter and architect, born in Udine. He moved to Rome and entered the workshop of RAPHAEL, for whom he assumed responsibility for the decoration of the Vatican Loggias (1517–19) and the Villa MADAMA (1519). Giovanni made extensive use of GROTESQUES in his decorative work, which was executed in a combina-tion of fresco and stucco; his style remained in-fluential for centuries, especially in the work of eighteenth-century neoclassical designers. He later returned to Udine, where he became city architect in 1522.

Giovanni da Verona, Fra

(*c.*1457–1525/6), Italian woodworker and INTAR-SIA craftsman, best known for his work in the Church of Santa Maria in Organo in Verona, where he built the choir, candelabra, and lectern (1494–9); he subsequently returned to build the sacristy cupboards (1519–23). Fra Giovanni was also responsible for the panels in the choir (commissioned 1502) of the abbey of Monte Oliveto Maggiore (35 kilometres (22 miles) south-east of Siena), which he built with the assistance of Fra Raffaele da Brescia (1479–1538); the intarsia includes depictions of birds, architectural perspectives, musical instru-ments, and the Town Hall of Siena.

Giovanni di Paolo

(*c.*1399–1482), Italian painter, the most individu-alistic painter and the most aggressive exponent of an archaic style in fifteenth-century Siena. His surviving paintings include *Paradise* and the

Creation and Expulsion from Paradise (both in the Metropolitan Museum in New York). He also painted a series of illustrations for Dante's *Divine Comedy* (1438–44, British Museum).

Giovanni Maria di Mariano

(*fl.* 1508–30), Italian MAIOLICA painter who worked in CASTEL DURANTE (1508), Urbino (1508 and 1530), and Venice (1523). The canon of his works has been reduced by scholarly scrutiny, but those that remain secure are typically plates decorated with allegorical subjects surrounded by GROTESQUE borders.

girdle-books

Small devotional books with lavish bindings decorated with gold, enamel, and jewels. The books were worn hanging from the belt, for which the sixteenth-century English word is 'girdle'. The British Museum has a girdle-book attributed to Hans van Antwerpen (1540–5). The girdle-book of Princess Augusta of Denmark (1617) is in the Rosenburg Palace in Copenhagen.

Girolamo da Carpi

(1501–56), Italian painter and architect. He trained in the Ferrara studio of GAROFALO and subsequently worked in the service of the Este family as an architect and decorator; he also worked in Parma, Modena, and Rome; his Roman notebook (now dispersed) reflects his interest in the decorative motifs of antiquity. Girolamo's paintings include copies of works by CORREGGIO and PARMIGIANINO and original paintings for churches in Bologna (notably an *Adoration of the Magi* for San Martino) and Ferrara (including three paintings in the cathedral).

Giulia, Villa

or Villa de Papa Giulio, a Roman VILLA built by Giacomo VIGNOLA, Bartolomeo AMMANATI, and Giorgio VASARI for Pope Julius III (1551–5), who consulted MICHELANGELO on details of its construction. The villa was connected to a dock on the Tiber by a majestic walk lined by 36,000 trees; visitors of state requiring a ceremonial entry to Rome proceeded up the path to the villa where they were accommodated.

The principal courtyard, which is modelled on the imperial villas of antiquity, is built as a porticoed semicircle; the curved façade of the villa embraces the courtyard and is extended by a colonnade that meets the screen dividing the courtyard from a sunken NYMPHAEUM with a mosaic on the floor. At the end of the garden there is a small GIARDINO SEGRETO.

The villa was richly decorated with *topia* (landscape paintings) and statues, but the internal decoration has disappeared, and on the death of Julius III the collection of statues was removed to the Vatican; the boats carrying the statues had to undertake 160 journeys to complete the job. By 1569 the villa had been completely emptied; it now accommodates an Etruscan museum.

Giuliano da Maiano

(1432–90), Italian architect, the elder brother of BENEDETTO DA MAIANO. As a young man he worked as a woodcarver and INTARSIATORE, notably on the choir stalls in Pisa Cathedral and on the cupboards (still in place) in the New Sacristy of Florence Cathedral (1463–5). He subsequently worked as an architect in Tuscany and in Naples, and from 1477 served as architect to Florence Cathedral. His greatest surviving building is Faenza Cathedral (1474–86), on which the façade was left unfinished; he also built the Chapel of Santa Fina in the cathedral in San Gimignano (1468), Palazzo Spannocchi in Siena (1473) and Palazzo Venier (1477, later rebuilt), and the doorway of the Church of San Domenico in Recanati. In Naples he built the Porta Capuana (1484) and was probably the architect of three chapels in the Church of Monte Oliveto.

Giulio Romano

or Giulio Pippi or Giuliano Giannuzzi (*c.*1499–1546), Italian painter and architect, born in Rome, where he trained in the studio of RAPHAEL. He worked as Raphael's assistant on the Sala del Incendio (1515), and after Raphael's death in 1520 finished several of his works, including the *Transfiguration* and the Sala di Costantino frescoes in the Vatican; he also worked with GIOVANNI DA UDINE on the painted and stucco decorations of Raphael's Villa MADAMA.

Giulio's earliest independent paintings were a *Madonna* for the Church of Santa Maria dell'Anima in Rome and *The Stoning of St Stephen* for the Church of Santo Stefano in Genoa. He began his career as an architect in Rome, where his first buildings were the Palazzo Adimari Salviati (from 1520, later altered), the Villa Lante on the Gianicolo (from 1520/1, now the Finnish Academy), and the Palazzo Stati Maccarani in Piazza Sant'Eustachio (from 1522/3, now the Palazzo di Brazza).

In 1524 Giulio designed a set of erotic prints that displeased the Vatican and was obliged to leave Rome. He sought refuge in Mantua, where he entered the service of Federico II Gonzaga, who commissioned Giulio's finest building, the Palazzo del TÈ (1525–35). Giulio painted frescoes in the Palazzo del Tè (notably those in the Sala de' Giganti) and in the Sala di Troia (1536–9) of the Palazzo Ducale in Mantua. His other architectural projects in Mantua were the Cortile della Cavallerizza in the Palazzo Ducale (from 1539), the remodelling of the cathedral (from 1545), and the construction and decoration of his own house (1544–6), which is now a museum. Beyond Italy, Giulio may have been the architect of the Italian wing of the Stadtresidenz at Landshut (1537–43), in Germany.

Giulio Romano is mentioned in Shakespeare's *Winter's Tale* as a sculptor, but is not known to have worked as one.

Giunti Press

A group of three publishing houses, the first of which was established in Venice by Luca Antonio Giunti the Elder (1457–1538), a Florentine who had moved to Venice in 1477. The first book to be published by the press was an Italian translation of the *De imitatione Christi* of Thomas à Kempis, which appeared on 26 November 1489; by the end of the century another 52 titles had been published. The press specialized in liturgical works, and throughout the sixteenth century the Venetian branch of the Giunti Press was the largest publisher of liturgical works in Europe. In the last quarter of the sixteenth century the press was managed by Luca Antonio Giunti the Younger (1542–1602), who ruthlessly protected his virtual monopoly of liturgical works; by the time of his death the press had published more than 1,000 books. By the time it closed in 1657, the Venetian Giunti Press had published almost 1,500 books.

The Florentine branch of the Giunti Press was founded by Filippo Giunti (1450–1517) in 1497. It published vernacular texts, but also competed with the Aldine Press of ALDUS MANUTIUS by publishing classical texts in Latin and Greek; by 1600 it had published some 500 volumes. The Lyon branch of the Giunti Press was founded by Giacomo Giunti (nephew of Luca Antonio) in 1520 and survived until 1592. Its books include many counterfeit versions of Aldine editions, prepared with the connivance of Luca Antonio the Elder.

All three branches of the press affixed the family emblem (an adaptation of the Florentine lily) to their books, except for forgeries.

Giusti, Giardino dei

The Giardino dei Giusti in Verona has been owned by the same family for centuries. Its origins are unknown, but the fact that the family incorporated the garden into their surname (the full family name is Giusti del Giardino — the Giusti of the Garden) implies that it must have been the earliest important garden in Verona. The designer is not known, nor does any documentation survive, so details of the original garden can only be inferred from the enthusiastic descriptions of generations of travellers for whom this was one of Italy's greatest gardens. The English traveller Thomas Coryate extolled the garden as a second paradise, and described its terraces planted with figs, oranges, and apricots, its 33 rows of cypress trees, and a small refectory containing an artificial rock decorated with scallop shells; this last detail reflects the Tuscan origins of the family, as decorative shells are a feature of GROTTOES in Tuscan gardens such as the BOBOLI GARDENS. John Evelyn was chiefly impressed by the cypresses, describing one by the gate as 'the goodliest in Europe'.

In the nineteenth century the garden was redesigned as an English landscape garden, and the only original features to survive this restoration were a small CASINO and some of the cypresses; most of the remaining cypresses were destroyed by bombs during the Second World War.

glass

An artificial compound made by fusing a silica (usually sand or quartz) with an alkaline flux (usually soda-ash or potash) in a furnace. The silica was usually sand, but quartz was also in use for fine glass: the quality of Venetian glass was enhanced by the use of white quartz pebbles quarried from local river beds. In Mediterranean glasshouses the usual alkali was soda-ash, which since antiquity had been derived from soda-bearing seaweeds; in northern centres such as Bohemia, Germany, and England, potash (brushwood ash) was used as the alkali. Until the fifteenth century, the presence of iron in the silicates resulted in glass that was tinted with green or brown. Venetian glassmakers discovered that the addition of

manganese dioxide to the compound would remove the tints and clarify the glass (an effect later achieved with arsenic and nickel); the clarity of their glass was comparable to that of ROCK CRYSTAL and so came to be known as *vetro di cristallo* (crystal glass), from which English 'crystal' and Spanish *cristal* derive. Lead oxide was added in small quantities to the compound to give weight and clarity to glass, but did not become a major ingredient until the late seventeenth century, when English glassmakers replaced imported Venetian quartz with indigenous flint, which caused interior cracks in the glass; the solution to the problem was a substantial admixture of lead, which produced the glass now known as lead crystal. In Venice, Bohemia, and Germany a similar effect was achieved by the use of lime rather than lead.

The two techniques for making glass were moulding and blowing. Moulding was a technique in which ductile glass was pressed onto a shaped mould. This technique was particularly useful for the production of CAMEO glass, which consisted of two layers of glass of contrasting colours; the technique was known in antiquity (the finest surviving example is the first-century Portland Vase in the British Museum) and was revived at the Renaissance. The blowing of glass through a hollow rod, which seems to be of Syrian origin, had been practised since antiquity for the production of containers. In the fourteenth century Arab glassmakers began to fashion swan-necked decanters, an art that was perfected in fifteenth-century Venice; such glass is still blown on the Venetian island of Murano.

Glass could be decorated by adding coloured strands to make LATTIMO (or *Latticino*) or by engraving by hand with a diamond point or with a grindstone, the lapidary's wheel. The technique of enamelling on glass was developed in Venice, probably by the BAROVIER FAMILY, in the fifteenth century; the earliest surviving piece is a blue glass goblet dated 1465. Enamelled armorial glasses were made by Venetian glassmakers for the German market, and from the mid-sixteenth century were also made in Germany (notably in Nuremberg), where they continued to be produced until the eighteenth century. In the sixteenth century the technique of enamelling glass transformed the technology of STAINED-GLASS windows.

The most important centre for the production of glass in Renaissance Europe was Venice, where in 1292 the production of glass was transferred to the island of Murano as a precaution against fire. Venetian glass was made from soda-ash (usually imported), quartz (from river beds), and lime (from powdered marble). The guild system distinguished makers of different types of glass: coloured beads, which accounted for the largest proportion of foreign income, were made for the religious market (principally for rosaries) by the craftsmen variously known as *paternosteri* or *margaritai* or *perlai*, glass for windows was made by *fioleri*, optical glass for eyeglasses by *cristallai*, and glass for MIRRORS by *specchiai*. The technology of glass was protected by the Venetian state, which forbade glassmakers to emigrate on pain of death. In the late sixteenth century Venetian exiles nonetheless established centres of glassmaking elsewhere in Italy, initially at Altare (near Genoa), where from 1495 craftsmen were required to work for a time abroad; Altarese craftsmen and Venetian exiles took Italian styles to northern Europe, principally Bohemia, Germany, and Flanders. In 1569 a Venetian glassmaker established a workshop in Florence at the request of Grand Duke Cosimo de' Medici, and from 1619 a small factory in the BOBOLI GARDENS made glass for the grand ducal household, including optical lenses for Galileo.

In the German lands, the most important centres of glass production in the fifteenth and sixteenth centuries were Bohemia (which made the finest glass), Moravia, Franconia, Hesse, Saxony, Thuringia, and Carinthia. The most common German glass was *Waldglas* (forest glass, sometimes known in English as 'green glass'), so named because the alkaline was potash derived from the ashes of forest woods, principally beech. Most German glass was utilitarian, and *Waldglas* was most commonly used for the production of the *Römer*, a wineglass which in the fifteenth century was a simple beaker decorated with raspberry prunts; the descendants of the *Römer*, which gradually acquired a hemispherical bowl and hollow foot, are still used in the Rhineland (and the Netherlands) for white wine. Other common glasses included the *Krautstrunk* (a fifteenth-century glass tumbler, also known as a *Warzenbecher*, decorated with reliefs modelled on cabbage stems), the *Nuppenbecher* (a fifteenth-century drinking-glass decorated with drops of glass drawn out to points), the *Passglas* (a sixteenth-century communal glass in which individual shares were marked by rings), the *Humpen* (a sixteenth-

century beer glass, often with a handle like a tankard), and the *Reichsadlerhumpen* (a mid-sixteenth-century glass, also known as *Adlerglas* or *Adlerhumpen*, decorated in enamel with the eagle of the Holy Roman Empire, displaying on its wings the armorial bearings of the 56 noble families of the Empire). The finest German glass was made in Hall-in-Tirol, where a glasshouse was established in 1534, and in Innsbruck, where Archduke Ferdinand of Tirol founded a glasshouse soon after becoming regent of the Tirol in 1567; a beaker said to have been blown personally by the duke is now in the Kunsthistorisches Museum in Vienna.

In Bohemia the *Krautstrunk* and the *Passglas* were made on a small scale, but production was centred on the manufacturing of fine glass for the imperial court. The most important glassmaker was Kaspar LEHMANN, who developed the art of wheel engraving on glass.

In the early sixteenth century an influx of Venetian craftsmen to Flanders (especially Antwerp and Liège) created a fashion for Venetian glass, which when made in the Venetian style under the influence of expatriate Venetian craftsmen came to be known as *façon de Venise*.

Elsewhere in Europe glass was predominantly functional, even in countries which were later to become important centres of glass manufacturing, such as England (Newcastle), France (Saint-Louis and Baccarat, both in the Vosges), and Spain (La Granja). The equivalent of *Waldglas* in France was *verre de fougère*, which was made with bracken. In England the comparable product was Weald glass, in which, as in Germany, the alkaline was potash derived from the ashes of forest woods. In the 1580s deforestation forced glassmakers to move first to Hampshire and Gloucestershire and then north to Staffordshire and the Scottish borders; in 1615 the use of wood for glassmaking was prohibited. Glass in the Venetian style was first made in England by Giacomo VERZELINI.

glaze

A vitreous surface applied to pottery to make it watertight. Clay pottery that is unglazed can only be vitrified (and so made impermeable) by firing it at a temperature so high that there is a considerable risk of fracturing or melting. The glazing of pottery is the solution to the problem of rendering vessels watertight at comparatively low temperatures. Glazes are made of clay to which is added a fluxing agent (such as lead) that will melt at a low temperature. The glaze is applied as a liquid after the pottery has been fired and (usually) after it has been painted. The pottery is then fired at a low temperature, which causes the glaze to melt and to adhere to the pottery.

The principal glazes in use in Renaissance Europe were the lead glaze, the tin glaze, and the salt glaze. Lead glazes were used for domestic pottery from remote antiquity until the nineteenth century, when their use was restricted by law because of the risk of lead poisoning when lead oxide (litharge) and lead carbonate were in their raw state. TIN-GLAZED EARTHENWARE was used for the display potteries known as MAIOLICA in Italy, FAIENCE in France, Germany, Scandinavia, and Spain, Delft in the Netherlands, and English DELFTWARE in Britain. Salt glazes were used for STONEWARE pottery such as BELLARMINES.

Goes, Hugo van der

(c.1440–1482), Flemish painter, born in Ghent, where he entered the Guild of Painters in 1467; the following year he worked in Bruges on the design of a pageant for the wedding of Charles the Bold and Margaret of York, and in 1473 he designed the pageantry for the funeral of Philip the Good. He then entered the monastery of the Rode Kloster in Brussels as a lay brother, but continued to paint. In the final year of his life he became insane.

Hugo's major work was the Portinari altarpiece, which was commissioned by Tommaso Portinari (the Bruges agent of the Medici bank) for the church of the Hospital of Santa Maria Nuova (on the site of what is now the University of Florence). The central panel of this huge altarpiece, which is now in the Uffizi, is a *Nativity*; Hugo's mastery of the Flemish tradition of STILL LIFE is apparent in the symbolic flowers in the foreground. The wings of the altarpiece depict the donor and his family when open, and an *Annunciation* when closed.

None of Hugo's paintings is signed or dated, but the securely documented attribution of the Portinari altarpiece facilitates other attributions on stylistic grounds, though dating remains problematical. His other important paintings are the Monforte altarpiece (Gemäldegalerie, Berlin), the diptych of *The Fall of Adam and Eve* (Kunsthistorisches Museum, Vienna), the *Death of the Virgin* (Groeningemuseum, Bruges), and

the wings of an altarpiece (or possibly the shutters of an organ) commissioned by Edward Bonkil for Trinity College, Edinburgh (National Gallery of Scotland, Edinburgh); on the reverse of one of the panels Hugo depicts one of the music-making angels playing an organ.

golden section

The nineteenth-century name for what Euclid and his successors knew as 'extreme and mean proportion' (*Elements*, book 6, proposition 3), which in the Renaissance was sometimes called 'divine proportion'. In his treatise of this title (1509) the Italian mathematician Luca Pacioli suggests that the proportion would be useful to architects, but there is no evidence that it proved to be so. In particular, it is not found in the list of useful proportions provided by SERLIO (1545). There is no evidence that 'divine proportion' played any part in the work of painters or sculptors. What is now known about the Renaissance suggests very strongly indeed that the supposed importance of the 'golden section' is an artefact of nineteenth-century historiography.

Goltzius, Hendrik

(1558–1617), Dutch engraver of German ancestry, trained in the studio of Dirck COORNHERT. He worked as an engraver in Haarlem, and in 1590 travelled to Rome to study Italian art. The work that Goltzius produced after his return to the Netherlands shows the stylistic influence of his Italian experience. His finest works are landscape and portrait drawings.

Hendrik Goltzius is sometimes confused with Hubert Goltzius (1526–83), a Flemish printmaker.

Gonçalves, Nuno

(*fl.* 1450–71), Portuguese painter who appears fleetingly in the documentary record in 1463, when he was a court painter to King Afonso V. Gonçalves is assumed to be the artist who in the 1460s painted the *St Vincent* reredos (now in the Museu Nacional de Arte Antiga, Lisbon), which portrays in a realistic idiom members of the court and the estates, including what may be lifelike portraits of the royal family.

Gossaert

or Gossart, Jan, or Jan Mabuse (*c.*1478–1532), Flemish painter, draughtsman, and printmaker, probably a native of Maubeuge (then in Flemish Hainaut, now in France). He was admitted to the Antwerp guild in 1503, and in 1508/9 visited Rome in the train of the Burgundian ambassador; thereafter his paintings show a marked Italian influence, which may mean that the *Adoration of the Kings* in the National Gallery in London was painted before his journey to Italy. Later works such as the Malvagna Triptych (Galleria Nazionale della Sicilia, Palermo) and *Neptune and Amphitrite* (Gemäldegalerie, Berlin) include many Italianate features such as putti. DÜRER admired the technical achievement of Gossaert's art, which he described as being 'nit so gut im Haupstreichen als im Gemäl' ('not as good in inventiveness as in execution'), and VASARI praised Gossaert as 'quasi il primo che portasse d'Italia in Fiandra il vero modo di fare storie piene di figure ignude' ('virtually the first artist to carry the true method of representing nude figures from Italy to Flanders'); Gossaert's sensuous *Hercules* (Barber Institute, Birmingham) is a fine example of his Italianate nudes.

Gothic

An architectural and art-historical term for a style of architecture and art that emerged in the twelfth century and in architecture lived on until the Gothic revival of the nineteenth century. In ecclesiastical architecture, with which the term 'Gothic' was primarily associated, the style is characterized by soaring vertical lines and the use of pointed arches, rib vaults, flying buttresses, traceried stained-glass windows, high clerestory windows, and pinnacles. In the conventional sequence of styles, Gothic follows Romanesque and precedes Renaissance. The term was first used in the Renaissance to disparage the architecture of earlier generations by recourse to a spurious association with the Gothic tribes that had sacked Rome in late antiquity.

Individual features of Gothic architecture had long been apparent in late Romanesque architecture (and, in the case of pointed arches, Islamic architecture), but Gothic first coalesced into an integrated style in the Île de France in the mid-twelfth century: the first building to have been conceived in what later became known as the Gothic style was the choir and chevet (i.e. apse and ambulatory) of the Abbey of Saint-Denis (1140–4), and this was soon followed by Notre-Dame of Paris (begun 1163) and the cathedrals of Bourges and Laon. The Gothic style

soon dominated French architecture, and spread from France to the rest of Europe, often through the buildings of the Cistercians.

In sculpture and painting, the term 'Gothic' refers to the style of such works in Gothic buildings. In sculpture it refers to the naturalistic style of the sculpture of cathedral portals, which was then replicated in tombs. In painting the term refers to the style of late medieval illuminated manuscripts, and of altarpieces such as DUCCIO's *Maestà* for Siena Cathedral and the Wilton Diptych (National Gallery, London). The term 'Gothic' is also used with reference to objects into which Gothic architectural motifs have been incorporated (e.g. reliquaries and tabernacles) and to a style in which lightness and intricacy are central features. The term INTERNATIONAL GOTHIC was coined in 1892 by Louis Courajod to denote a style in painting and related arts which emerged in the courts of Burgundy and France.

Goujon, Jean

(*c*.1510–*c*.1565), French sculptor and engraver. He lived in Rouen in the early 1540s, and there carved the columns supporting the organ loft in the Church of Saint-Maclou; he may also have been the designer of the tomb of Louis de Brézé (husband of Diane de Poitiers) in Rouen Cathedral, though the execution seems to be the work of another hand. In about 1543 Goujon moved to Paris, where he worked as a decorative sculptor with the architect Pierre LESCOT. Their collaborations include the Hôtel Carnavalet, for which Goujon carved allegorical figures representing the *Seasons* (1547), the Fontaine des Innocents (1547–9, now reconstructed), and the LOUVRE, for which Goujon made the classical caryatides in the Salle des Caryatides (1550–1). Goujon left Paris at the outbreak of the Wars of Religion in 1562, and spent his final years in Bologna. He is now regarded as France's finest Renaissance sculptor. His work as an engraver includes the plates for the first French translation of VITRUVIUS (1547).

Gower, George

(*c*.1540–1596), English portrait painter. He became established as a portrait painter in London in the 1570s and in 1581 was appointed serjeant-painter to Queen Elizabeth. His portraits include *Sir Thomas Kitson* and *Lady Kitson* (1573, Tate Gallery, London), a *Self-Portrait* (1579, Milton Park, Cambridgeshire), and (probably) the 'Armada' portrait of *Queen Elizabeth* (Woburn Abbey, Bedfordshire).

Gozzoli, Benozzo di Lese

(*c*.1421–1497), Italian painter, a native of Florence, where he was apprenticed as a goldsmith; he subsequently worked as an assistant to GHIBERTI on the baptistery doors in Florence (*c*.1444–7) and to Fra ANGELICO in the Vatican and in Orvieto Cathedral (*c*.1447–9). In 1459 Piero de' Medici commissioned Gozzoli to decorate the chapel in the Medici Palace (now Palazzo Medici-Riccardi) in Florence. His fresco cycle *The Journey of the Magi*, which covers three walls of the chapel, represents members of the Medici family amongst the attendants. In 1467 Gozzoli painted another fresco cycle (which survives only in fragments) in the Camposanto in Pisa.

Graf, Urs

(*c*.1485–1527/9), Swiss goldsmith, designer, and engraver, born in Solothurn, the son of a goldsmith. He worked as an apprentice in Strasburg and then settled in Bern. He produced large numbers of designs for goldsmiths, woodcut engravers, and glass stainers, and also executed many low-life drawings (some with a satirical edge) of peasants, prostitutes, and mercenaries; he was employed by Johann FROBEN to produce ornamental borders for his books. His principal work as a goldsmith was a reliquary (now lost) executed in 1514 for the Monastery of St Urban.

graffito

(plural *graffiti*) or *sgraffito*, a drawing scratched on a wall. In decorative art, the term refers to a method of decoration (used on the façades of Renaissance palaces and occasionally on interiors) in which successive layers of differently coloured plasters were applied, and a scratched design then exposed a ground of a different colour from that of the surface. The same technique was used in north Italian pottery (especially in Venice) from the thirteenth century onwards; such pottery, which is known in English as incised slipware, was a cheap alternative to MAIOLICA. Some maiolica factories, notably those in Bologna and Ferrara, used the technique to produce *maiolica graffita*.

The form *sgraffito* appears to be an English pseudo-Italian coinage formed on the analogy of terms such as *sgrammaticato* in which the prefixional 's' represents the Latin 'ex'.

Grafton, Richard

(d. 1572), English printer. A London merchant with reformist beliefs, Grafton, in conjunction with WHITCHURCH, arranged for the printing of 'Matthews's Bible' in Antwerp c.1536; a further edition followed, printed in Paris. In 1539 he collaborated with Whitchurch on the printing of the 'Great Bible'. Grafton also printed the first Book of Homilies in 1547 and the first and second Books of Common Prayer.

Granacci

or Grannacci, Francesco (1469–1543), Italian painter, a native of Florence, where he trained in the studio of GHIRLANDAIO. His fellow pupil was MICHELANGELO, with whom he formed an enduring friendship. His paintings include *The Arrest of Joseph* (c.1515, Palazzo Davanzati, Florence).

Granjon, Robert

(1513–after 1589), French type founder, born in Paris, the son of a printer. He worked as a type founder in Paris before moving in 1566 to Lyon (where he designed characters for the printing of music) and thence Rome (where he designed oriental founts, including Arabic); on returning to Paris he continued to develop new founts, including one in Greek. In 1557 he designed a cursive typeface known as *Civilité*, which was widely used in France but was eventually displaced by italic. Granjon's Greek, Syriac, and *Civilité* founts were used by Christophe PLANTIN in his Polyglot Bible (1568–73).

Grasser, Erasmus

(c.1445/50–1518), German sculptor and woodcarver who trained in his native Tirol and subsequently worked in Bavaria. His best-known work is the late Gothic *Moreska Tänzer* (1480), now in the Bayerisches Nationalmuseum in Munich.

Greco, El

or (Greek) Domenikos Theotokopoulos (c.1541–1614), Cretan painter in Spain, born in Phodele (near Candia, now Herakleion). He lived in Venice in the late 1560s and from 1570 to 1577 worked in Rome. His surviving paintings from this period include *The Purification of the Temple* (Institute of Arts, Minneapolis), *The Healing of the Blind Man* (Galleria Nazionale, Parma), and portraits of *Giulio Clovio* (Museo Nazionale, Naples) and *Vincenzo Anastagi* (Frick, New York).

In 1577 Domenikos moved to Toledo, where he lived for the rest of his life. In Spain he was known as El Greco ('the Greek'); he signed his paintings 'El Greco' in Greek characters, sometimes adding *Kres* (Cretan). El Greco's earliest surviving painting to have been executed in Toledo is *Christ Stripped of his Garments* (1579, sacristy, Toledo Cathedral). His finest surviving painting from the 1580s is *The Burial of Count Orgaz* (1586, Church of San Tomé, Toledo), which contains all the elements of El Greco's mature style: harsh colour, unremitting light, and figures infused with intense religious emotion. The same features are apparent in late paintings such as *The Assumption* (1613, Church of San Vicente, Toledo), but as his style matured his figures became longer. The development of El Greco's tendency to elongate his figures can be seen in his portrayals of St Francis, of which more than 100 are recorded. These distortions are sometimes attributed to madness or astigmatism, but may simply reflect the influence of Greek icon painting and the MANNERIST idiom in which El Greco worked.

El Greco was primarily a painter of religious pictures, but he also painted some 40 portraits (e.g. *Cardinal Guevara*, c.1601, Metropolitan Museum, New York; *Gentleman with his Hand on his Breast*, 1577–9, Prado, Madrid) and a small number of paintings on classical subjects (*Laocoön*, c.1610, National Gallery, Washington); the influence of Flemish art is apparent in his LANDSCAPE without figures, *Toledo Landscape* (Metropolitan Museum, New York).

Grenier, Pasquier

(d. 1496), Flemish tapestry contractor and weaver, the head of a workshop in Tournai; he was also a tapestry merchant, so it is possible that some of his tapestries were made in other centres, despite their execution in the style of Tournai. Grenier's principal patron from 1459 was Philip the Good, duke of Burgundy, for whom Grenier made his finest work, a series of sumptuous tapestries illustrating *The Life of Alexander* (two panels survive in the Palazzo Doria Pamphili in Rome). Grenier's workshop also produced tapestries illustrating *Esther and Ahasuerus* (of which panels survive in the Louvre and in the Musée Lorrain in Nancy), *The Knight of the Swan* (of which panels survive in the Museum für Angewandte Kunst in Vienna and the Church of St Catherine in

Kraków), and *The Passion* (of which panels survive in the Vatican and in the Musées Royaux d'Art et d'Histoire in Brussels).

Griffo, Francesco

(*c*.1450–1518), Italian type founder. He was a native of Bologna who moved to Venice, where he was appointed as the principal type founder of ALDUS MANUTIUS. Griffo was the inventor of italics, the fount modelled on the cursive chancery hand (*cancelleresca corsiva*) used in the Vatican secretariat; italic was used from 1501 for classical texts printed on small pages. He also designed Roman founts, including the one used for Francesco Colonna's *Hypnerotomachia Polifili* (1499).

grisaille

The English and French term used since the nineteenth century to denote a method of decorative painting in grey (French *gris*) monochrome with a view to representing solid objects in relief. In Renaissance painting and stained glass grisaille was characteristically used to depict sculpture (e.g. in the figures of the two St Johns in Hubert and Jan van EYCK's *Adoration of the Lamb* in Ghent) or architectural decoration such as friezes and mouldings (e.g. on the ceiling of the SISTINE CHAPEL).

Grolier bindings

The French bibliophile and statesman Jean Grolier de Servières (1479–1565) amassed a library of some 3,000 volumes, of which approximately 600 books are known to survive. Grolier lived in Milan (which was occupied by the French) from 1510 to 1520, serving as treasurer of the duchy; during this period he commissioned a small number of bindings from local craftsmen; these bindings are typically decorated with medallions illustrating classical scenes.

Most of the bindings now known as Grolier bindings were executed in Paris in the twenty years following Grolier's return in 1520. Grolier commissioned bindings from a number of Parisian binders, the identities of which are mostly unknown. These bindings are in calf, and the designs executed in the 1520s tend to consist of geometrical STRAPWORK. In the 1530s the designs became more complex, and often included intricate interlacing patterns. The surviving examples from the 1540s and 1550s are more elaborate, often including ARABESQUES

hatched with parallel lines and strapwork coloured black or red; these bindings may have influenced the development of FANFARE BINDINGS in the late sixteenth century.

Grosso, Niccolò

(*fl. c*.1500), Italian ironsmith, praised by VASARI as the best of ironsmiths; his nickname 'Caparra' ('payment in advance') presumably refers to his financial arrangements. His finest work is mounted on the exterior of the Palazzo Strozzi in Florence and includes a lantern shaped like a temple and flag-pole holders decorated with fabulous creatures.

grotesque

The rooms of ancient Roman buildings revealed by excavation seem to have been known as *grotte*; the murals on the walls of rooms in ancient houses such as Nero's Domus Aurea (excavated *c*.1480) on the Esquiline were decorated with distorted representations (sometimes in low relief) of human and animal forms (typically monkeys and sphinxes) interwoven with foliage and flowers. 'Grotesque' is the French and English term, cognate with Spanish and Portuguese *grutesco*, for this decorative style, which was principally used in decorative painting and sculpture; the modern Italian term for works of art in this style is *grotteschi*. In early modern usage 'grotesque' is never a pejorative term; such senses evolved in the eighteenth century.

Grotesque motifs first appear in ornament in the 1480s in paintings such as Carlo CRIVELLI's *Annunciation* (1486, National Gallery, London), and were soon incorporated into decorative schemes such as PINTORICCHIO's ceiling for the Piccolomini Library in Siena Cathedral (1503) and SIGNORELLI's frescoes for Orvieto Cathedral (1499–1504). The earliest decorative scheme in the grotesque style was executed by RAPHAEL in Cardinal Bibbiena's bathroom (*stufetta*) in the Vatican; Raphael subsequently used grotesques in the Vatican Loggias (*c*.1519), and GIOVANNI DA UDINE, who had been largely responsible for the execution of Raphael's designs in the Vatican Loggias, later used grotesques in the Villa MADAMA (1520–1). From the 1530s onwards, the foliage associated with grotesques was usually executed in ARABESQUES.

Engravings of Raphael's grotesques were soon circulating all over Europe, and established a fashion for grotesques that was to persevere for centuries, not only in decorative

painting, but also in arts such as tapestries, MAIOLICA, and sculpture.

grotto

In garden art a grotto is an artificial recess designed to resemble a natural cave. The term is sometimes used to refer to a NYMPHAEUM, but more commonly refers to a rusticated cave containing FOUNTAINS and other waterworks and decorated with statues and shells. The statuary sometimes reflects the contemporary fashion for the GROTESQUE, which can be seen in related features such as the garden monsters of the Villa ORSINI at Bomarzo. The Renaissance grotto was thought to be a revival of the grottoes of classical antiquity; ALBERTI, for example, assured his readers that the ancients applied rough dressings to the walls of their caverns, and daubed them with green wax in imitation of slime (*De re aedificatoria* 9. 4). Rustic grottoes were constructed in the BOBOLI GARDENS and in the gardens of the Villa D'ESTE, the Villa MADAMA, the MEDICI VILLA at Castello, and the Palazzo del TÈ. In France grottoes were constructed at Meudon (by PRIMATICCIO), Bastie d'Urfé (Loire), Écouen, CHENONCEAUX, and the TUILERIES. Grottoes sometimes incorporated AUTOMATA into their waterworks, most memorably at PRATOLINO and SAINT-GERMAIN-EN-LAYE.

In the late sixteenth century grottoes were used as the setting of plays and entertainments, and in the early seventeenth century grottoes were transplanted from gardens onto stages by designers such as Inigo JONES. The garden grotto became less popular in the early seventeenth century, but was revived in the eighteenth-century English landscape garden.

Grünewald, Mathias

(1475/80–1528), German painter. No records of Grünewald's early life are known to survive; he may have been born in Würzburg, but he first emerges in the historical record in the small town of Seligenstadt (near Frankfurt), where he had his workshop from 1501 to 1525. His name, however, was not Grünewald, that being a name first used (in error) by Joachim von Sandrart in his *Teutsche Akademie* of 1675. The artist's real name, Mathis Neithardt, together with the name by which he was called, Gothardt, was established in 1938; this discovery explains the monogram MGN that appears on four of Grünewald's paintings. He was employed by two successive archbishops of Mainz (1516–25), the second of whom (Albrecht II of Mainz) commissioned a series of ALTARPIECES for the Cathedral in Halle an der Saale; the few surviving works commissioned by Cardinal Albrecht include a *Lamentation* (Schloss Johannisburg, Aschaffenburg) and a panel depicting *SS Erasmus and Maurice* (Alte Pinakothek, Munich). No paintings have survived from the final years of his life; he died in Halle in 1528, when he was described as a painter and *Wasserkunstmacher* (i.e. hydraulic engineer).

Grünewald's early paintings include a *Derision of Christ* (Alte Pinakothek, Munich), datable to 1503 by an inscription which is now lost, and the wings (depicting saints) for DÜRER's *Helleraltar* (*c.*1510, now divided between the Städelsches Kunstinstitut in Frankfurt and the Fürstlich-Fürstenbergische Sammlungen in Donaueschingen). His late works include a *Carrying of the Cross* and a dramatic *Crucifixion*, both now in the Staatliche Kunsthalle in Karlsruhe.

Grünewald's masterpiece is the Isenheim altarpiece (see plate 3), now in the Musée d'Unterlinden in Colmar, where it was moved in 1852, 60 years after the suppression of the Isenheim monastery. Its date is unknown, but it is probably a work of the 1510s. The central image on the front wings of the altarpiece depicts the tortured body of Jesus on the cross, his hands twisted by the pain of the nails and his feet contorted by the single nail driven through them. This distortion, together with the wounds on the body and the look of suffering on Jesus' face, make this painting the most powerful expression of the horror of crucifixion in western art. Within the monastic hospital for which it was commissioned, the degraded and tortured body of Jesus must have been a reflection of the afflictions of the patients and so an affirmation that spiritual grace can survive the destruction of the body.

guadameci

The spanish term, derived from the Libyan oasis of Ghadāmis (Spanish Ghadamés), for wall hangings made from sheepskin leather decorated with hand-tooled designs in bright colours. For centuries the principal centre for the production of *guadameci* was Córdoba, but in the seventeenth century Flemish leatherworkers captured much of the market by using

stamps to impress designs on the leather and so reducing labour costs and retail prices.

Guas, Juan

(c.1430–1496), Spanish architect and sculptor of French descent. He arrived in Toledo, possibly from Brussels, in about 1450. In 1459 Juan and his father are recorded as working with Hanequín of Brussels (see EGAS FAMILY) on the Puerto de los Leones at Toledo Cathedral. He served as master of works in the cathedrals of Segovia (1473–91) and Toledo (c.1483–95). He received the royal commission to design Queen Isabella's monastery of San Juan de los Reyes (1479–80), and was also the principal architect of the Infantado Palace at Guadalajara (1480–c.1483). It is likely that he designed the exuberant late Gothic façade of San Gregorio in Valladolid (1487–96), but that has also been attributed to Gil de SILOÉ.

Gucci Fiorentino, Santi

(c.1530–1599/60), Italian sculptor and architect in Poland, born in Florence, where he trained in the workshop of his father Giovanni Gucci, who had worked on the restoration of Florence Cathedral. In about 1550 Santi Gucci moved to Poland, where he settled in Kraków. He served as court architect to Sigismund II, Anna Jagiełło, and Stefan Bátory, and eventually carved their tombs in Kraków Cathedral. Gucci's surviving buildings in Kraków include the Boners' house (1560; now 6 Market Square) and a chapter house (after 1582; now 21 Kanonicza Street).

Guglielmo della Porta

See DELLA PORTA, GUGLIELMO.

Gutenberg, Johann

(c.1394/9–1468), inventor of printing, born in Mainz, the son of Friele Gensfleisch; the name Gutenberg derives from the name of the family home, Haus zum Gutenberg. He trained as a goldsmith and in 1430 moved to Strassburg, where he worked with a goldsmith and began to experiment with printing techniques. He returned to Mainz c.1448 and in 1450 borrowed 800 gulden from Johann FUST (who was later to invest another 800 gulden and become his business partner) in order to establish a printing workshop. He worked with Fust and with Peter SCHÖFFER (Fust's son-in-law) until 1455, when Fust foreclosed on his loans and Gutenberg became bankrupt. Thereafter the workshop was run by Fust and Schöffer, and Gutenberg was gradually excluded from the business; he seems to have printed nothing after 1460. In 1465 he entered the service of the archbishop of Mainz, whose patronage he enjoyed until his death.

It was Gutenberg who developed the technology of printing, which included cutting punches and casting type; the method for stamping matrices may have been the invention of Schöffer. It is difficult to assign specific books to any one of the three partners, especially as they often collaborated, but Gutenberg is traditionally accredited with the 42-line Latin Bible published between 1452 and 1456; of its 180 copies (of which 48 survive in whole or in part), 30 were printed on vellum and the rest on paper. This Bible is also known as the Mazarin Bible, because the first copy to be identified was in Cardinal Mazarin's library.

The Gutenberg Museum in Mainz has Gutenberg's hand-press and a collection of his books, including a 42-line Bible.

H

Hagenauer

or Hagnower, Nikolaus or Niclas (*fl.* 1493–before 1538), German woodcarver responsible for the figures on the Isenheim altar (now in the Musée d'Unterlinden in Colmar), of which the wings were painted by GRÜNEWALD ten years later.

Handstein

(German; 'hand stone'), a sixteenth-century German collectors' object, the size of a human hand, carved from a lump of ore mounted on a silver stand and decorated with enamel figurines to illustrate mining or biblical scenes.

handwriting

See CALLIGRAPHY.

Hans von Reutlingen

(*fl.* 1492–1524), German goldsmith and seal-engraver who worked in Aachen, where he engraved seals for the emperors Maximilian I and Charles V. His most famous piece is the silver-gilt case (now in the Weltliche Schatzkammer in the Kunsthistorisches Museum, Vienna) made for the *Reichsevangeliar* ('Imperial Gospels'), probably on the occasion of Maximilian's coronation in 1500. The Aachen cathedral treasury (Domschatzkammer) holds several pieces by Hans, including a reliquary statue of St Peter (*c.*1510).

Hatfield House

A house and garden in Hertfordshire built for Robert Cecil, earl of Salisbury, between 1607 and 1612. The U-shaped house is a distinguished example of a Jacobean nobleman's house, with a central hall and two symmetrical wings. The large two-storeyed hall with its minstrels' gallery and plastered ceiling is a development of the English medieval hall. The state apartments are on the first floor, in the Italian style. The oak staircase that leads to these apartments is one of the finest in England.

The east garden was initially laid out on two terraces by Thomas Chandler, but in 1611 Salomon de CAUS redesigned the garden, though he retained the services of Simon Sturtevant, Chandler's water engineer. Water ran from the grand Fountain of Neptune in a garden laid out in PARTERRES down to a water-garden for which Sturtevant built the hydraulics, which included a stream and FOUNTAINS on an island with a PAVILION. The collection of plants from the BOTANICAL GARDENS of the Netherlands, France, and Italy was entrusted to John TRADESCANT. The garden has evolved continuously since the early seventeenth century, but the outlines of the Jacobean garden are still visible.

Heemskerk, Maarten van

(1498–1574), Dutch painter, born in Heemskerck (near Alkmaar). He trained with local artists in Haarlem and Delft and then entered the Haarlem studio of Jan van SCOREL, who was only one year older than Heemskerk; the influence of Jan van Scorel on Heemskerk's style of portraiture was so strong that it is sometimes difficult to attribute their unsigned portraits. Heemskerk was similarly overwhelmed by the work of MICHELANGELO when he lived in Italy (mostly in Rome) from 1532 to 1536. While in Rome he drew ancient and modern buildings and sculptures; leaves from his sketchbooks are now preserved in two albums in the Kupferstichkabinett in Berlin.

On his return to the Netherlands Heemskerk, still mesmerized by Michelangelo, painted large muscular figures in energetic movement, a stark contrast to the sombre realism of his portraits. Heemskerk's portraits include a self-portrait now in the Fitzwilliam Museum in Cambridge. His huge ALTARPIECE for the Church of St Laurentius in Alkmaar (1538–41) was sold to a Russian buyer in 1581, but the ship on which it was sent was wrecked off the coast of Sweden; the altarpiece was salvaged and is now in Linköping Cathedral.

Heere, Lucas de

(c.1534–1584), Flemish painter and poet, born in Ghent and trained in the Antwerp studio of Frans FLORIS. On returning to Ghent he established a school of painting; his pupils included Karel van MANDER. His painting of *Solomon and the Queen of Sheba* (1559) is in St Bavo's Cathedral in Ghent. Lucas lived in France from 1559 to 1561, working in Paris and Fontainebleau as a TAPESTRY designer in the service of Catherine de Médicis.

Lucas returned to Ghent in 1561, but in April 1567 he was banished because of his Calvinism. He sought refuge in London, where his pupils included Johan DE CRITZ and Marcus GHEERAERTS the Younger. In 1577 he again returned to Ghent, where he designed the pageants for the entry of William of Orange into the city. He is also thought to have been the designer of the Valois Tapestries (now in the Uffizi in Florence) woven in Flanders in 1582 to celebrate the arrival of François, duke of Anjou.

Many of the portraits formerly attributed to Lucas on the basis of the 'HE' monogram used as a signature are now attributed to Hans EWORTH.

Hellbrunn

A castle and garden on the south side of Salzburg, was built between 1613 and 1615 for Markus Sittikus von Hohenems (1574–1619), prince-archbishop of Salzburg; the designer was the Italian architect Santino Salari. Stone for the castle was quarried from the grounds of the estate, and Sittikus turned the quarry into an AMPHITHEATRE called the Felsentheater. On 31 August 1617 Monteverdi's *Orfeo* was performed in the Felsentheater, which is still used for plays and concerts. The grounds were laid out in aquatic PARTERRES, and there were temples, summer PAVILIONS, and balustraded galleries. The fashion for GROTTOES was at its zenith when Hellbrunn was built, and it is amply provided with grottoes in the castle and ranged along a walk in the garden. The grottoes contained AUTOMATA and *GIOCHI D'ACQUA* inspired both by examples in Italian gardens and by the rediscovery of HERON. The grotto of Orpheus and the sleeping Eurydice contained water-driven mechanical songbirds, the grotto of Midas featured a crown floating on a jet of water, and the dragon grotto housed a dragon who drank from a fountain before vanishing. The *giochi d'acqua* included FOUNTAINS with stone tables on which drinking-glasses were filled from a spout; unsuspecting visitors who sat on the seats were promptly drenched, and as they tried to escape they were soaked in rain from small pipes in the ceiling.

The gardens were altered in the 1730s, and a water-powered marionette theatre was added between 1748 and 1752, but many features of the original gardens survive, and many of the automata are still in good working order; the garden also has a zoo which is the descendant of the menagerie which was established before 1424.

Helmschmied family

A dynasty of German armourers whose original surname, Kolman, was replaced by one reflecting their profession as 'makers of helmets'; their armours (see ARMS AND ARMOUR) are signed with the mark of a helmet. Throughout the late fifteenth and sixteenth centuries, members of the family produced armours in their Augsburg workshop for emperors and princes. In 1477 Lorenz Helmschmied (1445–1516) made a complete set of armour for the Emperor Friedrich III and his horse (Kunsthistorisches Museum, Vienna), and in 1491 was appointed as principal armourer to Friedrich's son Maximilian (later Emperor Maximilian I). Lorenz's son Kolman (1471–1532) produced armours for the Emperor Charles V, including the 'KD' garniture (c.1526) of which portions survive in the Armería Real in Madrid. Kolman's son Desiderius (1513–78) produced parade armours for King Philip II of Spain. Kolman's daughter became the second wife of Jörg Sorg the Elder, an armour etcher in the Helmschmied workshops, and their son, Jörg SORG the Younger, also became an armour etcher.

Hemessen, Jan Sanders van

(*fl.* 1519–56), Flemish painter, admitted to the Antwerp guild in 1524; he may have moved to Haarlem in 1550, but the evidence is inconclusive. Similarities to the style of the MASTER OF THE BRUNSWICK MONOGRAM have encouraged some scholars to think that Hemessen is the Master, but the evidence is again inconclusive. Hemessen's documented work consists of portraits (some of which are satirical), GENRE scenes (of which he was one of the earliest Flemish exponents), and popular religious pictures, including *The Parable of the Prodigal Son* (1536, Musée d'Art Ancien, Brussels) and *Judith with the Head of Holofernes* (c.1549, Chicago, Art Institute).

Henlein, Peter

(*c*.1485–1542), German locksmith and horologist who worked in his native Nuremberg. The accuracy of his clocks was considerably enhanced by his invention of the mainspring in about 1510. His portable clocks, which were shaped like small boxes and were intended to be hung from the belt, were the predecessors of the pocket watch. One of his box clocks, now in the Fridericianum in Kassel, is known as the Egg of Nuremberg; versions of this clock manufactured in Nuremberg after Henlein's death were popularly known as Nuremberg eggs (*Nürnberger Eier*).

Hering, Loy

(*c*.1485–*c*.1554), German sculptor, born in Eichstätt; he worked as a sculptor in Eichstätt, Augsburg, and in other Bavarian towns. His subjects were usually religious but sometimes courtly (such as the relief *The Garden of Love* in the Gemäldegalerie, Berlin), and for his designs he often adapted figures from DÜRER's prints. His sculptures contain Gothic elements but are predominantly executed in the style of the Italian Renaissance, which he is deemed to have introduced into German sculpture. His most important surviving monumental sculpture is the seated figure of St Willibald as an old man (*c*.1514) in Eichstätt Cathedral.

Herlin, Friedrich

(*c*.1425–1500), German painter. He may have been born in Ulm; he was active in Rothenburg ob der Tauber and in Nördlingen. His paintings, mostly of religious subjects, are executed in the manner of Rogier van der WEYDEN. His *Presentation in the Temple*, a panel from the altarpiece painted in 1466 for the Jakobskirche in Rothenburg (and still in the church), characteristically borrows its architectural setting from Rogier.

Heron

or Hero of Alexandria in the Renaissance. Heron (fl. AD 60) was a mathematician and engineer. In the Renaissance the best known of his works were the *Pneumatica*, a treatise on the construction of devices powered by compressed air, steam, and water, and the *Automatopoietica*, on the construction of AUTOMATA for temples. In the sixteenth century the Greek texts of both treatises were published, as were translations into Latin and Italian.

Pirro LIGORIO read a manuscript of the *Pneumatica*, and constructed some of the waterworks described by Heron at Villa d'ESTE in Tivoli. The clearest debt to Heron at Villa d'Este is the Owl Fountain (1566–8): Heron had described a device in which flowing water was used to make birds sing and fall silent by turns, and in Ligorio's Owl Fountain a group of birds whose song was generated by the pressure of water stopped singing whenever the owl (which was also water-driven) turned towards them.

The influence of Heron's *Automatopoietica* is most apparent in Salomon de CAUS's *Raisons des forces mouvantes* (1615), which draws heavily on the treatise for the descriptions of automata such as water-organs, trumpets, and fire-engines.

Herrera, Juan de

(1530–97), Spanish architect. He was educated in Valladolid and in 1548 entered the service of Prince Philip (later King Philip II), in whose retinue he travelled to Italy and thence to Flanders. He remained in Brussels to study mathematics before returning to Spain in 1551. By 1553 he was serving as a soldier in Italy and Flanders, and he later joined the personal bodyguard of Charles V. Throughout his architectural career he maintained his interest in mathematics: he assembled a large scientific library, invented instruments to assist navigation, and in 1582 founded the Academy of Mathematics in Madrid.

In 1563 Herrera was appointed as an assistant to Juan Bautista de TOLEDO at the ESCORIAL. On Juan Bautista's death in 1567, Philip II entrusted the various tasks on which he had embarked to several architects, including Giambattista CASTELLO (who built the monumental staircase), Francesco PACIOTTO (who designed the church), and Antonio de Villacastín (who proposed the extra storey to increase the monastic accommodation). Herrera was not formally appointed as architect, but it was he who co-ordinated the efforts of others, designed the infirmary and chapel, imposed his personal stamp on the style of the Escorial, and ensured that it was finished in 1584. Herrera also worked as an architect at ARANJUEZ (1569) and in the Exchange at Seville. His last important project was the cathedral in Valladolid, which he began in 1585 on the foundations laid by Rodrigo GIL DE HONTAÑÓN. Herrera's style, which came to be known as the *estilo desornamentado*, was an

important influence on subsequent Spanish architecture.

Hillebrandt, Friedrich

(d. 1508), German goldsmith and engraver, born into a Nuremberg family of goldsmiths and engravers. He became a master in 1579 and thereafter specialized in vessels shaped like large birds, some of which incorporate NAUTILUS SHELLS. Several of his pieces are displayed in the Grünes Gewölbe in the Albertinum in Dresden.

Hilliard, Nicholas

(c.1547–1619), English MINIATURE painter, goldsmith, and carver, born in Exeter, the son of a goldsmith, and trained as a jeweller. He was appointed as court limner (i.e. miniaturist), goldsmith, and carver to Queen Elizabeth in about 1570, and in 1586 designed and engraved her second great seal of England in collaboration with Derick Anthony (fl. 1550, d. 1599), engraver to the mint. There is some evidence that he visited France: in 1577 François, duke of Anjou, employed one 'Nicholas Belliart, peintre anglais', and the subject of a miniature portrait by Hilliard (dated 1577) in the Pierpont Morgan Library in New York is a maid of honour at the French court.

Hilliard painted a miniature self-portrait at the age of 13 (versions of which survive in the collection of the duke of Buccleuch and in Welbeck Abbey, Notts.). He painted two portraits of Queen Elizabeth (1572, National Portrait Galley, and a later portrait in the Victoria and Albert Museum) and in 1578 painted a portrait of Mary, queen of Scots (versions of which survive in Windsor Castle and the Victoria and Albert Museum). On 5 May 1617 Hilliard was granted the exclusive right (for twelve years) to execute portraits of King James I. He painted miniature portraits of many of his contemporaries; his royal sitters included Anne of Denmark, Prince Charles, and Princess Elizabeth (all in the Victoria and Albert Museum). He is praised in John Donne's 'The Storm'. His most famous pupil was Isaac OLIVER.

Hirschvogel, Augustin

(1503–53), German etcher, potter, glass painter, medallist, cartographer, and mathematician, born in Nuremberg, the son of a stained-glass artist. He specialized in etchings of landscapes and maps; his best-known work is a large map of Austria commissioned by the Emperor

Ferdinand I in 1542. Hirschvogel's pottery consists of Italianate TIN-GLAZED EARTHENWARE; he may have been the inventor of the EULENKRUG, of which he made the earliest known examples.

Hoefnagel, Joris

(1542–1601), Flemish painter, born in Antwerp, the son of a diamond merchant. He travelled in France and Spain (1561–7), England (1569), and Italy (1577), often in the company of the cartographer Abraham Ortelius. Many of his paintings and drawings of towns were reworked as illustrations for the Civitates orbis terrarum (1572–1618) of Georg Braun and Franz Hogenberg. Hoefnagel worked for the Fuggers in Augsburg and in 1591 entered the imperial service of Rudolf II in Prague, where the subjects of his drawings included many plants and animals. He was the illuminator of Mira calligraphiae monumenta, a work on CALLIGRAPHY by the Hungarian Georg Bocskay.

Holanda, Francisco de

(1517–84), Portuguese miniaturist and art historian of Dutch extraction, known to have been in Rome in 1538; his drawings of Italian artists (including MICHELANGELO) and antiquities are now in the ESCORIAL. By 1545 Francisco had returned to Portugal, where he worked as a court painter, executing portraits of the royal family. He also drew up plans for a comprehensive redesign of Lisbon on the Roman model, with new walls, roads, bridges, fortifications, and churches.

In 1548 Francisco completed a treatise on ancient painting (Da pintura antigua). The first book deals with the theory and practicalities of art, and the second contains four dialogues in which Francisco conducts conversations about art with contemporary figures such as Vittoria Colonna, Giulio CLOVIO, and Michelangelo; in 1549 he added ten more dialogues on the subject of drawing from nature (Do tirar polo natural). The treatise was not published until the nineteenth century (1890–6), but nonetheless circulated in manuscript and so exercised a significant influence in its advocacy of Italian models for Portuguese art.

Holbein, Hans the Younger

(1497/8–1543), German painter, born in Augsburg, the son of the painter Hans Holbein the Elder (c.1465–1524), in whose studio he trained. In about 1514 he moved to Basel, where he worked as a designer for the printer Johann

FROBEN and where he also met Erasmus. In Basel he painted the portraits of Burgomaster Meyer and his wife (1516, Kunstmuseum, Basel); the drawings for the portraits survive, and show that from the outset of his career it was Holbein's practice to draw his sitters and then to paint from his drawings.

From 1517 to 1519 Holbein worked in Lucerne, where he decorated the Haus zum Tanz (demolished 1907) for the von Hertenstein family. In the years following his return to Basel he painted the portrait of *Bonifacius Amerbach* (1519, Kunstmuseum, Basel). Paintings executed by Holbein in the next few years include *Christ in the Tomb* (1522, Kunstmuseum, Basel), *The Last Supper* (Kunstmuseum, Basel; the painting has been cut down), and *The Madonna and Child with Saints* (1522, Museum der Stadt, Solothurn). In this period he also accepted a commission from the city of Basel to decorate the Town Hall with scenes illustrating Justice (now mostly lost) and continued to work as a designer, in which field his most important commissions were the title page of Luther's Bible of 1522 and the series of 51 plates illustrating the DANCE OF DEATH (1523–6, published Lyon, 1538). His portraits in the early 1520s include three of *Erasmus* (Louvre; Kunstmuseum, Basel; earl of Radnor, on loan to the National Gallery, London). In 1524 Holbein visited France, and two years later painted *The Madonna of Burgomaster Meyer* (1526, Altschloss, Darmstadt).

From 1526 to 1528 Holbein lived in London, where a letter of introduction from Erasmus to Sir Thomas More led to a commission to paint a group portrait of the More family; the portrait is lost, and is known only from drawings in Windsor and Basel and copies in Nostell Priory (Yorkshire) and the National Portrait Gallery in London. Surviving portraits from Holbein's first visit to London include those of *Sir Thomas More* (Frick Collection, New York), *Sir Henry Guildford* (Windsor) and *Lady Guildford* (St Louis Art Museum), *Nicolaus Kratzer* (Louvre), *Archbishop Warham* (Louvre and Lambeth Palace), and *Lady with a Squirrel and a Starling* (National Gallery, London). In 2004 the lady was identified as Anne Lovell, whose family arms included a red squirrel; the starling is a visual pun on East Harling (ë-starling), her Norfolk residence.

In 1528 Holbein returned to Basel, which was becoming a Protestant centre. In 1529 the city adopted the Reformation and Holbein accepted the new Zwinglian orthodoxy. The iconoclasm of the Reformation put an end to religious art, but Holbein was able to resume his commission to decorate the Town Hall and to design stained glass. During this period he painted a portrait of his wife and two children (Kunstmuseum, Basel).

In 1532 Holbein left his family in Basel and returned to London, and about this time he painted what seems to have been his last religious picture, *Noli me tangere* (Hampton Court). Sir Thomas More was no longer in a position to exercise patronage, but Holbein found new patrons in the merchants of the Steelyard, the London 'counter' of the Hanseatic League. His portraits of German merchants include those of *Georg Gisze* (Gemäldegalerie, Berlin) and *Derick Born* (Windsor Castle); he also decorated the Banqueting House of the Steelyard merchants with pictures of *The Triumph of Riches* and *The Triumph of Poverty* (destroyed).

Holbein's other important patron in London was Thomas Cromwell, whose portrait he painted (Frick Collection, New York) and through whom he may have received the commission for *The Ambassadors* (1533, National Gallery, London) (see plate 4), a double portrait filled with books and scientific and musical instruments and with a distorted skull (see ANAMORPHOSIS), an image of mortality, in the foreground. Cromwell may also have been the link that enabled Holbein to secure royal patronage. His paintings of King Henry VIII include a panel now in the Thyssen Collection in Madrid, a large group portrait for the Company of Barbers and Surgeons (Barber-Surgeons' Hall), and a wall painting in the Palace of Whitehall of the king with his parents (Henry VII and Elizabeth of York) and his third consort (Jane Seymour); the painting was destroyed in the fire of 1698, but part of the cartoon survives (National Portrait Gallery, London), as do copies of the mural (Hampton Court) and of the figure of Henry VIII (Walker Art Gallery, Liverpool); he also included a small portrait of King Henry in his design for the title page of the Coverdale Bible (1535), the first Bible in English. His other portraits in this period include those of *Jane Seymour* (Kunsthistorisches Museum, Vienna), *Anne of Cleves* (1539/40, Louvre), *Christina of Denmark, Duchess of Milan* (1538, National Gallery, London), and the miniature *Mrs Pemberton* (c.1540, Victoria and Albert Museum, London). He died in London, probably of the plague.

Holl, Elias

(1573–1646), German architect, born in Augsburg into a family of masons that long enjoyed the patronage of the Fuggers. He travelled in Italy, pausing in Venice for a protracted period (1600–1), and then returned to Augsburg, where he was appointed city architect in 1602. In this capacity he presided over a huge building programme which included provision for the guilds (guildhalls, market halls, warehouses, merchants' houses), schools, hospitals, fortifications (gates and towers for the city walls, the Arsenal) and the Town Hall. His Protestantism became increasingly problematical during the Thirty Years War, and led to his suspension from 1630 to 1632 and his dismissal in 1635.

Holl was the leading exponent of Renaissance architecture in Germany. Most of his work was undertaken in Augsburg, but Holl also built the residence of the prince-bishops (the Willibaldsburg) in Eichstätt and is likely to have been the architect responsible for the design of Bratislavský Hrad (1632–49), the four-towered castle of Pressburg (Hungarian Pozsony, now Bratislava) that was burnt in 1811 and restored from 1953 to 1968, whereupon it became the emblem of the city. Holl's building programme within Augsburg began with the Arsenal (1602–7) and finished with the Hospital of the Holy Ghost (1626–30). His buildings typically had courtyards surrounded by arcades (e.g. St Anne's School, 1612–16) and exteriors characterized by symmetry (especially in fenestration) and classical proportion. Such features are even apparent in Holl's fortifications: his remodelled Red Gate (Rotes Tor) of 1622 is part of an ensemble with a central courtyard. Holl's masterpiece is the Augsburg Town Hall (1615–20), which was badly damaged in the Second World War and has since been rebuilt.

Hone, Galyon

(fl. 1492–1526), Flemish glass stainer who was admitted to the Antwerp guild in 1492 and subsequently moved to England, where he was appointed royal glazier, in which capacity he succeeded Bernard FLOWER as the glass stainer responsible for the windows of the Chapel of King's College, Cambridge, including the magnificent east window; the windows had been designed by Dirick VELLERT.

Hopffer

or Hopfer, Daniel (c.1470–1536), German armourer and etcher. He was born in Kaufbeuren (60 kilometres (37 miles) south of Augsburg) and became a burgher of Augsburg in 1493. He worked as an engraver of parade armour (see ARMS AND ARMOUR) and designed architectural decoration, including Gothic foliage and Renaissance gargoyles. He seems to have been the first person to have made prints on paper by ETCHING iron plates rather than by line ENGRAVING. He developed this technique in order to facilitate the decoration of armour, but soon became a printmaker, the first maker of mass-produced etchings. His huge range of etchings included religious scenes, GENRE scenes such as village festivals, many reproductions of Italian art, and some of the earliest etched portraits.

Hornick, Erasmus

(d. 1583), Flemish goldsmith and designer. He may have worked in Antwerp in the 1540s, but first enters the historical record in 1555, by which time he was living in Augsburg. In 1559 Hornick moved to Nuremberg, where he was admitted to the guild in 1563 and where he lived until 1566, when he returned to Augsburg. In 1582 he was appointed imperial Kammergold-schmeid to the Emperor Rudolf II in Prague, where he died the following year.

No examples of Hornick's goldsmith work are known to survive, though 83 etchings and some 600 drawings are attributed to him or to his workshop on the basis of his printed designs. These designs, typically for vases, medallions, and jewellery, were published in a series of books with engraved illustrations, and were intended for execution in a wide range of materials, including rock crystal, mollusc shells, and precious metals.

Hortus Palatinus

A garden built in the grounds of Heidelberg Castle. The designer was Salomon de CAUS, who had followed Princess Elizabeth to Heidelberg after her marriage to the elector in 1613. The gardens, on which work began in 1615, are constructed on five narrow terraces with high retaining walls. The terraces were divided into compartments by hedges and pergolas, and are embellished in the Renaissance style with a MAZE, statues, gazebos, and ornamental ponds. These characteristic features are supplemented

by waterworks and GROTTOES with AUTOMATA, including water-organs for which Caus composed the music. Caus described and illustrated the garden in his *Hortus palatinus* (1620), but the abandonment of the garden in 1619 when Friedrich was forced to leave Heidelberg creates uncertainties about the extent to which Caus's designs were implemented. The terraces and a grotto remain today, but the planting is modern and Caus's buildings are in ruins.

Huber, Wolf

(c.1485–1553), German painter who worked in Passau. His religious paintings include a crowded *Raising of the Cross* (c.1522–4, Kunsthistorisches Museum, Vienna). His three-quarter-length portraits include portrayals of *Anton Hundertpfundt* (1526, National Gallery, Dublin), master of the Bavarian mint, and of his wife *Marggret Hundertpfundt* (1526, Johnson Collection, Philadelphia).

Huguet, Jaume

(c.1415–1492), Catalan painter, the most prominent Catalan artist of the late fifteenth century. He was born in Tarragona and settled in Barcelona in about 1448. Attributed work thought to pre-date his arrival in Barcelona includes the *St George and the Princess* (Museu d'Art de Catalunya, Barcelona). Jaume's earliest documented work was the ALTARPIECE of *Sant Antoni Abat* for the Confraría dels Tractants en Animals in Barcelona (1455), which was destroyed in 1909. His principal surviving works are *The Consecration of St Augustine* (commissioned 1463, completed 1486; Museu d'Art de Catalunya, Barcelona) and an *Epiphany* (1463) now in the Chapel Royal in Barcelona.

I

illuminated manuscripts

The term 'illuminate' in the context of medieval manuscripts does not have its modern sense of lighting up an object, but rather has a specialized meaning, denoting the embellishment of a manuscript with gold, silver, and luminous colours or with elaborate tracery and miniature pictures which are sometimes illustrative; this embellishment may be restricted to initial letters and words or may extend to borders or entire pages. The word 'miniature' is also used in a specialized sense distinct from the usual sense of a portrait MINIATURE: in manuscript illumination, the minium was the red lead colouring used by the miniator to decorate initial letters; medieval Latin *miniatura* did not refer to size, but rather derived from the verb *miniare*, to rubricate or illuminate. The decoration sometimes took the form of a small picture in an initial letter; such letters are called 'historiated initials'.

The manuscripts chosen for embellishment during the thousand-year period (*c*.500–*c*.1500) in which illuminated manuscripts were produced varied over the centuries, and by the fourteenth and fifteenth centuries the older taste for illuminated Gospels (from late antiquity to the eleventh century) and psalters (from the eleventh to the thirteenth centuries) had been supplanted by illuminated BOOKS OF HOURS, famously the early fifteenth-century *Très Riches Heures* in part illuminated by the LIMBOURG brothers for Jean, duc de Berry, and now in the Musée Condé in Chantilly. Later in the fifteenth century, the most important illuminators were Sanders BENING and Jean FOUQUET.

The advent of print rendered illuminated manuscripts an anachronism. There are instances of illuminations being added to printed books, and in the early sixteenth century a few very fine illuminated manuscripts were made, notably Simon BENING's Grimani Breviary (now in the Marciana in Venice) and the Hours of Anne of Brittany (now in the Bibliothèque Nationale in Paris).

impresa

(Italian plural *imprese*), an EMBLEM or device consisting of a picture accompanied by a motto. The impresa was distinguished from other emblems by virtue of the fact that it was regulated by academies. The idea of the impresa was originally French, and was transmitted to Italy through the French occupation of Milan early in the sixteenth century. Thereafter Italian humanist courtiers commissioned MEDALS bearing a portrait on one side and an impresa on the obverse. The historian Paolo Giovio set out five rules for the impresa in his *Dialogo dell'imprese militari et amorose* (1555): it must be properly proportioned, strike a middle course between obscurity and transparency, be attractive to the eye, eschew the human figure, and be accompanied by a motto in a language different from that of the formulator of the device.

incunabula

The Latin term (literally 'swaddling clothes') for books printed before 1500, in the 'infancy' of printing; the singular form is incunabulum. In English the terms 'incunable' and 'incunables' are sometimes used as alternatives to the Latin forms.

Inglés, Jorge

(*fl.* 1455), Spanish painter, possibly of English origin, who was one of the earliest exponents of the Hispano-Flemish style of Spanish art. Contemporary documents associate him with only one work, the ALTARPIECE mentioned in the will of the marqués de Santillana (1455), who had commissioned a series of panels to illustrate a poem that he had written in honour of the Virgin; the surviving panels are now in the

private collection of the present marquis. Other works are attributed to Inglés on stylistic grounds, notably the altarpiece *St Jerome in his Study* (Museo Nacional de Escultura, Valladolid).

intaglio

(Italian plural *intagli*), an engraved or incised GEM in which the design is sunk beneath the surface; the process, which can also be used with glass or shell or ceramics, is the reverse of CAMEO, which is carved in relief. Intaglio gems were sometimes used as seals, which were pressed onto wax to produce a likeness in relief.

intarsia

or tarsia. In fifteenth-century Italy the generic term for inlay and marquetry was *tarsia*; the infinitive form was *intarsiare* and those who practised the craft were called *intarsiatori*. In the nineteenth century the term *tarsia* fell out of use and was replaced by the back formations *intarsio* and *intarsia*; modern Italian has settled on the masculine form, *intarsio*, while English has chosen the feminine form, *intarsia*.

The art of intarsia decoration was developed in the fourteenth century by Sienese craftsmen, initially for the backs of choir stalls; early examples include the work of Giovanni Ammannati (d. 1340) in Orvieto Cathedral and of Domenico de' Cori (*c*.1362–1450) in the chapel of the Palazzo Pubblico in Siena. In the fifteenth century the principal centre of pictorial intarsia was Florence, where *intarsiatori*, often trained in the studio of Francesco di Giovanni (1428–95; also called Francione), decorated furniture (including CASSONI) and wall panels with intarsia STILL LIFES, pictorial scenes, and architectural perspectives. A favourite motif was the TROMPE L'ŒIL partly opened cupboard door revealing a collection of books and instruments; one of the finest examples is in the *studiolo* of the Palazzo Ducale in Urbino (1479), which may be the work of the architect Baccio PONTELLI. The dual vocation of architect and *intarsiatoro* is also apparent in the work of BACCIO D' AGNOLO and GIULIANO DA MAIANO.

Intarsia was memorably used to decorate *studioli* in Gubbio (now in the Metropolitan Museum in New York) and Urbino, but its principal application in fifteenth- and early sixteenth-century Italy was the decoration of choir-stall panels, notably those of Fra GIOVANNI DA VERONA in Monte Oliveto Maggiore near Siena, Domenico DEL TASSO in Perugia Cathedral, Agostino de Marchi (1458–90) in San Petronio in Bologna, and Francesco Zambello (d. 1549) in San Lorenzo in Genoa.

In the Veneto and Lombardy a kind of intarsia called *certosina* or *intarsia della certosina* (from an association with Carthusian monasteries) became a common feature of *cassoni* in the fifteenth century; it consisted of abstract geometrical patterns (derived from Arabic designs) and was made with polygonal tesserae of inlaid bone, ivory, wood, metal, or mother-of-pearl. In the early sixteenth century geometrical intarsia was introduced to Slovakia by Johannes MENSATOR.

Pictorial intarsia was introduced in south Germany by the carver Peter FLÖTNER and the painter Lorenz Stoer, who collaborated on *Geometria und Perspectiva* (1567), a collection of woodcut designs for intarsia panels. South German cabinetmakers (especially in Augsburg and Nuremberg) used intarsia panels for wall panels, doors, and furniture. The most common motif, that of the exterior of a real or fanciful building, spread from south Germany to the Netherlands and then to England, where intarsia panels (often illustrating buildings) were used in Elizabethan and Jacobean furniture, especially the fronts of chests and the headboards of beds.

In France, the group of 22 Italian craftsmen taken to France by King Charles VIII after the capture of Naples in 1495 included two *intarsiatori*, Domenico da Corona and Bernardo da Brescia. Their work was immensely influential, and through their intarsia they introduced colour to French furniture.

An **intarsia** panel in the *studiolo* (1479) of the Palazzo Ducale in Urbino. The room was probably planned by Francesco di Giorgio Martini, but the intarsia is almost certainly the work of Baccio Pontelli. This panel is a fine example of the motif of the trompe l'œil representation of a partly opened cupboard containing books and scientific instruments.

International Gothic

An art-historical term coined in 1892 by Louis Courajod to denote a style prevalent between *c.*1375 and *c.*1425 in painting and related arts such as illuminations, mosaics, tapestries, enamels, and stained glass. The style, which is characterized by an elegant and sometimes sensuous curvilinear stylization in its representation of natural objects, emerged in the courts of Burgundy and France. In the late fourteenth century the most important centres of International Gothic were Mehun-sur-Yèvre (seat of the dukes of Berry), Bourges (the capital of Berry), Dijon (seat of the dukes of Burgundy), and Paris; beyond Burgundy and France, International Gothic found important exponents in northern Italy (GENTILE DA FABRIANO, PISANELLO, and STEFANO DA ZEVIO), Bohemia (in paintings such as the Trebon altarpiece in the National Gallery in Prague), the Rhineland (Master FRANCKE), and England (in paintings such as the Wilton Diptych, now in the National Gallery in London). In the early fifteenth century the style became unfashionable in Burgundy and France, but continued to flourish in Italy and Spain, notably in Catalonia (Lluís DALMAU, Jaume HUGUET, and Bernat MARTORELL).

istoriato

A form of Italian display MAIOLICA in which the polychrome decorations consist of narratives (*istoriato* means 'storied') drawn from history, classical mythology, or the Bible. The principal centres of production were CASTEL DURANTE, FAENZA, and Urbino. In the nineteenth century this maiolica came to be known in English as Raffaelle ware or Raphael's ware, because it was (mistakenly) believed that Raphael had painted some of the pottery. His designs were certainly used, as were designs by painters such as Battista FRANCO and Taddeo ZUCCARO, but the principal istoriato painters were Orazio FONTANA, NICOLA DA URBINO, and Francesco Xanto AVELLI.

italic

A fount invented by Francesco GRIFFO for ALDUS MANUTIUS, who used it from 1501 on editions of classical texts in small formats. The fount was modelled on the cursive chancery hand (*cancelleresca corsiva*) used in the Vatican secretariat. The same humanistic script became the basis of a more elaborate cursive hand which was first published in 1522 by Ludovico ARRIGHI in his *Operina da imparare di scrivere littera cancellaresca*, which was the first printed handbook on CALLIGRAPHY. Both script and fount were known as Italic to distinguish them from Gothic hands and Roman and Gothic types.

In France italic type was introduced by Simon de Colines in 1528. His designs were modelled on Roman types, but introduced an italic slope into lower-case letters. The style of French italics was permanently fixed later in the sixteenth century by Robert GRANJON. Inclined italic upper-case letters were first made in Vienna in 1532, and by mid-century were in general use.

In the early sixteenth century italics were used to set entire texts, but thereafter they were increasingly used to distinguish parts of a book other than the main text, such as commendatory verses. In the 1550s the Antwerp type founder François Guyot introduced the first italic fount designed to match a roman fount.

ivory

or (Latin) *ebur*. The term 'ivory' is used in a narrow sense to refer to the tusk of the elephant, but carved ivory artefacts may derive from the tusk of various animals (narwhal, walrus, hippopotamus, fossil mammoth) or the horn of the rhinoceros or the teeth of various mammals (including whales and humans) or of the crocodile. Ivory carving was an important art form in medieval Europe and in Byzantium, but in the mid-fifteenth century it declined in importance. In the sixteenth century ivory was little used for sculpture, but was an important material in the decorative arts, and was widely used for articles such as handles (of daggers and table-knives), sword pommels, hunting horns, powder flasks, and domestic objects (combs and mirror cases). In the same period, Portuguese traders were importing West African ivories fashioned for the European market (and so termed 'Afro-Portuguese ivories') such as salt cellars and hunting horns by Benin and Sherbo carvers (examples are preserved in the British Museum). Ivory carving was revived in the seventeenth century by German, Flemish, and French carvers, but the art form died in the early nineteenth century, surviving until the ivory bans of the late twentieth century only in attenuated form, chiefly Chinese 'magic balls' of concentric spheres of openwork which are more remarkable as feats of patience and skill than as works of art.

J

Jacobello del Fiore

(c.1370–1439), Italian painter, born in Venice, the son of a painter; he trained with his father and with GENTILE DA FABRIANO. His surviving works include a *Lion of Saint Mark* (1415, Ducal Palace, Venice), the *Triptych of Justice* (1421, Accademia, Venice), and *The Life of St Lucy* (c.1410, Pinacoteca Comunale, Fermo).

Jacomart

or Jaume Baço (c.1413–1461), Spanish painter. He worked in Valencia before being summoned to Naples in 1440 by Alfonso V of Aragon, for whom he worked as a court painter. The incomplete paintings that he had to abandon in Valencia were completed by Juan Rexach (fl. 1431–84). In Naples he painted an ALTARPIECE (now lost) depicting the appearance of the Virgin to King Alfonso.

By 1451 Jacomart was back in Valencia, where he continued to enjoy royal patronage, executing an altarpiece for the Royal Chapel. The work of his second Valencian period, in which his Hispano-Flemish idiom may have been accentuated by his years in Naples (where the style was popular), is attributed to Jacomart on the basis of stylistic comparisons to the only surviving documented work, an altarpiece (executed with assistants) representing the martyrdom of St Peter and St Lawrence painted for the parish church of Catí.

Jacopino del Conte

(1510–98), Italian painter, born in Florence, where he trained in the studio of ANDREA DEL SARTO. The finest of his Florentine paintings is a *Virgin and Child with John the Baptist and St Elizabeth* (c.1535, National Gallery, Washington). Jacopino moved c.1538 to Rome, where he painted two fresco cycles in the Oratory of San Giovanni Decollato (the Roman church of the Florentine Confraternity of the Misericordia).

Thereafter he became a portrait artist; his sitters included *Michelangelo* (Metropolitan Museum, New York) and *Pope Paul III* (Church of San Francesco Romano, Rome).

Jacopo da Trezzo

(c.1514–1589), Italian goldsmith and medallist in Spain, a native of Milan who in 1555 travelled to the Netherlands to enter the service of King Philip II; his finest surviving work from this period is a portrait MEDAL of Queen Mary I of England (British Museum). In 1559 he followed the court to Spain. He established workshops in Madrid and at the Escorial, and brought to Spain several members of the MISERONI FAMILY. His jasper monstrance (1579–86) mounted in gilt bronze is in the Escorial.

Jacopo della Quercia

(c.1374–1438), Italian sculptor, born in Siena. VASARI records that in 1401 Jacopo was an unsuccessful entrant in the competition to design new baptistery doors in Florence; his sample panel is lost. His earliest surviving work, the tomb of Ilaria del Carretto in Lucca Cathedral (c.1406), combines Gothic drapery with Renaissance putti and scrolls; it was an obscure work of art until lavishly praised by Ruskin. A similarly syncretic style is apparent in Jacopo's Fonte Gaia (1409–19), a FOUNTAIN designed for the Campo of Siena; substantial fragments survive in the Palazzo Pubblico in Siena. From 1417 to 1431 Jacopo collaborated with DONATELLO and GHIBERTI on the font in the baptistery in Siena, for which he supplied a relief. He interrupted this task in 1425 to sculpt panels depicting biblical scenes for the central portal of the Church of San Petronio in Bologna. His surviving work in wood includes a pair of statues depicting *The Annunciation* (1421) in the Cathedral (Collegiata) of San Gimignano.

Jacopo del Sellaio

(1441–93), Italian painter, born in Florence, the son of a saddler (Italian *sellaio*); he may have trained in the studio of Fra Filippo LIPPI. His earliest documented paintings are an *Angel Annunciate* and a *Virgin Annunciate* (1477, Santa Lucia dei Magnoli). His later paintings include a huge *Crucifixion with the Virgin and Seven Saints* (Church of San Frediano, Florence).

Jamnitzer, Wenzel

(1508–85), German goldsmith. He was born into a Viennese family of goldsmiths, but moved with his father Hans Jamnitzer the Elder (d. *c.*1549) and his brother Albrecht (d. 1555) to Nuremberg at an unknown date before 1534, when he became a burgher of the city and a master of the Guild of Goldsmiths. He was appointed in 1543 as the die-cutter of the city's coins and seals and in 1552 he became master of the city mint, a post that brought with it *de facto* recognition as Nuremberg's leading goldsmith. He was also appointed to a series of increasingly prestigious civic appointments, beginning with membership of the city council in 1556, and served as *Kaiserlicher Hofgoldschmeid* (imperial goldsmith) to the Emperors Charles V, Ferdinand I, Maximilian II, and Rudolf II.

Jamnitzer seems to have been the originator of the fashion for casting minutely realistic ornamental figures of small animals (*alle Tier auf Erden*, 'all animals on earth') such as beetles, frogs, and lizards; extravagant examples of these silver menageries include a silver writing case made for Archduke Ferdinand II (*c.*1570, Kunsthistorisches Museum, Vienna) and a table clock (1560, Residenzmuseum, Munich) for which the design survives (Kupferstichkabinett, Berlin). Some of Jamnitzer's finest pieces are table-centres, of which the best known are the Mother Earth or *Merckelsche* centrepiece (Rijksmuseum, Amsterdam) of 1549, so named after the Nuremberg merchant who in 1809 saved it from the melting-pot, and the *Lustbrunnen* of 1556, a table-centre with a FOUNTAIN commissioned by Maximilian II and completed for Rudolf II; it is now lost except for the four gilt-bronze supporting figures of Flora, Ceres, Bacchus, and Vulcan (Kunsthistorisches Museum, Vienna).

Jamnitzer's workshop trained goldsmiths such as Mathias ZÜNDT and many members of his own family. His son Hans Jamnitzer the Younger (1539–1603), who became a master in 1563, may have been the maker of a handbell covered with silver wildlife (British Museum), but the bell has also been attributed to his father. Albrecht's son Bartel (*c.*1548–1618), who became a master in 1575, was the maker of a pair of NAUTILUS SHELL cups now in the Hessisches Landsmuseum in Kassel. Hans the Younger's son Christoph (1563–1618), who became a master in 1592, was the maker of several well-known pieces, including a cup in the shape of an angel (Armoury Museum, Moscow), the extravagant Trifoni ewer and basin (1603, Kunsthistorisches Museum, Vienna), and, most appealing to modern tastes, a table-fountain shaped like an elephant (*c.*1610, Kunstgewerbemuseum, Berlin). He also published a pattern book of GROTESQUE ornaments (*Neue Grotesken buch*, Nuremberg, 1610).

Janssens, Abraham

(*c.*1575–1632), Flemish painter who worked in Antwerp, where he became dean of the guild in 1606. He visited Rome in 1598, and may have returned to Italy *c.*1604; the influence of Italian models is readily apparent in his paintings. His most important civic commission was the *Scaldis and Antwerpia* (1610) painted for the States Chamber of the Town Hall and now in the Koninklijk Museum voor Schone Kunsten in Antwerp. His religious paintings include a *Lamentation* (St Janskerk, Mechelen) and a *Scourging of Christ* (1626, St Michielskerk, Ghent).

Jenson, Nicolas

(*c.*1420–1480), French type founder and publisher in Venice. He was born near Troyes and trained in Germany before settling in Venice. He published more than 70 books, mostly in Greek and Latin; some of his books were illuminated by hand, as if they were manuscripts. Some were printed in Gothic founts (notably his Latin Bible of 1476), but Jenson is best known for his invention of a clear roman typeface which by 1467 was in use in Strasbourg and Rome as well as Venice.

jet

or (French) *jais* or (German) *Gagat*, a highly polished black stone that derives from the fossilized driftwood of the *araucaria* (monkey-puzzle tree) genus. Jet was mined in Whitby (Yorkshire), the Lias of Württemberg, and the Aude, but the principal source of jet in the early modern

period was Villaviciosa de Asturias, on the north coast of Spain. Jet has been valued for its amuletic properties since antiquity, and for millennia personal ornaments carved from jet have been used to ward off the evil eye and attacks by demons and serpents; they also afford protection from diseases of the eye.

The proximity of Villaviciosa to the pilgrim route to Santiago de Compostela enabled Santiago craftsmen to carve jet for the pilgrim trade. In the fifteenth century the jet carvers of Santiago organized themselves into guilds, each of which had its own retail outlet and its own regulations (including the presentation of 'master works' by apprentices seeking admission). In the sixteenth century production reached its highest levels, and large numbers of crucifixes, paxes, and rosaries were produced, as were carvings of the soldiers of the *reconquista* (*matamoros*) and of pilgrims.

Joan, Pere

(1398–after 1458), Catalan sculptor in the Gothic tradition who carved the gilded alabaster reredos in the central apse of Tarragona Cathedral (1426–33); the reredos depicts scenes from the life of St Tecla, the patron saint of the city. He started work on the reredos of Zaragoza Cathedral, but was called to Naples by King Alfonso V in 1447. In Naples he contributed to the triumphal arch built to commemorate the king's entry into Naples on 26 February 1443.

Joest, Jan

(c.1450–1519), Dutch painter, born in Wesel, near Rocklinghausen. He moved to Haarlem in about 1510. His most important surviving work is a *Life of Christ* (1505–8) in the Church of St Nicholas in Calcar on which he was assisted by JOOS VAN CLEVE. He was also commissioned (1505) to paint an altarpiece for Palencia Cathedral; it consists of seven panels of *Sorrows of the Virgin* and one of the donor with Mary and St John.

Johann von Speyer

(d. 1470) and Wendelin von Speyer (d. c.1477), German printers, brothers from Speyer (English exonym Spires) who arrived in Venice in 1467. Johann was awarded a printing mono-poly, and in 1469 the two brothers opened a printing workshop. Their first book was an edition of Cicero's *Epistolae ad familiares* (1469) printed in roman type in an edition of 300 copies. After Johann's death, Wendelin continued the business until 1477; his books included an Italian translation of the Bible (1471), an edition of Petrarch, and many classical works in Latin.

Johnson, Gerard the Elder

or (Dutch) Geraert Janssen (d. 1611), Dutch sculptor and mason who emigrated to England from Amsterdam, a refugee from the violence of the Revolt of the Netherlands which erupted in 1567. He settled in Southwark (on the south bank of the Thames opposite London) and established a workshop that specialized in tombs but also made CHIMNEY PIECES and basins for FOUNTAINS. His most important tombs are the ALABASTER monuments of the third and fourth earls of Rutland (1587 and 1588) in Bottesford Church in Leicestershire.

Johnson's four sons by his English wife, Bernard, John, Nicholas, and Gerard (or Garat) the Younger, all followed him into the profession: Bernard (fl. 1610) was principal mason at Northumberland House in the Strand (demolished 1874) and Audley End in Essex, Nicholas (d. 1624) made the tomb for the fifth earl of Rutland (1612), and Gerard the Younger (fl. 1611–16) achieved posthumous fame as the sculptor of Shakespeare's monument in Holy Trinity Church in Stratford, though the attribution is not wholly secure.

Jones, Inigo

(1573–1652), English architect and stage designer, born in London, the son of a recusant cloth worker. As a young man he secured the patronage of the earl of Pembroke, at whose expense he visited Italy. In 1605 Jones began to design scenery and costumes for masques, initially those of Ben Jonson but subsequently for many other writers of masques. From 1613 to 1615 he was again in Italy, this time accompanying the earl of Arundel. It seems to have been on this journey that he began to study the architecture of PALLADIO, whose principal English exponent he was soon to become.

In 1615 Jones was appointed surveyor of the king's works, and in this capacity designed the Queen's House in Greenwich (1616–18 and 1629–35), an Italianate VILLA which is the first classical house in England, and the Queen's Chapel in St James's Palace (1623–5), which was the first classical church in England. He was also the architect of the BANQUETING HALL in the Palace of Whitehall (1619–22) and the likely

architect of Lincoln's Inn Chapel (1617–23), of which the foundation stone was laid by John Donne. His lost works include the Corinthian portico of St Paul's Cathedral (destroyed 1666) and Covent Garden, the first London square (of which only the church survives). Many of his drawings survive in Worcester College, Oxford (which also has his annotated copy of Palladio's *Quattro libri dell'architettura*), and at Chatsworth House in Derbyshire.

Jonghelinck, Jakob

or Jacques (1530–1606), Flemish sculptor and medallist, born in Antwerp. He studied in Milan, where he may have worked with Leone LEONI, and returned to Flanders in 1555. From 1558 to 1560 he fashioned the bronze table-tomb of Charles the Bold (who had died in 1477) for the Church of Our Lady in Bruges. The tomb was (and is) situated beside the fifteenth-century tomb of Charles's only daughter, Mary of Burgundy (who had died in 1482). Most medieval and Renaissance artists were happy to juxtapose radically different styles, but Jonghelinck took the unusual step of imitating the style of his predecessor who had sculpted Mary's tomb.

Jonghelinck executed many portrait bronzes, notably the bronze bust of the *Duque de Alba* (1571, Frick Collection, New York). His lifesize bronze of the *Duque de Alba* (1571), formerly in Antwerp Castle (the Steen), was destroyed in the 'Spanish fury' that engulfed Antwerp in November 1576.

Joos van Cleve

or Joos van der Beke (*c*.1490–*c*.1540), Flemish painter, admitted to the guild in Antwerp in 1511; his name implies that he was a native of the city or province of Cleves. Joos travelled widely as a portrait painter. The subjects of paintings attributed to him include King Henry VIII (*c*.1536, Hampton Court) and King Francis I (Philadelphia Museum of Art). He also painted religious pictures, such as the *Holy Family* in the National Gallery in London.

The Master of the Death of the Virgin, whose name derives from the triptych of *The Death of the Virgin* in the Wallraf-Richartz Museum in Cologne, is now agreed to be Joos van Cleve. The canon of Joos's works includes ten prints, including the unique surviving impression of a *Battle Scene* now in the Louvre.

Joos van Wassenhove

or (English) Justus of Ghent or (French) Juste de Gand or (Italian) Giusto da Guanto (*fl.* 1460–80), Flemish painter, admitted to the Antwerp guild in 1460. He lived from 1464 to 1465 in Ghent, where he was admitted to the guild and met Hugo van der GOES. His early paintings include an *Adoration of the Magi* (Metropolitan Museum, New York). In 1475 he entered the service of Duke Federico II da Montefeltro, and remained in Urbino until 1475. During this period he painted *The Communion of the Apostles* (Palazzo Ducale, Urbino) and a series on the seven liberal arts, of which *Music* and *Rhetoric* survive in the National Gallery in London and *Astronomy* and *Grammar* were destroyed in Berlin in 1945. The *Crucifixion* in Ghent Cathedral is usually considered to be the work of Joos. The series of 28 *Famous Men* now divided between the Palazzo Ducale in Urbino and the Louvre in Paris is sometimes attributed to Joos, but it is more likely that it is the work of a group of painters, including Joos and Alonso BERRUGUETE.

Juan de Flandes

(*c*.1465–*c*.1519), Flemish painter in Castile, employed by Queen Isabella. In the late 1490s, while living in Burgos, he painted a polyptych known as the *Oratorio de la reina católica*; 27 of its 47 small panels are known to survive. He lived from 1505 to 1508 in Salamanca, and then spent the final years of his life in Palencia, where he painted an altarpiece for the Church of San Lázaro (of which three panels are in the Prado and three in the National Gallery in Washington) and a series of panels on *The Life of Christ* for the Cathedral, where the twelve panels are still in place.

Juan de Juanes

See MAÇIP

Juan de Juni

or (French) Jean de Joigny (*c*.1507–1577), Burgundian sculptor in Spain who worked in León and Salamanca in the 1530s and settled in Valladolid in 1540. The subject of his sculptures is always religious, and they are characterized by the dramatic expression of strong emotion, a feature that anticipates the advent of the BAROQUE in Spanish art. Juan's best-known works are depictions of *The Entombment*: the early version executed for the Monastery of San Francisco in Valladolid (1545) is now in the Valladolid Museum, and the later version

(1571) is in the Capilla del Entierro in Segovia Cathedral. Between 1545 and 1561 he was chiefly occupied with the vast MANNERIST reredos for the Church of Santa María la Antigua in Valladolid (now in Valladolid Cathedral).

Juan de la Huerta

(*fl.* 1431–62), Spanish sculptor who in 1443 succeeded Claux der WERVE as the artist responsible for the tomb of John the Fearless, duke of Burgundy (d. 1419), and his wife in the Chartreuse de Champmol near Dijon. Juan imitated the nearby tomb of Philip the Bold in his carving of the minor figures, but left in 1457 without finishing the tomb, which was eventually completed by Antoine MOITURIER. The Charterhouse is now a psychiatric hospital, and the tombs of the dukes of Burgundy have been moved to the Musée des Beaux-Arts in Dijon.

Juste, Jean

(1485–1549), Italian sculptor in France. He was born in San Martino (near Florence) and in the early years of the sixteenth century settled in Tours with his two brothers; in 1513 he was appointed royal sculptor. The finest work of the three brothers was the tomb of Louis XII and Anne of Brittany, which was made in their workshop in Tours (1517–18) and installed in the Abbey of Saint-Denis, near Paris (1531). The tomb depicts the kneeling king and queen attended by the twelve apostles (who are seated) and four allegorical figures representing Virtues; reliefs depict the king's victories in Italy. The tomb is executed in an Italian Renaissance idiom except for the presence of corpses (*gisants*) on the sarcophagus, which represents the continuation of a medieval tradition.

K

Kaltemail

(German; 'cold enamel'), a form of lacquer used as a substitute for enamel on ceramics, metals, and wood when they could not be fired, because of either fragility or size.

Karcher, Nicolas

or Nicola (*fl.* 1517, d. 1562), Flemish TAPESTRY weaver who worked with his brother Jan (Italian Giovanni) in the Este tapestry workshop in Ferrara; hangings produced in the workshop depicted classical themes drawn from Ovid. From 1539 to 1541 Nicolas worked in the service of the Gonzaga family in Mantua; his Mantua workshop wove a series of *Playing Boys* designed by GIULIO ROMANO (Gulbenkian Museum, Lisbon; Museo Poldi Pezzoli, Milan). He subsequently moved to Florence, where he established a tapestry workshop for Duke Cosimo I de' Medici; the products of this workshop include a *History of Joseph* designed by BRONZINO (Palazzo Vecchio, Florence).

Kellerthaler, Hans

or Johann (*c.*1562–1611), German goldsmith who worked in Dresden. He made the silver plaques (1585) for the Schmuckschrank (jewellery cabinet) of the Electoral Princess Sophia of Saxony (now in the Grünes Gewölbe in the Albertinum in Dresden).

Kels, Hans the Younger

(*fl.* 1546–*c.*1570), German woodcutter who worked in Augsburg for the Fugger family. The doors and door-cases executed for Schloss Donauwörth (now the Bayerisches Nationalmuseum, Munich) in 1546 are attributed to Kels. He collaborated with a local carver, Thomas Heidelberger von Memmingen (*c.*1541–*c.*1597), on the carved and inlaid sacristy furniture in the church of the Benedictine abbey at Ottobeuren (near Memmingen), for which Heidelberger made the organ-case and choir stalls (later incorporated into a sacristy cupboard).

Kenilworth Castle

In 1265 the medieval castle at Kenilworth (Warwickshire) was granted by Henry III to his second son Edmund Crouchback, earl of Lancaster, and for the next three centuries it was passed back and forth between the crown and various noble families. In 1563 the castle was granted by Queen Elizabeth to her favourite Robert Dudley, earl of Leicester, who decided to convert the castle into a great house fit to receive occasional visits from the queen. He retained the banqueting hall that had been built in 1392, and redesigned the Norman keep (built 1120), inserting mullioned and transomed windows on the first floor and renovating the accommodation within the building. He also demolished part of the curtain wall to construct the magnificent guest house that has been known since the seventeenth century as Leicester's Building.

Dudley also built a gatehouse, beside which a large garden was laid out. The design shows indirect French influence, mediated through the English royal palace gardens. Like the gardens at Hampton Court Palace, Whitehall, and Nonsuch Palace, Dudley's gardens consisted of a square divided into quarters, laid out in KNOT GARDENS; at the centre of the square there was a fountain. One important factor separated Dudley's garden from those at the royal palaces: whereas the royal gardens could all be viewed from the state apartments on the first floor, the Kenilworth gardens could not be seen from the castle, and so a large terrace was constructed from which the gardens could be viewed. The terrace was decorated with obelisks and heraldic animals on posts; this distinctly English element, which also appeared in the fountain at the centre of the garden (which was topped by Dudley's personal device, the bear and 'ragged staff', i.e. a staff with projecting knobs), seems to derive from the royal garden at Hampton Court.

Ketel, Cornelis

(1548–1616), Dutch portrait and history painter and draughtsman, born in Gouda, where he received his early training from his uncle Cornelis Jacobszoon. He trained for one year (*c*.1565) in the Delft studio of Anthonis Bloklandt van Montfoort (1532/4–83) and then worked at FONTAINEBLEAU (1566) and in Paris (1567–8) and London (1573–*c*.1581) before settling permanently in Amsterdam. His surviving individual portraits include one of the explorer Sir Martin Frobisher (1577, Bodleian Library, Oxford) and another of *Queen Elizabeth Holding a Sieve* (Pinacoteca, Siena); his surviving group portraits include the *Company of Captain Rosencrantz and Lieutenant Paul* (1588, Rijksmuseum, Amsterdam).

Key, Adriaan Thomaszoon

(*c*.1544–after 1589), Flemish portrait painter, the pupil (and possibly a relative) of Willem KEY. He was admitted to the Antwerp guild in 1568. His portrait of William of Orange exists in several versions, of which the best known is in the Rijksmuseum in Amsterdam.

Key, Lieven de

(1560–1627), Dutch mason and architect, born in Ghent. He worked in London for many years (1580–91) and then returned to the Netherlands; in 1593 he was appointed as a civic architect in Haarlem, where he settled permanently. He was responsible for churches and public buildings in Haarlem and Leiden. He built the Meat Hall in Haarlem (1602–3) and the Town Hall in Leiden (1593–7), in which the centre of the façade is topped with a scrollwork gable and the octagonal flèche that rises in storeys above the building incorporates Moorish elements. Key was also the architect of the tower on the Nieuwe Kerk in Haarlem (1613).

Key, Willem Adriaenszoon

(*c*.1515– 1568), Flemish portrait painter, trained in the studio of Lambert LOMBARD in Liège; in 1542 he was admitted to the guild in Antwerp, where he settled permanently. His surviving works include *Susanna and the Elders* (1546, Schloss Weissenstein, Pommersfelden), *The Holy Family* (1551; sold London, Christie's 1988), and a *Lamentation* (1553, private collection).

Keyser, Hendrick Corneliszoon de

(1565–1621), Dutch architect and sculptor, appointed city architect of Amsterdam in 1595.

His most important large secular buildings are the Amsterdam Exchange (1608) and the Delft Town Hall (1618). His austere churches, notably the South Church (1603–14) and West Church (begun 1620) in Amsterdam, were long influential in Protestant church design in the Netherlands and in Germany, in significant part because they successfully shifted the focus of the interior from the altar to the pulpit. A similar urge to subdue decoration and emphasize structural lines is apparent in Keyser's domestic architecture, in which he reduced the number of steps in gables and introduced the classical ORDERS of architecture. Many of Keyser's buildings were engraved by Salomon de Bray and published as *Architectura moderna* (1631). His most important sculptural works are the tomb of William of Orange at Delft (1614–*c*.1621) and a statue of Erasmus (1618) in Grote Kerkplein, in front of St Laurenskerk in Rotterdam.

knot gardens

or (French) *entrelacs*. The term 'knot garden' is sometimes used in fifteenth-century English to refer to a MAZE and in sixteenth- and seventeenth-century English to a French PARTERRE. The term is now used by garden historians to refer to a small garden laid out in a series of continuous interlacing bands. Knot gardens seem to have originated in the knot designs of CARPETS AND RUGS imported into Europe from the Middle East in the fifteenth century. The earliest published designs of garden knots are the woodcuts in Francesco Colonna's *Hypnerotomachia Polifili* (Venice, 1499), where the flowers and herbs planted in the knots are explicitly said to resemble a carpet. The knot garden reached its apogee in England and France. Anyone thinking of building one could consult designs printed in Thomas Hill's *The Profitable Art of Gardening* (1568, 1608) and in *L'Agriculture et la maison rustique* (1564, 1570, 1572, 1582) by Charles Estienne and Jean Liébault; the 1572 edition was translated into English as *Maison rustique; or, The Country Farm* by Richard Surflet in 1600, and the 1608 edition of Hill's text replaces the knot design of the earlier edition with one borrowed from the 1582 edition of *L'Agriculture*.

Thomas Hill suggested that the knots be set in thyme or hyssop. In the seventeenth century John PARKINSON recommended box because of its strong lines, but allowed that the same effect could be achieved with 'lead, boards, bones, tiles or pebbles' (*Paradisus*, 1629).

Köberger

or Koburger, Anton (c.1440–1513), German publisher who introduced printing to Nuremberg in 1470 and sold his books through his sixteen shops and his network of agents throughout Europe. He published more than 200 folio INCUNABULA, many of which were lavishly illustrated with woodcuts, including Hartmann Schedel's 'Nuremberg Chronicle'. On his death the business passed to his heirs, but went bankrupt in 1526.

Koster

or Coster, Laurens Janszoon (c.1370– c.1440), Dutch xylographer, born in Haarlem, where he worked as a printer of BLOCK BOOKS (or xylographs) and from 1417 to 1434 held a series of important civic posts, including member of the Great Council, assessor (scabinus), and city treasurer; his surname, which means 'sacristan', reflects the position that he held in the church in Haarlem.

The claim that GUTENBERG was the originator of printing with movable type was challenged for centuries by champions of Koster. The rival claims of Mainz and Haarlem to be the birthplace of printing were long prosecuted with a view to claiming an honour for a nation or denying an honour to an unpopular nation, and these nationalist considerations overwhelmed the scholarly debate. The balance of argument now favours Mainz.

Kraft

or Krafft, Adam (c.1455/60–1509), German sculptor, born in Nuremberg. His principal surviving work is the huge ciborium (a canopy supported by columns) in the choir of the Lorenzkirche in Nuremberg. This richly decorated Gothic structure, which is almost 20 metres (65 feet) high, includes many sculpted figures of humans and animals; the tradition that one of the figures is a self-portrait is not supported by documentary evidence.

Krause, Jakob

(c.1531–1586), German bookbinder, based in Dresden, where he was the first bookbinder to use gold tooling and the first to use French and Italian designs. In 1566 he was appointed court binder to the Elector Augustus I of Saxony, a post which he held for the rest of his life. The library of the electors (now in the Sächsische Landesbibliothek in Dresden) contains many volumes bound by Krause in gilded bindings with portrait stamps and initials of members of the electoral family.

Krug, Ludwig

(c.1488/90–1532), German goldsmith, born in Nuremberg, the son of a goldsmith; he became a master in 1484 and served as master of the Nuremberg mint from 1494 to 1509. The only documented artefact known to survive from his workshop is not metalwork, but rather the Solnhofen stone relief of Adam and Eve (1514) now in the Skulpturengalerie in Berlin. His attributed works in stone include a large red marble relief (c.1524) now in the Bayerisches Nationalmuseum in Munich. Attributions of work in precious metals are based on a design for a covered cup which is known from a drawing in an inventory of the treasury at Halle; this drawing (c.1526), which is now in the Hofbibliothek in Aschaffenburg, is the basis of attributions of cups in Budapest, Berlin, and Vienna and nefs (silver miniatures of ships) in Nuremberg and Padua.

Krumpper

or Krumper, Hans (c.1570–1634), German sculptor, architect, designer and painter, born in Weilheim (35 kilometres (22 miles) south-west of Munich). In 1584 he entered the service of Duke Wilhelm V in Munich, where he was trained as a sculptor in the studio of Hubert GERHARD and then sent to Italy (1590–2) to study Italian art and architecture. He married the daughter of Frederich SUSTRIS, the court architect, and from 1594 was employed by the court; after Duke Wilhelm's abdication in 1598, Krumpper continued to work for him in a private capacity. Duke Wilhelm's successor Maximilian I additionally appointed him to the post of court painter (1609). Krumpper presided over the reconstruction of the Ducal Palace (Residenz) in Munich and also worked as a sculptor and a producer of designs for goldsmiths.

Kulmbach, Hans Süss or Suess von

(c.1485–1522), German painter. He was born in Kulmbach and studied in the Nuremberg studio of Albrecht DÜRER. He subsequently worked for several years as Dürer's assistant, often collaborating in the design of woodcuts, and in 1511 became a burgher of Nuremberg and an independent artist. He designed stained-

glass windows and painted portraits, and after Dürer stopped painting ALTARPIECES (c.1510) Kulmbach became the city's principal supplier of triptychs. Of his numerous surviving altarpieces the best known is his *Adoration of the Magi* (1511, Gemäldegalerie, Berlin), which formed the central panel of an altarpiece on *The Life of the Virgin* originally in the Pauline monastery in Kraków, which he visited in 1514; in the years immediately following his visit Kulmbach painted wings for two more altarpieces in Kraków, one of *St Catherine* (in the Church of St Mary) and another of *St John* (in the Church of St Florian).

L

lace

An openwork fabric, normally made of linen but also made with silk or wool and sometimes supplemented with gold and silver threads. It is often called after its place of manufacture (Brussels lace, Venetian lace) or its particular purpose (e.g. bride lace, which is sometimes made of silk or gold and used to bind the sprigs of rosemary carried at weddings). Lace is made by one of two techniques. Bobbin lace, which is also known as pillow lace, bone lace, and bonework lace, is made on a pillow with bobbins made of bone or wood. Needlepoint lace, which is also known as point lace (French *point à l'aiguille*, Italian *punto in aco*), is made with a needle rather than with bobbins; it is a form of NEEDLEWORK derived from medieval spiderwork (Latin *opus araneum*) and fifteenth-century LACIS, RETICELLA, and PUNTO IN ARIA. These two kinds of lace differ in appearance, in that bobbin lace is more delicate (and so was used to decorate personal clothing) and needlepoint lace is more sculptural (and so was used for ceremonial vestments), but each technique was on occasion used to imitate the effects of the other; the two types can be distinguished by the groundwork threads, which in bobbin lace are twisted or plaited and in needlepoint lace untwisted.

The earliest laces were made in Italy and Flanders at the end of the fifteenth century. In Italy, Venetian lace was made by the needlepoint technique and Genoese lace by the bobbin technique. In the late sixteenth century Venetian pattern books (initially those of Mateo PAGANO) were available all over Europe, and the term 'Venetian lace' (French *point de Venise*) came increasingly to denote style rather than provenance; in Flanders, where the most important centre for the manufacturing of lace was Brussels, needlepoint lace was known as *point de gaze* and bobbin lace included varieties known as *point plat* and *point d'Angleterre*. In the early 1620s bobbin lace began to be manufactured in Honiton (Devon); Honiton lace used Antwerp thread to execute floral designs, and Honiton became the principal centre of English lace until the eighteenth century.

lacis

or filet lace or darned netting, a form of NEEDLEWORK in which a net of threads, knotted at the crossing points, was used as the background for an ornamental pattern. Both the network and the darned pattern were normally made of linen, but occasionally coloured silks and gold thread were used for the pattern. Lacis evolved into the forms of LACE known as RETICELLA and PUNTO IN ARIA.

Lafréry, Antoine or Antonio

(1512–77), Burgundian engraver and publisher who settled in Rome, where he secured many of the copperplates of Marcantonio RAIMONDI. Throughout the 1540s he produced engraved views of ancient and contemporary Rome, some 130 of which he collected as *Speculum romanae magnificentiae* ('The Mirror of Rome's Magnificence').

Laib, Conrad

(*fl.* 1440–60), German painter. He was born in the Riesgau and settled in Salzburg *c.*1440. His style has a strong realist element, as evinced in details such as his depiction of fabric, and his facial expressions are highly individualized, even in his depictions of crowds in pictures such as the *Crucifixion* (1449, Belvedere, Vienna), which is the central panel of an altarpiece now dispersed (Palazzo Vescovile, Padua, and Seminario Patriarcale, Venice).

Lamberti, Niccolò

(*c.*1370–1451) and Piero (*c.*1393–1435), Italian sculptors from Florence. Niccolò worked on

carved doors depicting the four evangelists for the façade of Florence Cathedral, and in 1416 moved to Venice, where he worked with his son Piero (who predeceased him) and with Paolo UCCELLO on sculptural decorations for the Basilica San Marco.

Piero's work in Florence includes sculptures in Orsanmichele (including St James) and the tomb of Onofrio Strozzi in the Church of Santa Trinita. In 1424 he became capomaestro of the new wing of the Ducal Palace in Venice, for which he executed many sculptures; he also carved the tomb of Doge Tommaso Mocenigo in the Church of SS Giovanni e Paolo.

landscape painting

Elements of landscape appeared as background in some strands of the visual art of classical and medieval Europe, but the notion that the landscape itself could constitute a suitable subject for a painting did not emerge until the sixteenth century. Indeed, there is no evidence that the natural world was perceived as a unified scene (as opposed to an unending assemblage of natural objects) until artists taught viewers of paintings to view nature as 'picturesque'. The idea of the picturesque was not introduced into English until the eighteenth century, but it can be traced back through French pittoresque and Italian pittoresco to Dutch and Flemish schilderachtig, which has the sense of a landscape worthy of artistic representation. It was in Flemish art that landscape painting was to find its finest expression.

Landscape painting began with the watercolour drawings made by Albrecht DÜRER in the course of his visit to Italy in 1495. The first artist to make a career out of landscape art was Albrecht ALTDORFER, who painted (in oils and watercolours) and etched landscapes, sometimes without figures in the foreground. The abandoning of figures signalled a break with the tradition that pictures containing landscape had to have a narrative element. For Altdorfer, the landscape became an autonomous subject, and even in paintings such as the Rest on the Flight into Egypt (Gemäldegalerie, Berlin), the true subject is the scenery rather than the resting figures; indeed, this motif was to become an important pretext for landscape painting for centuries to come, as evidenced in paintings such as the Rest on the Flight into Egypt by CORREGGIO (Uffizi), Joachim PATINIR (Koninklijk Museum voor Schone Kunsten, Antwerp),

Rembrandt (National Gallery, Dublin), and Claude Lorraine (Galleria Doria, Rome).

In fifteenth-century Flanders, landscape played an increasingly prominent part in paintings ostensibly devoted to other subjects, and in the sixteenth century Flemish artists such as Joachim Patinir, Henri Met de BLES, and Pieter BRUEGEL the Elder transformed landscape painting into a major genre. Flemish artists soon introduced the landscape painting to other parts of Europe. Gillis van CONINXLOO was one of the most important disseminators of the genre: in 1587 he migrated as a Protestant refugee to Frankenthal (in the Palatinate) and there formed an artists' colony specializing in woodland scenes that influenced German landscape painters such as Adam ELSHEIMER; in 1595 Coninxloo moved to Holland, where he became an important influence on the Dutch school of landscape painters in the seventeenth century.

The growth of landscape painting in both Protestant and Catholic regions may in part be a product of its confessional neutrality. Edward Norgate, who bought pictures on behalf of King Charles I, commented with respect to the collecting of paintings that landscapes were 'of all kinds of pictures the most innocent, and which the Devil himself could not accuse of idolatry'. This quality was a particular advantage in northern Europe, where the iconoclastic strain in Protestantism had discouraged religious art.

In sixteenth-century landscape painting, landscapes were formally constructed, particularly in respect of colour: the foreground tended to be brown, the middle distance green, and the background blue, though Pieter Bruegel the Elder and Joos MOMPER II both resisted this convention. In early seventeenth-century Rome, where artists such as Annibale CARRACCI and Adam Elsheimer were active as landscape painters, the notion of the idealized landscape began to supplant the constructed landscapes of the sixteenth century. These Edenic landscapes were to become typical of painters such as Claude Lorraine and Nicolas Poussin, and were to have a profound influence on garden design.

Lante, Villa

A villa in Bagnaia, 5 kilometres (3 miles) east of Viterbo; the architect was almost certainly Giacomo VIGNOLA. Construction began c.1566, when the villa was commissioned by Cardinal

Gambara, bishop of Viterbo; it was completed by his successor, Cardinal Montalto, and in 1655 passed to the Lante family, from whom it takes its name. There is no imposing house, but rather two elegant CASINI that are treated as ornamental features in the finest of all Italian gardens.

The axis of the garden is marked by a stylized stream that falls from a wooded hillside over a series of low terraces to a pool. The water falls from the top of the hill through the Fountain of the Deluge between two PAVILIONS to the Fountain of the Dolphins; this fountain has replaced the Fountain of Coral built in 1596. The water is then channelled into a sculpted cascade (catena d'acqua) shaped at its head like an elongated crayfish (a visual pun on the literal meaning of gambero) and falls into the Fountain of the Giants, from which it emerges as a channel that runs the length of a stone table, which is the centrepiece of a graceful outdoor dining room; the channel was used to cool wine, and dinner dishes may have been floated on the water, in imitation of the practice at the Tuscan villa of Pliny the Younger. Finally, the water passes through the Fountain of Lights, which is flanked by GROTTOES dedicated to Neptune and Venus, and flows between the two casini to a square pool in the centre of which is a fountain with four youths holding aloft the arms of Cardinal Montalto, surmounted by water jets that spray the water into the lake. The lake is divided into four sections, each with a stone boat crewed, as Montaigne noted, by a musketeer and a trumpeter who shoot water into the lake; the features contribute to the imaginative re-creation of a naval battle known as a naumachia. The lake is set in a square terrace that is now laid out in four PARTERRES de broderie (in Italian, ricami), which replaced the eight original flower parterres in the seventeenth century.

The casini are both cubes some 23 metres (25 yards) square. The Palazzina Gambara (the one on the left as the viewer looks up the hill) was completed in 1578; its loggia contains wall paintings depicting the Villa FARNESE, the Villa d'ESTE at Tivoli, and the Villa Lante itself. Gambara did not build the other casino, instead diverting the money to build a hospital; the second casino, the Palazzina Montalvo, was eventually built by Carlo Maderno.

The garden of the Villa Lante is the best-preserved garden of the Italian Renaissance. In the seventeenth century Montaigne described it as the supreme water-garden, and in the twentieth century Sacheverell Sitwell, who declared that 'Villa Lante is as much a work of art as any poem, painting, piece of music', memorably reflected that 'were I to choose the most lovely place of the physical beauty of nature in all Italy or all the world that I have seen with my own eyes, I would name the gardens of the Villa Lante at Bagnaia'.

lattimo

or *opalia* or *vetro latteo* or (English) milk glass or opaque white glass or (German) *Milchglas* or *Porzellanglas* or (French) *blanc-de-lait*, an opaque white glass manufactured on the Venetian island of Murano from the early sixteenth century. It was the preferred glass for the background of ENAMEL painting (see plate 15).

When threads of *lattimo* were alternated with clear glass, the glass was called *Latticino* or *Lattincino* and the pattern was termed *vetro a filograna* (now known as *vitro de trina*); more complex patterns were known as *vetro a reticelli* or *vetro a retortoli*.

Lauber, Diebold

(fl. 1425–67), German manuscript illuminator who had a workshop in Hagenau (now French Haguenau) in Alsace, 15 kilometres (9 miles) north-east of Strassburg. His workshop is known to have produced more than 50 manuscripts (in both German and Latin) between 1425 and 1467.

Laurana, Francesco

or François (c.1430–c.1502), Dalmatian sculptor and medallist, born near Zara (then a Venetian possession, now Croatian Zadar). He worked from 1453 on the sculptural decoration of the triumphal arch erected in the Castelnuovo in Naples in honour of King Alfonso V of Aragon. His other work in Naples includes portrait busts of female members of the viceregal court, including those of Battista Sforza (Bargello, Florence) and Beatrice of Aragon (Kunsthistorisches Museum, Vienna). In Sicily, Laurana worked on the Mastrantonio Chapel (1468) in the Church of San Francesco in Palermo.

Laurana also worked in France, where he made several medals for René d'Anjou, titular king of Naples, a relief altarpiece of *Jesus Carrying the Cross* (Church of Saint-Didier, Avignon), and the Chapel (and altarpiece) of St Lazarus (1481) in the Ancienne Cathédrale de la Major in Marseille.

Laurana, Luciano

(c.1420–1479), Dalmatian architect, born at Lo Vrana, near Zara (then a Venetian possession, now Croatian Zadar). His principal work is the Palazzo Ducale at Urbino, of which he was appointed architect in 1468, by which time construction had already begun. In the course of his four years in Urbino he designed many interior features such as CHIMNEY PIECES and doorcases; he was probably the architect of the graceful arcaded courtyard in the Florentine style and of the west façade. The palace was later completed by FRANCESCO DI GIORGIO.

lead

A base metal which in medieval Europe was valued for its impermeability (and so was used for roofs, water pipes, and font linings) and for its malleability. The principal sources of lead were mines in England (Derbyshire and the Mendip Hills), Germany (Saxony), Austria (Carinthia), and southern Spain. In the sixteenth century the Roman practice of using lead for outdoor sculptures was revived. Lead was sometimes hammered or beaten into shape, but could also be melted and cast. It was also alloyed with tin to make PEWTER. Lead was also used for taking casts of objects made in more costly metals; there is a large collection of lead casts in the Historisches Museum in Basel.

The use of lead in water pipes and cisterns caused the stomach disorders known in England as Devon colic and in France as Poitou colic; in the eighteenth century medical scientists realized that the disorders could be attributed to lead poisoning.

Le Bé, Guillaume

(1525–98), French type founder, born in Troyes and trained in the workshop of Robert ESTIENNE. In 1545 he moved to Venice, where he worked as a type founder for several printers. He designed Latin and Greek founts, but his best-known founts are Hebrew.

Lehmann

or (later) Lehmann von Löwenwald, Kaspar (1563/5–1623), German lapidary, born in Uelzen. He entered the service of Duke Wilhelm V of Bavaria and in 1588 moved to Prague, where he worked at the court of the Emperor Rudolf II, who in 1595 ennobled him as Kaspar Lehmann von Löwenwald; he worked from 1606 to 1608 at the court of the elector of Saxony in Dresden, but thereafter returned permanently to Prague. In 1610 the emperor appointed him *Kaiserliche Kammer-Edelgestein und Glasschneider* ('imperial jeweller and glass engraver') and awarded him a monopoly of glass engraving in the Habsburg territories.

Lehmann was widely regarded as a distinguished carver and engraver of rock crystal, but no example of his work in this medium can now be identified. He was also an innovative worker in glass, developing the art of wheel engraving on glass (which led to the production of a strong potash-lime glass with the strength requisite for such engraving) and the technique of engraving hard stones with a lapidary's wheel for use in the decoration of crystal. The only signed example of his work in glass is an armorial beaker of 1605 in the Museum of Decorative Arts in Prague; attributions include an engraved glass plaque depicting Perseus and Andromeda in the Victoria and Albert Museum in London.

Leinberger, Hans

(1475/80–1530), German woodcarver and sculptor; his principal surviving work is the Gothic altarpiece (1514) carved for the former collegiate Church of St Castulus in Moosburg (50 kilometres (30 miles) north-east of Munich), in Bavaria; it remains in the church, but is not in its original state.

Lencker family

German goldsmiths in Augsburg. Hans Lencker (1523–85) was admitted to the guild in 1549 and became a burgher the following year; his works, which are remarkable for their enamel decoration, include the silver binding of the prayer book of the Emperor Maximilian I (Staatsbibliothek, Munich). Hans's brother Elias Lencker (d. 1591), who was also a skilled decorator in enamel, became master in 1562; his works include a ceremonial cup (c.1565–70, Germanisches Nationalmuseum, Nuremberg) and a book-rest (c.1590, Kunsthistorisches Museum, Vienna).

Another branch of the Lencker family is represented by Christoph Lencker (c.1556–1613) and his sons Zacharias (d. 1612) and Johannes (1573–1637). Christoph was appointed assay master of Augsburg in 1610; his best-known work is a silver-gilt ewer and basin embossed with scenes from the legend of Europa; the ewer is lost, but the basin is in the Kunsthistorisches Museum in Vienna. The work of Zacharias is represented by a relief of *The Infant Jesus with*

Angels (Kunsthistorisches Museum, Vienna). Johannes was appointed assay master in 1616 and served for many years as burgomaster of Nuremberg; the last ewer made by his father is known by a copy made by Johannes in 1620 and now in a private collection.

Leonardo da Vinci

(1452–1519), Italian artist and polymath, born in the village of Anchiano, near the Tuscan town of Vinci; he was the illegitimate son of a Florentine notary and a young peasant called Caterina. He was probably trained in the Florentine studio of VERROCCHIO, to whose *Baptism* (*c.*1472, Uffizi) Leonardo contributed the head of an angel. His early works, all painted in Florence, include an *Annunciation* (Uffizi) painted in Verrocchio's workshop, the *Benois Madonna* and the attributed *Madonna Litta* (both in the Hermitage in St Petersburg), the portrait of a young woman known traditionally as *Ginevra de' Benci* (National Gallery, Washington), and the unfinished *Adoration of the Kings* (Uffizi), which was commissioned in 1481; the rearing horses in the background of the *Adoration* were to become an important motif in Leonardo's drawings.

In 1482 Leonardo left Florence for Milan, where he entered the court of Ludovico Sforza, possibly as a musician. Leonardo shared Ludovico 's interest in the arts of war and was soon designing fortifications, waterways, weapons (including a tank), and flying machines. The drawings from Leonardo's seventeen years in Milan include these designs and innumerable drawings of the natural world, including flowers, birds, and unborn children. In Milan Leonardo painted at least four portraits, one of *Cecilia Gallerani*, the mistress of Ludovico Sforza, holding an ermine (*c.*1483, Muzeum Czartoryskich, Kraków), portraits of a *Musician* and of a *Woman in Profile* (both in the Biblioteca Ambrosiana, Milan), and the *Portrait of a Woman* (Louvre; also

known as *La Belle Ferronière*). He also began work on the Sforza Monument, a bronze EQUESTRIAN STATUE of Francesco Sforza which might have been one of his greatest works; Leonardo's preliminary drawings survive, but his full-sized clay model of the horse was damaged in the French invasion of Milan in 1499 and then moved to Ferrara, where it eventually disintegrated.

It was in Milan that Leonardo painted two of his greatest works, *The Virgin of the Rocks* and *The Last Supper*. *The Virgin of the Rocks*, which was commissioned in 1483, exists in two versions, and the relationship between the two is not entirely clear, though it is usually assumed that the version in the Louvre is earlier than the one in the National Gallery in London. *The Last Supper* (1495–7) was painted in the refectory of the Church of Santa Maria delle Grazie (for which BRAMANTE built the dome and cloisters), and began to flake away in the sixteenth century; VASARI reported that in 1556 it consisted largely of blots, and it was subsequently restored on several occasions. On 16 August 1943 the church was hit by an Allied bomb, and one of the side walls of the refectory collapsed; the *Last Supper* had been protected, and survived the attack.

In 1499 the French occupation of Milan led to the dispersal of Ludovico's court. Leonardo left Milan, and, after visits to Mantua and Venice, returned to Florence, where he lived from 1500 to 1516, during which time he also worked in Rome and Milan. In 1504–5 he worked on the cartoon and mural of *The Battle of Anghiari* (now lost) in the Sala del Maggior Consiglio in the Palazzo della Signoria in Florence. His other work in Florence includes *Leda and the Swan* (now lost; known from copies, including one by Cesare da Sesto in Wilton House) and the enigmatic *St John* (*c.*1515, Louvre); another painting of St John was later taken to Fontainebleau and converted into a *Bacchus* (Louvre). Similarly, he began

Leonardo da Vinci, *The Virgin of the Rocks* (*c.*1508), in the National Gallery, London. The painting is properly entitled *The Virgin with the Infant Saint John Adoring the Infant Christ Accompanied by an Angel.* The words on St John's scroll are 'ecce a[g]nus [dei]', 'Behold the lamb of God'. The original version of this painting, now in the Louvre (*La Vierge aux rochers*), was commissioned in 1483 by the Milanese Confraternity of the Immaculate Conception for their oratory in San Francesco. When this version was sent to France, Leonardo painted a replacement for the Confraternity, and it is this painting that is now in the National Gallery.

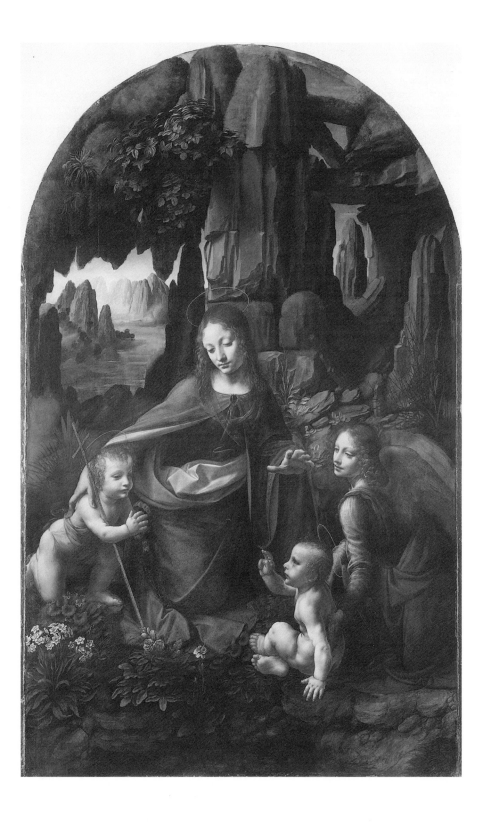

Colour plates 9–16

9. Filippo Brunelleschi, the dome of Florence Cathedral (1420–38). The 42-metre opening of the drum which the dome was to surmount was too wide to be bridged with conventional timber structures, so Brunelleschi had to devise a method of building that would be self-supporting as it rose. He contrived to distribute the stresses between the eight principal ribs, which were steeply pitched to reduce the pressure on the centre. For the infill between the ribs Brunelleschi revived the Roman technique of arranging the brickwork in herringbone patterns. The dome is the greatest triumph of fifteenth-century engineering, and in the course of succeeding centuries has become the iconic image of the Florentine skyline.

10. The octagonal staircase turret (1515–24) **at Blois**, commissioned by King Francis I. The turret was originally in the centre of the façade, but when the chateau was rebuilt (1635–8) by François Mansart, the symmetry was lost; the staircase inside the turret was reconstructed in 1932 to a design by Mansart.

11. Sandro Botticelli, *The Birth of Venus* (*c.*1484), in the Uffizi Gallery, Florence. The painting was commissioned by (or for presentation to) Lorenzo di Pierfrancesco de' Medici, who hung it in the MEDICI VILLA at Castello. The painting (like *Primavera*) depicts the arrival of the goddess Venus in the spring. Venus is emerging from the sea in which she was born and being blown by Zephyr (carrying Chloris) towards the land, where Flora, in her white dress decorated with budding flowers, is about to cover Venus with a cloak decorated with fully opened flowers. The figure of Venus is modelled on ancient marble statues of the goddess that Botticelli had studied; this was the first time since antiquity that Venus had been shown nude. The painting was restored in 1987.

12. & 13. Piero della Francesca, diptych with portraits of *Federico II da Montefeltro*, count (later duke) of Urbino, and his countess *Battista Sforza* (1464), in the Uffizi Gallery, Florence. The profile portraits derive from the tradition of portrait MEDALS; this convention was convenient for the depiction of Federico, who had lost his right eye and part of the bridge of his nose in a jousting tournament. The backgrounds portray Urbino and the Montefeltro territories.

14. Pirro Ligorio's *Fountain of the Dragons* at Villa d'ESTE in Tivoli. The fountain, which is framed by a horseshoe staircase, was built in honour of a visit of Pope Gregory XIII in September 1572; the water-spouting dragons are an allusion to the dragon on the Pope's coat of arms. The fountain was formerly known as the *Fountain of the Girandola* (i.e. spinning fireworks), with reference to the sound effects created by Tommaso da Siena; the water-driven explosions ranged from pistol shots to cannon shots, and were said to resemble the sound of fireworks.

15. *Lattimo* **glass flask** with a portrait of King Henry VII of England (1485–1509). The flask was made in Venice early in the sixteenth century and is now in the British Museum; the other side of the flask depicts the king's personal emblem, a portcullis and chains in a sunburst. The image of the king seems to have been copied from an English coin. It is possible that the flask was brought to England in 1506 as one of the gifts presented to the king on behalf of Guidobaldo da Montefeltro, duke of Urbino.

16. The Galerie François I at FONTAINEBLEAU, decorated in the early 1530s by Il ROSSO FIORENTINO and PRIMATICCIO. The gallery, which is 60 metres long and six metres wide, is decorated with walnut wainscoting surmounted by a stucco frieze that frames fresco paintings; the frieze inaugurated the ornamentation known as STRAPWORK, a feature that proved to be immensely influential. The windows on the left were sealed in 1785, when an adjacent wing was constructed.

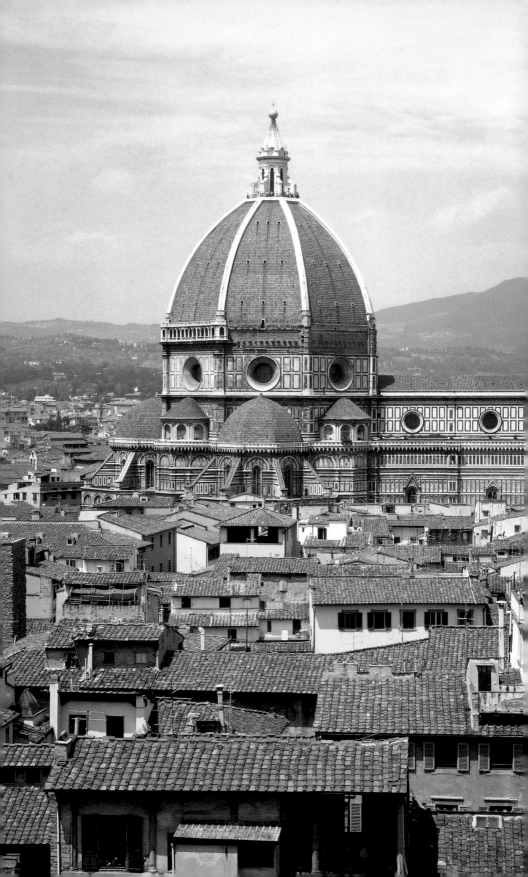

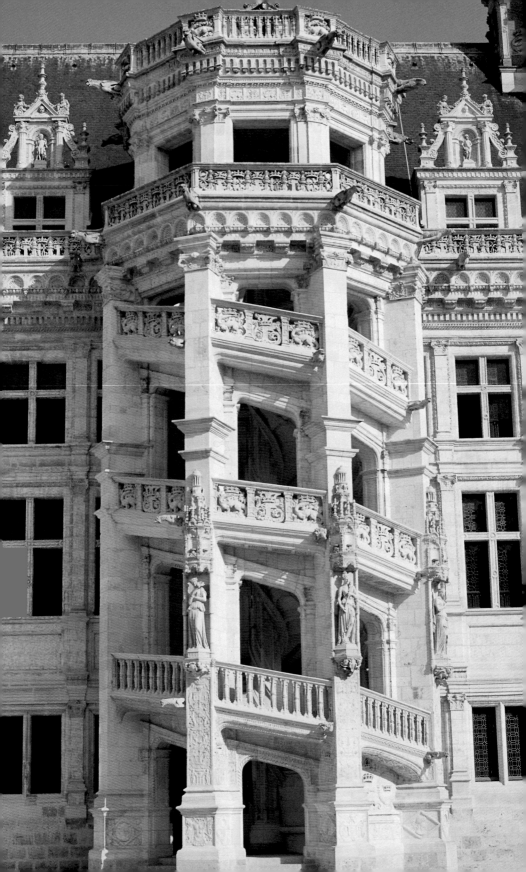

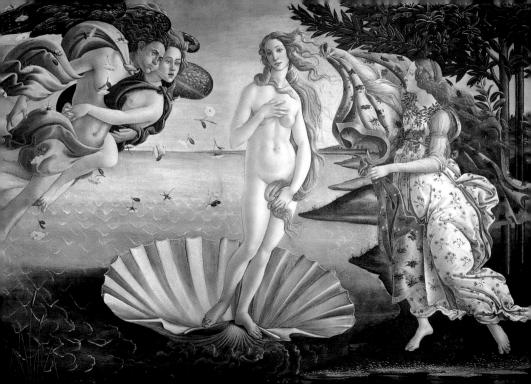

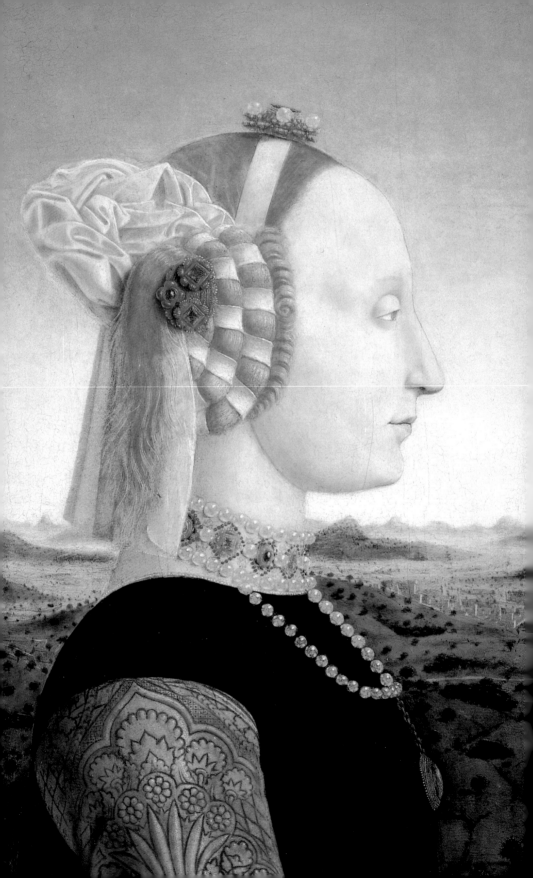

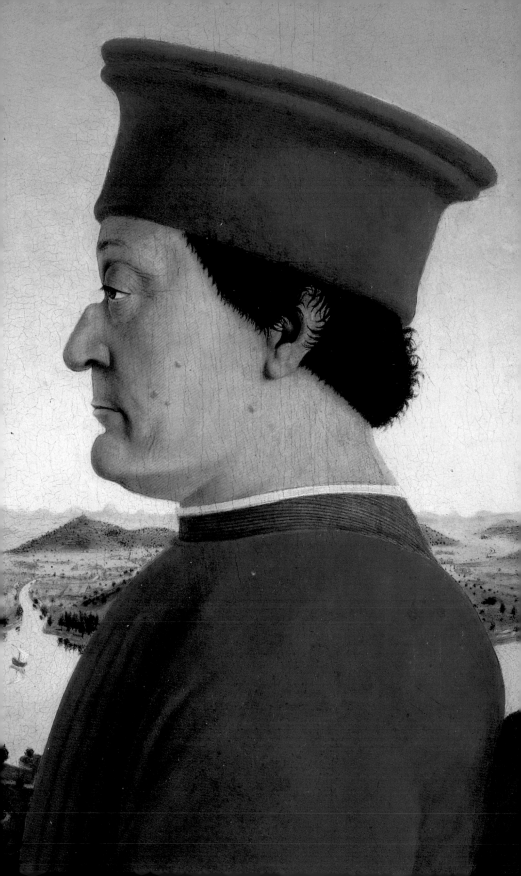

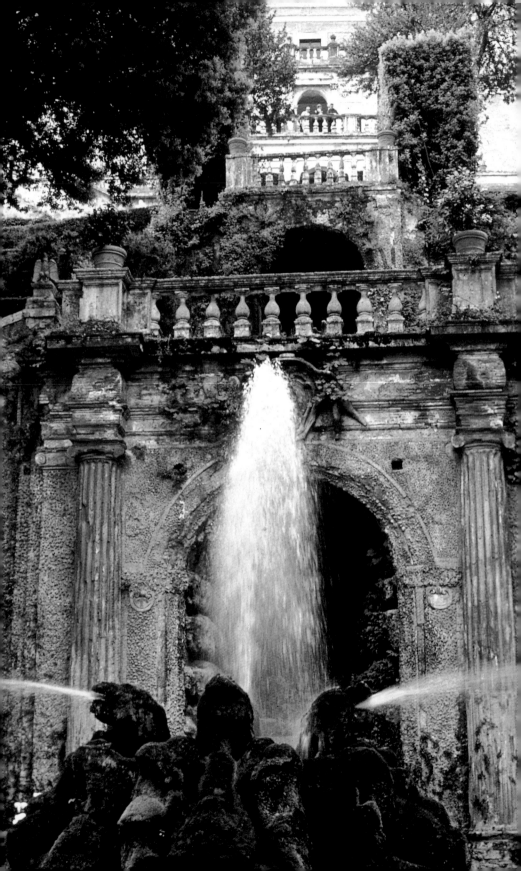

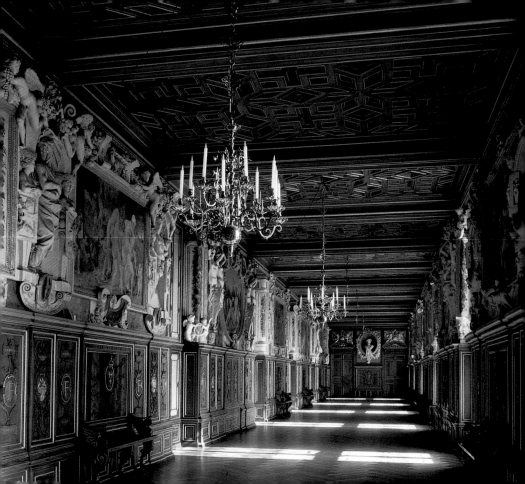

work on *The Virgin and Child with St Anne* (Louvre) while still in Florence, but some of the later drawings are on French paper, which must reflect an intention to complete the painting in France. The most famous of Leonardo's Florentine paintings (and of all paintings) is the *Mona Lisa* (*c*.1503–7, Louvre) (see plate 5), which is also known as *La Gioconda* and (in French) *La Gioconde*; the sitter was Lisa Gherardini, the wife of the Florentine merchant Francesco del Giocondo; 'Mona' is an abbreviation of 'Madonna'.

In 1517 Leonardo travelled to France at the invitation of King Francis I; the projects that he proposed to the king included the regulation of the waters of the Loire. He died on 2 May 1519 at the Manoir du Clos Lucé (now a Leonardo museum) near Château d'Amboise. He was buried in the chapel of the chateau, which was destroyed in the French Revolution; his remains were recovered in 1863 and reinterred in the nearby Chapelle Saint-Hubert.

The interests reflected in the 3,500 pages of Leonardo's notebooks include anatomy, architecture, astronomy, athletics, botany, colour, drawing, geography, geology (including stratigraphy), mathematics, music, optics, painting, perspective, philosophy, sculpture, town planning, zoology, and several branches of engineering (notably hydraulic, nautical, mechanical, military, and structural), but his innovative thinking on these and other subjects made no impact on sixteenth-century culture or science, because there was no public awareness of their existence until 1570, when his pupil Francesco Melzi, to whom Leonardo had left them, died; even then, the notebooks were a mass of notes rather than a series of treatises, a tribute to intelligent curiosity on a heroic scale but not a readily publishable work. The largest collection of Leonardo's notes and drawings is in Windsor Castle, but there are also important collections in the Biblioteca Ambrosiana in Milan, the Bibliothèque Nationale in Paris, the British Museum, the Louvre, the Biblioteca Reale in Turin, the Uffizi, and the Vatican Library.

Leonardo di Ser Giovanni

(*fl.* 1358–71), Italian goldsmith, a native of Florence. In 1361 he assumed responsibility for the chasing and gilding of the nine silver relief panels on the south side of the silver altar of St James (1217–1456) in Pistoia Cathedral; he later designed and made the nine relief panels of *The Life of St James the Greater* on the north side of the altar (1367–71). In Florence Leonardo collaborated with Betto di Geri (*fl.* 1366–1402) on a silver altar depicting scenes from *The Life of St John the Baptist* (now in the Museo dell'Opera del Duomo).

Leoni, Leone

or Aretine (*c*.1509–1590), Italian goldsmith, medallist, and bronze sculptor, born in Menaggio on Lake Como and trained as a goldsmith. In the 1530s he worked as a medallist in Padua and then moved to Rome, where he engraved COINS for the papal mint (1537–40). He subsequently engraved coins for the mint in Milan (1542–6) and then entered the imperial service of Charles V, working in Germany and the Netherlands (and possibly in Spain) before settling in Milan.

None of Leoni's work in precious metals is known to survive, but his goldsmith's skills are apparent in a sardonyx CAMEO (1550) now in the Metropolitan Museum in New York. His portrait MEDALS include depictions of Pietro Aretino, Pietro Bembo, Andrea Doria, Cardinal Granvelle, Michelangelo, and Titian. His portrait sculptures include depictions of *Philip II* (1553–5, Prado), *Mary of Hungary* (1553–4, Prado), and *Charles V Victorious over a Fury* (1549–64, Prado), in which the effigy of the emperor is fitted with removable armour. In Italy Leoni's sculpted bronze tombs include those of Vespasiano Gonzaga (Church of the Incoronata, Sabbioneta) and Gian Giacomo Medici (1560–2, Milan Cathedral).

Leoni's son Pompeo Leoni (*c*.1533–1608) was also a sculptor, medallist, and goldsmith. He worked in Spain, where he finished bronze statues sent by his father (notably the retable of the Capilla Mayor of the ESCORIAL) and also executed tombs. Pompeo Leoni possessed and preserved many of the papers and drawings of LEONARDO DA VINCI.

Leopardi, Alessandro

(*fl.* 1482–1522), Italian architect, bronze sculptor, and goldsmith, born in Venice, where he worked at the mint before turning to bronze casting. In 1492 he completed the casting of VERROCCHIO's equestrian statue of the *condottiere* Bartolomeo Colleoni. He later collaborated with Antonio LOMBARDO on the tomb of Cardinal Zen in the Basilica San Marco (1503–4). His principal architectural work was the Church of Santa Giustina in Padua.

Lescot, Pierre

(1510/15–1578), French architect who collaborated with the sculptor Jean GOUJON on the reconstruction of the LOUVRE, the Hôtel Carnavalet (c.1545–50, now substantially altered), and the Fontaine des Innocents (1547–9, now reconstructed). Little of Lescot's work survives unaltered, but his Italianate square courtyard (Cour Carrée, 1546–51) for the Louvre was a seminal influence on the development of the French classical style in architecture.

Le Tavernier, Jean

(fl. 1434–60), Flemish painter of book illuminations, a native of Oudenaarde (50 kilometres (30 miles) west of Brussels) who entered the service of the dukes of Burgundy; his best-known work is the illumination of The Miracles of Our Lady (Bibliothèque Nationale, Paris). He also seems to have worked in Bruges, though the Bruges illuminations are sometimes attributed to a 'Jean Le Tavernier the Younger' (fl. 1450–70), who was almost certainly the same person.

Leu, Hans

(c.1490–1531), Swiss painter and draughtsman, born in Zürich. He was trained by DÜRER in Nuremberg and in about 1514 settled in Zürich, where his work included the painting of small altarpieces and of LANDSCAPE pictures and the design of stained-glass windows. His surviving paintings include St Jerome (1515) and Orpheus (1519), both in the Kunstmuseum in Basel, and a series of chiaroscuro drawings, including Landscape with Mountains and Lake (Kunstmuseum, Basel).

Liberale da Verona

(c.1445–c.1529), Italian painter and illuminator, trained in Verona. From 1467 to 1474 he worked as a book illuminator in the library of Siena Cathedral and in Monte Oliveto Maggiore, near Siena. He subsequently worked in Florence and Venice, and c.1488 returned to Verona, where he established an independent workshop. His paintings include a Madonna with Saints (Gemäldegalerie, Berlin), a Pietà (Residenzmuseum, Munich), an Adoration of the Magi (Verona Cathedral), and a St Sebastian set against a Venetian canal (Brera, Milan).

Liechti family

A Swiss family of horologists active in Winterthur from c.1500 for more than 300 years. Their turret clocks (i.e. clocks set in the bell towers of churches and civic buildings to sound the hours) and domestic clocks (known as Gothic clocks because of their mouldings) were made almost entirely of iron and were (with one exception) driven by suspended weights. The collection of the family's clocks in the Heimatsmuseum in Winterthur includes a turret clock made in 1529 by Laurenz Liechti (d. 1545) which contains the earliest known example of epicyclic gearing, a device that enabled the astronomical dial on the face to display the position of the sun and the position and phase of the moon.

Liédet, Loyset

(c.1420–1479), Flemish manuscript illuminator, active in Bruges from 1468 to 1479. His surviving work includes seven illuminations in a copy of Froissart's Chronique de France now in the Deutsche Staatsbibliothek in Berlin and three illuminations in a copy of Philippe de Megière's Songe du vieil pelerin (Bibliothèque Nationale, Paris).

Liesborn, Master of

(fl. c.1460–90), German painter whose name derives from an ALTARPIECE painted for the Benedictine abbey in Liesborn (near Münster); six of the fourteen surviving fragments are in the National Gallery in London.

Ligorio, Pirro

(c.1510–1583), Italian architect, garden designer, painter, archaeologist, and antiquarian. Ligorio was born in Naples, but spent most of his professional life in Rome. As a young man he excavated Hadrian's villa at Tivoli. He turned to landscape design and architecture and produced two masterpieces: the garden of the Villa d'ESTE in Tivoli (see plate 14) and the CASINO that he built for Pius IV (the Villa PIA) in the Vatican gardens. He was appointed as MICHELANGELO's successor at St Peter's, but was quickly dismissed for changing Michelangelo's designs.

Ligozzi, Jacopo

(1547–1627), Italian painter, born in Verona; he migrated to Florence, where he was appointed court painter to the Medici family in 1575, in which capacity he painted a cycle of frescoes depicting the history of Florence in the Salone del Cinquecento in the Palazzo Vecchio. He was also an accomplished draughtsman; many of

his drawings are preserved in the Ashmolean Museum in Oxford.

Limbourg

or Limburg family, French manuscript illuminators. The brothers Pol, Hennequin, and Herman were responsible for the paintings in the most famous illuminated manuscript of the fifteenth century, the *Très Riches Heures du duc de Berry* (Musée Condé, Chantilly). The *Très Riches Heures* was left unfinished at the death of the duke of Berry in 1416, and was completed c.1486 by Jean Colombe (brother of Michel COLOMBE).

Limoges enamels

The French city of Limoges was an important centre for the production of ENAMEL from the mid-twelfth to the sixteenth centuries. Initially production was in monastic workshops, but secular workshops were soon active in the manufacturing and export of ecclesiastical enamels such as candlesticks and reliquaries. Limoges enamel was of the type known as *champlevé enamel* (or *émail en taille d'épargne*), which is made by incising the design on the metal ground and placing vitreous paste in the incisions.

In the fifteenth century Limoges enamellers developed a technique for producing painted enamel, of which the city remained the principal European centre for two centuries. In the fifteenth and early sixteenth centuries the metal surface (usually copper) was covered with white enamel and then fired; the design was then applied in a series of colours, each of which was fired separately. From the mid-sixteenth century the first covering was black enamel, which then formed the basis for GRISAILLE painting.

The fifteenth-century revival of enamelling in Limoges is traditionally associated with the Monvaërni workshop, the work of which is represented by some 40 painted enamels which have in common the use of German designs, often adapted from prints by DÜRER and SCHONGAUER. The existence of such a workshop is not supported by the documentary record, and it is possible that the enamels are the work of independent enamellers. In sixteenth-century Limoges, the most important enamellers were Léonard LIMOSIN, Pierre REYMOND, Jean and Suzanne de COURT, and the members of the PÉNICAUD family.

Limosin

or Limousin, Léonard (c.1505–c.1576), French enamel painter who, alone amongst his distinguished contemporaries, left LIMOGES to serve in the royal court. He enjoyed the patronage of King Francis I and then of Henri II, who appointed him royal enamel painter (*émailleur peintre du roi*). His early work includes a series of eighteen scenes from the Passion (1532, Musée de Cluny, Paris) modelled on DÜRER's *Small Passion*. He later adopted the MANNERIST style associated with the School of FONTAINEBLEAU for his portraits (notably that of *Anne de Montmorency* in the Louvre) and religious works, notably twelve enamelled plaques of the Apostles (commissioned by Francis I in 1545 and now in the Musée des Beaux-Arts in Chartres) and a *Crucifixion* altarpiece of 1553 made for the Saint-Chapelle in Paris (now in the Louvre).

Lindenast, Sebastian

(c.1460–1526), German coppersmith, born into the Nuremberg family that held the monopoly on gilded and silvered copperware manufactured in the city and was to hold the monopoly till the mid-sixteenth century. His best-known work is the *Männleinlaufen*, a clock with animated figures mounted above the porch of the Liebfrauenkirche in Nuremberg; at noon every day the action commemorates the Golden Bull of 1356 when the jacks appear as the seven electors coming to swear allegiance to the Emperor Charles IV. Attributions to Lindenast include a silvered copper bowl with the statuette of a hart in the centre, a silvered and gilded copper relic statuette of St James the Greater (both in the Germanisches Nationalmuseum in Nuremberg), and a gilded and enamelled copper castle cup with a lid decorated with miniature buildings (now in the Victoria and Albert Museum in London).

line engraving

See ENGRAVING.

linen

A textile woven from the bast fibres of flax (*Linum usitatissimum*) and then bleached. In early modern Europe it was the most important woven textile; it was cheaper than cotton and silk and in most of Europe was preferred to wool. From the fifteenth to the eighteenth centuries the principal European centre for the production of linen was the Netherlands, where most of the factories were in Haarlem. Elsewhere in Europe a linen warp was woven with a cotton weft to make FUSTIAN.

A linen-armourer was a maker of gambesons (military tunics), but as a proper noun the term denoted a member of the Merchant Taylors' Company, which was officially called the Guild of Taylors and Linen-Armourers (Latin Cissoribus et Armurariis Linearum).

'Linenfold' is a nineteenth-century term for a decorative pattern carved on wall-panels and furniture (especially wardrobe doors); it was so named because it represents or resembles linen arranged in vertical folds. Linenfold decoration originated in fifteenth-century Flanders and by the end of the century was in use in France, Germany, and England. It is one of a small number of late Gothic woodworking motifs that does not have an architectural precedent.

Lippi, Filippino

(1457–1504), Italian painter, born in Florence, the illegitimate son of Fra Filippo LIPPI and a novice nun called Lucrezia Buti. He was trained in his father's workshop and, after his father's death in 1469, in the workshop of BOTTICELLI, where he painted CASSONI and devotional pictures such as *Adoration of the Magi* and *Virgin and Child with St John the Baptist* (both in the National Gallery, London).

Botticelli's departure for Rome in 1481 marked the beginning of Filippino's independent career, of which one of the finest paintings is his *Vision of St Bernard* (1486, Badia, Florence). This celebrated picture led to an important series of commissions, including the completion of the Brancacci Chapel in Santa Maria del Carmine (which MASOLINO and MASACCIO had left unfinished) in 1484 and the decoration of the Strozzi Chapel in Santa Maria Novella in 1487 (postponed for many years and finally completed in 1502).

From 1488 to 1493 Filippino lived in Rome, where his principal commission was the decoration of the Carafa Chapel in Santa Maria sopra Minerva. On returning to Florence he was commissioned to paint an *Adoration of the Magi* (now in the Uffizi) for the Monastery of San Donato a Scopeto to replace the *Adoration* (also in the Uffizi) left unfinished by LEONARDO.

Lippi, Fra Filippo

(c.1406–1469), Italian painter, born in Florence, the son of a butcher; on being orphaned in 1421 he was placed in the Monastery of Santa Maria de Carmine. He became a Carmelite friar, a life

for which he was not suited. His early paintings include a fresco (now damaged) in Santa Maria del Carmine entitled *Institution of the Carmelite Rule* (c.1432), a theme that understates his relaxation of the rule: in the years to come he faced a criminal charge of fraud, and abducted Lucrezia Buti, a novice nun; their son was Filippino LIPPI.

Fra Filippo's *Tarquinia Madonna* (1437, Palazzo Barberini) and *Annunciation* (c.1438, Church of San Lorenzo, Florence) reflect the compositional style of MASACCIO as well as a burgeoning interest in PERSPECTIVE and a precociously strong response to contemporary Netherlandish painting. In the 1440s and 1450s Fra Filippo's style changed: his figures became more linear, and he became interested in delicate decorative motifs; in some respects this new style recalled the style of Gothic painting. In 1452 he painted *The Madonna and Child with Scenes from the Life of the Virgin* (Pitti Palace, Florence) and in the same year moved to Prato, where he painted the fresco cycle on *The Lives of SS Stephen and John the Baptist* in the cathedral. His greatest paintings from this period often portray graceful Madonnas, notably *The Adoration of the Child* (Gemäldegalerie, Berlin) and *The Madonna Adoring her Child with St Bernard* (c.1453, Uffizi). Fra Filippo's last commission took him to Spoleto, where, together with his son Filippino, he painted scenes from *The Life of the Virgin* in the apse of the cathedral and where he died in October 1469.

Fra Filippo is the speaker of Browning's dramatic monologue 'Fra Lippo Lippi', which is based on Vasari's account; he also became an important model for the Pre-Raphaelites.

Lippo Memmi

(fl. 1317–50), Italian painter, a native of Siena. He was the brother-in-law of SIMONE MARTINI, with whom he sometimes collaborated, notably on the *Annunciation* in the Uffizi (1333), which they both signed. Some of Lippo's finest works, such as the *Virgin in Majesty* in the San Gimignano Palazzo del Popolo (1317, restored by Benozzo GOZZOLI c.1467), are imitations of paintings by Simone; others, such as the *Servi Madonna* (Pinacoteca, Siena), evince a delicacy of palette and sentiment that exceeds that of Simone. The *New Testament* cycle in the Collegiata at San Gimignano has recently been attributed to Lippo Memmi.

Little Masters

The traditional English translation of German Kleinmeister, a group of sixteenth-century German engravers; the term would more accurately (but less idiomatically) be translated 'masters of the small', because it refers to artists who chose to engrave large subjects (typically biblical or mythological or GENRE scenes) on very small plates. The school of 'Little Masters' centred on a group of DÜRER's pupils in Nuremberg, including Hans Sebald BEHAM, his brother Bartel BEHAM, and Georg PENCZ. The term is sometimes extended to engravers elsewhere in Germany who worked on a similar scale, including Heinrich ALDEGREVER, Albrecht ALTDORFER, and Hans BROSAMER.

Lochner, Stefan

(fl. c.1440–1454), German painter, born in Meersburg (on Lake Constance). In 1442 he settled in Cologne, where he became a prominent painter; in the nineteenth century he came to be described as the founder of the Cologne school, but the existence of such a school is now doubted. The principal work associated with Lochner is an ALTARPIECE painted for the Town Hall in Cologne; it is now in Cologne Cathedral and so is known as the *Dombild*. Albrecht DÜRER greatly admired this altarpiece, noting in the diary of his journey to the Netherlands that he had to pay in order to see the painting.

Lomazzo, Giovanni Paolo

(1538–1600), Italian painter, art theorist, and poet, born in Milan, where he trained in the studio of Gaudenzio FERRARI. At the age of 33 he went blind, and thereafter dictated two important treatises on the theory of art, *Trattato dell'arte della pittura, scultura e architettura* (1584) and *Idea del tempio della pittura* (1590). The seven books of the *Trattato* examine proportion, colour, light, PERSPECTIVE, technique, and the history of art, the last of which describes classical and Christian iconography. The *Tempio* is a Neoplatonic work which delineates the complex symbolism of astrology and of numbers and relates these symbols to seven artists who are deemed to govern art: Gaudenzio Ferrari, MICHELANGELO, POLIDORO DA CARAVAGGIO, LEONARDO DA VINCI, RAPHAEL, MANTEGNA, and TITIAN. Lomazzo also published a collection of *Rime* (1587) with an autobiography.

Lombard, Lambert

(1505–66), Flemish painter, engraver, architect, and antiquarian, born in Liège. He trained in Antwerp and Middelburg before travelling in the Netherlands, France, and Germany and studying Italian painting in Rome (1537–9). On returning to Liège he founded an academy of painting; his pupils included Frans FLORIS, Hendrik GOLTZIUS, and Willem KEY. Karel van Mander described Lombard as 'no less a teacher than learned in the arts of painting, architecture, and perspective; one can confidently rank him amongst the best Netherlandish painters, both past and present'. This judgement echoes that of VASARI (with whom Lambert had corresponded), who praised Lombard as the finest of Flemish artists, 'a man well versed in literature, and painter of judgement, a learned architect, and, not least, the master of Frans Floris and Willem Key'.

These generous judgements cannot now be evaluated, because most of Lombard's paintings are known only through copies, drawings, and engravings: the large collection in the episcopal palace in Bonn was lost in a fire in 1703, and those in the churches of Liège were destroyed in the French Revolution. Surviving works include scenes from the life of St Denis (c.1533, now divided between the Musée de l'Art Wallon in Liège, the Church of Saint-Denis in Liège, and the Musée de l'Art Ancien in Brussels), the *Rejection of Joachim's Offer* (Musée de l'Art Wallon, Liège), and *Judith*, *Esther*, *Claudia Quinta*, and the *Tiburtine Sibyl* (all in the Church of St Amand in Stokrooie, near Hasselt).

Lombardo family

A dynasty of Venetian sculptors and architects, including Pietro (c.1433–1515), Tullio (c.1455–1532), and Antonio (c.1458–1516). Pietro Lombardo was born in Carona (Lombardy), the son of an architect. He probably worked in Florence and certainly worked in Padua, where, as well as his principal work, the Roselli monument, he sculpted the tomb of Giannantonio (son of the *condottiere* Gattamelata) in the Basilica del Santo. Moving c.1467 to Venice, he designed and carved decorations for the distinctly Florentine chancel of San Giobbe (1471–85) and built the syncretic Church of Santa Maria dei Miracoli (1481–9), which has marble panels on both interior and exterior, a Veneto-Byzantine dome, and Florentine decorative motifs; he also began the façade of the

Scuola di San Marco (1488–90), of which the upper levels were completed by Mauro CODUSSI.

In sculpture Pietro introduced to Venice the large architectural tomb adorned with classical sculpture; his most important Venetian tombs are those of Doge Pasquale Malipiero (d. 1462), Doge Pietro Mocenigo (d. 1476), and Doge Niccolò Marcello (d. 1474), all in the Church of SS Giovanni e Paolo; he was probably the sculptor of the effigy and tomb of Dante in Ravenna (1482, rebuilt 1780) and the Zanetto tomb in Treviso Cathedral (1485). Various Venetian palaces have been attributed to Pietro, notably Palazzo Dario (c.1487) and Palazzo Loredan (1500–9; now Palazzo Vendramin-Calergi), which had been begun by Codussi and is one of the most elegant buildings in Venice, despite the jungle of television masts on its roof.

Pietro Lombardo employed his sons Tullio and Antonio in his workshop, notably in the work for Santa Maria del Miracoli. Tullio's independent work includes the tombs of Doge Giovanni Mocenigo (d. 1485) and Doge Antonio Vendramin (d. 1478), both in the Church of SS Giovanni e Paolo, the effigy of Guidarello Guidarelli now in the Accademia in Ravenna (1525), and various reliefs, including the *Bacchus and Ariadne* in the Kunsthistorisches Museum in Vienna and the *Coronation of the Virgin* in the Church of San Giovanni Crisostomo in Venice. Antonio sculpted one of the reliefs of *The Miracles of St Anthony* for the Basilica del Santo in Padua and a *Madonna della Scarpa* for the Zeno Chapel in Basilica San Marco in Venice; he also sculpted reliefs on mythological subjects (now mostly in the Hermitage in St Petersburg) commissioned by Alfonso I d'Este for the Camerini d'Alabastro in the Castello Estense at Ferrara.

Antonio's sons Aurelio (c.1501–1563), Girolamo (c.1505–1589), and Ludovico (c.1507– 1575), were also sculptors, as was Sante Lombardo (1504–60), the son of Tullio Lombardo.

Longhi, Martino

See LUNGHI, MARTINO THE ELDER.

Lopes, Gregório

(c.1490–c.1550), Portuguese court painter to Manuel I and John III, primarily a painter of AL-TARPIECES. His subjects are invariably religious, but his depiction of faces and clothing distinguishes carefully between individuals, and in his backgrounds he depicts in extraordinary detail the life of sixteenth-century Portugal in towns, villages, and, pre-eminently, in the court. His principal works are the altarpieces that he executed for the Convento de Cristo in Tomar, of which the most celebrated is the *Last Supper* in the nearby Church of John the Baptist (in what is now the Praça da República).

Lorenzetti, Pietro

(*fl. c.*1316–1345) and Ambrogio (*fl. c.*1317– 1348), Italian painters, brothers who lived in Siena. Pietro's earliest datable work is a polyptych of *The Madonna and Child with Saints* (1320) in the Church of Santa Maria della Pieve in Arezzo. Other works are attributed to Pietro and dated by reference to the Pieve altarpiece: panels of the *Maestà* in the Diocesan Museum in Cortona and the *Deposition* in the Lower Church of San Francesco in Assisi seem to have been painted before the Pieve altarpiece; later works include a *Madonna* in the Uffizi and frescoes of the *Crucifixion* in the Church of San Francesco in Siena and a *Birth of the Virgin* (1342) in the Museo dell'Opera del Duomo in Siena.

Ambrogio's earliest datable work is a *Madonna and Child* (1319, Museo Diocesano, Florence). The documentary record shows that he was in Florence in the early 1320s, but no paintings survive from this period. His most important painting is a fresco cycle (traditionally entitled *Good and Bad Government*) in the Palazzo Pubblico in Siena; this picture contains the earliest significant portrayal of LANDSCAPE in Italian art. Ambrogio's other surviving paintings include frescoes in the Church of San Francesco in Siena and pictures of the *Madonna and Child* in the Pinacoteca in Siena and in the Palazzo Pubblico in Massa Marittima and of the *Presentation in the Temple* (1342) in the Uffizi.

The only known collaboration between the brothers is the fresco cycle of *The Life of Mary* (1335) painted on the façade of the Spedale di Santa Maria della Scala in Siena and now lost.

Lorenzo di Credi

(c.1457–1536), Italian painter, born in Florence, the son of a goldsmith; he trained in the studio of VERROCCHIO, where his fellow pupils may have included LEONARDO DA VINCI. Lorenzo worked as an assistant to Verrocchio and eventually became the manager of his workshop. In 1497 Lorenzo became a disciple of Savonarola, and is said to have destroyed his secular paintings. His surviving works include the altarpiece

of the *Madonna di Piazza* in Pistoia Cathedral and a self-portrait drawing (1490) in the National Gallery in Washington.

Lorenzo Monaco

(1370/5–1425/30), Italian painter, born in Siena. He entered the Camaldolese Monastery of Santa Maria degli Angeli in Florence and became a miniature painter; several of his illuminated manuscripts are now in the Biblioteca Laurenziana. He painted many altarpieces for his order, notably two versions of *The Coronation of the Virgin* (1414, Uffizi; *c.*1415, National Gallery, London). His frescoes include a cycle on *The Life of the Virgin Mary* in the Bartolini Chapel of Santa Trinita in Florence. His late polyptych of *The Deposition* (Museo San Marco, Florence) was finished by Fra ANGELICO.

L'Orme, Philibert de

See DELORME, PHILIBERT.

Lotto, Lorenzo

(*c.*1480–1556), Italian painter, born in Venice and trained in the studio of Giovanni BELLINI, where, according to VASARI, his fellow pupils included GIORGIONE and TITIAN. His early paintings include *Madonna with St Peter Martyr* (1503, Museo Nazionale, Naples) and *St Jerome* (1506, Louvre). Lotto lived in Rome in the service of the Vatican from *c.*1508 to 1512, but no work from this period is known to survive. The latter part of his career was largely spent in Bergamo, and the paintings of this period combine Roman and Venetian elements. His late works include *Man on a Terrace* (Museum of Art, Cleveland) and a *Madonna and Child with St Catherine* (Accademia Carrara, Bergamo). In 1552 he entered the Monastery of Santa Casa in Loreto, where he stayed for the rest of his life. The account book (*Libro di spese diverse*) that he kept from 1538 to 1554 (now in the Archivo della Santa Casa in Loreto) is a chronicle of financial hardship.

Louvre

The Louvre first became a royal residence in the fourteenth century when Charles V converted the fortress built *c.*1200 into a palace, in one wing of which he installed his library, which was later to evolve into the founding collection of the Bibliothèque Nationale. The palace was plundered by British troops in the wake of their victory at Agincourt in 1415, and was subsequently neglected by French kings until Francis I announced in 1528 that he was going to take up residence in the Louvre. He demolished the great keep, thereby opening up a courtyard, but waited till 1546 before commissioning Pierre LESCOT to build a new royal palace consisting of four wings around a square court. When Francis died the following year, the foundations were barely above the ground, but construction continued until it was disrupted by the outbreak of the Wars of Religion in 1562. Francis never saw the building that he had commissioned, so in a sense his memorial at the Louvre is the royal collection of art that it still houses, including two of Francis's early acquisitions, LEONARDO's *Mona Lisa* and RAPHAEL's *Belle Jardinière*. Lescot completed the west wing with the assistance of the decorative sculptor Jean GOUJON; of Lescot's plans only the Italianate square courtyard (Cour Carrée) was executed according to his design.

While the Louvre was under construction it became the principal residence of Francis II and Charles IX. The last French king to use the Louvre as his principal residence was Henri IV, who instructed Jacques DUCERCEAU the Younger to build the gallery facing the Seine. Construction continued throughout the seventeenth century, but was suspended in 1675; the building was completed in the nineteenth century (1806–78) and the glass pyramid at the entrance was added in the twentieth century (1986–9).

Loyet, Gérard

(*fl.* 1466, d. 1502–3), Flemish goldsmith and seal engraver, born in Lille. He entered the service of Charles the Bold, who commissioned a gold enamelled reliquary (1466–71) which includes a statuette of Duke Charles in a kneeling position; it is now in the cathedral treasury in Liège.

Lucas van Leiden

(*c.*1494–1533), Dutch painter and engraver, printer, and draughtsman, born in Leiden, the son of a painter, Hugo Jacobszoon. He trained as a painter in the studios of his father and of Cornelis ENGELBRECHTSZOON. Lucas was admitted to the Leiden Guild of Painters in 1514. He is known to have travelled occasionally, visiting Antwerp in 1521 (where he could have met DÜRER) and Middelburg in 1527 (where he met Jan GOSSAERT), but he spent most of his short life in Leiden.

In painting Lucas favoured GENRE subjects in works such as his *Chess Players* (Gemäldegalerie, Berlin) and *Card Players* (Wilton House, Wiltshire), and also painted religious subjects, notably the triptych of *The Last Judgement* (1526, Municipal Museum, Leiden).

It is not known where Lucas trained as an engraver, but he must have learnt the technique at an early age: his skilful *Mohammed and the Monk* is dated 1508, when Lucas was 15 years old, and it displays an assured grasp of foreshortening and the setting of groups of figures against landscapes. Two years later he produced *Ecce homo*, a large engraving in which the figures are placed in a complex architectural setting. Thereafter his engravings (all of which are dated) continued to depict religious subjects, but the seriousness of his themes was habitually subverted by elements of genre painting that border on the satirical. His work was greatly admired by VASARI (who thought Lucas a greater artist than Dürer) and by Rembrandt.

Luini, Bernardino

(c.1480/5–1532), Italian painter. He was born in a village on Lake Maggiore and by 1512 was working in Milan. Throughout his career his style was indebted to that of LEONARDO DA VINCI. Luini's youthful fresco cycle *Cephalus and Procris* (c.1520) in the Casa Rabia (near Monza) survives in fragments now in the National Gallery in Washington. There are many examples of his later paintings in the Brera (Milan) and the churches and monasteries of Lombardy.

Lunghi

or Longhi, Martino the Elder (c.1534–c.1591), Italian architect, born near Milan. In 1573 he moved to Rome, and two years later he was appointed papal architect. He added the tower of the Senate to MICHELANGELO's Capitol and built the Church of San Girolamo degli Schiavoni (1588–90) and the Chiesa Nuova (1575–1605). He also completed the Palazzo Altemps, built part of the Borghese Palace, and contributed a CASINO to the Villa MONDRAGONE in Frascati.

Lyonese bindings

A style of mid-sixteenth-century French BOOKBINDING, often (but not always) used to cover books printed in Lyon. Covers are typically decorated with polychrome STRAPWORK panels which are then painted, lacquered, or enamelled; some covers are decorated with ARABESQUES. The style was used in late sixteenth-century England, where bindings typically had a large central device and corner ornaments on a dotted ground. Unlike GROLIER BINDINGS, which were hand-tooled, Lyonese bindings were usually impressed with a panel stamp, a process that yielded considerable savings in labour with very little diminution of quality.

M

Machuca, Pedro

(d. 1550), Spanish architect and painter who worked as a painter in Italy before returning to Spain between 1517 and 1520. His *Madonna del sufragio* (now in the Prado), which is signed and dated 1517, seems to have been painted in Italy. In 1520, Machuca undertook the colouring of a carved reredos in Jaén Cathedral. He settled in Granada, where he worked as a painter of AL-TARPIECES between 1521 and 1549; the surviving examples all contain Italian stylistic features.

Machuca's reputation as an architect rests on the palace of Charles V in the grounds of the Alhambra in Granada. The idea for the palace was mooted during the emperor's visit to Granada in 1526; construction began in 1531 and continued until 1568, but the original design was never fully realized. The structural features of the design are resolutely Italian, and are reminiscent of RAPHAEL and GIULIO ROMANO, but some of the decorative features, such as the garlanded window frames, are PLATERESQUE.

Maçip, Vicent

(d. *c.*1550) and Joan Vicent (*c.*1523–1579), Valencian painters. Vicent's principal work was the main ALTARPIECE at Segorbe Cathedral, which he finished in 1535. Vicent's son and collaborator Joan Vicent, who is often known as Juan de Juanes, strengthened the Italianate influence on Valencian art. His *Assumption of the Virgin* in the Provincial Museum in Valencia, for example, is clearly influenced by the style of RAPHAEL. His best-known work is the altarpiece series depicting *The Life of St Stephen*, painted for the parish Church of St Esteve (Valencia) and now in the Prado.

Macuarte

See MARKWART.

Madama, Villa

The Villa Madama is now absorbed into the north-eastern edge of Rome (close to the Olympic Stadium), but when it was built it lay well outside the city; it was the first Renaissance VILLA to be built outside the walls of Rome. The villa was commissioned by Cardinal Giulio de' Medici (later Pope Clement VII) as a place for entertainment rather than habitation. The architect was RAPHAEL, who began work in 1516; after his death in 1520 the commission passed to Antonio da SANGALLO the Younger, whose drawings are preserved in the Uffizi. The decoration is the work of Raphael's two assistants, GIULIO ROMANO and GIOVANNI DA UDINE, who squabbled so much that the pope had to send an emissary to reconcile them; Cardinal Maffei discharged this task with difficulty, declaring both artists to be madmen. The villa was only partly completed when it was burnt during the Sack of Rome in 1527. In about 1537 the house was bought by Princess Margaret of Austria, the illegitimate daughter of the Emperor Charles V and the young widow of Alessandro de' Medici; she is the *madama* from whom the villa takes its name. Margaret later married Ottavio Farnese, through whom the villa eventually passed to the Bourbon kings of Naples. Most of the statuary disappeared in the occupation that followed the Sack of Rome, but one of the finest pieces, an ancient statue of Jove admired by Isabella d'Este when she was entertained at the Villa, survived and is now in the Caryatid Gallery of the Louvre.

The villa was intended to recreate the ideal Roman villa of classical antiquity. In Raphael's original design, it was conceived as a circular central court surrounded by a series of reception rooms and loggias. These structures were intended to merge into four distinct formal landscapes. The garden façade on the east overlooked terraces and the Tiber valley, beyond which lay the city of Rome. To the south the large entrance court opened onto the main approach, which was a monumental staircase. To the west a loggia was supposed to have opened onto an open-air AMPHITHEATRE, hollowed out of Monte Mario in the Greek style,

but this side of the building was never completed. To the north, a loggia led to terraced gardens which contain a *GIARDINO SEGRETO* that is the sole remnant of the original gardens. Of the garden architecture all that survives is Giovanni da Udine's richly decorated Elephant Fountain; VASARI says that this fountain was carefully modelled on one in a recently excavated Temple of Neptune, but no such elephant's head is known to have survived. All that now remains of the main building is part of the central circle and the magnificent north loggia, which is richly decorated with frescoes and *stucchi*.

The villa was never completed, but it was one of the most influential buildings of the Renaissance. It achieved an unprecedented integration of house and garden, and this design was copied in villas all over Italy.

Maestri, Adriano di Giovanni de'

See ADRIANO FIORENTINO.

Maggini, Giovanni Paolo

(1580–c.1630), Italian maker of violins, who studied with Gasparo da Salò in Brescia. His instruments produced a darker and perhaps more responsive tone than those of the AMATI, which was to influence Stradivarius and other Cremonese makers as well as providing a model copied by French and German makers in the nineteenth century. His work in reducing the size of both the viola and the cello resulted in different members of the violin family producing a more homogeneous sound.

Mainardi, Bastiano

(1466–1513), Italian painter, born in San Gimignano, the son of an apothecary, and trained in Florence by GHIRLANDAIO, whose sister he married. His principal work is a fresco cycle in the Cappella di San Bartolo in the Church of Sant'Agostino in San Gimignano. His surviving paintings include Madonnas in the Museo Civico in San Gimignano, the Museo Civico in Pisa, the National Gallery in London, and the Metropolitan Museum in New York.

Maioli bindings

A group of almost 100 BOOK BINDINGS made in Paris in the 1550s, possibly by the same craftsmen who supplied GROLIER BINDINGS. Each volume is stamped with the name 'Thos Maioli', who is probably Thomas Mahieu (Latin Maiolus), secretary to Catherine de Médicis and one of Jean Grolier's successors as treasurer of France. The sumptuous bindings are decorated with ARABESQUES and STRAPWORK, sometimes set against backgrounds in which gold has been rubbed into the leather.

maiolica

The Italian name for TIN-GLAZED EARTHENWARE, which is known as FAIENCE in France, Germany, Scandinavia, and Spain and as DELFTWARE in Britain and the Netherlands; cognate terms exist in French (*majolique* and *maïolique*) and English (*majolica*). According to the Renaissance scholar Julius Caesar Scaliger, the term derived from the name of the island of Majorca (for which the medieval name was Majolica), which was the source of the finest earthenware; in fact Majorca was not the ultimate source of the pottery, which came from the Spanish mainland but was carried to Italy by Catalan merchants from Majorca.

The Italian maiolica of the fourteenth and fifteenth centuries was decorated with Gothic designs and painted green and purple. In the last quarter of the fifteenth century, FLORENCE POTTERIES and FAENZA POTTERIES began to develop new designs (often with oak-leaf motifs) and to extend the colour range to include orange and yellow.

In the sixteenth century the decorative patterns often consisted of allegorical figures, sometimes based on paintings. Maiolica factories were established in many Italian centres, including CAFAGGIOLO, CASTEL DURANTE, DERUTA, and MONTELUPO. The potters of Castel Durante developed a form of display maiolica known as ISTORIATO ware, and in the 1550s they began to introduce designs based on GROTESQUES by RAPHAEL set against white backgrounds; in the nineteenth century this maiolica came to be known in English as Raffaelle ware or Raphael's ware, because it was (mistakenly) believed that Raphael had painted some of the wares. In Faenza, where white backgrounds soon came to dominate pottery (and some tableware was entirely white), such wares were called *bianchi di Faenza*.

The most important treatise on maiolica was Cipriano PICCOLPASSO's *Tre libri dell'arte del vasaio* (1556–9).

Malouel, Jean

(c.1365–1415), Flemish painter, probably a native of Nijmegen; he worked in Paris before being appointed in 1397 as court painter to the dukes of Burgundy in Dijon, working first for Philip the Bold and then for Philip's successor John

the Fearless. His principal surviving works, both of which are attributions, are a *Martyrdom of St Denis* and a *Pietà* tondo, both now in the Louvre.

Manara, Baldassare

(*fl.* 1526, d. 1546/7), Italian MAIOLICA painter in Faenza whose signed ISTORIATO work includes a bowl decorated with a *Triumph of Time* in the Ashmolean Museum in Oxford.

Mander, Karel

or Carel van (1548–1606), Flemish painter, poet, and biographer, trained in the Ghent School established by Lucas de HEERE and then by Pieter Vlerick (1539–81) in Kortrijk (Courtrai) and Tournai (Doornik). In 1583 he settled in Haarlem, where he worked as a religious and allegorical painter and together with Cornelis CORNELISZOON and Hendrik GOLTZIUS founded an academy.

In 1604 Mander published *Het schilderboeck* ('The Painter's Book'), a three-part handbook for artists which forms the basis of his reputation as the 'Dutch VASARI'. The first part consists of biographical accounts of some 175 Netherlandish and German artists from Jan van EYCK to Mander's contemporaries; this was the first collection of biographies of north European artists and is in some cases a unique source of information. The second part is an abbreviated translation into Dutch of the second edition of Vasari's *Lives* (1568) and also contains accounts of more recent Italian artists; material for this continuation of Vasari was for the most part assembled when Mander lived in Italy (1573–7) but also draws on information derived from his network of friends and correspondents. The third and final part of the book, entitled *Lehrgedicht*, is a long poem in fourteen parts; much of the poem mediates between the views of Italian theorists and the practical needs of young Dutch artists, and some parts, such as the material on LANDSCAPE painting, are Mander's original work.

Manfredi, Bartolomeo

(1582–1622), Italian painter, born near Mantua and trained in Rome. His depictions of gamblers, fortune-tellers, and soldiers, which derive from CARAVAGGIO's early paintings, became one of the conduits through which Caravaggio's subjects and his dramatic CHIAROSCURO were transmitted to painters from the Netherlands and France.

manière criblée

(French; 'dotted manner'), a term deriving from the word *crible* (sieve), denoting a type of relief ENGRAVING on metal (usually copper) that first appeared in the mid-fifteenth century. The prints, which resemble nineteenth- and twentieth-century wood engravings, consist of a white design made from lines and dots set against a dark background. The lines were engraved with a burin and the dots were added with punches of various sizes.

Plates engraved in the *manière criblée* were sometimes used to make paste prints, a type of embossed print in which the raised portions have a contrasting colour.

Mannerism

The art-historical term used to designate the style of Italian art from the 1520s to the 1590s; it is therefore the style that follows the Renaissance style and precedes the BAROQUE. The term derives from Italian *maniera*, which was used by VASARI to denote the style of artists who produced works of idealized grace (*grazia*) in the elegant 'manner' of MICHELANGELO. In the nineteenth century Mannerism became an issue in the debates between German cultural historians about stylistic periods in art and literature. In the view of historians such as Heinrich Wölfflin, Mannerism was tainted with the notion of degeneracy, and represented a decline from the standards achieved by RAPHAEL. A subsequent generation of German historians, led by Max Dvořák, portrayed Mannerism as a European movement that began with late Michelangelo and culminated in the religious vision of El GRECO. In the second quarter of the twentieth century, nationalist historians attempted to reclaim Mannerism for Germany by representing it as a revival of the Gothic spirit.

The notion of a repudiation of the ideals of Raphael and early Michelangelo by the artists of the period 1530 to 1590 is a fiction invented to support a historiographical theory. Such artists were not, however, content merely to replicate the achievements of their predecessors. The importance of neoplatonism in sixteenth-century thought encouraged a movement away from realism towards idealism and fantasy, and also encouraged a taste for novelty (which reached its apogee in ARCIMBOLDO and the court of Rudolf II) and for esoteric allusion. In the representation of figures, mannerist artists developed the ascending corkscrew (or *figura serpentina*) of

Michelangelo into an ideal of etiolated elegance typified in the paintings of PARMIGIANINO and PONTORMO and the statuary of GIAMBOLOGNA as represented in *The Rape of the Sabine Women* in the Loggia dei Lanzi in Florence (see p. 111). In France, *maniérisme* was introduced through the decoration of FONTAINEBLEAU by Il ROSSO FIORENTINO and PRIMATICCIO.

Mannerism is also used as a term in architectural history, and is used of sixteenth-century buildings in which motifs are used in deliberate opposition to their original purposes and contexts. The most important Italian mannerist architects are Michelangelo (especially his Biblioteca Laurenziana in Florence, which has columns that carry no cornices), GIULIO ROMANO (especially his Palazzo del TÈ in Mantua, which has keystones out of line and twisted pilasters), VIGNOLA (especially his Villa FARNESE and Villa GIULIA), LIGORIO (especially the *CASINO* of Pope Pius IV), VASARI (especially the UFFIZI), Jacopo SANSOVINO, and SANMICHELI. In France, the principal mannerist architects were Jean BULLANT and Jacques Androuet DUCERCEAU the Elder.

Mansueti, Giovanni di Niccolò

(*fl.* 1485–1526/7), Italian painter who spent his working life in Venice, of which he may have been a native; he was trained in the studio of Gentile BELLINI. He was, like CARPACCIO, one of the first artists to paint townscapes, and his large paintings depict contemporary Venetian architecture and costume with an attentiveness to detail that gives them considerable documentary value. His finest surviving painting is *The Miracle of the True Cross* (1494, Accademia di Belli Arti, Venice).

Mantegna, Andrea

(1430/1–1506), Italian painter, engraver, and antiquarian, born near Vicenza, and trained in the Paduan studio of Francesco SQUARCIONE. He lived in Padua until 1460, during which time he developed the mastery of foreshortening that is one of the most remarkable features of his art. His paintings from this period include a triptych of *The Madonna and Saints* for the Church of San Zeno Maggiore in Verona (1459), one of the finest fifteenth-century altarpieces to have survived in its entirety, and his fresco cycle on *The Lives of SS Christopher and James* in the Ovetari Chapel of the Church of the Eremetani in Padua (1459); the church was badly damaged in 1944, and the frescoes now survive only in fragments.

In 1460 Mantegna was appointed court painter to the Gonzaga family in Mantua, where his finest work was the decoration (completed 1474) of the Camera Depicta (known since 1648 as the Camera degli Sposi) in the Castello San Giorgio. Group portraits of the Gonzaga family are arranged on two walls, culminating in the depiction of Marquis Ludovico II Gonzaga and his wife Barbara of Brandenburg listening to the reading of an apostolic letter announcing the appointment of their son Francesco as a cardinal. The wholly unprecedented achievement of the room is the illusion that the actions depicted in the paintings on the walls appear to be happening within and outside the space of the room; this illusion is even extended to the ceiling, which has an oculus that depicts the sky framed by a balcony from which figures leaning over the rails look down into the room.

In 1486 Mantegna began to work on a cycle of nine large paintings on *The Triumph of Caesar*; these paintings were bought by King Charles I of England in 1628 and are now at Hampton Court. Mantegna's allegorical paintings of *Parnassus* (1497) and *The Triumph of Virtue* (c.1500), both now in the Louvre, were painted for Francesco's marchioness, Isabella d'Este.

In 1453 Mantegna married the daughter of Jacopo BELLINI, and thereafter became a formative influence on Giovanni BELLINI, his brother-in-law. Their respective versions of *The Agony in the Garden* hang on the same wall in the National Gallery in London.

Manuel, Niklas

or Niklas Manuel Deutsch (c.1484–1530), Swiss painter, poet, playwright, and anti-Catholic polemicist, a native of Bern, where in 1512 he became a member of the city council. As a young man he worked as a painter, executing ALTARPIECES, murals, drawings, and woodcuts (now mostly in the Basel Kunstmuseum) in the style of the Italian Renaissance. Manuel's most famous painting, a *Dance of Death* painted for the Dominican monastery in Bern, did not survive and is known only from copies. His preoccupation with death and with the DANCE OF DEATH is evident also in his surviving drawings.

Manueline

A style of Portuguese architecture and architectural decoration named after King Manuel I, with whose reign (1495–1521) it is primarily associated. It is essentially a blend of late GOTHIC and

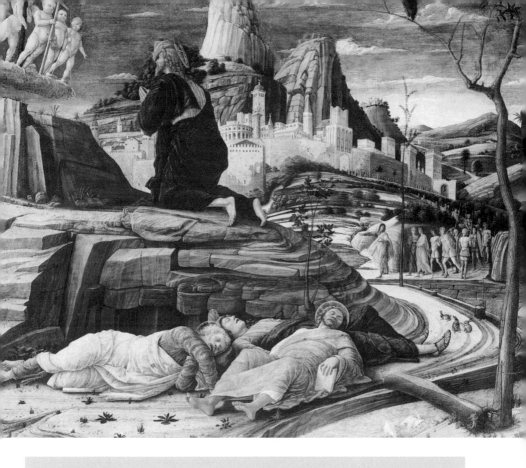

Andrea **Mantegna**, *The Agony in the Garden* (*c.*1460), in the National Gallery, London. The painting is signed 'opvs andreae mantegna' ('the work of Andrea Mantegna'). Jesus kneels before a rock formation that resembles an altar, above which angels present the Instruments of the Passion (most visibly, the cross and the column). The apostles, drawn like statues and expertly foreshortened, sleep while Judas and the Roman soldiers approach. Mantegna's draughtsmanship is particularly apparent in the depiction of Jerusalem as an orientalized city with buildings modelled on surviving ancient Roman structures such as the Coliseum.

MUDÉJAR elements, and so is the Portuguese variant of the PLATERESQUE, by which it was influenced. The feature that distinguishes Manueline architecture from the Plateresque is that structures as well as decorations are influenced by Mudéjar styles: the Plateresque is essentially lavish surface decoration, but the Manueline integrates decoration and structure by transforming structures; the clearest example of such transformation is the twisted pier, a spiral column that appears in many Portuguese churches. In sculpted decoration, the Manueline is also said to be characterized by eastern influences from the overseas explorations of Manuel's reign, notably in its extensive use of vegetation (laurel leaves, roses, poppy heads, ar-

tichokes, etc.), maritime images (anchors, ropes, terrestrial globes, and armillary spheres), and the ever-present Cross of the Order of Christ.

The Royal Palace (Palácio Real) at Sintra, in which Manuel I added Mudéjar features, such as Moorish windows (*ajimeces*), to the Gothic building erected in the fourteenth century by King John I, is sometimes described as Manueline (not least because Manuel I commissioned the work), but would perhaps be more accurately described as Portuguese Plateresque, because the Mudéjar elements are decorative rather than structural. The greatest of Manueline monuments is the nave of the Convento de Cristo at Tomar, in which Diogo de ARRUDA has produced Portugal's most exuberantly Manueline building, the

windows of which are a mass of twisting coral, ropes, corks, masts, seaweed, anchor chains topped by an armillary sphere, and the Cross of the Order of Christ.

The most prominent exponents of the Manueline were Diogo and Francisco Arruda and Diogo BOYTAC (who inaugurated the Manueline style in his Church of Jesus at Setúbal). The influence of these architects and their contemporaries such as Mateus Fernandes and João de Castilho extended beyond metropolitan Portugal to Funchal (Madeira) and Goa and even to mission churches in Mexico sustained by religious orders that recruited from both Spain and Portugal. The most famous example of portable Manueline decorative art is the enamelled and gilded Belém monstrance (1506) made by the dramatist Gil Vicente and now in the Museu Nacional de Arte Antiga in Lisbon.

marble

In Renaissance Italy the marble preferred by sculptors was the pure white Carrara marble which had been quarried since antiquity (when it was known as *marmor carystium*) in the mountains near Carrara and in the nearby quarries at Massa and Pietrasanta; MICHELANGELO is known to have visited Carrara to select marble, and Domenico FANCELLI was based there. In northern Europe the black marble used by Netherlandish, French, and German sculptors was quarried near Tournai and known as Tournai marble; it is now called Belgian black marble.

Marcolini, Francesco

(*c*.1500–1559), Italian printer and type founder, born in Forlì. He moved to Venice, where he established himself as a printer in 1534. His books include the revised version of Aretino's comedy *La cortigiana* (1534) and parts of SERLIO's *L'architettura* (1537–51). He also experimented with the printing of musical notation.

Marinus van Reymerswaele

(*c*.1490/5–*c*.1567), Flemish painter of whom little is known, save that his works show stylistic affinities with the Antwerp painting of the period. His paintings, which exist in many versions, return repeatedly to two subjects: St Jerome in his study and GENRE scenes depicting bankers, usurers, and excisemen; his *Two Tax Collectors* (or *Two Excisemen*) survives in at least 25 versions, one of which is in the National Gallery in London.

Markwart

or (Spanish) Macuarte family, a family of German gunsmiths in Spain. In about 1530 Simon Markwart and his brother Peter, sons of the Augsburg gunsmith Bartholomäus, travelled to Madrid at the invitation of Charles V and remained in Spain as gun-makers to Philip II and Philip III; in the next generation the most prominent gunsmith was Simón Macuarte the Younger. The family's guns, which were highly regarded throughout Europe, were marked with a sickle.

Marmion, Simon

(*c*.1425–1489), Franco-Flemish painter and illuminator, born in Amiens and admitted to the guild at Tournai (1468) before settling in Valenciennes. He is best known for an attributed work, the retable of *St Bertin* (1459), which is now divided: it is mostly in the Gemäldegalerie in Berlin but there are fragments in the National Gallery in London. His paintings are typically populated with many small figures, and he used an unusually large range of colours.

marquetry

A term now used to denote a technique developed in the seventeenth century whereby a decorative veneer consisting of pieces of material shaped into a mosaic is glued to a rough surface, typically the carcass of a piece of furniture.

Michelangelo, *David* (1501–4), in the Accademia, Florence. Michelangelo carved the statue in Florence from a block of **marble** that had been roughly carved by Agostino di Duccio and then abandoned. This preliminary carving inevitably constrained Michelangelo's design; the arrangement of the legs, for example, was (according to Vasari) a consequence of Agostino's piercing of the marble. Depictions of David (such as Donatello's on p. 39) traditionally included a head of Goliath and a sword, but nothing in Michelangelo's statue distracts from the classical nudity of the figure. The origins of this ideal of the heroic male nude lie in the statuary of classical antiquity, but Michelangelo may also have been influenced by Nicola Pisano's sculpture of Christian fortitude (see p. 208).

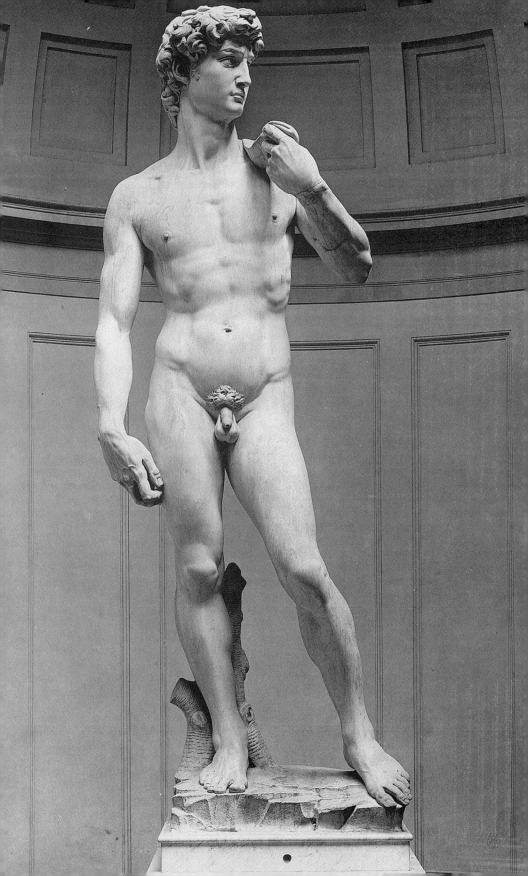

Renaissance marquetry, however, is a form of inlay, on which see INTARSIA.

Martini, Simone

See SIMONE MARTINI.

Martorell, Bernat

(*fl.* 1433–52), Catalan painter and miniaturist. His most important documented work is the ALTARPIECE of Púbol Castle (1437–42), now in the Gerona Museum. Paintings attributed to him include panels from an altarpiece of *St George* now divided between the Louvre and the Art Institute in Chicago.

Masaccio

or Tommaso di Ser Giovanni di Monte Cassai (1401–*c.*1428), Italian painter, born in San Giovanni Valdarno (Tuscany). He lived in Florence from about 1422, and in 1428 moved to Rome, where he died at the age of 27.

The canon of Masaccio's surviving paintings consists of only four works, of which two are collaborative. He worked with MASOLINO on the panel painting of *The Virgin and Child with St Anne* (Uffizi) and the frescoes in the Brancacci Chapel of Santa Maria del Carmine in Florence (see plate 2). His independent paintings are the fresco of *The Trinity* in the Church of Santa Maria Novella in Florence and the polyptych painted in 1426 for Santa Maria del Carmine in Pisa; the surviving panels are now dispersed: the central panel of *The Madonna and Child Enthroned* is in the National Gallery in London, the predella panels in the Gemäldegalerie in Berlin, and the *Crucifixion* in the Museo Nazionale in Naples. There are also smaller panels in Pisa and the Getty Museum.

Masaccio's importance was fully recognized by VASARI, who noted Masaccio's debt to BRUNELLESCHI for his understanding of PERSPECTIVE and his debt to DONATELLO for the classical modelling of the human figure. The most original aspect of Masaccio's art was his innovative use of light to delineate his human figures and their clothing and, in the case of the Brancacci Chapel, to unify a composition extending over several walls by creating the illusion of a single source of light.

Maso di Banco

(*fl.* 1335–50), Italian painter to whom Lorenzo GHIBERTI attributes the fresco cycle *The Life of St Sylvester* in the Bardi di Vernio Chapel of the Church of Santa Croce in Florence. The style of the cycle, which resembles that of GIOTTO, is sufficiently distinctive for other murals to be attributed to Maso, but the canon of his works remains unstable and even his identity is uncertain.

Masolino

or Tommaso da Panicale or Maso di Cristofano Fini (*c.*1383–after 1435), Italian painter, born near Florence, where he was admitted to the Guild of Painters in 1423. He collaborated with MASACCIO on *The Virgin and Child with St Anne* (Uffizi) and the frescoes in the Brancacci Chapel of Santa Maria del Carmine; his style became so similar to Masaccio's that attributions were long regarded as problematical. He subsequently lived in Rome (*c.*1428–31), where he painted a fresco cycle on *The Life of St Catherine* in San Clemente and may have been responsible for part of the triptych of *The Miracle of the Snow* for Santa Maria Maggiore; the panel depicting *St Jerome and St John* (now in the National Gallery in London), however, is now generally attributed to Masaccio. Masolino eventually moved to northern Italy, where his surviving works include frescoes of *The Life of the Virgin* in the collegiate church at Castiglione Olona (near Como).

Massys

or Matsys or Metsys, Quentin (1466–1530), Flemish painter, born in Louvain, the son of a clockmaker. His early life is not well documented, but in 1491 he settled permanently in Antwerp. The mastery and majesty of his earliest known paintings, the *St Anne* altarpiece (1507–9, Musée d'Art Ancien, Brussels) and the *Lamentation*, the central panel of a *St John* altarpiece (1508–11, Koninklijk Museum voor Schone Kunsten, Antwerp), may imply an early *œuvre* that has been lost. He is not known to have visited Italy, but Italian influence is evident in his paintings: in the altarpiece St Anne is depicted in an Italianate building, and the influence of LEONARDO DA VINCI is apparent in his portraits (e.g. *Profile of an Elderly Man*, Musée Jacquemart André, Paris) and devotional paintings (e.g. *Magdalene*, in the Koninklijk Museum voor Schone Kunsten, Antwerp). His pictures of merchants and bankers (notably *The Banker and his Wife*, Louvre, 1514) have a satirical edge (in this case deprecating avarice) that may imply the influence of Erasmus; Massys painted a portrait of *Erasmus* (1517, Hampton Court) which Erasmus intended as a gift for Sir Thomas More.

Master E.S.

or Master of 1466 (*fl.* mid-fifteenth century), German engraver and goldsmith whose engravings are signed with what are assumed to be his initials; one of his engravings is dated 1466. He was one of the most innovative of early German engravers. His predecessors had largely been content to engrave outlines, whereas Master E.S. created sophisticated tonal effects by the adept use of parallel and cross-hatchings. His subjects were usually devotional, and include representations of the Annunciation, the Nativity, and the Man of Sorrows.

Master of

For place names see under the name of the place.

Master of St Giles

(*fl.* 1480–1500), French artist whose name derives from two panels representing *The Life of St Giles* (National Gallery, London); the style of these panels is the basis of attributions of other works to the same artist. The topographical views of Paris and (in the case of one of the National Gallery panels) of the interior of Saint-Denis have been taken as evidence that the Master lived in or near Paris and may have been French.

Master of St Martha

or Master of Chaource (*fl.* 1510–30), French sculptor whose name derives from the statue of St Martha (*c.*1515) in the Church of La Madeleine in Troyes. The emotionally restrained figure of Martha, with her fastidiously carved draperies, forms the basis of attributions of other statues from the same area, including a *Pietà* in the Church of Saint-Jean in Troyes and an *Entombment* in the Church of Saint-Jean-Baptiste in Chaource (the source of the Master's alternative name).

Master of the Brunswick Monogram

(*fl.* 1520–40), Flemish artist whose name derives from the monogram on a painting of *The Parable of the Last Supper* (Herzog-Anton-Ulrich Museum, Brunswick); there is no scholarly consensus about the meaning of the monogram. Pictures attributed to the same hand share a common style characterized by fine drawings and by an unusual ability to depict figures in landscapes; the subject matter of these pictures, however, is sharply divided into those that depict religious subjects in landscapes and those that portray scenes in brothels. The Master has been identified with various artists, including

Jan Sanders van HEMESSEN, but is now thought by many scholars to be Jan van Amstel (*c.*1500–42), the brother of Pieter AERTSEN.

The Master of the Brunswick Diptych (*fl.* 1480–1510) is a different painter, named after a diptych also in the Herzog-Anton-Ulrich Museum in Brunswick.

Master of the Death of the Virgin

See JOOS VAN CLEVE.

Master of the Housebook

or (formerly) Master of the Amsterdam Cabinet (*fl. c.*1470 –1500), German painter and engraver in the Middle Rhineland whose present name derives from a collection of his drawings in a commonplace book (*Hausbuch*) in Castle Wolfegg (Upper Swabia); his former name derives from the fact that the largest collection of his drawings is held in the Print Room of the Rijksmuseum in Amsterdam. His engravings are characterized in technique by their use of drypoint and in subject by their wholly secular character. The influence of these engravings can be discerned in several of the early drawings of DÜRER, who either took copies or committed details to memory.

Master of the Legend of St Barbara

(*fl.* 1470–1500), Netherlandish painter whose name derives from the subject of a triptych of which the right panel is lost, the centre panel is in the Musée d'Art Ancien in Brussels, and the left panel is in the Confrérie du Saint-Sang in Bruges. The Master's hand is apparent in fragments of an altarpiece on *The Legend of St Géry* in the National Gallery of Ireland and the Mauritshuis in The Hague.

Master of the Life of the Virgin

(*fl.* 1460–80), German painter based in Cologne whose name derives from a series of eight panels illustrating the life of the Virgin Mary; seven of the panels are in the Alte Pinakothek in Munich and the eighth, *The Presentation in the Temple*, is in the National Gallery in London. Four other panels in the National Gallery (painted for Werden Abbey, near Essen) are likely to be products of the same workshop, as may a *Crucifixion* at Kues (on the Mosel).

This artist was formerly known as the 'Master of the Lyversberg Passion', whose name derives from a *Passion* sequence in the Wallraf-Richartz Museum in Cologne. This cycle is now thought to be the work of another artist.

Master of the Playing Cards

(*fl.* 1425–50), German engraver of a set of playing cards which contain finely drawn pictures of people, animals, and plants. Examples of the cards are preserved in the Bibliothèque Nationale in Paris and the Kupferstichkabinett in Dresden.

Master of the View of Sainte-Gudule

(*fl.* 1470–90), Netherlandish painter whose name derives from a panel (now in the Louvre) which has in its background a view of the façade of the Church of Sainte-Gudule in Brussels. The same artist's *Portrait of a Young Man Holding a Heart-Shaped Book* (National Gallery, London) contains in its background a view of another Brussels church, Notre-Dame-du-Sablon.

Master of the Virgo inter Virgines

(*fl.* 1483–98), Netherlandish painter based in Delft whose name derives from a picture of the Virgin Mary in the midst of a group of virgins (Rijksmuseum, Amsterdam). His surviving pictures, notably the *Crucifixion* (Uffizi) and the *Lamentation* (Walker Art Gallery, Liverpool), convey the intensity of devotional passion through the depiction of gaunt figures and bleak landscapes painted in vivid colours.

Matteo di Giovanni

(*c.*1435–1495), Italian painter, born in Sansepolcro (Borgo Sansepolcro, Umbria), the son of a tinker, and trained in VECCHIETTA's studio in Siena. He eventually became Siena's most prominent painter, specializing in elegant Madonnas (e.g. *Virgin and Child with Angels*, Pinacoteca, Siena). He also added the wings to PIERO DELLA FRANCESCA's *Baptism of Jesus*. Matteo's other paintings include an *Assumption*, a *Christ Crowned with Thorns*, and a *St Sebastian* (all in the National Gallery in London). His dramatic *Massacre of the Innocents* survives in four versions, three paintings (1482–91) and an inlaid marble mosaic in the floor of the cathedral in Siena.

Mazerolles, Philippe de

(*c.*1420–1479), Flemish miniaturist who worked in Paris as a young man and in 1467 became court painter to Charles the Bold in Bruges. His best-known work is the illumination of *The Conquest of the Golden Fleece* (Bibliothèque Nationale, Paris).

mazes and labyrinths

Mazes are sometimes called labyrinths, with reference to the four famous labyrinths of antiq-uity in Knossos (the original labyrinth), Egypt (the funeral temple of Amenemhet), Lemnos (which survived in Pliny's time), and Italy (the tomb of Porsena at Clusium, now Chiusi). All four labyrinths were lost, but their memory was preserved in literature, and they were depicted on Cretan coins, Greek vases, and Roman mosaics; the recovery of such artefacts revived interest in the form. The four great labyrinths of antiquity were all buildings, but when the form was revived it was implemented in three forms: floor mazes in churches (of which the best Renaissance example was built in 1495 in the collegiate Church of Saint-Quentin), the medieval turf maze, and the garden maze.

In the sixteenth century garden mazes were usually constructed from low shrubs and herbs; the hedge maze was an invention of the seventeenth century. There were mazes in gardens all over Europe: the first to be built in an English garden was at Nonsuch; in Germany, there was a maze in the HORTUS PALATINUS; in France, *bosquets* (see BOSCO) were sometimes planted as mazes; in Italy, the garden of the Villa d'ESTE had four mazes.

Mazzoni, Guido

or Paganino (*c.*1450–1518), Italian sculptor. He was born in Modena, and worked there and in Ferrara, Venice, and Naples. The sculptures that he carved in Italy include many dramatic *Lamentation* scenes (e.g. Santa Anna dei Lombardi, Naples). In 1495 he travelled with Charles VIII from Naples to France; his EQUESTRIAN STATUE of *King Charles* (1498) in the Abbey of Saint-Denis was destroyed in 1789; his equestrian statue of *King Louis XII* at the Château de BLOIS was also destroyed. The realism to which he aspired in his effigies was achieved through his use of life and death masks.

Meckenem, Israhel von, the Younger

(1440/5–1503), German engraver, born in Bamberg and trained by his father (and namesake) and by MASTER E.S. Most of his work, which runs to at least 600 copperplate engravings, consists of copies of designs by other engravers. His most important original work is a series of illustrations of *The Passion*. He was the first German artist to engrave a self-portrait, which appears in a double portrait with his wife.

medal

A metal disc struck or cast with the head or effigy of a person on the obverse and a related

Germain Pilon, bronze portrait medallion of Catherine de Médicis (1575), queen of France and, when this **medal** was struck, mother of King Henri III; this example is in the British Museum. This is one of a series of medals portraying the Valois monarchs and their court, usually in three-quarter view rather than in profile.

design (normally an IMPRESA in Italy or a coat of arms in northern Europe) on the reverse; its purpose is to commemorate a person or an event. It is this commemorative purpose that distinguishes Renaissance medals from COINS (which are primarily a medium of exchange), PLAQUETTES (which have mythological or religious subjects), and modern military medals (which reward acts of heroism and distinguished service); this element also points to the origin of the medal as a revival of the Roman imperial commemorative medallion. All Renaissance medals except those of the Papal State were privately manufactured.

Italian medals were usually made from bronze, which had not been systematically used for coinage since the sixth century; silver, lead, and gold were also used. In the fifteenth and early sixteenth centuries, medals were normally cast by a variation on the *cire-perdue* ('lost-wax') method of casting statues: a wax model of the medal (each side of which had been separately moulded) was surrounded by a heat-proof mould, typically a paste made from ashes or chalk; the molten wax was then melted out through a vent, and molten bronze was poured into the space formerly filled by the wax. The casting of medals disappeared with the

introduction of struck medals in Augsburg in 1550; in this method a heated metal disc was placed between two engraved dies, which were then hammered together or forced together with a screw-driven vice. In cast medals the mould could only be used once, and so medals were made in relatively small numbers; the advent of struck medals allowed for mass production, because dies could be used repeatedly.

The first Renaissance medallist was PISANELLO, who in 1438 cast a portrait medal of the Emperor John VIII Palaeologus, who was visiting the Council of Florence: on the obverse there was a relief profile of the emperor, and on the reverse a scene in which the emperor, mounted on his horse, rides past a cross; the emperor's title surrounding the portrait on the obverse is in Greek, but the signature of Pisanello on the reverse is in both Latin (*OPUS PISANI PICTORIS*) and Greek. Pisanello subsequently struck medals for many north Italian princes and for Alfonso V, king of Naples (1448–9). Other Italian medallists followed in Pisanello's wake, notably BERTOLDO DI GIOVANNI (who struck a medal commemorating the Pazzi Conspiracy), Giovanni BERNARDI, CARADOSSO, Costanzo da Ferrara (notably his portrait of Sultan Mehmet II), Annibale FONTANA, FRANCIA, Francesco LAURANA, Leone LEONI, Matteo de' PASTI, Savelli SPERANDIO, ADRIANO FIORENTINO (notably his Giovanni Pontano), Niccolò Fiorentino (notably his Savonarola, Lorenzo de' Medici, and Charles VIII of France), and Domenico and Gianpaolo POGGINI.

In Germany medals were struck by Italian craftsmen as early as 1477, when Archduke Maximilian commissioned a medal from Giovanni Candida to commemorate his wedding. German medallists used the same methods as their Italian predecessors, but often cast in silver rather than bronze. The first German medallist was Hans SCHWARZ of Augsburg. His numerous successors included DÜRER, whose most memorable portrait medals are those of his aged father and the youthful Emperor Charles V. In the Netherlands, the finest medallist was the painter Quentin MASSYS, whose magnificent portrait medal of Erasmus is his only known medal.

In France the court employed a succession of Italian medallists, but in the sixteenth century native artists received commissions, notably the sculptor Germain PILON, who made portrait medals of Henri II, Henry III, and Catherine de Médicis. The French tradition culminated in the early seventeenth century with Guillaume Dupré, the greatest of north European medallists, whose early work includes a double portrait medal of Henri IV and Marie de Médicis (1601).

Medici villas

The Medici family owned fourteen VILLAS near Florence, of which the most important were in Careggi, Castello, Fiesole, and Poggio a Caiano; in the sixteenth century the family also acquired a villa in Rome and built PRATOLINO.

The Villa Careggi, in what is now a northern suburb of Florence, is the creation of Cosimo de' Medici the Elder, who in 1457 commissioned MICHELOZZO DI BARTOLOMEO to convert an old manor house that Cosimo's brother Giovanni de' Bicci had bought in 1417. In rebuilding the fortified manor house as a contemporary villa, Michelozzo chose to leave much of the original exterior intact, but added a graceful double loggia which overlooked a garden. The garden was intended to revive the ancient Roman villa garden, and so was planted with bay, box, cypress, myrtle, pomegranate, quince, lavender, and scented herbs and flowers; the only post-classical plants were carnations from the Levant and orange and lemon trees from North Africa. One of the FOUNTAINS added to the garden by Lorenzo de' Medici contained VERROCCHIO's bronze *Boy with a Dolphin* (c.1480), which is now in the court of the Palazzo Vecchio in Florence. After Lorenzo's death and the expulsion of the Medici the villa was vandalized and looted. It was later restored by BRONZINO and PONTORMO for Alessandro de' Medici and Cosimo I de' Medici. The garden has since disappeared, and the villa is now part of a hospital complex.

The Medici villa in Fiesole, on a hill overlooking Florence from the north, was constructed by Michelozzo between 1458 and 1461; it was commissioned by Cosimo the Elder for Giovanni, his second son. Massive foundations were dug to secure the house on the steep slope of the hill, and the cellars were used to accommodate stables as well as wine and oil presses and storage rooms. The rooms above included reception rooms, a music room, and a library; the interior decoration did not survive the ministrations of Lady Walpole, the dowager countess of Oxford, who redecorated it in 1772.

The villa opens out directly onto the upper terrace, which overlooks Florence in the valley below; the original planting on this terrace has been replaced with grass, but the GIARDINO SEGRETO still survives, with its box PARTERRES, sub-

dued fountain, and stone balusters through which can be seen a vista of Florence and the Arno valley. There was originally no access from the upper terrace to the lower terraces, which were reached from the cellars of the house; connecting stairs and ramps were to become a feature of this and other Italian gardens in the sixteenth century. The second terrace is dominated by a pergola flanked on its retaining wall by a raised border; the border and the pergola were part of the original garden, though the original supporting columns of the pergola do not survive. On the lowest terrace an elegant Renaissance garden with a fountain and rectangular parterres surrounded and intersected by box has been reconstructed, but the extent to which this garden replicates the layout of the original is not clear.

The Medici villa in Poggio a Caiano, to the west of Florence, was commissioned in 1480 by Lorenzo de' Medici, who instructed Giuliano da SANGALLO to convert the old Villa Ambra into a contemporary villa. By 1485 the house had been surrounded by a balustraded loggia which acts as a balcony for the rooms on the first floor (*piano nobile*). Lorenzo's son Giovanni (later Pope Leo X) continued to commission additions to the house, notably a six-columned (hexastyle) portico on the first floor, with a frieze and pediment; the structure is modelled on the pedimented temple fronts of classical antiquity, and its use in this building inaugurated the Renaissance revival of the form, which later became the distinguishing feature of PALLADIO's buildings. Villas were traditionally built around a court, but at the centre of the Poggio a Caiano villa there is a large two-storey salon with a gilded stucco ceiling (containing the arms of Leo X) and frescoes by ANDREA DEL SARTO and Pontormo which use classical subjects to record and glorify the history of the Medici family. The gardens were uprooted in the nineteenth century to make way for an English garden with a mock-Gothic ruin, and much of the interior was ruthlessly modernized at the same time; one fine bedroom, however, survives in its original form. The house is now a museum.

The Medici villa at Castello, to the north of Florence, had been in the family for a century when Cosimo I de' Medici commissioned the gardens. The garden was begun c.1540 by Niccolò TRIBOLO, and completed after his death by Bartolomeo AMMANATI and Bernardo BUONTALENTI. Its design is in some respects anachronistic, in that the garden is shaped as a square

enclosed by a wall and planted as a series of rectangular beds with a statue at the centre; this was the layout characteristic of Italian gardens a century earlier. There are, however, distinctive sixteenth-century features: there is a central axis rising to a magnificent GROTTO (1546–69), and there are many statues (and there were many more, both free-standing and in relief) and fountains. The grotto, which is built into the enclosing wall, is decorated with shell mosaics and fountains in the form of animal statues from whose beaks, ears, noses, and wings water pours. In the Fountain of Hercules and Antaeus, water spews from the mouth of Antaeus as Hercules strangles him; this was the first time that water had been incorporated into the narrative of a sculpture rather than merely issuing from a convenient orifice. A second fountain, GIAMBOLOGNA's Fountain of Venus squeezing the water from her hair, was removed in the eighteenth century to the nearby Villa Medici in Petraia, and the Fountain of Hercules, which originally stood near the house, was put in its place. The Fountain of Venus had been surrounded by a BOSCO in the form of a MAZE of bay, cypress, and myrtle, which meant that the statue emerged from a crown of evergreen; the Fountain of Hercules now in its place stands nakedly above flat geometrical parterres.

The garden still contains some elements of its original layout, but a lunette by UTENS and the account given by Montaigne of his visit in 1580 record additional features that have since disappeared. The Utens lunette shows the house standing on a terrace used for riding and jousting, and Montaigne describes a *cabinet de verdure* (see BOSCO) with a spring rising from a marble table and also describes GIOCHI D'ACQUA that could be triggered by remote control at a distance of 200 paces. In Utens's picture, and in Vasari's description of the garden, there was a wall decorated with fountains at the back of the main garden, beyond which was a lemon garden. There were *giardini segreti* on either side of the main garden: the one on the left, according to Montaigne, contained a tree house approached by a stair decorated with ivy that concealed *giochi d'acqua* that played tunes and squirted visitors; the one on the right, according to Vasari, contained a herb garden. Vasari said that the gardens, had they been completed, would have been the finest in Europe, and singled out the central fountain for particular praise: 'la più bella fonte e la più ricca, proporzionata e vaga, che sia stata fatta mai' ('the most beautiful fountain, the

richest, the best proportioned, the most charming that has ever been made').

The Villa Medici in Rome was built *c.*1544 on the site of an ancient villa of Lucullus; it was designed by Annibale Ricci for Cardinal Ricci. The villa was subsequently acquired by the Medici family, and has since the early nineteenth century been the home of the Académie de France, which had been founded in Rome in 1666. The most remarkable feature of the villa is its garden, which has preserved its sixteenth-century layout and includes statues (both classical fragments and contemporary *stucchi*), a MOUNT crowned with cypresses, and two ilex *boschi* (see BOSCO). In the seventeenth century, Galileo lived in the villa and John Evelyn visited the gardens, which were painted by Velázquez and Poussin.

Meit, Konrad

(*fl. c.*1506–1550), German sculptor and woodcarver, born in Worms. He worked from 1511 in Wittenberg in the service of the Elector Friedrich III, and subsequently moved to the Netherlands, where from 1526 to 1532 he executed his finest works, the tombs of Margaret of Austria and her family in the Church of St Nicholas of Tolentino in Brou (on the outskirts of Bourg-en-Bresse). In 1536 Meit settled in Antwerp, where he worked for the rest of his career. His best-known small-scale work is the ALABASTER statuette of *Judith* now in the Bayerisches Nationalmuseum in Munich.

Melozzo da Forlì

(1438–94), Italian painter, a native of Forlì (Emilia). Little is known of his early life, but he worked in the ducal court in Urbino (1465–76) and came into contact with PIERO DELLA FRANCESCA, to whose style he is indebted. The debt to Piero is readily apparent in Melozzo's best-known painting, *Platina Appointed Librarian of the Vatican by Pope Sixtus V* (1477, Pinacoteca Vaticana). He also painted the frescoes in the Sacristy of San Marco in the Santuario della Santa Casa in Loreto and frescoes (which survive only in fragments) in the cupola of the Church of SS Apostoli in Rome. Much of Melozzo's work is lost, but his contemporary standing is attested by Giovanni SANTI, who praised Melozzo in verse as a master of perspective.

Memling, Hans

(1430/5–94), German/Flemish painter. He was born in Seligenstadt (near Mainz), but in 1465 became a free mason of Bruges, where he spent the rest of his life. His style, which is characterized by its attention to detail and colours, remained stable throughout his career, and reflects the influence of Rogier van der WEYDEN, which may imply that he was trained in Rogier's studio. His patrons included the Hôpital de Saint-Jean in Bruges, which now has the best collection of his paintings; the Martin van Nieuwenhove Diptych (1482), which portrays the donor together with the Madonna and Child, demonstrates Memling's virtuosity as a portrait painter, and its background shows his mastery of LANDSCAPE. His surviving paintings are widely scattered, because his clients also included the Burgundian court and several Italians who were resident in Bruges; one of the finest products of such commissions is the double portrait of *Tommaso Portinari and his Wife* (Metropolitan Museum, New York). His other works include the Donne Triptych (1468, National Gallery, London) and *Portrait of a Young Man* (Thyssen Collection, Madrid).

Memmi, Lippo

See LIPPO MEMMI.

Mennicken family

A family of German potters who worked at Raeren (10 kilometres (6 miles) south of Aachen in what is now Belgium); in the second half of the sixteenth century their workshop produced large STONEWARE jugs decorated with reliefs. Until the late 1570s the jugs were brown, and usually depicted mythological scenes; thereafter the jugs were often grey, and usually depicted religious scenes. The most prominent member of the family was Jan Emens Mennicken (*fl.* 1568–94). He was the first (*c.*1580) to apply cobalt-blue glaze to wares, a technique that was later to become characteristic of wares produced at Westerwald potteries. The surname was so common in Raeren that the Mennicken potters, including Jan Emens, used only their given names or initials to sign their wares. Jan Emens's relatives included Baldem Mennicken (*fl.* 1577–90) and his son Jan Baldems (*fl.* 1589–1613). Johann Mennicken moved to Westerwald in about 1595, and the Leonard and Wilhelm Mennicken who were working there in 1615 may have been his sons.

Mensator, Johannes

(*fl.* 1507–11), German woodworker who introduced INTARSIA to Hungary in his geometrical decoration of doors and a cupboard in the

Town Hall (Radnica) at Bardejov (Hungarian Bártfa, German Bartfeld), the first building in Slovakia (then part of Hungary) to contain elements in the style of the Italian Renaissance.

Mentelin, Johann

(c.1410–1478), German printer, born in Schlettstadt (now French Sélestat). In about 1468 he became the first printer in Strassburg. In 1460 Mentelin published a 49-line Bible, which enabled him to print the entire text on 850 pages (as opposed to GUTENBERG's 1,286 pages); in 1466 he published the first Bible in German. His workshop also printed popular romances.

Mezzarisa, Francesco di Antonio

(fl. 1527–81), Italian potter in FAENZA. He was initially a manufacturer of ISTORIATO ware (c.1527–40) but in about 1540 began to work with Virgiliotto CALAMELLI on the development of BIANCHI. Within five years he was exporting huge quantities of his characteristic florid bianchi to Genoa.

Michelangelo

or Michelagnolo Buonarroti (1475–1564), Italian sculptor, painter, draughtsman, architect, and poet, born on 6 March 1475 in Caprese (now Caprese Michelangelo), the son of Ludovico Buonarroti (a Florentine nobleman working in Caprese as the podestà of Caprese and Chiusi) and his wife Francesca dei Neri; he was trained in the Florentine studio of Domenico GHIRLANDAIO and possibly with BERTOLDO DI GIOVANNI. His surviving early work includes a relief of The Battle of Lapiths and Centaurs (c.1492, Bargello, Florence).

The advent of Savonarola's rule made life as an artist in Florence untenable, and in October 1494 Michelangelo left for Bologna, where he carved three figures for the shrine of St Dominic in the Church of San Domenico. By June 1496 he was in Rome, where he carved the two statues that were to establish his fame as a sculptor: the Bacchus (1496, Bargello) and the Pietà (1497–9, St Peter's Basilica, Vatican).

From 1501 to 1505 Michelangelo lived in Florence, where his principal work was David (Accademia, Florence; see p. 167), which has become the foremost visual image of the Florentine Renaissance. During this period he also sculpted the Madonna and Child now in the Church of Notre Dame in Bruges and probably carved the Madonna relief now in the Royal Academy in London. His painting during this period includes the Doni Tondo (Uffizi) and preliminary work on a battlepiece for the Sala del Maggior Consiglio in the Palazzo Vecchio; this commission, which was shared with LEONARDO, never reached the stage of painting, but a cartoon known as The Bathers is known from a copy (Holkham Hall, Norfolk), and some of Michelangelo's preliminary drawings survive.

In 1505 Michelangelo was called to Rome by Pope Julius II, who commissioned him to make his tomb. They soon quarrelled, and in April 1506 Michelangelo returned to Florence. The commission for the tomb, which involved the carving of more than 40 large figures, was quietly set aside, though it was renewed by the della Rovere family after the death of Pope Julius in February 1513, and Michelangelo carved the Moses and two Slaves. Michelangelo signed three more contracts (1516, 1532, 1542) for the tomb, each of which reduced the amount of work that he was expected to do, and in 1545 a much-reduced version of the monument was erected in the Church of San Pietro in Vincoli; the monumental Moses is still in the church, but the two Slaves are now in the Louvre.

Michelangelo returned to Rome in 1508, this time to work on the fresco cycle that covers the vault and part of the upper walls of the SISTINE CHAPEL. He worked quickly: the first half was officially unveiled on 15 August 1511, and after fresh scaffolding enabled him to complete the commission, the whole of his work was unveiled on 31 October 1512; thereafter his standing was such that he was known as Michelangelo il divino.

In December 1516 Pope Leo X commissioned Michelangelo to design a façade for the Church of San Lorenzo in Florence, the Medici church of which BRUNELLESCHI had built the interior. The façade was never built, but Michelangelo did contribute two works to San Lorenzo, the Medici chapel known as the New Sacristy (which complemented Brunelleschi's Old Sacristy) and the Biblioteca Laurenziana. The New Sacristy was commissioned in November 1520, but work was suspended during the exile of the Medici (1527–30), when Michelangelo declared himself to be a firm supporter of the republic and assumed responsibility for fortifications; when the Medici were restored, Michelangelo was pardoned by Pope Clement VII and resumed work on the Medici chapel.

In 1534 Michelangelo moved permanently to Rome, leaving the Medici chapel unfinished. In Rome he was immediately commissioned by Pope Paul III to paint the Last Judgement on the

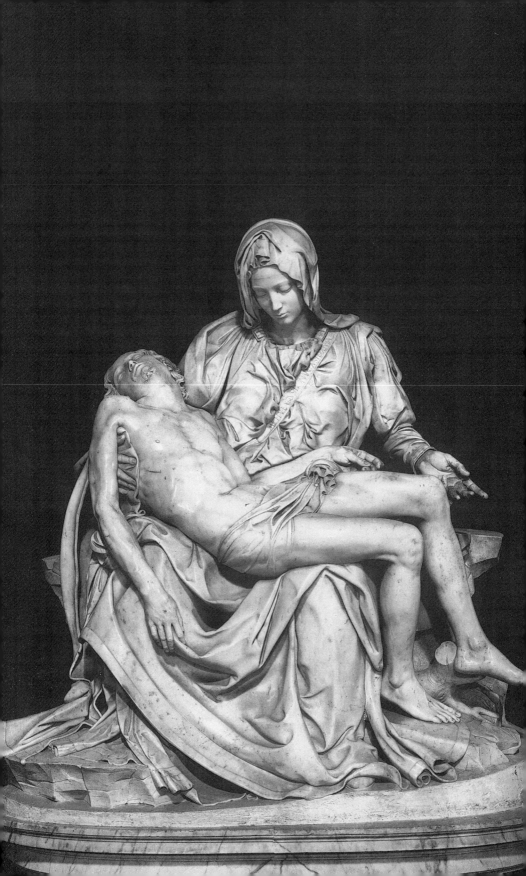

altar wall of the Sistine Chapel; the fresco was unveiled on 31 October 1541, which was 29 years to the day after the unveiling of the ceiling. Pope Paul subsequently commissioned frescoes on *The Conversion of St Paul* and *The Crucifixion of St Peter* for the Cappella Paolina (1542–50). In 1546, at the age of 71, Michelangelo began his final architectural work, the completion of ST PETER'S BASILICA. Michelangelo designed a huge hemispherical dome, which was left unfinished at his death on 18 February 1564; the dome was completed by Giacomo DELLA PORTA and Domenico FONTANA, who altered Michelangelo's design by making the top of the dome pointed.

As work on St Peter's proceeded, Michelangelo continued to draw, to write poetry, and to sculpt. He had earlier become one of the first exponents of the presentation DRAWING (of which examples survive at Windsor Castle, the Ashmolean, and the British Museum), and in his old age turned to religious subjects, including a series on *The Crucifixion*. In the final weeks of his life Michelangelo worked on the marble *Rondanini Pietà* now in the Castello Sforzesco in Milan, which is one of the statues that led admirers to associate Michelangelo with the awesome power known as *terribilità*.

Michelozzo di Bartolomeo

or Michelozzi Michelozzo (1396–1472), Italian architect and sculptor, born in Florence, the son of a Burgundian. He worked as an assistant to GHIBERTI (c.1417–24) and then entered into a partnership with DONATELLO (1424–33). The niche that he is said to have designed to accommodate Donatello's statue of St Louis in Orsanmichele (1425) is one of the first examples of a design revived from Roman antiquity—but it is possible that the niche is the work of Donatello. There is no doubt that Michelozzo carved the architectural parts of Donatello's tomb for the antipope John XXIII in the baptistery (1427).

Michelozzo first secured the patronage of the Medici family in late 1434, when he began to work on the MEDICI VILLA at Careggi, to which he added the courtyard and loggia. In 1444 he designed for Cosimo de' Medici the first Renaissance palace, the Palazzo Medici, which is now known as the Palazzo Medici-Riccardi. This seminal building has three storeys divided by classical string courses and graded rustication which is heavy on the ground floor and delicate on the top floor; the interior has an arcaded courtyard modelled on BRUNELLESCHI's Ospedale degli Innocenti. Michelozzo also built the Medici villas at Cafaggiolo (1451) and Fiesole (1458–61, rebuilt in the eighteenth century).

In 1437 Michelozzo began to work on the Convent of San Marco, to which he contributed the sacristy in the church, the cloisters, and the elegant three-aisled library (1437–43). He subsequently (1444–55) worked on the Church of the SS Annunziata, for which he designed the centralized tribune (later completed by ALBERTI) and the sacristy; the round choir, which is an adaptation of the design of the ancient Roman Temple of Minerva Medica, scarcely acknowledges the liturgical requirement that laity and clergy (in this case the Servite friars who used the choir) be separated by a screen. A bronze *St John* cast by Michelozzo for the Annunziata has recently been identified and is now in the Kimsell Museum in Forth Worth, Texas.

Beyond Florence, Michelozzo designed the tomb of Bartolommeo Aragazzi in Montepulciano (1427, now mostly destroyed, but two angels survive in the Victoria and Albert Museum as do several fragments in Montepulciano), the pulpit of Prato Cathedral (1428–38, a collaboration with Donatello), the square Church of Santa Maria delle Grazie in Pistoia (1452), and the Palazzo dei Rettori (1462–3, now a museum) in Ragusa (now Dubrovnik); the traditional attribution of the Portinari Chapel in Sant'Eustorgio in Milan (c.1462), which

Michelangelo, *Pietà* (1497–9), in St Peter's Basilica, Vatican, Rome. This marble group was commissioned in 1497 (when Michelangelo was only 22) by Cardinal Jean Villiers de La Grolais. The virtuosity of the carving is particularly apparent in the drapery, in which the deep contours of Mary's robes are contrasted with the smooth skin of the inert Jesus, who wears only a dampfold loincloth (i.e. one in which the drapery is carved as if wet and clinging to the skin beneath). The Virgin's face is not contorted in grief but is composed; her left hand is held in a gesture in which she presents her dead son to the viewer. In 1972 the statue was attacked by a madman who broke off the Virgin's arm at the elbow and damaged her nose and one of her eyelids; skilful restoration has rendered the damage all but invisible.

introduced the Renaissance style to Lombardy, is now doubted. Michelozzo's only known work in silver is a statuette of *St John the Baptist* (1452) in the Museo dell'Opera del Duomo in Florence.

miniature

The term 'miniature' is used in art history in two distinct senses: it can denote either a picture in an illuminated manuscript or a small portrait. In manuscript illumination, the *minium* was the red lead colouring used by the miniator to decorate initial letters; medieval Latin *miniatura* did not refer to size, but rather derived from the verb *miniare*, to rubricate or illuminate.

A pseudo-etymological association of *miniatura* with the Latin terms that express smallness (e.g. minimum) led to the idea that a miniature was a small picture. Such miniatures were usually minutely finished portraits painted on vellum, ivory, or card. The portrait miniature did not derive (except in name) from the pictures on illuminated manuscripts, but rather has its origins in the Renaissance portrait MEDAL. The earliest portrait miniatures were painted in late fifteenth-century France, but the genre developed in the Netherlands. It may have been Flemish miniaturists in England who introduced the form to HOLBEIN. In the course of the sixteenth century the portrait miniature became an independent genre, often worn as a dress ornament, and its shape changed from round to oval. Such miniatures became particularly popular in England, where they were known as 'limnings' or 'pictures in little'; the finest English exponents of the form were Nicholas HILLIARD and Isaac OLIVER.

Mino da Fiesole

(1429–84), Italian sculptor, trained in the Florentine studio of DESIDERIO DA SETTIGNANO. He worked in both Florence and Rome and specialized in tombs and portrait busts. He sculpted several tombs in the Church of the Badia in Florence; his Roman tombs include that of Francesco Tornabuoni in Santa Maria sopra Minerva. Mino's bust of *Piero de' Medici* (1453, Bargello, Florence) is the earliest dated Renaissance portrait bust. Mino da Fiesole is sometimes identified with the sculptor who designated himself 'Mino del Reame', but the name implies that this other Mino was a Neapolitan.

mirrors

or looking-glasses. Medieval mirrors were made either from polished metal or from glass backed by lead, and were framed ornamentally, often in ivory. Throughout the fifteenth century glassmakers in south Germany (notably Nuremberg, where a guild of mirror-makers had existed since at least 1373) produced convex mirrors known as bull's eyes (*Ochsen-Augen*), the shape being determined by the concavity of the glass from which they were blown. At the end of the fifteenth century Venetian glassmakers in Murano developed a technique (known as the 'Lorraine' or 'broad' technique) for making flat mirrors: glass was blown into a cylindrical bubble which was then cut at each end and along its axis and flattened on a stone under heat with a wooden tool; the flattened glass was then polished and bevelled before being 'silvered' with a compound of mercury and tin. This process enabled Venice (which created a corporation of mirror-makers in 1564) to dominate the European market for mirrors for two centuries, until Bernard Perrot's invention of plate glass in 1687 enabled French manufacturers to produce mirrors of a higher quality.

Miseroni family

A Milanese family of lapidaries, many of whose members worked in Prague or elsewhere in the imperial service. Girolamo (1522–84) and his brother Gasparo (1518–73) entered the service of Cosimo I de' Medici. Four of Girolamo's sons entered the imperial service: Giulio (1559–93) worked in Spain from 1582; Ottavio (1567–1624) worked from 1588 in the court of the Emperor Rudolf II in Prague, and was later joined by his brothers Giovanni Ambrogio and Alessandro. Ottavio was appointed as official lapidary to the imperial court, a post that was in due course passed to his son Dionysio (d. 1661) and his grandson Ferdinand Eusebius (d. 1684). A group portrait painted *c*.1653 by Karel Skréta (now in the Czech National Gallery's Convent of St George in Prague) portrays *Dionysios Miseroni and his Family* with their carved gems.

Missaglia

or Negroni da Ello family, a family of Italian weapon-makers and armourers (see ARMS AND ARMOUR) active in Milan in the fifteenth century. The heads of the family workshop were Pietro Missaglia (d. before 1429), his son Tommaso (d. 1452), and his grandson Antonio (d. 1496), on

whose death the workshop closed; their successors were the NEGROLI family. Products of the Missaglia workshops were sold all over Europe, and examples are preserved in the Kunsthistorisches Museum in Vienna, the Royal Armouries in Leeds, the Wallace Collection in London, and the Metropolitan Museum in New York.

Moiturier, Antoine

(*fl.* 1463–76), French sculptor, a native of Avignon. Several years after the departure of JUAN DE LA HUERTA from Dijon in 1457, Moiturier completed the unfinished tomb of Duke John the Fearless and his wife in the Chartreuse de Champmol; the Charterhouse is now a psychiatric hospital, and the tombs of the dukes of Burgundy have been moved to the Musée des Beaux-Arts in Dijon. Attributions to Moiturier include the tomb of Philippe Pot, seneschal of Burgundy, made for the Abbey of Citeaux (*c.*1477) and now in the Louvre.

Mollet family

A dynasty of French royal gardeners. Jacques the Elder (d. *c.*1595) was gardener to the duc d'Aumale, at Aumale (north-east of Rouen); he later became head gardener at ANET. Jacques's son Claude the Elder (*c.*1564–*c.*1649) worked as his assistant at Anet, where Jacques laid out the first PARTERRES de broderie in France (*c.*1582), implementing the designs of Étienne DU PÉRAC. Parterres had previously been designed individually, but under du Pérac's influence the Mollets designed parterres as part of a unified pattern. In about 1595 Claude became gardener to Henri IV, and in that capacity designed the gardens at FONTAINEBLEAU and SAINT-GERMAIN-EN-LAYE. He later worked on the TUILERIES, where his responsibility was the parterre to the east of the palace. Claude's designs for the parterres of the royal gardens in which he worked are included in Olivier de SERRES's *Théâtre d'agriculture* (1600); Claude's own book, the *Théâtre des plans et jardinages*, which was not published until 1652, is an important record of French gardens in the late sixteenth and early seventeenth centuries. He was the first gardener to plant herbaceous perennials that flowered in succession against a background of evergreen shrubs, and so became the inventor of the herbaceous border.

Claude's five sons all became royal gardeners. André (d. 1655) designed gardens at St James's Palace (*c.*1630) and WIMBLEDON HOUSE

(1642), and returned to St James's Palace in 1658 with his kinsman Gabriel (d. 1663; possibly Claude the Younger's son); both were described in 1661 as royal gardeners. André subsequently designed gardens in The Hague and (with his son Jean) in Stockholm; his *Le Jardin de plaisir* (Stockholm, 1651) articulates the principles that governed French garden design in the first half of the seventeenth century. André's brothers Pierre (d. 1659), Noël, and Claude the Younger (d. 1664) followed their father into positions in the gardens of the Tuileries, and Claude the Younger laid out the first *parterre de broderie* at Versailles. Another son, Jacques the Younger (d. *c.*1622), was head gardener at FONTAINEBLEAU. Claude the Younger's son Charles (*fl.* 1660–93) and grandson Armand-Claude (*c.*1670–1742) worked as royal gardeners at the Tuileries and Fontainebleau.

Momper, Joos II

or Josse II de (1564–1635), Flemish LANDSCAPE painter who worked in Antwerp. In his pictures he mediated between the formal landscapes of sixteenth-century Flemish artists and the naturalistic landscapes of early seventeenth-century Dutch artists. He expanded the range of colours used in landscape painting, supplementing the traditional blues and greens with browns, greys, and reds. In his portrayal of figures in mountain landscapes, e.g. *Mountain Landscape with a Watermill* (Gemäldegalerie, Dresden), he usually delegated the painting of the small foreground figures to assistants in his studio or to fellow artists such as Jan BRUEGHEL, and in his flat landscapes he sometimes dispensed with foreground figures altogether.

Mondragone, Villa

A VILLA in Frascati, 25 kilometres (16 miles) south-east of Rome. In 1573 Cardinal Altemps built a CASINO to the designs of Martino LUNGHI. The house sits on a terrace, below which an avenue of cypresses runs to the Villa Vecchia. In 1577 the cardinal commissioned a new palace, the Palazzo della Ritirata, which eventually grew to 365 rooms in commemoration of Gregory XIII being in residence when he signed the bull promulgating the Gregorian calendar.

In 1613 the villa was bought by Scipione Borghese, and Giovanni FONTANA built a water-theatre, the Fontana della Girandola ('FOUNTAIN of the Catherine Wheel'), which contained polypriapic GIOCHI D'ACQUA. He also laid out a

huge PARTERRE below the water-theatre, and at the other end constructed a GIARDINO SEGRETO.

Mone, Jean

or Jan, or Jean de Metz or Jean Lartiste (c.1485/90–c.1549), French sculptor, born in Metz. As a young man he moved to Barcelona, where he lived from 1497 (or earlier) until at least 1519 (though he was in Aix-en-Provence in 1512 and 1513 and perhaps longer); from 1517 to 1519 he worked with Bartolomé ORDÓÑEZ on the decoration of the cathedral choir. In 1521 he returned to Antwerp, where he met DÜRER, and the following year he was appointed as court sculptor to Charles V, in which capacity he worked in Antwerp, Brussels, and Mechelen (French Malines). The style of his sculptures is resolutely Italianate rather than Flemish, and his preferred building material was marble. His best-known work is the altar of 1533 in the Church of Notre Dame at Halle (Brabant, near Brussels). He also sculpted the majestic tomb of Cardinal Guillaume de Croy (1525–8) for the Celestine church at Heuerlee; the tomb, which was damaged during the French Revolution, is now in the Capuchin church at Enghien (Belgium). In 1524 Mone was appointed imperial artist (artiste de l'empereur) by Margaret of Austria, and moved to Mechelen, where he remained for the rest of his life.

Montagna, Bartolomeo

(c.1450– 1523), Italian painter, born in Orzinuovi (near Brescia); he may have been a pupil of MANTEGNA. In 1482–3 he worked in Venice, where he executed large religious paintings for the Scuola di San Marco. Thereafter he lived in Vicenza, though he worked on occasion in Padua (where he contributed paintings to the Scuola del Santo) and Verona. A series of huge paintings executed about the turn of the century include Madonna Enthroned between Four Saints (Brera, Milan), a Pietà for the Monte Berico Basilica (near Vicenza), and a Nativity for the church in Orgiano (25 kilometres (16 miles) south of Vicenza). His monumental style was imitated by his son Benedetto Montagna (1481–1558).

Montanés, Juan Martínez

(1568–1649), Spanish sculptor, the most prominent member of the Seville School of Spanish art. His first major work was the reredos of St Isidore at Santiponce (near Seville), which he began in 1609, working with Francisco PACHECO as his polychromist. His finest mature work is the Immaculate Conception in Seville Cathedral. In 1636 he travelled to Madrid to undertake his only known secular work, a portrait head of Philip IV (now lost) to be sent as a model to Florence, where Pietro Tacca was preparing an equestrian statue of the king (now in the Plaza de Oriente in Madrid). His workshop in Seville had a thriving export trade with Peru, where many of his statues and reredoses survive.

Montelupo potteries

A group of independent Tuscan potteries established in the fourteenth century in and around Montelupo, between Florence and Pisa. In the sixteenth century MAIOLICA produced by these potteries was exported throughout Europe and beyond. Since the early seventeenth century the Montelupo potteries have concentrated on brightly coloured 'peasant ware', typically depicting soldiers and animals.

Montorsoli, Giovanni Angelo

(c.1507–1563), Italian sculptor, born in Montorsoli (near Florence). He worked in the 1520s as an assistant to MICHELANGELO, and in 1531 entered the Servite Order, for which he executed commissions in the Church of SS Annunziata in Florence. In 1536 he moved to Naples, in 1539 to Genoa, and in 1547 to Messina, where he became master of the works (capomaestro) at the cathedral and made his best-known works, the Fountain of Orion on the Piazza del Duomo and the Fountain of Neptune on the nearby Piazza del Governo; the original figures of Neptune and Scylla are now in the Museo Nazionale. Montorsoli moved to Bologna in 1558 and returned to his convent in Florence in 1561.

Morales, Luis de

(c.1520–1586), Spanish painter who worked in Extremadura, sometimes known as 'Morales el Divino' because of his predilection for devotional subjects. His paintings, which have a markedly individualistic style, include a Pietà and an Ecce homo; versions of both are in the Real Academia de Bellas Artes de San Fernando in Madrid.

Morel, Jacques

(fl. 1418, d. 1459), French sculptor, born into a family of sculptors in Lyon. In 1418 Jacques Morel was appointed master of works at Lyon Cathedral, for which he carved a monument of

Cardinal de Saluces (since destroyed but known to have included an effigy of the cardinal kneeling before an angel). Morel left Lyon in the early 1420s and in 1448 he was appointed as master of works at Rodez Cathedral; while holding this post he was principally occupied with the carving of the Bourbon tombs at the Cluniac abbey of Souvigny (near Moulins), which are particularly remarkable for their ornamental treatment of drapery. His final project was the tomb of René d'Anjou in Angers.

moresques

See ARABESQUES.

Moretto da Brescia

or Alessandro Bonvicino (c.1498–1554), Italian painter, a native of Brescia, where he painted portraits such as his *Portrait of a Young Gentleman* (1526, National Gallery, London) and religious pictures for local churches, such as his series in the Cappella del Sacramento in San Giovanni Evangelista, Brescia, and *Santa Giustina* (now in the Kunsthistorisches Museum in Vienna). His pupils included Giovanni Battista MORONI.

Moro, Antonio

or (Dutch) Antonis Mor van Dashorst (c.1516/20–1576/7), Dutch portrait painter usually known by the Spanish version of his name, born in Utrecht, where he trained in the studio of Jan van SCOREL. His access to the Burgundian court and his extensive travels (he visited England, Italy, Portugal, and Spain) gave him the opportunity to paint members of many of the ruling houses of Europe. The subjects of his portraits include King Philip II (Escorial), Emperor Maximilian II (Prado, Madrid), Queen Mary I of England (1554, versions in the Prado and at Compton Wynyates, Warwickshire), and Sir Thomas Gresham (Rijksmuseum, Amsterdam). His most famous work, *Man with a Dog* (1569, National Gallery, Washington), is indebted to TITIAN's portrait of *Charles V* (Prado, Madrid).

Morone, Domenico

(c.1442–c.1518), Italian painter, a native of Verona, where he established a workshop in which many artists were trained. His most important surviving work is *The Victory of the Gonzaga over the Bonacolsi*, a battlepiece with townscape commissioned by Francesco Gonzaga for the Ducal Palace in Mantua.

Moroni, Andrea

(d. c.1560), Italian architect who worked principally in Padua, where he designed the colonnaded courtyard of the university (1552) and the courtyard of the Palazzo del Podestà (now the Municipio). He also built the Church of Santa Giustina, considerably modifying the plan drawn up in 1502 by Andrea RICCIO.

Moroni, Giovanni Battista

(c.1520/4–1578), Italian painter, born near Bergamo and trained in the Brescia studio of MORETTO DA BRESCIA. Like Moretto, Moroni painted both religious pictures and portraits. His portraits, which were praised by the aged TITIAN, include *The Tailor* (c.1570, National Gallery, London).

Mortlake

An English tapestry factory established in 1619 by King James I at Mortlake (a village in what is now west London). The German designer Franz Cleyn (later Sir Francis Crane), who served as director from 1619 to 1636, assembled a team of Flemish weavers to make tapestries for Prince Charles (later King Charles I) and his courtiers. The first product of the family workshop was a series of nine panels depicting the story of Venus and Vulcan. In 1622 Prince Charles purchased for the factory RAPHAEL's cartoons of *The Acts of the Apostles* (now in the Victoria and Albert Museum), from which many tapestries were woven. The other important tapestries woven before the Civil War cut off royal patronage were depictions of the story of Hero and Leander (of which a set survives in the collection of the Swedish royal family) and of the *Twelve Months*.

The factory survived the Interregnum, during which it produced a series on *The Triumph of Caesar* based on paintings by MANTEGNA that are now at Hampton Court, and carried on after the Restoration (producing a set of *Playing Boys* from a design by GIULIO ROMANO) until 1703. Mortlake tapestries are marked with a red cross on a white shield.

mosaic

The art of making pictures and geometrical patterns from pieces of coloured glass and marble fixed in a bed of cement was highly developed by the Romans and survived in Byzantine architecture. Greek mosaicists worked in Venice from the early twelfth century, and by the

thirteenth century mosaic had been assimilated as a Venetian art and had started to appear in churches in Florence and Rome. In the fifteenth century Lorenzo de' Medici formulated a plan to cover the interior of the dome of the Duomo in Florence with mosaic; the plan was never realized, but GHIRLANDAIO designed a mosaic *Annunciation* (c.1490) for the north door of the cathedral. In the early sixteenth century the Sienese banker Agostino Chigi commissioned the Venetian mosaicist Luigi da Pace to make a mosaic of *God the Father* (from a cartoon by RAPHAEL) for the Chigi Chapel in the Church of Santa Maria del Popolo in Rome.

Mosaic was also used for the decoration of interiors and furniture. FLORENTINE MOSAIC is the English term for the type of decorative mosaic panels known in Italian as *commeso di pietre dure*.

Moser, Lukas

(*fl.* 1431), German painter known only for one magnificent work, the ALTARPIECE of Tiefenbronn (near Constance), which he signed and dated 1431. The altarpiece, which depicts the story of Mary Magdalene, has an enigmatic inscription which says 'schri kunst schri und klag dich ser din begert iecz niemen mer' ('shout, Art, shout and complain; no one wants you now'); there was no iconoclastic movement in early fifteenth-century Germany, so the inscription may be Moser's complaint about being unpaid or underpaid.

Mostaert, Jan Janszoon

(*c.*1475–1555/6), Dutch painter, born in Haarlem; the influence of GEERTGEN TOT SINT JANS on Mostaert's style may imply that he was trained by Geertgen. Mostaert was appointed as court painter to Margaret of Austria, regent of the Netherlands, and painted portraits of her courtiers as he travelled with her court. His portraits include a marriage diptych of *Hendrik van Merode* and *Franziska van Brederode* (St Dimpnakerk, Geel). He never travelled to the Americas, and yet he painted scenes from the New World, such as his *Landscape of the West Indies* (Frans Hals Museum, Haarlem); these paintings may be based on sketches or oral accounts. Many of his paintings were destroyed in the Great Fire of Haarlem in 1576.

mother-of-pearl

or (German) *Perlmutter*, the calcite and calcium carbonate deposits that line the shell of many types of mollusc, principally the type known as nacre (which is another name for mother-of-pearl); the deposited layers form prismatic folds that reflect light, and so the effect is slightly different from that of the pearl, which is formed from the same deposits.

Mother-of-pearl was first used in Europe by fourteenth-century German craftsmen, who used it principally as an inlay for church furniture and musical instruments but also as a medium in which crucifixes and religious medallions could be carved. In the fifteenth and sixteenth centuries German goldsmiths, notably those of the JAMNITZER family, mounted engraved and etched shells (chiefly NAUTILUS SHELLS) on gold bases.

Moulins, Master of

(*fl.* c.1480–1500), Bourbon painter whose name derives from a triptych (c.1498) in Moulins Cathedral depicting the *Madonna and Child with Saints and Donors*. His distinctive use of luminous colours and his meticulous sculptural depiction of drapery are so individualistic that other paintings have been attributed to him with unusual confidence, including *The Meeting of Joachim and Anna* in the National Gallery in London.

mount

A garden mount is an artificial hill. The mount was often hollow, and its interior could be used for storage and to provide shelter for delicate plants. Mounts first appear in Italy, where they were a feature of both BOTANICAL GARDENS (where they helpfully produced differentiated microclimates) and VILLA gardens. The original mounts still survive in the botanical gardens at Padua, Montpellier (where the terraced mount is oblong), and in the Jardin des Plantes in Paris, where the mount was originally planted with vines. The garden of the Villa Quaracchi had a mount, and the one in the garden of the MEDICI VILLA in Rome survives. The fashion later spread to England, where mounts were constructed at New College, Oxford (1529, still in the garden), THEOBALDS, Lyveden New Bield, Northants (where two large mounts survive), and, most elaborate of all, Hampton Court Palace. The mount never became fashionable in French gardens, despite the proselytizing efforts of Olivier de SERRES, who illustrated several mounts in his *Théâtre d'agriculture* (1600). Mounts were ascended on spiralling paths, and so were often called 'snail mounts' (e.g. the

mount built at Elvetsham, Hampshire, in honour of a visit by Queen Elizabeth in 1591).

Mudéjar

The term *mudéjar* is a Hispanized corruption of an Arabic word meaning 'domesticated' or 'subjugated', and literally refers to the Muslims who remained under the Christian *reconquista*; when applied to people (as opposed to an architectural style) the term implies a continued adherence to Islam, and so is contrasted with *morisco*. The term Mudéjar is also used to denote a style of architecture and decorative art which evolved in Spain and Portugal during the period of the *reconquista*, from the twelfth to the fifteenth centuries. The style is Islamic in its origins, but was used by Spanish Christian architects; in practice, the result was often GOTHIC structures embellished with oriental motifs. When used as a stylistic term, it initially denoted the work executed by Moorish craftsmen for Spanish masters, but later came to denote the hybrid Moorish style of Christian architects, decorative artists, and craftsmen working in brick, clay (for CERAMICS), iron (for DAMASCENING), IVORY, tooled leather (for BOOKBINDING), plaster, wood (for FURNITURE and for wood inlays called *taraceas*), and tile (*AZULEJOS*). Mudéjar decoration is also an important element in the MANUELINE and PLATERESQUE styles.

The earliest significant Mudéjar building is the thirteenth-century Chapel of Alfonso VIII at the monastery of Las Huelgas (Burgos). In the fourteenth century, the finest of all Mudéjar palaces, the Alcázar, was constructed in Seville, and its Arabic elements even include Kufic inscriptions in praise of Spanish Christian rulers. In Toledo, there are two fine Mudéjar synagogues: the Sinagoga del Tránsito (1360–6), which is so called because, after the expulsion of the Jews, it was dedicated to the death (*tránsito*) of the Virgin, and the even older synagogue now known as Santa María la Blanca, from which the Jews were expelled in 1405. In Aragon, there are many examples of Mudéjar bell towers (e.g. Calatayud, Teruel, and Zaragoza) that are clearly based on Moorish minarets.

Multscher, Hans

(*c*.1400–*c*.1467), German painter, born in Reichenhofen, Bavaria. His most important surviving works are a *Virgin and Child* (the central panel of the Werzach altarpiece of 1437 in the Church of St Maria Himmelfahrt, Landsberg am Lech, in Bavaria) and an altarpiece of 1456 in Vipiteno (German Sterzing) in Tirol, where the four panels are kept (together with sculptures from the same altarpiece) in the Multscher Museum.

Munich School

A group of late sixteenth- and seventeenth-century German iron-chisellers who specialized in the decoration of arms (see ARMS AND ARMOUR). Ottmar Wetter (d. 1598) was active in Munich from 1583 to 1589 and then moved to Dresden. He was appointed as court iron-worker (*Eisenarbeiter*), in which post he was succeeded by the Antwerp iron-chiseller Emanuel Sadeler (d. 1610) and then by Emmanuel's brother Daniel (d. *c*.1632) and finally by Caspar Spät (d. 1691), who had been trained by the Sadeler brothers.

The workshops of Wetter and his successors specialized in sword-hilts and firearm mounts which they decorated by chiselling reliefs of scenes and foliage, often coloured blue against a gold background. Examples of their work are preserved in the Bayerisches Nationalmuseum in Munich, the Kunsthistorisches Museum in Vienna, the British Museum, the Victoria and Albert Museum, and the Wallace Collection in London, and the Metropolitan Museum in New York.

Muziano, Girolamo

(1532–92), Italian painter and engraver who worked in his native Brescia. His paintings often have religious subjects, but inevitably incorporate local mountain scenery into the prominent LANDSCAPE background, notably in his *Raising of Lazarus* (1555, Pinacoteca Vaticana), which was praised by MICHELANGELO, and his *St Jerome* (Accademia Carrara, Bergamo).

N

Nanni di Banco

(c.1380/5–1421), Italian sculptor, born in Florence, where he trained in the studio of his father, the sculptor Antonio di Banco. Most of his sculpture was designed for two architectural settings, Florence Cathedral and Orsanmichele. His finest work is the *Quattro santi coronati* (c.1411–13), a marble group for Orsanmichele. Nanni's work for the cathedral, which began when he was apprenticed to his father, culminated in his relief of the *Assumption of the Virgin Mary* (begun 1414) over the Porta della Mandorla.

nautilus shell

A large nacreous shell from the Indian Ocean, used by goldsmiths in late sixteenth-century and seventeenth-century Europe (principally Germany, England, and the Netherlands) to fashion display cups, some of which were mounted on gold stands. The nautilus shells set by European craftsmen had sometimes been engraved by Chinese craftsmen.

needlework

The most common forms of needlework in early modern Europe were decorative EMBROIDERY and various forms of netting, knitting, and knotting.

Netting, which was used by fishermen and fowlers and for many domestic purposes, was fashioned with netting needles made from wood or bone that had been notched at either end. In the eleventh and twelfth centuries nets ceased to be purely utilitarian, and in the case of veils were darned or embroidered to enhance their appearance. In the thirteenth and fourteenth centuries increasingly elaborate decoration came to be known as 'spiderwork' (Latin *opus araneum*), and in the fifteenth century spiderwork evolved into LACIS and thence into the forms of LACE known as RETICELLA and PUNTO IN ARIA. Needlework CARPETS, which were popular from the sixteenth century onwards, were made by working threads through the mesh of coarse canvas, and so are a form of network.

Knitting was effected with straight pointed needles, often used with a pegged or pinned ring. The tradition that the Virgin Mary knitted the seamless garment that Jesus wore before he was stripped for crucifixion (John 19.23–4) is portrayed in many paintings, notably the Buxtehude Altarpiece of Master Bertram (c. 1370, Hamburg Kunsthalle), in which the Virgin knits on four needles. There is some evidence of domestic knitting by women, but commercial knitting was a male occupation. Knitting was commonly used to make gloves, caps, and pockets, but was not used to make stockings until the sixteenth century; until then hose consisted of pieces of fabric sewn together. Knitting was transformed by the invention (in 1589) of the knitting frame by William Lee, a clergyman in Calverton (Nottinghamshire).

Knotting has been used to make cords and braids since remote antiquity. In medieval Europe weavers tied the loose ends of the warp

A **nautilus shell** cup (1585–6) in the Fitzwilliam Museum, Cambridge. The silver gilt mounting, in which Neptune holds the shell, is the work of a London goldsmith. The shell was scratch-carved in China, and is probably Ming (i.e. post-1368); the carving may have been left 'blind' (i.e. uncoloured), but it is also possible that the lines have lost their colouring.

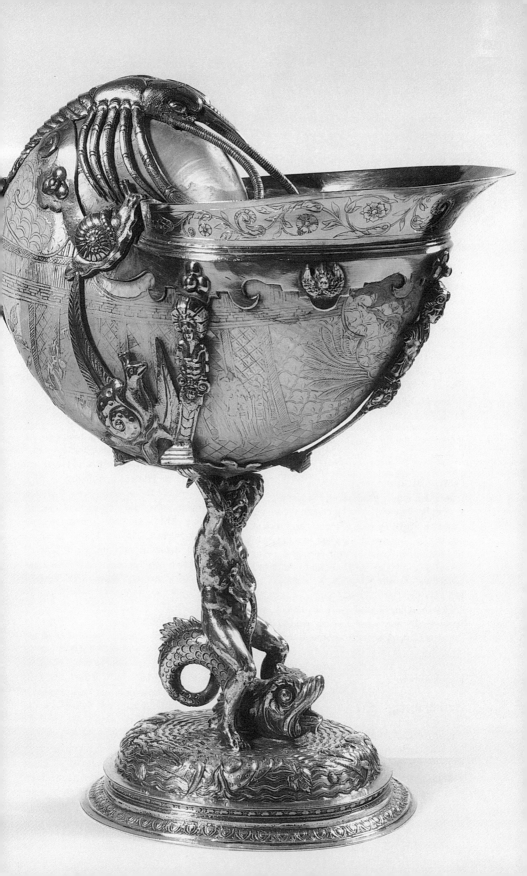

threads of carpets, towels, and shawls into ornamental borders, so preventing fraying and giving weight to the edges. In Renaissance Europe this process evolved into a separate craft which is now known in English and French as macramé, a term derived from Turkish *makramà* ('napkin';). In macramé the thread is knotted across the width of the border, which is a laborious process. Eventually a technique was developed for working the thread along its length, so obviating the need for knotting; such borders were the origin of bobbin LACE or pillow lace.

Negroli

or Barini detti Negroli family, a family of Italian weapon-makers and armourers active in Milan in the sixteenth century, when they became the successors of the MISSAGLIA family. At least 22 members of the family are known to have been employed in the family workshop, which enjoyed a European reputation for its embossed parade armours (see ARMS AND ARMOUR), of which examples are preserved in the Armería Real in Madrid, the Kunsthistorisches Museum in Vienna, the Royal Armouries in Leeds, and the Metropolitan Museum in New York. The most prominent member of the family was Filippo Negroli (*fl.* 1531–51), whose armours for Charles V are now in the Armería Real.

Neri, Antonio

(1576–1614), Italian glassmaker. He was a priest in Florence when in 1602 he began to conduct experiments with a view to replicating precious and semi-precious stones in glass. In 1604 he visited Amsterdam to consult the Portuguese glass scientist Emmanuel Ximénes and to work in a glasshouse. In 1612 he published a treatise on glassmaking, *L'arte vetraria*, which was translated into Latin, English, German, French, and Spanish. An annotated English edition published by Christopher Merrett in 1662 was translated into German and published in 1679 by the distinguished glassmaker and technologist Johann Kunckel.

Neri di Bicci

(1418–92), Italian painter, born in Florence and trained in the studio of his father Bicci di Lorenzo (1373–1452). He was a prolific painter whose surviving work includes an *Annunciation* and an *Assumption of the Virgin* in the Accademia in Florence; his Diary (*Ricordanze*) of the years 1453–75 is preserved in the Uffizi.

Neroccio dei Landi

(1447–1500), Italian painter and sculptor, born in Siena, where he remained all his life, working from 1467 to 1475 in collaboration with FRANCESCO DI GIORGIO MARTINI. His surviving work includes a *Madonna with Saints*, a CASSONE panel depicting Antony and Cleopatra, and a *Portrait of a Girl* (all in the National Gallery in Washington) and two *Madonna and Child* paintings (both in the Pinacoteca in Siena).

Neudörfer, Johann

(1497–1563), German type designer and biographer of artists, born in Nuremberg. His contemporary reputation centred on his mastery of CALLIGRAPHY and his views shaped the final form of Fraktur, the German 'black letter' or 'Gothic' type founts. In 1547 he published *Nachrichten von Künstlern und Werkleuten*, a collection of biographical notes on German artists.

Neumeister

or Numeister, Johann (1430/40–1512), German printer who may have been a pupil of GUTENBERG in Mainz. He worked from 1470 to 1474 in Foligno (near Assisi), where he published the first edition of Dante's *Divine Comedy* (1472). He subsequently worked in Mainz (1479) and then moved to France, first living in Albi, north-east of Toulouse (1480), and then settling in Lyon (1483), where his press was an important element in the development of Lyon as a printing centre. The best-known products of his press were his two editions of Juan de Torquemada's *Meditationes* (1479 and 1481), which were illustrated with metal cuts of paintings by Fra ANGELICO.

Niccolò dell'Abbate

(*c.*1509–1571), Italian painter, born in Modena. From 1548 to 1552 he worked in Bologna, where he decorated palaces (notably Palazzo Pozzi) and painted portraits. In 1552 he moved to France at the invitation of King Henri II to work as an assistant to PRIMATICCIO at FONTAINEBLEAU; his work in the palace has not survived. In France Niccolò also painted LANDSCAPES peopled with mythological figures (e.g. *The Death of Eurydice*, National Gallery, London), and these paintings became the foundation of the French classical landscape painting later developed by Claude and Poussin.

Niccolò dell'Arca

or Niccolò di Bari or Niccolò da Bologna (*fl.* 1462, d. 1494), Italian sculptor who took his name from the shrine (*arca*) of St Dominic in the Church of San Domenico in Bologna, for which Niccolò carved the graceful canopy and many of the free-standing figures; he worked on the tomb from 1469 until his death 25 years later. He also sculpted the terracotta *Lamentation over the Body of Jesus* in the Church of Santa Maria della Vita in Bologna.

Nicola da Guardiagrele

or Nicola Gallucci (*c.*1395–before 1462), Italian goldsmith and sculptor in the Abruzzi. His early work, such as the monstrance (1413) in Santa Maria Maggiore in Francavilla al Mare (near Pescara), is wholly Gothic in design. The Florentine elements in his later work may imply a visit to Florence in the 1420s: his enamel and niello processional cross of 1434 (Museo Diocesano, L'Aquila) shows the influence of GHIBERTI's baptistery doors, as does his silver and enamel altar front of 1448 in Teramo Cathedral. His latest surviving work, which may be unfinished, is the gilded silver and enamel processional cross (1451) for the Church of San Giovanni in Laterano in Rome.

Nicola da Urbino

or Nicola di Gabriele Sbrage (*fl.* 1520–1537/8), Italian MAIOLICA painter in Urbino and the creator of ISTORIATO ware. The signature Nicola da Urbino on five surviving pieces was until the twentieth century thought to indicate the work of Nicolò Pellipario, an Urbino potter who was wrongly assumed to be the father of Guido Durantino and the grandfather of Orazio FONTANA. The standing of Pellipario as the inventor of istoriato ware was wholly unwarranted, because Nicola da Urbino was in fact a previously unnoticed Urbino potter called Nicola di Gabriele Sbrage, who had an independent workshop in Urbino and also decorated pottery in the workshop of Guido Durantino. In addition to the five signed pieces, which are plates now in the Bargello (1528), the Hermitage (1521), the Louvre (1525–8), the Church of San Stefano in Novellara (*c.*1530), and the British Museum (*c.*1535), Nicola is thought to have been the maker of a set of seventeen plates (*c.*1520) now in the Museo Correr in Venice and of a service (now dispersed) made for Isabella d'Este.

Niculoso, Francisco

or Niculoso Pisano (d. 1529), Italian potter in Spain. He was probably a native of Pisa and may have been trained in a FAENZA workshop. By 1498 he had established a workshop in Triana, a suburb of Seville, and there introduced the Italian idea of a single pictorial design made up of panels of AZULEJOS. His earliest dated work is a pictorial tomb slab (1503) in the Church of Santa Ana in Triana. In 1504 he made an altarpiece depicting *The Visitation* (framed with GROTESQUES) for the Chapel of the Catholic Kings in the Alcázar in Seville, and in the same year made the superb tiles (designed by Pedro Millán) that adorn the portal of the Convent of Santa Paula in Seville. His finest surviving work is an altarpiece of 1518 (now damaged) in the Monastery of Santa María de Tentudía in the Sierra Morena.

niello

The Italian and hence English term, derived from medieval Latin *nigellum* ('black'), for the black compound of copper, lead, silver, sulphur, and (sometimes) borax used to inlay engraved designs on precious metals; the term is also used to denote products decorated using this technique. Niello was first used in ancient Egypt, and has a continuous history thereafter. In the fifteenth century it was widely used in Germany and Italy for the decoration of rings, cups, and paxes. Maso FINIGUERRA took paper prints from his *nielli*, and so inaugurated the niello print. Niello is sometimes called Tula (because it was revived in the Russian town of Tula in the nineteenth century) or platina (though platinum was never part of the compound).

Nosseni, Giovanni Maria

(1544–1620), Swiss furniture-maker, sculptor, architect, and poet, a native of Lugano who spent most of his career in Saxony; he moved to Torgau in 1575 and settled in Dresden in 1583. His best-known work is a set of twelve chairs commissioned by the Elector Augustus I in 1585; the chairs, of which seven survive in the Zwinger in Dresden, are sumptuously gilded and inlaid with semi-precious stones. After the death of Augustus in 1586 Nosseni worked as an architect and figurative sculptor.

Notke, Bernt

(*c.*1440–1509), German painter and woodcarver, probably a native of Lassan (Pomerania). His

most important work is a huge rood-screen (17 metres (56 feet) high) and *Triumphal Cross* group in Lübeck Cathedral (1470–7). He later carved the double-winged altarpiece in Aarhus Cathedral (1479) and the free-standing *St George and the Dragon* in the Storkyrka in Stockholm (*c*.1487).

Noye

or Noyen or Oye, Sebastiaan van (*c*.1493–1557), Netherlandish architect, born in Utrecht. He worked as a military architect for the Emperor Charles V, in which capacity he built the star-shaped fortress at Philippeville (Flanders, now Belgium). He was also the architect of Antoine Perrenot de Granvelle's Italianate palace in Brussels.

nymphaeum

Literally a temple of the nymphs, especially the naiads (Latin *naiades*), the goddesses of rivers and FOUNTAINS; in practice the nymphaeum was an architectural GROTTO containing fountains and statues. The nymphaeum was a Roman form which was familiar in the sixteenth century because of ancient accounts of nymphaea and the survival of the Acqua Julia, a public nymphaeum in Rome. There are Renaissance nymphaea in the Villa FARNESE in Caprarola, the Villa d'ESTE at Tivoli, the Villa GIULIA in Rome, and in the water-theatres of the Villa ALDOBRANDINI and the Villa MONDRAGONE at Frascati.

O

oak-leaf jars

See FLORENCE POTTERIES.

oil painting

A range of techniques which have in common the use of oils which when dried in air hold the particles of pigment in position and bind them to the ground. VASARI attributed the invention of oil painting to Jan van EYCK, but the attribution is a tribute to Jan van Eyck's standing rather than the identification of the inventor of a process, because although Jan van Eyck made innovative use of oils and varnishes, and so had what Vasari called a 'secret method of painting in oils', such oils had been in occasional use for generations before Jan van Eyck began to experiment with the medium.

The transmission of the technique to Italy is similarly obscure: Vasari's assertion that AN-TONELLO DA MESSINA trained in the studio of Jan van Eyck and then brought oil painting to Italy is problematical, not least because no evidence survives of a visit by Antonello to the Netherlands. The technique was probably introduced in Italy by Flemish artists, and it was only adopted slowly: throughout the fifteenth century, oils were used as if they were TEMPERA, and paintings were built up in thin transparent glazes. The technique known as impasto, in which oil paint was applied in thick solid masses (which could not be done with tempera), was not developed until the end of the fifteenth century; one of the earliest impasto paintings was Giovanni BELLINI's *Doge Loredan* (*c.*1501, National Gallery, London; see plate I). The textures that could be achieved in oils through the use of impasto led quickly to the displacement of tempera in the early decades of the sixteenth century.

Oliver

or Olivier, Isaac (1558/68–1617), French portrait miniaturist in England, born into a Huguenot family in Rouen. He was brought to England as a young child and became a pupil of Nicholas HILLIARD. He painted life-sized portraits, historical scenes, religious scenes, and portrait MINIA-TURES, which were usually of the head and shoulders. His miniatures include depictions of *John Donne*, *Prince Henry*, and *Anne of Denmark* (all in Windsor Castle). The Royal Collection in Windsor also holds Oliver's *Portrait of a Young Man*, which was for centuries mistakenly thought to be a portrait of Sir Philip Sidney. Oliver also drew a portrait (unfinished) of Queen Elizabeth (Victoria and Albert Museum). His *Entombment of Christ* (Musée des Beaux-Arts, Angers), which was admired by his contemporaries, was completed by his son Peter Oliver (1594–1647), who was also a portrait miniaturist.

Oporinus, Johannes

(1507–68), Swiss humanist printer, born in Basel. He studied Greek in Strassburg and then re-turned to Basel as a teacher of Greek and as an editor for the publisher Johann FROBEN. He eventually established his own press, specializing in editions of scientific works and classical authors. His press published a Latin translation of the *Koran* (1542) with prefaces by Luther and Melanchthon and the first edition of Vesalius' *De humani corporis fabrica* (1543), which contained illustrations engraved by Jan Steven van CALCAR.

Orcagna

or Andrea di Cione Arcagnolo (1315/20–68), Italian painter, sculptor, and architect, the most prominent artist in Florence in the third quarter of the fourteenth century. He was admitted to the Guild of Painters in 1343 and to the Guild of Masons in 1352. In about 1350 he painted a fresco trilogy (which survives in fragments) on the *Triumph of Death*, the *Last Judgement*, and *Hell* in the Church of Santa Croce; he later painted the altarpiece of *The Redeemer* (1354–7) in the Strozzi Chapel of the Church of Santa Maria Novella. From 1355 to 1358 he worked on the marble tabernacle for the Madonna in Orsanmichele, and

from 1359 to 1362 he served as *capomaestro* of Orvieto Cathedral. At the time of his death he was working on a *St Matthew* altarpiece (Uffizi) which was finished by his brother Jacopo di Cione.

Orcagna's work was untouched by the innovations of GIOTTO; he was rather an imaginative exponent of the medieval style known as Byzantine Gothic, and his remote and dignified figures are suspended in golden space.

orders, architectural

An architecture order consists of a column incorporating a base (if any), shaft, and capital surmounted by its entablature (architrave, frieze, and cornice). The Doric, Ionic, and Corinthian orders are Greek in origin, and the Tuscan and Composite orders are Roman. In ancient Greece the Doric column, which had twenty broad flutes with sharp edges, had no base (though it acquired one in Roman Doric); its capital had an ovolo moulding (i.e. one whose profile was one-quarter of a circle) that in medieval and Renaissance architecture was known as quadrant moulding. The Ionic column usually had 24 flutes divided by fillets; its capital resembled a partly opened scroll, the spirals of which are known as volutes. The Corinthian order is distinguished from Ionic by its capital, which is decorated with ACANTHUS leaves. The Tuscan order was a simplified form of Doric in which the shaft was unfluted. The Italic order (which SERLIO renamed the 'Composite order') was an elaboration of the other two Greek orders in which the capitals included both Ionian volutes and Corinthian acanthus.

The only ancient discussion of the architectural orders to survive into the Renaissance was contained in the *De architectura* of VITRUVIUS, which was first published in Rome in 1486. The most important Renaissance treatments of the orders were Serlio's *Architettura* (1559–62), VIGNOLA's *Regole delli cinque ordini d'architettura* (1562), and PALLADIO's *I quattro libri dell'architettura* (1570).

The term 'colossal order' (or 'giant order') is the modern term for any order in which columns or pilasters run through more than one storey in a façade. The finest Renaissance example is MICHELANGELO's Capitol in Rome.

Ordóñez, Bartolomé

(c.1485–c.1520), Spanish sculptor. He is known to have been working in Naples in about 1515 together with Diego de SILOÉ on the marble reredos of the Caracciolo Chapel of the Church of San Giovanni a Carbonara. By 1517 he was in Catalonia, working on the carved decoration of the choir in Barcelona Cathedral, to which he contributed the walnut screens and the *trascoro* (retrochoir) marble screen. He was commissioned by the Emperor Charles V to carve the tomb for Charles's parents (Philip I and Juana la Loca) for the Chapel Royal in Granada, but died while working on the tombs with his Italian assistants at Carrara.

Orley, Bernaert van

(c.1488–1541), Flemish painter and designer of stained glass and tapestries. He established a studio in Brussels, where in 1518 he became a painter in the court of Margaret of Austria and her successor Mary of Hungary. None of his paintings is dated later than 1530, and he seems to have spent the last decade of his life designing stained-glass windows (notably the transept windows in the Church of Sainte-Gudule) and tapestries. His tapestries include a series on *The Hunts of Maximilian* (Paris, Louvre), two sets on *The Passion* (one of which survives in the Royal Palace in Madrid), an *Agony in the Garden* and a *Crucifixion* (National Gallery, Washington), a *Christ Carrying the Cross* (Musée Jacquemart-André, Paris), and a *Last Supper* (Metropolitan Museum, New York).

Orsi, Lelio

(1508/11–87), Italian painter and architect, born in Novellara, 20 kilometres (12 miles) north of

The Tower of the Five Orders (1613–24) in the Schools Quadrangle, Bodleian Library, Oxford. The coupled columns of this Italo-French Renaissance frontispiece represent the five architectural **orders**: in ascending order, Doric, Tuscan, Ionic, Corinthian, and Composite. The lower two-fifths of each column is decorated. Between the Corinthian columns King James I of England sits in a canopied niche; to the left is Fame, and to the right the kneeling university.

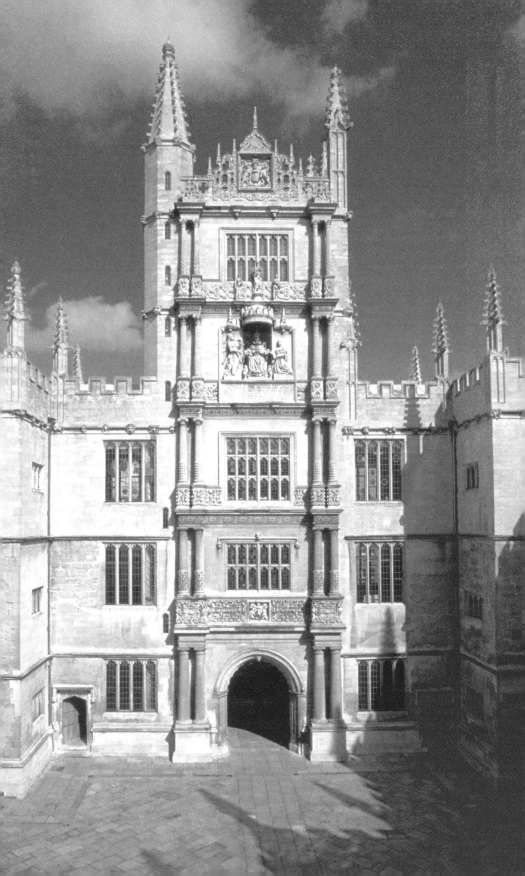

Reggio nell'Emilia (then part of the Este duchy of Modena). He may have been trained in the studio of CORREGGIO. He was banished from Reggio in 1546, and after periods in Venice and Rome returned to Novellara. His frescoes in Reggio and Novellara have perished, but the delicate elegance of paintings such as *The Rest on the Flight into Egypt* (York) shows strong links with Parmesan art and a stylistic debt to PARMIGIANINO. His *Road to Emmaus* (National Gallery, London) recalls the dramatic lighting characteristic of Correggio. His only documented architectural work is the Collegiata di San Stefano in Novellara (1567), for which a study survives in Windsor Castle.

Orsini, Villa

A villa in Bomarzo, 21 kilometres (13 miles) north-east of Viterbo. The villa is a converted castle perched on top of a hill, below which a rudimentary terraced garden was constructed on the precipitous slope. Pier Francesco ('Vicino') Orsini (d. 1585) decided to commemorate his late wife Giulia Farnese with a second garden in the valley at the bottom of the hill. This garden, which was constructed between 1552 and 1585, was not laid out, and may not have had an architect, but was instead constructed adventitiously around natural outcrops of volcanic rock protruding from the valley floor. Unknown sculptors carved these outcrops into an extraordinary range of colossal sculptures, including a temple (one of the few conventionally built structures), a leaning house, Etruscan urns, masks, giant humans, naturalistic animals such as elephants and tortoises, and many monsters (see p. xxiii).

The gardens were virtually unknown before the end of the Second World War, when they were described by Mario Praz and filmed by Salvador Dalí.

Osona, Rodrigo de

(c.1440–1518) and Francisco de (c.1465– 1514), Spanish painters of the Valencian School of Spanish art; a third painter, Rodrigo the Younger, is a ghost, and the paintings assigned to him were executed by Francisco.

The only major painting known to have been executed by Rodrigo de Osona without the assistance of his son Francisco is the *Crucifixion* ALTARPIECE (1476) in the Church of St Nicolau in Valencia. Thereafter father and son collaborated on a series of paintings. The most distinguished paintings by Francisco working without his father are his various pictures of *The Adoration of the Magi*, notably those in the Victoria and Albert Museum in London (signed 'Lo fil de Mestre Rodrigo'), both of which were painted in the first five years of the sixteenth century.

Ostendorfer, Michael

(1490/4–1559), German painter and woodcut artist who worked in Regensburg, where he may have been trained by Albrecht ALTDORFER. His best-known woodcut is a genealogy of the Ottoman sultans illustrated with imaginary portraits; his other woodcuts include many LANDSCAPES. His paintings include at least four versions of *Judith with the Head of Holofernes* (e.g. Wallraf-Richartz Museum, Cologne).

Oudenarde tapestries

The Flemish town of Oudenarde (now Oudenaarde) became an important centre for tapestry weaving in the fifteenth century, and by the seventeenth century it had become a rival to Brussels, 50 kilometres (30 miles) to the east. The factories of Oudenarde specialized in furniture tapestries, but also produced VERDURE TAPESTRIES and LANDSCAPES, most of which were woven in blues, greens, and yellows; the tapestries are marked with a pair of spectacles, sometimes attached to a shield. The factories declined in the late seventeenth century as the weavers migrated to France, and the last factory closed in 1787.

Ouwater, Albert van

(fl. 1440–65), Dutch painter, a native of Haarlem. He was praised by Karel van MANDER as a LANDSCAPE painter, but the only work that can be confidently attributed to Ouwater, *The Raising of Lazarus* (Gemäldegalerie, Berlin), is set in the apse of an imaginary Romanesque church. It is likely that GEERTGEN TOT SINT JANS trained in his studio.

P

Pacello da Mercogliano

(d. 1534), Neapolitan priest and garden designer. In 1495 he entered the service of Charles VIII in Naples, and moved to France to work in the royal gardens at AMBOISE; he subsequently worked for Louis XII and Francis I at BLOIS and for Cardinal Georges d'Amboise at GAILLON. His precise role in these gardens is not documented, but he certainly laid out the PARTERRES and introduced new fruit and vegetables, and he may have been responsible for the overall designs. He is the first gardener known to have grown citrus trees in tubs with a view to moving them into sheltered storage during the winter months.

Pacheco, Francisco

(1564–1644), Spanish painter and art historian who established a painting academy in Seville, where his pupils included Velázquez, who later married his daughter. His *El arte de la pintura, su antigüedad y grandeza* (Seville, 1649) contains unique material on the history of Spanish art. Pacheco also served as a censor of paintings for the Inquisition. His own paintings, such as the *Immaculate Conception with a Portrait of Miguel Cid* (Seville Cathedral), reflect the transition from MANNERISM to BAROQUE, and their naturalistic elements reflect his conviction that art should serve the Church in its imitation of nature.

Pacher, Michael

(*fl.* 1462–98), Austrian painter and woodcarver, a native of the Tirol. His best-known work is the high altar in the Church of St Wolfgang on the Abersee (near Salzburg), which was commissioned in 1471 and completed ten years later; it contains scenes from *The Life of the Virgin* and *The Legend of St Wolfgang*. He was also responsible for the altar at Gries (1471–88), near Bolzano, and for the central panel (*The Baptism of Christ*) of the painted ALTARPIECE (*c.*1479–82) in the north chapel of the Frauenkirche in Munich. Pacher was an innovator in his creation of pictorial space: he excelled in one-point PERSPEC-TIVE and foreshortening, and the low viewpoint that he habitually adopted created an illusion of monumentality.

Pacini, Piero

(*c.*1440–*c.*1513), Italian printer, a native of Pescia (Tuscany) who established a printing house in Florence, where he became the city's most prominent publisher. His titles, many of which had woodcut illustrations, included Aesop's *Fables* (1496), Petrarch's *Trionfi* (1499), and Luigi Pulci's *Morgante* and *Sonetti*.

Paciotto, Francesco

(1521–91), Italian architect and military engineer, born in Urbino, where he was trained by Gerolamo GENGA. He worked in Rome and entered the service of the Farnese family, acting as tutor to Alessandro Farnese (from 1553) and designing the *cittadella* (now the Palazzo Farnese) in Piacenza (1558) for Alessandro's mother Margaret of Parma; the *cittadella* has a fine arcaded courtyard, but was never completed.

In 1558, shortly after drawing up the plans for the *cittadella*, Paciotto accompanied Margaret of Parma and Alessandro Farnese to the Netherlands, where King Philip II (Margaret's half-brother) commissioned Paciotto to design a viceregal palace in Brussels; the palace was never built. In 1559 Paciotto built harbour defences in Nice for Emanuele Filiberto, duke of Savoy, and in 1561 he went to Spain to work on designs for the ESCORIAL. In 1567 he built a military fortress in Antwerp (destroyed 1874). In 1568 he returned to Italy, and spent the rest of his career as a military architect in the service of various Italian princes.

Pagano

or Pagini, Mateo (*fl.* 1530–59), Italian fabric designer, and the author of a series of pattern books (all published in Venice) for floral and geometrical designers in CUTWORK, LACE (including PUNTO IN ARIA), and RETICELLA. His books, all of which are now exceedingly rare, include

Giardinetto nuovo di punti tagliati (1542), *Ornamento de le belle et virtudiose donne* (1543), *Il speccio di pensieri delle belle et virtudiose donne* (1544), *L'onesto essempio* (1553), *Specchio di virtù* (1554), *La gloria e l'onore de punti tagliati e punti in aere* (1558), and *Trionfo di virtù* (1559).

palaces

The residence of the Emperor Augustus on the Palatine Hill (Mons Palatinus) in Rome was known as the *palatium*, and it is this classical term that underlies the Renaissance idea of the palace. In Italy the term *palazzo* had no princely or gubernatorial associations, but simply meant a large city dwelling, the urban equivalent of a VILLA; many occupants of *palazzi* were wealthy merchants. In England, France, and Spain the terms 'palace', *palais*, and *palacio* were used for royal and episcopal residences; in France the term *palais* was also used for buildings representing the authority of the crown, such as courts of justice, but large urban residences were known as *hôtels* and large country houses as CHÂTEAUX.

In Italy, the architecture of the Renaissance *palazzo* reflected its origins as a fortified house, characteristically with vaulted ground-floor shop fronts opening onto the street, and the main apartments on the floor above (*piano nobile*) which could be reached by a stone staircase (*scala*) rising from an inner courtyard (*cortile*). The Gothic *palazzo*, of which the finest examples are the Palazzo Vecchio and the Bargello in Florence and the older portions of the Ducal Palace in Venice, was gradually superseded by the Renaissance palace, in which the vaulted shop fronts were filled in, corner towers reduced or eliminated, and the classical ORDERS introduced in façades (e.g. ALBERTI's Palazzo Rucellai in Florence). Luciano LAURANA's Ducal Palace in Urbino (1465–72) exercised considerable influence on such Roman palaces as the papal Cancellaria and the Quirinal; the Palazzo Farnese built by Antonio SANGALLO the Younger introduced to Rome the Vitruvian idea of the symmetrical façade. The Sack of Rome in 1527 forced patrons and architects to leave the city, and palaces with Roman features soon appeared throughout northern Italy, particularly in SANMICHELI's palaces in Verona and PALLADIO's in Vicenza. The Venetian palace remained distinctive, because the combination of political stability and the aquatic barrier of the lagoon meant that large houses had never been heavily forti-

fied; instead, there was typically an entrance on the canal façade sufficiently capacious to accommodate the unloading of merchandise from boats, and the upper floors of the canal façade were typically pierced with glazed windows (the GLASS was made on Murano) that were virtually unknown elsewhere in Italy. Palaces designed by SANSOVINO retained these features in a classicized form, and CODUSSI's palaces introduced the classical orders. In Genoa, where a distinctive type of palace design had evolved, the Perugian architect Galeazzo ALESSI designed the palaces of the Genoese patricians in the 1550s. If villas were sufficiently large, the term *palazzo* was sometimes used, as in the Palazzo del TÈ in Mantua and the Villa FARNESE at Caprarola, which is also known as the Palazzo Farnese.

Engravings and architectural treatises disseminated Italian designs for palaces all over Europe. In France, the most important palaces were the LOUVRE, the TUILERIES (destroyed 1871), SAINT-GERMAIN-EN-LAYE and the chateaux of AMBOISE, BLOIS, CHAMBORD, CHENONCEAUX, and FONTAINE-BLEAU. In Spain, the most important Renaissance palaces were the ESCORIAL and the imperial palace (now called the Palacio de Carlos V) in Granada built by Pedro MACHUCA in the grounds of the Alhambra. In Germany, Italian ideas informed the transformation of the medieval castle in Heidelberg into a Renaissance palace. In England, Cardinal Wolsey's palace at Hampton Court contains some Renaissance decorative motifs, and Nonsuch Palace (1538–47) was designed in the Renaissance style. The greatest plan for an English palace, Inigo JONES's Palace of Whitehall, was never fully realized; the BANQUETING HOUSE was completed and survived the fire of 1691, but other additions, none of which was finished, were destroyed.

Palissy, Bernard

(*c*.1510–1590), French potter and natural historian, born in Agen, where he trained as a glass painter. He established a workshop in Saintes (*c*.1542), which was on a pilgrim route to Santiago de Compostela, and in the course of sixteen years of experiments (1538–54) developed a pure white ENAMEL that could be used for the decoration of pottery. His enamelled pottery attracted the patronage of Anne de Montmorency, for whom Palissy made a pottery GROTTO for the constable's chateau at Écouen (1555). In 1562 Palissy was imprisoned in

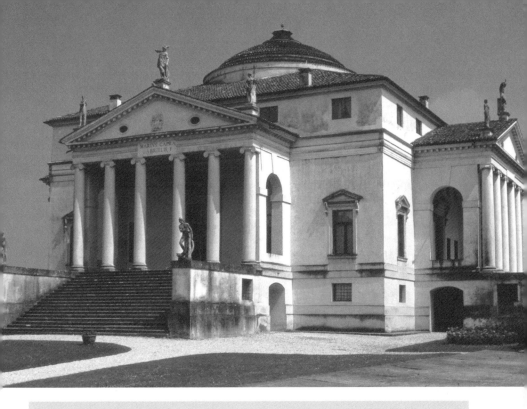

The Villa Rotonda in Vicenza, designed by **Palladio** (1567) and completed by Vincenzo Scamozzi; the building is now called Villa Almerico-Valmarana, and is also known as Villa Capra. Palladio's design for the cupola (imperfectly implemented by Scamozzi) was based on the Pantheon in Rome; the Pantheon is also known as La Rotonda, hence the nickname of the villa. The cupola covers a circular central room from which four passages lead to monumental porticoes on all four sides. The building is set on a small hill for reasons that include security, aesthetics, and social dominance, and there are panoramic views of the countryside in every direction.

Bordeaux for preaching Huguenot doctrine, but he was released through the intervention of Montmorency.

In 1566 Palissy moved to Paris, where his principal patron was Catherine de Médicis, who commissioned a ceramic grotto (decorated with terracotta figures) in the TUILERIES GARDENS (*c.*1573). His richly enamelled dishes and bowls were decorated with reptiles (on which he was an authority), fish, insects, and plants that (like JAM-NITZER in Germany) he had cast from specimens; he also used casts of silver and pewter dishes to make pottery replicas. The quality of his reptilian dishes was recognized with the title 'inventor of the king's rustic pottery' (*inventeur des rustiques figulines du roi*), which afforded a measure of protection against the persecutors of Protestants.

In 1575 Palissy began to lecture on scientific subjects, and in 1580 he published his *Discours admirable de la nature des eaux et fontaines*, which contains an essay on 'L'Art de terre' in which

Palissy describes his sixteen years as a potter. He was imprisoned for heresy in 1585 and died as a prisoner in the Bastille du Bucy. Little of his pottery has survived intact, but some 5,000 fragments have been excavated from the Tuileries and in land close to the Louvre.

Palladio, Andrea

or Andrea di Pietro della Gondola (1508–80), Italian architect. He was born in Padua and grew up in Vicenza, where he became a stonemason. In about 1536 he secured the patronage and personal interest of the playwright Gian Giorgio Trissino, who named him Palladio (from Pallas, the epithet of the Roman goddess Minerva and the name of a character in *Italia liberata dai Gothi*, which Trissino was then writing) and inducted him into mathematics, music, and Latin literature (especially VITRUVIUS).

In 1545 Trissino took Palladio to Rome, where for two years he studied the surviving remains of

ancient architecture. On returning to Vicenza in 1547 Palladio won the competition to recase the Palazzo della Ragione, which because of its interior design and Palladio's exterior is known as the Basilica Palladiana, even though it is a secular building. Palladio started work in 1549, surrounding the building with two superimposed galleries in the Doric and Ionic ORDERS, and the rebuilding was eventually completed in 1614; the ugly roof is not Palladio's, but is rather a product of rebuilding after the Second World War. This building established Palladio's reputation, and thereafter he was permanently engaged in the design and construction of palaces, villas, and churches.

Palladio's Vicenza buildings began with the completion of the Palazzo Thiene (started 1542), in which heavy rustication covers the entire exterior, including the Ionic columns. He then turned to Palazzo Porto (1548–52, now Palazzo Porto-Colleoni), which has a symmetrical layout and a façade which is indebted to BRAMANTE and RAPHAEL. Palazzo Chiericati (1550, now the Museo Civico) is an imitation of a Roman forum. Palazzo Valmarana (begun 1565) is a mannerist building in which pilasters and other architectural decorations cover most of the exterior. The Loggia del Capitaniato (1571) is an extravagant MANNERIST creation covered in relief. Palladio's last commission in Vicenza was the Teatro Olimpico, a re-creation of an ancient THEATRE begun in 1580 and completed by Palladio's pupil Vincenzo SCAMOZZI.

From 1537 to 1542 Palladio built his first VILLA, the Villa Godi-Malinverni at Lonedo di Lugo (north of Vicenza), which in its walled courtyard and its symmetrical wings and façade adumbrates many of Palladio's later designs. His villas around Vicenza include the severe Villa Poiana (1540s), Villa Quinto (c.1550; the façade resembles an ancient temple), the austere La Malcontenta (1559–61) near Fusina on the Brenta, Villa BARBARO at Maser (late 1550s), Villa Emo at Fanzolo (1560–5; a plain building without window surrounds), and La Rotonda (1567; an elaborate building, modelled on the Roman Pantheon, with porticoes on all four sides). Most of his villas have colonnades, often curved, reaching out (in Palladio's metaphor) like arms to welcome those who approach the house.

Palladio's Venetian churches include San Giorgio Maggiore (1565–80, on an islet opposite the Doge's Palace), Il Redentore (begun 1577 in thanksgiving for deliverance from plague the previous year), and the façade of San Francesco della Vigna (1562); the façades all have porticoes like those on ancient temples.

In 1554 Palladio published *Le antichità di Roma* and *Descrizione delle chiese . . . di Roma*. He subsequently illustrated Daniele Barbaro's edition of Vitruvius (1556). In 1570 he published his *I quattro libri dell'architettura*, which sets out the principles of his architecture and illustrates many of his buildings. The far-reaching influence of this book extended to England (e.g. Inigo JONES'S BANQUETING HOUSE) and the Palladian movement of the eighteenth century.

Palma Giovane

or Jacopo Negretti (c.1548–1628), Italian painter, born in Venice, the son of a painter and the great-nephew of PALMA VECCHIO; he was trained in the studios of his father and (probably) of TITIAN, whose *Pietà* (Accademia, Venice) he was to complete after Titian's death in 1576. In the mid-1560s Palma Giovane worked in Urbino and Rome, returning c.1570 to Venice, where his commissions included large allegorical and narrative paintings for the Sala del Maggior Consiglio in the Ducal Palace. His finest surviving work is the cycle *The Doge Pasquale Cicogna* in the Oratorio dei Crociferi (1583–95). In the first quarter of the seventeenth century he was widely regarded as the pre-eminent painter in Venice.

Palma Vecchio

or Jacopo Negretti (c.1480–1528), Italian painter. He was born in Serimalta (Lombardy) and spent his short working life in Venice, where he first appears in the documentary record in 1510. Although he painted a small number of altarpieces and portraits, most of his surviving paintings (none of which is signed or dated) are richly sensuous female half-figures, a genre introduced to Venice by GIORGIONE. Many of these paintings depict mythological figures (e.g. *Flora*, National Gallery, London) or religious scenes (e.g. *St Barbara with Four Saints*, Church of Santa Maria Formosa, Venice).

Palmezzano, Marco

(c.1459/63–1539), Italian painter, born in Forlì, where he trained in the studio of MELOZZO DA FORLÌ, several of whose frescoes he later completed. His many surviving paintings are mostly on religious subjects, but include a small number of portraits. His best-known painting is the altarpiece of *St Anthony Abbot and Other Saints* (Pinacoteca Civile, Forlì).

Paludanus, Gulielmus

or (Dutch) Willem van den Broeck (1530–80), Flemish sculptor who may have been born in Mechelen (French Malines); he joined the Guild of Artists in Antwerp in 1557 and became a burgher in 1559. He worked on Cornelis FLORIS's Town Hall for Antwerp, carving many of the architectural details. His alabaster relief of the *Crucifixion* in the Maximilianmuseum in Augsburg is one of five alabaster reliefs commissioned in 1560 for an altar in the Dominikanerkirche (now the Roman Museum) in Augsburg. Italianate elements in the work of Paludanus have been used to hypothesize an otherwise unrecorded visit to Italy, but it is equally possible that he knew the work of Italians at the imperial court in Brussels (e.g. Leone LEONI, who was there from 1556 to 1559). His terracotta statuette of *St Bartholomew* (dated 1569), now in the Kunsthistorisches Museum in Vienna, seems to imply a familiarity with the work of GIAMBOLOGNA.

panelling

The interior walls of houses first began to be panelled in wood in fifteenth-century Flanders, and from Flanders the practice spread throughout northern Europe. The 'linenfold' panelling of the period was so named because it represents or resembles LINEN arranged in vertical folds.

Panelling was also used for the construction of FURNITURE such as beds, chests, and cupboards, and the development of joined panelling in Flanders at the beginning of the fifteenth century created lighter furniture than was possible with construction in planks. At the end of the sixteenth century the advent of the mitred diagonal joint enabled each panel to be individually framed.

Pannartz, Arnold and Konrad Sweynheym

(*fl.* 1463–77), German printers. They were apprenticed in Mainz, possibly in GUTENBERG's workshop, and in 1463 moved to Italy, where they established the first printing press outside Germany in the Benedictine abbey of Subiaco (near Rome). Their publication in 1465 of an edition of Cicero's *De oratore* was set in a round type that was the first example of Roman type. The printers secured the patronage of Cardinal Juan de Torquemada and so were able to move to Rome, where between 1468 and 1472 they published 46 editions of classical and patristic

texts, each of which had a print run of 275 copies. Sweynheym prepared the copperplate maps for their press's edition of Ptolemy's *Cosmographia*, but he died before the edition was published in 1478.

Pannemaker family

Flemish weavers whose workshop produced BRUSSELS TAPESTRIES. Pieter Pannemaker the Elder (*fl.* 1517–32) worked in the tapestry factory of Pieter van Aelst (d. *c*.1530), who in 1514 received a commission from Pope Leo X to weave tapestries from RAPHAEL's cartoons of the *Acts of the Apostles*. In 1518 Pieter the Elder secured the imperial patronage of the Emperor Maximilian I and he later received commissions from Margaret of Austria. His sons Pieter the Younger and Willem (*fl.* 1535–78) also enjoyed the patronage of the Habsburgs. The huge output of the Pannemaker workshop included the weaving of a series of twelve tapestries designed by Jan VERMEYEN to commemorate Charles V's attack on Tunis in 1535.

Paolo da Verona

(*fl.* 1470–1516), Italian embroiderer praised by VASARI as the greatest exponent of EMBROIDERY. Vasari believed Paolo to be the sole embroiderer of the scenes from the life of St John the Baptist on vestments known as the Paramento di San Giovanni, which were designed by Antonio POLLAIUOLO (and are now in the Museo dell'Opera del Duomo in Florence); in fact, work on the vestments began in 1466 and Paolo did not join the team of embroiderers until 1470.

paper

(Latin *papyrus*). Until the mid-fifteenth century documents were usually written on VELLUM or parchment, though the process of making paper from pulped vegetable fibres (usually extracted from linen or cotton rags, scraps of parchment, and fishing nets) was introduced into Moorish Spain in the tenth century. A paper mill was established in Sicily by 1109 (the date of the earliest surviving European paper document), and thereafter paper manufacturing was introduced in Spain (Játiva, 1150), Italy (Fabriano, 1276; Padua, 1340), France (near Troyes, 1348), and Germany (Nuremberg, 1390); in England paper was imported from the beginning of the fourteenth century, but no paper was manufactured until John Tate opened a paper mill in Hertford in 1495.

The process whereby paper was made consisted of beating boiled rags to a pulp which was then poured onto a framed sieve (known as the mould). The moisture was then drained away through the apertures in the sieve and the dried sheet was removed and pressed. Paper made by this method (which was in universal use until the invention of the paper machine in 1798) has translucent marks which become visible when sheets are held against a strong light. The thick parallel lines are called 'chain lines', the thin lines are called 'wire lines', and the decorative devices are called WATERMARKS.

Paper was occasionally used for drawing from the early fifteenth century, when CENNINI noted that paper (carta bambagina) was an alternative to parchment. The advent of printing led to the mass production of paper, and from the mid-fifteenth century paper was principally used for printing. Most paper was white, but coloured paper was developed in the later fifteenth century, notably the blue-toned paper (carta azzurra) manufactured in Venice. Grey unsized paper was used for blotting from the mid-fifteenth century, but did not displace sand for several centuries.

paragone

(Italian; 'comparison'), a debate in Renaissance Italy about the relative merits of painting and sculpture. The topic is discussed in LEONARDO DA VINCI's notebooks and in Castiglione's Il cortegiano. In 1546 the historian Benedetto Varchi gathered material on the subject by sending a set of questions to sculptors (including CELLINI and MICHELANGELO) and painters (including PONTORMO and VASARI).

parchment

See VELLUM AND PARCHMENT.

Parkinson, John

(1567–1650), English gardener and herbalist. Parkinson's life is not well documented, nor is his garden at Long Acre (near Covent Garden, in London), but he published two important horticultural books and was designated Botanicus Regius Primarius by Charles I. The title of his Paradisi in sole, paradisus terrestris ('The Paradise in the Sun, the Earthly Paradise', 1629) articulated the commonplace of the man-made garden as a re-creation of the garden of Eden, which is depicted in a woodcut as filled with plants but devoid of animals. The book illustrates plants suitable for flower gardens, kitchen gardens, and orchards. His second book was Theatrum botanicum: The Theatre of Plants (1640), an illustrated herbal.

Parler family

German masons in south Germany, Bohemia, and Italy; their surname derives from German Parlier (modern Polier), which means 'foreman', and in contemporary documents it is not always clear whether the reference is to members of this family, at least twelve of whom were masons. Heinrich Parler (fl. c.1330–1371) seems to have worked at Cologne Cathedral before his appointment as master mason of the hall church (i.e. a church in which the aisles are as high as the nave) in Schwäbisch Gmünd (40 kilometres (25 miles) east of Stuttgart); the chancel that he built had a seminal influence on the development of the south German GOTHIC style known as Sondergotik. The chancel of the huge minster at Ulm (which has the world's tallest spire) was also designed by one Heinrich Parler, but it is not clear whether this was the same man or a namesake. In 1391–2 another Heinrich Parler (Enrico da Gamondia, i.e. Heinrich of Gmünd) was employed at Milan Cathedral.

Two sons of Heinrich Parler of Schwäbisch Gmünd became distinguished masons. Johann Parler (fl. 1356–9), who is also known as Johann von Gmünd, was appointed master mason of Freiburg im Breisgau in 1359, and so is likely to have been the architect of the chancel (1354–63) of the minster. Peter Parler (c.1333–99), who is also known as Peter von Gmünd, was the most eminent member of the family. He lived in Nuremberg from c.1352, and in 1356 moved to Prague to succeed Matthias of Arras, who had begun work on Prague Cathedral in 1344. Peter Parler completed the choir (1385) and then built the south transept and the side chapels; his sculpted self-portrait in the triforium of Prague Cathedral is the earliest known self-portrait in stone. In 1373 Parler began work on the Charles Bridge (Karlův Most) in Prague. He was probably the designer and builder of St Barbara's Cathedral in Kutná Hora and of the choir of St Barthelemý in Kolín (50 kilometres (30 miles) east of Prague).

Parmigianino, Il

or Francesco Mazzola or (Victorian English) The Parmesan (1503–40), Italian painter and etcher, born in Parma (hence his nickname), the son of a

painter. His youthful *Marriage of St Catherine* (1521, Canonica di Bardi, near Parma) shows the stylistic features that were to characterize his paintings throughout his short life: the calligraphic drawing of elongated figures positioned with an eye to linear rhythms rather than classical principles of balance. Parmigianino's early work also includes frescoes in four chapels in the north aisle of San Giovanni Evangelista, which were executed at the same time as CORREGGIO's frescoes in the dome and pendentives of the same church.

From 1524 to 1527 Parmigianino lived in Rome, where he worked primarily as an etcher; he seems to have been the first Italian artist to execute etchings and CHIAROSCURO WOODCUTS from his own designs. His few surviving paintings from this period include *Self-Portrait in a Convex Mirror* (Kunsthistorisches Museum, Vienna) and *The Vision of St Jerome* (both in the National Gallery, London).

In 1527 Parmigianino was captured in the Sack of Rome, but escaped to Bologna, where he lived until 1531. The backgrounds of his paintings of this period show a new interest in LANDSCAPE, notably in his *Madonna with Saints* (Uffizi). His portrait paintings include an allegorical picture (now lost) of *Charles V*, who visited Bologna in 1530. While in Bologna Parmigianino painted the *Madonna della rosa* (Gemäldegalerie, Dresden); according to VASARI, Parmigianino painted this picture for Pietro Aretino, whose tastes could account for the sensuousness of a devotional work.

In 1531 Parmigianino returned to his native Parma, where he painted his most famous work, the *Madonna of the long neck* (Uffizi), the most extreme example of Parmigianino's tendency to elongate figures, particularly the neck and hands. During this period he also painted the picture known as *Antea* (Museo Nazionale, Naples); the subject of this painting, which is one of the finest portraits of the sixteenth century, is unknown, and there is no particular reason to identify her with the Roman courtesan Antea. He undertook to paint frescoes in the Church of Santa Maria della Steccata, but his failure to complete these frescoes within twice the contracted time led in 1539 to his imprisonment by his patrons. On his release Parmigianino moved to Casalmaggiore (15 kilometres (9 miles) from Parma), where he painted his last work, a *Madonna with Saints and a Donor* (Gemäldegalerie, Dresden), and where he died on 24 August 1540 at the age of 37.

The style of Parmigianino influenced both NICCOLÒ DELL'ABBATE and PRIMATICCIO, and through their work at FONTAINEBLEAU influenced French art.

parterre

(French *par terre*, 'on the ground'), an ornamental flower garden laid out in geometrical or botanical designs. *Parterres de broderie* or embroidered parterres (Italian *ricami*) were parterres with symmetrical botanical designs, executed in box against a background of coloured soil; the first *parterres de broderie* were constructed by Jacques MOLLET at ANET to designs by Étienne DU PÉRAC; they subsequently became central features at many gardens, notably FONTAINEBLEAU. Parterres in which the individual components of the design are flower beds rather than box, as in the designs of Jan VREDEMAN DE VRIES, are called *parterres de pièces coupées* (cutwork parterres). The late seventeenth-century *parterres à l'anglaise*, which were called 'plats' in England, were constructed with cut turf (*gazon coupé*) set against coloured stones or soil.

Passarotti, Bartolomeo

(1529–92), Italian painter, born in Bologna, where he trained in the studio of VIGNOLA. He lived in Rome from c.1551 to 1565, working as an assistant to Taddeo ZUCCARO; his Roman works include the *Martyrdom of St Paul* in the Church of San Paolo alle Tre Fontane. He returned to Bologna, where he continued to paint altarpieces (e.g. *St Ursula with her Companions*, Church of Santa Maria di Pietà, Bologna) and portraits of popes and cardinals (e.g. *Pope Gregory XIII c.1572*, Schlossmuseum Gotha). He also painted a large number of pictures in a sub-genre of his own invention, a conflation of GENRE and STILL LIFE painting that depicted peasants with flowers and dead birds; these paintings include *The Butcher's Shop*, *The Fishmonger's Shop*, and *The Dog Breeder*, all in the Palazzo Barberini in Rome. Passarotti's pupils included Agostino CARRACCI.

Pasti, Matteo de'

(c.1420–1467), Italian illuminator, architect, and medallist. He was born in Verona and worked for a time in Venice. He illuminated Piero de' Medici's copy of Petrarch's *Trionfi* (now lost), built the Palazzo Rucellai in Florence (to ALBERTI's plans), and cast a series of portrait MEDALS, notably those of Sigismondo Malatesta (for whom PISANELLO had cast a portrait medal the previous year) and Malatesta's mistress Isotta degli Atti da Rimini. His most important

architectural work was the interior of the Tempio Malatestiano in Rimini, which was commissioned by Malatesta and designed by Alberti.

pastiglia

A hardened paste (literally 'tablet') used to decorate the outer surface of small wooden boxes to create decorative effects imitative of those on large Renaissance CASSONI. Pastiglia, which typically consisted of GESSO or of a lead compound fixed with egg, was spread on the surface while still wet and then moulded in relief with small metal matrices, each of which portrayed a human figure or a plant or animal.

patchwork

A textile technique in which small shaped pieces of fabric are sewn together to form a cloth mosaic, often in a geometrical pattern. Patchwork has for many centuries been a peasant craft (since the eighteenth century used mainly for quilts), but in Renaissance Europe tailors also used silks and velvets to fashion patchwork ceremonial vestments for the Church and for the civil authorities.

Patinir

or Patinier or Patenier, Joachim (c.1480–c.1524), Flemish LANDSCAPE painter who first appears in the historical record when he became a member of the Guild of Painters in Antwerp in 1515. In 1521 he acted as DÜRER's host during his visit to the Netherlands; Dürer made a silverpoint drawing of Patinir in one of his sketchbooks and praised him as a 'good landscape painter' ('Maister Joachim, der gut Landschaft Mahler'). His landscape paintings are ostensibly narrative pictures, but the small human figures are typically enveloped by the landscapes in which they are situated. Many paintings are attributed to Patinir, but very few are signed, including a Baptism of Christ (Kunsthistorisches Museum, Vienna), a Flight into Egypt (Koninklijk Museum voor Schone Kunsten, Antwerp) and a St Jerome (Staatliche Kunsthalle, Karlsruhe). He also painted landscape backgrounds for other artists, often his friend Quentin MASSYS, such as their Temptation of St Anthony (Prado, Madrid).

pavilion

A garden house, usually constructed from wood or stone. Pavilions housed FOUNTAINS in the gardens at AMBOISE, BLOIS, and GAILLON, but were normally comfortable shelters designed for viewing the gardens, and were often placed at the end of galleried promenades, as at ANET and SAINT-GERMAIN-EN-LAYE. In Italy the finest Renaissance examples are the pavilions at the Villa LANTE and the Villa FARNESE in Caprarola.

Pellipario

See NICOLA DA URBINO.

Pencz, Georg

(c.1500–1550), German painter and engraver who arrived in Nuremberg in 1523 and seems to have been trained in DÜRER's workshop. In 1525 he was accused of blasphemy and sedition and was expelled to nearby Windsheim. He seems to have lived in northern Italy in the late 1520s and to have returned to Italy c.1539–1542. The influence of BRONZINO can be discerned in his portraits, and his late work suggests a familiarity with GIULIO ROMANO. Pencz worked on a small scale, and so is numbered amongst the LITTLE MASTERS.

pendentive

The architectural term for a concave spandrel (i.e. a curved triangular structure) that leads from the angle of two walls up to a circular dome. The domes of Florence Cathedral and ST PETER'S BASILICA in Rome are both supported by pendentives.

Pénicaud family

A family of enamel painters in sixteenth-century Limoges. The works of Léonard (or Nardon) Pénicaud (c.1470–1542/3), who often took his designs from contemporary prints, include a Crucifixion (1503, Musée de Cluny, Paris) and Deposition, Entombment, and Resurrection (British Museum). Works attributed to his younger brother Jean Pénicaud (fl. 1510–40), including a Flagellation in the Victoria and Albert Museum, are distinguished by a greater attention to details such as hair and plants. Jean's son Jean II (fl. 1530–88), who specialized in GRISAILLES, executed both ecclesiastical works (especially reliquaries) and secular works (especially portraits, notably Pope Clement VII in the Louvre). In the next generation Jean III (d. 1570) and Pierre Pénicaud (d. after 1590) made enamels in the MANNERIST tradition of the Second School of FONTAINEBLEAU.

Penni, Giovan Francesco

or Il Fattore (c.1496–after 1528), Italian painter. He was born in Florence and worked together with GIULIO ROMANO as an assistant to RAPHAEL in Rome; after Raphael's death he continued to work with Giulio Romano. His finest surviving painting is a tondo of *The Holy Family* (c.1520, Museo della Badio della Santa Trinità di Cava, Cava dei Tirreni).

Percellis, Jan

See PORCELLIS, JAN.

Perino

or Perin del Vaga or Pietro Buonaccorsi (1501–47), Italian painter, born near Florence. He moved as a young man to Rome, where he worked as one of RAPHAEL's assistants (who included GIULIO ROMANO) on the stucco and fresco decoration of the Vatican Loggias. In 1527 he fled from the Sack of Rome to Genoa, where he painted mythological frescoes in the Palazzo DORIA until c.1540. He then returned to Rome, where he worked with a large number of assistants on the decoration of the Vatican and Castel Sant'Angelo and several palaces, notably the Palazzo Massimo alle Colonne. Perino also designed engravings for rock crystal, notably Giovanni BERNARDI's set of rock-crystal panels of the Cassetta Farnese, for which the silver setting was made by Bastiano SBARRI (1561, Museo Nazionale, Naples).

Perréal, Jean

or Jehan de Paris (fl. 1483–1530), French painter, sculptor, architect, medallist, and decorator, the son of a court artist and poet. He became the most prominent French artist of his generation, working in the service of Charles VIII, Louis XII, and Francis I, often arranging public festivities; his principal patron was Anne of Brittany. In 1494 he accompanied Charles VIII on his invasion of Italy, and returned to Italy with Louis XII in his campaigns of 1502 and 1509, but his surviving work is not markedly Italianate.

Perréal's work includes a miniature portrait of the Lyonnais poet Pierre Sala (now in the Stowe Manuscripts in the British Library) and the magnificent tomb of Duke François II of Brittany (commissioned by his daughter Anne of Brittany and executed in collaboration with Michel COLOMBE) in Nantes Cathedral. A fine portrait of Louis XII in the Royal Collection at Windsor Castle is also attributed to him.

perspective

is the name now given to constructions designed to give an effect of depth in flat pictures, or to the result of using them successfully; it is derived from the Latin term *perspectiva* which was the name given in the Middle Ages to what is now called by the Greek-derived name 'optics'. In Italian *perspectiva* is either *perspettiva* or *prospettiva*, the terms being used interchangeably. As the use of perspective in works of art became more common, in the fifteenth century, the science of vision came to be called *perspectiva communis* ('ordinary perspective') to distinguish it from the construction techniques, which were called *perspectiva artificialis* ('artificial perspective') or *perspectiva pingendi* ('perspective for painting'). By the mid-sixteenth century the medieval name *perspectiva* and its vernacular cognates had come to denote the new construction techniques, and the old science of vision was known by the newer term 'optics'.

In 1413, or shortly before, Filippo BRUNELLESCHI invented a mathematical technique for making the objects shown in a picture look three-dimensional. This invention probably arose from his interest in *perspectiva* proper, namely in thinking about how the geometry of vision would affect the perception of the proportions that had been part of the design. Unfortunately, so little is known about Brunelleschi's perspective construction that it is not even possible to decide whether his choice of subjects for his two demonstration panels, first the baptistery and second the Palazzo Vecchio seen across the square, was made because these buildings were suitable for showing off the technique or simply because they were well-known civic monuments. Matters are not greatly helped by analysis of the use of perspective in MASACCIO's *Trinity* fresco (c.1426), which, apart from some reliefs by DONATELLO, seems to be the earliest use of perspective construction. It seems likely that what Brunelleschi had discovered was that the perspective images of lines that in reality run perpendicular to the plane of the picture (that is, images of 'orthogonals') converge at a point that is the foot of the perpendicular from the eye of the ideal observer to the picture plane.

Perspective pictures still convey a sense of depth even if the observer is rather far from the ideal viewing position built into the construction. It is hardly surprising that painters seem to have interpreted this as an indication that getting the

mathematical construction exactly right did not matter much. Correct perspective is an extreme rarity in the art of the fifteenth and sixteenth centuries, being found mainly in elaborate pieces of INTARSIA. In fact, perspective did not become generally fashionable, even in Florence, until the 1430s. It does, however, figure prominently in ALBERTI's short treatise on painting, *De pictura* (1435), though Alberti does not give enough detail to allow one to use the rules he describes. He takes it for granted that the images of orthogonals converge to a point he calls the 'centric point', and describes how to put in the images of lines that in reality run parallel to the picture plane ('transversals'). He gives instructions for drawing a chequerboard floor with one edge parallel to the picture plane. Alberti may have invented the method he describes, which has some connections with techniques of surveying. Tiled floors are found in many fifteenth- and sixteenth-century paintings.

The first detailed treatment of perspective is PIERO DELLA FRANCESCA's *De prospectiva pingendi*, which despite its Latin title was written in Italian. This analysis is rigorous and coherent; Piero proves that the construction he uses, which resembles Alberti's, is mathematically correct. Later treatises generally omit Piero's mathematical preliminaries, and his method of using what is effectively ray-tracing to obtain images of 'more difficult' shapes; but such treatises regularly use his work, usually copying his examples. Daniele Barbaro (1568) even uses Piero's words, with an occasional modification to bring the style up to date. The earliest printed treatise was that of Viator (1505), but once illustrated books become cheaper to produce, from the 1530s onwards, perspective treatises proliferate. In the mid-sixteenth century, learned mathematicians begin to take an interest in perspective, probably because their patrons asked them for opinions on some aspect of it. The mathematician G. B. Benedetti wrote a short essay *De rationibus operationum perspectivae* (1585) that investigates the constructions, relates them to geometrical optics, and treats everything in three dimensions, a significant mathematical advance. Unfortunately the book was too difficult for a reader in 1625 who mistakenly believed that Benedetti had proved that only the Albertian construction was correct and accordingly, in his own book, accorded it the name 'construzione legittima', by which it is still sometimes known, though it is of course by no means the only correct construction. The math-

ematician Guidobaldo del Monte's treatise *Perspectivae libri sex* (1600) is notable for proving that not only the images of orthogonals but those of any set of lines that in reality are parallel to one another converge to a point on the horizon. This theorem is of some use in constructing pictures, and led to important mathematical developments when it was taken up by Girard Desargues (1591–1665), who worked on perspective and went on to invent projective geometry (1639).

During the period of the most intensive production of perspective treatises, perspective was steadily becoming less important in paintings, but it was a standard element in the design of stage sets and there was a developing fashion for fictive (TROMPE L'ŒIL) architecture. The terms 'linear perspective' and 'vanishing point', for what Alberti called the 'centric point', were introduced in 1715.

Perugino, Pietro Vanucci

(*c*.1440–1523), Italian painter. He was born in Città della Pieve (near Perugia) and moved as a young man to Florence. He quickly became familiar with the new technique of OIL PAINTING; stylistic evidence suggests he worked with VERROCCHIO. By 1481 his reputation was such that he led the team invited to paint frescoes in the SISTINE CHAPEL in Rome alongside BOTTICELLI, GHIRLANDAIO, and ROSSELLI. He worked with his assistant PINTORICCHIO in the Sistine Chapel, where his frescoes, including *Jesus Delivering the Keys to St Peter* (1482), were widely acclaimed; some of his other frescoes in the chapel were destroyed to make way for MICHELANGELO's *Last Judgement*. In 1500 Perugino worked on the decoration of the Audience Chamber in the Collegio del Cambio in Perugia, by which point Agostino Chigi could acclaim him as the finest painter in Italy. He died of the plague in Fontignano, near Perugia.

Perugino's other paintings include a *Crucifixion with Saints* (1481, National Gallery, Washington), a *Madonna with Saints* (1491–2, Louvre), a *Pietà* (1495, Pitti), a *Vision of St Bernard* (1491–4, Alte Pinakothek, Munich), and an *Assumption* (1506, Church of the SS Annunziata, Florence). His *Nativity* (1491, private collection, Rome) was painted for the future Pope Julius II.

The sweetness of Perugino's style led to some deprecation of his paintings, but this quality endeared him to the Pre-Raphaelites of the

nineteenth century. He remains more accessible to popular taste than virtually any other painter of the Renaissance.

Peruzzi, Baldassare

(1481–1536), Italian painter, architect, and stage designer, born in Siena, where he worked as a painter. In 1503 he moved to Rome, where he was employed as an assistant to BRAMANTE on the planning of ST PETER'S BASILICA; he worked intermittently and in various capacities on the building for the rest of his life, and on the death of RAPHAEL in 1520 became its principal architect.

Peruzzi was the architect of the Villa Farnesina built in Trastevere (1505–11) for the banker Agostino Chigi. This VILLA, which is amongst the finest of the secular buildings of the Roman Renaissance, consists of a square block with an open loggia at the centre of the garden front and projecting wings; in a *palazzo*, the *piano nobile* is normally raised, but in this villa the main rooms are on the ground floor. Peruzzi, together with Raphael, Il SODOMA, SEBASTIANO DEL PIOMBO, and UGO DA CARPI, contributed to its decoration; the technical accomplishment of Peruzzi's Sala delle Prospettive, which has a false PERSPECTIVE view through the walls, adumbrates his later stage designs.

Peruzzi was captured by imperial troops in the Sack of Rome (1527); he escaped to Siena, of which he became the official architect. In Siena he designed fortifications and built palaces, including the Palazzo Polini and, outside the city, the Villa Belcaro. He returned to Rome in 1530 or 1531 and there built the Palazzo Massimo alle Colonne, an early mannerist building in which Peruzzi dealt imaginatively with an awkward site by constructing a curved façade.

Pesellino, Francesco di Stefano

(*c*.1422–1457), Italian painter, probably trained in the Florentine studio of Fra Filippo LIPPI. His paintings include an *Annunciation* diptych (Courtauld Galleries, London) and an altarpiece of *The Trinity with Saints* which was left unfinished at his death, completed in Lippi's studio, and subsequently divided into several pieces, all bar one of which have been gradually reunited in the National Gallery in London.

petit point

or tent stitch, an EMBROIDERY knot stitch, in effect half of a cross stitch, which lies diagonally across the threads of the canvas. It has been used since the fifteenth century for NEEDLEWORK pictures.

Petzolt

or Petzoldt, Hans (1551– 1633), German goldsmith and silversmith who became a master of the Nuremberg Guild of Goldsmiths in 1578; on the death of Wenzel JAMNITZER in 1585, Petzolt became Nuremberg's most eminent goldsmith and thenceforth took a prominent part in civic affairs. His surviving works are mostly cups, many of which embody stylistic features associated with earlier generations of goldsmiths; some recall designs by DÜRER, and others contain Gothic elements and so are described as *Neugotik*.

pewter

An alloy which consists principally of tin and also contains lead or bismuth or copper. The proportion of tin to lead in Roman pewter was usually 7 : 3 or 4 : 1; by the fifteenth century, when the earliest surviving regulations concerning the composition of pewter were formulated, the proportion of lead had been reduced: in Montpellier in 1437 the ratio of tin to lead was fixed at 24 : 1 for dishes and bowls and 9 : 1 for salt cellars and pitchers. In 1576 Nuremberg specified a ratio of 10 : 1 for all pewter. The motive for the reduction of lead was appearance rather than health: pewter with a low proportion of lead can be polished to the point at which it resembles silver, but the admixture of lead darkens the colour to a blackish grey.

Pewter was usually moulded into functional tableware, but in the sixteenth century a more elaborate 'display pewter' was developed. Decorated display pewter originated in Lyons, where its most important exponent was François BRIOT. Nuremberg later became an important centre of display pewter: the city's most prominent pewterers were Nicholas Horchhaimer (d. 1583) and Albrecht Preissensein (d. 1598), who made large bowls decorated with low-relief figures; their most important successor was Caspar ENDERLEIN. In England, where London pewterers were recognized as a guild in 1348, the most outstanding pewterer whose work has survived was William Grainger (*fl.* 1616), a Master of the Pewterers' Company who is the eponym of the relief cast candlestick known as the Grainger candlestick which is now in the Victoria and Albert Museum.

English pewter was required to bear a maker's mark under a statute of 1503. Early modern marks tend to consist of an oval or circular punch surrounding initials, sometimes with a simple device. As the tables (or 'touch-plates') recording these marks and their makers perished in the fire of 1666, attribution of London pewter is sometimes problematical.

Pfeffenhauser

or Peffenhauser, **Anton** (c.1525–1603), German armourer, based in Augsburg, where he made armours (see ARMS AND ARMOUR) for the princes of Germany and the court of King Philip II in Spain. Examples of his armours are preserved in the Royal Armouries in Leeds, the Wallace Collection in London, the Kunsthistorisches Museum in Vienna, Musée de l'Armée in Paris, the Real Armería in Madrid, the Historisches Museum in Dresden, and the Metropolitan Museum in New York.

Pfister, Albrecht

(c.1429–c.1466), German printer who worked for many years as a secretary for the bishop of Bamberg before becoming a printer in Bamberg in the early 1460s. He was the first printer to use hand-coloured woodcuts as illustrations and the first to publish books in German, notably Johann von Saaz's Der Ackermann aus Böhmen (1460) and Ulrich Boner's Edelstein (1461); he also published an illustrated Biblia pauperum (or Armenbibel).

Pia, Villa

A small VILLA with interior garden in the Vatican built in 1560 by Pirro LIGORIO as a retreat for Pope Pius IV. The three-storeyed CASINO is one of the most elegant surviving examples of mannerist architecture. The villa faces a small oval court, 27 metres × 18 metres (30 × 20 yards), which is surrounded by three structures independent of the main building; the four buildings are linked by a low wall fitted with seats and decorated with vases. The interior court is ornamented with stucchi modelled on ancient Roman coins, and the decoration of the entrance loggia, which is covered in mosaics that are reflected in a pool fed by a fountain, is also based on the ancient Roman practice of combining water and mosaics.

The Villa Pia was the first casino in Italy to have its own GIARDINO SEGRETO, and so was an important precursor of the FARNESE Villa at

Caprarola. The landscaping has been modified over the centuries, and the lower gardens have disappeared, but the villa is still, as Jakob Burckhardt observed, the 'most perfect retreat imaginable for a midsummer afternoon'.

Piccinino, Lucio

(fl. 1578–95), Italian armour embosser, the last great Milanese manufacturer of embossed parade armours (see ARMS AND ARMOUR), and the successor to Filippo NEGROLI as Italy's most prominent armourer. An armour made for Alessandro Farnese, duke of Parma (c.1578), is preserved in the Kunsthistorisches Museum in Vienna; this armour, which is decorated with scenes in relief and damascened in gold and silver, forms the basis for other attributions to Piccinino, including armours in the Wallace Collection in London, the Victoria and Albert Museum, and the Metropolitan Museum in New York.

Piccolpasso, Cipriano

(c.1524–1579), Italian potter from CASTEL DURANTE, the author of a treatise on MAIOLICA entitled Tre libri dell'arte del vasaio. The treatise was written between 1556 and 1559, which makes it the earliest surviving European study of pottery, but was not published until 1860, when a French translation appeared; the Italian original was first published in 1857. The manuscript, which is illustrated, is in the Victoria and Albert Museum in London.

Pienza

See ROSSELLINO, BERNARDO.

Pierino da Vinci

(c.1529–1553), Italian sculptor and silversmith, born in Vinci; he was the nephew of LEONARDO DA VINCI. He was trained in Florence by Baccio BANDINELLI and Niccolò TRIBOLO, and then worked in Rome for a year before settling in Pisa, where he died in his mid-twenties. His surviving works include bronze statuettes of Pomona and Bacchus (Ca' d'Oro, Venice) and a marble relief called Pisa Restored (c.1552, Vatican), in which Cosimo I de' Medici is shown expelling vice from Pisa.

Piero della Francesca

(1415–92), Italian painter and art theorist, born in Sansepolcro (Borgo Sansepolcro, Umbria). He first enters the documentary record in 1439, when

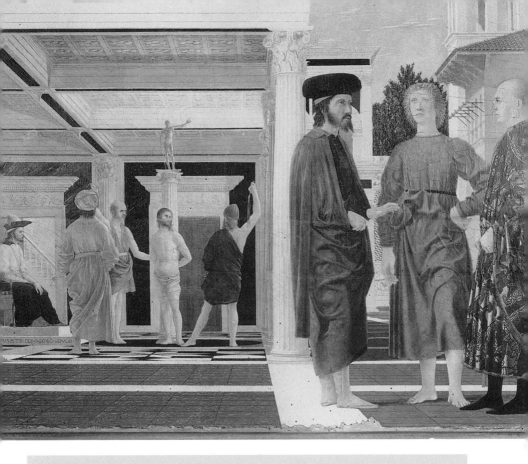

Piero della Francesca, *The Flagellation* (c.1456), in the Palazzo Ducale, Urbino. This enigmatic painting is sometimes said to be the finest small painting of the Renaissance, a judgement based on its mathematically rigorous construction, its complex use of light, and its integration of architectural and figural elements. On the left, Jesus is being flogged in the temple. The turbanned man observing the flagellation is dressed in Turkish costume, probably to represent Islamic persecution of Christians; Pontius Pilate is seated on the left (with Piero's signature below). On the right, three figures converse; their identity is unknown, as is their relation to the flagellation.

he is recorded working with DOMENICO VENEZIANO on the frescoes of San Egidio (now lost). Thereafter his paintings include the *Baptism of Jesus* (c.1448–50, National Gallery, London), the polyptych of the *Madonna della Misericordia* (commissioned 1445, Palazzo Communale, Sansepolcro), the *Flagellation* (c.1456, Palazzo Ducale, Urbino), the fresco cycle of *The Legend of the Holy Cross* (c.1455–65, in the choir of the Church of San Francesco in Arezzo), the portraits of *Federico II da Montefeltro* and his countess *Battista Sforza* (1464, Uffizi) (see plates 12 and 13), and a *Nativity* (c.1472, National Gallery, London). This surviving corpus is characterized by precise drawing, subtle lighting, broad masses of colour, the innovative use of PERSPECTIVE, and an emotional restraint that gives his figures great poise.

The most important of Piero's writings for an understanding of his art is *De prospectiva pigendi*, which sets out the mathematical rules of foreshortening; the treatise was written before 1482, and survives in an Italian version in Piero's hand and a Latin version annotated in his hand. Piero was not placed in the highest rank by VASARI, who determined the canons of taste in Italian Renaissance art for centuries. In the early twentieth century, however, art historians reassessed Piero, and he is now acclaimed as one of the greatest of quattrocento painters.

Piero di Cosimo

(1461/2–1521), Italian painter, trained in the Florentine studio of Cosimo ROSSELLI; he was originally called Piero di Lorenzo, but later

assumed the name of his teacher. He painted many religious pictures which, after 1500, show the influence of SIGNORELLI and LEONARDO. His most distinctive pictures are mythological fantasies, some of which are comic, such as *The Discovery of Honey* (Art Museum, Worcester, Mass.) and *The Discovery of Wine* (Fogg Museum, Cambridge, Mass.); others depict sometimes violent scenes in a spirit of sentiment or pathos, such as *Hunting Scene* (Metropolitan Museum, New York), *The Battle of the Lapiths and Centaurs* (National Gallery, London), *The Death of Procris* (National Gallery, London), *Mars and Venus* (Gemäldegalerie, Berlin), and *The Forest Fire* (Ashmolean Museum, Oxford). Piero was also a highly accomplished portrait painter, as is evident in his *Giuliano da Sangallo* (Rijksmuseum, Amsterdam) and his *Simonetta Vespucci* (Musée Condé, Chantilly), a nude bust in which his sitter is portrayed with a snake around her neck. Piero's pupils included ANDREA DEL SARTO.

pietà

A genre of sculpture and painting (literally 'piety') in which the Virgin Mary bears the body of Jesus on her knees or cradles him at her feet. This composition, which may originate in the Passion plays of medieval Europe, first appears in the early fourteenth century in a limewood carving in Naumburg Cathedral. There are occasional examples of the form in France (such as the mid-fifteenth-century Avignon *Pietà* in the Louvre) and Flanders (notably the *Pietà* of Petrus CHRISTUS in the Metropolitan Museum in New York), but the composition was most popular in Italy: in painting the finest examples are those by Giovanni BELLINI (Accademia, Venice) and SEBASTIANO DEL PIOMBO (Museo Civico, Viterbo), and in sculpture the greatest example of the form is MICHELANGELO's *Pietà* in St Peter's Basilica in Rome.

pietre dure

(Italian; 'hard stones'). The singular form, *pietra dura*, is used within Italy to denote a single type of stone but is widely used by non-native speakers outside Italy to denote combinations of more than one type of stone. The *pietre* are semi-precious stones, typically agate, chalcedony, jasper, and lapis lazuli, but do not include marble or precious stones (GEMS). *Pietre dure* had been carved in classical Rome, and the techniques for cutting such hard stones were revived in sixteenth-century Florence, where a workshop established under the patronage of Grand Duke Cosimo I de' Medici produced the decorative panels known in English as FLORENTINE MOSAICS; the workshop was refounded in 1588 as the Opificio delle Pietre Dure, which still manufactures mosaics.

Pilgram, Anton

(c.1450–1515), Moravian sculptor and architect, probably born in Brno, where he worked from 1502 to 1508. He moved to Heilbronn and then in 1512 to Vienna. At Heilbronn he designed the spired tabernacle for the sacrament in the Kilianskirche. In Vienna he worked on St Stephan, where his organ foot (1513) and pulpit (1514–15) each include a sculpted self-portrait.

Pilon, Germain

(1537–90), French sculptor and medallist, born in Paris. He worked as an assistant to PRIMATICCIO on the monument for the heart of King Francis I in Haute-Bruyère. He contributed the kneeling bronze figures and the partly nude marble figures of Henri II and Catherine de Médicis for their tomb in Saint-Denis. He later sculpted figures commissioned by Queen Catherine for the Valois Chapel (destroyed 1719) in Saint-Denis. His work for the Birague family includes *The Virgin of Pity* (Louvre), *St Francis* (Church of Saint-Jean-Saint-François), and the bronze statue of *René de Birague* (Louvre). In 1572 he was appointed master of the mint and in 1575 he executed a series of bronze portrait medallions (see p. 171).

Pinturicchio

or Pintoricchio or Bernardino di Betto (c.1452–1513), Italian painter, born in Perugia. His teachers included PERUGINO, for whom he worked as an assistant on the frescoes of the SISTINE CHAPEL (1481–2). Pinturicchio's principal works are fresco cycles in the Vatican and in Siena Cathedral: in the Vatican he painted lunettes in the Borgia apartments illustrating amongst others *The Life of Jesus* and ceiling-panel frescoes of (unusually) *Scenes from Egyptian Mythology* (1492–5); in the Piccolomini Library in Siena Cathedral he painted *Scenes from the Life of Aeneas Sylvius Piccolomini* (1503), who in 1458 had become Pope Pius II.

Pisanello, Il

or Antonio Pisano (c.1395–1455/6), Italian painter, draughtsman, and medallist who lived

as a young man in Verona, where he may have trained in the studio of STEFANO DA ZEVIO. He collaborated with GENTILE DA FABRIANO on frescoes in the Doge's Palace in Venice (1415–20) and later completed Gentile's frescoes (left unfinished at his death in 1427) in the Lateran Basilica in Rome (1431–2).

Pisanello's surviving independent paintings consist of frescoes and a small number of panel paintings. The frescoes are an *Annunciation* in the Church of San Fermo Maggiore in Verona (c.1426), a *St George and the Princess of Trebizond* in the Church of Sant'Anastasia in Verona (1434–8), and a set of frescoes of *Scenes of War and Chivalry* (1439–42) in the castle at Mantua that was rediscovered in the 1970s. The paintings include portraits of Leonello d'Este (c.1441, Accademia Carrara, Bergamo) and of an unidentified Este princess (c.1440, Louvre) and paintings of *The Vision of St Eustace* and *Virgin and Child with SS Anthony the Abbot and George* (both in the National Gallery, London).

Pisanello was a prolific draughtsman, and large numbers of his drawings survive, including splendid pictures of birds and animals and tinted costume studies. The finest collection is in the Codex Vallardi (Louvre); a sheet of his drawings of hanged men is in the British Museum.

Pisanello was a pioneer of the Renaissance portrait MEDAL, beginning with his medal of the Emperor John VIII Palaeologus (1438). He subsequently cast medals for Sigismondo Malatesta of Rimini, Ludovico II Gonzaga and Cecilia Gonzaga of Mantua, Lionello d'Este of Ferrara, Don Iñigo d' Avalos (grand chamberlain of Naples), and Alfonso V of Aragon, king of Naples.

Pisano, Andrea

(c.1295–1348/9) and Nino (d. 1368), Italian sculptors. Andrea Pisano first appears in the historical record in 1329, when he was commissioned to make a pair of bronze doors for the baptistery in Florence. The doors, which were finished in 1336, depict *The Virtues* (in eight panels) and *The Life of John the Baptist* (in twenty panels). He succeeded GIOTTO as capomaestro (master mason) for the campanile of the cathedral, and carved most of the reliefs (e.g. *The Weaver* and *The Rider*); he was succeeded c.1343 by Francesco TALENTI. In 1347 Andrea was appointed capomaestro of Orvieto Cathedral, and on his death the following year he was succeeded by his son Nino.

There is documentary evidence that Nino Pisano worked as an architect and a goldsmith, but his only surviving works are marble sculptures, of which three are signed: a *Madonna* in Santa Maria Novella in Florence, the *Virgin* of the Cornaro monument in SS Giovanni e Paolo in Venice, and a statue of a bishop in the Church of San Francesco in Oristona (Sardinia).

Andrea and Nino Pisano were not related to Nicola and Giovanni PISANO or to Il PISANELLO.

Pisano, Nicola

or Niccolò (1220/5–before 1284) and Giovanni (1245/50–before 1320), Italian sculptors. Nicola Pisano moved to Pisa from his native Apulia in the mid-thirteenth century. His Gothic pulpit for the Pisa Baptistery (1260) was the first important work to revive the conventions of ancient Roman statuary: his *Simeon* derives from Dionysius, his nude *Christian Fortitude* from Hercules, and his *Virgin* from Phaedra. The naturalism and dignity of the human figures remains a feature of Pisano's subsequent work, which included the reliefs on the pulpit of Siena Cathedral (1265–8), on which he was assisted by his son Giovanni and ARNOLFO DI CAMBIO, and the decorative sculpture on the FOUNTAIN (Fontana Maggiore) in what is now the Piazza 4 Novembre in Perugia (completed 1278), on which he was again assisted by Giovanni.

Giovanni Pisano carved the saints and prophets on the exterior of the Pisa Baptistery; the project was completed by 1284, and it is possible that Giovanni had worked together with his father (whose date of death is not known). This decorative scheme was the first in Tuscany in which large-scale statuary was incorporated into the architectural design. Giovanni subsequently built the façade of Siena Cathedral (from 1284), contributed designs for Massa Marittima Cathedral (1298), and carved the reliefs for pulpits at the Church of Sant'Andrea in Pistoia (1301) and Pisa Cathedral (1302–10), all of which deploy classical motifs. Giovanni's freestanding statues include *Madonna and Child with Two Acolytes* (c.1305, Arena Chapel, Padua), the *Madonna della Cintola* (c.1312, Prato Cathedral), and the monument to Margaret of Luxemburg (wife of the Emperor Henry VII) sculpted for the Church of San Francesco in Genoa (1313; substantial fragments are preserved in the Palazzo Bianco in Genoa), the last of which was the first monument to depict its subject rising from the grave.

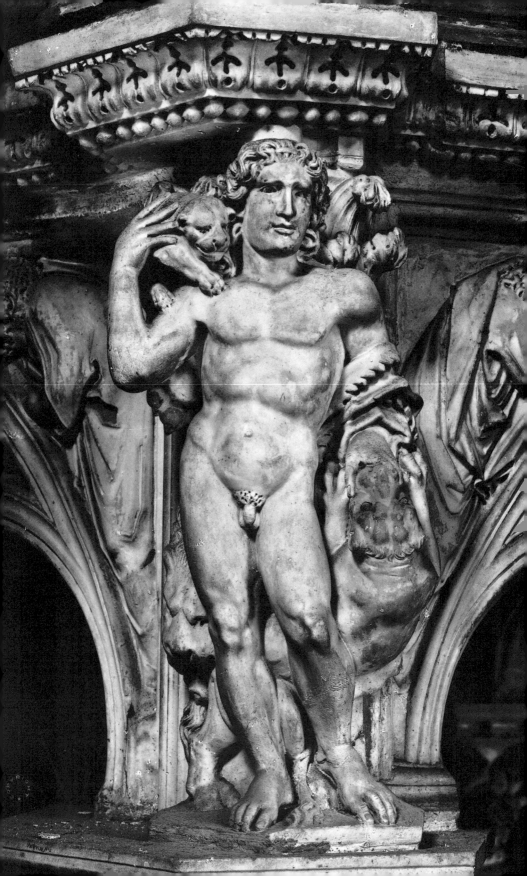

Nicola and Giovanni Pisano were the first sculptors to revive Roman carving, and were in effect the creators of the trecento Gothic style which was the starting point of sculptors such as JACOPO DELLA QUERCIA, GHIBERTI, and DONATELLO. In the historiography of sculpture they are therefore said to be the fathers of modern sculpture.

Nicola and Giovanni Pisano were not related to Andrea and Nino PISANO or to Il PISANELLO.

Pitti Palace

or (Italian) Palazzo Pitti, a Florentine palace commissioned by Luca Pitti, a wealthy merchant. The initial plans were drawn up by BRUNELLESCHI, and construction began in 1435; it was eventually finished in 1570 by AMMANATI. In 1549 the unfinished palace was bought from Jacopo Pitti by Eleanor of Toledo, the duchess of Cosimo I de' Medici, who commissioned the BOBOLI GARDENS and extended the palace. In 1565 VASARI added a corridor over the Ponte Vecchio (which spans the Arno) in order to link the Pitti Palace with the UFFIZI PALACE, which accommodated the offices of the Medicean civic administration, and with the Palazzo della Signoria, later renamed Palazzo Vecchio. In 1550 the Medici family (who had lived in what is now the Palazzo Medici-Riccardi from 1460 to 1540) moved into the Pitti Palace, which remained the principal residence of the grand dukes of Tuscany until 1859; for the next 50 years it was owned by the Italian royal family, and in 1919 it passed to the state. The palace now houses a silver museum (Museo degli Argenti) on the ground floor and one of the world's finest collections of Renaissance art (including 11 paintings by RAPHAEL, 14 by TITIAN, 16 by ANDREA DEL SARTO, 8 by TINTORETTO, and 5 by VERONESE) in the Palatine Gallery on the first floor.

Plantin, Christophe

(c.1520–1589), French printer in Antwerp. He was born in a village near Tours and worked in Caen and Paris before settling in Antwerp in 1549. His press specialized in classical texts, the church fathers, dictionaries, medicine, science (particularly botany), and music, but the most famous of its 1,500 titles was the polyglot Bible commissioned by King Philip II of Spain and known as the *Biblia regia* (8 vols., 1568–73); Plantin was subsequently appointed as *prototypographus regius* and given the monopoly of printing all liturgical books for the territories of King Philip. After Plantin's death the press passed to his son-in-law Jan Moretus, whose descendants managed the press until 1876, when the archives, library, and presses of the Plantin press were bought by the city of Antwerp and became the foundation collection of the Musée Plantin-Moretus, which opened on 19 August 1877 as Antwerp's museum of the history of printing.

plaquettes

The nineteenth-century term for small decorative reliefs in metal, normally bronze or lead, made from the late fourteenth to the mid-sixteenth centuries; Renaissance plaquettes were usually cast, but were occasionally struck like COINS. Plaquettes characteristically depicted mythological or religious subjects, and so may be distinguished from MEDALS (which are primarily commemorative portraits) and coins (which are primarily a medium of exchange). The plaquette was typically decorated on one side and left blank on the other.

The plaquette was often made as a cheap replica of a goldsmith's product; the rock-crystal intaglios of Valerio BELLI and Giovanni BERNARDI were particularly popular models. They were also used, notably by Peter FLÖTNER, to disseminate designs. Many plaquettes were cast as paxes, and in secular use plaquettes were incorporated into sword-hilts and inkwells.

Most plaquettes were made anonymously, but in Italy plaquettes were made by Il RICCIO and by the studio of DONATELLO, and in Germany by Flötner and 'HG', who may have been Hans JAMNITZER.

Nicola **Pisano**, *Christian Fortitude* (1260), a relief sculpture on the pulpit of Pisa Baptistery. This Gothic pulpit was the first important work to revive the conventions of ancient Roman statuary; this nude figure is modelled on classical Roman representations of Hercules, and is the earliest representation of a heroic nude in post-classical art. The combination of nudity and physical strength, together with the *CONTRAPPOSTO* pose, make this figure the ancestor of Michelangelo's *David* (see p. 167), on which it may have had a direct influence.

plateresque

A late GOTHIC and early Renaissance style in Spanish architecture; the term implies a similarity to the work of a silversmith (*platero*). Architectural historians commonly distinguish two phases: the Gothic-Plateresque, which is sometimes called the 'Isabelline' style (with reference to Isabella the Catholic, who was an important patron of architecture), is deemed to be broadly conterminous with her reign (1474–1504); the Renaissance-Plateresque is used to describe the dominant style of the first half of the sixteenth century. The transition from Gothic-Plateresque to Renaissance-Plateresque is said to be marked by the publication of SAGREDO's *Medidas del romano* in 1526, and the end of the Renaissance-Plateresque is deemed to be marked by the publication of VILLALPANDO's translation of two books of SERLIO's *Architettura* in 1552. The Plateresque was a style used primarily in small buildings; the cathedrals of the period increasingly eschewed ornamentation, and so anticipated the unornamented style (*estilo desornamentado*) of Juan de HERRERA that was to supersede the Plateresque in the later sixteenth century.

The Plateresque in both phases is characterized by the lavish use of ornamental motifs that are often unrelated to the structural form of the surfaces on buildings, ALTARPIECES, and sculptural monuments to which they are applied: they neither repeat motifs in segments, as is common in Gothic decoration, nor derive from a unified design, as is the case in Renaissance decoration. The ornamental motifs, usually in relief, may be Gothic (in the early period), Italian Renaissance (in the later period), or MUDÉJAR (in both periods).

Gothic-Plateresque was primarily a Castilian style centred on Burgos, Toledo, and Valladolid. Its exponents, who were often of northern (especially Flemish) origin, included Simón de COLONIA, Enrique EGAS, Juan GUAS, and Gil de SILOÉ. Renaissance-Plateresque was a pan-Hispanic style that influenced Portuguese (see MANUELINE) and Latin American architecture. Its principal exponents were Alonso de COVARRUBIAS, Rodrigo GIL DE HONTAÑÓN, Diego de RIAÑO, and Diego de SILOÉ.

Pleydenwurff, Hans

(*c*.1425–1472), German painter. He was probably born in Bamberg, but was active in Nuremberg from 1457 or possibly earlier. His most important surviving works are a *Calvary* panel (Alte Pinakothek, Munich), probably from a Nuremberg church, and a pair of wings from a *Passion* altar painted in 1465 for Michaelskirche (the chapel, now destroyed, of the Residenz in Munich) and now in the Alte Pinakothek. Pleydenwurff's son Hans (d. 1494) and Michael WOLGEMUT both trained in his studio and later collaborated on the woodcuts for the 'Nuremberg Chronicle'.

Poggini, Domenico

(1520–90) and Gianpaolo (1518–82), Italian medallists, born in Florence, the sons of a gem engraver. Gianpaolo, the elder brother, worked in the service of King Philip II in Brussels and (from 1559) in Madrid; his MEDALS include two of King Philip. Domenico produced medals in Florence and also worked as a sculptor, usually in bronze. His works include a marble *Apollo* (1559) in the Boboli Gardens in Florence, a bronze *Pluto* in the Palazzo Vecchio, and portrait medals of Cosimo I de' Medici and two of the historian Benedetto Varchi. In 1585 he moved to Rome to enter the service of Pope Sixtus V, and cast a series of portrait medals of the pope and one of the pope's sister Camilla Peretti.

Polidoro da Caravaggio

or Polidoro Caldara (*c*.1500–*c*.1543), Italian painter who worked in Rome, where his contemporary reputation rested on his illusionistic façade paintings, none of which has survived;

Rodrigo Gil de Hontañón, the central section of the façade (1541–3) of the Colegio de San Ildefonso, now the University of Alcalá de Henares. The façade is one of the most important Renaissance structures in Spain. It is built in the Renaissance-**plateresque** style, with mathematical proportions in its design and Plateresque decoration which includes Gothic elements (e.g. the rope motif, representing the girdle of St Francis) and Renaissance features (e.g. the ball-topped obelisks that surmount the balustrade).

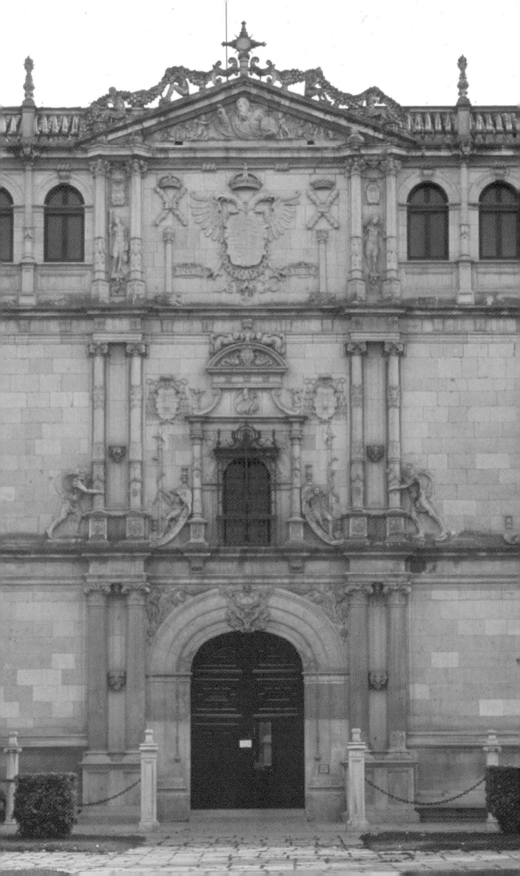

engravings and drawings of these paintings show that they often imitated classical reliefs. Of his surviving Roman paintings, the most important is a fresco of *St Mary Magdalene* in the Church of San Silvestro al Quirinale in Rome, which is a precursor of the 'heroic' LANDSCAPE painting which was to be developed in the seventeenth century by Poussin (who worked in Rome) and Claude. In the wake of the Sack of Rome in 1527 Polidoro left the city and settled in Messina, where he was later murdered. The greatest painting of his final years is the *Way to Calvary* (1534) in the Museo Nazionale in Naples, of which the National Gallery in London acquired an early version in 2003.

Pollaiuolo, Antonio

(*c*.1432–1498) and Piero (*c*.1441–1496), Italian goldsmiths, painters, and sculptors, brothers who shared a workshop in Florence. Antonio was primarily a goldsmith, bronze sculptor, engraver, and draughtsman, and Piero was primarily a painter.

In 1456 Antonio collaborated with two other artists on a silver crucifix for the Florentine baptistery, and the following year collaborated on a reliquary; this magnificent ensemble, which was completed in 1459, is now in the Museo dell'Opera del Duomo, together with another of Antonio's work for the baptistery, a silver relief of *The Birth of St John the Baptist* for the altar. He also contributed a set of candlesticks (made 1465, melted down in 1539) and the design for the finest surviving EMBROIDERY of the Renaissance, the vestments known as the Paramento di San Giovanni (1466–80, Museo dell'Opera del Duomo). Antonio's only autograph engraving, *The Battle of the Naked Men* (*c*.1470; see p. 83), suggests an interest in anatomy which according to VASARI extended (as it was later to do with LEONARDO) to undertaking dissections of executed criminals; however, no good evidence for such dissections exists. His bronzes include the tombs of two popes, Sixtus V (1493, now in the Grotte Vaticane) and Innocent VIII (*c*.1495, now in ST PETER'S BASILICA in Rome), and a *Hercules and Antaeus* (Bargello, Florence).

Piero Pollaiuolo sometimes painted independently (e.g. six of the *Seven Virtues* of 1469/70 now in the Uffizi), but many of his paintings may be collaborations with his brother, notably *The Martyrdom of St Sebastian* (1475, National Gallery, London).

Pontelli, Baccio

(1454–1494/5), Italian architect and *intarsiatoro*, born in Florence, where he trained as a woodcarver. He worked as a young man in Pisa and subsequently worked in Urbino (1479–82) and Rome (1482–92); he was probably responsible for the INTARSIA in the *studiolo* (see CABINET) of the Palazzo Ducale in Urbino (see p. 135). His greatest work as a military architect was the fortification of Ostia; in the Marches he built fortifications at Iesi, Osimo, and Senigallia and contributed to the Santuario della Santa Casa at Loreto. Roman buildings attributed to Pontelli include the papal Cancellaria (*c*.1485) and the Church of San Pietro in Montorio (*c*.1490), which was financed by Ferdinand and Isabella of Spain.

Pontormo, Jacopo da

or Jacopo Carucci (1494–1556), Italian MANNERIST painter, born near Empoli (Tuscany) and trained with ANDREA DEL SARTO in Florence, where he remained throughout his life. Pontormo's early works include the altarpiece *Holy Family Surrounded by Angels* (1518, Church of San Michele Visdomini, Florence), a *Joseph in Egypt* (1519, National Gallery, London), and *Vertumnus and Pomona*, a lunette in the MEDICI VILLA at Poggio a Caiano (1520–1).

From 1522 to 1525 Pontormo painted a fresco cycle on *The Passion* in the cloisters of Certosa del Galluzzo (near Florence); some of the designs are taken from prints by DÜRER, and so illustrate how the technology that enabled art to be reproduced mechanically was able to shape the development of original art in the sixteenth century. From 1526 to 1528 Pontormo worked in the Church of Santa Felicità (Florence), where he painted a *Deposition*, an *Annunciation*, and several roundels; the *Deposition*, which is now regarded as one of the greatest mannerist paintings, is a crowded and brightly lit composition in which elongated androgynous figures are frozen in improbable postures. Pontormo's last great commission, which occupied him from 1545 until his death, was the decoration of the choir of the Church of San Lorenzo in Florence; these frescoes were destroyed in 1738.

Pontormo's highly individualistic paintings, which are characterized by spatial distortions and elongations of the human figure, are often read through the prism of his Diary for the period 1554–6, which reveals a melancholic and hypochondriacal personality. Such oversimplified retrospective readings unhelpfully reduce fine paintings to psychological documents.

porcelain

A hard white translucent POTTERY, distinguished by the temperature of the firing into hard-paste porcelain (*pâte dure*) and soft-paste porcelain (*pâte tendre*). Hard-paste porcelain has been manufactured in China since the ninth century; Chinese hard-paste porcelain was imported into sixteenth-century Europe by Portuguese and Dutch merchants, but the technique was not re-discovered in Europe until the first decade of the eighteenth century.

Soft-paste porcelain, which is fired at a lower temperature and is not as resonant when struck, may have been first made in Europe in Venice, where an imitation *porcellana* was manufactured early in the sixteenth century; as no example of this porcelain has survived, it is possible that the reference is to LATTIMO rather than porcelain. The earliest unequivocal examples of European soft-paste porcelain are those made in the Medici factory in Florence between 1575 and 1587.

Porcellis

or Percellis, Jan (*c*.1584–1632), Flemish painter and etcher in Holland. He was born in Ghent and migrated as a religious refugee to Rotterdam. He specialized in marine painting, and his seascapes typically depicted a small fishing boat in a choppy sea with the shoreline in the background. Whereas his predecessor Hendrik VROOM had concentrated on the depiction of ships in vivid colours, Porcellis painted monochromic images of sea and sky.

Pordenone, Il

or Giovanni Antonio de' Sacchis (1483–1539), Italian painter, born in Pordenone (Friuli). His principal work, which shows the influence of MICHELANGELO, is a series of frescoes on *The Passion* in Cremona Cathedral (1520–2); he also painted frescoes in Treviso Cathedral (1522, now partly destroyed). In 1527 Pordenone settled in Venice, where his surviving paintings include two saints in the choir of San Rocco (1528–9) and several altarpieces, of which the best known depicts an angel showing the way to three saints (*c*.1535–6, Church of San Giovanni Elemosinario).

porphyry

or (Italian) *pórfido*, a hard volcanic rock which ranges in colour from green to red; the variety used in Renaissance Florence and Venice was a deep red variety known as *pórfido rosso antico*. In ancient Egypt porphyry had been quarried at Mount Porphyrites (now Jebel Dhokan, on the west coast of the Red Sea), and when Egypt became a Roman province on the death of Cleopatra, the quarries were taken over by the Romans and used for statues, sarcophagi, and even columns. The quarries were exhausted in the fifth century, and thereafter the only source of porphyry was Roman ruins. The excavation of ancient Rome in the sixteenth century provided the porphyry used by sculptors, of whom the most important was Francesco FERRUCCI.

Porta

See DELLA PORTA.

portraits and self-portraits

A portrait is usually a painted image, but portraits can also take the form of statues (including busts, wax figures, and EQUESTRIAN STATUES), MEDALS, PRINTS, and DRAWINGS; painted portraits range from heroic representation to MINIATURES. Portraits may attempt to create a likeness of the sitter, or may be imaginary; the recently dead may have representational effigies on their tombs (sometimes made from death masks) but, in the case of long-dead saints and monarchs, the painter sometimes used a living model: DÜRER's *St Jerome* (1521, Museu de Arte Antiga, Lisbon) portrays the features of an elderly man whom Dürer sketched in Antwerp, but is nonetheless a representation of St Jerome. Such pictures can only be considered as portraits in a very limited sense.

The portraits painted by CRANACH and HOLBEIN are images of their sitters that convey a sense of character and social standing without idealizing their subjects. Portraits can be sympathetic even with the portrayal of disfiguring features; GHIRLANDAIO's *Portrait of an Old Man and a Boy* (Paris, Louvre) portrays the old man's elephantiasis, which Ghirlandaio had studied in his silverpoint preparatory sketch (Nationalmuseum, Stockholm). The sense of a portrait as an object of surrogate adoration, which originated in pictures of the Virgin Mary, was sometimes carried over into secular portraits. In John Webster's *White Devil* (1612) Isabella kneels before the portrait of her husband, and is killed when she kisses the poisoned lips of the portrait.

Artists are often said to have included self-portraits in crowd scenes, but documented examples are rare; one such example survives in a

fresco by Benozzo GOZZOLI in the Palazzo Riccardi in Florence: the self-portrait is identified with a Latin inscription declaring the painting to be the work of Gozzoli, and so in this instance the self-portrait is a form of signature. The genre is more common in sculpture: the earliest such self-portrait is Peter PARLER's in Prague; Anton PILGRAM twice sculpted self-portraits in Vienna and GHIBERTI included his own portrait on the baptistery doors of Florence. The tradition of self-portraits as a means of depicting character was initiated in the drawings of Dürer and culminated in the etched and painted self-portraits of Rembrandt.

pottery

Clay has been shaped and fired to make vessels since remote antiquity, and these have been decorated with incised or painted ornament since neolithic times. The three principal types of pottery are earthenware, STONEWARE, and PORCELAIN. Most Renaissance pottery is TIN-GLAZED EARTHENWARE, which is known in Italy as MAIOLICA and in France, Germany, Scandinavia, and Spain as FAIENCE.

Pratolino, Villa

A VILLA with gardens 13 kilometres (8 miles) north-east of Florence. The house and garden were built between 1561 and 1581 on a 240-hectare (600-acre) site on the side of a south-facing hill. The work was commissioned by Francesco de' Medici (1541–87), and the architect and hydraulic engineer was almost certainly Bernardo BUONTALENTI. Above the house an AMPHITHEATRE was carved out of the hillside, dominated by a colossal FOUNTAIN of Apennine, probably by GIAMBOLOGNA; this statue, which is the principal surviving architectural feature of the garden, depicts Apennine pressing the head of a monster out of whose mouth the water flows. Above the fountain there was a large MAZE and a fountain that functioned as a reservoir for the waterworks that lay below.

The lower garden was not laid out in terraces. Instead it was structured by means of a central axis running through the house from the top to the bottom of the hill, but the various features of the garden were not set out symmetrically around this axis: fountains, GROTTOES, MOUNTS, PAVILIONS, and fish ponds were scattered through the garden.

The garden was chiefly remarkable for its imaginative use of water, which was said to surpass even the Villa D'ESTE. The house was surrounded by a balustraded artificial terrace, beneath which lay eight grottoes with GIOCHI D'ACQUA. In the Grotto of the Flood, the unwary visitor who sat on an inviting bench to admire the sculpture was quickly squirted with water from all directions, and retreat up the stairs to escape the drenching was inhibited by water pouring onto the staircase from hundreds of jets. The grottoes were fitted with many AUTOMATA, some based on the designs of HERON; visitors such as MONTAIGNE were particularly delighted by the animals that stooped to drink from the fountains and the sound of the water-organs. Below the house a long avenue ran down the hill, lined with free stone walls that accommodated scores of fountains. At the bottom of the avenue there was a fountain with a statue of a woman doing her laundry. Water fell from a marble cloth which she was holding, and a pot held water that seemed to be boiling.

In the sixteenth and seventeenth centuries the garden of Pratolino was the most famous in Europe; it is now the greatest of the lost gardens of Europe, because it was destroyed in 1819 to make way for a *giardino inglese*. The Renaissance garden is now being gradually restored.

Preda

or Predis, Ambrogio da (c.1455–after 1508), Italian painter and illuminator, appointed court painter to the Sforza of Milan in 1482. His only fully authenticated painting is a signed and dated portrait of the *Emperor Maximilian I* (1502, Kunsthistorisches Museum, Vienna); he may have been the artist who painted a portrait of *Francesco di Bartolomeo Archinto* (1494, National Gallery, London).

Preda was named together with his elder half-brother Evangelista Preda in the contract of 1483 in which LEONARDO DA VINCI was commissioned by the Confraternity of the Immaculate Conception in Milan to paint the altarpiece known as *The Virgin of the Rocks*, of which there are versions in the National Gallery in London and the Louvre. The wings of Leonardo's altarpiece (also in the National Gallery) depict angels with musical instruments; the *Angel in Red Playing the Lute* may be the work of Ambrogio da Preda.

predella

See ALTARPIECE.

Preuning family

German potters in Nuremberg of whom the most prominent were Kunz Preuning and Paul Preuning, both of whom were active 1540–50. Since the fourteenth century relief tiles decorated with biblical subjects had been made by the stove-makers (*Hafner*) of Germany. The Preunings adapted the techniques of Hafnerware tiles to lead-glazed earthenware jugs. Attributions are not secure, but jugs decorated with crucifixes and processions are attributed to Kunz and jugs with half-length portraits of German Protestant princes are ascribed to Paul. Jugs on which they collaborated proved to be controversial, and in 1541 they were prosecuted for depicting biblical and secular subjects on the same jug. The Victoria and Albert Museum contains examples of their work.

prie-dieu

(plural prie-dieux), the French term (meaning 'pray God'), first brought into English in the fourteenth century, for a praying-desk (or kneeling-desk) with a footpiece on which to kneel and a top designed to support the arms or a book. Prie-dieux were made throughout Europe from the fourteenth to the seventeenth centuries; in sixteenth-century Italy the footpiece was sometimes adapted into a chair. The prie-dieu was revived in England in the nineteenth century as part of the antiquarian impulse of the Oxford Movement.

Prieur, Barthélemy

(c.1536–1611), French sculptor influenced by the Mannerism of the second School of FONTAINEBLEAU. His best-known works are the sculptures of *Peace* and *Felicity* that he carved for the monument for the heart of Anne de Montmorency (Louvre), which was designed by Jean BULLANT.

Primaticcio, Francesco

(1504/5–1570), Italian painter and architect, born in Bologna. He moved to Mantua c.1526 to assist GIULIO ROMANO in the decoration of the Palazzo del TÈ. In 1532 he moved to France at the invitation of King Francis I to collaborate with Il ROSSO FIORENTINO on the decoration of FONTAINEBLEAU; the precise nature of their collaboration is unclear. After Il Rosso's death in 1540 Primaticcio decorated rooms such as the Salon de la Duchesse d'Étampes (completed 1543), the Salle de Bal (1551–6), and the Galerie d'Ulysse (completed 1570), which illustrates 58 episodes from Homer's *Odyssey*. The work of Primaticcio and Il Rosso at Fontainebleau proved to be very influential, partly because of its innovative combination of stucco and paint but also because it established a preference for classical mythological instead of religious images in decorative schemes; their work eventually came to be regarded as the foundation of a style of art known as the School of FONTAINEBLEAU.

On the accession of Francis II in 1559, Primaticcio succeeded Philibert DELORME as royal architect, and in this capacity designed the Valois Chapel in the Basilica at Saint-Denis (near Paris) and the rear wing (Aile de la Belle Cheminée) projecting towards the pond at Fontainebleau (1568).

printing

The advent of printing and of movable type gave to fifteenth-century Europe the technology requisite for the mass production of written texts and engraved pictures. Printing in Europe began with the advent of BLOCK BOOKS in the 1440s. Movable type was introduced by Johann GUTENBERG of Mainz, who developed the brass moulds known as matrices in which replicas of lead letters could be reproduced. Gutenberg also improved the process of printing by adapting the wooden screw technology of grape crushing to the needs of printing. The first book to be produced with this new technology was Gutenberg's 42-line Bible (1452–6).

Printing presses were established in Strassburg (1460), Cologne (1464), Rome (1464), Basel (1467), and Venice (1469). Thereafter growth was rapid: in 1470 presses were established in Nuremberg, Paris, and Utrecht; in 1471, in Milan, Naples, and Florence; in 1473, in Lyon; in 1474, in Budapest, Kraków, Valencia, Louvain, and Bruges; in 1476, in England. Most of these early books were in Latin, but by the late fifteenth century publishing in the vernaculars had become an important enterprise, and vernacular presses stimulated an increase in translation from the learned languages into the vernaculars and from one vernacular to another. WOODCUTS offered a cheap and technically compatible method of introducing BOOK ILLUSTRATIONS

alongside print, and throughout the fifteenth and sixteenth centuries books were richly illustrated. Gothic, roman, and italic type was developed, and soon printing presses were able to produce type for Greek (1465), Hebrew (1473), musical notation (1473), and mathematics (1482).

In the INCUNABULA period printers were also the publishers of the books that they printed. Germany had the largest number of publishers (and of books in print) in Europe, and printer-publishers such as Anton KÖBERGER, who owned the largest publishing empire in Germany, also operated through agents in other parts of Europe.

prints

In typographical and artistic usage, a print is a picture or design printed from a block or a plate. The impression on the paper can be made from a design on a raised surface (e.g. WOODCUT) or a recessed surface (e.g. DRYPOINT, ENGRAVING, and ETCHING) or a flat surface (e.g. lithographs).

The methods that create recesses in the surface that are then inked are called INTAGLIO methods, and they differ in the means by which the designs are incised in the metal plates: in drypoint the surface is scratched with a steel needle; in engraving the design is engraved with a burin; in etching the design is bitten into the plate with acid.

Prints often survive in more than one 'state': a change of state occurred whenever the printer altered a plate or block to improve the quality of the print. The early states of prints are often aesthetically inferior to later states, but, as in the case of early editions of books, the early states of prints now command higher prices than do later states.

Etching was more efficient than engraving, and so was often used as a preliminary process. It is difficult for the untrained eye to distinguish etchings from engravings, even in cases in which prints were produced entirely by etching. In the case of fifteenth- and sixteenth-century prints, there is a subtle difference in the lines: etched lines have fuzzy edges of unchanging width, engraved lines have hard edges but width that varies with the pressure of the engraver's hand.

Provost, Jan

(c.1465–1529), Flemish painter, born in Mons. In 1491 he married the widow of Simon MARMION

in Valenciennes; in 1493 he was admitted to the Painters' Guild in Antwerp, and the following year he settled in Bruges, where he remained for the rest of his life. He is not known to have signed any paintings, but the attribution to him of a *Last Judgement* (1525, Groeningemuseum, Bruges) is securely rooted in contemporary documents. In 1521 he entertained DÜRER, who apparently drew his portrait (now lost).

Pucelle, Jean

or Jehan (c.1300– c.1355), French illuminator, the head of a large workshop in Paris. His illuminated manuscripts, of which some fifteen survive, include the Hours of Jeanne d'Évreux (The Cloisters, New York), in which the iconography and perspective derive from the early period of the Italian Renaissance.

punto in aria

(Italian; 'stitch in air'), a form of needlepoint LACE in which a single thread is used to add stitch to stitch, without any background of fabric. It was first made in Venice in the fifteenth century.

putto

(plural putti), the Italian term for a young boy, used in art history to denote a small child, nude or with swaddling bands and often with wings, used in decorative art since classical antiquity but particularly characteristic of fifteenth- and sixteenth-century Italian art. Putti were sometimes called *amores* in Latin, which is indicative of their pagan origins (Amor was a Roman personification of love, usually called 'Cupid' in English), but their wings point to their Christian origins as small cherubim. The syncretic blending of angelic and pagan origins is apparent in the putti looking up from the bottom of RAPHAEL's *Sistine Madonna* (c.1512, Gemäldegalerie, Dresden); the fashion for using these putti on Christmas cards has made this detail of Raphael's altarpiece one of the most popular images in Renaissance art.

Pynas, Jan

(1581/2–1631), Dutch painter and etcher, probably born in Alkmaar. In 1605 he travelled to Rome, where he was influenced by the work of Adam ELSHEIMER. On returning to the Netherlands Pynas established a studio in Amsterdam where he produced etchings as

well as paintings and where Rembrandt was for a short time his pupil. His best-known painting is the *Raising of Lazarus* (1605, Schloss Johannisburg Staatsgalerie, Aschaffenburg).

Pynson, Richard

(d. 1530), Anglo-Norman printer. He was born in Normandy and became a printer in London, initially as an assistant to CAXTON. In the early 1490s he succeeded William de Machlinia as the principal printer of law books in London; his press also printed an illustrated edition of Chaucer's *Canterbury Tales*. On the accession of King Henry VIII in 1509, Pynson was appointed as king's printer, and in the same year he introduced roman type into England.

Quarton

or Charonton, Enguerrand (*c*.1410–*c*.1461), French painter. He was born in the Laonnais and worked as a painter in Avignon from the late 1440s. His paintings are executed in a syncretic style which reflects both Italian and Flemish influences. His surviving paintings include a *Virgin of Mercy* (1452, Musée Condé, Chantilly) painted in collaboration with Pierre Vilate (*fl.* 1451–95) and a *Coronation of the Virgin* (1454, Musée Municipal, Villeneuve-lès-Avignon) which includes depictions of hell in a Flemish idiom.

quattrocento

An apheretic form of *mil quattro cento* ('one thousand four hundred'), the Italian term for the fifteenth century (14—) and for the art and architecture of the period.

Quentell, Heinrich

(d. 1501), German printer, born in Strassburg. He established his workshop in Cologne, where his most successful publications were illustrated editions of the Bible in Low German (1479). Quentell's press, which passed to his son and grandson, was in the first half of the sixteenth century an important publisher of Latin texts (mainly theological works) for the University of Cologne. In 1525 the press published William Tyndale's English translation of the New Testament.

Quercia, Jacopo della

See JACOPO DELLA QUERCIA.

Quesnel, François

(1543–1619), Franco-Scottish painter, born in Edinburgh, where his father Pierre was a French painter in the service of James V of Scotland. Pierre worked mainly in France as a portrait painter; his paintings include *Mary Ann Waltham* (1572, Althorp, Northants) and *Henri III* (Louvre).

quilting

The term, derived from Latin *culcita* (a stuffed cushion), for the process whereby two layers of cloth are stitched together with an interlining of flock or down; the stitches follow geometrical designs, typically a lozenge or network pattern but sometimes a complex arabesque pattern. In the early modern period it was used to make clothing and bed covers; quilted clothing included undergarments for ARMOUR and satin doublets and breeches. Quilted bed covers, sometimes decorated with EMBROIDERY or PATCHWORK, are mentioned in sixteenth-century inventories, but no examples are known to survive; such quilts were popular in early seventeenth-century England, the Netherlands, Portugal, and Italy, and later in the century became established as a folk art in America.

R

Raffaello da Montelupo

(1504–66), Italian sculptor and architect, born in Florence, the son of the sculptor BACCIO DA MONTELUPO. He worked in Rome from 1524 to 1527, when he fled from the Sack of Rome. He subsequently lived in Loreto, Florence, and Orvieto before returning to Rome (1543–52) to serve as architect of Castel Sant'Angelo and finally settling in Orvieto, where he became *capomaestro* of the cathedral. His best-known statue is a depiction of *St Damian* for the New Sacristy of the Church of San Lorenzo in Florence; the design is an adaptation of one by MICHELANGELO.

Raimondi, Marcantonio

(*c*.1470/82–*c*.1527/34), Italian engraver, born near Bologna and trained in the Bolognese studio of Il FRANCIA. He travelled to Venice *c*.1505 and there copied some woodcuts by DÜRER (who would later accuse him of plagiarism), notably his *Life of the Virgin*. He subsequently worked in Rome (*c*.1510–27) as an engraver; many of his designs were copies of paintings and designs by RAPHAEL and GIULIO ROMANO. Raimondi established ENGRAVING as a reproductive medium that could be achieved in a workshop, and through his engravings the work of Raphael, Giulio Romano, and other Italian artists became known throughout Europe. His copies were in turn used as designs for MAIOLICA dishes.

Raphael

or (Italian) Raffaello Sanzio (1483–1520), Italian painter, born in Urbino, where his father Giovanni SANTI was a painter in the court of Federico da Montefeltro; Giovanni Santi died in 1494, when Raphael was 11, and the palpable influence of PERUGINO in Raphael's early paintings, such as *The Coronation of the Virgin* (1502–3, Vatican), *The Crucifixion* (1503, National Gallery, London), and *The Marriage of the Virgin* (1504, Brera, Milan), may imply that shortly after his father's death he became a pupil in Perugino's studio in Perugia.

In 1504 Raphael visited Florence, where he fell under the influence of LEONARDO DA VINCI and MICHELANGELO. The works of his Florentine period include many of his greatest Madonnas; these paintings, in which the Madonna and Child are variously painted in the company of the infant John and his mother Elizabeth and the aged Joseph, include the *Madonna del Granduca* (*c*.1505, Pitti Palace, Florence), *La Belle Jardinière* (1507, Louvre, Paris) (see plate 7), and the 'Canigiani' *Holy Family* (*c*.1507, Alte Pinakothek, Munich).

In 1508 Raphael was invited to Rome by Pope Julius II, who commissioned him to paint the frescoes in the room that he had designated as his library; this room is now known as the Stanza della Segnatura because it was later used by the Signatura Gratiae (which, together with the Signatura Iustitiae, made up the Apostolic Signatura, the supreme tribunal of the Church). On the ceiling Raphael painted four women whose attributes associate them with Theology, Poetry, Philosophy, and Jurisprudence; the wall below each figure amplifies these personified abstractions. The wall beneath Theology contains the *Disputa* and depicts the fathers of the Church discussing the doctrine of transubstantiation, watched from above by the Trinity; the wall beneath Poetry shows the poets on Parnassus; the wall beneath Philosophy, traditionally known as the *School of Athens*, depicts ancient philosophers in an architectural setting; the wall beneath Jurisprudence depicts personifications of the cardinal virtues (Fortitude, Prudence, and Temperance), below which Justinian is shown with the *Pandects* and Pope Gregory IX with the *Decretals*. These paintings are one of the supreme achievements of western art, and were influential in shaping the future development of that art. Raphael subsequently decorated two other rooms in the papal apartments, the Stanza d'Eliodoro (1511–14) and (together with his assistants) the Stanza dell'Incendio (1515–17); he also designed the

ceiling and wall arabesques in the Vatican Loggias, and these designs were to have a lasting influence on interior decoration.

Raphael remained in Rome for the rest of his short life, during which he worked as a painter of Madonnas, altarpieces, and portraits, an architect, a tapestry designer, and a draughtsman. His Madonnas from this period include the *Madonna Alba* (c.1511, National Gallery, Washington), the *Madonna di Loreto* (c.1511, Musée Condé, Chantilly), and the *Madonna della Sedia* (c.1514, Palazzo Pitti). His altarpieces include the *Sistine Madonna* (c.1512, Gemäldegalerie, Dresden) and the *Transfiguration* (Vatican), on which he was working when he died (and which was displayed over his coffin in the Pantheon). His portraits include *Pope Julius II* (c.1511, National Gallery, London), *Baldassare Castiglione* (c.1515, Louvre), and *Pope Leo X with Cardinals Giulio de' Medici and Luigi de' Rossi* (1518, Uffizi).

In 1514 Raphael was appointed architect of ST PETER'S BASILICA and later designed the Villa MADAMA (c.1518); his work for the banker Agostino Chigi included the design for the Chigi Chapel in Santa Maria del Popolo (c.1513–16), the decoration of the Villa Farnesina in Trastevere with a wall fresco (*Galatea*, c.1512) and of its garden loggia with a fresco cycle of *Cupid and Psyche* (c.1518), and the design for the Chigi Stables (1514–18, now destroyed). Pope Leo X commissioned Raphael to design and prepare cartoons of *The Lives of SS Peter and Paul* to be woven in Brussels; the cartoons are now in the Victoria and Albert Museum and the tapestries in the Vatican, where they were for centuries hung in the Sistine Chapel on ceremonial occasions.

Raphael was one of the greatest draughtsmen of the Renaissance. He worked with pen and ink in drawings such as his *Study of Leonardo's Leda* (c.1506, Royal Library, Windsor) and *Nude Male Warriors* (Ashmolean Museum, Oxford), but also used black chalk (e.g. *Study for the Head of a Muse*, c.1510, Horne Museum, Florence) and red chalk, notably in *Jupiter and Cupid* and, on the verso, *Girl Holding a Mirror* (c.1517–18, Louvre).

Ratdolt, Erhard

(1447–1527/8), German printer. He was born in Augsburg, but while still a child moved to Mainz, where he trained as a printer, probably in the workshop of GUTENBERG. In the 1470s and early 1480s he worked as a printer in Venice, and in 1486 he accepted an invitation to return to his native Augsburg, where his workshop became the most important producer of colour printing in Germany. Ratdolt's many innovations include the first title page, the first type-face catalogue, the first texts of geometry and astronomy to be illustrated with diagrams, and the first books with illustrations in three colours. He first printed music in 1487, using WOODCUTS, and in 1491 began to use movable type to print music.

Ratgeb, Jerg

or Jörg (c.1480–1526), German painter. He was born in Herrenberg and was active there and in Stuttgart, Frankfurt, and finally Pforzheim, where he died. His experience of the political and social unrest that eventually led to the Peasants' War is reflected in his most famous painting, the Herrenberg altarpiece (1514–17), which is now in the Stuttgart Staatsgalerie.

Redman, Henry

(fl. 1496, d. 1528), English master mason, the son of the master mason of Westminster Abbey; he worked as a mason at the abbey from 1496 (or earlier), and in 1516 succeeded his father as master mason. In 1519 he became king's master mason, initially with William VERTUE and then alone. He visited the chapel of King's College, Cambridge, with Vertue in 1507, but the extent to which their views affected the construction of the fan vaulting is not clear. Redman and Vertue collaborated on a design for Lupton's Tower (1516) at Eton College (though it is unclear whether theirs was the design that was built) and on the fan-vaulted cloister of St Stephen's Chapel in the Palace of Westminster (c.1526). Redman was appointed as Cardinal Wolsey's architect, so he may have been the designer of Hampton Court. He was, together with John Lebons, the architect of Cardinal College (later Christ Church), Oxford.

relief

or (Italian) *relievo*, the art-historical term for a work of sculpture in which figures stand out from a plane and the dimension of depth is reduced; the term is not peculiar to any medium, and is used with reference to sculptures in stone, wood, metal (e.g. GHIBERTI's bronze doors on the Florentine baptistery), and gems (see CAMEO). The term 'high relief' (*alto relievo*) is used when the scale of projection (i.e. the

dimension of depth) is more than half of the other two dimensions; in the case of architectural decoration the term is used more loosely to denote sculpture carved fully in the round (i.e. when the scale of projection equals the other dimensions). The Italian term *mezzo relievo* is used when the scale of projection is approximately half that of the other dimensions. The term 'low relief' (Italian *basso relievo*, French *bas-relief*) is used when the scale of projection is less than half of the other dimensions and there is no undercutting. In Italian, the very low relief used by sculptors such as DONATELLO and DESIDERIO DA SETTIGNANO is known as *relievo stiacciato* or simply *stiacciato*.

reredos

See ALTARPIECE.

retable

See ALTARPIECE.

reticella

A form of needlepoint LACE used in sixteenth- and early seventeenth-century Italy for civil and ecclesiastical ceremonial garments. The technique involved cutting away portions of woven linen fabric and then filling the gaps with openwork patterns worked in buttonhole stitching. It differs from CUTWORK in that it makes less use of the linen threads of the fabric and more use of free needlework.

Reuwich, Erhard

(c.1455–1490), Dutch engraver, born in Utrecht. In 1483 he accompanied Canon Bernhard von Breydenbach (chamberlain to the archbishop of Mainz), Graaf Johann zu Solms-Lich, and the Ritter Philipp von Bicken on a pilgrimage to Jerusalem. Reuwich's sketches, which included a map of Venice and views of Corfu and Rhodes, were made into woodcuts and incorporated by Breydenbach in his *Peregrinationes in Terram Sanctam*, which was published in Mainz by Peter SCHÖFFER in 1486 and was subsequently translated into other languages, including German (1486), Dutch (1488), French (1488), Spanish (1497), and Italian (1500).

Reymond, Pierre

(1513–84), French enamel painter, the head of a large workshop in LIMOGES; the products of his workshop bear his initials but are not necessarily his work. He specialized in tableware (cups, ewers, plates, dishes, etc.) decorated with mythological scenes, typically in GRISAILLE against a dark blue background. Reymond also made the enamelled altarpiece commissioned by Anne de Montmorency for the chapel of his Château d'Écouen (now the Musée de la Renaissance).

Riaño, Diego de

(d. 1534), Spanish architect who served as cathedral architect in Seville, where he designed and built the chapter house and sacristy; he also designed the elaborately decorated Seville Town Hall, which was constructed after his death according to his plans (1534–72). He is regarded as the most important exponent of the Renaissance-PLATERESQUE style in Andalusia.

Ribalta, Francisco

(1565–1628), Spanish painter, probably trained at the ESCORIAL under Juan FERNÁNDEZ DE NAVARRETE. By 1599 he was living and working in Valencia, where his style gradually changed from MANNERIST to Spanish BAROQUE. His paintings include *The Vision of Father Francisco Jerónimo Simó* (1612, National Gallery, London) and two works made for the Capuchins, *St Francis Comforted by an Angel* (c.1620, Prado) and *St Francis Embracing Christ* (c.1620, Museo de Bellas Artes, Valencia).

Riccio, Il

or Andrea Briosco (1470–1532), Italian sculptor, a native of Trento who spent his working life in Padua as a sculptor in bronze and terracotta. He specialized in small bronzes, sometimes for churches but often for domestic use in objects such as inkwells and firedogs or for display as statuettes. His finest surviving work is a bronze paschal candlestick (1507–16, Basilica del Santo, Padua) which combines classical and Christian ornament in a profusion of figures and relief scenes. He also made PLAQUETTES based on engravings by MANTEGNA.

Richier, Ligier

(c.1500–1567), French sculptor, born into a family of sculptors in Lorraine. His best-known sculpture is the group carved in 1553 for the Easter Sepulchre in the Church of Saint-Étienne in Saint-Mihiel (Lorraine), in which Gothic figures are combined with Italianate drapery. In these statues, and in the skeleton statue on the tomb of René de Châlons (now in the Church of

Saint-Pierre in Bar-le-Duc), the religious intensity and grim naturalism of the figures takes the Gothic idom to a macabre extreme. Richier became a Huguenot, and in 1564 left France as a religious refugee and settled in Geneva.

Ried

or Rieth von Piesting, Benedikt (c.1454– 1534), German mason and architect who served as master of the king's works in Bohemia. His structures mediate between the GOTHIC style that he inherited and the Renaissance Italian style that he introduced into Bohemian architecture. Ried's greatest work is the Vladislav Hall (1493–1502) in the Old Royal Palace (Starý Královský Palác) on the Hradčany in Prague; this vast room is remarkable both for its ribbed Gothic vaulting, in which the structural ribs are supplemented with liernes (decorative tertiary ribs), and for the resolutely Italianate decoration of the windows and doorways. The late Gothic organ gallery constructed in Prague Cathedral in the early 1490s, in which the vault ribs imitate the branches of a tree, also seems to be Ried's work, but the attribution is not secure.

Ried was also responsible for the design of the vault of the magnificent Gothic Cathedral of St Barbara in Kutná Hora, in which the ribs resemble a network of lozenges (the vault was constructed in the 1540s to his design), and for the design and construction of the similarly exuberant vault in the Church of St Nicholas at Louny.

Riemenschneider, Tilman

(c.1460–1531), German sculptor and woodcarver. He was born in Osterode am Harz, the son of the master of the mint in Würzburg, where he moved in 1483 and opened a workshop. Riemenschneider worked in wood, marble, limestone, and sandstone. His best-known work is the marble tomb (completed 1513) of the Emperor Henry II (d. 1024) and his Empress Kunigunde in Bamberg Cathedral (of which Henry was the founder). His other works include the ALTARPIECE of Mary Magdalene for the high altar at Münnerstadt (1490–2; two panels remain in the church, but the carving of St Mary Magdalene with Six Angels is now in the Bayerisches Nationalmuseum in Munich), limestone statues of Adam and Eve for Würzburg town council (1491–3, Mainfränkisches Museum, Würzburg), the Altar of the Holy Blood for the

Jakobskirche in Rothenburg ob der Tauber (1501–5), a triptych for Windsheim (c.1508), an altarpiece of the Twelve Apostles for St Kilian, Windsheim (1507–9, now in the Kurpfälzisches Museum in Heidelberg), and a sandstone Lamentation group (1520–5) for the high altar of the Cistercian abbey (now the Pfarrkirche) at Maidbronn (near Würzburg).

Ritter family

A late sixteenth- and seventeenth-century family of German goldsmiths based in Nuremberg. The founder of the family was Christoph Ritter the Elder (d. 1572), whose best-known surviving work is a salt cellar topped with an enamelled Crucifixion group (now in a private collection in London) which he made in 1551 for the Nuremberg city treasury. His son Christoph the Younger (1548–1616) and grandson Jeremias (1582–1646) both made covered cups. Another member of the family, Wolf Christoph Ritter (1592–1634), made a table-fountain shaped like an elephant (Germanisches Nationalmuseum, Nuremberg) and a remarkable basin and bird-shaped ewer in which both pieces are covered with rock crystal (Schatzkammer der Residenz, Munich).

Rizzo, Antonio di Giovanni

(c.1439–c.1499), Italian sculptor and architect, a native of Verona. In 1466 he settled permanently in Venice, though he worked for a time with Giovanni AMADEO on the Certosa di Pavia. In Venice Rizzo carved the tomb of Doge Niccolò Tron in Santa Maria Gloriosa dei Frari and collaborated with Andrea BREGNO on the Adam and Eve sculpted for niches in the Arco Foscari (c.1485, now in the Doge's Palace); they are among the earliest nude statues of the Venetian Renaissance. His architectural work in the Doge's Palace includes the Scala de' Giganti (named after the giants carved by SANSOVINO) and the façade on the eastern side of the courtyard, which had been damaged in the fire of 1483.

Roberti, Ercole de'

See ERCOLE DE' ROBERTI.

Robin, Jean

(1550–1629), French botanist, herbalist, and gardener. He constructed a garden at the downstream end of the Île de la Cité in Paris. The garden was at first named after King Henri IV, who had commissioned it, but since the early

seventeenth century it has been known as Place Dauphine; the dauphin was Henri IV's son, the future Louis XIII. The garden was used to develop and display Robin's collection of ornamental plants, many of which were illustrated (as botanical designs for needlework) in Pierre Vallet's *florilegium* of 1608 (*Le Jardin du roi très chrétien Henri IV*), which illustrated the plants on 75 plates. Robin grew the first false acacia in Europe from seeds collected in Virginia, and so became the eponym of *Robinia pseudoacacia*; he also popularized the tuberose (*Polianthes tuberosa*), and this interest in scented flowers led eventually to his (anonymous) publication of the *Histoire des plantes aromatiques*. He also published catalogues of his plants (*Catalogus stirpium*) in 1601 and 1619.

Henri III conferred the title of *arboriste et simpliciste du roi* on Robin, and made him responsible for the gardens of the LOUVRE; these posts were subsequently renewed by Henri IV and Louis XIII. When the University of Paris decided in 1597 to create a BOTANICAL GARDEN, Robin was commissioned to design it. The garden, which was known as the Jardin Royal des Plantes Médicinales, was eventually constructed by Guy de la Brosse in 1626, and Robin's son Vespasian (1597–1662) was appointed head gardener; in 1718 its name was changed to Jardin Royal des Plantes, and after the Revolution it became the Jardin des Plantes.

rock crystal

The lapidary term for silicon dioxide, popularly known as quartz, of which it is a variety. Its transparency commended it to GEM carvers, who found it particularly suitable for objects decorated in INTAGLIO; its hardness meant that it was usually ground with a wheel rather than carved. The grinding of rock crystal has a continuous history in Europe since antiquity. The most important engravers of rock crystal were Valerio BELLI, Giovanni BERNARDI, Annibale FONTANA, the MISERONI FAMILY (who worked in the imperial service), and the SARACCHI FAMILY. Crystal glass (Italian *vetro di cristallo*) was developed to imitate the qualities of rock crystal, and the relative lightness of crystal glass meant that it eventually displaced rock crystal.

Rogers, William

(*fl.* 1589–1604), the first known professional English engraver. He may have been trained in the Netherlands, possibly in the studio of the WIERIX FAMILY in Antwerp. He specialized in portraits and title pages; his portraits include Queen Elizabeth, the earl of Essex, and King Henri IV of France, and his title pages Camden's *Britannia* (1600) and Gerard's *Herbal* (1597).

Romanino, Girolamo

(1484/7–1559/61), Italian painter, a native of Brescia and a contemporary of MORETTO DA BRESCIA. The influence of GIORGIONE on his style was so marked that problems of attribution arise. His surviving religious paintings include the *Enthroned Madonna with Saints and Angels* (Museo Civico, Padua) and *St Matthew and the Angel* (San Giovanni Evangelista, Cremona). His finest work is a mythological cycle of frescoes in the Castello del Buon Consiglio in Trento.

Romano, Gian Cristoforo

or Giovanni Cristoforo Ganti (*c*.1465–1512), Italian sculptor, born in Rome, where he trained in the studio of Andrea BREGNO. He subsequently worked in a series of north Italian cities. In Milan he carved the tomb of Gian Galeazzo Visconti for the Certosa di Pavia (1493–7) and executed a sculpted portrait of Francesco Sforza (Bargello, Florence); in Mantua he executed a marble bust of Isabella d'Este (Louvre); in Urbino he sculpted Federico da Montefeltro (Bargello, Florence).

Roritzer

or Roriczer family, a dynasty of German architects in fifteenth- and early sixteenth-century Regensburg, where they built the cathedral; Wenzel, the first master mason, died in 1419 and was succeeded by his son Konrad (*c*.1419–1477) and his grandson Mathäus (d. 1495). The family also contributed to the Frauenkirche in Munich, the Lorenzkirche in Nuremberg, and the Stefansdom in Vienna. In 1486 Mathäus published *Büchlein von der Fialen Gerechtigkeit*, a treatise on Gothic finials, the ornamental pieces (usually in the form of a fleur-de-lis) at the top of canopies and pinnacles. Mathäus was succeeded by his brother Wolfgang, who was executed in 1514, thus bringing the dynasty to an end.

Rosselli, Cosimo

(1439–1507), Italian artist, a native of Florence who trained in the studio of Benozzo GOZZOLI. His surviving paintings include an *Annunciation* (1473, Louvre), frescoes in the cloister of the Church of the SS Annunziata and the Church of

Sant' Ambrogio in Florence, and frescoes in the SISTINE CHAPEL in Rome (1481). His own pupils included Fra BARTOLOMEO and PIERO DI COSIMO.

Rossellino, Antonio

(1427/8–79), Italian sculptor, born in Florence; he was the younger brother of Bernardo ROSSELLINO. His principal surviving work is the tomb of the cardinal-prince of Portugal in San Miniato al Monte (1461–6), Florence. The tomb was admired by Antonio Piccolomini, duke of Amalfi, who commissioned a replica for the Church of Monte Oliveto in Naples to commemorate his wife Maria of Aragon (d. 1470). A terracotta *Madonna and Child*, presumably made in preparation for a now unknown marble statue, is in the Victoria and Albert Museum.

Rossellino, Bernardo

(c.1407/10–1464), Italian architect and sculptor, born in Florence. In the early 1430s he worked as a sculptor in Arezzo, where his surviving work includes a terracotta *Annunciation* in the cathedral and the *Madonna della Misericordia* relief in the tympanum of the Palazzo della Fraternità. His principal work of the 1440s was the architectural tomb of the humanist Leonardo Bruni (1444–50), in Santa Croce, Florence.

In the second half of his career Rossellino worked primarily as an architect. In the 1450s he worked in Rome as *ingegnere di palazzo* to Pope Nicholas V, and on returning to Florence he built the Palazzo Rucellai (to ALBERTI's design) and added the lantern to BRUNELLESCHI's dome on the cathedral.

Rossellino's most important work as an architect and town planner was the remodelling of Pienza (1459–64) for Pope Pius II. Rossellino laid out the piazza (in Florentine style) and a grid of streets; the layout is the earliest example of symmetrical town planning. When Pope Pius and Rossellino died in 1464, only a few houses had been completed, but the project continued, and Rossellino's plans were implemented in the buildings grouped around the Piazza Pio II, including Palazzo Piccolomini and the cathedral.

Rossetti, Biagio

(1447–1516), Italian architect and town planner. He became ducal architect of Ferrara in 1483, and in that capacity designed an extension to the city of Ferrara that trebled the space within the walls; his extension is called the *Addizione Erculea* (Herculean Addition) in honour of his patron Ercole I d'Este. The most important building in the *Addizione* is Rossetti's Palazzo dei Diamanti, which owes its name to the 12,500 diamond-shaped blocks of marble in its façade; it is now the city art gallery. He also designed the principal buildings in the Piazza Nuova: Palazzo Bevilacqua, Palazzo Rondinelli, and his own house, Casa Rossetti. Of the four very different churches that he designed for the *Addizione*, San Cristoforo and San Francesco have been relatively unchanged, but San Benedetto and Santa Maria in Vado have been damaged and rebuilt.

Rosso Fiorentino, Il

or Giovanni Battista di Jacopo (1494–1540), Italian painter, a native of Florence, where he probably trained alongside PONTORMO in the studio of ANDREA DEL SARTO. He worked in Florence (1413–23) and Rome (1423–7) and elsewhere in Italy before accepting the invitation of King Francis I to decorate FONTAINEBLEAU in collaboration with PRIMATICCIO. Their work proved to be very influential, and eventually came to be regarded as the foundation of a style of art known as the School of FONTAINEBLEAU.

The paintings of Il Rosso's Italian period, such as his *Deposition* (1521, Palazzo dei Priori, Volterra) and *Moses and Jethro's Daughters* (1523,

An iron chair made in 1574 by Thomas **Rucker** (see p. 226) for the collection of Rudolf II in Prague and now in Longford Castle, Wiltshire. The Homeric characters at the base (of which four survive and four are missing) inaugurate a series of scenes that represent the history of the Roman Empire from Aeneas to Rudolf II. The wide panel at the back represents a Roman triumph, topped by figures of Nebuchadnezzar and Daniel, between which is a representation of the dream of Nebuchadnezzar, which was understood as a prophecy that the Holy Roman Empire would endure till the Last Judgement. The highest finial on the back of the chair shows the pine-cone device of Augsburg, where the chair was made.

Uffizi), are characterized by distorted figures and daring colour contrasts which combine to create an atmosphere of dramatic intensity. At Fontainebleau Il Rosso was responsible for the decoration of the Galerie François I, which includes the first STRAPWORK, a decorative motif that Il Rosso seems to have invented. The paintings of his French period, such as the *Pietà* executed for Anne de Montmorency (now in the Louvre), have an individualistic style, albeit one adapted to the tastes of the French court.

Rucellai, Bernardo

(1448–1514), garden designer and historian. Rucellai laid out the gardens known in English as the Rucellai Gardens and in Italian as the Orti Oricellari; these gardens, just off the Via della Scala in Florence (between what is now the Via Bernardo Rucellai and the Via degli Orti Oricellari), were famous for their TOPIARY, which was used to create plants shaped as humans, animals (apes, donkeys, and a bear), buildings (porticoes and temples), geometrical shapes, urns, and giants. The gardens later became the setting for an outdoor academy convened by Rucellai's grandson Cosimo; Machiavelli, who was one of the participants, set the dialogues in his *Libro dell'arte della guerra* ('Book of the Art of War', 1521) in the gardens.

Rucker, Thomas

(c.1532–1606), German sword cutler (*Schwertfeger*). The most famous product of his Augsburg workshop is a chair (see p. 225) made in 1574 for the Emperor Rudolf II in Prague and kept in his Kunstkammer. The chair, which is now in Longford Castle (Wiltshire), is made of wrought and chiselled iron, and is decorated with more than 100 reliefs, each of which is enclosed within a strapwork frame.

Ruckers family

Antwerp makers of harpsichords and virginals (1579–1667) including Hans (c.1550–1598), Johannes (1578–1643), and Andreas (1579–after 1645). The quality of their craftsmanship was evident in the beauty of their instruments and the sound they produced. The surviving virginals are rectangular, with one set of strings that runs across the player, who would sit against the long side of the instrument. The harpsichords were set up with two sets of strings, an octave apart. The double manual instruments were constructed with offset keyboards sounding a fourth apart; further complex designs were also present in compound instruments where a virginal was combined with a harpsichord.

Ruggeri, Ugo

(c.1450–c.1508), Italian printer and caster of cannons. He was born in Reggio Emilia and studied law in Bologna, where he became a printer in about 1473; his press published law books in Latin and popular literature in Italian. He also cast cannons for Giovanni Bentivoglio, the ruler of Bologna.

Ruppel, Berthold

(d. 1495), German printer. He was trained in GUTENBERG's workshop in Mainz and in 1464 established the first printing workshop in Basel. One of his most popular publications was an edition of Gregory of Nyssa's *Commentary on Job* (1467).

Rustici, Giovanni Francesco

(1474–1554), Italian sculptor, born into a prosperous family in Florence and trained in the studio of VERROCCHIO. His finest surviving work, which reflects the influence of LEONARDO, is the bronze group *John the Baptist Preaching* (which includes figures of a Levite and a Pharisee) which was mounted in 1515 above the north entrance of the Florentine Baptistery. He also worked in marble (e.g. *Virgin and Child with Infant St John*, Bargello, Florence) and in terracotta (e.g. *Victorious Knight*, Museo Horne, Florence). In 1528 Rustici moved to France at the invitation of Francis I, and remained there for the rest of his life; he died in Tours. No work from his long residence in France is known to have survived.

S

sacra conversazione

A painting in which the Virgin Mary and the infant Jesus are portrayed together with saints; the form is distinguished from the Holy Family (*Sacra Famiglia*), in which the Virgin and Child are accompanied by Joseph and sometimes by other relatives. The *sacra conversazione* became very popular in fifteenth-century Italy, where its exponents included Fra ANGELICO, Giovanni BELLINI, Fra Filippo LIPPI, MANTEGNA, PIERO DELLA FRANCESCA, RAPHAEL, TINTORETTO, TITIAN, and DOMENICO VENEZIANO. The Virgin's role as a divine protector meant that the form was often chosen to acknowledge divine assistance in war, as in Mantegna's *Madonna of Victory* (Louvre) and Titian's *Pesaro Madonna* (Santa Maria dei Frari, Venice), and in recovery from disease, as in HOLBEIN's painting for the burgomaster of Basel (Darmstadt Museum).

When the saint portrayed in a *sacra conversazione* is St Catherine, as in Gérard DAVID's *Sacra Conversazione* (National Gallery, London) and Tintoretto's *Sacra Conversazione* (Palazzo Ducale, Venice), she is represented receiving her wedding ring from the infant Jesus; a painting containing this image is known as a 'Mystic Marriage of St Catherine'.

Sadeler family

A dynasty of Flemish engravers whose huge output consists mostly of reproductions of paintings by other artists rather than original designs. The founder of the family was Johannes (Dutch Jan) Sadeler the Elder (1550–c.1600), a native of Brussels who became a member of the Antwerp guild and later worked in Frankfurt, Munich, Florence, Verona, Rome, and Venice; his brother Raphael the Elder (1560/1–c.1630), a native of Antwerp, accompanied Johannes to Frankfurt. In the next generation, Justus (1583–1620), the son of Johannes, was an engraver and Aegidius (c.1570–1629), a nephew of Johannes, was a painter and engraver who c.1579 accompanied Johannes to Cologne and later travelled to Munich, Antwerp, and Rome. He eventually settled in Prague, where he worked as imperial engraver at the courts of Rudolf II, Matthias, and Ferdinand II. The three sons of Raphael the Elder, Raphael the Younger (1584–1632), Philip (fl. 1620s), and Johannes the Younger (1588–1665), all worked in Munich. Many of the prints produced in the family's workshops are signed only with a single initial, so precise attribution is often problematical.

Sagredo, Diego de

(fl. 1526), Spanish architectural theorist, a chaplain at the court of Queen Juana la Loca (Joanna the Mad) and the author of *Medidas del Romano*, the first Spanish book on Renaissance architecture. The treatise was first published in Toledo in 1526; a French translation, *Raison d'architecture*, followed in 1530. The treatise is a commentary on VITRUVIUS, illustrated with woodcuts, and advocates a return to the purity of the ancient Roman style leavened by an admixture of the Spanish PLATERESQUE.

Sagrera, Guillem

(fl. 1416–50), Catalan architect and decorative sculptor, one of the twelve architects assembled in 1416 to plan the construction of the monumental nave of Girona Cathedral (the widest of any Gothic cathedral in Europe). In 1422 he carved the statues for the Porta del Mirador, the south door of Palma Cathedral in Majorca, and in 1426 he began work on the sculpted decoration for the Merchants' Exchange in Palma. Sagrera left Palma for Naples in 1449, and he was thereafter employed by King Alfonso V on the reconstruction of the Castel Nuovo; the large square hall is Sagrera's finest accomplishment.

Saint-Germain-en-Laye

A royal estate overlooking the Seine at Yvelines, 18 kilometres (11 miles) west of Paris. From 1282 until 1682, when Louis XIV moved the court to Versailles, Saint-Germain-en-Laye was the

summer palace of the kings of France. The twelfth-century castle was built by Louis VI, and, except for the chapel, was destroyed by the Black Prince and rebuilt by Charles V in 1368; in 1539 Francis I commissioned the architect Pierre Chambiges to rebuild the castle, retaining only the chapel (c.1235) and the keep (1368), which he capped with a turret. This is the pentangular building with towers at each of its five corners known as the Old Chateau, and is important as the first flat-roofed building in Europe; the roofs are edged by a stone balustrade surmounted with urns. The Old Chateau was for ten years the childhood home of Mary, queen of Scots; it is now the Museum of National Antiquities.

The New Chateau (Château Neuf) was begun in 1557 by Philibert DELORME at the command of Henri II; Delorme was succeeded by Francesco PRIMATICCIO in 1559, and construction continued for 50 years. Henri II laid out gardens descending in seven terraces linked by staircases to the river below; these gardens were completed by Henri IV, who installed water-driven AUTOMATA (designed by Thomas FRANCINI) depicting mythological figures in the GROTTOES; these automata included GIOCHI D'ACQUA with which the king delighted in spraying his guests. In the Grotte des Flambeaux, special effects created the illusion of a storm with thunder and lightning. The fourth terrace was a promenade that extended at each end towards the river, on the roofs of two galleries that projected out onto the fifth terrace and terminated in twin PAVILIONS; this U-shaped promenade looked down on the Jardins des Dentelles; below this garden the slope was planted with fruit trees. The Château Neuf was the favourite residence of Louis XIII; after his death in 1643 it was neglected, though it served as the residence of Henrietta Maria (daughter of Henri IV and queen of Charles I) from 1645 to 1648. The terraces collapsed in 1661, and were rebuilt by Louis XIV, and new gardens were laid out. The chateau was given to the exiled James II in 1688; it was demolished between 1777 and 1782, and all that remains is the two pavilions: the Pavillon Henri IV is now a hotel, and the Pavillon du Jardinier, now called Pavillon de Sully, is a private residence. The huge terrace promenade survives because it was incorporated into Le Nôtre's redesigned gardens (1663–75).

St Peter's Basilica

or (Italian) Basilica di San Pietro in Vaticano. The first church of Catholic Christendom is named after St Peter because it was erected over the place where he was believed to have been buried. It is called a basilica because of the shape of the original church on the site, an oblong consisting (from west to east) of a porch, an atrium flanked by cloisters, a narthex, and a nave flanked by four aisles; at the east end, behind the altar, the pontifical chair was accommodated in an apse. This church, which is known in English as Old St Peter's, was built c.AD 330 and demolished early in the sixteenth century to make way for its successor.

In the mid-fifteenth century Pope Nicholas V had commanded his architect (ingegnere di palazzo) Bernardo ROSSELLINO to draw up plans for a new church in the form of a Latin cross, but the project was abandoned on the death of Pope Nicholas. It was Pope Julius II who revived the project by commissioning BRAMANTE to design a new church, which was to be shaped like a Greek cross; Pope Julius laid the foundation stone on 18 April 1506. The cost of the building could not be met from current reserves, so in 1516 Pope Leo X issued an indulgence to raise money for the project. In Germany Archbishop Albrecht von Mainz charged Johann Tetzel with the responsibility for preaching the indulgence, the income from which was to be divided between the archbishop and the Vatican. Martin Luther was so scandalized by Tetzel's assurances that cash payments would deliver donors from purgatory that he returned to Wittenberg and issued his 95 Theses. The financing of the new church proved to be the touchpaper of the Reformation.

Bramante died in 1514 and was succeeded by RAPHAEL (d. 1520), Baldassare PERUZZI (d. 1536), Antonio da SANGALLO the Younger (d. 1546), and MICHELANGELO (d. 1564), each of whom modified Bramante's plans as construction proceeded. In 1546, when Michelangelo was appointed as chief architect, he enlarged the plan and redesigned the dome. The dome was completed after Michelangelo's death by Giacomo DELLA PORTA and Domenico FONTANA, who altered his design for a hemispherical dome by making the top of the dome pointed. The two smaller domes were added by Giacomo VIGNOLA. The Egyptian obelisk on the square was erected by Domenico Fontana in 1586.

In the early seventeenth century Carlo Maderno altered Michelangelo's centralized plan by adding a nave (which blocked the view of the dome from the piazza) and a façade on

which work began in 1607. The building was finished in 1614 and consecrated by Pope Urban VIII on 18 November 1626. Gianlorenzo Bernini framed the Piazza di San Pietro with his colonnade between 1656 and 1667.

Salviati

or Francesco de' Rossi (1510–63), Italian painter and friend of VASARI. He was a native of Florence, where he trained in the studio of ANDREA DEL SARTO. He migrated to Rome c.1530 and entered the service of Cardinal Salviati, whose name he adopted. His first important painting, a fresco of the *Visitation* (1538) in the Oratory of San Giovanni Decollato, established his reputation as an artist. In 1539 he travelled to Venice; the subsequent influence of PARMIGIANINO on his paintings may indicate that he visited Parma on his way to or from Venice. He worked for several years (1544–8) for Cosimo I de' Medici on the decoration of the Sala dell'Udienza in the Palazzo della Signoria in Florence. In 1544 he visited France, where he worked for the cardinal of Lorraine, and then returned to Rome, where his principal commission was a set of frescoes in the Palazzo Farnese in Rome depicting the history of the Farnese family. His other commissions included tapestry designs and portraits.

Sambin, Hugues

(1515/20–1601/2), French architect, sculptor, woodcarver, and furniture designer. He was born in Gray (Burgundy) and worked throughout Burgundy, where architects and woodcarvers associated with his Dijon workshop created a distinctive decorative style characterized by fanciful high-relief sculpture (e.g. Maison Milsand, Dijon, c.1561) and intricate rustication (e.g. the Petit Château at Tanlay, c.1568). His principal building was the Palais de Justice in Besançon (1581), and his carved work includes a walnut cupboard of 1570 (now in the Louvre). His Œuvre de la diversité des termes, dont on use en architecture (1572) contains his fine engravings of sculptural forms, especially caryatides.

sampler

A cloth panel worked with various types of stitches in EMBROIDERY. The sampler was a means by which stitches were taught to beginners (usually young girls), and also helped the embroiderers to learn letters and numbers; professional samplers, like pattern books, were a means by which exemplary designs and motifs could be displayed, and it is this sense that is embedded in the word 'sampler'. In the sixteenth century designs were taken from pattern books that were printed in Germany and Italy from the 1520s, in France from the 1580s, and in England from the 1590s.

The sampler first appeared in late fifteenth-century Europe, and so coincides with the emergence of the idea that NEEDLEWORK was an appropriate pastime for women of leisure. Characters such as Hermia and Helena in Shakespeare's *Midsummer Night's Dream* could recall how they had 'with our needles created both one flower, / Both on one sampler'. Of the seven samplers known to survive from the sixteenth century (mostly now in the Victoria and Albert Museum), one is German, one Italian, and five English (including the earliest dated example, made in 1598 and discovered in 1960).

Sánchez Coello, Alonso

(c.1531–1588), Spanish painter of Portuguese parentage, born in Benifaró de Valls (Valencia) and educated in Brussels, where in 1571 he succeeded Antonio MORO as court painter to Philip II. He painted many formal court portraits, including *Joanna of Austria* (1557, Kunsthistorisches Museum, Vienna), *Infante Don Carlos* (c.1558, Prado), and a double portrait of *The Infantas Isabella Clara Eugenia and Catalina Micaela* (c.1575, Prado).

Sánchez Cotán, Juan

(1561–1627), Spanish painter, born near Toledo and trained in the Toledo studio of the STILL LIFE painter Blas de Prado. His early pictures are still lifes of food (especially vegetables), a genre known in Spain as the *bodegón*. His pictures in this genre include *Still Life with Quince, Cabbage, Melon, and Cucumber* (c.1602, Museum of Art, San Diego, California). In 1604 he entered a Carthusian monastery, and thereafter painted religious subjects; between 1615 and 1617 he painted a cycle of pictures illustrating the life of St Bruno and the history of the Carthusian Order for the monastery in Granada, where the pictures remain.

Sangallo, Antonio da, the Elder

(c.1460–1534), Italian architect, born in the Sangallo district of Florence, the son of a woodworker; he was the younger brother of Giuliano da SANGALLO and the uncle of Antonio da SANGALLO the Younger. His best surviving work is

the Church of San Biagio in Montepulciano (1518–45), which is one of the finest centrally planned Renaissance churches; it is loosely modelled on BRAMANTE's plan for ST PETER'S BASILICA, and so takes the form of a Greek cross surmounted by a dome. He also built the Palazzo Nobili-Tarugi and the Palazzo Conducci in Montepulciano.

Sangallo, Antonio da, the Younger

(1484–1546), Italian architect, born in the Sangallo district of Florence; he was the nephew of Giuliano da SANGALLO and of Antonio da SANGALLO the Elder. He was trained by his uncles and then moved to Rome, where by 1503 he was working as a carpenter for BRAMANTE in the workshop of ST PETER'S BASILICA. His earliest building in Rome was probably the Church of Santa Maria di Loreto (c.1507), to which Giacomo del DUCA later added the cupola.

In 1516 Sangallo succeeded his uncle Giuliano da Sangallo as architect of St Peter's Basilica; he held the post for 30 years, and although he made extensive plans (and built an elaborate model which is now in the museum of St Peter's), he built relatively little, and most of what he did build was lost in the redesign of his successor, MICHELANGELO. He designed the interior of the Cappella Paolina in the Vatican and also built the Banco di San Spirito and the Palazzo Baldassini in Rome. His works as a military engineer include fortifications at Florence (notably the Fortezza da Basso, 1534–7) and Rome and the elegant St Patrick's Well (Pozzo di San Patrizio) at Orvieto (1537), which was commissioned by Pope Clement VII to supply the town with water in the event of a siege.

Sangallo's principal patrons were the Farnese family, particularly Cardinal Alessandro Farnese (later Pope Paul III), for whom he designed the Palazzo Farnese in Rome. He was succeeded as architect of the palace (which is now the French embassy) by Michelangelo (till 1564), Giacomo da VIGNOLA (until 1573), and Giacomo DELLA PORTA (till 1589); in 1837 the façade was imitated (but not duplicated) for the Reform Club in London. Sangallo also built the foundations of Villa FARNESE at Caprarola, which was later completed by Vignola.

Sangallo, Giuliano da

(c.1445–1516), Italian architect, military engineer, and sculptor, born in the Sangallo district of Florence, the son of a woodworker. Giuliano

was the elder brother of Antonio da SANGALLO the Elder and the uncle of Antonio da SANGALLO the Younger; he became the favourite architect of Lorenzo de' Medici. The influence of BRUNELLESCHI is apparent in his small church of Santa Maria delle Carceri in Prato (1484–91), which was among the first Renaissance churches to be designed on a Greek cross plan. Sangallo's Florentine buildings include the Palazzo Gondi (begun 1490), the Palazzo Corsi (now the Museo Horne), the sacristy in Brunelleschi's Church of Santo Spirito (1492–4, in collaboration with Il CRONACA), the atrium of Santa Maria Maddalena de' Pazzi (c.1490–5), and a design for the façade of Brunelleschi's Church of San Lorenzo (1516), for which MICHELANGELO also produced designs. Elsewhere in Tuscany, he built the MEDICI VILLA at Poggio a Caiano. His work as a military engineer for Lorenzo de' Medici includes the fortifications at Sarzana and Poggio Imperiale.

In 1514 Sangallo succeeded BRAMANTE as architect of ST PETER'S BASILICA, where he was soon succeeded by his nephew Antonio the Younger. His most important Roman building is the Church of Santa Maria dell'Anima (1514). Sangallo also designed the Palazzo della Rovere (1496) in Savona for the future Pope Julius II; the façade remains, but the rest of the palace is now much altered.

Sanmicheli

or Sanmichele, Michele (c.1487–1559), Italian architect and military engineer, born in Verona, the son of an architect. In about 1500 he moved to Rome, where he may have worked as an assistant to Antonio da SANGALLO the Younger. Within the Papal State he supervised the construction of the central and right gables of the Gothic façade and the campanile of Orvieto Cathedral (1510–24), in which he built the Petrucci Chapel (c.1516), and later worked with Sangallo on the fortifications of Parma and Piacenza (1526).

In 1527 the Sack of Rome ended Sanmicheli's papal patronage; he returned to Verona, where he became a military engineer in the service of the Venetian republic. He designed fortifications for Verona (Porta Nuova, 1539–50; Porta San Zeno, 1547–50; Porta Palio, 1548–9), Venice, and the Venetian dependencies of Corfu, Crete, Cyprus, and the Dalmatian coast; in Venice he built the Forte di San Andrea on the Lido (1535–40), now neglected but in the sixteenth century described by VASARI as one of the most imposing fortresses in Europe.

Sanmicheli was also a designer of palaces. In Venice he built Palazzo Corner-Mocenigo (*c*.1543) and Palazzo Grimani (*c*.1566, now the Court of Appeal), on the Grand Canal. In Verona he built Palazzo Pompei (*c*.1527–57, now the Natural History Museum), Palazzo Canossa (*c*.1530), and Palazzo Bevilacqua (*c*.1530). His Veronese buildings also include the Pellegrini Chapel (*c*.1528) in the Church of San Bernardino, and the round Church of the Madonna di Campagna (1559).

Sano di Pietro

or (formally) Ansano di Pietro di Mencio (1405–81), Italian painter and the head of the largest workshop in fifteenth-century Siena. The workshop produced ALTARPIECES in the style of SASSETTA for village churches near Siena.

Sansovino, Andrea

or Andrea Contucci (*c*.1457–1529), Italian sculptor and architect, born in a Tuscan village near Monte San Savino and trained in the Florentine studio of Antonio POLLAIUOLO. He worked in Portugal from 1491 to 1501, but no work from this period is known to survive. He subsequently moved to Rome, where he sculpted the companion tombs for Cardinal Ascanio Sforza and Cardinal Basso della Rovere (1505–9, Church of Santa Maria del Popolo) and *The Virgin and Child with St Anne* (1512, Church of Sant'Agostino). Sansovino worked from 1513 to 1527 in Loreto, where he was responsible for the sculpture of the shrine of the Holy House (Sanctuario della Santa Casa). The finest surviving example of his architecture is the courtyard of the Palazzo della Signoria in Jesi.

Sansovino, Jacopo Tatti

(1486–1570), Italian architect and sculptor, born in Florence, where he trained in the studio of Andrea SANSOVINO, whose surname he assumed. He lived in Rome from *c*.1505, working as a sculptor and a restorer of antique statues, and in 1517 had a well-publicized quarrel with MICHELANGELO; his principal architectural project in Rome was Palazzo Gaddi.

In 1527 the Sack of Rome forced Sansovino to leave the city, whereupon he moved to Venice, where he was appointed *protomagister* of San Marco (in effect, city architect) in 1529. He began work on the Church of San Francesco della Vigna (to which PALLADIO was to add the façade) in 1534, and in the late 1530s embarked on a series of important buildings now known as the Libreria Vecchia, the Palazzo della Zecca, and the Loggetta. The Libreria Vecchia, which was long known as the Libreria del Sansovino, was built to house the Biblioteca Marciana and now houses the Museum of Archaeology; Palladio praised the building as the finest since classical antiquity. The adjoining Palazzo della Zecca was the mint, which now houses the Biblioteca Marciana. His other buildings in Venice include the façade of the Church of San Giuliano (1553–55), Palazzo Corner della Ca' Grande (*c*.1550, now the seat of the Prefecture), and, on the mainland, Villa Garzoni, Pontecasale (*c*.1530). His best-known sculptures in Venice are the statues of *Mars* and *Neptune* (1550), the 'giants' at the top of Antonio RIZZO's Scala de' Giganti in the Doge's Palace.

Santi, Giovanni

(*c*.1435/40–1494), Italian painter and writer who worked as court painter and chronicler for the ducal court in Urbino. His surviving paintings include a *Madonna* in the Ducal Palace in Urbino and an *Annunciation* in the Brera (Milan). His verse chronicle in 23,000 verses, *La vita e le geste di Federico di Montefeltro* (composed 1484–7), is a history of the dukes of Urbino dedicated to Guidobaldo da Montefeltro; it also contains incidental comments about many contemporary artists in its 'Disputa della pictura' (chapter 91). Santi is now principally known as the father of RAPHAEL.

Santi di Tito

(1536–1602), Italian painter, born in Sansepolcro (Borgo San Sepolcro, Umbria) and trained in the Florentine studio of BRONZINO. He worked in Rome with Federico BAROCCI and Federico ZUCCARO before returning to Florence and establishing himself as a painter of ALTARPIECES for churches such as Santa Maria Novella, Santa Croce, San Salvatore, San Giuseppe, and, in his later years, for churches in the *contado* (dependent territory) of Florence.

Saracchi family

A family of goldsmiths and ROCK-CRYSTAL engravers in late sixteenth- and early seventeenth-century Milan. In the late sixteenth century Giovanni Ambrogio (1540/1–after 1595), the head of the family business from 1579, worked in partnership with his four brothers, Simone (1547/8–before 1595), Stefano (1550/1–before 1595), Michele (after 1550–after 1595), and

Raffaello (*c*.1550–before 1595). The next generation consisted of Giovanni Ambrogio's four sons: Gabriele (who became court jeweller in Mantua in 1617), Pietro Antonio, Gasparo, and Costanzo.

The products of the family workshop, especially engraved rock-crystal vases, were collected by courts in Italy and Germany. Examples of the family's work are preserved in the Pitti Palace in Florence, the Residenzmuseum in Munich, and the Kunsthistorisches Museum in Vienna.

Saraceni, Carlo

(*c*.1579–1620), Italian painter. He was born in Venice, but spent most of his short life in Rome. The influence of ELSHEIMER (whose pupil he may have been) and CARAVAGGIO is particularly apparent in his LANDSCAPES on copper (of which nine survive in the Museo Nazionale in Naples), typically portraying mythological scenes. Saraceni contributed to the decorative frescoes in the Quirinal Palace and also painted altarpieces for Roman churches.

Sassetta, Il

or Stefano di Giovanni (*c*.1400–1450), Italian painter, a native of Siena, where his first recorded work is an altarpiece (now dispersed; panels for the predella are now in the Pinacoteca in Siena, the Vatican, the Museum of Fine Arts in Budapest, and the Bowes Museum in Barnard Castle) for the Arte della Lana Chapel (1423–6). His *Madonna of the Snow* (1432), an early SACRA CONVERSAZIONE, is now in the Pitti Palace in Florence. His most famous work is an altarpiece depicting *The Life of St Francis of Assisi* painted in 1444 for the Church of San Francesco at Sansepolcro (Borgo San Sepolcro, Umbria), of which seven small panels survive in the National Gallery in London and one in the Musée Condé in Chantilly.

Savery, Roelandt

(*c*.1576–1639), Flemish painter and etcher. He was born in Kortrijk (French Courtrai) and worked in the Amsterdam studio of his brother Jacques (and possibly in the court of Henri IV of France) before travelling to Prague (*c*.1604) to enter the service of Rudolf II. He painted many of the animals in the emperor's menagerie (e.g. *Paradise*, in the National Gallery in Prague), and his drawings include a dodo drawn from a living specimen. He travelled with the imperial court in Tirol and the Alps, where he executed many LANDSCAPE paintings and drawings. From 1612 to 1616 he worked in Vienna in the service of the Emperor Matthias, and in 1619 he settled in Utrecht, where he remained for the rest of his life and became a distinguished painter of STILL LIFES, particularly flower paintings in the Flemish tradition.

Savoldo, Giovanni Girolamo

(*fl*. 1506–48), Italian painter, born in Brescia; he trained in Florence and worked principally in Venice. His few surviving paintings, which show the influence of TITIAN, include a *Transfiguration* (Uffizi) and a *Mary Magdalene* (National Gallery, London). His portrait of *Gaston de Foix* (Louvre) uses the device of the double mirror reflection to illustrate the PARAGONE, the debate about the relative merits of painting and sculpture.

Sbarri, Manno di Bastiano

(1536–76), Italian goldsmith, a native of Florence; he may have been trained in the studio of Benvenuto CELLINI. His best-known work is the silver setting of the Cassetta Farnese, a set of rock-crystal panels engraved by Giovanni BERNARDI (1561, Museo Nazionale, Naples). In 1561 Cardinal Alessandro Farnese commissioned a crucifix and a pair of candlesticks for St Peter's Basilica in Rome. Two years after Sbarri's death in 1576, Cardinal Farnese passed the commission for three pieces to Antonio GENTILI, who completed the task (1581) and signed the altar set before it was placed in the sacristy of St Peter's in 1582; the role of each artist in this collaborative work has been the subject of scholarly debate, but Sbarri is usually thought to have been responsible for the figures in the style of MICHELANGELO at the base of each piece.

Scamozzi, Vincenzo

(1548–1616), Italian architect and architectural theorist, born in Vicenza, the son of a builder; he was trained by PALLADIO, whose principal successor he became in northern Italy. His finest early work is the Rocca Pisana, a hilltop VILLA at Lonigo, near Vicenza (1575–8). After Palladio's death in 1580 Scamozzi completed several of his unfinished buildings, including La Rotunda and the Teatro Olimpico (to which he added the permanent stage set) in Vicenza (1583–4) and San Giorgio Maggiore in Venice. His most important independent works are the Procuratie Nuove in Venice (*c*.1584), a Palladian building designed to

complement the style of SANSOVINO's adjoining library, the THEATRE in Sabbioneta (1588), and the Palazzo Trissino (now the Palazzo del Comune) in Vicenza (1592).

Scamozzi's *Discorsi sopra le antichità di Roma* (1582) describes the surviving antiquities of Rome. His influential architectural treatise *L'idea dell'architettura universale* (Venice, 1615) is a defence of Palladian principles which hardly mentions Palladio and an attack on the baroque style; this treatise contained the codification of the architectural ORDERS that was to remain authoritative for centuries.

Scarsellino

or Scarsella, Ippolito (c.1550–1620), Italian painter, draughtsman, and miniaturist, born in Ferrara and trained in Bologna and Venice; he worked in several north Italian towns, but mainly in Ferrara. Large numbers of his paintings survive, including a fine *Nativity* (Brera, Milan) and an allegorical *Fame Conquering Time* (Wadsworth Atheneum, Hartford, Conn.).

Schaffner, Martin

(1477/8–1549), German painter and medallist, a native of Ulm. For most of his career Schaffner specialized in ALTARPIECES, and when the Reformation destroyed that market, he turned to portraiture. His paintings show the influence of Hans BURGKMAIR and Hans SCHÄUFELIN, but also contain Italian elements drawn from LEONARDO DA VINCI. His religious paintings include *Descent into Limbo* (1519, Staatsgalerie, Stuttgart, on loan to Ulmer Museum in Ulm), and his portraits include *Eitel Besserer* (1516, Ulmer Museum) and *Eitel Hans Besserer* (1529–30, Alte Pinakothek, Munich).

Schardt, Jan Joriszoon van der

(c.1530–after 1581), Netherlandish sculptor, born in Nijmegen. He lived in Italy in the 1560s, and in 1569 entered the service of the Emperor Maximilian II in Vienna. In the early 1570s he was often in Nuremberg, and from 1576 to 1579 worked at the Danish court. His best-known works are terracotta busts of the Nuremberg merchant and art collector *Willibald Imhoff* (1570) and his wife *Anna Imhoff* (1581), both now in the Gemäldegalerie in Berlin.

Schäufelin

or Schäufelein, Hans Leonhard (c.1480–1538), German painter and wood engraver, a native of Nuremberg, where he worked in the studio of DÜRER. In 1505 he moved to Augsburg, and later settled permanently in Nördlingen, of which he became a citizen in 1515. The best-known products of his workshop were the illustrations for the *Teuerdank* (1517) of the Emperor Maximilian I. His paintings include ALTARPIECES and other pictures for churches (notably the *Christgärteneraltar* in the Bayerisches Staatsgemäldesammlung in Munich, of which six panels are on loan to the Schaezlerpalais in Augsburg) and civic buildings (notably the fresco of *The Siege of Bethulia* in the Nördlingen Town Hall, 1515). Schäufelin's son Hans the Younger also became an engraver.

Schedoni

or Schidone, Bartolomeo (1578–1615), Italian painter, born near Modena; by 1597 he had moved to Parma, where he spent his career in the service of the Farnese family except for an interlude (1602–6) at the ducal court in Modena, where he executed an emblematical series on *The Life of Coriolanus* in the Palazzo Pubblico. Many of his other paintings survive in the Galleria Nazionale in Parma and the Museo Nazionale in Naples.

Schiavone

or Andrea Meldolla or (Croatian) Andrija Medulić (c.1510–1563), Dalmatian painter, engraver, and etcher, born into an Italian family in Zara (then a Venetian possession, now Croatian Zadar). He settled in Venice, where he painted two of the pictures of philosophers in the Great Hall of the Biblioteca Marciana. He also painted frescoes on the façades of Venetian palaces, but none has survived. Of his panel paintings the best known is *Christ before Herod* (c.1560, Museo Nazionale, Naples).

Schiavone, Giorgio

or (Croatian) Juraj Ćulinović (c.1433/6–1504), Dalmatian painter, born in Sebenico (then a Venetian possession, now Croatian Šibenik); his surname reflects his Slavic origins. Schiavone worked with SQUARCIONE in Padua from 1456 to 1461, during which time he painted the polyptych *Virgin and Child with Saints* (National Gallery, London). He then returned to Dalmatia, where he worked in Zara (now Croatian Zadar) for two years before settling in Sebenico; his paintings for Sebenico Cathedral have been destroyed, but the *Virgin and Child*

Enthroned in the Church of St Louro in Sebenico is probably a late work by Schiavone.

Schickhardt, Heinrich

(1558–1635), German architect, a distinguished exponent of the Italian Renaissance style whose historical importance is occluded by virtue of the historical accident that none of his buildings survives. He worked with his mentor Georg Beer (d. 1600) on the Neues Lusthaus at Stuttgart (1584–93, since demolished) and in 1590 was appointed as the official architect to Ludwig, duke of Württemberg; he subsequently accompanied Ludwig's nephew and successor, Friedrich I of Mömpelgard, on a protracted visit to Italy (1598–1600).

Schickhardt returned to Germany with an informed understanding of Italian Renaissance architecture and immediately began work on an Italianate wing for Stuttgart Castle (1600–9, destroyed 1777); the extension was a symmetrical building with scores of Tuscan columns. Schickhardt also contributed to the development of town planning by designing the town of Freudenstadt; its many unusual features include an L-shaped church (1601–9) with separate naves for men and women and an altar and pulpit at the corner. The town was destroyed in April 1945 but has been rebuilt from the ashes.

Schöffer, Peter

(c.1425–c.1503), German printer. He was born in Gernsheim (Rhine) and by 1449 was working as a scriptor (i.e. manuscript copyist) in Paris. He later married Dyna (or Christina), the daughter of Johann FUST, and in 1466 succeeded his late father-in-law in his PRINTING business in Mainz. He was, together with GUTENBERG, one of the earliest printers, and he is said to be the first printer to have developed a satisfactory method of stamping matrices.

On 14 August 1457 Schöffer and Fust published the elegant Mainz Psalter, which was the first book to use colours, and in 1462 a two-volume Latin Bible. Their edition of Cicero's *De officiis* (1465) was the first book to contain Greek characters. After Schöffer inherited the business he printed the first book advertisements and the first title pages. His son Johann inherited the business and ran it until his death in 1531; his best-known books are an edition of Johannes Trithemius' *Compendium* and a complete Livy (1518–19).

Schongauer, Martin

(1435/50–1491), German engraver and painter, born in Colmar (Alsace), the son of a goldsmith from Augsburg; except for a brief spell at the University of Leipzig in 1465, he lived in Colmar throughout his life. Schongauer's contemporary reputation as Germany's greatest artist was based on his engravings (which he always initialled), in which he endowed popular religious subjects with the dignity of his lyrical idiom. Of his few surviving paintings, the best known is the *Madonna in the Rose Garden* (or *Virgin and the Rosebush*) of 1473 (Church of St Martin, Colmar). Schongauer's fame attracted the young DÜRER, but by the time he reached Colmar in 1492, Schongauer had died.

Schönsperger, Johann

(1481–1523), German printer in Augsburg. Schönsperger was appointed imperial court printer to Maximilian I, for whom he published a magnificent prayer book (1513) set in a specially designed Gothic type and printed in ten copies on vellum. He also published the emperor's *Teuerdank* (1517).

Schwarz, Hans

(c.1492–c.1522), German medallist and sculptor, born in Augsburg. He was the first German exponent of the portrait MEDAL, an art that had been revived in Italy; the faces of Schwarz's sitters are shown in profile or in three-quarters view, which was the Italian style. His subjects included the imperial councillor Kunz von der Rosen (c.1519), Lucia Dorer (1522), and three members of the Schauderspacher family (1522), Magdalena, her son Georg, and her daughter Ursula.

Schwarz's sculptures, which are usually in low relief, include work for the Fugger family chapel in the Church of St Anne in Augsburg, executed to designs by DÜRER.

Scorel, Jan van

(1495–1562), Dutch painter and humanist, born in Schoorl (near Alkmaar), the son of a priest: an imperial Act of 1541 rescinded his illegitimacy. He worked for a period in 1516–17 in the Utrecht studio of Jan GOSSAERT and in 1519 set out on a journey that was to take him as far as Jerusalem. He stopped for long periods in Speyer, Strassburg, Basel, and Nuremberg and finally reached Venice, where he joined a party of Dutch pilgrims and sailed to Crete, Rhodes,

Cyprus, and Jerusalem; his portraits of *Twelve Members of the Haarlem Brotherhood of Jerusalem Pilgrims* (*c.*1528, Frans Halsmuseum, Haarlem) and his series of Utrecht Pilgrim portraits (Central Museum, Utrecht) are early examples of the Dutch tradition of group portraiture; some sheets from his sketchbook survive in the British Museum. After returning to Venice he travelled to Rome, where he was warmly received by Pope Adrian VI (a native of Utrecht), whose portrait (now lost) he painted. In 1524 Jan returned to Utrecht, where he was appointed a canon and remained for the rest of his life.

Jan van Scorel painted ALTARPIECES (mostly destroyed or lost) which show that while in Rome he had studied antique sculpture and the work of RAPHAEL and MICHELANGELO. His LANDSCAPES are rooted in a Netherlandish tradition, but also show the influence of Italian painting. In addition to painting, Jan van Scorel worked on the restoration of St Mary's Church in Utrecht and cleaned the Ghent altarpiece of Hubert and Jan van EYCK.

Scrots

or Scrotes or Stretes, Guillim (*fl.* 1537–53), Flemish painter. He was court painter to Mary of Hungary (regent of the Netherlands) in 1537 and by 1546 had entered the service of King Henry VIII of England. His paintings include the distorted portrait of King Edward VI in the National Portrait Gallery in London (see ANAMORPHOSIS).

Sebastián de Almonacid

or Sebastián de Toledo (*fl.* 1482–9), Spanish sculptor also known as 'El Maestro Sebastián'. He contributed to the main reredos at Toledo Cathedral, where he or one of his pupils also made the tomb of Álvaro de Luna and his wife (1489). His other Castilian tombs, all in the Flemish late Gothic style, include the splendid tomb of Archbishop Alfonso Carrillo (d. 1482) in the Iglesia Magistral in Alcalá de Henares; the church and the tomb were badly damaged in the Spanish Civil War, but the tomb has been restored and placed in a side chapel.

Sebastiano del Piombo

or Sebastiano Luciani (1485/6–1547), Italian painter, born in Venice, where he initially trained as a musician and then trained as a painter in the studio of Giovanni BELLINI and subsequently became a disciple and friend of GIORGIONE. In 1511 he moved to Rome under the patronage of the banker Agostino Chigi, and lived there for the rest of his life except for a brief return to Venice in 1528–9. In 1531 he was appointed keeper of the seal for the papal curia; he took religious orders, abandoned painting for a comfortable life in the Church, and was thereafter known as 'del Piombo' ('of the lead [seal]').

The paintings of Sebastiano's Venetian youth, such as *Salome* (National Gallery, London), show the strong influence of Giorgione. On arriving in Rome he worked alongside RAPHAEL, PERUZZI, and Il SODOMA on the decoration of Chigi's villa (now known as the Villa Farnesina). He subsequently concentrated on portraiture, a genre in which his painting retained some Venetian features, such as a preference for the half-length portrait (e.g. *Portrait of a Young Woman*, 1512, Uffizi) and the dramatic use of CHIAROSCURO (e.g. *Portrait of a Young Man*, 1514, Uffizi). His finest surviving portraits are those of *Andrea Doria* (Palazzo Doria, Rome) and *Pope Clement VII* (Museo Nazionale, Naples).

Sebastiano was befriended by MICHELANGELO, who assisted him in works such as *The Raising of Lazarus* (1516–18, National Gallery, London), which was painted in competition with Raphael's *Transfiguration* (Vatican); Michelangelo's drawings for the figure of Lazarus are preserved in the British Museum. According to VASARI, Michelangelo also provided the design for Sebastiano's famous *Pietà* (*c.*1520–5, Museo Civico, Viterbo); the influence of Michelangelo is also apparent in the *Holy Family with Donor* (1517–18, National Gallery, London).

secco

(Italian; 'dry'), the term for wall painting executed on plaster that had completely dried; *secco* was thereby distinguished from FRESCO, which was painted on wet plaster. The pigments were applied to the wall either in TEMPERA (which was applied to dry plaster) or suspended in lime-water (which was applied to dampened plaster). In frescoes such as Fra ANGELICO's series in the Convent of San Marco in Florence, *a secco* colours were added to the dried frescoes to delineate points of detail.

Seisenegger, Jakob

(1505–67), German painter, appointed court painter to the Habsburgs in 1531; his principal

patron was Archduke Ferdinand, brother of the emperor. Seisenegger's portrait of *The Emperor Charles V with his Hunting Dog* (1532, Kunsthistorisches Museum, Vienna) was the model for TITIAN's celebrated portrait (now in the Prado in Madrid) which so impressed the emperor that he appointed Titian as his court painter.

self-portraits
See PORTRAITS AND SELF-PORTRAITS.

Sellaio, Jacopo del
See JACOPO DEL SELLAIO.

Serlio, Sebastiano
(1475–c.1554), Italian architect, architectural theorist, and painter, born in Bologna, where he trained with his father as a painter; he subsequently moved to Rome, where he studied architecture and antiquities in the studio of Baldassare PERUZZI. In 1527 Serlio fled the Sack of Rome and settled in Venice, where he lived until 1541, when he moved to France at the invitation of King Francis I to work on FONTAINEBLEAU. Serlio's only known surviving architectural works are a doorway at Fontainebleau (the only surviving portion of a house known as the Grande Ferrare) and the chateau of ANCY-LE-FRANC.

Serlio published the first volume of his monumental treatise *Tutte l'opere d'architettura e prospettiva* in Venice in 1537; this volume, which was book 4 of the planned treatise, was devoted to the architectural ORDERS. Book 3, on antiquities, followed in 1540. While at Fontainebleau he published book 1 (1545, on geometry), book 2 (1545, on perspective), and book 5 (1547, on churches). On being superseded by Philibert DELORME at Fontainebleau, Serlio moved to Lyon, where he wrote book 6 (on domestic architecture); this book was not published, and the first of the two known manuscripts was discovered in 1925. In 1575 the antiquarian Jacopo Strada published book 7, which supplemented the first six books with Serlio's drawings, many of which derive from plans that Serlio had inherited from Peruzzi. An extra book, the *Libro extraordinario* (1551), was devoted to portals.

Serlio's *Architettura* was enormously influential. It was the first treatise to codify the five architectural orders, and diffused the style of BRAMANTE and RAPHAEL throughout Europe.

Translations of parts of the treatise were published in various languages, including Dutch (1539 and 1606), French (1542), Spanish (1563), and English (1611).

Serres, Olivier de
(1539–1619), French Huguenot horticulturist and writer on gardens. He published three books on agriculture, of which the best known was *Théâtre d'agriculture et ménage des champs* (1600), a huge volume on estate management. The agricultural material is based on his experience of managing an estate at Pradel (near Villeneuve-de-Berg), but the material on gardens derives from Claude MOLLET, who supplied diagrams of his PARTERRES at FONTAINEBLEAU, SAINT-GERMAIN-EN-LAYE, and the TUILERIES.

settles
See CHAIRS, SETTLES, AND STOOLS.

Seusenhofer family
A German dynasty of armourers. Konrad Seusenhofer (1450/60–1517), a native of Augsburg, moved in 1504 to Innsbruck, where he established an imperial armoury for Maximilian I. He was succeeded as court armourer by his brother Hans (1470–1555) and Hans's son Jörg (1500/5–80). In the course of the sixteenth century plate armour evolved from a kind of protective clothing to an emblem of rank and standing, and the armour of the Seusenhofer family became increasingly elaborate in its decorative details (see ARMS AND ARMOUR). Examples of Seusenhofer armours are preserved in the Royal Armouries in Leeds, the Kunsthistorisches Museum in Vienna, the Musée de l'Armée (Les Invalides, Paris), and the Metropolitan Museum in New York.

sfumato
In VASARI's account of the development of painting, the transition from early quattrocento paintings in which colours were separated by lines to later paintings by LEONARDO DA VINCI and GIORGIONE in which colours were elided and transitions imperceptible was deemed to have been effected by the use of *sfumato*, a technique (mentioned by Leonardo) analogous to the disappearance of smoke (Italian *fumo*) into the air.

sgraffito
See *GRAFFITO*.

Luca **Signorelli**, *The Casting out of the Wicked*, a scene in *The Apocalypse* (1499–1504) in the Chapel of San Brizio in Orvieto Cathedral. In this scene three armoured archangels are repudiating the fallen angels above a scene of hell. The portrayal of nude figures was influenced by Pollaiuolo's *Battle of the Naked Men* (see p. 83).

Sheldon tapestries

The first professional TAPESTRY workshops in England were established in the early 1560s by William Sheldon (d. 1570) on his estates at Barcheston (Warwickshire) and Bordesley (Worcestershire); after Sheldon's death the ownership of the workshops passed to his son Ralph Sheldon (1537–1613) and his grandson Ralph Sheldon the Younger. The workshops were managed by Richard Hyckes (c.1524–1621) and his son Francis (c.1566–1630), who had been trained in tapestry weaving in the Netherlands.

Of the tapestries that can be shown to be products of the factory, the best known is a set of pictorial maps of English counties centred on Warwickshire (1588, Bodleian Library, Oxford). The most important attributions to the Sheldon factory are the *Judgement of Paris* (Victoria and Albert Museum) and the *Four Seasons* (Hatfield House).

shell cameos

The carving of cameos in sea-shells began in the sixteenth century, when merchants returning from the Caribbean began to import Helmet shells, of which the principal species are the Horned Helmet, the Red Helmet, the King Helmet, and the King Conch. Benvenuto CELLINI's account of his experiments in carving cameos from shells, together with his reflections on ancient shell cameos (which he thought were Roman amulets), constitute the first description of shell cameos. The subjects of these cameos were usually religious; there is, for example, a set of eight German shell cameos in the Victoria and Albert Museum (dated 1571) that depict the lives of Jesus and the Virgin Mary.

Signorelli, Luca

(c.1450–1523), Italian painter, born in Cortona and, according to VASARI, trained in the studio of

PIERO DELLA FRANCESCA. His paintings include a *Flagellation* (*c.*1475, Brera, Milan) and the *School of Pan* (*c.*1490, destroyed in Berlin during the Second World War), both of which depict sculptural figures. His finest surviving work is the fresco series *The Apocalypse* in the Chapel of San Brizio in Orvieto Cathedral; the series was begun in 1447 by Fra ANGELICO and Benozzo GOZZOLI and finished by Signorelli (1499–1504).

Siloé, Diego de

(*c.*1495–1563), Spanish architect and decorative sculptor, born in Burgos; he was the son of the sculptor Gil de SILOÉ. Diego studied in Florence, where he learnt to sculpt in the style of MICHELANGELO and to design buildings in the idiom of the Italian Renaissance.

On returning to Spain Diego embarked on his finest work both as architect and decorative sculptor, the gilded staircase (Escalera Dorada) in Burgos Cathedral, which is modelled on the staircase designed by BRAMANTE to link the terraces of the BELVEDERE COURT; this debt may imply that Diego had worked in Rome as well as Florence while studying in Italy. The staircase is decorated with a profusion of putti and carved heads in the Renaissance manner.

In 1528 Diego succeeded Enrique EGAS as architect of Granada Cathedral, and so embarked on the greatest project of his career. He inherited the Gothic foundations of his predecessor, and daringly decided to impose a vast domed chancel with ribbed vaults over the sanctuary apse; the cathedral was finally completed in 1561.

Diego repeated his idea of a circular domed sanctuary imposed on a rectangular nave in the Church of El Salvador in Úbeda (1536), which was built by Andrés VANDELVIRA. His other important buildings are the tower of Santa María del Campo (1527), near Burgos, the courtyard of the Colegio Fonseca in Salamanca (1529–34), and the Church of San Gabriel in Loja (1552–68); he is also credited with the designs of Guadix Cathedral (1549) and, less certainly, Málaga Cathedral (1538).

Siloé, Gil de

(*fl.* 1486–99), French sculptor and woodcarver in Spain, a native of Orléans. He carved the central section of the façade of the Colegio de San Gregorio (now the Museo Nacional de Escultura) in Valladolid and designed the reredoses for two churches in Burgos (San Gil and San Nicolás) and the tombs (1489–93) of John II and Queen Isabella of Portugal and of their son Prince Alfonso in the Carthusian monastery of Miraflores near Burgos. The style of his sculptures is Gothic, with recollections of Flemish conventions and a marked MUDÉJAR influence. Gil is regarded as the last great exponent of the Gothic in Spain, just as his son Diego de SILOÉ is regarded as one of the earliest exponents of the Renaissance style.

Simone Martini

(*c.*1284–1344), Italian painter, a native of Siena, where he trained in the studio or circle of DUCCIO. His earliest surviving painting is *The Virgin in Majesty* (1315; reworked 1321) in the Palazzo Pubblico in Siena. He may have painted the equestrian portrait (the earliest surviving example of this genre) of the soldier Guidoriccio da Fogliano on the opposite wall (1328); the attribution to Simone has recently become controversial. At an unknown date he painted scenes illustrating *The Life of St Martin* in Lower Church of San Francesco in Assisi.

In 1317 Simone was in Naples, where he painted an altarpiece (Museo Nazionale, Naples) depicting St Louis of Toulouse resigning his crown to his brother Robert of Anjou. He subsequently painted altarpieces for Pisa (1320, Museo Civico, Pisa) and Orvieto (1320, Museo dell'Opera del Duomo), both of which may be collaborations with LIPPO MEMMI, his brother-in-law; Simone and Lippo later signed their collaborative *Annunciation* (1333, Uffizi), painted as an altarpiece for the cathedral in Siena: this was the first altarpiece with a narrative subject in Italian art. In 1340 or 1341 Simone joined the papal court in Avignon, where he painted *Jesus Reproved by his Parents* (1342, Walker Art Gallery, Liverpool) and the frontispiece to the copy of Servius' commentary on Virgil owned by Petrarch (Biblioteca Ambrosiana, Milan), whom Simone met in Avignon.

Sistine Chapel

The principal chapel of the Vatican, so called from the adjectival form of Sisto, the Italian name of Pope Sixtus IV, who in 1473 commissioned the construction of the chapel, which since its completion has been used as the meeting place of the conclave of cardinals during the election of new popes. In 1476 Pope Sixtus commissioned a series of sixteen frescoed scenes

and a frescoed alterpiece; these were painted (1481–3) by BOTTICELLI, GHIRLANDAIO, PERUGINO, PINTURICCHIO, ROSSELLI, and SIGNORELLI. Bartolomeo DELLA GATTA and PIERO DI COSIMO both worked as assistants on the project. The north and south walls still retain six frescoes each; the liturgical frescoes on the east and west walls were later lost (the former, by Perugino, to MICHELANGELO's *The Last Judgement*).

Pope Julius II engaged Michelangelo to paint the ceiling (1508–12); 30 years later Michelangelo returned to paint *The Last Judgement* on the altar wall (1533–41). On ceremonial occasions the side walls were covered by the tapestries commissioned by Pope Leo X, designed by RAPHAEL (whose cartoons are in the Victoria and Albert Museum in London), and woven in Brussels (1515–19). The marble screen and cantoria were made in the workshop of Andrea BREGNO.

Sluter, Claus

(*c*.1360–1406), Netherlandish sculptor. He was born in Haarlem and entered the service of Philip the Bold, duke of Burgundy, for whom he worked on the Chartreuse de Champmol (near Dijon), which was built as a ducal mausoleum and is now a psychiatric hospital; in 1389 he succeeded Jean de Marville as master sculptor. Sluter built the chapel doorway, which contains a complex programme of sculpture, and also constructed the *Calvary*, of which the base, known as the *Puits de Moïse*, survived the despoliation of the French Revolution as a mutilated but magnificent fragment; he also designed the duke's tomb, which was built by Sluter's nephew Claux de WERVE and is now in the Musée des Beaux-Arts in Dijon. In 1404 Sluter retired to the Monastery of Saint-Étienne in Dijon.

Smythson

or Smithson, Robert (*c*.1535–1614), English architect, the most important exponent of the Elizabethan country-house style. He worked as principal mason at Longleat (1568–75) before embarking on his most original building, WOLLATON HALL (1580–8), in Nottinghamshire. This innovative building, which may have derived from a plan by Sebastiano SERLIO, is a single monumental pile organized internally around the two axes which meet in a large central hall; the building is now a natural history museum. Plans and drawings by Smythson (now in the Royal Institute of British Architects in London) show that he designed Worksop Manor (*c*.1585,

now destroyed) in Nottinghamshire, Hardwick Hall (1590–7) in Derbyshire, and Burton Agnes (1601–10) in Yorkshire. Houses attributed to Smythson on stylistic grounds include Barlborough (Derbyshire), Wootton Lodge (Staffordshire), and Fountains Hall (Yorkshire).

John Smythson (*c*.1570–1634), Robert's son, designed several of the buildings at Welbeck Abbey, Nottinghamshire (including the riding school, 1622–3), and most of the buildings at Bolsover Castle (1612–34). His papers (also in the RIBA) include a narrative of a journey to London in 1618.

Sodoma, Il

or Giovanni Antonio Bazzi (1477–1549), Savoyard painter. He was born in Vercelli (which was then in Savoy) and worked in the vicinity of Siena except for a three-year sojourn in Rome (1508–10). VASARI attributed his nickname to pederasty; this may be true, but he also fathered at least two children and enjoyed both civic and ecclesiastical patronage, which implies that Vasari's account of his reputation may be exaggerated.

Il Sodoma painted frescoes in the Olivetan Convent of Sant'Anna in Camprena, near Pienza (1503–4) and in the Abbey of Monte Oliveto Maggiore (1505–8). In Rome, where his painting took on some of the characteristics of RAPHAEL and LEONARDO, he painted a fresco illustrating *The Marriage of Alexander and Roxana* in Agostino Chigi's Roman villa, now known as the Farnesina (1516). After his return to Siena Il Sodoma painted his finest fresco cycle, *The Life of St Catherine* (1526), in the Church of San Domenico in Siena.

Solario

or Solari, Andrea (*c*.1465–*c*.1524), Italian painter. He was a native of Milan and was influenced by LEONARDO DA VINCI, who lived in Milan, with a break of seven years, from 1482 to 1509. His best-known painting is *Madonna with a Green Cushion* (1509), which was once in the collection of Marie de Médicis and is now in the Louvre. Andrea was the younger brother of Cristoforo Solario (*c*.1460–1524), a sculptor and architect who worked for the Sforza in Milan and the Este in Ferrara.

Solario

or Solari, Guiniforte (1429–81), Italian architect and sculptor, born in Milan, the son of Giovanni

Solario (1410–80), the architect of the Certosa di Pavia. Guiniforte was a resolutely Gothic architect, and when he succeeded FILARETE as architect of the Ospedale Maggiore, he completed Filarete's Renaissance building as a Gothic building. He worked on Milan Cathedral and, in succession to his father, on the Certosa di Pavia; he also built the Gothic nave of the Church of Santa Maria delle Grazie (1465–90), which was completed by BRAMANTE.

Solario

or Solari, Pietro Antonio (c.1450–1493), Italian architect and sculptor, the son of Guiniforte SOLARIO; he worked with his father in Milan until 1490, when he moved to Russia, where he designed three of the fortification towers in the Moscow Kremlin (Nikol'skaya, Spasskaya, and Borovitskaya). He collaborated with an otherwise unknown Italian architect called Marco Ruffo on the uncompromisingly Italianate Granovitaya Palata ('faceted palace', so called from its diamond-shaped stone facings) in the Kremlin (1487–91).

Solis, Virgilius

(1514–62), German engraver, book illustrator (especially of bibles), and prolific designer. His Nuremberg workshop produced more than 600 ornamental and figurative prints, many of which were intended for use by German silversmiths in chalices and ewers but were also used for a century after his death by woodcarvers, furniture designers, and decorative artists working in stucco. His large number of children included Virgilius Solis the Younger, who worked as a painter and designer in the court of Rudolf II in Prague, and Nikolaus Solis, a printmaker.

Somer, Paul van

(1576–1621), Flemish portrait painter. He was born in Antwerp and in 1604 established a studio in Amsterdam. In 1616 he settled in London as a court painter. His best-known painting is a portrait of *Queen Anne of Denmark* (1617), which is now in the Royal Collection.

Soncino family

A dynasty of Jewish printers in Germany, Italy, Bohemia, and the Ottoman Empire. The family settled in Soncino (near Cremona) in 1454, and the press was inaugurated by Joshua Solomon (d. 1493) in 1484 with the publication of *Berakhot*, a Talmudic treatise; in 1488 he published the first printed edition of the complete Hebrew Bible.

Joshua's nephew Gershom ben Moses (d. 1534) printed more than 100 Hebrew texts (both sacred and secular) and a similar number of works in Greek, Latin, and Italian; he was an innovator in the nascent field of Hebrew typography and was the first printer to use woodcut illustrations in Hebrew works. He printed books in several Italian cities (including Brescia, Fano, Pesaro, and Rimini) before establishing presses in the Ottoman Empire, first in Thessaloniki (from 1527) and then in Istanbul (from 1530).

Gershom's son Eliezer (d. 1547) inherited his father's business in Istanbul. Eliezer's son Gershom (d. 1562) established a branch of the family business in Cairo. Another branch of the family settled in Prague, where they established a Hebrew press in 1512.

Sorg, Jörg the Younger

(d. 1603), German armour etcher, the son and grandson of Augsburg armourers; his maternal grandfather was Kolman HELMSCHMIED. Examples of armour (see ARMS AND ARMOUR) etched to Sorg's designs are preserved in the Royal Armouries in Leeds, the Kunsthistorisches Museum in Vienna, and the Metropolitan Museum in New York. These armours are not signed, but can be identified from an album of pen and wash drawings (now in the Staatsbibliothek in Stuttgart) that depict 45 armours decorated by Sorg between 1548 and 1563; each armour is marked with the names of the armourer who made it and the owner for whom it was made.

Sperandio, Savelli

(1425–1504), Italian medallist, goldsmith, and sculptor who may have been a native of Mantua. He worked variously in Mantua, Ferrara, Faenza, and Bologna and finally settled in Venice in 1496. He made several portrait MEDALS, notably those of the merchant Bartolomeo Pendaglia and Giovanni II Bentivoglio of Bologna; his best-known sculpture is the terracotta monument to the antipope Alexander V in the Church of San Francesco in Bologna.

Speyer, Johann von and Wendelin von

See JOHANN VON SPEYER.

Spinello

or Spinelli Aretino (1350/2–1410), Italian painter, born in Arezzo and probably trained in Florence. He was primarily a narrative painter of fresco cycles. His four principal cycles were the series on St Benedict for the sacristy of San Miniato al Monte in Florence, on St Catherine of Alexandria for the Church of San Francesco in Arezzo, on SS Ephysius and Potitus for the loggia of the Campo Santo in Pisa (now partly ruined), and on Pope Alexander III in the Palazzo Pubblico in Siena.

Spranger, Bartholomäus

(1546–1611), Flemish painter, born in Antwerp, the son of a wealthy merchant; he trained in several Antwerp studios, notably that of Frans FLORIS. Spranger travelled widely in France and Italy (where he was influenced by the paintings of CORREGGIO and PARMIGIANINO) before settling in Prague in 1581 as court painter to the Emperor Rudolf II. He became a prominent MANNERIST artist whose paintings included many erotically charged nudes; the formality of his compositions, which are often structured as a spiral, seems to derive from Correggio. Spranger's friend Karel van MANDER, whom he had met in Rome, returned to Haarlem as Spranger's avowed disciple, and so many features of Spranger's style became prominent elements in the painting of the Haarlem Academy.

Squarcione, Francesco

(c.1395–1468), Italian painter and tailor, born in Padua, the son of a notary. He worked as a tailor until his mid-thirties, when he became a painter. He is said to have amassed a large collection of antique art while travelling as a young man in Italy and Greece, but no trace of such a collection survives. He trained scores of painters in his workshop (including MANTEGNA) and is regarded as the founder of the Paduan school of painting. No surviving painting is known to represent the unassisted work of Squarcione; the three surviving products of his workshop are a half-length *Madonna* (Gemäldegalerie, Berlin), a damaged polyptych (Museo Civico, Padua), and a fragmentary fresco cycle on *The Life of St Francis* on the exterior of the Church of San Francesco in Padua.

stained glass

Glass dyed with coloured oxides while still in its molten state or (in the sixteenth century) painted on its dried and hardened surface. Stained-glass windows normally consist of pieces of glass of various shapes and sizes held together by a lead framework. From the eleventh century the stained glass of churches was arranged in representational designs, and in the twelfth and thirteenth centuries huge stained-glass windows were installed in the Gothic cathedrals of Europe. In the fourteenth century, advances in the technology of glass meant that the glass panels could be larger, which afforded painters the opportunity of enhancing details of the design with the use of enamels; in this period stained-glass windows began to appear in French houses. The size of the glass panels again increased in the fifteenth century, by which time designs had become the province of fresco painters and domestic installations of stained glass had extended to England, Germany, the Netherlands, and the Swiss Confederation.

In the sixteenth century the technology of glass painting underwent a significant change, in that transparent enamel pigments could be painted onto sheets of clear glass. The finest surviving stained glass of the early sixteenth century is that in the chapel of King's College, Cambridge, which was designed by Dirick VELLERT and made by the glass stainers Bernard FLOWER and Galyon HONE. In the second half of the century, the most remarkable surviving stained glass is the series of windows installed by the CRABETH brothers in St Jans Church in Gouda.

Steenwyck, Hendrick van, the Elder

(c.1550–c.1600), and Hendrick van, the Younger (c.1580–c.1649), Netherlandish painters of architectural views. Hendrick the Elder, who was probably a pupil of Jan VREDEMAN DE VRIES, is said to have been the first painter to develop the painting of church interiors as a distinctive form (e.g. *Interior of a Church*, Musée d'Art Ancien, Brussels). Hendrick the Younger lived from 1617 to 1637 in England, where he painted architectural interiors in the pictures produced by Anthony Van Dyck's studio (e.g. *Charles I* and *Queen Henrietta Maria*, Gemäldegalerie, Dresden).

Stefano da Zevio

or Stefano (di Giovanni) da Verona (c.1375–c.1438), Italian painter, a native of Verona who became a major Italian exponent of the INTERNATIONAL GOTHIC style. His two finest

surviving works are a *Virgin and Child with St Catherine in a Rose Garden* (Castelvecchio, Verona) and an *Adoration of the Magi* (Brera, Milan).

Stethaimer

or Stettheimer, Hans, or Hans von Burghausen (c.1360–1432), German architect who designed churches in a late Gothic style; in his brick 'hall-churches', the aisles are approximately the same height as the naves, and so the naves are lit from the windows of the aisles rather than from above. His tomb in St Martin's, Landshut (Bavaria), lists seven churches which he had built in Landshut and Salzburg, notably St Martin's in Landshut and the chancel of the Franciscan church in Salzburg.

still life

or (Dutch) *stilleven* or (formerly) *stilstaand leven* or *stilliggend leven* or (German) *stillleben* or *stillliegende sachen* or (French) *nature morte*, the term (plural 'still lifes') for a painting of inanimate objects (typically fruit, flowers, dead game, or vessels), usually displayed on a table. From the fifteenth century paintings contained elements of still life, notably GIOVANNI DA UDINE's preparatory studies (later executed as GROTESQUES) of fruit and birds. The earliest still life is sometimes said to be Jacopo de' BARBARI's portrayal (1504) of a dead partridge and a pair of gauntlets (Alte Pinakothek, Munich), but this too may be a preparatory study.

Still life painting became an important part of Dutch and Flemish art. In the sixteenth century painters such as Pieter AERTSEN showed the kitchen of Martha (in the house of Mary and Martha visited by Jesus) piled high with vegetables and kitchenware. By the end of the sixteenth century, the portrayal of a meal on a table (known as a 'banquet piece') had become a popular Netherlandish genre. In Antwerp, the studios of Rubens, Jan BRUEGHEL (who specialized in flowers), and Frans Snyders (who painted animals exuberantly) all produced still lifes, and in the Protestant north, the form often incorporated didactic elements such as the skull and the hourglass, though Catholic Utrecht perpetuated the Flemish tradition of flower painting without any overt moral purpose.

Stimmer, Tobias

(1539–84), Swiss painter, engraver, and book illustrator who designed the paintings and sculptures on the astronomical clock in Strassburg Cathedral. He also painted a large number of Italianate FRESCOES, notably at Haus zum Ritter in Schaffhausen and the Altes Castle (now in ruins) in Hohenbaden, near Baden-Baden. His woodcuts included the illustrations in two books by Paolo Giovio and a new edition of Sebastian Brant's *Narrenschiff* (Basel, 1574).

Stone, Nicholas

(1586/7–1647), English sculptor and mason, born in Devon, the son of a quarryman. In 1606 he travelled to Amsterdam, where he trained in the workshop of Hendrick de KEYSER, whose daughter he married. He returned to England in 1613 and settled in London as a sculptor of TOMBS, notably his effigies of Francis Hollis (d. 1622) in Westminster Abbey (the first English example of a contemporary figure shown in Roman armour) and of John Donne in St Paul's Cathedral (which shows Donne standing in his shroud); his workshop also produced the monuments to Edmund Spenser (1620) and Isaac Casaubon (1634) in Westminster Abbey. The activities of Stone's workshop are well documented, because his Notebook and Account Book survive in Sir John Soane's Museum (London).

In 1619 Stone was appointed master mason of Inigo JONES's BANQUETING HOUSE in Whitehall and in 1632 became the king's master mason, in which capacity he worked on Inigo Jones's portico for St Paul's Cathedral and on the Goldsmiths' Hall, both of which were destroyed in the fire of 1666.

stoneware

or (German) *Steinzeug* or (French) *grès*, pottery made of clay and a fusible stone (usually feldspar) fired at high temperatures to achieve vitrification of the stone (but not the clay). Stoneware is non-porous, and glazing is added only for decorative effect. Stoneware was produced in ancient China, but the technique seems to have been reinvented in the twelfth century in the Rhineland, which remained the principal centre of production until the late seventeenth century, after which it was made in England (Nottinghamshire and Staffordshire) and the Netherlands (Delft). Early modern Rhenish stoneware, which was produced in Cologne, Raeren (near Aachen in what is now Belgium), and Siegburg, was usually covered with a salt glaze: salt (sodium chloride) was thrown into the heated kiln, whereupon the

chlorine evaporated and the sodium combined with the silicates in the pot to form a glaze with a pitted surface. Sixteenth-century Siegburg stoneware was usually white, and typically took the form of *Sturzbecher*, which were drinking-cups in which the stem was shaped as an inverted human head or body. Cologne and Raeren stoneware often had a brown and yellow surface (and so came to be known as tiger ware in England); in Raeren the outstanding craftsmen were members of the MENNICKEN FAMILY. The most distinctive product of the Cologne potteries was the BELLARMINE.

stools

See CHAIRS, SETTLES, AND STOOLS.

Stoss, Veit

or (Polish) Wit Stwosz (*c.*1450–1533), German sculptor and woodcarver, a native of Horb am Neckar (Swabia). He lived from 1477 to 1479 in Kraków, where he carved the vast ALTARPIECE for the Church of Our Lady, which is one of Poland's most important works of art. The central panel dramatically portrays *The Dormition of the Virgin* below *The Assumption of the Virgin*; the figures of the mourning apostles, some larger than life size, are carved in the round, and their faces are highly individual, often with exaggerated gestures and facial expressions. The bodies of his figures are not carved with close attention to human anatomy, but rather as dramatic figures in which light and shade are controlled through the adept use of intricately folded drapery, of which Stoss was a master. He later carved the tomb of King Casimir IV Jagiełło for the Wawel Cathedral in Kraków; the tomb is signed and dated 1492, but as that was the year of Casimir's death, it seems likely that the tomb was sculpted in the course of the next few years.

Stoss returned to Nuremberg in 1489 and worked as a carver and sculptor for the city's churches. He was accused of forging a document, and thereafter his life in Nuremberg was dominated by criminal proceedings. His unpainted limewood carving of *St Roch* (*c.*1523, SS Annunziata, Florence) was proclaimed by VASARI as a 'miracle in wood'.

Straet, Jan van der

or (Italian) Giovanni Stradano (1523–1605), Dutch painter and TAPESTRY designer, born in Bruges and trained as a painter in the Antwerp studio of Pieter AERTSEN. Shortly after becoming a master in the Bruges Guild of Painters in 1545, he moved to Florence, working as assistant to VASARI on the fresco decoration of the Palazzo Vecchio and designing tapestries, including a series of hunting scenes for the MEDICI VILLA at Poggio a Caiano (1567).

strapwork

or rollwork, a decorative pattern in architectural ornamentation consisting of interlacing bands which resemble leather straps or carved fretwork. The earliest use of strapwork is a stucco frieze (1533–5) in the Galerie François I at FONTAINEBLEAU; the frieze was designed by Il ROSSO FIORENTINO as a frame for a group of paintings. Thereafter strapwork decoration, which was typically used in ceilings and funerary ornaments, is associated primarily with designers in the Netherlands (e.g. Cornelius BOS, Cornelius FLORIS DE VRIENDT, and Jan VREDEMAN DE VRIES) and Germany (e.g. Wendel DIETTERLIN). Strapwork was widely used in Elizabethan England and had a long afterlife in both England and America as a motif in furniture decoration, particularly in Chippendale designs.

Strigel, Bernhard

(1460–1528), German painter, born in Memmingen (near Ulm) and trained in the studio of his father and uncle, whom he assisted on their ALTARPIECES for Disentis and Obersaxen. His work in the 1490s was influenced by ZEITBLOM, in whose studio he may have worked. He held several municipal and guild offices in Memmingen, where he continued to paint altarpieces (notably those in the Germanisches Nationalmuseum in Nuremberg and the wings of the Schusseuried altarpiece now in the Gemäldegalerie in Berlin). From 1499 he also worked as a painter in the service of the Emperor Maximilian I, whose portrait he painted many times.

studiolo

See CABINET.

Sustris, Frederich Lambertszoon

(*c.*1540–1599), Italian painter of Dutch descent, born in Padua, the son of Lambert SUSTRIS. After training in his father's studio in Padua, Sustris visited Rome (1560) and for several years lived in Florence (1563–7), where he worked as an assistant to VASARI on the decoration of the Palazzo Vecchio. In 1568 he moved to

Augsburg, initially in the service of Anton Fugger, for whom he worked with other Italian painters on the decoration of the Fugger palace in Munich; only fragments of two interiors survived the Second World War. From 1573 Sustris worked in Landshut and (from 1580) in Munich in the service of Wilhelm von Landshut (later duke of Bavaria), for whom he probably decorated the Jesuit Michaelkirche (1583) in Munich and designed the garden and GROTTO (Grottenhof) of the ducal Residenz (1582–86) in Munich; he also worked with Pieter de WITTE on the decoration of the Munich Antiquarium.

Sustris, Lambert

(*c*.1515/20–*c*.1584), Dutch painter, a native of Amsterdam who by the mid-1540s was living in Venice and working as a painter of landscape backgrounds in the workshop of TITIAN; in 1548 and again in 1550–1 Sustris accompanied Titian to Augsburg, where he painted several portraits, including those of *Hans Christoff Vohlin* and *Veronika Vohlin* (Alte Pinakothek, Munich). He moved to Padua in 1554 and returned some fifteen years later to Venice. The few works that can confidently be assigned to his late Venetian period include *The Bath* (Kunsthistorisches Museum, Vienna).

Swart van Groningen, Jan

(*c*.1500–*c*.1553), Netherlandish book illustrator, painter, and designer of stained-glass windows. He worked in Gouda (from 1522) and later in Antwerp, where he died; his familiarity with the conventions of Venetian art may imply that he visited Venice. Swart made 73 of the 97 woodcuts in the Dutch Bible published in Antwerp in 1528. The most distinctive aspect of his paintings is a penchant for unusual head-coverings, including turbans and high hats. His designs for stained glass include drawings for a series of three windows illustrating the story of Ruth (*c*.1535–40, Albertina, Vienna).

Sweynheym, Konrad

See PANNARTZ, ARNOLD.

Syrlin, Jörg

(*c*.1425–*c*.1491), Swabian woodcarver, a native of Ulm, where he carved the magnificent Gothic choir stalls in the cathedral (*c*.1469–75). The human figures of prophets and sibyls on the bench-ends are not distinguished simply by inscriptions or traditional attributes: they have also been endowed with individual faces, each of which expresses strong emotion.

T

table clocks and tabernacle clocks

The term table clock could now be used to denote any clock that is ordinarily kept on a table, but in the technical language of horology the term refers specifically to spring-driven clocks in gilt-metal cases shaped like drums. In the first half of the sixteenth century, the German and French manufacturers of table clocks designed the drum, which was typically 5 centimetres (2 inches) high, to sit on a flat surface; the dial of these horizontal table clocks was on the top surface and was usually fitted with an hour hand and touch-pins to enable the time to be ascertained at night without the need to strike a light.

In the mid-sixteenth century, the dials began to be moved to the side of the drum, and such clocks were known as tabernacle clocks. French tabernacle clocks typically took the form of a hexagonal tower, whereas German tabernacle clocks usually consisted of a square tower surmounted by an open spire or a pierced dome covering the bell.

tables

The large communal dining table consisting of boards on trestles originated in the practice of north European tribes and was the most common form of dining table from the Middle Ages to the eighteenth century. As such tables became objects of display when not in use, they were sometimes waxed on one surface, and the table top was turned upside down (with the waxed surface facing down) when the table was to be used for eating. Such tables were usually called 'boards' in early modern English, a terminology that survives in phrases such as 'bed and board' and 'board of directors'.

In the fifteenth century furniture-makers revived the design of the Roman table, an oblong or rectangle resting on two upright supports, though they usually used wood rather than marble, as the Romans had done; the marble-topped table was revived in the late sixteenth century and was often inlaid with PIETRE DURE.

The sixteenth-century hall table (i.e. a table designed for use in the hall, the principal room of a house) usually had carved baluster-shaped legs, and sometimes had flaps beneath the surface which could be drawn out to extend its length; such tables were called draw tables. In English houses the nearby serving table, which typically had cupboards below its long, narrow surface, was called a hutch table.

In wealthy households diners sat along one side of the table, leaving the other side free for service. This convention was convenient for artists, who in paintings such as LEONARDO's *Last Supper* were able to depict the faces of everyone at the table. When large tables were used by peasants, however, diners sat on both sides, as in Pieter BRUEGEL's *Peasant Wedding*.

Taccola, Mariano

(1382–before 1458), Italian civil and hydraulic engineer and sculptor, a native of Siena who in 1432 secured the patronage of the Emperor Sigismund, with whom he seems to have served in the campaigns against the Ottomans. Taccola's sketches of civil and military structures (Latin *machinae*) began in 1427 with pictures of bridges and harbour works, and expanded to include both pictures of existing structures and original designs for new ones. In 1449 Taccola collected these drawings into a ten-book treatise, *De machinis libri decem*, which was never printed but nonetheless became very influential. He also wrote an early treatise (*c.*1419) on 'engines' (*De ingeneis*) such as watermills and river works.

Taddeo di Bartolo

(*c.*1363–*c.*1422), Italian painter, born in Siena, where he painted the frescoes in the chapel of the Palazzo Pubblico (1407–14) and in the Palazzo Piccolomini. His paintings include a polyptych (now dismembered) of *The Virgin and Child* and *St Francis Trampling the Vices* (1403) in the Galleria Nazionale dell'Umbria in Perugia.

Talavera de la Reina potteries

The Castilian town of Talavera de la Reina, so called because from the reign of Alfonso XI (1312–50) it was deemed to be the marriage portion of the queens of Castile, became an important centre for the manufacturing of TIN-GLAZED EARTHENWARE in the mid-sixteenth century. In 1562 King Philip II appointed the Fleming Jan FLORIS to make tiles (AZULEJOS) in Talavera for his royal palaces. Four years later Jerónimo Montero, a potter from Seville, was brought by royal command to Talavera to offer tuition in the painting and glazing of pottery. In 1570 the Talavera workshop of Juan Fernández (fl. 1570–1603) received a commission to manufacture 24,800 tiles for the ESCORIAL, and three years later received a supplementary order for 136 vessels (jars, pots, and vases). Tiles from the Fernández workshop are typically decorated with white ACANTHUS leaves set against a blue background, and its early pots and jars are decorated with STRAPWORK and GROTESQUE motifs in yellow and blue, usually set against a white background. Talavera factories also made large pictorial panels for the churches of Castile.

In the early seventeenth century Talavera factories continued to make tiles (notably the order for 102,980 tiles for the Dominican Convent of Porta Coeli in Valladolid) and pots (notably the flower pots made for the palace of the dukes of Lerma in Valladolid), but a new market in domestic tableware was occasioned in 1601 by a sumptuary law restricting the use of table silver; thereafter the Talavera factories made large numbers of plates, jars, ewers, and basins. The industry has survived until the present day.

Talenti, Francesco

(fl. 1325–69), Italian architect, a native of Florence who is first recorded working in Orvieto in 1325, presumably as an assistant to Lorenzo Maitani (c.1275–1330), who was building Orvieto Cathedral. By 1343 Talenti had returned to Florence and was working on the cathedral campanile, to which he contributed the windowed upper storeys. In 1350 he was appointed capomaestro of the cathedral, and in this capacity modified the original plans of ARNOLFO DI CAMBIO, significantly altering, and probably extending, Arnolfo's façade; this façade was destroyed in the sixteenth century.

tapestry

A decorative woven fabric with a pictorial or ornamental design. In wealthy households tapestries were hung on walls and draped over beds and tables; like carpets, they were not used on floors, which were covered with rush matting. In churches tapestries were draped over altars and choir stalls.

In the process of WEAVING tapestries the coloured weft threads were passed alternately over and under the warps; the wefts do not pass from selvage to selvage, but are rather checked by the requirements of the pattern and then battened down so that in the finished product the warps are not visible. Tapestries were woven on high-warp or low-warp looms, and in both cases the weaver worked from the back of the tapestry. A high-warp tapestry (tapisserie de haute lice or lisse) was woven on a upright loom in which the threads were wound on rollers arranged in a vertical row, and the threads were parted manually; the cartoon stood behind the weaver (and so could be checked for points of detail against the design that he had transferred to the warp threads) and on the other side of the loom mirrors were placed to enable the weaver to see the front of the tapestry as he worked. A low-warp tapestry (tapisserie de basse lice or lisse) was woven on a horizontal loom in which the warps were controlled by harnesses attached to treadles; this method was faster and cheaper, but in the hands of all but the most skilled craftsmen the quality of the tapestries was compromised by two problems of visibility: the cartoon, which was placed underneath the warp, was not easily visible, and the front of the tapestry could not be seen at all. Warp threads were typically made of linen or hemp, but wefts, which would be visible in the finished product, were usually wool or even silk, and silver and gold threads were sometimes added to the weft.

The earliest surviving European tapestry was woven in the eleventh century for the Church of St Gereon in Cologne; it is now divided between the Germanisches Museum in Nuremberg, the Musée des Tissus in Lyon, and the Victoria and Albert Museum in London. For the next three centuries, tapestries were produced throughout the German lands, and although many seem to have been woven in monastic workshops, the designs were often secular: the chivalric narratives of the Minnesang were visualized in woven Minneteppiche.

In the last quarter of the fourteenth century Burgundy and France emerged as the most important European centres for the production of

tapestry. Nicolas Bataille produced tapestries for the courts of King Charles V of France and his three brothers, the dukes of Anjou, Berry, and Burgundy. The *Apocalypse* tapestries (1375–9) produced for the duke of Anjou were 152 metres (500 feet) long; most of the set survives in the Musée des Tapisseries in Angers. Between 1387 and 1400, Bataille's workshop produced more than 250 tapestries for his royal patrons.

In 1384 Artois was annexed to the duchy of Burgundy and Arras became an important centre of weaving. Many of its tapestries were exported to England, and the name of the town passed into English as a generic name for tapestry; when Shakespeare's Polonius hides behind the arras, he is hiding behind a tapestry suspended from a ceiling close to a wall. Several important tapestry sets are thought to have been woven in Arras, but the only one known to have been made in Arras is *The Story of St Piat and Eleuthère* (1402) in Tournai Cathedral.

After the sack of Arras in 1477 the Burgundian centre for the manufacturing of tapestries shifted to Tournai (Hainaut), where tapestries had been made since the early fourteenth century. In the fifteenth century the stylistic similarities between tapestries woven in Arras and Tournai make it difficult to attribute tapestries to one centre or another on the basis of style; the four panels of the *Chatsworth Hunts* (Victoria and Albert Museum, London), for example, could have been made in either town. The tapestries of Pasquier GRENIER, however, can confidently be assigned to Tournai. The provenance of a large group of tapestries known as *milles-fleurs* is disputed. These tapestries, which acquired their name from the brightly coloured flowers in the background of the courtly and pastoral scenes which they depict, were woven in the late fifteenth and early sixteenth centuries; they may have been woven at workshops in Tournai, but it is also possible that they are the work of itinerant weavers in the Loire valley or of urban centres such as Brussels. The most famous of the *milles-fleurs* tapestries is the series known as *La Dame à la licorne* (c.1495, Musée de Cluny, Paris). The dominance of Arras and Tournai in the French-speaking lands meant that the tapestry industry in Paris did not recover its ascendancy until the seventeenth century. Elsewhere in France, the only important centre was the temporary workshop established by King Francis I in about 1540 at FONTAINEBLEAU in order to weave one set of

tapestries (now in the Kunsthistorisches Museum in Vienna); the patterns reproduce the decorations on the walls of the Galerie François I at Fontainebleau.

From the early sixteenth century the European tapestry industry was dominated by the factories of Flanders. The most important centres were Brussels, Bruges, Ghent, Lille, Louvain, Oudenarde, and Valenciennes. The OUDENARDE TAPESTRIES were marked with a pair of spectacles; in 1528, BRUSSELS TAPESTRIES first began to include the well-known mark of a shield between two Bs. In the late sixteenth century some Flemish weavers migrated to the northern Netherlands, where the most prominent weaver was Frans Spierinc, whose Delft workshop, founded in 1591, produced tapestries for export to England (such as the *Story of Diana* at Knole) and to the Danish court.

In Italy the manufacturing of tapestries began in the mid-fifteenth century, when Flemish weavers began to work in Milan and Ferrara. In Milan, where a tapestry workshop was established by Francesco Sforza in 1455, the most important surviving product of the workshop is an early sixteenth-century *Caesar Receiving Pompey's Head* (Musée des Arts Décoratifs, Paris). Benedetto da Milano, who trained in the Milan factory, established a workshop in Vigevano, where in the first decade of the sixteenth century he wove a set of *Months* (Museo Castello Sforzesco, Milan) modelled on BRAMANTINO; these are the earliest surviving tapestries to show the influence of Italian Renaissance art. In Ferrara a workshop was established by Leonello d'Este in the mid-1450s; in the mid-sixteenth century this workshop was operated by Hans and Nicolas KARCHER. Nicolas Karcher twice (1539–45, 1553–6) worked in the service of the Gonzaga family in Mantua; this workshop is the likely provenance of the series of *Playing Boys* now divided between the Gulbenkian Museum in Lisbon and the Museo Poldi Pezzoli in Milan. In 1546 Nicolas Karcher founded a workshop in Florence for Duke Cosimo I de' Medici; the first and most important product of this workshop was the sumptuous twenty-piece *History of Joseph* (1546–52) designed by BRONZINO, PONTORMO, and SALVIATI and now in the Palazzo Vecchio in Florence.

In northern Europe buyers were long content to import Flemish tapestries, sometimes in large numbers: King Henry VIII owned more than 2,000 tapestries. The indigenous English

industry began with the SHELDON TAPESTRIES in the sixteenth century and the MORTLAKE TAPESTRIES of the seventeenth century. Denmark also imported Flemish tapestries, but in the 1580s an important set known as the ELSINORE TAPESTRIES was woven in Denmark.

Tè, Palazzo del

A palatial VILLA in Mantua converted from stables between 1525 and 1535 for Federico II Gonzaga, marquis of Mantua; the architect was GIULIO ROMANO. The villa is a single-storeyed square building with a plain exterior that gives little hint of the MANNERIST palace that lies within. The finest room, the Sala di Psiche, is decorated with frescoes by Giulio Romano and Rinaldo Mantovano illustrating the legend of Psyche; other rooms were decorated by GIOVANNI DA UDINE and Francesco PRIMATICCIO.

The three subdued arches of the *cortile d'onore*, the court in which important visitors were received, lead through a richly sculpted and stuccoed loggia to the gardens. The *GIARDINO SEGRETO* and its GROTTO survive, but the original PARTERRES have been replaced with a herb garden; early visitors also reported mock naval battles being fought on two lakes in the garden, both of which have disappeared.

tempera

A kind of paint and method of painting, sometimes called 'distemper' in English and *détrempe* in French; the most common form is egg tempera, in which the pigments of the paint are mixed (or 'tempered') with egg yolks. Tempera was the most common technique for painting wooden panels from the late twelfth to the early sixteenth centuries, by which time it had been superseded by OIL PAINTING. Even after oil painting had become well established, artists such as MICHELANGELO and RAPHAEL continued *pingere a tempera* ('to paint in tempera') as well as oils. The effect of tempera differs from oils in being more vivid and luminous (which suited the hieratic style of trecento painting) and in its restricted colour range, which meant that it could not achieve the naturalistic illusions of oils. When tempera was used for wall painting, it was known as *fresco a secco* (see *SECCO*).

Tempesta, Antonio

(1555–1630), Italian painter and engraver, a native of Florence, where he assisted VASARI in the decoration of the Palazzo Vecchio. He moved to Rome, where he entered the service of Pope Gregory XIII, for whom Tempesta decorated buildings in the Vatican; he also worked in the villas of Tivoli and Caprarola. His engravings, of which almost 2,000 are known, usually depict scenes from mythology, the Bible, and history; his particular skill lay in the depiction of horses, which are often portrayed in battlepieces and hunting scenes.

Terbrugghen

or ter Bruggen, Hendrick Jansoon (1588– 1629), Dutch painter, a native of The Hague who from 1604 to 1614 lived in Italy, where he joined the circle of CARAVAGGIO. He returned to Utrecht in 1616, and together with Gerrit van Honthorst (1590–1656) introduced Caravaggio's style (especially his use of pale colours) into Dutch painting; the two painters are regarded as the founders of the Utrecht School. Of his religious paintings, the best known is *Jacob and Laban* (National Gallery, London); his finest GENRE PAINTINGS are the two pictures of *A Flute Player* (Schlossmuseum, Kassel).

terracotta

or (Latin) *terra cocta* or (French) *terre cuite*, the term (from Italian, meaning 'baked earth') for a red unglazed pottery used mostly for bricks and decorative tiles but also as a medium for sculpture. The term is sometimes used with reference to the glazed earthenware associated with the DELLA ROBBIA workshop in Florence. This oxymoronic sense has developed because Luca della Robbia invented a technique of using vitreous glazes to colour his terracotta sculptures; this 'glazed terracotta', which was impervious to damp and so could be used in outdoor architectural settings, is distinct from the TIN-GLAZED EARTHENWARE which in Italy is known as MAIOLICA.

Terzi

or Tércio, Filippo (1520–97), Italian architect and engineer who moved to Portugal in 1576 to enter the service of King Sebastian I. In 1578 he accompanied the king to North Africa as a captain of artillery, and was present at the battle of El-Ksar el-Kebir, where the king was killed and Terzi was captured. Attempts to ransom Terzi failed, but he escaped and returned to Portugal, where he entered the service of Cardinal-Prince Henrique. His buildings, which include the Church of São Vicente de Fora in Lisbon and

the fortifications north and south of Lisbon, were important influences on later Portuguese architecture, as was the school that he founded for the training of architects.

Terzi

or Terzio, Francesco (c.1523–1591), Italian painter and draughtsman. He was born in Bergamo and as a young man painted a large *Crucifixion* in the Church of SS Bartolomeo e Stefano in Lallo (near Bergamo). In 1551 he became court painter to Ferdinand I (later the Emperor Ferdinand) and spent more than 25 years in the imperial service in Austria and Bohemia. He executed many portraits of the imperial family and associated figures such as Andrea Doria and Ferrante Gonzaga; these portraits are mostly in Schloss Ambras in Innsbruck or the Kunsthistorisches Museum in Vienna.

theatre architecture

The revival of interest in classical drama in the Renaissance led in turn to a growth in theatre building. In sixteenth-century Italy, theatre architecture was based on classical models, most notably in PALLADIO's Teatro Olimpico at Vicenza. First used in 1585, its acting area was backed by a *scaenae frons*, with five openings for entrances and exits, and faced an orchestra space and semicircular seating for the audience. SERLIO, the most important writer on theatre architecture, developed the perspective scenery; his *Second Book of Architecture* was published in French in 1545 and in English in 1611.

Outdoor theatre in England had rather different origins, developing from the *ad hoc* arrangements for plays in innyards, great halls, pageant wagons, and other spaces. Playhouses such as the Globe had a thrust or apron stage surrounded by a courtyard and galleries; there was little or no perspective scenery. Indoor theatres were more influenced by Italian models; the Cockpit Theatre, for instance, on which Inigo JONES collaborated, drew on Jones's findings during his visit to Vicenza.

Theobalds

(pronounced 'tibalds'), a palace and garden near Waltham Cross, in Hertfordshire, built between 1575 and 1585 for William Cecil, Lord Burghley. The two gardens were both square, and were laid out beneath the principal apartments of the house; in this respect they imitated the royal gardens, albeit on a grander scale. The design of the

gardens was probably the work of Cecil and the herbalist John Gerard. The private garden (Privy Garden) to the west, which was overlooked by the rooms of the Cecil family, was laid out in hedges and knots (see KNOT GARDENS). The Great Garden, to the south, which was overlooked by the state apartments, was a garden of more than 1 hectare (2 acres) divided into nine squares, with a FOUNTAIN in the central square. Paul Hentzner, a German traveller who attended Cecil's funeral in 1598, described MAZES, a fountain with a *jet d'eau*, and a semicircular PAVILION with marble busts of the twelve Roman emperors (*Itinerarium Germaniae, Galliae, Angliae, Italiae*, 1612). The canal which surrounded the Great Garden when Hentzner visited was supplemented a few years later by two artificial rivers and a MOUNT.

The palace was dismantled in the seventeenth century, and replaced by four houses, of which one remains (Old Palace House); the site of the gardens is now a park.

Tibaldi

or Pellegrino Pellegrini (1527–96), Italian painter, sculptor, and architect, a native of Bologna who from 1549 to 1553 lived in Rome, where he fell under the influence of MICHELANGELO. On returning to Bologna he painted his finest work, a series of scenes from the *Odyssey* in Palazzo Poggi, which is now part of Bologna University. In the 1560s and 1570s Tibaldi worked as an architect, usually under the patronage of Cardinal Carlo Borromeo, for whom he built the Collegio Borromeo in Pavia (1564), the Jesuit Church of San Fidele in Milan (1569, one year after the construction of the Gesù in Rome), the round Church of San Sebastiano in Milan (1576), and the austere Canonica courtyard of the Archiepiscopal Palace in Milan (commissioned 1565, begun 1572). From 1567 to 1576 he served as principal architect of Milan Cathedral, in which capacity he built the crypt under the choir and erected the barriers between the choir and the ambulatory.

In 1587 Tibaldi travelled to Madrid to supervise the decorative works of the ESCORIAL, to which he contributed sculptural decoration and a series of 46 frescoes in the library. He returned to Milan a few months before his death.

tiles

Glazed pottery tiles were manufactured for use as pavement in the ancient Middle East, but not

in ancient Greece and Rome. The art of making such tiles in early modern Europe was not revived from classical antiquity, but was rather adopted from the Arabic tradition which was transmitted through Portugal and Spain to the rest of Europe. The tiles that embodied both the technology and the designs were the AZULE-JOS of Portugal and Spain, which were exported throughout the Mediterranean. In the fifteenth century, Italian potteries in FAENZA and Naples responded to the importation of Spanish tiles by manufacturing their own MAIOLICA tiles. Italian tiles were made for floors rather than for the decoration of walls, and they differed from *azulejos* in that each tile had a complete design.

Italian techniques facilitated a broader range of colours than was available to Iberian potters, and by the early sixteenth century Italian technology had been carried to Spain and Portugal by potters such as Francisco NICULOSO of Pisa, who opened a pottery in Seville and introduced the idea of a single pictorial design made up of panels of *azulejos*. Such designs were taken up by other potters, including Cristóbal de AUGUSTA and Jan FLORIS DE VRIENDT. The fashion for pictorial tiles spread to Flanders and thence to Friesland and Holland. In these northern centres polychrome was eventually abandoned in favour of the blue monochrome which became associated with Delft, which dominated the European tile industry from the seventeenth to the nineteenth centuries.

Early examples of floor tiles survive in France, notably the twelfth-century tiles in the Basilica (now Cathedral) of Saint-Denis (now a suburb of Paris), but it only became a significant art form in the sixteenth century; the finest example is the tile pavement attributed to Masséot ABAQUESNE and made for the Château d'Écouen (now the Musée de la Renaissance) between 1542 and 1549.

tin-glazed earthenware

Pottery decorated with a technique that originated in the Islamic world and entered medieval Europe through Spain. After the pottery has been fired it is dipped in a glaze consisting of lead and tin oxides mixed with potash. The resultant glaze is white, but may be coloured with designs in pigments derived from metallic oxides. The vessel is then fired again, which fixes the glaze.

Italian tin-glazed earthenware is called MAIOLICA, but in France, Germany, Scandinavia, and Spain it is called FAIENCE, a term derived from the Italian potteries in FAENZA.

Tino di Camaino

(c.1280–1337), Italian sculptor and architect, a native of Siena who worked in Siena, Pisa, Florence, and (from 1324 until his death) Naples. Tino was primarily a carver of tombs, including those of the Emperor Henry VII (of which the surviving portions are in the Museo dell'Opera del Duomo in Pisa), Bishop Orso (Florence Cathedral), and, one of his most important works, Cardinal Riccardo Petroni (Siena Cathedral). The seated effigy of Bishop Orso is the earliest known example, and it is possible that Tino invented this memorial pose. In Naples Tino carved tabernacled tombs for the Angevin court (including Queen Mary of Hungary's tomb in Santa Maria Donna Regina) and worked as an architect on the reconstruction of the Monastery of San Martino.

Tintoretto

or Jacopo Robusti (1519–94), Italian painter, born in Venice, the son of a dyer (Italian *tintore*, hence *tintoretto*, 'little dyer'). Tintoretto's early life is not well documented, but he seems to have trained for a short period in the studio of TITIAN; by 1539 he was established as an independent artist. In 1547 he painted *The Last Supper* (also known as *The Institution of the Eucharist*) in the Church of San Marcuola, and the following year he painted *St Mark Rescuing a Slave* (1548, Accademia, Venice; also known as *The Miracle of the Slave*), one of four paintings commissioned by the Scuola di San Marco; this painting is an early product of Tintoretto's unusual method of composition, whereby he made small wax models of his figures and then experimented with various possibilities for composition and lighting. He sometimes reused these models, which is why Tintoretto's pictures sometimes repeat the same figures but portray them from different angles.

In the 1550s and early 1560s Tintoretto painted *Cain and Abel* (c.1550, Accademia, Venice), *The Discovery of the Body of St Mark* (1562, Brera, Milan), and one of his most famous works, *Susanna and the Elders* (c.1556, Kunsthistorisches Museum, Vienna); variations on the voluptuous nude figure of Susanna appear in *The Liberation of Arsinoë* (1554–6, Gemäldegalerie, Dresden) and *The Origin of the Milky Way* (c.1575, National Gallery, London).

During this period Tintoretto also painted three vast pictures for the Church of Madonna dell'Orto (where he is buried): *The Worship of the Golden Calf* and *The Last Judgement*, on either side of the altar, are 15 metres (50 feet) high; the finest of the three pictures is *The Presentation of the Virgin* (1551), which hangs over the sacristy door.

From 1565 to 1587 Tintoretto worked on a series of more than 50 paintings on biblical themes for the Scuola di San Rocco; excellently restored in recent decades, these paintings provide evidence to counter the tenacious view that MANNERIST art represents a decline from the standards of the High Renaissance, and the series should be valued (as it was by Ruskin) for its grandeur of conception alongside MICHELANGELO's Sistine Chapel ceiling and RAPHAEL's Vatican *Stanze*. During the latter part of his work on the Scuola di San Rocco Tintoretto also worked with VERONESE on the redecoration of the Doge's palace after the fire of 1577. His paintings in the Palace include huge works on *The Siege of Zara* (1584–7) and *Paradise* (1588).

Tintoretto's son Domenico (1562–1635) worked as an assistant to his father and executed many portraits, but the canon of his work is uncertain; Jacopo was commissioned to paint the portrait sequence of 76 doges in the Sala del Maggior Consiglio of the Ducal Palace, but the portraits are substantially the work of Domenico and the Tintoretto studio.

Titian

or (Italian) Tiziano Vecellio (*c*.1489–1576), Italian painter, born in Pieve di Cadore (Veneto); he trained in the Venetian studio of Giovanni BELLINI and subsequently worked on the external decoration of the Fondaco dei Tedeschi as an assistant to GIORGIONE, whose style he emulated so exactly that some paintings (e.g. *Concert champêtre*, Louvre) could be by either artist.

Titian's earliest documented work is a group of three frescoes in the Scuola del Santo in Padua (1511). On returning to Venice, Titian painted the altarpiece of *St Mark with Four Saints* (*c*.1511; now housed in the Santa Maria della Salute) and his first masterpiece, *Sacred and Profane Love* (*c*.1514, Galleria Borghese, Rome). In the ten-year period between 1516 and 1525 Titian painted the works that were to establish him as the principal painter in Venice for the next 50 years. The best-known portrait of this period is *Man with a Glove* (*c*.1520, Louvre).

A series of altarpieces includes his *Assumption* (1516–18, Santa Maria dei Frari, Venice), a *Resurrection* triptych with a magnificent *St Sebastian* (1518–22, SS Nazaro e Celso, Brescia), a *Madonna and Saints with a Donor* (1520, Galleria Comunale Francesco Podesti, Ancona), the *Pesaro Madonna* (1519–26, Santa Maria dei Frari, Venice), and the celebrated *St Peter Martyr* (1525–30, painted for the Venetian Church of SS Giovanni e Paolo but now lost and known only from copies). Secular pictures from this period include allegories, notably *Three Ages of Man* (*c*.1514, National Gallery, Edinburgh), portraits, such as *Flora* (*c*.1515–20, Uffizi) (see plate 6), and three mythological pictures (1518–23) commissioned by Alfonso I d'Este for the Camerino d'Alabastro in the castle in Ferrara: *Worship of Venus* (Prado, Madrid), *Bacchanal* (Prado), and *Bacchus and Ariadne* (National Gallery, London).

In the 1530s the style of Titian's paintings changed: compositions became less flamboyant and more contemplative, and juxtaposed colours were increasingly used to complement rather than contrast. His paintings during this decade include a portrait of Charles V with his dog (1533, Prado), based on one by Jakob SEISENEGGER, a portrait of Doge Andrea Gritti (National Gallery, Washington), and portraits of Francesco Maria della Rovere, duke of Urbino, and of his duchess (1536–8, Uffizi). During this period he also painted the *Presentation of the Virgin* (1534–8, Accademia, Venice), the *Pardo Venus* (*c*.1535–40, Louvre), and the *Venus of Urbino* (*c*.1538, Uffizi).

In the early 1540s Titian painted his *Ecce homo* (Kunsthistorisches Museum, Vienna), a *Crowning with Thorns* (Louvre), and three large ceiling canvases of biblical figures (*c*.1543–4; now in Santa Maria della Salute) for SANSOVINO's Church of Santo Spirito, which was demolished in the late seventeenth century. In 1545 Titian made his only journey to Rome, where his paintings were admired; his *Danaë* (Museo Nazionale, Naples) was praised for its colour, but, according to VASARI, criticized by MICHELANGELO for poor draughtsmanship. While in Rome he painted his unfinished portrait of *Pope Paul III and his Nephews* (Museo Nazionale, Naples). Titian returned to Venice in 1546, and two years later was summoned by Charles V to Augsburg, where he painted two portraits of the emperor: the EQUESTRIAN portrait of Charles at the battle of Mühlberg (Prado) and a seated portrait (Alte Pinakothek, Munich).

In the 1550s Titian's most important patron was Philip of Spain (later King Philip II), of whom he painted several portraits (notably *Philip of Spain in Armour*, 1550–1, Prado) and for whom he painted in 1554 a series of mythological pictures that Titian described as *poesie*, including another *Danaë* (Prado), *Venus and Adonis* (Prado), and *Perseus and Andromeda* (1554, Wallace Collection, London); in the same year he painted *La Gloria* (Prado), a double portrait of the emperor (in his death shroud) and his dead consort, Isabella of Portugal, being presented to God. In 1559–60 Titian executed two more *poesie* for King Philip, the *Rape of Europa* (Isabella Stewart Gardner Museum, Boston) and *Diana and Actaeon* (London, National Gallery). His most important religious picture of this decade was a *Martyrdom of St Lawrence* (Gesuiti, Venice).

In the 1560s and 1570s Titian worked primarily as a studio painter. His own paintings included a second version of the *Martyrdom of St Lawrence* (c.1570, Escorial), a second version of the *Crowning of Thorns* (c.1570, Alte Pinakothek, Munich), the pastoral idyll *Shepherd and Nymph* (c.1570, Alte Pinakothek, Munich), and the *Pietà* (c.1573–6, Accademia, Venice) left unfinished at his death and completed by PALMA GIOVANE.

Toeput, Lodewijk

or Il Pozzoserrato (c.1550–c.1603/5), Flemish painter who moved to Venice in the mid-1570s, and may have seen the fire in the Doge's Palace which he subsequently painted (1577, Museo Civico Bailo Treviso). After periods of residence in Florence (late 1570s) and Rome (1581) Toeput settled in Treviso (Veneto). He was primarily a painter of LANDSCAPES (e.g. *Landscape with a Hermit*, 1601, Alte Pinakothek, Munich). Several of his paintings depict *commedia dell'arte* performances.

Toledo, Juan Bautista de

(d. 1567), Spanish architect, philosopher, and mathematician who studied in Rome, where he may have been the 'Juan Bautista Alfonsis' who assisted MICHELANGELO at ST PETER's. He worked as viceregal architect in Naples before being recalled to Spain in 1559 by King Philip II to serve as royal architect in Madrid. He built the façade of the Church of the Convento de Descalzas Reales in Madrid, and in 1563 began work on the ESCORIAL, for which he drew the ground plan but built only the two-storeyed Patio de los Evangelistas (modelled on SANGALLO's Palazzo Farnese in Rome) and the forbiddingly severe south façade. On his death in 1567 he was succeeded by his assistant Juan de HERRERA, who in completing the building modified the plans, but the basic design is nonetheless that of Juan Bautista de Toledo.

tombs and mausoleums

The tomb re-emerged as an important art form in the eleventh century, when burials began to take place in churches; such tombs took the form of a sarcophagus or of an inscribed slab laid on the church floor. The term 'mausoleum' to denote a tomb of particular magnificence was revived in the Renaissance in allusion to the Mausoleum of Halicarnassus, which survived until 1522 in what is now Bodrum, in Turkey. Tombs were usually made of stone, though ALABASTER was sometimes used in England and BRASS was occasionally used in England and in Germany. In Italy, tombs tended to be attached to a wall, with the sarcophagus mounted within a niche, but in northern Europe they were usually free-standing.

Tombs often included an effigy in which the figure was shown in death as if asleep or, occasionally, as in life. Antonio POLLAIUOLO's tomb of Pope Innocent VIII (1492) in St Peter's Basilica in Rome depicts the pope seated as in life and lying recumbent as in death. In the sixteenth century, the representation typically (as in the French royal tombs at Saint-Denis) took the form of a *gisant*, in which the deceased was shown in death (sometimes as a skeleton or a mouldering corpse), above which was an *orant*, which was a depiction of the deceased as if alive.

In the late Middle Ages, the tombs of important personages were often surmounted by a canopy and the figure of the deceased was attended by small figures of mourners or, at a later stage, by angels. In Italian tombs, sculpted curtains sometimes hang from the canopy, and the curtains are parted by figures standing beside the sarcophagus. The small mourners, who are known as 'weepers', reached their apogee in the work of Claus SLUTER in Dijon (c.1404–11). By the end of the fifteenth century weepers had begun to carry the effigy of the deceased on a slab, and in sixteenth- and early seventeenth-century England and Flanders, the weepers were replaced as bearers by angels (who in the seventeenth century wore Roman armour) or

by representations of the theological virtues (faith, hope, and charity) or the cardinal virtues (prudence, justice, temperance, and fortitude). The number of mourners gradually increased, so that by the sixteenth century the tomb of the Emperor Maximilian I in Innsbruck consists of a sarcophagus (which is empty) surrounded by 24 figures of his ancestors.

In fourteenth-century Italy, tombs began to be erected outside churches, usually mounted on colonnettes in public squares. In 1380 Petrarch's sarcophagus was mounted on the square outside the church in what is now Arquà Petrarca, and the della Scala family tombs were erected between 1277 and 1387 in the churchyard of Santa Maria Anticà in Verona.

The art of the tomb culminated in the early sixteenth century with MICHELANGELO's tombs for the Medici (1521–34) in the Church of San Lorenzo in Florence.

topiary

The art of shaping plants by clipping and training was practised in classical antiquity and revived in the late fifteenth century. The term derives from Pliny the Elder, who used the phrase *topiarium opus* (plural *topiaria opera*) both as a generic term for ornamental gardening and as a specific term for intricate tableaux carved from cypresses to depict fleets of ships, hunting scenes, and various natural and constructed landscapes such as woods, hills, lakes, canals, and streams. Topiary was revived in fifteenth-century Italy. The woodcuts in the *Hypnerotomachia Polifili* (1499) of Francesco Colonna depicted elaborate topiary designs both in geometrical shapes and in representational images of humans, animals, and architectural forms. The most elaborate topiary known to have been executed in Italy was in the Orti Oricellari created by Bernardo RUCELLAI in the late fifteenth century. Among English gardens, the best example of such topiary seems to have been in the Privy Garden at Hampton Court. The topiary described by English writers of the period is chiefly remarkable for the wide range of plants that were clipped and trained: the poet Barnabe Googe mentions in his translation of the *Four Books of Husbandry* (1577) from the Latin of *Rei rusticae libri quatuor* (Cologne, 1570) by Konrad Heresbach (1496–1576) that rosemary was popular with women gardeners, who clipped it in such shapes as carts and peacocks;

John PARKINSON recommends privet, deprecates box as a novelty, and acknowledges the popularity of thrift (sea-pink), hyssop, lavender, germander, and thyme. Francis Bacon, in his essay *Of Gardens* (1625), describes the fashion for topiary cut in juniper; he dismisses representational topiary as childish, but advocates the use of geometrical topiary to define borders ('welts'), and to create shapes such as pyramids and columns. This preference adumbrates the later fashion for what came to be known as 'hortulan architecture'.

Torralva, Diogo de

(c.1500–1566), Portuguese architect, the son-in-law of Diogo ARRUDA. His early buildings, such as the Graça Church in Évora, contain MANUELINE elements but are essentially Italian Renaissance structures. His most celebrated building is the two-storeyed Palladian cloister of the Convento de Cristo in Tomar, in which a Serlian motif (an arch with three openings, the central one arched and wider than the others, so called from its illustration in SERLIO's *Architettura*) is used as an open arcade on the upper floor; the name of the cloister (Claustro dos Felipes) recalls that this was the place where Philip II was proclaimed king after the death of Sebastian I at the battle of El-Ksar el-Kebir. Diogo also designed the apse of the Jeronimite church in the Lisbon district of Belém (1540–41), and the octagonal Church of Nossa Senhora da Consolação in the Dominican convent at Elvas (1543–7) is often attributed to him. Diogo is widely regarded as the leading architect of the Portuguese Renaissance.

Torrentius, Johannes

or (Dutch) Jan Simonszoon van der Beeck (1589–1644), Dutch painter in Haarlem and London who specialized in STILL LIFES and in erotic GENRE scenes. In 1627 he was tried in Haarlem as a suspected Rosicrucian; he was tortured and sentenced to be burnt at the stake, but the sentence was commuted to twenty years in jail. He was freed through the intercession of King Charles I of England, and lived in England from 1630 until c.1641, when he returned to Amsterdam. The only picture that can be attributed to Torrentius with confidence is a *Still Life* organized as an emblem of temperance (1614) which belonged to Charles I and is now in the Rijksmuseum in Amsterdam.

Torrigiano

or Torrigiani, Pietro (1472–1528), Italian sculptor, born in Florence, where he was trained in the Medici sculpture collection by BERTOLDO DI GIOVANNI and later specialized in terracotta statues and busts. He famously broke the nose of MICHELANGELO (who may have been his fellow student) in a fight, and so incurred the obloquy of writers such as CELLINI and VASARI, both of whom vilify Torrigiano. He left Florence for Rome (where he worked in the Borgia apartments in the Vatican in 1493), Bologna, and Siena, becoming a soldier and then travelling to Antwerp in 1509 to enter the service of Margaret of Austria.

In 1511 Torrigiano moved to England, where he was to produce his finest work. He carved the marble and gilt-bronze tomb of King Henry VII and his queen Elizabeth of York in Westminster Abbey (1512), the finest example of Italian Renaissance sculpture in England; he also carved the nearby tomb of Lady Margaret Beaufort, King Henry's mother and the eponym of the Lady Margaret professorships at Oxford and Cambridge. The figures portrayed in his terracotta portrait busts include Henry VII (Victoria and Albert Museum), Henry VIII, and Bishop John Fisher (both in the Metropolitan Museum in New York).

In about 1520 Torrigiano left England for Spain, where he worked in Seville as a sculptor of painted terracotta statues, including *St Jerome* kneeling in penitence and a *Virgin and Child* (both in the Museo de Bellas Artes in Seville). He was arrested and imprisoned by the Inquisition and died in prison, apparently by starving himself to death.

tortoiseshell

The carapace of the hawksbill turtle (*Chelonia imbricata*), which was hunted in the tropical seas of the West Indies and the coast of Brazil, is covered with thirteen overlapping epidermic plates (five in the centre and four on each side). These plates were removed and moulded under heat and pressure, a process which produced a brittle translucent yellow material mottled with brown tints. Tortoiseshell was used as an inlay in furniture and as a veneer for caskets and small boxes.

Tory, Geofroy

(*c.*1480–1533), French humanist printer and woodcut artist. He was born in Bourges and studied in Rome and Bologna. From 1507 to 1515 he taught in Paris and worked as an editor for Henri ESTIENNE, and in 1516 he returned to Rome to study classical remains. On returning to France (*c.*1518) Tory became an exponent of printing in roman founts, and in 1530 he was appointed royal printer and engraver (in which capacity he also designed book bindings).

In 1529 Tory published *Le Champfleury*, a treatise of aesthetics in which he related the proportions of letters of the alphabet to those of the natural world and advocated the use of punctuation marks.

Tottel, Richard

(d. 1954), English stationer and printer. He is the eponym of the so-called 'Tottel's Miscellany', a collection of *Songs and Sonnets* (1557) which contained 40 poems by the earl of Surrey and the major works of Sir Thomas Wyatt. He also published Thomas More's *Dialogue of Comfort* (1553), Surrey's *Aeneid* (1557), and a large number of law books.

Tournes, Jean de

(1504–64), French printer, a native of Noyon who established a printing workshop in Lyon *c.*1540. His books include elegant editions of Petrarch (1550) and Vitruvius (1552). His son and namesake Jean de Tournes the Younger (1539–1615) became a Protestant and in 1585 left Lyon for Geneva, where he re-established the family printing workshop.

Tradescant, John

(*c.*1570–1638), English traveller, gardener, and collector of plants and curiosities, who established a famous physic garden in Lambeth. He was employed by Robert Cecil, for whom he laid out the gardens at HATFIELD HOUSE, and subsequently worked for Lord Wotton and the duke of Buckingham; after the assassination of Buckingham he became royal gardener to Charles I and Henrietta Maria. Aristocratic and royal patronage enabled Tradescant to travel abroad, and he used such journeys to collect new plants. He travelled in the Netherlands and France in 1609 and 1611, and acquired a large collection of trees (mostly fruit trees), 65 of which are portrayed in a manuscript known as 'Tradescant's Orchard', which is now in the Bodleian Library in Oxford. In 1618 he travelled to Archangel with Sir Dudley Digges, and his diary of the voyage ('A Voyage of Ambassade'),

which is also in the Bodleian Library, is the earliest extant account of Russian flora; his trophies included the Siberian larch and the purple geranium (cranesbill). He joined the fleet that blockaded Algiers in 1620–1, and used the occasion to collect North African plants. In 1627 he took part in the siege of La Rochelle, and again returned with a booty of plants, this time including 'sea-stock gillyflower' (*Matthiola sinuata*) and several varieties of rock rose (*Cistus*). Tradescant's membership of the Virginia Company provided yet another conduit for new plants: his North American trophies included spiderwort (*Tradescantia virginiana*), Virginia creeper (*Parthenocissus quinquefolia*), and stag's horn sumach (*Rhus typhina*).

Tradescant's son John (1608–62) succeeded his father as royal gardener at Oatlands; he undertook three voyages to Virginia, which enabled him to add considerably to the range of American plants cultivated in England. His *Museum Tradescantianum* (1656) notes the acquisition of the American cowslip (*Dodecatheon meadia*) and the swamp cypress (*Taxodium distichum*).

The collections of the Tradescants, which included large numbers of curiosities as well as botanical specimens, passed on the death of John the Younger to Elias Ashmole, who gave them to the University of Oxford, where they form part of the foundation collection of the Ashmolean Museum.

trecento

An apheretic form of *mil tre cento* ('one thousand three hundred'), the Italian term for the fourteenth century (13—) and for the art and architecture of the period.

Tribolo, Niccolò

or Niccolò di Raffaello de' Pericoli (1500–50), Italian sculptor and garden designer, a native of Florence. He designed the BOBOLI GARDENS in Florence and the garden of the MEDICI VILLA at Castello. As a sculptor his finest original works were FOUNTAINS, including the Fountain of Hercules and Cacus at Castello; he also copied works by MICHELANGELO (Bargello, Florence).

trompe l'œil

French art-historical term for a painting that deceives the viewer into thinking that represented objects are real. Perspectival *trompe-l'œil* effects could be achieved most effectively with INTARSIA. In the *studiolo* of the Ducal Palace in Urbino, intarsia in some 30 different woods

gives the illusion of cupboards, writing desks, musical instruments, and built-in bookshelves stocked with books (see p. 135). Such deception can rarely be achieved in painting, but illusionistic ceilings such as MANTEGNA's Camera degli Sposi in the Palazzo Ducale in Mantua give the impression that the ceiling is open to the sky, though the viewer always remains aware that the image has been created through art.

Tuileries gardens

or (French) Jardins des Tuileries. In 1563 Catherine de Médicis commissioned a new palace to be built beside the LOUVRE, on a site that had been used to make tiles (French *tuiles*). The palace was never finished, and was eventually burnt in the Commune of 1871, but the gardens still survive, albeit in a French classical form. The gardens were created on the model of Italian gardens between 1564 and 1572; they were destroyed during the siege of Paris (1590–4) and restored by Henri IV between 1594 and 1609. These early gardens were subsumed into the grand design of André Le Nôtre, who rebuilt the gardens for Louis XIV between 1666 and 1671.

The original gardens were laid out in rectangles by Pierre Le Nôtre; each of the three broad paths (*allées*) that separate the rows of rectangles was lined with a different species of tree: fir, elm, and sycamore. Close to the palace the size of the plants diminished, and dwarf shrubs and flowers were laid out in PARTERRES surrounded by trellis-work PAVILIONS and arbours. The lines of this garden were preserved in André Le Nôtre's design, and so survive today in attenuated form, but there is no continuity in the plantings. The rectangular compartments of Catherine's gardens contained features such as FOUNTAINS, a MAZE, and an enormous sundial. Some compartments contained fruit trees, and there were also trees planted *in quincunx* (Latin; 'by fives'), with one tree at each corner and the fifth in the middle; the decussation (if viewed from above) was significant in the numerology of the period, and the feature subsequently appeared in English gardens of the sixteenth and seventeenth centuries. Elsewhere in Catherine's garden there was a ceramic GROTTO decorated with terracotta figures by the potter and naturalist Bernard PALISSY.

Henri IV restored the gardens, and added the Terrace des Feuillants, which runs along what is now the rue de Rivoli. Henri's gardeners, who

included Claude MOLLET and Jean Le Nôtre (father of André and son or nephew of Pierre), planted some 20,000 mulberry trees in the garden (including a double row along the terrace), and introduced silkworms; silk was manufactured in a building in the gardens. The main structural features of Henri IV's gardens were palisades and vaulted trellises (*berceaux*); the palisades were rows of jasmine, judas trees, pomegranate, and quince elaborately clipped into green walls. The main *berceau* was 550 metres (600 yards) long, and ran parallel to the terrace; at the end of each of the eight formal paths running across the garden from the terrace, the *berceau* was broken by a pavilion.

The garden now survives vestigially in the André Le Nôtre design for Louis XIV, in which a terrace was built alongside the river and the parterres were aligned along a central axis which extended beyond the walls of the garden to an avenue which later became the Champs-Élysées.

Tura, Cosimo

or Cosmè (*fl.* 1450–95), Italian painter, the first great painter of Ferrara. He served as court painter to the Este family, for whom he executed wall paintings in the Palazzo Schifanoia (1469–70), now in poor condition. His surviving paintings include *An Allegorical Figure*, a *Virgin and Child Enthroned* (the central panel of an altarpiece), a *St Jerome* (all in the National Gallery in London), and a pair of organ shutters depicting *St George* (1469, Museo del Duomo, Ferrara). The sculpted quality of his paintings evinces a debt to MANTEGNA, Francesco SQUARCIONE, and PIERO DELLA FRANCESCA, but his use of metallic colours and the nervous energy of his painting characterize his individualistic style, which has sometimes been described as a precursor to twentieth-century Expressionism. In 1486 he was dismissed as court painter in favour of ERCOLE DE' ROBERTI, and died in poverty.

typography

See PRINTING.

U

Ubertino, Francesco di
See BACCHIACCA.

Uccello, Paolo
or Paolo di Dono (c.1397–1475), Italian painter, a native of Florence, where he trained in the workshop of GHIBERTI (1407–15); he subsequently worked in Venice as a mosaicist at San Marco. In 1436 Paolo was invited to execute a frescoed equestrian monument to the English *condottiere* Sir John Hawkwood for Florence Cathedral; this fresco, in which the horse is modelled on the ancient bronze horses that surmount the central doorway of San Marco in Venice, demonstrates Paolo's interest in PERSPECTIVE.

In the 1440s Paolo accepted two more commissions from the cathedral, a frescoed clock face depicting the heads of four prophets and designs for stained-glass rondels (depicting a *Nativity* and a *Resurrection*) to be mounted in the drum of BRUNELLESCHI's dome. It may have been in this decade that he painted a fresco of the *Flood* (now damaged) in the cloister of Santa Maria Novella; this picture is a virtuoso demonstration of Paolo's mastery of foreshortening and of complex drawing.

In the 1450s Paolo painted *St George and the Dragon* (c.1455, National Gallery, London) and completed the three large battlepieces (c.1455) painted for the Medici Palace depicting *The Rout of San Romano*, a minor battle in which the Florentines defeated the Sienese on 1 June 1432; the three panels are now divided between the Louvre, the Uffizi, and the National Gallery in London. Paolo's *Hunt in the Forest* (c.1460, Ashmolean Museum, Oxford, see p. 258) testifies to his ability as an evocative painter of animals and to his abiding interest in perspective; in the face of such a painting VASARI's damaging condemnation of Paolo Uccello as an artist excessively preoccupied with geometry and perspective seems unnecessarily harsh.

Udine, Giovanni da
See GIOVANNI DA UDINE.

Uffizi Palace
The Florentine palace designed by VASARI for Grand Duke Cosimo I de' Medici to accommodate the public offices of his administration. Construction began in 1560, and in 1565 Vasari added a corridor over the Ponte Vecchio (which spans the Arno) in order to link the Uffizi with the PITTI PALACE; Bernardo BUONTALENTI later added the loggia. In the 1570s and 1580s the art collection of the Medici family was moved to the Uffizi by Grand Duke Francesco I de' Medici. These collections were expanded by successive grand dukes, and formed the basis of the present collection, which is the world's greatest collection of Italian Renaissance art.

Ugo da Carpi
(fl. 1502–32), Italian painter and wood engraver. He was born in Carpi (near Modena) and became Italy's most important exponent of the CHIAROSCURO WOODCUT. His application of 1516 to the Venetian Senate for a patent on his method of using woodcuts to make PRINTS that seem to be painted may imply that he had invented the process independently of German artists. Many of his prints were designed by PARMIGIANINO (the most prolific chiaroscuro woodcut designer of the Renaissance); Ugo also used drawings of RAPHAEL as the basis of his prints.

Ugolino da Siena
or Ugolino di Nerio (fl. 1317–39), Italian painter whose principal surviving work, an ALTARPIECE of *The Virgin and Child with Saints*, painted for the Church of Santa Croce in Florence, was dispersed in the nineteenth century. There are fragments in private collections, in the National Gallery in London, and in the Gemäldegalerie in Berlin, but substantial parts of the altarpiece have been lost.

Ugolino di Vieri

(*fl.* 1329–80), Italian goldsmith in Siena, the maker of the gilt-brass reliquary of the Sacro Corporale (1337–8) in Orvieto Cathedral. The reliquary, which is shaped like the Gothic façade of the cathedral, is enriched with precious stones and enamel panels; it contains the bloodstained cloth in which the host was wrapped in the Miracle of Bolsena (in 1263 the host bled to reassure a doubting Bohemian priest about the doctrine of transubstantiation). Ugolino's only other surviving work is the reliquary of San Savino (Museo dell'Opera del Duomo, Orvieto), on which he collaborated with Viva di Lando.

Utens, Giusto

(1558–1609), an Italian painter of Flemish origin who between 1599 and 1602 painted a series of lunettes depicting VILLAS with their gardens near Florence; the fourteen lunettes (tempera on canvas) were executed for the *salone grande* of the Villa di Artimino, and are now in the Museo di Firenze Com'era. The paintings emphasize structural patterns, so all trees, for example, are the same height, regardless of age or species, but this artistic failing renders the paintings particularly valuable to historians of villas and gardens, because they preserve intention as well as realization. The Italian gardens depicted in the lunettes include the BOBOLI GARDENS, PRATOLINO, and the MEDICI VILLAS at Castello and Poggio a Caiano.

Uytewael

or Wtewael, Joachim (1566–1638), Dutch painter, born in Utrecht. As a young man he travelled to Flanders, Italy, and France, returning to Utrecht in 1592. He was a MANNERIST in style with a pronounced sense of the dramatic value of contrasting light and shade, and his favoured subjects were biblical and mythological themes. His surviving paintings include *The Deluge* (1592–5, Germanisches Nationalmuseum, Nuremberg) and *Kitchen Scene with the Parable of the Great Supper* (1605; Gemäldegalerie, Berlin).

Paolo **Uccello** (see p. 257), detail from *The Hunt in the Forest* (*c.*1460), in the Ashmolean Museum, Oxford. The bright colours (mostly reds and yellows) of the huntsmen and their animals are set dramatically against the darkness of the forest into which the chase is taking them. The faces of the figures are drawn perfunctorily (and without chins), but the mathematical perspective is markedly sophisticated: the viewer's eye is powerfully drawn past the spatial compartments defined by the tree trunks to the vanishing point at which the fleeing stags are placed.

V

Valckenborch

or Valkenborgh **family**, Flemish painters of LANDSCAPE and GENRE PAINTINGS. Lucas Valckenborch (*c*.1535–1597) joined the guild of his native Mechelen (French Malines) in 1560 and subsequently moved to Antwerp, from which he fled to Aachen in 1565 to avoid persecution as a Protestant. He entered the service of Archduke (later Emperor) Matthias, travelling with him to Linz (*c*.1582), and spent his final years (from 1593) in Frankfurt. His elder brother Marten Valckenborch (1524–1612) fled with Lucas but subsequently returned to Antwerp before leaving for Frankfurt to meet his brother and then travelling to Venice (1602) and Rome (1604).

Both Lucas and Marten painted series of *The Seasons* and both painted genre pictures in the tradition of BRUEGEL. The brothers returned repeatedly to the subject of the Tower of Babel: there are examples by Lucas in the Alte Pinakothek in Munich and the Louvre in Paris and by Marten in the Gemäldegalerie Alte Meister in Dresden.

Vandelvira, Andrés de

(1509–75), Spanish architect, apprenticed to Diego de SILOÉ. He was the last exponent in peninsular Spain of the style of Spanish architecture known as Granadine Renaissance. His masterpiece is Jaén Cathedral (1532–48), which influenced the redesign of Mexico Cathedral by Claudio de ARCINIEGA in 1584 and Francisco BECERRA's designs for the Peruvian cathedrals of Lima and Cuzco. Vandelvira's final building was the Chapel of El Salvador in the Santiago Hospital at Úbeda (1562–75).

Vanni, Andrea

(*c*.1330–1413), Italian painter, a native of Siena, where he held several civic offices. Apart from a period in Naples and Sicily (1384–91), he remained in Siena throughout his life. His most important painting is a portable tryptych originally in Naples and now in the Corcoran Gallery in Washington. The fresco of *St Catherine* in the conventual Church of San Domenico is usually attributed to Andrea.

Vasari, Giorgio

(1511–74), Italian painter, architect, and biographer, born in Arezzo, the son of a potter; he received his first lessons in drawing from Luca SIGNORELLI, to whom he was distantly related. In 1524 his precocity attracted the patronage of Cardinal Silvio Passerini, who was the guardian of the youthful Alessandro de' Medici and his cousin Cardinal Ippolito de' Medici, the nominal joint rulers of Florence; Cardinal Silvio decided to educate the three boys together, so giving Vasari access to the Medici patronage that was to sustain him throughout his life. Vasari subsequently trained as a painter with ANDREA DEL SARTO and as a sculptor with Baccio BANDINELLI; while an apprentice Vasari briefly met MICHELANGELO, whose biographer he was later to become.

In 1555 Duke Cosimo de' Medici appointed Vasari as *capomaestro* of the Palazzo della Signoria (1555), to which he contributed the decoration of several rooms, notably the room now known as the Salone del Cinquecento. His other work in Florence includes the altarpiece of the *Immaculate Conception* in the Church of SS Apostoli and a posthumous portrait of Lorenzo de' Medici (1534, Uffizi). In architecture his most important work in Florence was the UFFIZI PALACE. He also renovated the interiors of the churches of Santa Maria Novella (1565–72) and Santa Croce (1566–84), creating large open spaces in conformity with the prescripts of the Council of Trent.

In Rome Vasari collaborated with Bartolomeo AMMANATI and Giacomo VIGNOLA on the design of

the Villa GIULIA (1551–5). He also decorated the Sala dei Cento Giorni (so named because Vasari took 100 days to paint it) in the Palazzo della Cancellaria and the Sala Regia in the Vatican. In Pisa Vasari designed the Palazzo dei Cavalieri, and in his native Arezzo he decorated his family home (now a museum) and designed the abbey Church of SS Fiora e Lucilla (begun 1566) and the loggias (now known as the Logge Vasariane) on the Piazza Grande.

In 1543 Vasari began to plan a book on the lives of 'the most excellent painters, sculptors and architects', and in 1550 the first edition of *Vite de' più eccellenti architetti, pittori e scultori* was published; a heavily revised and substantially enlarged edition was published in 1568. Vasari's *Vite* was the first narrative history of art, and the model that he proposed has been qualified but never fully dislodged, and continues to exert a powerful influence on the canon of popular and academic taste. Art was reborn in Tuscany in the 1250s and there grew in three stages to a peak of perfection in the sixteenth century. The first stage of the revival, in which artists began to imitate nature, was inaugurated by GIOTTO; the second stage was the fifteenth century, in which the new understanding of perspective and anatomy was inaugurated by MASACCIO; the final stage, in which artists mastered and then surpassed nature, reaching the 'summit of perfection', was the age of LEONARDO DA VINCI, RAPHAEL, and Michelangelo.

Vázquez, Lorenzo

(c.1450–c.1514), Spanish master mason and architect, probably born in Segovia, to whom the earliest Spanish buildings in the Renaissance style are attributed. From 1489 he was employed as a master mason by Cardinal Pedro González de Mendoza, initially at the Colegio de Santa Cruz at Valladolid, which had been started in 1486 and was transformed by Vázquez in 1491 into a Renaissance building with an Italianate frontispiece medallion. His subsequent Mendoza commissions were the palace at Cogulludo (1495), which mingles Renaissance elements with Gothic windows, the palace at Guadalajara (completed before 1507), and (together with Michele Carloni of Genoa) the castle of La Calahorra, near Guadix (1509–12).

Vecchietta

or Lorenzo di Pietro di Giovanni (1410–80), Italian painter, sculptor, and architect, a native of Siena, where he was probably trained in the workshop of Stefano di SASSETTA. His surviving sculptures, such as his *SS Peter and Paul* (1458–62) in the Loggia della Mercanzia, reflect the influence of DONATELLO, who had visited Siena in 1457. His paintings include *St Catherine* (1461/2, Palazzo Pubblico, Siena) and an *Assumption* (1461/2, Pienza Cathedral). His most celebrated work is the bronze ciborium (1467–72) made for the high altar of Santa Maria della Scala in Siena and in 1506 moved to the high altar of Siena Cathedral to replace DUCCIO's *Maestà*. His other great work in bronze is the full-sized *Risen Christ* (1476) now on the high altar of Santa Maria della Scala in Siena.

Veen, Otto van

or (Latin) Vaenius (c.1556–1629), Netherlandish painter, born into a noble family in Leiden. He studied in Italy (c.1575–c.1580) with Federico ZUCCARO and then returned to the Netherlands. He worked in Brussels (from 1585) as court painter to Alessandro Farnese and in 1592 settled in Antwerp, where he became court painter to Albrecht von Habsburg. Otto van Veen's paintings drew heavily on Italian MANNERIST traditions, some features of which he commended to Rubens, who was for a time his pupil. His paintings include *The Mystic Marriage of St Catherine* (1589), an altarpiece commissioned for the Capuchin church in Brussels and now in the Musée d'Art Ancien in Brussels.

Vellert, Dirick

(1480/5–1548), Flemish glass designer, glass painter, etcher, and engraver who worked in Antwerp. He designed several of the windows for the Chapel of King's College, Cambridge, including the great east window; the windows were constructed to Vellert's designs by Galyon HONE. Vellert's own glass painting, which was executed in a markedly Italianate style, includes a set of glass roundels now in the Musée du Cinquantenaire in Brussels.

vellum

(French *velin*) and parchment, the untanned skins of animals which were bathed in lime, scraped, polished with pumice, and stretched before being used as luxurious surfaces for writing or printing or painting (usually for portrait MINIATURES) or as materials for bookbinding. The term 'parchment' normally denotes sheepskin or goatskin, whereas 'vellum' is normally the

softer unsplit skin of a calf, lamb, or kid. In Renaissance Europe particularly sumptuous volumes were printed on white uterine vellum made from the skin of still-born or newly born animals.

Vérard, Antoine

(d. 1513), French printer, probably a native of Tours. He settled in Paris, where his workshop made illuminated manuscripts. In 1485 Vérard became a printer, specializing in illustrated books. He published some 250 books, including many romances, religious works, and translations of classical literature.

verdure tapestries

A type of TAPESTRY woven at various tapestry centres, notably OUDENARDE, from the fifteenth to the eighteenth centuries. Verdure tapestries either depicted a landscape with leafy plants (sometimes with birds and animals) or consisted of a design depicting leaves. Tapestries in which the leaves are larger than they are in life are known as large-leaf verdures.

Vermeyen, Jan Corneliszoon

(c.1500–c.1559), Netherlandish painter and designer of tapestries and engravings, a native of Beverwijk. His long beard occasioned the nicknames Barbalonga and Jan met de Baard. Vermeyen travelled as court painter in the peripatetic courts of Margaret of Austria (1525–9), Mary of Hungary (1530), and the Emperor Charles V, in whose entourage he visited Tunis in 1535; he subsequently designed the twelve tapestries (executed in the PANNEMAKER workshop) that commemorated the campaign. Vermeyen's style as a painter was similar to that of his friend Jan van SCOREL, and it has not always been possible to be certain which of them was the painter of a picture; the Portrait of Evrard de la Marck (Pannwitz Collection, Heemstede, Holland), long attributed to Scorel, is now thought to be by Vermeyen.

Veronese

or Paolo Caliari (1528–88), Italian painter, born in Verona, the son of a sculptor; he was trained as a painter in the studio of a local painter, Antonio Badile (1486–1541). In the early 1550s Veronese moved to Venice, where his first important commission (c.1555) was the decoration of the Church of San Sebastiano, where he was to work intermittently for the next ten years (and where he is buried); he began with the ceil-

ing of the sacristy with paintings of The Coronation of the Virgin and the four evangelists, and then turned to the ceiling of the church (a cycle on Esther and Ahasuerus), the upper choir (two paintings of St Sebastian), the altarpiece (The Virgin in Glory with Four Saints), the doors of the organ (The Purification of the Virgin on the outside and The Pool of Bethesda on the inside), the front of the organ loft (The Nativity), and the chancel (two paintings on The Life of St Sebastian). These exuberantly sensuous paintings, crowded with processions, give San Sebastiano one of the finest interiors in Venice.

In the 1560s Veronese decorated several villas on the mainland, notably PALLADIO's Villa BARBARO in Maser. He also began to paint religious feast scenes, notably his huge Marriage Feast at Cana (1562, Louvre), which was painted for the refectory (now a conference hall) of the monastic Church of San Giorgio Maggiore. A later feast scene, The Last Supper, attracted the unwelcome attention of the Inquisition, before which Veronese was summoned on a charge of irreverence because of his inclusion of figures such as a dog and soldiers; Veronese defended himself successfully, by changing the title of the picture to The Feast in the House of Levi (1573, Accademia, Venice). One of the finest paintings of Veronese's maturity is The Family of Darius before Alexander (c.1570, National Gallery, London).

In his last years the scale of Veronese's commissions (which came from as far away as Prague) meant that he increasingly worked as a workshop painter, assisted in his studio by his sons Gabriele and Carletto and his brother Benedetto Caliari. His last major commission, which he shared with TINTORETTO, was the redecoration of the Doge's Palace after the serious fire of 1577. His finest painting in the palace, executed with his brother, is The Apotheosis of Venice (c.1585) in the ceiling of the Sala del Maggior Consiglio.

Verrocchio, Andrea del

(1435–88), Italian sculptor and painter, born in Florence. He trained initially as a goldsmith and then as a sculptor, possibly in the studio of DONATELLO. His expertise as a metalworker is apparent in his decoration (with ACANTHUS leaves) of the bronze tomb of Piero and Cosimo de' Medici in the Church of San Lorenzo (1470). His bronze sculptures include Boy with a Dolphin (c.1480, Palazzo Vecchio), a David (c.1475, Bargello), and the EQUESTRIAN STATUE of the

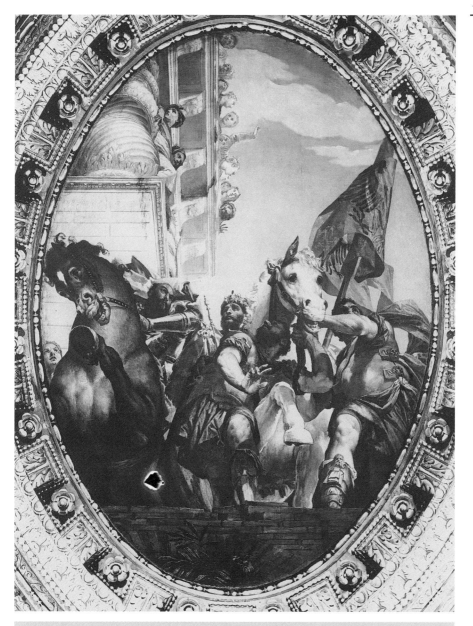

Veronese, *The Triumph of Mordecai*, in the cycle on *Esther and Ahasuerus* (1555–70) on the ceiling of the nave of the Church of San Sebastiano in Venice. This is one of three scenes from the life of Esther painted on the nave ceiling. The painting, which is lit by bright sunlight, is remarkable for its accomplished *di sotto in sù* (literally 'from below upwards') foreshortening. A triumph was the Renaissance (and classical) version of what would now be called a victory parade. In the story of Esther (the Jewish queen of Persia) and Ahasuerus (i.e. King Xerxes of Persia) told in the Book of Esther, Mordecai assisted Esther in the delivery of the Jews from destruction, an event now commemorated in the feast of Purim. In this scene Mordecai rides in triumph through the streets of Babylon.

condottiere Bartolomeo Colleoni in Venice (1470–88); his terracotta works include a fine portrait bust of Lorenzo de' Medici (National Gallery, Washington). Verrocchio's workshop produced many paintings, such as *Madonna and Child with Two Angels* (National Gallery, London), but no surviving painting is known to be the unaided work of Verrocchio. The breadth of Verrocchio's interests and abilities adumbrates that of his most famous pupil, LEONARDO DA VINCI.

Vertue, Robert

(*fl.* 1475, d. 1506) and William (*fl.* 1501, d. 1527), English masons, the sons of Adam Vertue, a mason at Westminster Abbey; Robert became king's master mason in 1487 and William in 1510. In 1501 the brothers were joint master masons of Bath Abbey, and were responsible for the fan vaulting. As king's master masons (together with Robert Janyns and John Lebons) they probably contributed to the vaults of King's College Chapel (which William visited in 1507) in Cambridge, Henry VII's Chapel in Westminster Abbey, and St George's Chapel in Windsor, but their precise role is not documented, even though William was a signatory to the Windsor contract.

Robert Vertue died in 1506, and thereafter William worked alone or with Henry REDMAN, who in 1515 became joint king's mason with William Vertue. He collaborated with Redman on a design for Lupton's Tower (1516) in Eton College (though it is unclear whether theirs was the design that was built) and on the fan-vaulted cloister of St Stephen's Chapel in the Palace of Westminster (*c.*1526). He seems also to have been the architect of St Peter in Vincula in the Tower of London (1512) and of the first two-storey range of buildings at Corpus Christi College, Oxford (1512–18).

Verzelini, Giacomo

(1522–1606), Italian glassmaker who became the most important manufacturer of glass in Elizabethan England. After training in his native Venice, Verzelini worked in Antwerp before moving in 1571 to CRUTCHED FRIARS (London), where he was employed by Jean Carré to make crystal glass in the style of Venetian crystal. The following year he succeeded Carré as the proprietor of the factory and in 1575 Queen Elizabeth awarded him a 21-year monopoly for the manufacture of Venetian-style glass in England; the value of the monopoly was enhanced by the imposition of an import ban on Venetian glass, though the ban proved to be ineffective. He retired to his estate in Kent in 1592.

Verzelini produced large goblets made from soda-lime; the eight surviving examples are engraved with diamond-point ornament, and some are dated (1577–90).

Vianen, Paulus van

(*c.*1570–1613), Dutch silversmith in Munich and Prague, the originator of the AURICULAR STYLE in silver. Paulus was trained in his father's workshop in Utrecht and subsequently worked at the ducal court in Munich (1596–1601), the archiepiscopal court in Salzburg (1601–3), and the imperial court of Rudolf II in Prague (1603–13), where he was court goldsmith. After his death in 1613, his designs were returned to his family in Utrecht, where his brother Adam (*c.*1569–1627) and Adam's son Christiaen (*c.*1600–1667) quickly adopted the Auricular Style. Christiaen worked in the English court of Charles I (1635–9) and subsequently twice returned to England (1652, *c.*1660–6).

Vigarny

or Biguerny, Felipe (*c.*1480–1543), Burgundian sculptor, architect, and medallist in Spain who migrated from his native Langres to Burgos in about 1498. He carved the relief *Christ Bearing the Cross* for the enclosure that surrounds the high altar of Burgos Cathedral and then, together with his partner Alfonso BERRUGUETE, carved the reredos for the Chapel Royal at Granada (1520–1). In 1539 Vigarny and Berruguete worked together on the carving of the upper part of the choir stalls in Toledo Cathedral. His medals include a portrait head of Cardinal Cisneros (now in the Complutensian University in Madrid). The architectural theorist Diego de SAGREDO praises Vigarny's art in his *Medidas del Romano* (1526), particularly in respect of the rule of proportion that he used when carving the human form.

Vignola, Giacomo

or Jacopo Barozzi da (1507–73), Italian architect, garden designer, and architectural theorist. He was born in Vignola (near Modena) and studied painting and architecture in Bologna. In 1530 he settled in Rome, where he became architect to Pope Julius III. He collaborated with Bartolomeo AMMANATI and VASARI on the Villa

GIULIA (1551–5) and in 1559 began work on the Villa FARNESE at Caprarola.

The first of Vignola's Roman churches was the Tempietto di Sant'Andrea, which was built for Pope Julius; this church had the first oval dome in Christendom. Vignola repeated the design on a larger scale in his late Sant'Anna dei Palafrenieri (begun 1573), which was to be extensively imitated by BAROQUE architects. His most influential church was Il Gesù, the mother church of the Jesuit Order, on which work was started in 1568. This is shaped like a Latin cross, and has a broad nave and a large dome area; the façade was added after Vignola's death by Giacomo DELLA PORTA. Il Gesù has been copied in Jesuit churches all over the world, and is probably the world's most imitated church. Its plan also sowed the seeds for the layout of the baroque church of the seventeenth century.

In 1562 Vignola published *Regole delle cinque ordini d'architettura*, which was widely regarded as the definitive codification of the five architectural ORDERS.

villa

A villa is an Italian country house and its estate (including garden spaces), the rural or suburban version of the PALACE (Italian *palazzo*); in practice the two terms overlap: a large villa in the country, such as the Villa FARNESE at Caprarola, is sometimes called a *palazzo* and a grand city house in a garden setting is often called a villa. ALBERTI's revival of the ancient idea of the *villa suburbana* further blurred the distinction, so that the suburban villa of the Gonzaga family on the edge of Mantua is called Palazzo del TÈ, and the Doria villa on the edge of Genoa is called the Palazzo DORIA PRINCIPE. Until 1700 the term 'villa' was used in vernacular languages only of houses in Italy. If the house was small, or small in comparison to the scale of the garden, it was sometimes known as a CASINO.

The revival of the Roman ideal of a house in the country fit for the leisure of the man of letters does not derive from VITRUVIUS, who does not mention the villa, but rather from literary sources such as the letters of Pliny the Younger and from archaeological excavations of ancient villas, such as Hadrian's villa at Tivoli. Pliny's idea of separate summer and winter dining rooms, for example, was implemented in the Villa MADAMA, and the influence of Hadrian's villa can be seen in the Ocean Fountain in the BOBOLI GARDENS and the statuary in the gardens of the Villa D'ESTE at Tivoli.

Early villas were fortified houses with utilitarian designs, but Renaissance architects refined the form, and built elegant houses on hilltop or hillside sites, with views of gardens and distant vistas. The designs of house and garden were fully integrated, and architects contrived to achieve an interpenetration of house and garden.

The first villas to realize the humanist ideal of the retreat for the civilized man were the MEDICI VILLAS at Careggi and Fiesole, both of which provided settings for learned debate. In Rome, the first villa to be built outside the city walls was the Villa Madama, the classical design of which was to prove enormously influential. Of the villas around Rome, the most important were the Villa GIULIA (then on the edge of Rome), the Villa Farnese at Caprarola, the Villa d'Este at Tivoli, the Villa LANTE near Viterbo, the Villa ORSINI at Bomarzo, and the villas of Frascati (including ALDOBRANDINI and MONDRAGONE); within the Vatican, the Villa PIA is a tiny rural retreat in the city.

In the 1520s the influence of Roman villas began to be felt in regions to the north of Rome (there were no significant villas to the south). The most important villas of northern Italy were the Villa PRATOLINO (Tuscany), the Villa BARBARO (Veneto), the Villa CICOGNA (Piedmont), and the Villa BRENZONE (Lombardy).

Villalpando, Francisco Corral de

(d. 1561), Spanish architect and metalworker, born in Palencia into a family of decorative artists working in plaster. In 1548 he built the chancel screen (plated in silver and gold) in Toledo Cathedral in a style that combines Renaissance and PLATERESQUE elements. In 1553 he was appointed as royal architect to Charles V, and in that capacity built the great staircase of the Alcázar in Toledo. He translated from Italian to Spanish two books of SERLIO's *Architettura*: books 3 (on the ORDERS of architecture) and 4 (on the architecture of antiquity).

Vinci, Leonardo da

See LEONARDO DA VINCI.

Vinci, Pierino da

See PIERINO DA VINCI.

Vinckboons, David

(1576–1632), Flemish painter and print designer in Amsterdam, born in Mechelen (French

Malines), the son of a watercolourist. In 1579 the family moved to Antwerp and in 1591 fled the advancing Spanish army and settled in Amsterdam. Vinckboons trained in the studio of his fellow émigré Gillis van CONINXLOO, from whom he inherited an enthusiasm for landscapes peopled by tiny figures. The depictions of peasant festivals in Vinckboons's GENRE pictures show the influence of Pieter BRUEGEL the Elder. Vinckboons sometimes punned on his name by including in his landscapes a finch (*vinck*) in a tree (*boom*).

Vischer Family

A family of Nuremberg sculptors and bronze-founders. The greatest product of their workshop is the bronze shrine mounted over the silver sarcophagus of St Sebaldus (1490) in the Sebalduskirche in Nuremberg. The initial design (now in the Gemäldegalerie in Vienna), which was prepared by Peter Vischer the Elder (c.1460–1529) in 1488, shows a three-bayed BALDACCHINO sheltering the sarcophagus. By the time the shrine was constructed (1508–19) the Italian experience of his sons Hermann the Younger (c.1486–1517) and Peter the Younger (1487–1528)—and their influence on their brother Hans (c.1489–1550)—meant that Renaissance elements were introduced: the canopy is Gothic, as are the figures of the apostles, but the base and the baldacchino depict biblical and mythological figures in a Renaissance idiom.

Hermann Vischer the Elder (*fl.* 1453, d. 1488) was responsible for the bronze font in the Stadtkirche in Wittenberg. His son Peter the Elder contributed the bronze figures of Theodoric and King Arthur to the tomb of the Emperor Maximilian I in Innsbruck (1513). Hans Vischer may have been the designer of the Apollo FOUNTAIN (1523) in the courtyard of the old Town Hall (Altes Rathaus) in Nuremberg; the figure of Apollo, which derives from an Italian engraving, is the earliest surviving freestanding nude to have been cast outside Italy. Hans was certainly responsible for three tombs in the Wittenberg Schlosskirche, including the tomb of the Elector Friedrich III (1527), and for reliefs in the Fugger Chapel in Augsburg. Hans's son Georg Vischer (c.1520–1592) specialized in small decorative bronzes such as inkwells.

Vitruvius in the Renaissance

The Roman architect and military engineer Vitruvius (*fl.* 46–30 BC), who in the Renaissance was identified as Marcus Vitruvius Pollo, was in his own time a minor figure known to have designed the basilica (now lost) at Fanum Fortunae (later Colonia, now Fano). In retirement he wrote the architectural treatise *De architectura*, which centuries later, as the only surviving ancient text on any of the visual arts, became the founding text of Renaissance architecture. The ten books of *De architectura* deal with town planning (1), building materials (2), temples, architectural ORDERS, and the rules of proportion (3 and 4), secular civic buildings (5), domestic buildings (6), pavements and decorative plaster (7), water supplies (8), the mathematical sciences of geometry, mensuration, and astronomy (9), and civic and military machines (10).

De architectura never disappeared entirely from public view, but in the fifteenth century it re-emerged as an important record of antiquity. In 1414 Poggio Bracciolini's discovery in St Gallen of a manuscript of *De architectura* excited considerable interest in learned circles. ALBERTI and FRANCESCO DI GIORGIO drew on the treatise for both their buildings and their architectural theory. *De architectura* was first printed in Rome c.1486 and appeared in an illustrated edition by Fra GIOCONDO in 1511; it appeared in an Italian translation overseen by RAPHAEL (c.1520) and in 1521 was published with the first of many commentaries. The learned edition and translation of Daniele Barbaro (1556, 1566) became the standard ones for later generations. It was subsequently translated into every major European language, and has remained permanently in print. In the sixteenth century the most important exponent of Vitruvian architecture was PALLADIO.

Vittoria, Alessandro

(1525–1608), Italian sculptor in marble, bronze, and terracotta, born in Trento; in 1543 he moved to Venice, where he was trained in the workshop of Jacopo SANSOVINO. He worked for many years in the Palazzo Ducale, where his work includes the stuccoed ceiling of the Scala d'Oro (1555–9) and three statues in the Sala delle Quattro Porte (1587); he was also heavily involved in the repairs after the fire of 1577. He also contributed to the Villa BARBARO at Maser (Veneto), where his stuccoes are combined with frescoes by VERONESE. His monumental sculptures are to be found in many Venetian churches, and there are examples of his bronze figures and portrait busts in the Ca' d'Oro and the Seminario Patriarcale.

Vivarini family

A family of painters in fifteenth-century Venice; their workshop was on the island of Murano. Antonio Vivarini (c.1415–76/84), who was also known as Antonio da Murano, worked with his brother-in-law Giovanni d'Alemagna (d. 1450); the ALTARPIECES that they produced together include the polyptych *Virgin and Child Enthroned with Saints* (1448, Pinacoteca Nazionale, Bologna), to which Antonio's younger brother Bartolomeo Vivarini (c.1432–c.1501) may have contributed. Antonio's son Alvise Luigi (1442/53–1503/5) was trained by his uncle Bartolomeo but was also influenced by Giovanni BELLINI, whose style he imitated; his finest paintings are portraits of contemporary and historical figures, notably his *St Anthony of Padua* (Correr, Venice).

Vos, Maarten Pieterszoon de

(1532–1603), Flemish painter. He was trained in the Antwerp studio of Frans FLORIS and in 1552 travelled to Italy, where he studied in Rome and Florence and then in TINTORETTO's studio in Venice. He returned to Antwerp in 1558, and worked there for the rest of his life. He painted ALTARPIECES that are characterized by the elongation of the figures that he portrayed and the skilful use of light to suggest spaciousness. Vos also painted portraits of Flemish burghers.

Vredeman de Vries, Jan

or Hans (1527–c.1606), Frisian painter, architect, and garden designer. He was born in Leeuwarden (Friesland) and worked in Antwerp, Aachen, Liège, Wolfenbüttel, Hamburg, Danzig, Prague, Amsterdam, and The Hague. He published a series of influential pattern books containing perspective drawings of buildings, gardens, and furniture as well as decorative ornaments. His book of garden plans (*Hortorum viridariorumque elegantes et multiplicis formae*, 1583) was the channel by which the designs of Dutch and Flemish gardens were disseminated throughout Europe.

The gardens which Vredeman designed himself were laid out with a painterly attention to detail and form; he was the first landscape architect to present the garden as a work of art. The most important architectonic element in his gardens was the gallery, which overlooked complementary structures containing FOUNTAINS and PARTERRES. His use of *parterres de pièces coupées* to exhibit exotic plants to best advantage was subsequently copied all over northern Europe.

Vredeman's own designs included the royal gardens in Prague, which subsequently set the style for other Bohemian gardens. His innovative experiments with PERSPECTIVE include TROMPE-L'ŒIL panels of garden vistas, a two-part collection of illusionist art (*Perspective id est celeberrima ars inspicient is*, Leiden, 1604 and 1605), and a treatise on architecture (*Architectura*, 1606).

Vrelant, Willem

or (French) Guillaume Wielant (d. c.1481), Netherlandish miniaturist. He was born in Utrecht, but spent most of his life in Bruges, where he was a friend and neighbour of Hans MEMLING. His most famous work is the *Mirror of Humility*, which was commissioned by Philip the Good and is now in the Bibliothèque Municipale in Valenciennes.

Vriendt

See FLORIS DE VRIENDT FAMILY.

Vries, Adriaen de

(c.1545–1625), Dutch sculptor in Italy and Bohemia. He was born in The Hague but moved as a young man to Florence, where he trained as a sculptor and bronze-founder in the studio of his countryman GIAMBOLOGNA; he subsequently worked in Rome and Prague. His greatest works are FOUNTAINS, notably those commissioned for Augsburg (1598 and 1602) and Copenhagen; the Copenhagen fountain was taken as war booty to Stockholm in 1660 and is now in the Palace of Drottningholm.

Vroom, Hendrik Corneliszoon

(c.1563–1640), Dutch marine artist and tapestry-maker, the first painter to specialize in seascapes and in the depiction of ships. He was commissioned to design tapestries for the Palace of Westminster depicting the defeat of the Spanish Armada; the tapestries were executed by Francis Spiring but were destroyed in the fire that consumed the palace on 16 October 1834.

W

wallpaper

Until the end of the fifteenth century, interior walls in large houses were covered with tapestries or linen wall hangings (e.g. the Wienhausen hangings, near Celle), leather hangings (e.g. GUADAMECÍ), or painted cloths. Wallpapers were a less costly substitute for such wall coverings, and first began to appear in England and France in the 1480s; a century later they were widely used, though they did not replace tapestries in the houses of the aristocracy. Early wallpapers may have been painted, but there are no surviving examples to confirm that hypothesis. In the late sixteenth century, surviving examples are printed from wood blocks and characteristically display black coats of arms and floral patterns on a white or pale background.

Wastell, John

(*fl.* 1485–1518), English builder, the successor of Simon Clark (*fl.* 1445–89) as master mason of the Abbey of Bury St Edmunds and of King's College, Cambridge. He was master mason of the King's College Chapel from 1486, and so is likely to have been the designer of the fan-vaulted ceiling. He later became master mason of Canterbury Cathedral, where he was probably the designer of the crossing tower (1494–7). Many buildings are attributed to Wastell on stylistic grounds, including the retrochoir of the Abbey (now Cathedral) of Peterborough.

watercolour painting

A watercolour is a painting in which the pigment, or colouring substance, is held in suspension with a medium (usually a plant gum) which is soluble in water rather than in oil; it is distinguished from other kinds of painting that use water by the fact that lighter tones are achieved by thinning with water rather than the admixture of a white pigment. The technique has a continuous history from antiquity (on the papyrus rolls of Egypt) to its apogee in nineteenth-century England. In the Renaissance, watercolour painting derives from the related art of manuscript illumination.

The use of watercolour apart from manuscript illumination is unusual in Renaissance art. The best-known watercolours of the period are the landscape pictures that DÜRER executed in the course of his visit to Italy in 1495 and the miniatures of Isaac and Peter OLIVER.

watermarks

Transparent designs embedded in PAPER during the manufacturing process, formed from the impression of bent wire fashioned into an emblem or monograph or personal mark and sewn to the wires of the mould. The wires from which the design is made render the paper on which they are impressed thinner and hence less opaque; the watermark is usually invisible, but can be seen if the sheet of paper is held against strong light. The earliest watermarks appear in Italian paper manufactured in 1282, and by the end of the next century they were commonplace throughout Europe. The purpose of watermarks was to identify the manufacturer and to denote the size and quality of the paper; scholars can use watermarks to establish the provenance and date of paper, and, because books consist of folded sheets of paper, can also detect whether additional sheets have been added to a book.

weaving

The process of manufacturing textile fabrics by interlacing twisted or spun threads in a continuous web; the warp threads are stretched on a loom and the weft threads are passed by turns above and below the warp threads. Weaving was practised in ancient civilizations such as Egypt and China, and has a continuous history in western Europe since antiquity. In the late Middle

Ages the horizontal ground loom was fitted with legs, thus enabling the weaver to use treadles to adjust the heddles which created a space (by lifting some of the warp threads) through which the weft could be passed. Horizontal looms, which are also known as low-warp looms, were used for the manufacture of plain and geometrical fabrics, and upright looms, which are also known as high-warp looms, were used to weave high-quality TAPESTRIES. Italian silk weavers introduced the draw-loom, in which complex machinery manipulated by a draw-boy enabled the weaver to vary the number of warp threads raised each time the weft threads were passed through the warp. LEONARDO DA VINCI designed an automated loom (c.1490), but automation did not begin to affect the practice of weaving until the seventeenth century, when the introduction of automatic looms caused civil disturbances in England, Germany, and the Netherlands.

Wechel family

A dynasty of German humanist printers active in Paris from the 1520s, in Frankfurt from 1572, and subsequently in Hanau and Basel. Christian Wechel (fl. 1520–54) inaugurated the publishing house in Paris, where he specialized in bilingual (Greek and Latin) editions of classical texts and also published contemporary books, including several editions of Alciati's emblem books (in French, German, and Latin), and a large number of medical treatises.

In 1554 Christian's son Andreas Wechel (d. 1581) inherited the business, and in 1572 he moved to Frankfurt to escape persecution as a Protestant in the Wars of Religion. Like his father, Andreas published both ancient and modern authors; many of the latter were radical thinkers.

Wechter, Georg the Elder

(c.1526–1586), German painter and printmaker in Nuremberg. In 1579 Wechter published a set of 30 designs of cups and tankards that remained in use for many years. One of the most influential designs is of a COLUMBINE CUP, which Wechter is sometimes said (in error) to have invented.

Weiditz, Hans

(c.1500–c.1536), German engraver of woodcuts and book illustrator, who may have been born in Strassburg. He was trained in the Augsburg workshop of Hans BURGKMAIR. He designed and engraved many devotional woodcuts and illustrated large numbers of devotional and scientific books and editions of classical authors.

Werve, Claux de

or (English) Nicholas of Werve (1396–1439), Dutch sculptor, born in Haarlem. In 1404 he succeeded his uncle Claus SLUTER as court sculptor to the dukes of Burgundy, and remained faithful to Sluter's style. He completed Sluter's tomb for Duke Philip the Bold at Dijon. He was commissioned to build a tomb for Duke John the Fearless (d. 1419) and his duchess, but died before work began; work on the tomb was continued by the Spanish sculptor Juan de la Huerta (fl. 1431–62), and after he abandoned the project in 1457 it was completed by Antoine MOITURIER. The tombs were designed for the Chartreuse de Champmol but are now in the Musée des Beaux-Arts in Dijon.

Weyden, Rogier van der

(c.1399–1464), Flemish painter, almost certainly the otherwise unknown Rogelet de la Pâture who joined the Tournai workshop of Robert CAMPIN in 1426 and emerged as Maistre Rogier in 1432. In 1435 Rogier van der Weyden was appointed by the city of Brussels as its official painter, and, apart from a visit to Italy in the jubilee year of 1450, remained in the city for the rest of his life. The canon and chronology of his work are both problematical, because none of the pictures attributed to him is signed or dated.

Rogier had a particularly large workshop, and his paintings exercised a profound influence on Netherlandish art. His key works include a dramatic Deposition (Prado, Madrid, see p. 270), attributed to Rogier in late fifteenth-century documents and can be shown to be an early work by virtue of the fact that a dated copy was made in 1443. Other pictures executed before 1450 include the Miraflores altarpiece (Gemäldegalerie, Berlin) and St Luke Painting the Virgin (Museum of Fine Arts, Boston). It was probably in the 1450s that he painted the Frankfurt altarpiece, (Städelsches Kunstinstitut und Städtische Galerie, Frankfurt) and the Entombment (Uffizi). The most important work of Rogier's final years is a Crucifixion (c.1460, Escorial). Products of his workshop include the St Columba altarpiece (Alte Pinakothek, Munich), the Bladelin Triptych (Gemäldegalerie, Berlin), and the polyptych of The Last Judgement in the chapel of the Hôtel Dieu (les Hospices de Beaune) in Beaune.

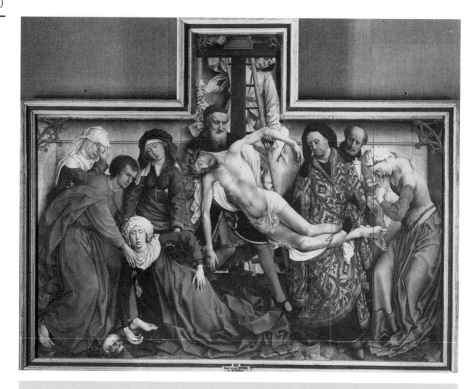

Rogier van der **Weyden** (see p. 269), *The Deposition* (*c*.1442), in the Prado, Madrid. The composition disdains the rules of perspective and the constraints of human posture, placing the Virgin Mary and Jesus (inclined at the same angle) between the figures (shaped like parentheses) of John the Baptist on the left and Mary Magdalene on the right. The figures are crowded together, but each individual is observed with scrupulous attention to detail; even minute details such as the wounds of Jesus and the tears of the mourners are meticulously rendered. The painting was restored in 1993, a process that rectified the shortcomings of an earlier restoration in 1941.

Whitchurch, Edward

(d. 1561), English Protestant publisher, a London grocer who entered into a partnership with Richard GRAFTON, with whom he distributed the English Bible (printed in Antwerp) known as 'Thomas Matthews's Bible', the first complete Bible in English. Together with Grafton he distributed the corrected version of Miles Coverdale's translation of the New Testament (Paris, 1538); they then established a press at which they printed the 'Great Bible' (1539) and the first edition of the Book of Common Prayer (1549).

Wierix family

Netherlandish engravers whose workshop was in Antwerp. Anthonie Wierix the Elder (*c*.1520/5–*c*.1572) was a painter and engraver; his three sons, Anthonie the Younger (*c*.1555/9–1604), Hieronymus (*c*.1553–1619), and Johan (1549–1618), were trained as engravers in their father's studio. The three brothers began to engrave complex designs when they were still very young, and their precocity was accentuated by the declaration of their ages (using the Latin formula *anno aetatis*, 'in the year of [his] age') on their engravings. Hieronymus copied DÜRER's *St George* when he was 12 and his *St Jerome* when he was 13; similarly, Johan copied Marcantonio RAIMONDI's *Venus and Cupid* at 14 and Dürer's *Fall of Man* at 16. In addition to these famous copies, the brothers produced more than 2,000 original engravings, many of which were devotional prints distributed by the Jesuits.

Wimbledon House

a lost house and garden in what is now south London, was built for Thomas Cecil, earl of Exeter (1542–1622); construction began in 1588. A drawing by Robert SMYTHSON made in 1609 shows that the gardens had been laid out in squares and rectangles (like those at THEOBALDS), and that there was a banqueting house in the garden. Shortly after the drawing was made, the planting was extended with an orchard, a vineyard, and a lime walk, all of which were formally organized to facilitate views of and from the garden. These Jacobean plantings were retained when Charles I bought Wimbledon House for Henrietta Maria and commissioned André MOLLET to redesign the gardens; in 1642 Mollet added a MAZE and the first English wilderness, the descendant of the Italian BOSCO. The Elizabethan gardens, however, were replaced by four PARTERRES, two of which had fountains and *parterres de broderie*.

Witte, Pieter de

or (Italian) Pietro Candido or (English and German exonym) Peter Candid (*c*.1548–1628), Netherlandish painter. He was born in Bruges and moved *c*.1570 to Italy, where he worked in Florence, Rome, and Volterra. In 1586 he moved to Munich, where he worked for the rest of his life. He collaborated with Frederich SUSTRIS on the decoration of the Antiquarium, Europe's first museum of antiquities; it was destroyed by Allied bombs during the Second World War. He painted a *Martyrdom of St Ursula* for the Michaelskirche (1588) and the main ALTARPIECE for the Frauenkirche (1620). He was also a designer of tapestries, and produced four series between 1604 and 1618, on *The Months* (of which *March* is in the Residenzmuseum in Munich), *The Deeds of Otto of Wittelsbach*, *The Seasons*, and *The Times of Day*.

Witz, Konrad

(*c*.1400/10–1445/7), German painter. He was born in Rottweil (Swabia), but worked principally in Basel and Geneva. Witz's most important work is the Heilspiegel altarpiece (*c*.1435), a polyptych in sixteen panels; the twelve surviving scenes are now divided between the Kunstmuseum in Basel, the Musée des Beaux-Arts in Dijon, and the Gemäldegalerie in Berlin. Witz's last major work was his altarpiece of *Christ Walking on the Waters* (1444, Musée d'Art et d'Histoire, Geneva), which is celebrated for its depiction of landscape. Witz was also the artist who painted one of the earliest surviving sets of playing cards (Kunsthistorisches Museum, Vienna).

Wolgemut, Michael

(*c*.1434–1519), German painter and woodcut engraver, a native of Nuremberg. He specialized in the design of WOODCUT illustrations for printed books. He was employed by Anton KÖBERGER to design the woodcuts for Hartmann Schedel's *Weltchronik* (1493). His most important surviving paintings are ALTARPIECES in Schwabach and Zwickau (Saxony).

Wollaton Hall

which has now been absorbed into Nottingham, was built between 1580 and 1588 by Robert SMYTHSON for Sir Francis Willoughby (*c*.1546–1596). The house is square, and its two high storeys rise to a third in the corner pavilions. The exterior is richly decorated with gables, pinnacles, and more than 200 statues. Many of the architectural details derive from the treatises of Sebastiano SERLIO and Jan VREDEMAN DE VRIES.

The gardens, which are now lost, are known from a plan by John Smythson (Robert's son) and a painting at Yale University; the plan shows that the gardens, which consisted of three adjoining squares extending from the back of the house, were organized symmetrically around an axis running squarely through the house. Although this arrangement is common in Italian and French gardens, this is the only Renaissance garden in England known to have been organized in this way; the design derives ultimately from Serlio, as mediated by Jacques DUCERCEAU's *Les Plus Excellents Bâtiments de France* (1576 and 1579).

woodcut

or (early modern English) wooden cut, a design cut in relief on a block of wood for the purpose of making PRINTS and the term used to denote the print obtained from this process. The artist draws a design on the flattened surface of a block of wood and then uses knives and gouges to cut away the parts that are to be left white in the print. The design, which stands proud in a relief, is then inked and pressed on a sheet of paper. The ensuing print bears a design which is the mirror image of that drawn by the artist. The technique is to be

distinguished from ETCHING and ENGRAVING, which are both intaglio processes in which designs are printed from the grooves incised in the plate.

The woodcut has existed in the Middle East and China since antiquity, but in Europe the earliest woodcuts date from the beginning of the fifteenth century; the delay may have been occasioned by the lack of any western technology for making PAPER until the end of the fourteenth century. In the course of the fifteenth century woodcuts came to be produced all over Europe, and were used extensively for the production of religious prints, playing cards, and BLOCK BOOKS. With the advent of printing, woodcuts became the ideal process for the production of book illustrations, because the relief surface of the block could be made the same height as the type, which meant that engraved blocks could be locked together with movable type in the press. The most celebrated woodcut illustrations of the fifteenth century are DÜRER's *Apocalypse* woodcuts of 1499 and those contained in the *Hypnerotomachia Polifili* (also 1499) of Francesco Colonna.

In the sixteenth century, when illustrated books were produced in large numbers, the various stages in the process became the province of specialized craftsmen: the designer of the print was sometimes a prominent artist such as Hans BALDUNG GRIEN, CRANACH, Dürer, Urs GRAF, or HOLBEIN; the artist's drawing was transferred to the engraver's block by a specialist in such transfers, and another artisan gouged the wood, whereupon the block was passed to the printer;

the names of the printers are usually known, as are those of many of the artists, but block cutters are normally anonymous.

Woodcuts were ideally suited to Gothic designs with strong lines, but were inferior to engravings and etchings as a means of reproducing complex shaded designs, in part because the woodcut is not amenable to cross-hatching. In the seventeenth century the use of woodcuts came to be restricted to utilitarian purposes such as printers' devices and the production of broadsheets.

Worde, Wynkyn de

or Jan van Wynkyn (d. 1535), Alsatian printer in England. Worde became assistant to CAXTON in 1476 on the latter's establishment of a printing press in London. He inherited the business on Caxton's death in 1492, continuing to run it from a new base in Fleet Street until his own demise. His catalogue of books published is an important record of the early book trade.

Wyngaerde, Anthonis van den

(c.1525–1571), Flemish painter, draughtsman, and etcher who travelled throughout the Netherlands and in England, France, Italy, and Spain. In the course of his travels he made many topographical drawings, of which the principal collections are in Antwerp (Plantin-Moretus Museum), London (Victoria and Albert Museum), Oxford (Ashmolean Museum), and Vienna (Österreichische Nationalbibliothek). The largest set of drawings are those of Spain, made when Philip II commissioned Wyngaerde to draw all the principal towns and cities in the country; more than 60 of these Spanish topographical drawings survive.

XYZ

Xanto Avelli, Francesco

See AVELLI, FRANCESCO XANTO.

Yáñez de la Almedina, Fernando

(*fl.* 1506–31), Spanish painter who collaborated with Fernando de Llanos (*fl.* 1506–16) on twelve panels depicting *The Life of the Virgin Mary* on the high altar of Valencia Cathedral. The style of the paintings is the basis for the suggestion that one of these Fernandos is the 'Ferrando Spagnolo' who was working with LEONARDO in 1505 on his painting of the battle of Anghiari. The two painters separated in 1513, and the last reference to Yáñez is to work being undertaken in 1526 on the altarpiece of Cuenca Cathedral.

Ysenbrandt, Adriaen

(d. 1551), Flemish painter. He worked in Bruges, where he was admitted to the guild as a master in 1510. He was a pupil of Gérard DAVID, and the pictures that have been attributed to Ysenbrandt, such as *Mary Magdalene in a Landscape* (National Gallery, London), are painted in the style of David and in some cases imitate works by David.

Zainer, Günther

(d. 1478), German printer, born in Reutlingen; he was probably the brother of Johann ZAINER. He seems to have been trained in the workshop of Johann MENTELIN in Strasbourg, and in 1468 he established the first printing workshop in Augsburg. His publications include the first illustrated Bible (1475), the first printed edition of the *De imitatione Christi* of Thomas à Kempis, and an edition of the thirteenth-century *Golden Legend* (*Lombardica historia*) of the Genoese hagiographer Jacobus de Voragine in which the lives of the saints are illustrated with 231 woodcuts.

Zainer, Johann

(d. *c.*1500), German printer, born in Reutlingen; he was probably the brother of Günther ZAINER. In the early 1470s Zainer moved to Ulm, where he established a printing workshop that specialized in illustrated books. In 1476 he published the first edition of Aesop's *Fables* in German.

Zeiner, Lucas

(*fl.*1479–1512), Swiss glass stainer in Zürich who specialized in small glass panels with heraldic designs. The intricate detail of his designs was achieved by using a quill to scratch the thin layer of coloured glass that covered the clear glass below.

Zeitblom, Bartholomaus

(*c.*1460–*c.*1520), German painter. He was born in Nördlingen, and may have been a pupil of Martin SCHONGAUER before settling in Ulm (*c.*1482), where he supplied large ALTARPIECES painted in a Gothic idiom to various towns in Swabia. The lyrical element in his work attracted the enthusiasm of nineteenth-century German Romantics, who described Zeitblom as the 'German PERUGINO' and even the 'German LEONARDO'.

Zell, Ulrich

(d. 1507), German printer who established the first printing workshop in Cologne in 1464. In the course of his career he printed more than 200 titles, mostly works of theology published for the benefit of members of Cologne University. His edition of the *Cologne Chronicle* (1499) contains an account of the invention of printing in which he claims that GUTENBERG was anticipated in his use of movable type by printers in Haarlem, of whom Laurens KOSTER was the first.

Zenale, Bernardino

(*c.*1464–1526), Italian painter, born in Treviglio (near Bergamo), where he collaborated with his fellow citizen Bernardino Butinone (*c.*1450–*c.*1507) on the polyptych for the cathedral. They also worked together on a fresco cycle depicting *The Life of St Ambrose* for the Church of San Pietro in Gessate in Milan. Near the end of his

life Zenale wrote a treatise on PERSPECTIVE, but it was not published and no manuscript copy is known to survive.

Zoppo, Marco

(1432–78), Italian painter and draughtsman, born near Bologna and trained in the workshop of SQUARCIONE in Padua. Zoppo pursued his career in Venice (1455 and 1468–73) and in Bologna, where he painted a triptych for the Collegio di Spagna. Fragments of his altarpiece for the Church of San Giustina in Venice (1468) survive in the National Gallery in London (*St Augustine*) and the Ashmolean Museum in Oxford (*St Paul*). A large collection of his drawings is preserved in the British Museum.

Zuccaro

or Zuccari, Federico (*c.*1540–1609), Italian painter and art theorist and the younger brother of Taddeo ZUCCARO, born in Vado (near Urbino) and trained in his brother's studio in Rome. He lived for a time in Venice, where he painted the fresco of *Barbarossa Kissing the Foot of the Pope* (1582) in the Palazzo Ducale. He returned to Rome in 1566, and on the death of his brother in the same year assumed control of the studio and of Taddeo's unfinished commissions, including the decoration of the Villa FARNESE in Caprarola, the Farnese Palace in Rome, and the Sala Regia in the Vatican.

In 1573 or 1574 Zuccaro travelled to England, where he drew Queen Elizabeth and the earl of Leicester (both drawings are in the British Museum) and is said to have painted portraits of the queen and members of her court, all of which are now lost. He later travelled and painted in Venice, Loreto, and Rome before accepting the invitation of Philip II of Spain to the ESCORIAL, where he painted several ALTARPIECES

(1585–8). He returned to Rome and became the founding president of the Accademia di San Luca, to which he later donated his house. In 1607 he published a theoretical treatise entitled *L'idea de' pittori, scultori ed architetti*.

Zuccaro

or Zuccari, Taddeo (1529–66), Italian painter, born in Vado (near Urbino). In 1551 he moved to Rome, where he decorated the Cappella Mattei (completed 1556) in the Church of Santa Maria della Consolazione. He became an exponent of history painting, which he produced in his large studio; his apprentices included his younger brother Federico ZUCCARO. Taddeo's commissions included the decoration of the Villa FARNESE in Caprarola, the Farnese Palace in Rome, and the Sala Regia in the Vatican; all three were completed by his brother after his death.

Zuccaro was the most important artist to have made designs for ISTORIATO wares. VASARI records that Zuccaro designed the table service commissioned by Guidobaldo II della Rovere, duke of Urbino, for presentation to King Philip II of Spain; the designs, which depict scenes from the life of Julius Caesar, were executed in MAIOLICA, apparently at the FONTANA factory in Urbino, and some of the plates survive in museums, including the Bargello in Florence.

Zündt, Mathias

(*c.*1498–1572), German goldsmith, etcher, and draughtsman who trained in the JAMNITZER workshop in Nuremberg and subsequently worked in Prague. None of his work is known to survive, but many of his engraved designs for jewellery and silver were implemented by other artisans. His etchings, which were published between 1565 and 1571, include maps, battlepieces, and portraits.

FURTHER READING

Reference books

The standard English-language reference book is the *Grove Dictionary of Art* (34 vols. 1996), which is now published by Oxford University Press in a print version and in a revised electronic version. Many of its 41,000 articles contain bibliographies on individual artists and architects.

Hugh Brigstocke (ed.), *The Oxford Companion to Western Art* (Oxford, 2001).

James Stevens Curl, *A Dictionary of Architecture* (Oxford, 2000).

John Fleming and Hugh Honour, *The Penguin Dictionary of Decorative Arts* (2nd edn, Harmondsworth, 1989).

Patrick Goode and Michael Lancaster (eds.), *The Oxford Companion to Gardens* (Oxford, 1986).

Harold Osborne (ed.), *The Oxford Companion to the Decorative Arts* (Oxford, 1975).

Early Sources

Leon Battista Alberti, *Della pittura* (1435), trans. J. R. Spencer as *On Painting* (London, 1956).
—— *De re aedificatoria* (1452; rev. edn. 1485), trans. Joseph Rykwert, Neil Leach, and Robert Tavernor as *On the Art of Building in Ten Books* (Cambridge, Mass., 1988).

Karel van Mander, *Het schilderboeck* (1604), trans. Hessel Miedema as *The Lives of the Illustrious German and Netherlandish Painters* (4 vol., Doomspijk, 1994–7).

Piero della Francesca, *De prospectiva pingendi* (before 1482), not readily available in English but translated into French by Jean-Pierre Le Goff as *De la perspective en peinture* (Paris, 1998).

Giorgio Vasari, *Vite* (1550; revised edition 1568), trans. Julia Conway Bondanella and Peter Bondanella as *Lives of the Artists* (Oxford, 1998).

General Surveys

Jan Bialostocki, *The Art of the Renaissance in Eastern Europe: Hungary, Bohemia, Poland* (Oxford, 1976).

Anthony Blunt, *Art and Architecture in France, 1500–1700* (5th edn., New Haven, 1999)

George Kubler and Martin Soria, *Art and Architecture in Spain and Portugal and their American Dominions 1500–1800* (Harmondsworth, 1959).

E. H. Gombrich, *Norm and Form: Studies in the Art of the Renaissance* (4th edn., London, 1985).

Frederick Hartt and David Wilkins, *A History of Italian Renaissance Art: Painting, Sculpture, Architecture* (5th edn., New York, 2003).

Gert von der Osten and Horst Vey, *Painting and Sculpture in Germany and the Netherlands* (Harmonsworth, 1969).

Erwin Panofsky, *Renaissance and Renascences in Western Art*, 2 vols. (2nd edn,. Stockholm, 1965).

James Snyder, *Northern Renaissance Art: Painting, Sculpture, the Graphic Arts from 1350 to 1575* (New York, 1985).

Painting

Jonathan Brown, *Painting in Spain, 1500–1700* (New Haven, 1998).

S. J. Freedberg, *Painting in Italy 1500–1600* (2nd edn., Harmondsworth, 1993).
—— *Painting of the High Renaissance in Rome and Florence*, 2 vols. (Cambridge, Mass., 1961).

Erwin Panofsky, *Early Netherlandish Painting: Its Origins and Character* (2 vols., Cambridge, Mass., 1953).

Grete Ring, *A Century of French Painting, 1400 to 1500* (London, 1949).

Evelyn Welsh, *Art in Renaissance Italy, 1350–1500* (Oxford, 2000).

Sculpture

Charles Avery, *Florentine Renaissance Sculpture* (London, 1970).

Theodor Müller, *Sculpture in the Netherlands, Germany, France and Spain* (Harmondsworth, 1966).

John Pope-Hennessy, *Italian High Renaissance and Baroque Sculpture* (4th edn., London, 2000).

Charles Seymour, *Sculpture in Italy, 1400–1500* (Harmondsworth, 1966).

Architecture

Paul Crossley, *Gothic architecture* (New Haven, 2001).

Ludwig Heydenreich, *Architecture in Italy, 1400–1500* (New Haven, 1996).

Henry-Russell Hitchcock, *German Renaissance Architecture* (Princeton, 1980).

Wolfgang Lotz, *Architecture in Italy, 1500–1600* (2nd edn, New Haven, 1995).

H. A. Milton and V. M. Lampugnani, (eds.), *The Renaissance from Brunelleschi to Michelangelo: The Representation of Architecture* (London, 1994).

Peter Murray, *The Architecture of the Italian Renaissance* (new rev. edn., London, 1986).

Rudolf Wittkower, *Architectural Principles in the Age of Humanism* (4th edn., London, 1988).

CHRONOLOGY

Year	Art and Architecture	The Contemporary World
1260	Nicola Pisano carves the Gothic pulpit of Pisa Baptistery	
1305	Giotto begins fresco cycle of the *Lives of the Virgin and Christ* in the Arena Chapel in Padua	Election of Pope Clement VII, who in 1309 established the papacy at Avignon, where it was to remain until 1377
1333	Simone Martini and Lippo Memmi paint their collaborative *Annunciation*	
1336	Andrea Pisano completes bronze doors for the baptistery in Florence	
1337		Hundred Years War between England and France (1337–1453)
1342	Ambrogio Lorenzetti completes *The Presentation in the Temple* (begun 1337)	
1403	Ghiberti begins work on the second set of bronze doors for the baptistery in Florence (completed 1424)	The Ottoman Sultan Beyazit I, who had been captured by Tamerlane, dies in captivity
1420	Brunelleschi begins work on the dome of Florence Cathedral	King Henry V of England captures Paris
1423	Gentile da Fabriano paints *The Adoration of the Magi*	
1425	Ghiberti begins work on the third set of bronze doors for the baptistery in Florence (completed 1452); Masaccio and Masolino work on the frescoes in the Brancacci Chapel in Florence	Henry the Navigator captures the Canary Islands, which are claimed by Portugal until 1479, when they revert to Castile
1432	Donatello's *David* is installed on a pedestal in the courtyard of Palazzo Medici; Hubert and Jan van Eyck complete the Ghent altarpiece	
1434	Jan van Eyck paints *Arnolfini and his Wife*	Cosimo de' Medici the Elder returns to Florence from exile and assumes control
1442	Rogier van der Weyden paints *The Deposition*	
1447	Andrea del Castagno paints *The Last Supper* on the refectory wall of the Monastery of Sant'Apollonia in Florence	
1453	Donatello completes his equestrian statue of the *condottiere* Gattamelata; Fra Filippo Lippi paints *Madonna Adoring her Child with St Bernard*	Ottoman Turks capture Constantinople; Hundred Years War ends
1456	Piero della Francesca paints *The Flagellation*	Gutenberg completes publication of the first printed Bible (begun 1452)
1460	Paolo Uccello paints *The Hunt in the Forest*	

Year	Art and Architecture	The Contemporary World
1464	Piero della Francesca paints portraits of Federico II da Montefeltro, count (later duke) of Urbino, and his countess Battista Sforza	
1470	Alberti designs the Church of Sant'Andrea in Mantua; Pollaiuolo engraves *Battle of the Naked Men*	
1474	Mantegna completes the decoration of the Camera degli Sposi in Mantua	Isabella the Catholic succeeds to the throne of Castile; in 1479 her husband Ferdinand succeeds to the throne of Aragon, so uniting Spain
1478	Botticelli paints *Primavera*	Ferdinand and Isabella establish Spanish Inquisition
1480	Leonardo da Vinci receives commission to paint *The Virgin of the Rocks*	
1484	Botticelli paints *The Birth of Venus*	
1490	Piero di Cosimo paints *The Forest Fire*	
1492		Columbus sails for America; Ferdinand and Isabella conquer Granada and expel Jews from Spain
1494		Charles VIII of France invades Italy, so inaugurating the Wars of Italy (1494–1599)
1495	Leonardo da Vinci starts work on the *Last Supper* in Milan; Dürer visits Italy	Manuel I, the eponym of Manueline architecture, succeeds to the throne of Portugal
1497	Michelangelo begins to carve the *Pietà* for St Peter's Basilica (completed 1499)	Vasco da Gama sails for India
1501	Giovanni Bellini paints portrait of Leonardo Loredan, doge of Venice	
1503	Leonardo da Vinci starts to paint *Mona Lisa* (completed 1507)	
1504	Michelangelo's *David* is installed in the Piazza della Signoria in Florence; Luca Signorelli completes his fresco cycle in Orvieto Cathedral	Columbus returns from his final voyage
1507	Raphael paints *La Belle Jardinière*	
1509		Henry VIII becomes king of England
1510	Construction of Bramante's Tempietto di San Pietro in Montorio (Rome) begins; Giorgione paints *Sleeping Venus*	
1512	Michelangelo completes the frescoes on the ceiling of the Sistine Chapel; Raphael completes the Stanza della Segnatura	French forces are driven out of Milan and the Sforzas return to power in the duchy (till 1515)
1515	Grünewald completes the *Crucifixion* panel of the Isenheim altarpiece	Francis I becomes king of France
1517	Titian paints *Flora* (c.1515–20); Andrea del Sarto paints *Madonna of the Harpies*	Luther posts his 95 Theses on the door of the castle church in Wittenberg
1527		Rome is sacked by imperial troops

Year	Art and Architecture	The Contemporary World
1533	Holbein paints *The Ambassadors*	Pizarro captures Cuzco, the Inca capital
1540	Benvenuto Cellini receives commission from King Francis I to make a golden salt cellar (completed 1543)	
1541	Rodrigo Gil de Hontañón designs the façade of the Colegio de San Ildefonso in Alcalá de Henares (completed 1543)	
1545	Cellini returns from Fontainebleau to Florence	Council of Trent (1545–63)
1549	Wenzel Jamnitzer casts the *Mother Earth* table-centre	
1550	Vasari publishes first edition of *Lives of the Artists* (expanded second edition, 1568)	
1555	Veronese begins fresco cycle on *Esther and Ahasuerus* in the Church of San Sebastiano in Venice (completed 1570)	Bishops Latimer and Ridley burnt at the stake in Oxford
1556	Tintoretto paints *Susanna and the Elders*	Emperor Charles V abdicates
1557	Pieter Bruegel the Elder's *Big Fish Eat Little Fish* (drawn 1556) engraved and published	
1558		Princess Elizabeth becomes queen of England
1562	Veronese paints *Marriage Feast at Cana*	Wars of Religion in France (1562–98)
1564	Death of Michelangelo	Birth of Shakespeare
1565	Tintoretto begins a cycle of more than 50 paintings for the Scuola di San Rocco in Venice (completed 1587)	Siege of Malta
1567	Palladio designs Villa Rotunda in Vicenza	Revolt of the Netherlands (1567–1609)
1571	Ammanati begins the Neptune Fountain in the Piazza della Signoria in Florence (completed 1575)	Battle of Lepanto
1572		St Bartholomew's Day Massacre
1580	Robert Smythson commences construction of Wollaton Hall, nexes Nottinghamshire	Sir Francis Drake completes his circumnavigation of the world; Spain an- Portugal (1580–1640)
1583	Giambologna's *Rape of a Sabine* is English installed in the Loggia dei Lanzi in Florence	Sir Humphrey Gilbert establishes an colony in Newfoundland
1588		England defeats Spanish Armada
1592	Marcus Gheeraerts the Younger paints the 'Ditchley Portrait' of Queen Elizabeth	
1618		Outbreak of Thirty Years War (ends 1648)

PICTURE ACKNOWLEDGEMENTS

Colour
Bridgeman Art Library 9; British Museum, London/Bridgeman Art Library 15; © Centre des Monuments Nationaux, Paris 16; Comune di Firenze, Servizio Musei Comunali 2; © Chris Lisle/Corbis 10; © National Gallery, London 1, 4, 8; © Photo RMN – J.G. Berizzi 7; © Photo RMN – Lewandowski/LeMage/Gattelet 5; © 1996, Photo Scala, Florence 3; ©1990, Photo Scala, Florence 14; © 1995, Photo Scala, Florence – courtesy of the Ministero per i Beni e le Attività Culturali 6; © 1991, Photo Scala, Florence – courtesy of the Ministero per i Beni e le Attività Culturali 11; © 2001, Photo Scala, Florence – courtesy of the Ministero per i Beni e le Attività Culturali 12, 13.

Black & white
Albertina, Vienna p.75; Archivi Alinari p.ix, p.3, p.10, p.39, p.73, p.111, p.112, p.167, p.205, p.208, p.263; Photo:Thomas Photos, Oxford/Copyright Bodleian Library, University of Oxford p.191; Ashmolean Museum, University of Oxford/Bridgeman Art Library p.258; Musée des Beaux-Arts, Dijon, France/Lauros/Giraudon/Bridgeman Art Library p.49; Merilyn Thorold/Bridgeman Art Library p.195; © Araldo de Luca/Corbis p.xxi; © Arte & Immagini srl/Corbis p.36; Private Collection. Photograph: Photographic Survey, Courtauld Institute of Art p.225; Fitzwilliam Museum, Cambridge p.185; © Fabbrica di San Pietro, Vatican p.176; Gemäldegalerie Alte Meister, Staatliche Kunstsammlungen Dresden p.115; Glasgow Museums: The Burrell Collection p.25; Institut Amatller d'Art Hispànic, Barcelona p.33; Copyright IRPA-KIK, Brussels p.88; Kunsthistorisches Museum, Vienna p.53; The Metropolitan Museum of Art, Purchase, Joseph Pulitzer Bequest, 1917 (17.50.99) p.83; Museo del Prado, Madrid p.270; © National Gallery, London p.151, p.165; By Courtesy of the National Portrait Gallery, London p.109; © Photo RMN – Arnaudet p.171; © 1990, Photo Scala, Florence p.xiv, p.70, p.99, p.211; © 2000, Photo Scala, Florence p.237; © 1990, Photo Scala, Florence – courtesy of the Ministero per i Beni e le Attività Culturali p.107, p.135; V&A Picture Library p.15.

Endpapers
The design is taken from a decorative panel (dated 1576) in a church in Breslau (now Wrocław).